,	¥ . *			
		,		

Also by John Canaday

The Metropolitan Seminars in Art, a series of twelve monographs (published by the Metropolitan Museum of Art, New York, at monthly intervals beginning in 1958), and Great Periods in Painting, a second series of twelve monographs beginning in 1959.

Mainstreams of Modern Art (Holt, Rinehart & Winston, 1959)

Embattled Critic (Farrar, Straus & Giroux, 1962)

Culture Gulch (Farrar, Straus & Giroux, 1969)

Lives of the Painters, 4 volumes (Norton, 1969)

The Artful Avocado (Doubleday, 1973)

Keys to Art, with Katherine H. Canaday (Tudor, 1964)

WHATISART?

				,
	5			
			,	

WHATISART?

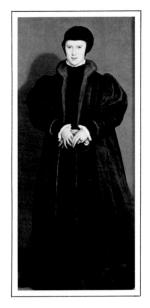

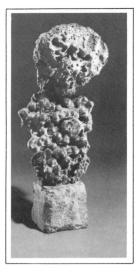

AN INTRODUCTION TO PAINTING, SCULPTURE AND ARCHITECTURE

by JOHN CANADAY

HUTCHINSON

Hutchinson & Co. (Publishers) Ltd
An imprint of the Hutchinson Publishing Group
3 Fitzroy Square, London W1P 6ID

Hutchinson Group (Australia) Pty Ltd 30–32 Cremorne Street, Richmond South, Victoria 3121 PO Box 151, Broadway, New South Wales 2007

Hutchinson Group (NZ) Ltd 32–34 View Road, PO Box 40–086, Glenfield, Auckland 10

Hutchinson Group (SA) (Pty) Ltd PO Box 337, Bergvlei 2012, South Africa

First published in Great Britain 1980

Copyright © 1980 by John Canaday

Published by arrangement with Alfred A. Knopf, Inc.

Grateful acknowledgment is made to Random House, Inc., and Faber and Faber Ltd for permission to reprint "Musée des Beaux Arts" by W. H. Auden. Copyright 1940 and renewed 1968 by W. H. Auden. Reprinted from W. H. AUDEN: COLLECTED POEMS, by W. H. Auden, edited by Edward Mendelson. Reprinted by permission of Random House, Inc., and Faber and Faber Ltd.

Coming Home for Thanksgiving by Grandma Moses, copyright © 1980 by Grandma Moses Property Co., New York.

Printed and bound in the United States of America

ISBN 0-09-141840-2

To Katherine

•			
	•		
		,	
		x	

CONTENTS

Introduction
WHAT IS ART?

3

WHAT IS A PAINTING?

11

SCULPTURE

33

ARCHITECTURE

53

REALISM

59

EXPRESSIONISM

95

ABSTRACTION

117

COMPOSITION AS PATTERN
145

ON AS STRUCTU

COMPOSITION AS STRUCTURE

COMPOSITION AS NARRATIVE

THE PAINTER'S TECHNIQUES

PRINTS

263

THE ARTIST AS SOCIAL CRITIC 289

THE ARTIST AS VISIONARY

325

EPILOGUE

362

GLOSSARY

365

INDEX

379

This book is a revision and extensive enlargement of The Metropolitan Seminars in Art, a series of twelve monographs on the appreciation of painting written for the Metropolitan Museum of Art and distributed by the Book-of-the-Month Club. Sections on sculpture and architecture have been added, and those on painting have been enlarged to cover recent developments as well as revised in the light of changed attitudes toward art—my own, and those of the public this book is written for. Even so, the discussions of painting are for the most part adapted directly from the Seminars, and I want to thank the Metropolitan Museum for having generously given permission to draw upon that material so freely.

John Canaday

New York, 1979

		,	

WHATISART?

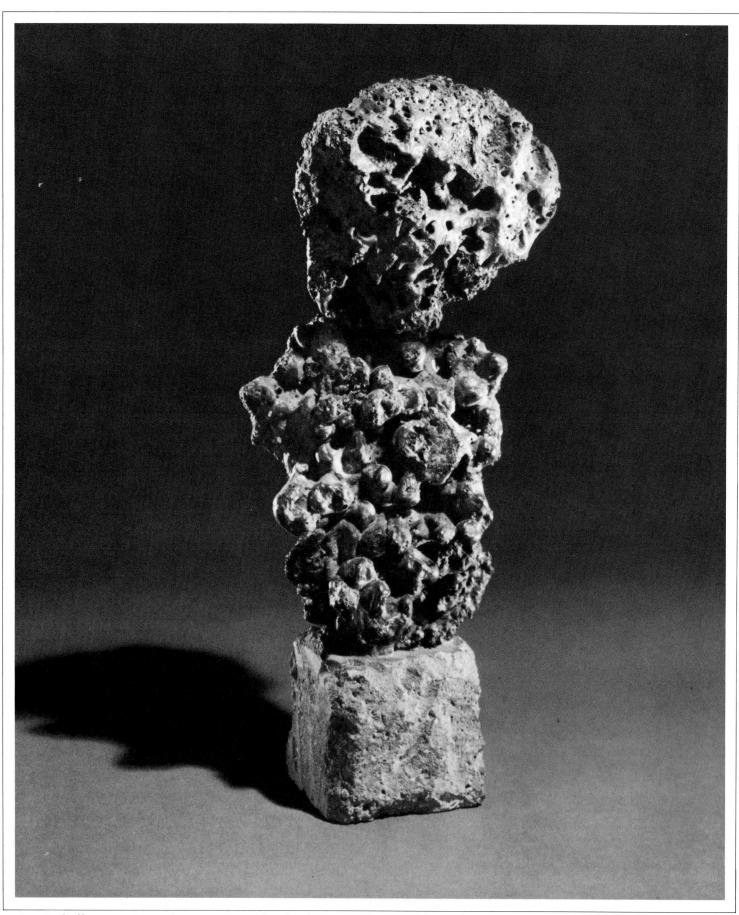

1. Jean Dubuffet. Nourrice Profuse. 1954. Iron slag, height 145% inches. Hirshhorn Museum and Sculpture Garden, Smithsonian Institution, Washington, D.C.

Introduction

WHAT IS ART?

The only way to begin this book is to make clear that we are not going to arrive at any single answer to the question, What is art? Art has so many aspects, takes so many directions, serves so many purposes in such a variety of ways, that the question is almost as big as the biggest of all, What is life?

The two questions, in fact, overlap. The popular phrase "art for art's sake" implies that art can be an escape from life, but this—fortunately—is a delusion. Rather than an escape, art is an enrichment, and the underlying premise of this book is that art and living are inseparable and mutually sustaining, and always have been, ever since the appearance of human beings on our planet. "Creativity of man as distinguished from the world of nature" is the dictionary definition (one of many) that comes closest to answering our first question. This creativity and an awareness of history are the two characteristics most frequently cited as distinguishing human beings from animals.

For most people who enjoy it without knowing much about it, art's first function is to be "pleasing to the eye"—a sound enough idea as far as it goes. Art has served life as an embellishment from the day our prehistoric ancestors first smeared magical signs on their bodies with colored clays up to this moment, when no one reading this page is likely to be in a position to look away from it without seeing dozens of embellishments in one or another form of art—the patterns of rugs, bookbindings, and upholstery; the shapes of moldings, ashtrays, and knickknacks; the color and design of clothing—blue jeans being just as much an embellishment as are embroidered robes—and whatever pictures hang on the walls. Presuming that these objects were chosen because they were more attractive than others, the eye that chose them is pleased. But to stop with this pleasure is to deny ourselves the further ones of understanding why the eye is pleased and how these various forms and patterns evolved over the centuries and millennia of art history. The genealogy of virtually any painting or sculpture, no matter how modern, can be traced back to the ancient world or even to savage and prehistoric peoples.

The idea that art is created to please the eye leaves unanswered the question as to how an object like *Nourrice Profuse* (1) by the modern French artist Jean Dubuffet can please art critics even though it grates on eyes habituated to the beauties of more conventional sculpture. To such eyes, *Nourrice Profuse* looks like a lump of slag iron—which is exactly what it is. But it is not *only* a lump of slag iron. Nor can this ugly object—we will call it ugly for the moment, since we will be seeing it again—be very easily explained by a definition of the function of art widely accepted by estheticians, which is "to bring order to the chaotic material of human experience."

This definition is applicable enough when we test it on the Parthenon (3), a work

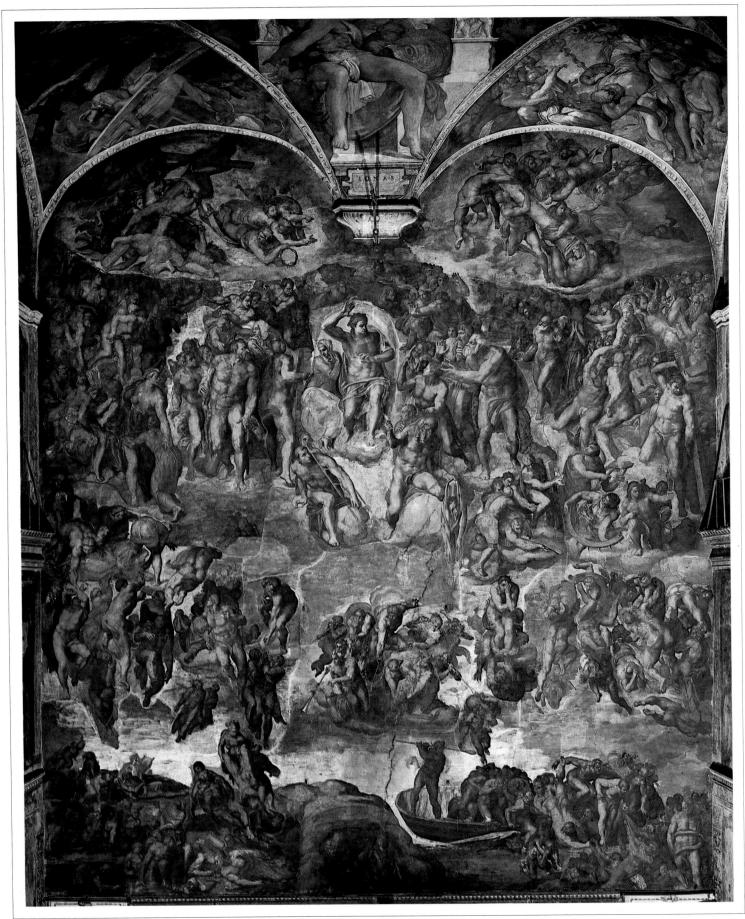

2. Michelangelo. Last Judgment. 1536-41. Fresco, 48 by 44 feet. Sistine Chapel, Vatican, Rome.

of art so perfectly ordered that even in ruins it is the consummate affirmation that life is a reasonable affair, that its goals can be formulated and achieved, that all confusion and ugliness can be vanquished in the creation of an ultimate harmony, a vital clarity.

But what becomes, then, of Michelangelo's thunderous Last Judgment (2) in the Sistine Chapel, which is all turbulence and terror? Even the martyrs, the saints, and the blessed on their way to Paradise seem to share the convulsions of the damned. On purely esthetic grounds we can rationalize that the Last Judgment is a carefully organized painting and thus "brings order" to its chaotic subject; but primarily this scene of universal damnation intensifies our experience of desperation and terror by investing these familiar human emotions with awesome grandeur.

So we extend the idea of bringing order to the chaotic material of human experience to form the second premise upon which this book is built, which is: The function of art is to clarify, intensify, or otherwise enlarge our experience of life. "Otherwise enlarge" affords a necessary catch-all that overlaps clarification and intensification but reaches into fields ranging from Dubuffet's *Nourrice Profuse* to the most acutely realistic paintings and sculptures ever created, with some of the most conventionally eye-pleasing in between.

Finally, every interpretation or analysis of a work of art in this book will be made within the all-embracing conviction that painting, sculpture, and architecture are the truest and most complete witnesses to the nature of the times and places that produced them. This is an argument that would have to be defended in debate with poets, musicians, dancers, playwrights, novelists, philosophers, and, above all, historians. Our defense would begin with the question as to which arts other than painting, sculpture, and architecture have left records dating back into prehistory and can bring the observer, or listener, or reader more vividly and immediately into the presence of immortal genius of all times and places without such obstructions as translation, notation, reconstitution, and guesswork. Fortunately, though, no art really has to be defended at the expense of another in the wonderful interplay of ideas by which all the arts make up the history of civilization. A knowledge of any art is an enrichment of the rest.

In its most obvious function as witness to centuries of change, art is a topical record describing how things, places, and people have looked, a function now preempted by the camera. The Clock Tower in the Piazza San Marco, Venice (4), by Antonio Canale, called Canaletto, tells us detail by detail how one wonderful spot in that always wonderful city looked when Canaletto recorded it about 1740. The picture is beautiful in the purest, least complicated sense of the word, and to say that it is "only" a topical record is both accurate and unjust. It is an impeccable technical performance by a master craftsman and certainly a work of art to delight any eye. Yet in the end it is a report, owing

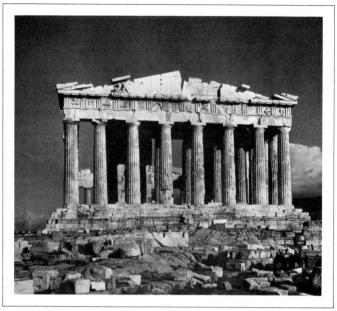

3. Iktinos and Kallikrates. The Parthenon. About 447–432 B.C. The Acropolis, Athens. Photograph by Alison Frantz, Princeton, New Jersey.

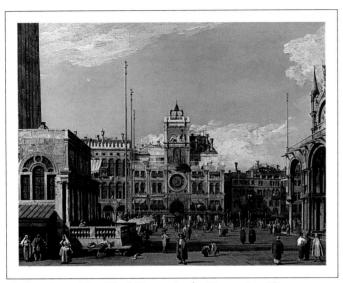

4. Canaletto. *The Clock Tower in the Piazza San Marco, Venice.* About 1740. Oil on canvas, 20¾ by 27¾ inches. Nelson Gallery–Atkins Museum, Kansas City, Missouri. Nelson Fund.

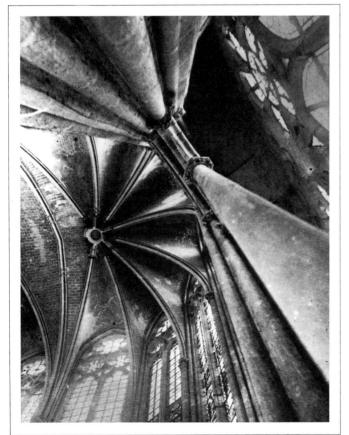

5. Choir vaulting, Cathedral of St. Peter, Beauvais. Thirteenth-century. France.

more to the beauty of a fantastic city than to creative invention on the part of the artist. Canaletto applied technical prowess of the highest order—but here we come to the difference between highly developed abilities and innate creative genius.

This is not to say that Canaletto is a human camera insensitive to esthetic values or to the mood of his extraordinary city. His adjustments of perspective and his unification of the sky and all below it in a consistent half-magical light are the crucial difference between his paintings and those of studio assistants who helped turn out hundreds of Venetian views for tourists of the day. The dictionary's second definition of art is "Skill: craftsmanship," and by that definition alone Canaletto would be one of the great masters in the world rather than an admirable painter of enchanting views, which is a fair statement of the position given him today by art historians.

As a more profound record of its time, art rarely depends on topical reference, distilling instead the essence of the faith or philosophy by which people of that time lived, or tried to live. New art forms seem almost literally to invent themselves in response to changing ideals.

As an example:

Around the middle of the twelfth century a miraculous process of germination seemed to be taking place in the soil of Europe, beginning in France, then spreading through the continent and into England. Churches began to rise as if gigantic seeds of stone had sprouted and thrust new and wonderful forms into the light, growing higher and higher and more and more elaborate in competition with one another, becoming eventually the piers and columns of the Gothic cathedrals, slender stalks flowering at last into vaults supported by webs of ribs like the veins of leaves or petals (5). On the exterior, this upward striving was continued in spires that rose higher than any structures ever before imagined, tapering and finally disappearing in points that merged with the sky.

The Gothic cathedral summarized the spiritual aspirations of an age that had at the very least its full share of human evils—cruel wars, torture, superstition, ignorance, filthy poverty, political and religious persecution, and mass hysteria. Some of these abominations were perversions of the forces of faith, terrible facts that historians have recorded. But the cathedrals rise above terrible facts as witnesses to a glorious truth, the mystical faith symbolized by the soaring forms.

Contradictorily, this mystical expression was achieved by new feats of practical engineering. The great height of the cathedrals, with their hovering, apparently weightless stone vaults, demanded building methods more daring than any the world had yet known—for that matter, as daring as any the world has ever known. Cathedral vaults are ordinarily etherialized by the dim light in which we see them from the floor; it is only when they are brightly lit for purposes of photography (6) that their geometrical patterns are fully revealed, patterns that are continued on the exterior by the geometrical forms of the buttresses supporting them (7).

Geometry, of all branches of mathematics, is the one that clarifies and organizes our daily experience of lines, planes, and volumes, revealing their logical interrelationships in a way that inspired one poet to write: "Euclid alone has looked on beauty bare." Euclidian geometry held an honored position in the Middle Ages, being one of the four liberal arts (arithmetic, geometry, astronomy, and music) designated by scholars as the quadrivium, the higher division of the seven liberal arts completed by the trivium of grammar, logic, and rhetoric. But it hardly seems probable that the architect-builders of the Gothic cathedrals, faced with the practical problems of inventing vaulting systems to cover spaces of unprecedented height and width, were much concerned with philosophical interpretations of the Euclidian patterns that they employed in meeting the structural demands of weight and stress-and even less probable that they were conscious of the beautiful coincidence by which their engineering, their creation of mystical space by practical means, paralleled the philosophical exercises by which theologians set out to prove the existence of a mystical God in nonmystical terms.

Beginning with the premise of revelation, medieval philosophers constructed logical systems to prove God's existence, even while architect-engineers were constructing vaults to create the space that, for the Middle Ages, was the symbol of God, crystallizing the coincidence of medieval cathedral architecture with medieval thought. Integrating architecture with the arts then still subservient to it, the cathedrals were encrusted with sculptures expounding theological and scientific doctrines, while painting was represented by tapestries, murals, and the ultimate glory of walls of stained glass telling the history of the world as the Middle Ages conceived it.

We have considered Gothic cathedral architecture at some length in this introduction because it exemplifies so well our premise that the forms art takes are inevitably determined, as if self-invented, by forces within the times that demand appropriate expression. The more complex a civilization becomes, the less possible it is for a single work of art to summarize its culture. Regarded as a single work of art combining architecture, sculpture, and (as it originally did) color, the Parthenon is such a summary, created when Athens was a small city (100,000 people) with a corresponding unity and clarity of goals, in contrast with the modern city that now sprawls out around the Acropolis. There is no single Gothic cathedral that can be called the perfect summary of its time (Chartres comes closest), but the Gothic cathedral generically is that summary. After that, there are complexes of architecture, sculpture, and painting—St. Peter's in Rome, for instance—that come close to summarizing their times or at least vital segments of those times; but when we get to the nineteenth century, the prolixity of contrasting monuments is evidence of the

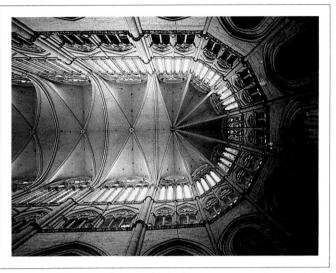

6. Choir vaults, Cathedral at Amiens. Begun 1220. France.

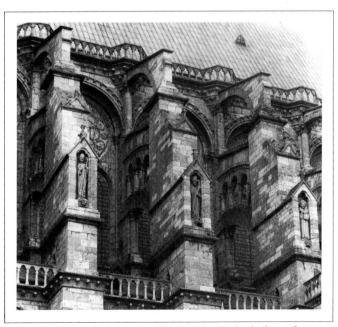

7. Flying buttresses of the nave, Cathedral at Chartres. 1194–1220. France.

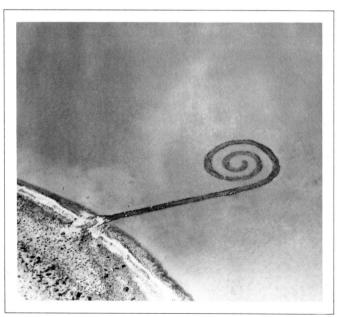

8. Robert Smithson. Spiral Jetty. 1970. Earth and minerals, diameter 40 feet. Great Salt Lake, Utah.

complexity of an age that defies summary in a single expression. In France alone we would have to pit the Paris Opera House (considered later on in this book), with its brilliant transmutation of traditional themes, against the Eiffel Tower, with its denial of those themes, and even then we would not have dealt with a century of painting that was itself a series of revolutions.

As for our own time, our wonderful and terrible century, is there a work of art or assemblage of works of art that represents us at our best, as the Parthenon represents ancient Greece, the cathedrals the medieval world?

Perhaps the question belongs at the end of this book, but let us anticipate it and propose that the spectacle of New York City from the air at night is that composite work of art. We can even make a direct comparison with what we have said about the Middle Ages, a far from ideal period in terms of daily life that produced a glorious expression of faith. Similarly, New York seen from the air rises above the dross that surrounds us.

New York at street level (like the rest of our civilization) is often ugly, violent, sordid, dirty, noisy, confused, corrupt, and inhumane. It is a city where good living is the prerogative of those who can pay for it. But none of this is any more true of New York today than it has been of the representative metropolises of the past—ancient Rome, medieval Paris, seventeenth-century Rome, eighteenth-century London, and nineteenth-century Paris, which held its own well into the twentieth century. As the supermetropolis of the latter half of our century, New York has a vitality about it that for many people, even some of those who suffer most from the difficulties the city imposes, makes living there an indispensable condition of existence.

Artists who have set out self-consciously to express our century in its own terms have capitalized on materials and methods unique to its technology—all kinds of plastics. neon lights, computer-directed motion for computer-designed sculpture, and, at the other extreme, industrial waste products (here we come again to Nourrice Profuse) and the detritus of a consumer society. Sculptures have been made from crushed automobile hoods and fenders, and welded from discarded machine parts. In the late 1950's and early 60's artists of all kinds (painters, sculptors, musicians, dancers, writers, and their ringsiders) pooled their efforts in impromptu events called "happenings," performances improvised in studios or sometimes in experimental museums, that were supposed to invest the arts with spontaneous life by freeing them from consumer strictures. But no happenings ever approached in interest or spontaneity the spectacle of life on the streets of New York. Some artists, believing that the day of art for collectors and museums is finished, have theorized that the solution to the problems that have removed art from life and entombed it in private collections and public institutions is to create works of art in nature, built from the ground they lie on. Robert Smithson's Spiral Ietty (8), one of the most ambitious and more enduring of such projects, has become the standard example of in situ works of art that declare man's capacity for transforming nature even while recognizing nature as a basic fact of our lives.

While none of our efforts, some foolish and others serious, to create new art forms appropriate to our times can be more than fragmentary expressions of our inconceivably complex culture, all of them are fused in the single compound work of art called New York City—not as experiments and not as art forms, but in satisfaction of demands peculiar to our times that had to be met in practical terms.

Manhattan is a small island transformed by the works of man. Seen from the air at night, it is an anonymous manmade work of art, a phenomenon possible only in this century, the century of the airplane, glass-and-steel construction, the automobile, and electric light. Seen from above in daylight, the skyscrapers are spectacular enough (9), their towering clusters transformed from architecture into titanic sculptures—or titanic natural forms of a newly discovered planet. At night (10) they dissolve in their own light; neon signs become scattered jewels; the blazing crisscross pattern of streets surrounds a large, dark rectangle through which wind a few wavering lines of light—Central Park. The spectacle is doubly kinetic: its masses shift as our aerial point of vision moves across the island, and on the island itself the traffic flows in liquid light. Everything sordid, ugly, and trivial disappears in an astounding affirmation that the values our society lives by are ultimately valid, whatever their distortions at close range.

But all of that, we said, perhaps belongs at the end of this book. As a beginning, we will subdivide the question, What is art?, and deal in some of the particulars of that vast generality, beginning with the question, What is a painting?, and following it with considerations of sculpture and then architecture. The same order will be followed chapter by chapter.

This is the reverse of a traditional sequence by which architecture is recognized as the parent art, with sculpture closely bound to it and subject to its demands, while painting is semi-independent of the filial bond. The bond in any case holds firmly only into the Middle Ages, weakening in the Renaissance. In our times both painting and sculpture have long since left the fold and are totally independent arts. Their union with architecture, when it occurs, is a matter of collaboration on an equal basis, not of meeting predetermined parental requirements. We have reversed the sequence in this book because painting is the art that people have the most questions about today, and because the answers so often apply to sculpture and architecture as well.

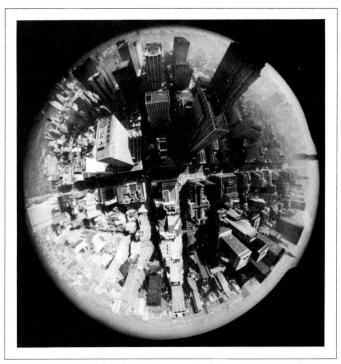

9. Rockefeller Center, aerial view. New York City.

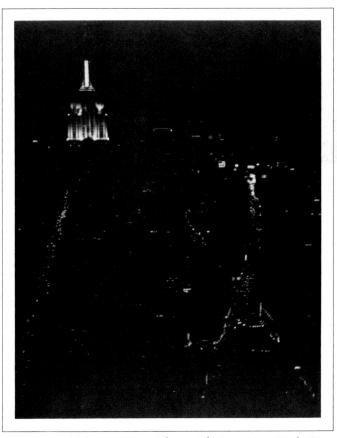

10. Midtown area, night aerial view. New York City.

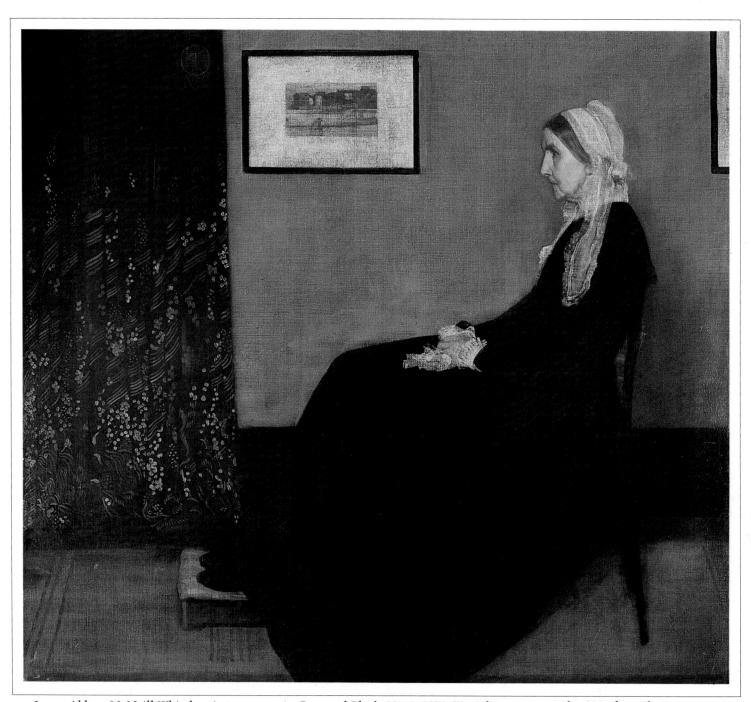

11. James Abbott McNeill Whistler. Arrangement in Gray and Black, No. 1. 1871–72. Oil on canvas, 56 by 64 inches. The Louvre, Paris.

Chapter One

WHATIS A PAINTING?

painting is a layer of pigments applied to a surface. It is an arrangement of shapes and colors. It is a projection of the personality of the artist who painted it, a statement—or at least a partial statement—of the philosophy of the age that produced it, and it can have meanings beyond anything concerned with the one person who painted it or the one period in which it was created.

For something like fifteen or twenty thousand years—that is, until our century and the revolution called modern art—a painting was also a picture of something, whether it was the work of Rembrandt or the sorriest hack alive, even though Rembrandt's painting of, say, an old beggar would be a profound philosophical comment on the human condition, and the hack's would be the tritest kind of picturesque sentimentality. In the nineteenth century, when art exhibitions first became a form of popular entertainment, art's new audience was not up to making that kind of distinction and felt safe enough in enjoying a painting simply as a picture (the words were virtually synonymous) of something—a man, a dog, a vase of flowers, the Madonna, a battlefield (in France, preferably Napoleonic), a small boy stealing cookies—and that was that.

To judge the merits of a painting by this standard was a simple affair. A picture was good first to the extent that the objects represented in it "looked real," and second to the extent that the artist's interpretation of the subject conformed to established ideas of what was entertaining (the small boy stealing cookies), or beautiful (the vase of flowers), or uplifting (the Madonna), or simply informative.

We like to think that all that has changed, and to a certain degree it has, but the twentieth century cannot look back smugly on the popular taste of the nineteenth. In spite of our proliferated museum and art education programs, this limited response to painting—not to esthetic qualities but to subjects that in themselves are entertaining, beautiful, uplifting, or informative in the most obvious ways—is not only persistent today but remains dominant outside a relatively limited circle. The American art public since about 1950, after decades of exposure to evangelism for modern art, is no doubt the most sophisticated in the world, yet the only artist to receive front-page headlines two days in a row in *The New York Times* on the occasion of his death was not Picasso but Norman Rockwell.

Norman Rockwell has been without doubt the general public's most beloved painter in the history of American art. Whether offering a humorous subject such as No Swimming (12), or the piously folksy Thanksgiving scene Freedom from Want (13), Rockwell's pictures are always easy to read, either as images, which are affectionately commonplace, or as ideas, which are so standard that preconditioned response is automatic. At this level of conception it makes no difference—in truth,

THE SATURDAY EVENING POST

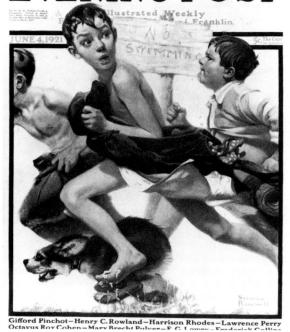

12. Norman Rockwell. *No Swimming.* 1921. Oil on canvas, 24¹/₄ by 24¹/₄ inches. Estate of Norman Rockwell.

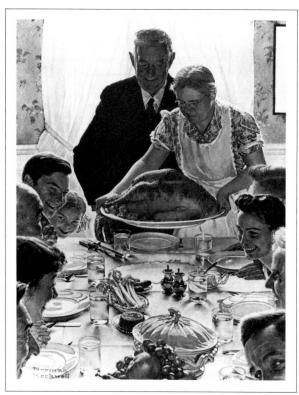

13. Norman Rockwell. Freedom from Want. 1943. Oil on canvas, 45½ by 35½ inches. Estate of Norman Rockwell.

it is a help—that the expressions on faces are just as posed, as self-consciously assumed, as are the bodily attitudes, and that any stimulation of the imagination, any extension or enlargement of experience, is rigorously avoided.

Pictures of this kind are easily derided—too easily perhaps, in view of one important virtue: they please and art is meant to be enjoyed. The trouble is that enjoyment at their level is nothing more than a stirring up of stock responses to stock subjects, a form of picture enjoyment unrelated to the inexhaustible pleasures offered by exploration of the art of painting—deeper pleasures that can often be discovered beneath popular surface attractions.

Take, as an elementary exercise, a painting that has become so barnacled with Rockwellesque associations that its true character has become obscured—the painting universally but incorrectly known as Whistler's Mother (11). It comes off very well by the standards we have just mentioned. It "looks real" to such a degree that it suggests soft-focus photography (14). Its subject immediately calls into play the double reverence we feel for motherhood and old age. These associations are stirred up even more vigorously because this picture of a mother in her old age was painted by her son, adding filial devotion to the already impressive sum of virtues tied in with the subject. With such admirable connections, Whistler's Mother might have found its way into popular favor even if it had been a very bad painting. It happens to be a very fine painting, but not because it is a lifelike portrait of an old lady by her son.

The correct title is still the one Whistler gave it and always insisted upon: Arrangement in Gray and Black. And the real subject is a mood, a mood compounded of gentleness, dignity, reflection, and resignation. This mood may be suggested by the quiet pose of the old lady, but it is completed by the shapes and colors Whistler chose to use and the relationships he established among them. The disposition of form and color, termed "composition"—that is, the way a picture is put together—can be, as here, the most important single factor in the expressive quality of a painting.

Surely it is obvious that the quiet and tender mood Whistler had in mind could not be relayed through vivid colors and jagged shapes in complex or agitated relationships to one another. Hence the artist reduces the background to a few subtly spaced rectangles of subdued neutral tones, and against this background the figure of the old lady is reduced to a silhouette nearly as geometrical and just as uneventful. The head, the hands, and the scattering of luminous flecks on the curtain serve as relieving accents, lighter in tone and livelier in shape, in a scheme that might otherwise have been monotonous and melancholy.

At the risk of being unfair to an honest and proficient illustrator who never pretended to be more than he was, and in the certainty of offending his enormous public, let us imagine how Norman Rockwell might have gone about painting *Whistler's Mother*. In the first place, the picture would not be an arrangement in gray and black but a lively

conglomeration of objects painted in cheerful colors, and the old lady would be *doing* something—not just sitting there. She might be knitting, in which case the immediate associative pictorial response of a kitten playing with a ball of yarn on the floor would be incorporated. A rag rug, affording an opportunity for maximum display of the artist's talent for precisely detailed description, might be included among other homely accessories in the sunny room to show how happy the old lady is in the modest family home where she lives. The pictures on the wall would lose their function as compositional elements and become narrative aids; perhaps the old lady's wedding photograph would be there, with some affectionately humorous pictorial comment on the groom's dandified moustaches. Any possible vestiges of

14. Detail from Arrangement in Gray and Black.

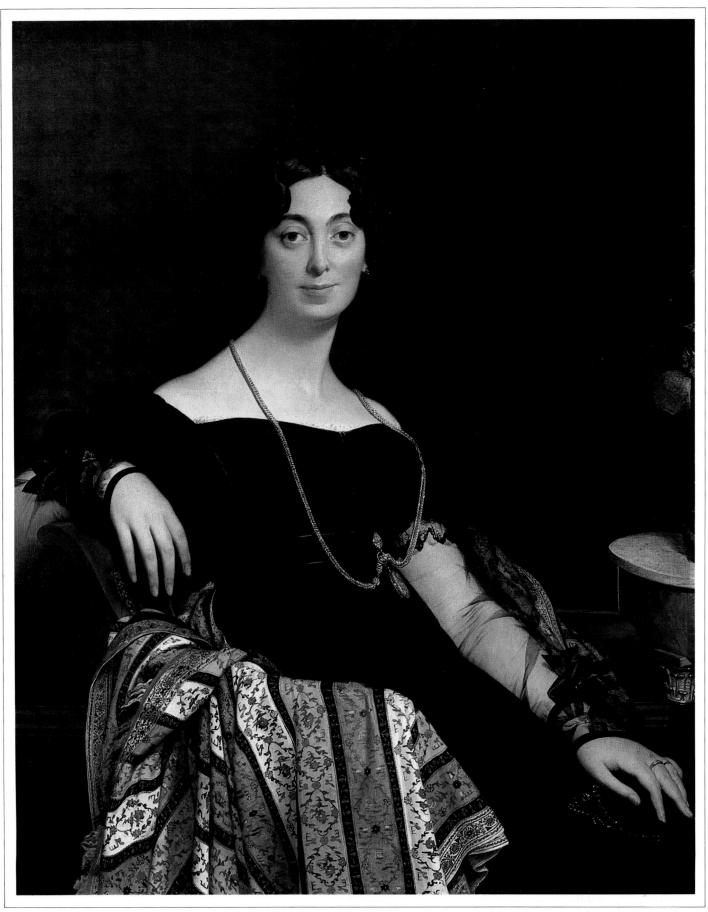

15. Jean-Auguste-Dominique Ingres. *Madame Leblanc*. 1823. Oil on canvas, 47 by 36½ inches. The Metropolitan Museum of Art, New York. Wolfe Fund, 1918.

the Whistlerian mood of loneliness and resignation would be removed by the introduction of a small boy or girl—or one of each—peeking into the room from behind the curtain at the left, and the whole thing would be polished off by a pair of granny-type spectacles over which the old lady would beam at her grandchildren. The fact that none of this would have anything much to do with life as it is has everything to do with why a vast audience would love *Rockwell's Mother*.

Why this same public loves *Whistler's Mother* must be explained on another basis. We have said that even if this had been a bad picture, it might have been a popular one. But it would never have become as widely known and loved as it is now, because even people who never doubt that their enjoyment comes from the subject matter of *Whistler's Mother* are being affected, whether they realize it or not, by the expressive composition of *Arrangement in Gray and Black*.

Composition affects our reaction to a picture, regardless of whether we think of it in compositional terms. If the arrangement of shapes and colors is successful, we respond as the artist intended us to, without asking ourselves why. But once we are aware of composition as an element in painting, we have the additional pleasure of discovering how the artist goes about evoking the response he is after. These two pleasures are perfectly compatible. In the same way, we may be moved by a great performance in the theater while simultaneously, quite aside from our emotional participation, we admire the actor's skill.

The structure of a composition can be tested by blocking off different areas with pieces of paper. Effective little pictures-within-pictures may be isolated in this way, but the fragments can never say the same thing as the total of a good composition, not because part of the subject matter is eliminated but because the relationships of shapes and colors have been disturbed. If everything in *Arrangement in Gray and Black* is blocked off except the central figure, you still have a picture of an old lady sitting in a chair. Nothing has been eliminated that tells part of a story or adds to what we know about this particular woman. But the picture's mood is gone. This picture, in fact, suffers in countless cheap reproductions where it is chopped off along the edges for convenience in putting it into a frame or onto a page.

We have said that a painting is a projection of the personality of the artist who painted it, and also a statement—or at least a partial statement—of the philosophy of the age that produced it. We will illustrate these points by comparing four portraits of young women, all of them fine or even great pictures, each of them different.

Ingres's *Madame Leblanc* (15) is more easily understood than the others because its intention is less profound. It has, superbly, what is usually expected in a woman's portrait—attractive grace, impeccable technique, and a personable sitter. It tells us nothing more about Madame

16. Detail from Madame Leblanc.

Leblanc than that she was a member of the prosperous upper middle class endowed with a pleasant combination of features.

Since it is the work of the most eminent portraitist of his day, we may take for granted that the likeness of Madame Leblanc has the required combination of veracity and flattery that a photographer achieves today by retouching. Madame Leblanc's features were probably less regular than they are shown here (16), her neck less elegant, and her fingers not so beautifully tapered. Without question, Ingres has made the most of her good points and minimized her shortcomings. The lady is further beautified by the presence of the exquisitely painted shawl, the jewelry, and the suggestions of fashionable interior decoration, since in a picture all the elements partake of the quality of all the others.

Madame Leblanc's is an utterly charming portrait. Perhaps it can suggest, too, the way of life of a certain class of people during a certain period in France, if we are already familiar with the period (the portrait is dated 1823); but as an interpretation, as an effort to present anything more than an entrancing effigy, it hardly exists, for it makes no attempt to explore the personality of the sitter. At most, we could say that this woman's individuality—her degree of intelligence, her capacity for emotion—has been concealed beneath the painting's exquisite surface in a way comparable to the way she herself perhaps concealed any strong individual characteristics in conformity to a social code of behavior.

Ingres's approach is, of course, a legitimate one in spite of its limitations. The picture has a virtue imperative to all good painting: harmony between what the painter wants to do and the means he uses to do it. Elegance, grace, and refinement disciplined by exquisite drawing and patterned by an artist with a genius for the creation of beautiful line—this is the recipe for an Ingres portrait. Further study could reveal complications and nuances, but essentially this is a picture we can accept at its most apparent values. It is all it appears to be—not much more, nothing less. Compositionally, it is a suave disposition of shapes whose contours have been designed into linear delights, and while this particular effigy is entrancing, it is not exactly an interpretation of the subject since Ingres applied the same formula to virtually all his portraits of women.

But not every picture, not even every portrait of a woman, wants to be or say the same thing. Madame Leblanc must have been delighted. She would certainly have been offended if she had been painted as Renoir painted his wife (17). Unlike Madame Leblanc's, this portrait holds deeper meanings beneath the simplicity of its apparent subject. This simplicity is extreme. A round-faced and buxom young woman in a hat and blouse sits facing us, smiling, her hands resting in her lap. That is all. There is no background of landscape, nor of a room, nor even of drapery. The entire image is there for us at a glance, without

elaboration or distractions. Its appeal is immediate. It is bright, fresh, and happy.

Still, any number of pictures of young women are bright, fresh, and happy but are not in museums. What does this one have that any bright, fresh, happy magazine cover does not? What makes Renoir a great painter?

He was a fine technician, but so were hundreds of other painters of his generation who could do anything they wanted with a brush except paint great pictures. His life, as a series of events, holds nothing extraordinary. He lived through early struggles to see himself accepted at last as an important artist, but so did many of his contemporaries whose names have been forgotten, whose pictures now seem so dull and pretentious that they have been relegated to museum basements.

It is as simple as this: Renoir is a great painter because he had a joyous adoration of life and the ability to translate it into visual terms so that all of us may understand and share it. Many fortunate men have held the same joyous faith, but few other painters have combined it with Renoir's special gift for expressing it so richly. Other painters are great for entirely different reasons. This particular greatness is Renoir's own.

His art flows from an unwavering conviction of the world's goodness. He sees happiness, in its deepest sense, as the natural state of mankind, and finds it everywhere in the world around him. His art is direct, simple, and profound because it reflects a personal philosophy that was direct, simple, and profound. For Renoir, life was such a miracle that simply to take part in it gave meaning to existence.

His *In the Meadow* (19)—we will return to the portrait of his wife in a moment—sums up his joyousness in an especially fresh and delicious painting. The canvas shimmers with color. Everything glows with budding fertility. The grass, the trees, the landscape in the distance, the young girls, even the light and air that permeate the picture—everything blossoms and breathes in the perfection of a spring day. There is nothing unusual about the girls or the meadow where they sit. Renoir's subjects are never unusual. He paints in the conviction that the greatest values in life are, quite naturally, the simplest ones.

For Renoir these values are materialized and concentrated in woman—but not woman as a temptress, not even as an individual, and certainly not as a being with psychological quirks and fancies worth exploring. She is none of these things because she is something more: she is the source of all warmth and life in the world. Children, flowers, and fruit are natural adjuncts of this conception. Renoir's men, when they appear at all, appear as suitors, not with the aggressive force of the conquering male but as gentle idolaters of the female principle. It is this concept of woman as a basic universal symbol that makes the difference between the importance of a Renoir and the triviality of a merely attractive magazine cover, no matter how skillfully the magazine cover may be executed and no matter how successfully it fulfills its limited function.

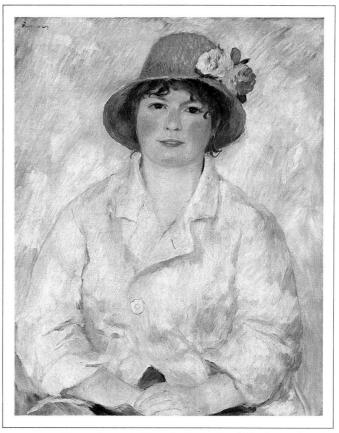

17. Pierre Auguste Renoir. *Portrait of Madame Renoir.* About 1885. Oil on canvas, 25³/₄ by 21¹/₄. Philadelphia Museum of Art. W. P. Wilstach Collection.

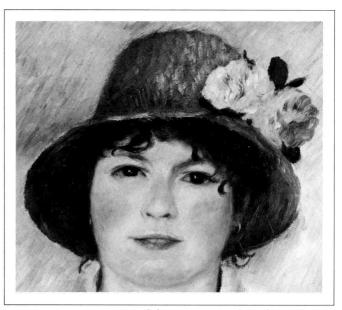

18. Detail from Portrait of Madame Renoir.

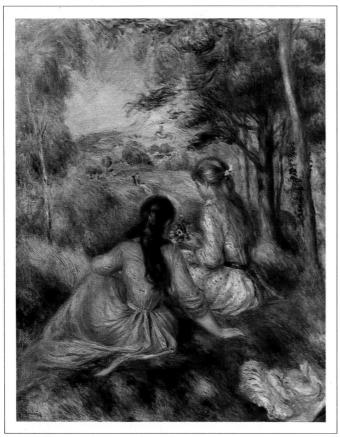

19. Pierre Auguste Renoir. *In the Meadow*. About 1890. Oil on canvas, 32 by 25¾ inches. The Metropolitan Museum of Art, New York. Bequest of Samuel A. Lewisohn, 1951.

And so, returning to the *Portrait of Madame Renoir*, the picture has a second and deeper meaning beneath the apparent one, by which it becomes the image of an earth goddess while remaining the tender record of an unexceptional young woman in a straw hat with a couple of roses pinned to it. In other words, the picture's message is universal, expressed in terms of the particular, a recipe for the interpretation of the world that in one variation or another has been effective for more than two thousand years and remains as vigorous as ever.

How does Renoir go about creating this universal symbol?

First, by using his subject as it existed in nature only as a point of departure, and by modifying it to suggest the eternal quality that woman, for him, represents. Artists of all periods, when they hunt for a meaning beneath the transient surfaces of things, have thought in terms of geometrical design. The fundamental nature of a symbol is somehow harmonious with the finality of a simple geometrical form.

Try now to see the *Portrait of Madame Renoir* not as a picture of a young woman but as a structure of strong, solid volumes.

These volumes, these forms, are much simpler than they would have been in a literal reproduction of the model's appearance. As Renoir has drawn them, the face and crown of the hat are combined to describe a solid, regular ovoid form. It is no accident that the hat brim repeats this oval in the opposite direction (18). And the mass of the figure, if we follow a line along the shoulders and arms, approximates half an oval or ovoid of the same shape, although it is larger and slightly irregular. The neck is a cylinder, and this same sturdy form is repeated, although not quite so obviously, in the arms.

If such an analysis sounds artificial, it is because the total effect of a work of art is more than the sum of the technical means used to achieve it. The point is that Renoir reduces his subject to large, solid, uncomplicated masses because such forms are suggestive of eternal values.

The danger Renoir runs in modifying the image in this direction is that it may become ponderous and inert. Hence he throws the figure slightly off balance (toward our right). As a kind of grace note, to relieve and accentuate the stability of the main forms, he combines the little bouquet of leaves and roses into a more broken silhouette, although he allows it at the same time to echo the oval forms. Finally he gives full freedom to the curling irregularities of the escaping locks of hair. The sharp V's in the lapels and the neckline of the blouse serve as contrast to the dominating rounded forms. The more the painting is studied in this way, the more apparent it becomes that everything in this deceptively simple composition is planned, and that to change any of it, for instance to make the button much larger or smaller, to change its position, or to make it one of a row of buttons, would put this detail out of its most harmonious relationship to the rest of the picture.

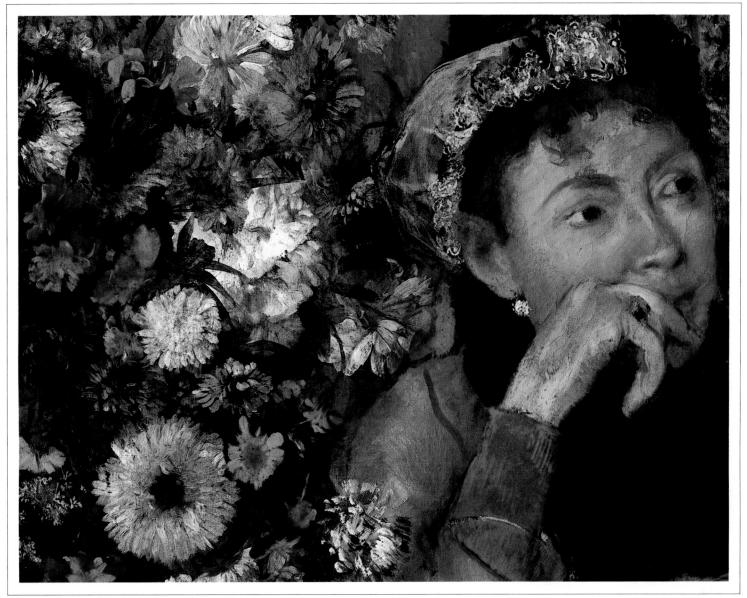

20. Detail from Woman with Chrysanthemums.

The image combines stability with a sense of vivid life. Much of this life comes from the rich sparkle of the pigment. The picture would be ruinously transformed if it were repainted with the almost chilly precision that is appropriate to Ingres's *Madame Leblanc* or with the softness of the Whistler. It is difficult to say why Renoir's paint is so alive; it is a matter of "touch"—the despair of the analytical critic, the defeat of the forger, the birthright of the natural painter, and for the observer a direct source of communication with the artist.

As for its reflection of a place and time, the picture is French through and through. Mystical or near-mystical veneration of woman is a constant factor in French art, expressed in forms ranging from medieval statues of the Virgin to allegorical portraits of eighteenth-century courtesans. Renoir is directly in line with this tradition, but he expresses it in terms of his own triumphantly bourgeois century. The nineteenth century placed its faith neither in

21. Edgar Degas. Woman with Chrysanthemums (Madame Hertel). 1865. Oil on canvas, 29 by 36½ inches. The Metropolitan Museum of Art, New York. Bequest of Mrs. H. O. Havemeyer, 1929, the H. O. Havemeyer Collection.

medieval mysteries nor in eighteenth-century refinements; a faith in the commonplace was basic to its philosophy. So was it to Renoir's. But he lifted the commonplace into the realm of the ideal, and in so doing became a spokesman for the love and respect for simple things that persists at the core of French life.

In discussing the Renoir as if it had achieved a kind of perfection, as indeed it has, we may seem to have left nothing for other portraits of women to achieve. But the glory of the art of painting is that instead of single perfections it offers multitudes of perfections. We will compare the Renoir with a picture by his friend and close contemporary, Edgar Degas, whose Woman with Chrysanthemums (21) was painted within a few miles and a few years of the Renoir.

We can imagine what Renoir would have done with the subject. Woman and flowers would have fused into a glowing symbol of bountiful fruition. But such an interpretation was impossible for Degas; he was as doubtful of life's goodness as Renoir was certain of it.

Degas's art reveals him as a man who is essentially a pessimist, who is not certain that he knows the meaning of life, not even certain that one exists. He is a doubter, except on one score: of life's fascination as a continuous, if haphazard, spectacle, he holds no doubt whatsoever. He is absorbed by the look of people, especially women, as they go about their daily affairs. He might be described as a passionate spectator. He is sensitive to human beings as psychological phenomena rather than (as Renoir's women must have seemed to him) as masses of protoplasm.

Like Renoir, Degas is a nineteenth-century Frenchman preoccupied with woman and the commonplace. But he is not the same kind of man as Renoir, and he is going to reflect this subject matter in a contrasting way.

Woman with Chrysanthemums is a brilliantly eccentric composition. Ordinarily the subject of a portrait holds the center of the canvas. Degas pushes this one far to one side. Ordinarily the subject either looks directly at the observer or regards some object within the frame or, at most, looks dreamily into space. This one looks out beyond the picture at something apparently familiar to her but unidentified and tantalizingly unidentifiable to us. The average portrait builds up its brightest colors and strongest contrasts in ways that ensure the subject its rightful climax of interest. But Degas not only gives over the center of this picture to a richly painted explosion of flowers while he crowds his subject against the frame; he also paints the woman in virtual monochrome and allows her to conceal part of her face with one hand (20). By violating all the conventions of portrait composition, he achieves a picture brilliant beyond anything most painters achieve by following them.

Why does Degas compose in this eccentric way? Because where Renoir composed to create an expression of eternal stability, Degas wants us to feel that we have come upon the woman with the chrysanthemums by chance. Where Renoir is enraptured by life in its wholeness, Degas is fascinated by its fragments. He composed the majority of his paintings as if they were segments of larger compositions. Paradoxically, though, the chance effect is meticulously controlled. Degas never falls into the trap of novelty for its own sake. His idiosyncratic compositions are always as sound as they are original, as satisfying as they are provocative.

We saw Renoir rejecting background in the portrait of his wife to enhance the universality of the image. A specific background tends to define place and time, thus reducing the timelessness and everywhereness appropriate to a universal symbol. Naturally Degas, interested in life as a transient spectacle, sharply defines the locale and the moment. In *Woman with Chrysanthemums* we can deduce such specific factors as the social level and financial bracket of the subject, just as we could with *Madame Leblanc*. But we are also aware of the woman as a person capable of thinking and acting in certain ways under certain circumstances.

Yet in the end she remains enigmatic, as Degas surely intended her to be. She half hides a half-smile, which may be half mocking. In her feminine elusiveness she is like another woman, known to us all in the most famous portrait in the world, painted four centuries earlier: Degas's Woman with Chrysanthemums is a nineteenth-century Mona Lisa.

Leonardo da Vinci's Mona Lisa (22), like the Renoir and the Degas we have just seen, is only secondarily a representation of the sitter, whose identity and personal relationship with Leonardo have inspired a great deal of romantic speculation. The woman we now call Mona Lisa was in fact the wife of a Florentine businessman, but there is no basis for the legend that the portrait commemorates an unhappy love affair (and even less for the argument, sometimes advanced, that the sitter was a man). None of this is of any real importance, since Mona Lisa, all other considerations aside, is a personality created by Leonardo da Vinci.

Some aspects of a picture that strike us as bizarre have been made bizarre by time. The eyebrows, if not shaved, have disappeared over the years. The hairline is raised far back by plucking or shaving in accord with a fashion of the day. The costume, richly theatrical to us, may also have been modish. As an additional difficulty, the picture has been too famous for too long; it is impossible to see it with a fresh vision. We never see it for the first time; it has always been around. It is no longer a picture; it is an institution.

Absurd legends have become attached to it—even such superstitious ideas as that the eyes "follow you around the room" and that the lips, stared at long enough, "begin to smile." It is unfortunate, too, that the picture has been called the greatest picture in the world. No picture can be

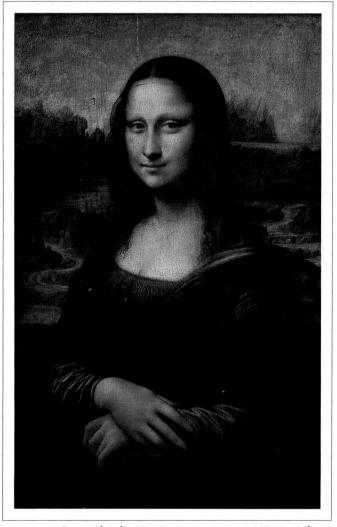

22. Leonardo da Vinci, *Mona Lisa*. 1503–6. Oil on panel, 30½ by 21 inches. The Louvre, Paris.

the greatest in the world because there is no single standard of perfection.

In spite of the obfuscations of legend and overfamiliarity, we can be sure that Leonardo set out to create a serene and timeless image, perhaps concerned with the mysterious origins of life and thought. The landscape background (in contrast with the snug domestic interior of *Woman with Chrysanthemums*) is a geological fantasy in which the works of man—roads and bridges—lead nowhere. And although the woman regards us directly, we know as little about what she is thinking as we do of what Degas's woman is looking at outside the picture. Nor are we supposed to know. *Mona Lisa* defies explanation; it is intentionally mysterious but hides no secret because it is concerned with imponderables.

Such difficulties explain why efforts at interpretation have a way of degenerating into literary maunderings like Walter Pater's notorious one, which has become the standard example of what art criticism should not be:

She is older than the rocks among which she sits; like the vampire, she has been dead many times, and learned the secrets of the grave; and has been a diver in deep seas, and keeps their fallen days about her; and trafficked for strange webs with Eastern merchants, and, as Leda, was the mother of Helen of Troy, and, as Saint Anne, the mother of Mary; and all this has been to her but as the sound of lyres and flutes, and lives only in the delicacy with which it has moulded the changing lineaments, and has tinged the eyelids and the hands.

Be that as it may, our concern is with the similarities and differences, four centuries removed, between the *Mona Lisa* and the *Woman with Chrysanthemums* as examples of the way pictures reflect the times and places of their creation.

Degas's picture would have been inconceivable to a man of the Italian Renaissance. It would have been intellectual heresy to suggest to Leonardo that a painting like Woman with Chrysanthemums, deliberately emphasizing the transient, the casual, and the everyday, could be just as effective in suggesting woman's enigmatic quality as the Mona Lisa with all its idealization. Renaissance man sought an ideal, and this ideal was order. Leonardo was as fascinated by the world as Degas was, but being a Renaissance man he refused to accept its accidents, its imperfections, its confusion, and its discord. The Mona Lisa is purified of all suggestion of the temporary, the haphazard, or the commonplace. The picture exists with such calm that Woman with Chrysanthemums, alongside, seems vivacious; and it is so impervious to the moment that the Degas becomes by comparison a comment on life's evanescence.

Oddly enough, it is possible to make some fairly direct parallels between the *Portrait of Madame Renoir* and the *Mona Lisa*. What we have said about the oval of the head in the Renoir, the cylinder of the neck and arms, the mass

of the rest of the figure, is applicable to the forms in the *Mona Lisa* too. But instead of Renoir's vigorous image, we have a subtle, almost sly, one. The forms in the Renoir face us directly; they are straightforward, while those in the *Mona Lisa* shift and turn. Leonardo presents us with the face from one angle, turns the body at another, shifts the arms to yet a third in order to return the curious, boneless hands to the same frontal position as the face.

Madame Leblanc, Madame Renoir, Madame Hertel (who posed for *Woman with Chrysanthemums*), and the forgotten Florentine immortalized as Mona Lisa—Ingres could have made any one of these women into a lovely effigy; Renoir, any one of them into an earth goddess; Degas, any one of them into a complete individual within a fragmented world; Leonardo, any one of them into an idealized enigma. The subject of a picture is only a point of departure for whatever the painter wants to say.

Once we have passed beyond the barrier of pure subject, our enjoyment of painting is limited only by our capacity to respond emotionally and intellectually to the infinitely varied expressions of the human spirit offered us in the art of all times and all places. This enjoyment is sometimes weighted on the side of thinking, sometimes on the side of feeling, and the artist works under the same double stimulus.

There is a popular and absurd conception of the "inspired" artist who works in a kind of hypnotic frenzy. His creations gush forth from some hidden reservoir of emotion without any effort on his part, although sometimes with considerable physical agitation followed by dramatic exhaustion. This simply does not happen. Or if it does happen, what gushes forth is formless and chaotic and hence not art.

At the opposite extreme are the few painters who have tried to eliminate all emotional and intuitive factors in an effort to work by pure calculation, even by mathematical formulas. This too is absurd, since even the most intellectualized painting must tie somewhere to the world of feeling, just as the most emotionalized must depend to some extent upon disciplined knowledge.

The words "romantic" and "classic" have so many meanings that we must define the way we will use them in this book: "romantic" will designate works of art that make their first appeal to the emotions or imagination, no matter how much calculation is involved; "classic" will refer to those making their strongest appeal to the intellect, no matter what emotional implications are present. We will look at two paintings comparable in subject (both being mountainous landscapes), the first treated romantically, the second classically—Scene from Thanatopsis (23), painted in 1850 by an American, Asher B. Durand, and Mont Sainte-Victoire (24), one of many versions of the subject, painted about 1904 by a Frenchman, Paul Cézanne. Not very long ago it would have been necessary to defend the Cézanne as a work of revolutionary modern art against the familiar

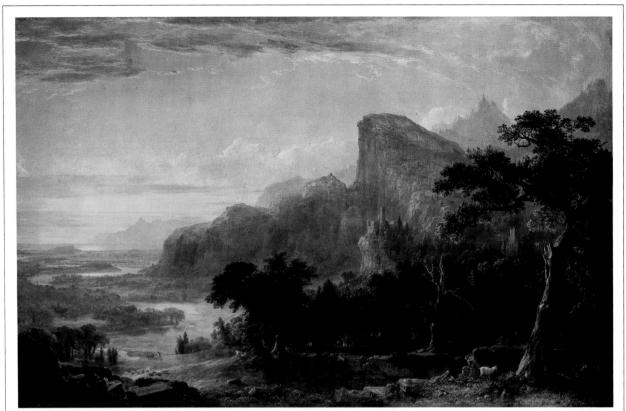

Durand. Scene from Thanatopsis. 1850. Oil on canvas, 39½ by 61 inches. The Metropolitan Museum of Art, New York. Gift of J. Pierpont Morgan, 1911.

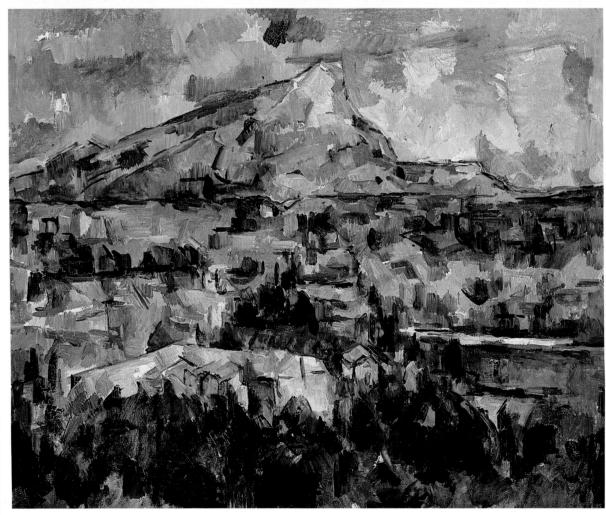

24. Paul Cézanne. Mont Sainte-Victoire. 1904–6. Oil on canvas, 28% by 36½ inches. Philadelphia Museum of Art. Purchased by The George W. Elkins Collection.

romantic imagery of *Scene from Thanatopsis*. If the tables are turned today, the important thing still is to remember that we limit our enjoyment if we refuse to tolerate contrasting conceptions and the mutually contradictory esthetic ideas that they entail. Either of these paintings is crippled if we try to force it into the other's category; neither is diminished by a recognition of the other's virtues.

Durand's imaginary landscape was inspired by one of the most admired poems of nineteenth-century America, by his friend William Cullen Bryant. "Thanatopsis" means "a meditation on death," but the poem, far from being gloomy, extols the grandeurs of nature as "thine eternal resting-place," "one mighty sepulchre" in which we may take comfort as members of the "innumerable caravan" of humankind. Durand's picturization of Bryant's "hills rockribbed and ancient as the sun,—the vales stretching in pensive quietness between: the venerable woods" reflects the spirit of excitement about the wonders of the American Far West, as new explorations revealed new grandeurs. Nominally, Durand was a member of the Hudson River School, which a generation earlier had been given its name because of its subject matter, stretching from the Hudson into the Adirondacks. But Durand and other "Hudson River" landscapists of his generation abandoned these relatively intimate scenes to celebrate the grandiose panoramas of the Rocky Mountains, where shadowy foregrounds receded into infinite distances studded with crags rising into dramatic lights. The majestic towering of trees, clouds, and mountains was set off by such intimate detail as grazing animals, men on horseback, people going about their little work (25). Ruined architecture on rocky peaks or small habitations in sheltering crannies suggested the infiltration of man into nature's vastness but remained diminutive or even spectral in the magnitude of their setting (26).

In Scene from Thanatopsis Durand is free to assemble all these trappings unfettered by the necessity of approximating the look of any actual view, and the painting becomes a kind of summary of all the devices he and his fellow romantics employed to invest nature with an air of mysterious powers. His imaginary mountains recede in ranges of pinnacles; a river stretches into the distance to culminate in the drama of the sun, hovering in space and illuminating the whole complicated spectacle by its colored light. Detail by detail the picture is explicit, but it does not seek so much to capture an illusion of nature as it does to intensify the awesome sensations we would feel if we could be confronted by the landscape itself.

Romantic landscape was nothing new. There is hardly a device in *Scene from Thanatopsis* that had not already been worn threadbare in European painting, but Durand uses them with all the enthusiasm of an explorer discovering a continent. If this excitement is diluted for us today by ease of travel and overfamiliarity through photographs and motion pictures, we can be all the more thankful that American nineteenth-century paintings have recorded the

25. Detail from Scene from Thanatopsis.

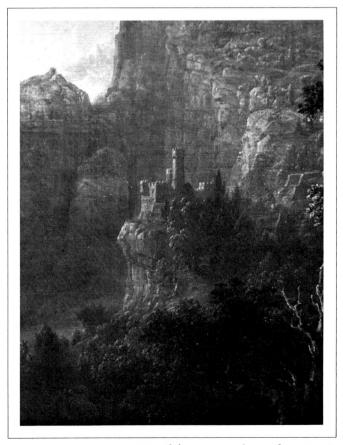

26. Detail from Scene from Thanatopsis.

27. Detail from Mont Sainte-Victoire.

sense of mystery, wildness, and grandeur that has so diminished during the past hundred years.

But mystery and wildness are exactly the opposite of the qualities Cézanne sought, and achieved, in his *Mont Sainte-Victoire*. Nature's romantic extravagances did not interest him; his first interest was to reveal the underlying clarity and logic that he sensed in the countryside he knew best, the fields and low mountains near his home and studio. If he had been faced by the Rocky Mountains that inspired American painters, this good Frenchman would simply have been appalled at the prospect of putting them into order.

In Mont Sainte-Victoire the sky is a curtain bounding the limits of the picture rather than an opening into infinite depth where the eye and the imagination are led and released. We do not wander away or escape from the Cézanne; we remain within its established boundaries, and even within them there is no exploring of nooks and crannies. Cézanne's mountain exists as one large, tangible, firmly integrated mass; Durand's mountains vanish here and there into suggestive shadowy recesses, or rise from them unexpectedly. The world within Cézanne's frame reaches us at first glance in its entirety; we discover Durand's bit by bit, led from detail to detail. Cézanne means his landscape to be complete. Durand means his to be inexhaustible.

Cézanne's subject happens to be an actual place, but he does not reproduce it. And if Durand could have sat beside Cézanne to paint the same scene, he would have found material for a landscape as romantic as Cézanne's is classic, as open as Cézanne's is self-contained. Nature in itself is meaningless; it is only as we interpret it that it has meaning. Durand seeks to open his landscape to the infinite reaches of the imagination. Cézanne seeks to contract his within the comprehension of the intellect. Through the two visions we may respond to both points of view.

Cézanne's art is difficult on first acquaintance. He was a revolutionary as far as technique is concerned, and his quality of order may not be apparent at first glance beneath the equally important vibrance, the quality of sparkling, all-permeating light that pulses from stroke to meticulously calculated stroke in the technique he developed. Nor will this order ever become apparent if the picture is regarded as an effort to imitate the appearance of nature. There is intentionally little expression of depth. The space is kept shallow, and the picture generally is highly abstract—that is, the forms in it tend to lose their identity as real objects and exist for form's sake (27). This, too, is the opposite of the Durand, where every form is recognizable in detail and surrounded by a host of associations. Durand regards nature as a manifestation of mysterious forces, while Cézanne regards it as an expression of the essential orderliness upon which the world must depend for its meaning. The basic contrast between the two pictures is between two points of view, romantic and classic.

We have been talking so far as if certain general principles, once understood, can make all painting understandable. Happily this is more true than not, but some pictures carry their messages in disguises that must be penetrated individually.

The disguise in Edward Hicks's *The Peaceable Kingdom* (28) is no puzzle to anyone who has a nodding acquaintance with American colonial history and the Old Testament. In the foreground a congregation of animals and children illustrates three verses from the eleventh chapter of Isaiah:

The wolf also shall dwell with the lamb, and the leopard shall lie down with the kid; and the calf and the young lion and the fatling together; and a little child shall lead them.

And the cow and the bear shall feed; their young ones shall lie down together: and the lion shall eat straw like the ox.

And the sucking child shall play on the hole of the asp, and the weaned child shall put his hand on the cockatrice' den.

The Pennsylvania Quaker preacher who painted *The Peaceable Kingdom* has followed these verses to the letter. Like other self-taught painters, he cultivates a meticulous technique. Unlike most of them, he is an inventive designer. He is an artist. If he does not always draw as well as he wishes he could, he never fails as a creator of patterns. The lack of conventional skills accentuates the innate artistry of the man and accounts for the arresting quaintness of his work.

So far the picture is only a biblical illustration invested with an agreeable air of fantasy by a charmingly awkward style. But in the background is a second illustration, William Penn concluding his treaty with the Indians (29). The picture now becomes a political or even sociological allegory. The peaceable kingdom of the Bible is reflected on earth through the concord of the red man and the white, and the Quaker preacher has left for us a confident statement of his belief that peace on earth and good will toward men is a realizable ideal.

It would be foolish to pretend that *The Peaceable Kingdom* rises to great expressive heights. It has charm rather than power; it is pious rather than profound, touching rather than moving. But it does enlarge our experience, as we have said a painting should do, by admitting us to a world of gentle faith that is no less true for being so small and so far away.

If we were ignorant of its historical and biblical references, *The Peaceable Kingdom* would be only a curious representation of animals, children, and men conducting themselves implausibly in a landscape. In this same way virtually everybody misses the significance of Jan van Eyck's double portrait of Giovanni Arnolfini and his wife, Giovanna Cenami (30). Probably not one person in a thousand among the tens of thousands who stop in front

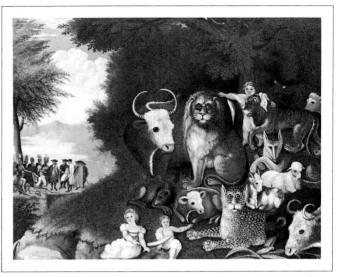

28. Edward Hicks. *The Peaceable Kingdom*. About 1848. Oil on canvas, 17½ by 23½ inches. Philadelphia Museum of Art. Bequest of Lisa Norris Elkins.

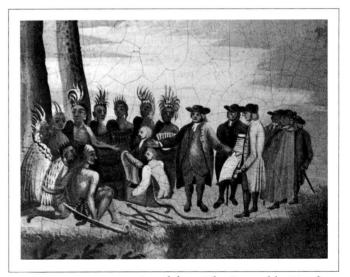

29. Detail from The Peaceable Kingdom.

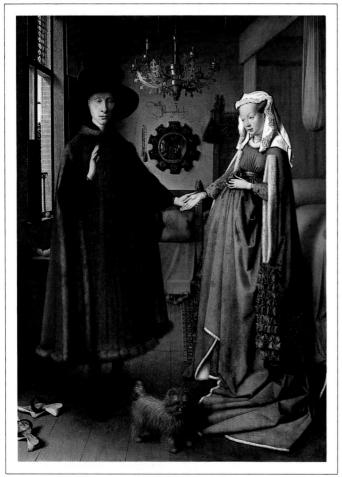

30. Jan van Eyck. *Marriage of Giovanni Arnolfini and Giovanna Cenami*. 1434. Oil on panel, 32¼ by 23½ inches. National Gallery, London.

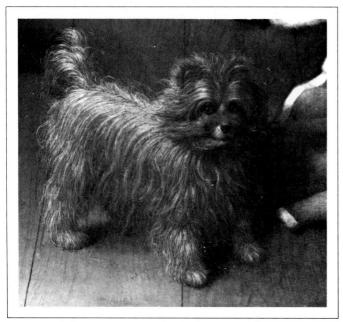

31. Detail from Marriage of Giovanni Arnolfini and Giovanna Cenami.

of it where it hangs in London's National Gallery suspects that its details are anything more than fascinating curiosities.

Even so, it is one of the most compelling pictures in the world. This grave, beautifully costumed couple are such convincing personalities that once we have met them they persist in our memory as real people. We remember their air of consequence and solemnity, although it is odd that they should have chosen to be pictured thus, standing in a bedroom and surrounded by trivia: a little dog (31), pieces of fruit scattered on the windowsill, and a pair of wooden sandals discarded on the floor. It is odd that there is only one candle in the chandelier, odd too that it is burning in the daytime, and that the artist has inscribed his name so conspicuously on the back wall (32). This last is additionally surprising since at the time the picture was painted, more than five hundred years ago, it was unusual for a painter to sign his work at all.

The fact is that as we stand before this picture we are witnesses at a marriage ceremony. The air of solemnity is explained when we know that the hands are joined in the marriage oath. The painter is not only painter but witness and has inscribed his name on the wall in legal script of the kind proper to a document. And the picture is a document, in effect—a marriage certificate. These two fine and serious people first solemnized their own marriage in complete solitude, as was possible under canon law at that time. The picture records the renewal of vows, apparently on the occasion of the wife's pregnancy, and the "trivia" are not trivia at all but symbolic references to the sacramental nature of the scene before us.

The discarded sandals refer to the biblical command, "Put off thy shoes from off thy feet, for the place whereon thou standest is holy ground." This same symbol is used in other pictures, notably Crucifixions, to establish the holy or sacramental nature of the spot, which in this case is the nuptial chamber. The dog symbolizes the marital virtue of faithfulness, the fruit refers to the fruit of the Garden of Eden, and the single candle is a multiple symbol, combining overlapping references to the candle that was carried in wedding processions and the burning candle frequently required at the taking of an oath, which is also the candle as a symbol of the all-seeing eye of God.

The mirror on the wall symbolizes purity. The carved figure on the chair near the bed is Saint Margaret, the patron saint of childbirth. All of these symbols were standard ones, now half-forgotten but familiar five hundred years ago, and their combination within a single picture is too consistent to be coincidental. Their rediscovery in relationship to the subjects of this double portrait changed the *Arnolfini Wedding Picture* from one of the most curious pictures ever painted into a reverent expression of sexual love sanctified by marriage.

No introduction to painting can conclude without some consideration of the way ideas change as to what is good art and what is bad. We will compare two paintings as representative combatants in the pitched battle between modernism and traditional academic painting that has been going on in a mild way indefinitely but has been carried on with greatest violence in our century. While the battle continues, we will select an area where the dust has settled.

Pierre Cot's *The Storm* (33), representing the losers, was a tremendously popular picture well into the twentieth century, dropped to the nadir of critical esteem by midcentury, and recently has made a tentative comeback. It was painted in 1880. Oskar Kokoschka's *The Tempest* (34), painted in 1914, has an opposite history. At that time Kokoschka's art, praised by advanced critics, was still damned as degenerate by the public and by critics who could stretch a point backward to admire pictures like Cot's *Storm*. Today the Kokoschka *Tempest* cannot look very radical to anybody, and even the uninitiated layman would hesitate to damn it although he might be unable to respond with full sympathy. We will examine it first.

There is no actual "tempest" visible. We see a pair of lovers lying in what appears to be a frail barque, encompassed by forms like windy clouds or waves or a nightmarish landscape. The color, dominated by turgid blues and greens, suggests (but does not represent) a stormy sky shot through here and there with light. These swirling colors surround the figures of a watchful man and a sleeping woman, who are intertwined not only with one another but with the surrounding swirls of color as well. As a matter of historical fact, the lovers are identifiable portraits of Kokoschka and a prominent woman with whom at that time he was having an intense and scandalous affair. But the painting is only secondarily a personal document and loses much of its expressive force if regarded only in those terms. From a profound personal experience Kokoschka conceived a symbolical painting, in which specific reference is transmuted into universal statement by means of expressive distortions.

The lovers' bodies are twisted, deformed, and discolored, yet this man and woman are serene in the midst of all the surrounding violence. Whether or not the painter thought of his subject in exactly these terms, the picture says that human love is the sustaining miracle of goodness in the confusion and malevolence of life. The figures are "ugly" because they must participate in life; they are worn by it. They have not escaped from life, they have found a refuge within it.

The theme is an affecting one but could easily turn mawkish. Kokoschka expresses it with a vigor that would be weakened if his lovers were glamorous creatures immune to hardship or ill fortune and the normal difficulties of existence.

Such an unreal and idyllic immunity is suggested by the pretty lovers who flee the storm in Cot's painting. Like Kokoschka's, they are beset by the elements. Both painters express the oneness of the lovers by tying them together with interlacing lines and a billowing, surrounding form (in the Cot, the wind-filled drapery). Both suggest the

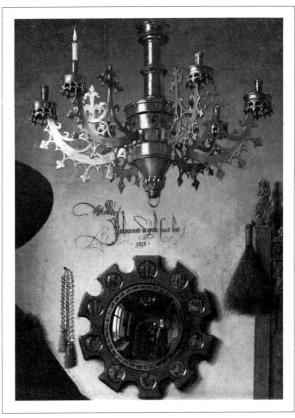

32. Detail from Marriage of Giovanni Arnolfini and Giovanna Cenami.

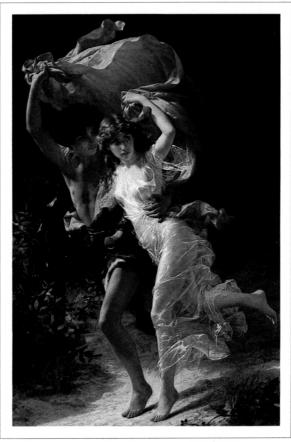

33. Pierre Auguste Cot. *The Storm.* 1880. Oil on canvas, 92¼ by 63¾ inches. The Metropolitan Museum of Art, New York. Bequest of Catharine Lorillard Wolfe, 1887.

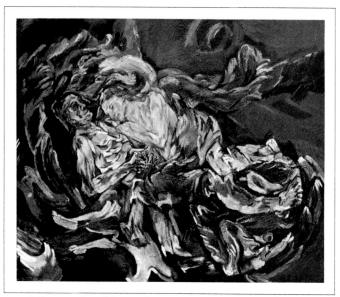

34. Oskar Kokoschka. *The Tempest.* 1914. Oil on canvas, 71¼ by 865% inches. Kunstmuseum, Basel.

35. Detail from The Storm.

relationship of protective male to more fragile female. But beneath these similarities, the differences are extreme.

An important one is that the Cot is specific and detailed in such a way that it becomes an illustration of the plight of one particular pair of lovers, while the Kokoschka is generalized and abstracted. In a more emotionalized way, the Kokoschka is a universal image just as the portrait of Madame Renoir became one when we stopped regarding it as a portrait of a particular woman. Compared with the strength of the Kokoschka, Cot's picture seems today a flossy bit of picturemaking concerned with second-rate values. It is a wondrously slick piece of work, but nothing much goes on beneath this surface of technical display. For all the signposts such as billowing drapery and bodily attitudes pointing out that the figures are supposed to be running, there is no expression of flight. The lovers remain frozen forever on tiptoe (35), continuing to suggest models posed in the studio. Kokoschka's figures are integrated with the rest of the picture; Cot's stand in front of a photographer's backdrop. Our attention is constantly urged toward their prettiness, not toward their quality as human beings, and we are asked to admire the rendition of such props as the horn at the boy's belt, the girl's filmy gown, and all the incidental complexities of folds and curls, instead of being given a reason for their being there. These details say nothing except that the painter is skillful in representing them. We are offered a collection of accessories instead of a message.

There is fascination in watching any demonstration of acquired skill, which is why tightrope walkers are able to make a living, but unless the skill is directed toward an expressive or productive end it is only diverting. We are diverted by Cot's *The Storm*; our perception is deepened by Kokoschka's *The Tempest*. The Cot appeals by telling a little story; it is an anecdote. But the Kokoschka is the emotionalized expression of an idea.

Since we have said nothing favorable about *The Storm*, why is it included here? Only as a whipping boy? In that case, why is it given exhibition space in one of the greatest museums in the world?

For one thing, it is an absorbing picture to anybody interested in the history of painting because it is a perfect example of the attitude that dominated public taste, and most critical taste too, for half a century. We have said that one function of painting is to reveal to us what people have thought and felt and believed. If this is important, is it safe to ignore a picture that appealed so strongly to so many people for so long? Museums may set themselves up as arbiters of taste, but they also have a function as visual histories of thought and feeling, which is why the Metropolitan Museum pulled The Storm out of storage and gave it a respectable position once more. We do not exclude important villains and incompetents from books of political history just because we don't approve of what they did. The French Academy of Fine Arts, sponsoring a style perfectly represented by Cot, is nowadays regarded as the

villain of nineteenth-century art history for rejecting painters like Cézanne, Manet, Monet, and Renoir in favor of painters like Cot and others now forgotten.

Aside from giving wall space to paintings like *The Storm* as historical examples, we should ask ourselves why a picture so easy to ridicule is so difficult to dismiss. Many painters successful in their lifetimes, including the great names of El Greco and Botticelli, have been dismissed by one century and rediscovered by the next. Recently there has been an enthusiastic renewal of admiration for a group of sixteenth-century painters, the Italian mannerists, who had been regarded with condescension.

If the meaning of a great painting is enriched with time, while that of a poor one withers away, then *The Storm* is still afflicted with all the symptoms of inferiority. But time is a matter of the very long run, allowing for ups and downs in reevaluations that seem impossible to us at the moment. In the meanwhile, even "bad" paintings are interesting as a counterpoint to the ones we call "good."

The most important—and the most disturbing—thing to remember about The Storm is that it was conceived as a serious work of art in accord with the dictates of the majority of contemporary critics, teachers, and historians. We have called the picture flossy and superficial, and implied that it is silly, but it was not a tongue-in-cheek product. Cot was making no effort to reduce his art to the level of the nineteenth-century public that rewarded him so generously; he was simply in tune with that public. So far as he was concerned, he represented the most highly developed esthetic standards of the day, backed up by the Academy's notion of the progress of art through the centuries. It seems unlikely—impossible—that paintings like The Storm can ever again be regarded with the seriousness with which they were conceived, or that Kokoschka's The Tempest will ever again look "degenerate," as it was called when it appeared. But both paintings make the disturbing point that it is never safe to leave unquestioned the dictates of official taste in any age, including our own, when we are so smug in our dismissal of any art that does not fall into line with our certainty of our own excellence. Art critics, on the whole, have a good record as evangelists but a very poor one as oracles.

36. Venus of Willendorf. About 30,000–25,000 B.C. Limestone, height 4% inches. Naturhistorisches Museum, Vienna.

37. Constantin Brancusi. *The Kiss.* 1908. Limestone, height 13 inches. Philadelphia Museum of Art. Louise and Walter Arensberg Collection.

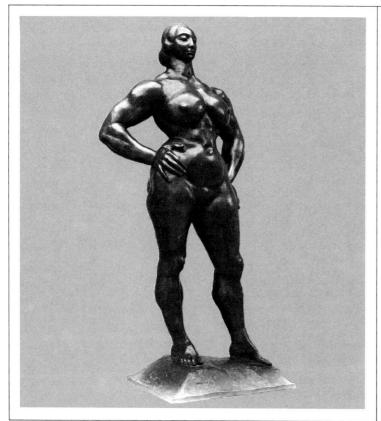

38. Gaston Lachaise. Standing Woman. 1932. Bronze, height $88\frac{1}{2}$ inches. The Brooklyn Museum. Frank S. Benson Fund and others.

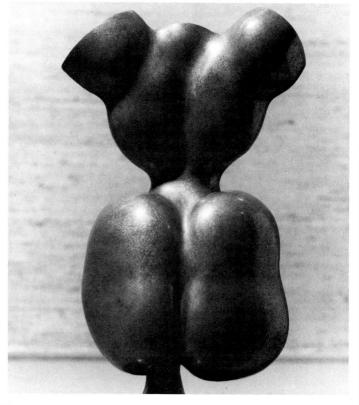

39. Gaston Lachaise. *Torso.* 1930. Bronze, 11½ by 7 by 2¼ inches. Whitney Museum of American Art, New York.

Chapter Two SCULPTURE

We were speaking in sculptural terms when we called Renoir's portrait of his wife (17) "a structure of strong, solid volumes" appropriate to the concept of "woman as a basic universal symbol." In these terms the pretty young woman in a straw hat with flowers on it becomes a nineteenth-century earth goddess with ancestry dating back about thirty thousand years to a limestone carving not quite 4½ inches high found near Willendorf in lower Austria (36).

This fertility image, the oldest sculpture known, is also a structure of strong, solid volumes appropriate to the concept of woman as a universal symbol, in this case a symbol of fertility alone, with none of the tenderness, the personal response, of the Renoir. The parts of the body not associated with pregnancy and maternity are given short shrift; there is no face, and the tiny arms, folded above enormous breasts, are hardly noticeable. Whether or not by accident (but certainly not by the application of any esthetic theory), the grotesquely enlarged parts of the body associated with fertility are conjoined in a monumental composition (monumentality is not a matter of size alone), as if to declare once and for all that solid geometrical forms held in balance will thenceforth be sculpture's primary concern.

To an appreciable degree, the history of sculpture respects this unintentional prophecy; one school of sculptural theory holds firmly to it today, maintaining that "closed form"—the existence of a sculptured object as, essentially, a single solid mass, self-contained—is sculpture's natural province. An extreme example is *The Kiss* (37) by Constantin Brancusi, which leaves the original stone block virtually unviolated.

Before going into the opposing concept of "open form," we may see how, some thirty millennia later than the Willendorf carving, the French-American sculptor Gaston Lachaise paid homage to this and other paleolithic fertility images with his sculptures of women in which he idealized the female principle by similar exaggerations, sometimes in standing figures of almost arrogant sexual vitality (38) and sometimes in near-abstract forms of torsos that brought his sculpture even closer to Willendorf via the long detour of modern abstraction (39). Certainly more beautiful by any conventional standard than their grotesque paleolithic ancestress, these twentieth-century fertility images scarcely rival the sheer power of the Willendorf carving in spite of, or more probably because of, their technical sleekness, their sophisticated application of esthetic laws, and the philosophical eroticism that has taken the place of primitive superstition and magic.

The Willendorf and other paleolithic female figures are called Venuses, a doubly inaccurate sobriquet since that goddess had yet to be born, and because the sculptures

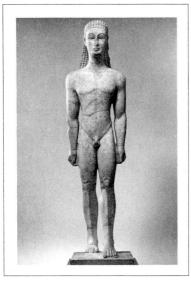

40. Archaic Athenian. *Kouros*. About 615–600 B.C. Marble, height 6 feet. The Metropolitan Museum of Art, New York. Fletcher Fund, 1932.

41. Kouros. Back of head

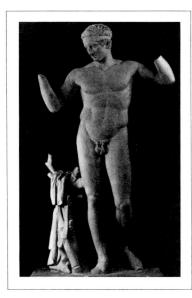

42. Polykleitos. Diadoumenos. Antique replica of original. About 430 B.C. Marble, height 76% inches. National Archaeological Museum, Athens.

are concerned with biological function rather than with ideal beauty. It was not until ancient Greece that the beauty of the human body, male or female, became a primary theme in sculpture, a theme so enduring that the history of sculpture from that time on could be told in terms of it alone. (We would meet limitations during the Middle Ages, but even in those times, when representations of nudity were taboo, exceptions had to be made for Adam and Eve and for the souls rising from their graves at the sound of the last trumpet, for they had to present themselves on Judgment Day as naked as on the day they were born.) The Greek veneration of the beauty of the male body was so profound that the phrase "Greek god" still denotes physical perfection, although Greek sculptures celebrate the beauty of athletes more frequently than that of deities.

Kouros (plural, kouroi), a Greek word for "young man," is the title conventionally given to the standing nude male statues of the Archaic period (600–480 B.C.). Kouroi vary considerably in proportions, as if an ideal type were being searched for; but all, like our example (40), are compact masses—"closed forms"—that continue to reflect the solid block from which the figure was carved, and all are emphatically geometrical, not only in the general masses of the body but in details such as the hair bound by a fillet (41), which is so conventionalized that it would be unrecognizable for what it is if we did not see it in context. Brancusi in our century was consciously working within the pattern of archaic sculptures like this one in *The Kiss*.

The kouros we have illustrated was carved about 600 B.C., early in the Archaic period. By the second half of the fifth century in Greece—the Golden Age—experiments and refinements had yielded a set of ideal proportions based on the normal proportions of an athletically developed body and set down as a canon by the sculptor Polykleitos. His Diadoumenos (42), an athlete with arms raised to bind his hair with a fillet (preparatory to being crowned with a victor's wreath), is less true to nature than it at first appears; details of musculature that would be strongly defined in an athlete's body are omitted, and those that are included are represented with an eye to design rather than strict adherence to anatomical truth. Some of these patterns had been set by the archaic sculptors. Our kouros and the Diadoumenos share several likenesses: eventful passages at the knees in contrast with the smooth volumes of the upper and lower legs; fleshy ridges separating the pelvis and abdomen; a central depression between ridges of muscle beginning at the navel and continuing to the neck; a winglike spread of the pectoral muscles and clavicles. The great difference is between the tense rigidity of the kouros and the grace and relaxation of the later figure—vet both conform to the basic sculptural goal of solid, uncomplicated masses in static balance. The balance in the kouros is as symmetrical as that of a column, while that of the Diadoumenos is more subtle, a matter of counterbalances the outward thrust of the hip that carries the weight of the torso on the strong, straight right leg with the knee joint locked, as opposed to the relaxation of the left, bent at the knee, and the raising of the left shoulder in counterbalance to the thrust of the right hip. From the slight bowing of the head to one side on down through the curving torso and an imagined curving center line shared by the legs, an S-curve has replaced the straight vertical central line that runs from base to top of the kouros.

Approximately twenty-four hundred years later—in 1056-7—the modern Austrian sculptor Fritz Wotruba offered his version of the ancient model in another geometrical bronze, Figure with Raised Arms (43), where the classical stance of the Diadoumenos (and thousands of subsequent statues over the centuries) is reconciled with modern abstraction. (Abstract art, the subject of a later chapter, is art of pure form and color with only secondary reference, or none at all, to the representation of nature.) With its repetition of the simple geometrical solid of the cylinder, Figure with Raised Arms is a more obvious balance of formal units than either the kouros or the Diadoumenos. But look again. As in the Diadoumenos, one leg is straight, the other bent at the knee. The knees, in contrast with the simple cylinders above and below them, are relieving eventful passages; the pelvis and torso are separated by a decisive boundary. We can even find a specific reference to the Diadoumenos in that the missing portions of its two raised arms, long ago broken and lost, are reflected in the fragmentary raised arms of the Wotruba.

In terms of modern sculpture the Wotruba is only semiabstract, especially with a figurative acknowledgment in its title. Forty years earlier Brancusi had already gone a few steps further with his Torso of a Young Man (44), consisting of three cylinders modifying the natural form of the tree trunk and two branches from which the piece was carved. (Brancusi later repeated it in bronze.) The question as to what has been gained and what has been lost in this passage from ideal realism to abstraction may be better answered if we omit the intermediate steps of the Wotruba and the Brancusi and compare the Greek statues with a totally abstract sculpture, one of David Smith's Cubi (45), a series of large stainless-steel sculptures burnished to reflect changing lights out of doors, and echoing—it is generally said the heroic stance of monumental figure sculpture of the past without recognizable derivations of form.

Admitting of no compromise with the human figure, then, the *Cubi* combine volumes in counterplay with one another that must be enjoyed without associative ideas, for the beauty of the material and the balances of form against form alone. The balances are purely esthetic, for while we accept the skeletal and muscular structure of the body as explanation of the formal relationships assumed by a sculpture representing it, there is no explanation as to why some of the elements in the *Cubi* do not tumble to earth—except that we know they are welded together, which is not quite the same thing as being held together by a mechanism of bones and sinews. Possibly we have reached not an affirmation but a refutation of the Venus of Willendorf's proph-

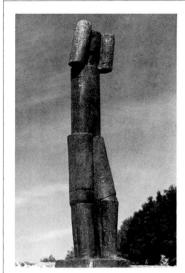

43. Fritz Wotruba.
Figure with Raised
Arms. 1956–57.
Bronze, height 751/4
inches. Hirshhorn
Museum and
Sculpture Garden,
Smithsonian
Institution,
Washington, D.C.

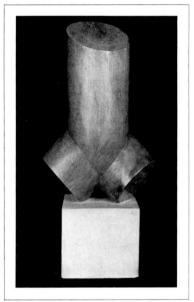

44. Constantin
Brancusi. Torso of a
Young Man. 1922.
Maple on stone
base, height 19
inches.
Philadelphia
Museum of Art.
Louise and Walter
Arensberg
Collection.

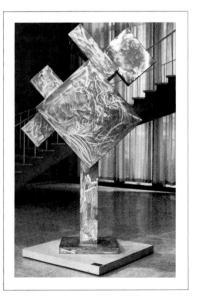

45. David Smith.

Cubi VII. 1963.

Stainless steel,
height 9 feet 33%
inches. The Art
Institute of
Chicago. Grant J.
Pick Purchase
Fund.

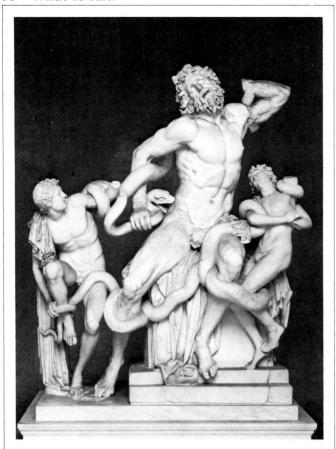

46. Hagesandros, Polydoros, and Athenodoros. *Laocoön and His Two Sons.* First century A.D. Marble, height 96 inches. Vatican Museums, Rome.

47. Greek, early classical. *Battle of Lapiths and Centaurs.* From west pediment of the Temple of Zeus, Olympia. Marble, height of central figure 10 feet 2 inches. Archaeological Museum, Olympia. Photograph by Alison Frantz, Princeton, New Jersey.

ecy that the province of sculpture will be "solid geometrical forms in balance," for that balance presupposes logical responses to the law of gravity, which the *Cubi* often flout.

The refutation of solid, self-contained sculptural form was made, as a matter of fact, in antiquity, with such sculptures as the famous *Laocoön* (46), with its separated figures, its writhing serpent, its tortured bodily attitudes, its projections of forms into space, and the penetration of space into the hollows and voids carved in and through the solid marble. All of this is a general denial of the idea of sculpture as a self-contained mass. The group's unity is of a different kind; the various masses are knit together by sinuous lines of action that weave in, out, and around the prolixity of elaborately carved shapes.

Or for closer comparison and even greater contrast between open and closed form, let us compare a single figure, Gianlorenzo Bernini's David (48), an early seventeenth-century statue, with the other single-figure sculptures we have seen. There is balance here, but it is a balance of action in space rather than of self-contained masses at rest. The torso twists in one direction, the head turns in counterbalance in the opposite direction; instead of the gentle S-curve of the traditional classical stance, we have a spiral, or several spirals interwoven, that can be picked up and followed from any point. More important, it is not only that space interpenetrates the twisting and curling forms of the marble; the psychological focus of the sculpture is outside the sculpture itself. The tension of the figure culminates in the strained features of the face as David looks beyond us at his target, the giant Goliath. Standing in front of the *David*, we are as aware of the giant's existence as if there were another statue in the distance behind us. We have come to the opposite pole from the compact and self-contained Greek ideal to a sculpture that recognizes no strictures in its union with unbounded space.

The psychological attributes of closed and open form should be self-evident. Closed form has to do with finalities, with emotional or philosophical certainties, with clarity, repose, and proven truths. Open form is the natural vehicle

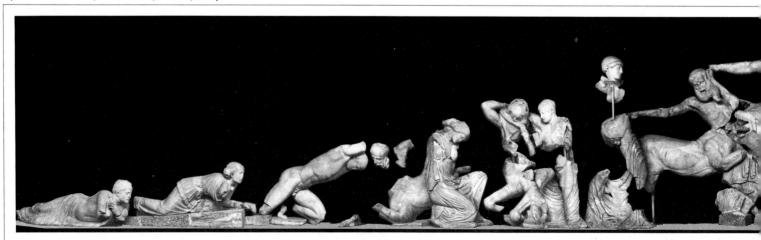

for the expression of stress, emotional tension, philosophical contradictions; intensification is more important than clarity, action preferable to repose. Open form allows maximum leeway for exploration, invention, and argument; it presupposes no single, conclusive truth. For these reasons the Polykleitos and the Bernini that we have chosen for comparison are expressions of the times that produced them—the Golden Age of Greece and the intellectually tumultuous aspect of the seventeenth century that we call baroque.

In rebuttal it might be argued that the Greeks were certainly among the most exploratory thinkers of all time, that they, too, were inventive, argumentative, and inspired by a vital curiosity that made ancient Greece the morning of the world. All of this is true, but it does not refute the appropriateness of closed form as the inevitable expression of the Greek ideal—for this ideal was based on the assumption of an ideal clarity and harmony toward which all invention and argument must lead, if not by art, then by science. The contrast between the Golden Age of Greece and what we could call the Age of Turbulence in Europe is demonstrated by the difference between geometry and calculus, between Archimedes and Sir Isaac Newton, between a small world that could be thought of as the center of a finite universe and a large world that, as men of the seventeenth century were learning, is only a mote among astral bodies in infinity.

In our chapter on painting we said that a picture is an expression of its time and also of the personality of the artist who painted it. Sculpture, while emphatically an expression of its time, has been less permissive in its allowance for personal expression. We say "has been" because the twentieth century has liberated sculpture from an old alliance so strong that "sculpture, the handmaiden of architecture" was a popular cliché with nineteenth-century art historians.

Painters have always been relatively free to add a dash of personal flavor to their work, and for the last five hundred years—or nearly six hundred—that flavor has been increas-

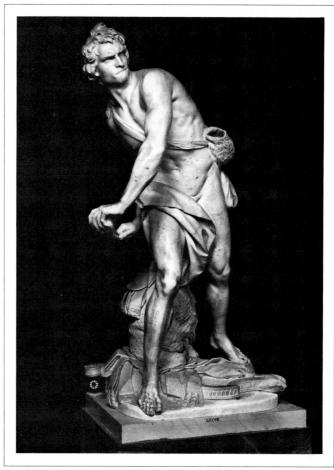

48. Gianlorenzo Bernini. *David.* 1623. Marble, height 67 inches. Galleria Borghese, Rome.

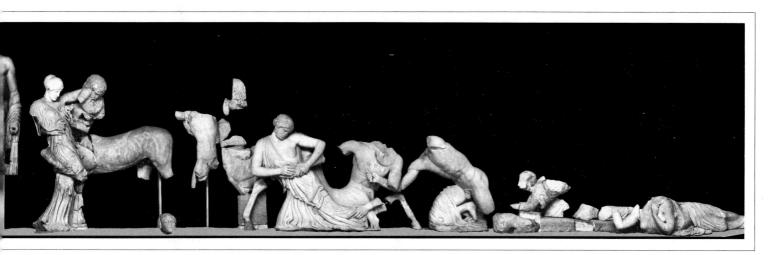

49. Assyrian. Eagle-Headed Winged Being Pollinating the Sacred Tree. Wall panel from the palace of Ashur-nasir-pal II at Calah, modern Nimrud. 885–860 B.C. Alabaster, 905/6 by 713/8 inches. The Metropolitan Museum of Art, New York. Gift of John D. Rockefeller, Jr., 1913.

50. Greek, classical. *Young Horseman*. Fourth century B.C. From Rhodes. Marble, 18 by 12 feet. The Metropolitan Museum of Art, New York. Rogers Fund, 1907.

ingly demanded by patrons and an audience that now thinks of both painting and sculpture in terms of artists' individual personalities, their unique ways of translating the visual world into images. But in Greek temples, Roman forums, or medieval cathedrals, even in Renaissance palaces, it would have been unthinkable for sculptors to have said this is *my* idea of Athena, or *my* idea of Caesar, or *my* idea of Christ, or *my* idea of the King. The various images had to be materializations of *the* idea of each, and the nature of that idea was set by the priests, the clergy, or the rulers. In addition, sculptors often had to work within rigidly set architectural areas, such as pediments, which required utmost ingenuity in the design and placement of figures (47).

Primary among these dictates was the degree of relief—the degree of projection of carved forms from the flat surface—permissible as a harmonious adjunct to the forms of the architecture. On the long, flat, unbroken stretches of walls of ancient Assyrian temples and palaces, sculptured decoration was hardly more than carved drawing (49), with the edges of the very low relief picked out in sharp linear shadows by the brilliant sun. To have destroyed—psychologically—the solidity of these walls with sculpture in high relief would have been an unthinkable disharmony.

Sculptural relief is traditionally divided into four degrees, and we had best introduce the terms here. They are low relief, of which the Assyrian carving is an example, and for which the French term bas relief is frequently used; medium relief, for which the Italian mezzo rilievo is usually used, and in which figures and objects are represented at approximately half their true thickness; high relief, or alto rilievo, which approaches the full round; and finally, full three-dimensional treatment, in which sculptures are free-standing, even though they may be closely related to architecture in niches or alcoves where they are an integral part of the overall design.

Obviously it is impossible to make these classifications precise, since every degree and fraction of degree between very low relief and free-standing sculpture is met from example to example, including sculptures in which several degrees are interrelated. In a late fourth-century Greek sculpture of a horse and rider illustrated here (50), we have everything from very low relief in the rider's foot on the far side of the horse to the full three dimensions of the freestanding foot near us (now missing). Progressively fuller stages of relief correspond to relative distances as forms go from farthest to nearest us. The far hind leg of the horse, for instance, is in low relief but not as low as the rider's far foot behind it, while the hind leg nearer us approaches full relief in a kind of sculptural perspective. All sculptural relief other than the full round is a matter of compression of forms, as if front and back planes were closing in on one another.

Aside from instances where low relief is enforced by architectural circumstances, low relief offers potential for beautiful sculptures where no illusion of fuller form is sought—where the illusion is even avoided in order to

capitalize on a special province of low relief, which is the play of linear rhythm and decorative form across a surface rather than into the volume behind it. A relief carved from the living rock of a cave in China about the year A.D. 522 (51) is an exquisite example reflecting the subtleties of Chinese painting of the period, which was very lightly modeled, in the gentle modulations of carved forms. It can be compared with a procession of Athenian maidens from the Parthenon frieze in a later chapter of this book (222), which falls within the area of medium relief.

Medium relief, or mezzo rilievo, probably offers the happiest combination of absolute integration with architecture along with sufficient freedom for independent creative expression on the part of the sculptor. And there is no happier demonstration of this union than the Royal Portal on the west façade of the Cathedral at Chartres (52 and 53). The anonymous master who carved the finest of the Old Testament kings, queens, and prophets on this, the main portal of the cathedral, can stand beside the great names of antiquity and the Renaissance. No sculptures, anywhere, are more respectful of the architecture with which they are integrated; each figure, carved on its own block of stone, is a structural as well as a decorative unit in the building. And as if to dispel any suspicion of sculptural independence, each figure in its extreme elongation and the arbitrary verticality of the lines composing it has the character of a column even while it is part of the wall. The figures are superbly designed as architectural sculpture—but something beyond design inspires the heads.

Here a great sculptor has created countenances as noble as any in the history of art (54). With their rich robes and their aristocratic mien, ranged on the jambs of doorways to the cathedral where those who enter must pass beneath their scrutiny, these personages are endowed with all the regality their exalted position demands. Expressions of royal hauteur would be understandable, acceptable, and impressive enough. But instead, the sculptor, not satisfied with so expected an interpretation, has invested the noble faces with a profound compassion prophetic of the divine forgiveness that a Redeemer will bring to the world. No sculptural formula and no model in painting (which sculpture at this time frequently followed) can be credited with this expressive innovation. It is the creation of an artist whose genius found expression without violating the bonds that medieval sculpture accepted in its union with architecture.

Most French Gothic cathedrals were built over such long periods of time that they were begun in one style and completed in a sequence of others. The chronological range at Chartres, partly by reason of rebuilding after two disastrous fires, is unusually wide, from an early eleventh-century crypt to an early sixteenth-century tower. The Royal Portal dates from about 1140–50, when the early medieval period called Romanesque (the eleventh century and most of the twelfth) was evolving into the one called Gothic. The north and south transept portals, fully Gothic,

51. Chinese, Northern Wei dynasty. *The Empress as Donor with Attendants*. From Pin-yang cave, Lungmen, Honan. About A.D. 522. Limestone, 6 feet 9 inches by 9 feet 1 inch. Nelson Gallery—Atkins Museum, Kansas City, Missouri. Nelson Fund.

52. Royal Portal. Cathedral at Chartres. About 1140–50. France.

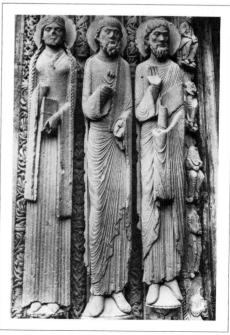

 Sculptures on jamb, Royal Portal. Cathedral at Chartres.

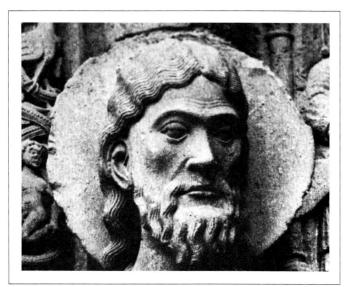

54. Head of statue on jamb, Royal Portal. Cathedral at Chartres.

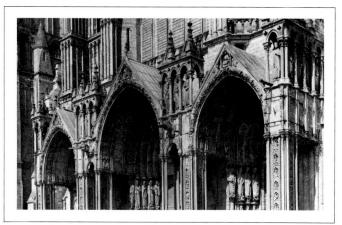

55. South porch. Cathedral at Chartres. Begun about 1200–1215. France.

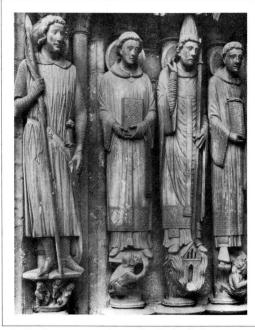

56. Sculptures, south porch. Cathedral at Chartres.

are larger, deeper, more elaborate (55), following the usual course of development of style in all periods from solid and simple to more open and complicated—a course that holds for both architecture and sculpture. The sculptures on the south portal (56), about seventy-five years later than those of the Royal Portal, show changes quite in line with those we saw in Greek sculpture from the archaic kouros to the Diadoumenos. The later figures are more relaxed; still selfcontained, they occupy space more easily; they are more realistic; they gesture freely, turn their heads this way and that. Nevertheless, they do not take full advantage of the flexibility inherent in these changes from the rigidity of the figures on the Royal Portal. Sculpture on the north and south portals is still quite consciously the handmaiden of architecture; the columnar form, even though much modified, is respectfully echoed.

Having already looked at sculpture in the full round, with its attendant variations of open and closed form, we may consider the conventional range from low relief to the full third dimension concluded. But two other forms of relief may be added, one at each end of this range. Even lower than the lowest low reliefs is *rilievo schiacciato* (the translation, "flattened relief," is seldom used), and we are going to suggest, somewhat hesitantly, and for purposes of argument, that there is a valid case for sculpture that goes beyond the familiar third dimension of full relief into the highly theoretical one called the fourth.

Rilievo schiacciato, invented by the Italian Renaissance sculptor Donatello, barely rises above the flat plane of two dimensions and is possibly even closer to drawing than it is to sculpture. In Donatello's marble panel Saint George and the Dragon (57), the relief of the arcade behind the princess is so delicately indicated that it is as much drawn as carved in linear perspective. Yet its definition is vigorous and specific in contrast with that of the schiacciato landscape in the distance, a mere veil of relief in which the marble seems to dissolve in an atmospheric mist. This beautiful form of relief—something like painting with a chisel and abrasive—is seldom employed for the double reason that it is difficult in its extreme subtlety, and because it needs a raking light at the proper angle to reveal it. In a direct light it can be literally invisible.

The fourth dimension? That one isn't easy. This dimension, or space-time, is a concept of modern physics that demands strained rationalizations when applied to art. The concept denies the Newtonian premise that space and time are independent realities (which all of us accept as an obvious fact of existence without wondering about theory) and proposes instead that space and time are indissolubly united. If that is true (some artists have argued), then we should be able to see all sides of an object at once, instead of sequentially as we move around an object in time. This idea has taken the form of cubism in painting, as we will see in a later chapter (170). In the meanwhile, is there such a thing, can there be such a thing, as a sculpture of which we can see all sides simultaneously?

Hardly. But the Italian sculptor Umberto Boccioni, leader of the movement called futurism, was working with some such idea in 1913 in his Unique Forms of Continuity in Space (58), with which he tried to illustrate in bronze his contention that no forms are finite: "No one can any longer believe that an object ends where another begins." Boccioni wanted to "break open the figure and enclose the environment within it." He demanded "absolute and complete abolition of definite lines and closed sculpture." We have seen that these ideas about open form and the interpenetration of sculpture and environment had been pretty well anticipated three hundred years earlier in sculptures like Bernini's *David*, but Boccioni also insisted that "objects never have finite ends, and they intersect with infinite combinations of sympathetic harmonies and clashing aversions." It was in this vital difference from the simpler idea of interpenetration of solids and voids—a sculpture and "the environment around it"—that Boccioni met his defeat, for his gleaming bronze Unique Forms of Continuity in Space, no matter what the theory behind it, remains a very solid and finite object-more so, even, than Bernini's marble. The fact that Boccioni's handsome, rushing figure also bears a strong, if coincidental, resemblance to the Nike of Samothrace (59), popularly known as the Winged Victory.

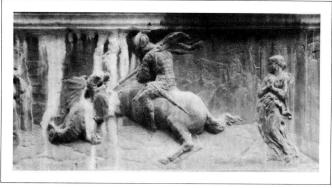

57. Donatello. *Saint George and the Dragon*. Relief below statue of Saint George. About 1415–16. Marble, 15% by 47¼ inches. Orsanmichele, Florence.

58. Umberto Boccioni. *Unique Forms of Continuity in Space.* 1913. Bronze (cast 1931), height 43% inches. The Museum of Modern Art, New York. Lillie P. Blixx Bequest.

59. Greek, Hellenistic. *Nike of Samothrace*. About 190 B.C. Marble, height 96 inches. The Louvre, Paris.

60. Naum Gabo. *Linear Construction, Variation*. 1942–43. Plastic and nylon thread, 24½ by 24½ inches. The Phillips Collection, Washington, D.C.

61. Alexander Calder. *Little Spider*. About 1940. Metal, painted, 55 by 50 inches. Courtesy Perls Galleries, New York.

and carved about the year 190 B.C., has also tended to take the edge off the modernity of *Unique Forms of Continuity in Space*.

It is difficult to see how any bronze object can be anything but finite by physical definition. Like the other traditional materials of sculpture, bronze stubbornly insists upon occupying space. The nearest thing to working with materials that do not occupy (or displace might be a better word) space, is to work with any that are transparent, as Naum Gabo does with clear plastic and nylon thread in Linear Construction, Variation (60). Made in 1943, this is one of numerous Gabos confirming a manifesto issued by the sculptor in 1920, in which he said: "We deny volume as the expression of space . . . we reject physical mass as a plastic element . . . a sculptural element, a material substance." It may still be necessary to walk around Gabo's "linear constructions" to get all views, but from any single view we do see intersecting spatial volumes—an approach, at least, to something like the fourth dimension, spacetime, in static sculpture.

Kinetic sculpture, sculpture that moves, often approximates a space-time concept. Alexander Calder's mobiles (61), familiar to everybody today, with their component parts floating and turning in space in response to air currents, assuming new relationships between themselves and space around them as the lighter parts move more swiftly, the heavier ones more slowly, shifting and changing—these mobiles are indeed "unique forms of continuity in space," a description that fits them more accurately than it does Boccioni's bronze.

Calder designed his mobiles to be activated by natural air currents with consequent variations in speed. There is something very pleasant about the idea of this union between a force of nature and a piece of engineered sculpture, even though many of the mobiles set up in museums and other public buildings are animated by concealed fans. Other artists interested in mobile sculpture have depended on motorization in the first place. A pioneer in the field, and a highly influential theorist, László Moholy-Nagy, published a manifesto, *System of Dynamo-Constructive Forces*, in 1922, and included light among the sculptor's structural materials. To demonstrate the principle, he built his *Lichtrequisit*, a steel-and-plastic rotating construction from within which 140 electric light bulbs threw changing images and colors onto the walls around it.

Among motorized sculptures today, Nicholas Schöffer's "spatiodynamic" constructions, one of his many experimental forms, have as their declared aim "the constructed and dynamic integration of space into plastic work." A Schöffer motorized sculpture virtually dissolves when set in motion; its solid forms describe ethereal planes and volumes that we perceive in terms of flickering lights as they merge, interpenetrate, and emerge again, with no single aspect of the sculpture that can be thought of as its typical one—until a photograph freezes the action and thus belies the evanescent space-time relationships (62).

62. Nicholas Schöffer. *Microtemps 22*. Motorized sculpture, static and in action. 1966. Metals, approximately 35½ by 24 inches. Courtesy Galerie Denise René, Paris.

There is surely something more significant than coincidence in the fact that Gabo's and Schöffer's sculptures,
striving for expression of a twentieth-century scientific and
esthetic concept, are created in materials and by means
peculiar to the century. (Schöffer has experimented with
sculptures that are set in motion by reactions to sound and
light, and has also designed computer-directed kinetic
sculpture.) The revolution of modern art, initiated by
painting, has changed the look—and definition—of sculpture more than that of any other art, largely because of the
variety of materials that have become accepted as legitimate
sculptural means. In addition to adapting the wide range of
synthetic substances originally developed for commercial
uses, sculptors now work in literally any material that may
appeal to them, from junk machine parts to chewing gum.

But sculpture's heroic materials remain the traditional ones—stone, bronze, and wood (in special instances, terra cotta). None of them can be called neglected today in spite of the excitement over innovation and experiment. We will see that the painters' various mediums are reflected in the esthetic character of their work, but paint mediums are much less insistent in their demands on the artist than are the materials of sculpture. Paint is paint, easily manipulable, even submissive in the hands of a skilled artist, his means to an end. But the sculptor must admit stone, bronze, and wood, or the minor materials such as precious metals, ivory, and gems, to partnership in the creative act. They

63. German. Book cover, *Mondsee Gospels*. Late eleventh century. Silver, ivory, and rock crystal on gold ground, approximately 11 by 8 inches. The Walters Art Gallery, Baltimore, Maryland.

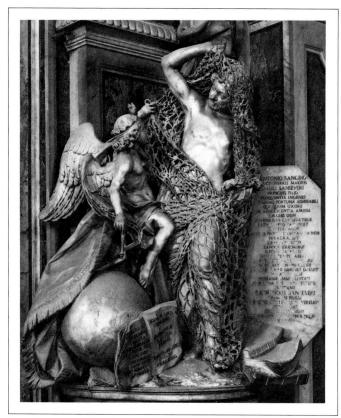

64. Francesco Queirolo. *Allegory of Deception*. Mideighteenth century. Marble, life size. Santa Maria della Pietà dei Sangro, Naples.

dictate how he may and may not employ them to best effect; they stay his hand, where the painter's hand is free to improvise. Marble, granite, limestone, sandstone, onyx, the dark Abyssinian marble called basalt, or the pure crystalline white marble of Carrara—each has its own potential and its own limitations in terms of grain, color, hardness, or softness, that must determine the sculptor's approach. Woods have their own textures, grains, and colors, almost as various as those of stones.

Ivory, a special case, combines workability, durability, and extremely fine texture that allows for precision in detail along with the warm white color in which that detail tells best. The gigantic statue of Athena in the Parthenon, long lost, was made of gold and innumerable pieces of finely joined ivory, but such sculptures were exceptions; part of ivory's charm is its adaptability to miniature scale. In medieval Europe, ivory was so precious as to rival gems, and carvings were set like jewels in small shrines, liturgical articles, and other religious objects where sumptuousness was a mark of devotion. The late eleventh-century Gospel book we are using as an example (63) is studded with miniature ivories of the four Evangelists, each, like the one of Saint Matthew shown here at full size, only 27/8 by 13/4 inches (65). They surround a large cabochon crystal covering a drawing of the Crucifixion in gold.

The sculptor who ignores or violates the special character that his materials offer him in partnership is lost. A notorious example of the prostitution of material to the display of technical elaboration is Francesco Queirolo's Allegory of Deception (64), in which marble, the noblest of stones, is subjected to one indignity after another in the course of this eighteenth-century Italian sculptor's unintentional revelation of himself as a skilled artisan with no imagination, rather than a creative artist.

The one traditional material employed in monumental sculpture since antiquity that can be called flexible is bronze. It is "flexible" because the sculptor does not create in that obdurate material but casts in it, reproducing sculpture modeled in wax or clay, malleable substances that are literally sensitive to a personal touch, that are easy to change or correct, immediately responsive to the sculptor's intention, and versatile in the forms they are willing to assume under his manipulation. The special qualities of bronze, ranging from strength in the most delicate detail to the sleekest of surfaces—surfaces like those in the Lachaise and the Boccioni that we have seen—may be kept in mind while the sculptor works in clay or wax, and these qualities may be introduced or emphasized by the polishing, trimming, and sometimes addition of detail that the bronze receives after casting. Yet up into the nineteenth century large bronzes were conceived essentially in terms of carved sculptures. It was not until the late nineteenth century that the malleability of clay and wax, the direct touch of the sculptor, his personal impress, became a goal for reproduction in bronze.

Rodin's The Age of Bronze (66), compared with two

65. Saint Matthew. Miniature from cover of Mondsee Gospels. Ivory, 2% by 1¾ inches. The Walters Art Gallery, Baltimore, Maryland.

other realistic male nudes, the Diadoumenos and Bernini's David, is startlingly lifelike, so much so that it was attacked by French critics, who accused Rodin of having cast it from the model, a well-muscled and beautifully proportioned young soldier who was given leave from his company to pose for the sculptor. It is true that Rodin tried to reproduce the perfect body accurately, convinced that perfection in nature could not be improved by idealization in the studio. Yet the extraordinary effect of life comes not from accurate reference to reality, but from the feeling of suppleness in the rippling contours of muscular structure set off by the lustrous surface of bronze, a surface modeled with the sensitivity of the hand added to the perception of the eye. Possibly our knowledge that bronze enters the mold in a molten state has something to do with our feeling that this material, which is actually dry and hard, is sympathetic to the representation of a moist and flexible living body.

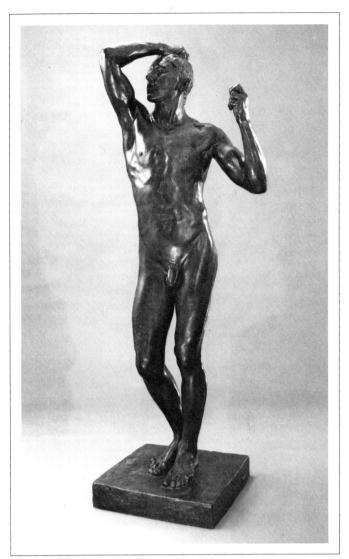

66. Auguste Rodin. *The Age of Bronze.* 1876. Bronze, height 71 inches. The Minneapolis Institute of Arts. John R. Van Derlip Fund.

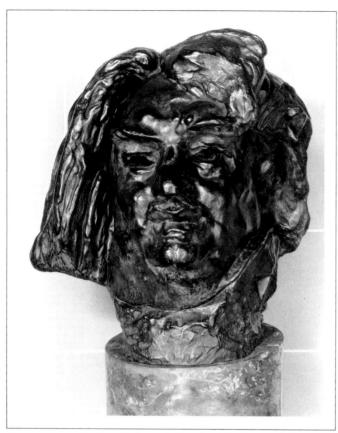

67. Auguste Rodin. *Colossal Head of Balzac.* 1897. Bronze, height 20 inches. Rodin Museum, Philadelphia.

The genius of Rodin's hands in contact with clay could respond to the sensuousness of a body, to the tenderness of a subject where tenderness was appropriate, and above all to the vigor of a personality as strong as his own. There is hardly a passage in his Colossal Head of Balzac (67) that conforms to actuality as does The Age of Bronze: the clay has been gouged, pushed, built up, pressed into ridges, smoothed flat with the thumb, manipulated in every fashion, always for purposes of expression, never imitation. In his early studies for a monument to Balzac, Rodin worked from a model who resembled photographs of the author. But after dozens of studies over some five or six years, the features had become only the raw material for a visionary conception of the man who wrote La Comédie Humaine. a man whose overwhelming creative energy paralleled Rodin's own. Originally Rodin had planned the monument as a gigantic nude with a thick, powerful body, but in the final version the head surmounts a vast all-encompassing cloak that swathes the figure from chin to toe (68). The two sides of Rodin's nature-everyone's nature, for that matter—are allegorized in the sensuous response to physical beauty in The Age of Bronze with its naked body, and the intellectual speculation upon the human condition in the bodiless Colossal Head.

The excitement that has greeted modern art in this century, expressing itself in applause, catcalls, and puzzled silence, was occasioned first by painting; but the transformation of sculpture was more extreme than that of any of the other arts. It was so extreme that we mean one thing when we say "sculpture" in the context of the thirty thousand years stretching between the Venus of Willendorf and Rodin, and another when we say "sculpture" in the context of the twentieth century. Objects now classified as sculpture are frequently neither modeled nor carved, but are glued or nailed or welded into a sculptural unit from odds and ends of material picked up here and there, with junked machine parts among the most popular. These sculptural "assemblages"—pronounced in the French fashion to rhyme with "collage"—have suffered drastically from their popularity with amateurs possessed of home welding kits and no acquaintance with design. In proper hands, the transfiguration of such material may take on the heroic stature of David Smith's sculptures, made from heavy machine parts, metal plates, and sometimes his own additions in forged iron (69). On a smaller scale, the ingenious forms of Richard Stankiewicz's sculpture revitalize scrap iron (70).

Individual bits of scrap metal or other industrial detritus of interesting shapes are sometimes mounted alone as "found objects" and can have an undeniable but rather tricky effectiveness, just as pieces of driftwood found on beaches may be mounted to set off their interesting shapes without modification. The found object has its art-historical ancestor in the "ready-mades" of Marcel Duchamp, the iconoclast of modern art who, by violating and mocking all

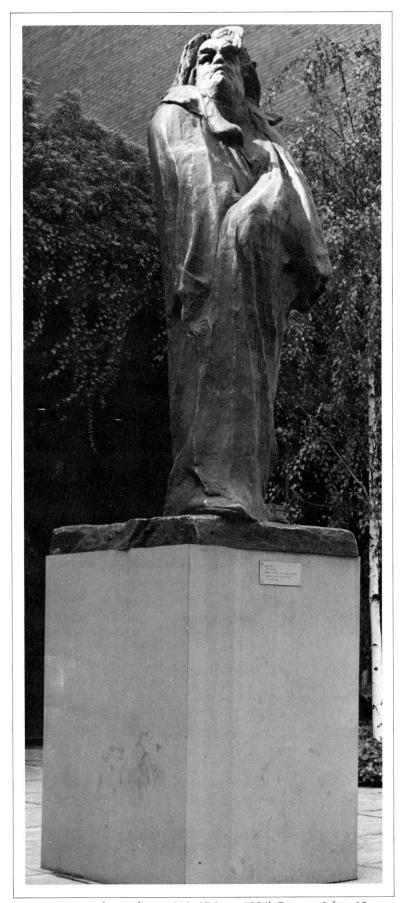

68. Auguste Rodin. *Balzac.* 1893–97 (cast 1954). Bronze, 8 feet 10 inches. The Museum of Modern Art, New York. Presented in memory of Curt Valentin by his friends.

69. David Smith. *Volton XV.* 1963. Steel, rusted, height 75 inches. Estate of David Smith, courtesy M. Knoedler & Co., Inc., New York.

70. Richard Stankiewicz. *Construction*. 1957. Welded iron and steel, 12½ by 13¼ by 85% inches. The Museum of Modern Art, New York. Philip Johnson Fund.

71. Photograph of bottle rack ("ready-made" sculpture) included in valise with other photographs, replicas, and color reproductions of works by Marcel Duchamp. The Museum of Modern Art, New York. James Thrall Soby Fund.

traditional art values, helped to clear our eyes of habitual ways of seeing and our responses from habitual ways of feeling. An ordinary bottle rack (71), when we see it displayed in a museum as sculpture, becomes an arrestingly designed object. It was not Duchamp's purpose, however, to increase our sensitivity to the interest or beauty of ordinary objects, but only to deflate the pretensions of the pundits who had dictated taste during the nineteenth and into the twentieth century. "Dada," the movement in which such deflations were promulgated during the débâcle of World War I, was an anti-art art movement that soon died but left Duchamp as its vital symbol and occasional practitioner until his death in 1968. Impertinence was a major weapon in Dada, and if the example of the bottle rack is not strong enough, there is the primary example of a urinal that Duchamp exhibited under the title Fountain.

We will see other departures from sculptural tradition as this book goes on. For the time being, we might point out that our drastic change of ideas about what sculpture is and what makes it interesting is tied up with the dominant single element of our civilization—the machine.

Today, with our responses to machines toughened by the prolixity of forms from dishwashers to spaceships, it is difficult to imagine the degree of fascination machines held for the public a hundred years ago. In the great international exhibitions—world fairs—of the end of the nineteenth century in Europe and America, the halls where machines were displayed were the most sensational. In 1889, celebrating the centenary of the French Revolution, Paris held the largest of these exhibitions, but its machine exhibit had had a precursor in Machinery Hall in Philadelphia, where the Centennial Exhibition of 1876 celebrated the signing of the Declaration of Independence. The Centennial halls dedicated to art were crowded with visitors self-consciously absorbing culture (73); but in Machinery Hall (72) the excitement was genuine and spontaneous, a contrast exemplified by one of the most popular sculptures, La Première Pose (75), and one of the most amazing machines, the I. P. Morris Blast Engine (74).

La Première Pose—a marble by Howard Roberts, a Philadelphian who had studied in Paris—capitalized on the disguised lubricity of a subject dear to the French since the eighteenth century, a young woman posing nude for the first time in an artist's studio, which combined the pleasures of genteel voyeurism and artistic connoisseurship. The carving of the fringe and embroidery on the fabric draped on the model stand was as widely admired as the slick forms of the body, and in the minds of the day both were sanctified by the classical tradition.

But there was no tradition to explain the logical yet fantastic new forms in Machinery Hall. It could not have occurred to the crowds who were amazed by the blast engine (which could deliver 10,000 cubic feet of air a minute to a steel-making furnace) that the machines they admired for their sheer size and power would one day be cited by twentieth-century art historians as harbingers of an esthetic

72. General view of south nave of Machinery Hall, Centennial Exposition, Philadelphia, 1876 (Krupp cannons in foreground). Wood engraving from Frank Leslie's Historical Register of the U.S. Centennial Exposition," published 1877.

73. A view of people at the arts exhibit, Centennial Exposition, Philadelphia, 1876. Engraving from McCabe, Illustrated History of the Centennial Exposition, 1877.

74. I. P. Morris blast engine. Wood engraving from J. S. Ingram, *The Centennial Exposition* (Philadelphia, 1876).

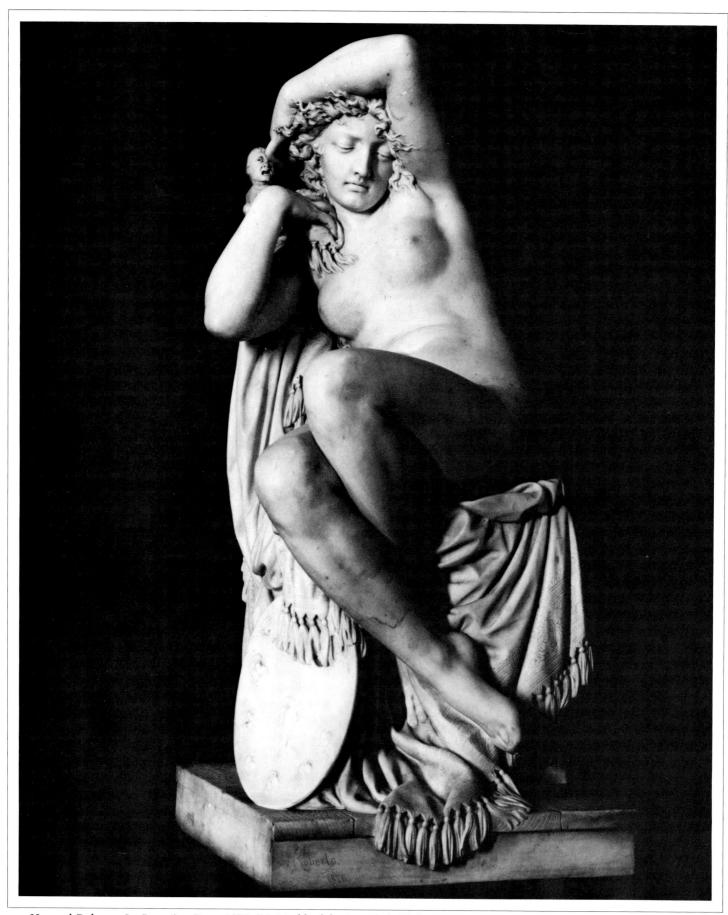

75. Howard Roberts. La Première Pose. 1875–76. Marble, life size. Philadelphia Museum of Art. Given by Mrs. Howard Roberts.

revolution—a revolution that would annihilate the values they had been taught to hold most dear in sculptures like La Première Pose. But today, the few antiquated nineteenth-century machines that have survived (mostly in science museums) seem to art historians to be the ancestors not only of modern machines that have become more sleek, more powerful, and in a way more impersonal and hence less interesting, but also to hold the genes that produced a varied school of modern sculpture. We have seen examples by David Smith and Richard Stankiewicz, in which the primitive heaviness and varied shapes of discarded machine parts were recognized as elements of a new sculptural esthetic, and by Alexander Calder, himself an engineer turned sculptor, whose mobiles, shifting and floating in the air, are machines etherealized.

The sources of modern sculpture are infinitely varied throughout the history of art; we have already compared the oldest sculpture known, the *Venus of Willendorf*, with the female nudes of a twentieth-century master, Gaston Lachaise. We can also compare that ancient so-called Venus with the first work of art shown in this book, Jean Dubuffet's *Nourrice Profuse* (1), to which we promised to return.

Nourrice is French for "wet nurse," a woman hired to suckle another's child. Profuse being self-explanatory, this lump of slag iron becomes a multi-breasted fertility image in a special way connected with art brut. The term, invented by Dubuffet, can best be translated as "art in the raw," and applies to his theory that such sources as the drawings of very young children, psychotics, the insane, and the perpetrators of graffiti on public walls are more vigorous and closer to art's most expressive sources than are all the rules and refinements that artists have developed and observed over the centuries. Extending the "raw" idea to materials, Dubuffet on occasion has used cinders and ashes for paints, just as, in Nourrice Profuse and a series of sculptures on the same order, he finds sculptural qualities in slag iron.

But *Nourrice Profuse* has another connection with the past that makes it a hypersophisticated transformation of "art in the raw" into art as a witty historical comment. Among the most curious sculptures from antiquity is the multi-breasted *Artemis of Ephesus* (76), a bronze and alabaster Roman copy of a Hellenistic cult figure whose confused attributes include her position as goddess of wild animals. Thus the ancestry of *Nourrice Profuse*, stretching from prehistory through antiquity to our century, becomes one instance among innumerable others (although not often so eccentric) of the ramifications that make an acquaintance with art history inexhaustibly rewarding.

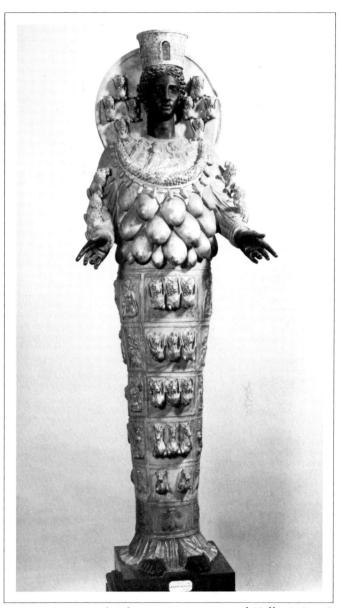

76. Artemis of Ephesus. Roman copy of Hellenistic original. Bronze and alabaster. Museo Nazionale, Naples.

77. John Russell Pope. Jefferson Memorial. Dedicated 1943. White marble. East Potomac Park, Washington, D.C.

78. Stonehenge. About 2000 B.C. Height 13 feet 6 inches. Salisbury Plain, England.

Chapter Three

ARCHITECTURE

A ll the arts—including poetry, music, and any others not discussed in this book—satisfy needs of the spirit and offer exercises for the intellect. Of them all, architecture alone is called upon to satisfy practical demands as well.

A building may satisfy practical demands without regard for esthetic effect. As instances, there are factories, warehouses, and hundreds of other modern buildings that unfortunately offer nothing more than adaptable space and protection from the weather for machines, stored goods, or office workers, although the same practical demands could have been—and in some instances have been—satisfied in ways that also offer esthetic pleasure.

At the opposite pole is the architectural monument subject to no practical demands at all, unless, as in the case of the Jefferson Memorial in Washington (77), the protection of the statue of a great man from the weather can be called a practical function. The Jefferson Memorial is the direct descendant of a long and aristocratic line of shrines to gods, heroes, kings, savants, and politicians. And in the broadest possible historical view it is even a descendant of another circular temple, the grandest prehistoric structure in existence, Stonehenge (78), built about four thousand years ago on Salisbury Plain in England.

The megaliths of Stonehenge were quarried (with who knows what primitive tools?) about twenty-five miles from the site and, weighing up to 50 tons each, were dragged (by what primitive means? perhaps rolled on enormous logs?) and erected as supports for the megalithic lintels that were somehow (here the imagination fails) lifted into place. Geometry, the mother science of architecture, was united with astronomical observations by which the great stones were spaced in such a way that at sunrise on the summer solstice the first rays of light cut through to an altar, the celestial cue for the performance of the rites of spring.

Compared with the primitive majesty of Stonehenge, the classical forms of the Jefferson Memorial in Washington may seem a bit threadbare, anemic, and chilly. The monument was not well received by critics when it was dedicated in 1943. But there were arguments to justify its design. It is companion to another monument in classical style, the Lincoln Memorial, and Thomas Jefferson himself was not only a classical scholar in the eighteenth-century mode but an architect, who designed the University of Virginia in Charlottesville and the Virginia state capitol in Richmond as adaptations of monuments of classical antiquity.

Are there any standards flexible enough to help us understand and enjoy an art that has as many facets as the history of mankind? Between the extremes of the practical functional building and the decorative monument, the story of architecture includes every degree of interrelationship, each affecting the other, one sometimes

79. Frank Lloyd Wright. Kaufmann House ("Falling Water"). 1936. Bear Run, Pennsylvania.

80. Frank Lloyd Wright. Taliesen East. 1925. Spring Green, Wisconsin.

supporting the other, sometimes demanding a compromise, as in every successful partnership. Thus, the first questions we will ask in evaluating some buildings selected as examples will be: How well does the building satisfy the demands of its function? and, How satisfying is it esthetically? Ideally, the union should be so harmonious as to be indivisible.

Indivisible, too, in the esthetic success or failure of a building, are the uses made of materials and the integration of design and site. An exceptionally dramatic example is the famous residence in Bear Run, Pennsylvania, designed by Frank Lloyd Wright, Falling Water (79), where cantilevered porches spring out over the natural stone ledges of the ravine site with its waterfall, while behind them the less conspicuous portion of the house, with thick walls of native stone rising from the raw stone itself, seems to have grown from the site rather than to have been built upon it.

Less spectacular and for that reason perhaps esthetically more satisfying in the long run, Taliesin East (80), one of Wright's own studio-residences, is a rambling structure designed to echo the long, low lines of the countryside around it. The structural materials are native stone and natural wood. With flagstone terraces continuing without a break as indoor floors, and with large areas where glass screens from floor to roof are the only division between indoors and out, house and site are perfectly mated.

Finally, and perhaps most rewarding for us as heirs of the past and witnesses of the present, architecture is not only an expression of the age that produced it, as are the other arts, but is probably the most dependable of those expressions. Because it is the least personal and the most sociological of the arts, architecture is the likeliest to give us the most unbiased and most complete reflection of the age it served.

So, in summary, our bases for the judgment of architecture in this book will be:

Functional efficiency. How well does the building work? Esthetic quality. Is it good to look at?

Materials and site. Is the most made of their potentials? Humanistic record. Does acquaintance with the building clarify, intensify, or enlarge our experience through its character as an expression of its time?

These bases can apply whether we are looking at a Greek temple or a Roman bath; a medieval cathedral or a Renaissance church; a nineteenth-century opera house or the Brooklyn Bridge; a radically modern structure that opened in Paris in 1977, the Pompidou Center, or a primitive tribal shelter in New Guinea, which is where we will begin.

There is no word for "architecture" or "architect" in the vocabularies of the builders of the men's ceremonial houses in New Guinea—we show here the framework of one under construction [81] and the interior of another [82]—yet these soaring structures could hardly have been bettered if the most sophisticated architects at work today

had been set down in the forest and commissioned to design shelters for the specific function served by these houses, and to build them from the only available materials, those at hand in the forest.

The ceremonial houses are meeting places for the men of the tribe, where pubescent boys are secluded for a period of instruction before initiation into manhood. Any crude, low-roofed structure of sufficient size would satisfy the demands of space and seclusion, but it would not express the significance of mysteries central to the life of these people, or the importance of the rituals by which tribal secrets are transmitted from generation to generation. It is only coincidence that the pointed form made by joined bamboo poles resembles the vault of a Gothic cathedral, and that the interior is divided into a nave and side aisles, but the coincidence is at least appropriate, for in each case it is associated with the performance of rituals basic to the spiritual existence of a people. And if we marvel at the use of stone in cathedral vaults, we may also admire the ingenuity with which poles of bamboo (in that part of the world growing to a height of as much as 80 feet) serve as the exposed ribs for a covering of thatch. The beauty of the taut, energetic curve of the bamboo arch is the natural result of the plant's inherent strength and flexibility. By the standards we have set, the men's ceremonial houses are architecture of a high order: they are functionally efficient and esthetically satisfying; they make ingenious use of materials; and they are vivid expressions of the society that produced them.

These houses are, in effect, at least as old as Stonehenge, or older, in terms of the stage of civilization that they represent. Since these structures, thousands of years removed from our own time, fit so neatly the criteria we have set for understanding architecture, we should expect no difficulty in applying the criteria to a building of our own moment. But the "pure, direct, and forceful expression" typical of primitive art is denied a civilization as complex as ours, and the Pompidou Center (83) defies easy judgments.

The Centre National d'Art et de Culture Georges Pompidou is named for the French president, who in 1969 envisioned "a cultural center that is both a museum and a center of creation where the plastic arts would be side by side with music, cinema, books, and audiovisual research." Completed in 1977, the center is now generally called Beaubourg, from the area of central Paris that it dominates. Materialized, Pompidou's vision became an architectural behemoth of spectacular originality; as the latest development in the architectural story that began so long ago, it was controversial from the beginning, and offers a clear, unequivocal answer to only the last of our four questions: Beaubourg is, indeed, emphatically an expression of our time—although even here we must concede that it is not an expression generated in response to the inherent spirit of our civilization, but a design arrived at through a combination of theoretical reasoning and a talent for architectural dramatics.

81. Framework of a davi, men's ceremonial and clubhouse, under construction. Maipua, Papua, New Guinea. Photograph, about 1900, courtesy Field Museum of Natural History, Chicago.

82. Interior of a *davi*, New Guinea. Photograph courtesy American Museum of Natural History, New York.

83. Piano & Rogers; Ove Arup & Partners. Centre National d'Art et de Culture Georges Pompidou ("Beaubourg"). 1971–77. Paris.

84. Gustave Eiffel. Eiffel Tower. 1889. Height 984 feet. Champ de Mars, Paris.

Then, immediately, we have to make another concession: if time should prove that Beaubourg is only a monstrous tour de force, it nevertheless satisfies two conditions most important to the French government that commissioned it. First, in its size, its aggressiveness, and its compelling originality, it is a proclamation of French determination to regain leadership in modern art, a leadership that Paris lost to New York after World War II. Second, in its hybrid character as an amusement park and an art center, Beaubourg proclaims that art in France is no longer an élitist activity. The Louvre, nearby, is a palace to which the public are admitted as spectators. Beaubourg is a public building where visitors become participants in an exciting experiment, both inside the building and in the street-fair atmosphere that is encouraged in the adjacent plaza.

Generally speaking, the older a building is, the more adaptable it is to something like final judgment on its merits and shortcomings. We are using Beaubourg here as an extreme example where judgment must be approached warily, where conventional esthetic criteria can serve only as a basis for pro and con examination until time settles the debate. It should not be surprising that Beaubourg is somewhat upsetting when we try to apply criteria that apply pretty well to a wide variety of historical building types—for Beaubourg is literally a building turned inside out.

Biology supplies a good term for Beaubourg's design: "exoskeletal." Exoskeletons are the hard external supporting structures in nature, such as the shells of oysters or the cuticle of lobsters, as distinguished from endoskeletons, our own and other vertebrates' internal bony structure. Beaubourg's supporting skeleton of steel scaffolding, as well as the conduits for water, ventilation, sewage, wiring, and other engineering functions of a large building, which are normally concealed within or behind walls, are exposed all the way around the immense structure. What we think of as the building itself is suspended within this exoskeleton in the form of an enormous multi-storied, glass-walled cage of space that may be subdivided by lightweight movable screen walls where needed. It is a building without a façade: the bright color that dramatizes the exoskeleton is utilitarian in origin: it follows the engineering convention by which the conduits for different functions are identified by different colors, both in working drawings and in completed buildings, not intended for the decorative purposes they serve at the Centre Pompidou but only for easy recognition by builders, workmen, and repairmen.

Then there is the other way of seeing Beaubourg, not as a revolutionary structure but as the latest chapter in a long, uninterrupted story of engineering-as-architecture. Even the idea of an architectural exoskeleton is not quite new: the flying buttresses of the Gothic cathedrals, which we have already seen (7), are exterior continuations of an endoskeleton of piers and ribbed vaults. Perhaps flying buttresses looked radical on their first appearance, but they

became so popular that later Gothic architects employed them in unfunctional proliferations. And like the piers and ribs of the exposed endoskeleton of the vaulting system, they were carved and patterned to increase their innate decorative character. The flying buttresses of Notre Dame are visible in the panoramic view of Paris from the upper levels of Beaubourg, as is another landmark in engineering, the Eiffel Tower (84), erected for the Paris Exposition of 1889 to demonstrate the potential of iron construction, and left standing after a narrow escape from protests that it disfigured the city—as does Beaubourg, to many eyes.

The catch in our set of qualities by which architecture can be judged is in the second of the four—esthetic appeal. No other art is subject to such extreme variations in style from epoch to epoch and hence to such extreme shifts in the esteem accorded a building as tastes change. It is chastening for an architecture critic to remember that in the eighteenth century, the Age of Reason when all things classical were revered above all things else, there was agitation in Paris to demolish Notre Dame as a barbarous eyesore. Nor need we go that far back. One of the finest monuments of nineteenth-century eclectic architecture in America, Philadelphia's City Hall (85), is standing today only because it is so solidly built that contractors would not offer firm bids for tearing it down in the late 1950's to be replaced by a more efficient building. The tower, including the statue of William Penn on top, is the highest building ever built without structural steel—that is, by putting one stone on top of another. The stones are massive, and the tower would have had to be disassembled stone by stone rather than knocked down with the swinging ball or dynamited; it was feared that the stones falling from such a height would go through the sidewalk and into the subway.

Having passed the dangerous age at which thousands of fine nineteenth-century buildings, especially residences, have been demolished, the Philadelphia City Hall is now conspicuous among buildings in a style that has been reevaluated upward esthetically, while the modern style of building with which it would have been replaced has taken a downward curve, as we will see in our next chapter. The tragedy of architecture is that while a painting or a sculpture may be relegated to basement storage during periods when its style is out of favor, nothing can bring back a destroyed building. If the judgment of a building as architecture is to be fair, we must take into consideration the terms that made it suitable for the time in which it was built. Again, as we go on in this book, we will see that terms usually applied only to painting or sculpture, such as "realism" and "expressionism," are also applicable to architecture, further complicating the standards by which architecture may be judged but, as a happy result, expanding the range in which it may be enjoyed.

85. John McArthur, Jr. Philadelphia City Hall. Cornerstone laid July 4, 1874. Completed 1901.

86. William Michael Harnett. *Music and Good Luck*. 1888. Oil on canvas, 40 by 30 inches. The Metropolitan Museum of Art, New York. Purchased by Catharine Lorillard Wolfe Fund, 1963.

Chapter Four REALISM

painting, a sculpture, or a building is a triple experience—visual, emotional, and intellectual. Since it is hardly possible to look at anything without reacting to it in one way or another, a certain amount of emotional response is inevitable. In character and degree this response depends on our willingness and capacity to respond to what the artist or architect offers us. But when it comes to intellectual enjoyment, our reaction is less immediate. It is more a matter of learning, and this is the point where many an interested person begins to protest his ignorance of what art is all about.

This protest is a natural defense in a time when art has been subjected to so much intellectual snobbery. The layman naturally takes refuge in the conviction that *all* intellectualization about art is snobbery. In its tiredest form, his protest is the familiar "I don't know anything about art but I know what I like." Translated into more formal jargon, the same thing can be said this way: "Intellectual understanding of art is not prerequisite to emotional response." Stated either way the proposition is only half-true, but, all other considerations aside, it is true that intellectual appreciation of art is a pleasure that need not involve snobbism.

This and our next two chapters are concerned with visual, emotional, and intellectual experience in the enjoyment of art—seeing, feeling, and thinking. Obviously what we see, what we feel, and what we think are so bound together they cannot easily be separated. But insofar as distinctions can be made, we are going to consider these pleasures separately under the titles, respectively, of realism, expressionism, and abstraction.

To begin, we will compare William Harnett's Music and Good Luck, a realistic painting (86); Raoul Dufy's The Yellow Violin, an expressionistic one; and Georges Braque's Musical Forms, an abstraction (87 and 88, p. 62). Their subjects are as nearly parallel as one could hope for in demonstrating such divergent results.

Harnett's *Music and Good Luck* is the kind of realistic painting the eager but unenlightened museum-goer encounters with relief. He knows that Harnett must be good because, after all, museums and collectors covet his work. But at the same time it is possible to enjoy Harnett without having to wonder what his art is all about. His pictures are guaranteed to be legitimate art, yet at the same time they are enjoyable at face value. In short, they are safe.

But confronted by Dufy's expressionist *The Yellow Violin*, our hypothetical layman may feel a little insecure. He may find the picture attractive enough in its way, yet it doesn't look as if it had been hard enough to do. Still, it is not too puzzling. You can tell what the images are supposed to represent, even if they are out of kilter.

Braque's abstraction is another matter altogether. By even the most relaxed standards of truth to nature, it defies every convention.

Yet the two paintings that are closest to one another as far as the artists' approaches are concerned, the two that can be enjoyed on most nearly the same basis, are the two that seem most unlike. The very realistic *Music and Good Luck* and the highly abstract *Musical Forms* are first cousins.

Music and Good Luck is an example of realism pushed to its ultimate extreme, illusionism; it sets out to please the eye by deceiving it, and is so sucessful that there are passages where different textures are simulated with such accuracy that it is hard to believe the texture is uniformly smooth over the entire surface of the picture, as of course it is. The illusion is intensified because the objects are painted at their exact size, but even in our small reproduction, it is as if we could take the violin off its nail; we can read the score of the music and the name on the calling card—which does double duty as the artist's signature; the horseshoe, violin bow, hasp, and piccolo hang so naturally that we can imagine lifting them off the picture; their shadows tell us just the distance between them and the door, and that the lower end of the piccolo touches the door while the upper swings away from it.

Any painter who has coped with the problem of illusionistic shadow—or any photographer concerned with fine printing that captures every nuance of tone between one shadow and another-will realize that Harnett's shadows, which are the least noticed element in his paintings, are the most subtly studied, their edges painted harder or softer in exact degrees according to their distances from the objects and the intensity of the light. It is next to incredible that the wooden frame around the rest of the picture is not a real one but an exercise in illusionism like the area it surrounds. The padlock is the giveaway here, once it is noticed. The date 1888 is "scratched" so realistically on the surface of the painted frame that it looks like a bit of vandalism. Actually, not scratched but painted, it is Harnett's way of dating the picture, just as the calling card is his way of signing it.

If illusionism were its whole content, Music and Good Luck would be a conglomeration of tricky simulations, nothing more, and would lose our interest once we had examined the imitated objects. But it continues to hold us. It holds us because it is more than an imitation of visual fact. This "natural" painting is not natural at all except from detail to detail. The arrangement of the objects, in the first place, is arbitrary. It is no accident that the bow is placed vertically, lining up with a system of other verticals including the axes of the violin and the hasp, the cracks between the boards of the door, and even the right and left borders of the picture, which we never think of as part of a painting although the artist is conscious that they must be incorporated into his arrangement. A second system of

horizontals at right angles to the verticals is defined by the hinges, the top and bottom of the door, and, again, the top and bottom of the painted frame.

In memory, anyone would probably describe the violin as hanging in the center of the picture. It does not. It hangs just to the left, although it is the focal center of a beautifully adjusted balance of lines and shapes. Not one of these objects, or any of the smallest details (nail holes, for instance) is casually disposed. (In this illusionistic picture, the illusion of casual arrangement is the most deceptive illusion of all.) The angle at which the piccolo hangs is determined by its weight on either side of the supporting string, and the angle of the calling card is a natural one for a piece of paper stuck into a crack by one corner; but the angles are manipulated to coincide with one another and, at approximately 45 degrees, to relieve while conforming to the basic vertical-horizontal linear skeleton.

The page of music coincides with the vertical system in the top-corner-to-bottom-corner line of its hanging position; its top edge is another 45-degree angle, and its side edges split the difference between 45 and 90—all as a part of geometrical certainties determined by arbitrary placement. Against all these angles and straight lines, the crisp in-and-out curves of the violin and the simple curve of the horseshoe—music and good luck—make their full effect as the key objects in the group.

To test the nicety of Harnett's arrangement (we will use the word "composition" from now on), imagine adding to the picture, eliminating an object, or changing its position. Shift the sheet of music to a normal, upright position and the entire composition becomes expected and monotonous. Shift the angle of the horseshoe similarly and almost as much is lost. Move the brass match holder at the left up or down. Up, and it balances too obviously with the hasp on the right; down, and the composition begins to settle as if of its own weight toward the bottom. Try any other changes and it will become apparent how carefully every detail has been disposed—and how arbitrarily.

That is the point. Ultimately this naturalistic picture depends on not-natural elements. As a work of imitation, even at the amazing level that Harnett achieves, this or any other realistic picture is only second-best to the objects it imitates. As a work of art, it is an independent esthetic entity.

The idea in back of expressionism is that the actual appearance of objects may be distorted in any way, no matter how extreme, that the artist feels will best relay to the observer his own emotional reaction to a subject. Expressionism is usually associated with morbid, violent, or sorrowful subjects (Kokoschka's *The Tempest* is an expressionist painting), but need not be. Dufy's *The Yellow Violin* is bright, vivacious, happy; the color has nothing to do with nature but everything to do with what the artist wants to tell us. There is no interest in textures; the violin is sketched in a few quick lines against the solid yellow of

87. Raoul Dufy. *The Yellow Violin*. 1949. Oil on canvas, 39½ by 32 inches. Art Gallery of Ontario, Toronto. Gift of Sam and Ayala Zacks, 1970.

88. Georges Braque. *Musical Forms*. 1913. Oil, pencil and charcoal on canvas, 36¼ by 23½ inches. Philadelphia Museum of Art. Louise and Walter Arensberg Collection.

the tabletop, which continues on the wall and mirror above. Dufy's drawing is as fluid and broken as Harnett's is concise, and hence its effect is as animated as Harnett's is static. The notes on the sheet of music are a series of staccato accents with only the loosest connection with a readable score. Everything expresses liveliness, spontaneity, improvisation. As for being "too easy to do," it was easy for Dufy to do in the same way that a skilled pianist may appear to execute a dashing series of runs and trills without effort. The seemingly spontaneous fluency of this happy example of expressionism is as important to the mood it projects as is the feeling of swirling violence with which Kokoschka imbued the paint surface of The Tempest (34). Both paintings are antirealistic in Harnett's terms of literal reference to visual fact; both seek the deeper reality of the emotive nature of their subjects, with appropriate distortions as their means to that end.

In spite of distortion, the objects in an expressionist painting are usually recognizable. But in abstraction the objects tend to lose their identity and to exist as pure form. Braque's *Musical Forms* is no longer a "picture of " a violin, although a violin was the point of departure for some of the most conspicuous elements. Nor is it an emotional reaction to the idea of "violin," as Dufy's is. It is purely what it is: a composition of lines, shapes, colors, and textures combined arbitrarily for esthetic effectiveness.

Beneath their differences, Braque's abstraction and Harnett's collection of realistically painted objects have strong similarities. Both compositions are disciplined by systems of rigid straight lines, both are relieved by contrasting curved ones. The area enclosing the first five letters of the word journal in the Braque meets a compositional demand similar to that of the calling card in the Harnett. Within the two schemes there is a related interest in textures. Harnett simulates them; Braque utilizes actual. physical ones, including pasted paper and corrugated cardboard, charcoal's naturally grainy texture is deliberately emphasized, while paint, thick in some areas, is scrubbed thin in others for variety. The paint on the area of the violin has been scratched while wet with a comblike implement to create a texture resembling the grain of wood but not meant to imitate it. Whatever they suggest, these textures exist for themselves rather than as adjuncts to something else, while all textures in the Harnett simulate the textures of the objects.

Harnett, in his earlier pictures, sometimes "textured" his paint so that a match head, for instance, might be built up in relief from the surface of the canvas. The difference between doing what Braque does and building up a match head to look like a match head or imitating the surface of an old violin to look like the surface of an old violin, is the difference between realism and abstraction. Braque abandons the appearance of things because he wants to capitalize fully on the same abstract elements that interested Harnett (and others) without disguising these elements within the

imitation of nature. Just why he chose also the further abstraction of breaking his forms up as he does is too long a story to tell here; as a phase of cubism it is better dealt with in a later chapter. In the meantime these three violins will serve as a reminder that although the subject of this chapter is realism, all painting—whether realistic, expressionistic, or abstract—involves the creation and combination of form and color according to the way the painter sees, feels, and thinks about the world.

Now "realism" is probably the broadest term in art, so broad that we must make our own working definition of it. We will call any painting or sculpture "realistic" in which a fairly close approximation of the look of things is retained. The realistic painter may considerably modify natural appearances, but he will stop short of the point where modification becomes distortion.

By this definition the bulk of painting and sculpture until the twentieth century is realistic. But the real world to one age is not the real world to another. The world around the artist changes, not only superficially in the obvious way of different buildings, different dress, and the like, but more fundamentally, since as times change artists see the world differently even when they begin by imitating the look of things. The visual world is only the raw material from which artists fabricate images reflecting the values fundamental to their times.

In the chapter on sculpture we saw a kouros and the *Diadoumenos* (40 and 42), examples of the ideal realism of ancient Greece, where the beauty of the perfect human body personified the ideal harmony envisioned beneath the accidentals and confusions of life. The creative method for this and other forms of ideal realism is to simplify and purify natural forms by eliminating accidentals, confusions, and other imperfections to an ideal standard of beauty that nature, unmodified, rarely if ever presents.

As inheritors of the Greek sculptural tradition, the Romans continued to imitate its ideal principles in many instances; but the Romans put less faith in an unattainable ideal world than they did in the practical world of power and politics, of personal achievement in a competitive society. One result was the most acutely realistic portrait sculpture in the history of art, in which, instead of idealizing or beautifying a countenance, sculptors reproduced every irregularity, every pouch and wrinkle, every sign of age and stress that marked a face, even such deformities as broken noses, toothless mouths, and tumors, in celebration of the uniqueness of every human countenance. (This extremity of realism is sometimes called "naturalism," but more often in literature than in painting and sculpture.)

In Republican Rome the family was a sturdy social unit wherein ancestral death masks were preserved and venerated. The realistic tradition of Roman sculptured portraits of living persons probably originated in stone copies of these fragile wax masks with their unrelenting veracity. Such sculptures depend for their effectiveness on the degree

89. Roman. *Portrait Head of a Man.* About A.D. 100. Marble, height 10²/₃ inches. The Cleveland Museum of Art. Gift of J. H. Wade.

90. Jan van Eyck, attributed. St. Francis Receiving the Stigmata. Date uncertain. Oil on panel, 5 by 5¾ inches. Philadelphia Museum of Art. John G. Johnson Collection.

of interest inherent in a face and involve no effort at revelation on the part of the sculptor. But there are Roman portraits of such force, such vivid reflections of personality, that we have to believe perceptive sculptors made small but revelatory modifications from literal reality in order to transform the record of a set of features into a record of character (89).

Having pointed out that "realism" is probably the most flexible term in the lexicon of art, and having spoken of "ideal realism," which is something of a contradiction in terms, let us go further and invent the term "mystical realism" to describe a salient aspect of the art of the late Middle Ages.

We have said that the function of art is frequently defined as the creation of order out of the chaos of human experience. This suggests a simplification and a purification of the raw material the visual world offers, which we have seen as the Greek way. But there is no one way, no best way, of achieving an expression of order and harmony appropriate to all places and times in history. Saint Francis Receiving the Stigmata (90), sometimes questioned, but also attributed reasonably to Jan van Eyck, goes about putting the world in order in just the opposite of the Greek way. Instead of simplifying, the painter multiplies detail. Paradoxical as that may sound, it was the reasonable approach for a painter of the late Middle Ages.

The medieval world was rich, violent, chaotic, complicated, swarming, colorful, and thoroughly contradictory. It was a world of cynicism and piety, of grossness and elegance. Licentiousness flourished. So did the cult of chastity. As we look back on the age, it seems to have been everything at once—except humdrum.

This welter of contradictions was unified by the assumption that the universe in its totality was a divinely ordained system of parallels in contrast. In this faith the age found its harmony. Heaven balanced Hell, winter balanced summer, sowing balanced reaping, birth balanced death. Each virtue balanced its corresponding vice. And in this universal harmony, ordained by God, the smallest detail of the world had its place. Nothing was accidental; everything was meaningful.

For medieval people the world of literal fact merged with the world of spiritual miracle and was frequently identical with it. This concept of the universe, reflected in painting, explains why the miracle of the stigmata could be represented in uncompromisingly realistic detail without contradicting its miraculous character. Within the small area of the picture, the complexity is enormous, a miniature world represented with staggering completeness, compressed into a few square inches (the picture is only 5 inches high) without any effect of crowding or jumbling. There are trees, flowers, crags, boulders, and pebbles. There is a river, a spring with its rocky basin of crystalline water. There are hills, clouds, and birds; a city with men on foot and on horseback around its gates; there are other cities in

the distance. There are roads and paths, a boatload of men. Lichens grow in miniature on miniature boulders and—so small that they are virtually invisible until magnified—there are woodsmen bearing loads of faggots in the hills. In the upper left corner (91) a man and a boy, smaller than fleas, walk on a rocky path, while tiny specks on and around a tree turn out to be a crow or some similar bird on the topmost branch with other birds in the air around it.

But breathtaking microscopic execution is not in itself of any esthetic merit. After all, the Lord's Prayer has been engraved on the head of a pin (a rather large pin) to no esthetic advantage. Certainly this tiny picture with its tiny details was painted with the help of a powerful lens; as a tour de force the execution is fascinating in itself, but in itself it could never have raised a stunt painting to the level of a work of art—which this painting undeniably is. What is meaningful is that the painter has combined the myriad details of the world into a picture where the total effect is one of unity rather than confusion, a world where rocks, grass, foliage, cloth, hair, and flesh retain their individuality and yet share a common quality of gentleness in the even flow of light that bathes the universe. The head of the saint can be covered with a dime; each bristle on the cheek, chin, and upper lip has been painted individually; individual hairs or small locks spring from the scalp with the same energy that invests the whole picture with a sense of life. But it is the sense of life that is remarkable, not the technical means by which it is achieved. Whether the head is the size of a dime or a dinner plate, it is a solid and forthright presentation of a person who exists with utterly convincing reality in a world both real and miraculous.

Does the miniature scale then serve no function at all? There may have been a practical reason; the picture might, for instance, have been part of a portable shrine. Whatever the case, the advantage for us is that here the eye rests on an entire world at once. The precision of minute realistic detail intensifies our reaction to the various objects by investing them with a magical concentration. Yet this could have been true of a much larger version also. The important point is that this medieval painter and inadvertent philosopher has seen the world as a place where every detail around him takes on spiritual significance because it has its place in the universal harmony. Detail by detail the picture is an assemblage of commonplace things painted quite literally—even, some critics have found, rather dryly. But as a whole the effect is not commonplace but miraculous. If any element in the picture is out of key it is, paradoxically, the un-commonplace apparition of the Cross. Against the elegant complication of the city, against the vivacity of the crowds of men and horses, the pattern of the rock ledges, and the shining water with its boat, the one obviously miraculous element, the Cross, seems extraneous. Its presence is not necessary to complete the impression of reverent spirituality already conveyed through the contradictory means of extreme realism. An age made up of contradictions achieved this final one in its painting.

91. Enlarged detail from St. Francis Receiving the Stigmata.

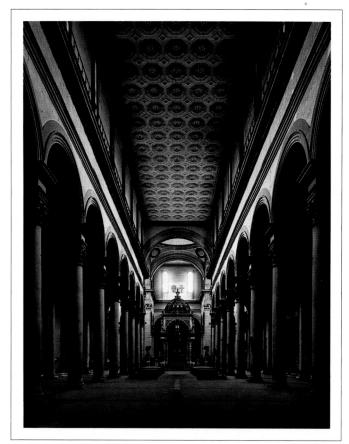

92. Filippo Brunelleschi. Santo Spirito. Began 1434. Florence.

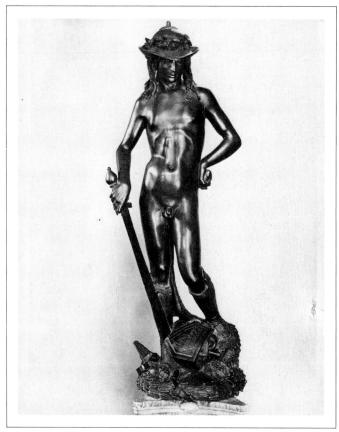

93. Donatello. *David.* About 1430–32. Bronze, height 62¼ inches. Bargello, Florence.

When the picture we have just seen was painted near the end of the Middle Ages in northern Europe, "the Age of Faith" had already given way in Italy to a period better described as an age of curiosity: the Renaissance. The fact that a thing existed was no longer any assurance that it had its own ready-made pigeonhole in an all-inclusive, divinely ordered system. The Middle Ages gave meaning to the world by filing every individual part of the universal clutter around us into a systematic harmony that already existed, and to which mankind was subject. But Renaissance man sought to discover a new harmony, more earthly, with himself as its center.

In art, this new attitude first took the form of passionate investigation of the world. Artists dissected corpses to learn anatomy and turned mathematician to codify the laws of perspective. They discovered that spiritually they were more closely related to the artists who had created the gods of ancient Greece and Rome in their own image than they were to the artists of the immediate past. They began to study the remains of classical antiquity, reviving its idealism and combining with it the factualism of their new knowledge. Renaissance architects labeled the soaring forms of the medieval cathedral an architecture of barbarians (thus christening the style "Gothic"). They synthesized a new church architecture from the columns, round arches, moldings, pediments, and other elements of classical antiquity, combined with the floor plan of the medieval church, scaling their new buildings to the earthbound human beings who would worship there, rather than aspiring to heavenly release (92). Sculptors rediscovered the human body as the paramount vehicle of expression that it had been for the Greeks, but modified Greek idealism with the new passion for investigative realism. Donatello's David, standing triumphant over the severed head of Goliath, is represented classically nude and in classical stance. but his bony young body, rather than being the ideal one of a boy-god, is that of a Tuscan shepherd (he wears the shepherd's identifying leather hat) in early adolescence (93).

Both of the examples we have just seen—the interior of Brunelleschi's Church of Santo Spirito, and Donatello's bronze *David*—are Florentine. Florence was the birthplace of the Renaissance, and produced during the fifteenth century an unparalleled concentration of artists (and art patrons) within a small city. Leonardo da Vinci, Florentine by birth and always a Florentine in spirit wherever he worked, was the supreme exemplar of the intellectual artistgenius.

Leonardo's Virgin of the Rocks (94) with its mysterious air may seem an odd choice to illustrate a form of realism that was concerned with the exploration of earthly things. A contradiction, if not quite a difficulty, for Renaissance artists was that mystical religious subjects continued to make up the bulk of commissions even in this nonmystical age. As a result, the age produced in its second-rate painters hundreds of pictures of madonnas where mysticism degen-

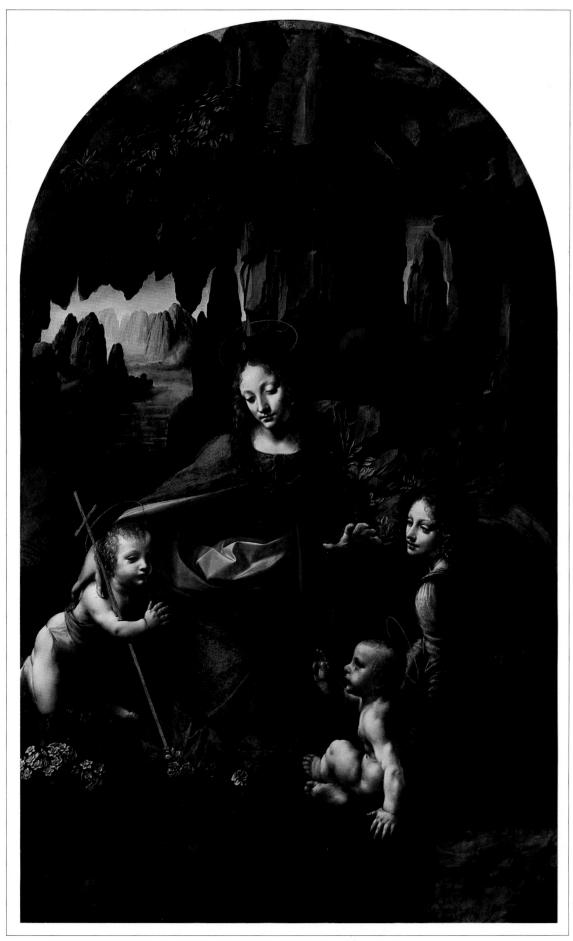

94. Leonardo da Vinci. Virgin of the Rocks. 1497–1511. Oil on panel, 743/4 by 741/4 inches. National Gallery, London.

erated into sentimentality. Leonardo's Virgin of the Rocks is an extraordinary achievement of mystical expression by way of scientific study.

Among the thousands of pages of analytical drawings and tens of thousands of words in Leonardo's notebooks, kept for himself but happily preserved for us, the word "God" is all but absent. Again and again and again we find Leonardo speculating upon the physical origins of the world around him, analyzing the dynamics of air, water, and fire in the shaping of the earth. The grotto in which the Virgin of the Rocks is seated is an imaginary spot but not a flight of fancy; it is an invention worked out from knowledge of geological principles of erosion by wind and water, and the accretion of mineral deposits by evaporation, stalactites and stalagmites among them. We sense the cool dampness of the air, can almost hear the occasional drip of water that seeps through cracks in the natural vault of the grotto. Small plants flourish, but not with the encyclopedic profusion we saw in Saint Francis Receiving the Stigmata. These plants are few and botanically perfect.

More predictable examples of Renaissance realism can be seen elsewhere in this book (231, 236, 273, and 297), yet none of them has foundations as deep as those of the *Virgin of the Rocks*, which is less concerned with the reality of the surfaces of things than with the scientific realities underlying them.

Nothing we have said about detecting the meanings beneath the surface of a work of art should be taken to imply that people in the past—the days of the "old masters"—had a livelier understanding of what art is all about than the average person has today. The opposite is the case. Until very recent times the art-minded percentage of the population even in the most creative periods of history was a very small fraction of the public at large. We tend to forget that most of the paintings and sculptures now available to everybody in museums were originally done for the private pleasure of connoisseurs. What we might call "public art" art in places open to everybody, especially churches—was enjoyed or revered by the mass public for its subject matter and simple visual effectiveness. If some of these "public" paintings and sculptures were admired more than others, it was because they offered more intense vicarious experiences through their subject matter and its dramatic presentation. It was frequently to the advantage of a governing body or an individual—let us say, the Church or the State to capitalize on the public's response to art not for art's sake ("art for art's sake" is a modern idea) but in order to stir feelings of reverence and loyalty through subject matter.

Artists of no other century have quite equaled those of the seventeenth in the creation of paintings and sculptures (and, for that matter, buildings) that could astonish and fascinate a lay audience while satisfying the most sophisticated demands of the most cultivated patrons. The phenomenon is most easily (a little too easily) explained as having originated as a tool of the Counter Reformation in the sixteenth century, by which the Catholic Church sought to check the inroads of Protestantism by dramatizing to the utmost an emotional Catholicism, with all the arts participating in a mighty spectacle to attract and hold a popular audience. Rulers could enhance the power of their images in the same way. But artists gave the same spectacular performances to other than Christian and political subjects, as Rubens did in *Prometheus Bound* (95), where he makes the most of the idea that an observer can participate in a pictured experience.

Prometheus, who stole fire from Olympus and gave it to mankind, was punished by the gods in the manner pictured. His liver was devoured by an eagle every day; every night it grew back, making his punishment eternal. Rubens treats us in as direct a way as possible to the spectacle of a giant writhing in agony as the voracious bird tears at his vitals through a wound in his side.

This was rich subject matter for a painter during a period when it was demanded that art appeal to the observer directly and forcefully through physical associations. Rubens offers us no invitation to divine meditation, nor to the contemplation of harmonious order. Here is an art that seeks to astonish. The spectator must, first of all, be shocked into an emotional response, must not be allowed to pass by. No chance may be taken with possible indifference. Any means of attraction is legitimate, no matter how spectacular, how violent, or, in some cases, how false.

Now, the quickest and surest way to shock is through physical experience. And since the artist who approaches us through astonishment cannot touch us with live coals, or dash us with cold water, or deal us a blow, he does the next best thing: he creates astonishing images so convincing that we share the pictured physical experience. In the case of this Rubens, the experience is offered directly but the same idea can be applied in ways not quite so obvious. Flesh or cloth or water or wind or hair or feathers or rock may be so painted or carved that they stir our associations of physical acquaintance rather than our ideological ones. An angel flying through the air is something we have never seen (any more than we have ever seen a giant chained to a rock), but if an angel can be painted or carved so that the flesh and cloth and hair and feathers are like physically real experiences to us, we are going to believe in the existence of that angel.

At least that is the intention behind dramatized realism of this kind. The appeal to our own physical experience of painful or pleasurable sensations is going to be most effective to the extent that the image is most tangible. For that reason there is no idealization in the figure of the powerful man who plays Prometheus. This is, actually, as realistic a painting as we have seen so far, for all its illusion of tempestuous drama and its fantastic subject. If Rubens had been a degree less skillful in maintaining the illusion, we would find ourselves imagining the model posed in the studio, illuminated by a spotlight and complaining that his left leg was going to sleep.

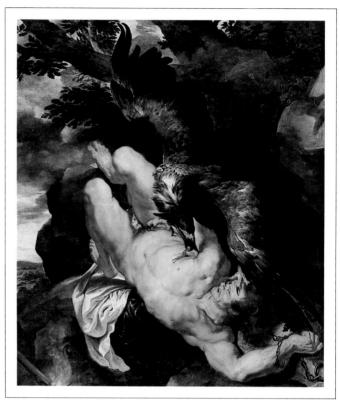

95. Peter Paul Rubens. *Prometheus Bound.* 1611–12. Oil on canvas, 95% by 82½ inches. Philadelphia Museum of Art. W. P. Wilstach Collection.

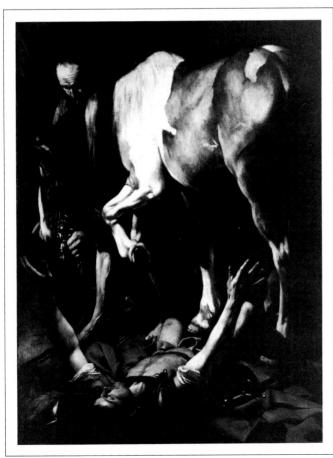

96. Caravaggio. Conversion of Saint Paul. About 1601. Oil on canvas, 90½ by 68% inches. Santa Maria del Popolo, Rome.

We have been avoiding the term "baroque" so far in our discussion of seventeenth-century realism because the term is an ill-defined one, covering everything from forms of grandeur derived from classical antiquity to the kind of dramatic performance staged in Rubens's *Prometheus*. Rembrandt, the profound humanist, was a "baroque" painter by chronological definition; we will see later to what extent he fits into his century's love of dramatic representation (with *The Night Watch*, 254), and where he is opposed to the sheer theatricality of the celebration of power that is a primary baroque ideal.

The seventeenth century—the baroque century—placed its faith in worldly power, whether the absolute power of such monarchs as Louis XIV in France, or the temporal power of the spiritual leader of the Church, the Pope in Rome. It was not an age that really believed in miracles, as the medieval world did; it did not really hope to discover harmony beneath confusion, as the early Renaissance did. The phenomenon of the age, as far as art was concerned, was that its artist-dramatists accepted the common denominator of appeal that painting and sculpture can present to the widest public—the appeal of physical experience at the expense of spirituality. Yet they managed to intensify that experience with such brilliance that any spiritual lack, or even much spiritual falsity, need not be forgiven but can simply be forgotten.

It was not too long ago that baroque painting and sculpture was dismissed as "in bad taste" by critics who judged it by the standards of the earlier periods of the Renaissance, with Leonardo da Vinci in the lead there. But all that has changed. It should already be apparent to readers of this book that to limit oneself to a single standard of esthetic values means cutting oneself off from the allinclusive pleasure art has to offer, which is the sharing of ideas that have succeeded one another century after century up to our own.

It is true that by the standards of classical idealism baroque art often slips over the edge of drama into melodrama and bathos. Even at its most impressive, it has a strong element of the theatrical. Michelangelo Merisi, called Caravaggio, sometimes seems as much a genius of stagecraft as one of the great masters of painting. The miracles in the New Testament, he argued, happened to ordinary people, and to represent them ideally was to falsify them. Instead of idealizing, in the manner, say, of Leonardo, Caravaggio dramatized otherwise realistic scenes by means of brilliant artificial light, sometimes from a miraculous source. His most spectacular use of this device, The Conversion of Saint Paul (96), shows the moment when Saul of Tarsus (his Jewish name), on his way to Damascus to help suppress Christianity there, is struck by a blinding light and hears Iesus ask: "Saul, Saul, why persecutest thou me?" (Acts 9:4). Converted by the experience, he became the greatest of the missionary apostles, preaching in synagogues and marketplaces.

It is impossible, surely, to look at this wonderful painting and see it only as a melodrama, or only as the breathtaking technical exhibition that it is. The light itself is a symbol of spiritual transfiguration—and is visible only to Saul. The attendant (who does not figure in the biblical account) is quite unaware that he is in the presence of a miracle; he remains commonplace, establishing the scene of the miracle in the everyday world that Caravaggio, as a militant realist, insisted was the artist's true domain.

Caravaggio's influence spread through all Europe, his contrast of light and dark, called *tenebroso*, being especially popular—but not often employed as expressively. Among Italians, Artemisia Gentileschi can serve as an example, partly because she is exceptional in being the first woman painter to attain her degree of prominence. In *Judith and Maidservant with the Head of Holofernes* (97) she capitalizes on the popular device of a logical, defined source of light, a candle that she employs in a combination of tour-de-force painting—she was a superb technician—and, to use the phrase again, theatricalism.

A few pages back we said that "The appeal to our own physical experience of painful or pleasurable sensations is going to be most effective to the extent that the image is most tangible." Sculpture, being literally tangible, flourished in seventeenth-century Italy with a vigor unmatched since the Middle Ages in France. Add to tangibility an effulgent theatricality, and it becomes apparent why Bernini's Ecstasy of Saint Theresa (98) can be called the superexample of Italian baroque dramatic realism. Tons of marble appear to float in the air, backed up by brass rays of light and illuminated by real light from a concealed opening above the group where the saint swoons in ecstasy as an angel prepares to pierce her vitals not with Cupid's dart but with one remarkably similar. (The scene is a sculptural transcription from the saint's own written description of the experience.) In addition, the sculpture occupies a chapel where the side walls are treated like those of a tiny theater, with members of the family that donated the chapel seated in boxes to watch the performance.

In a time of such violence and novelty as our own, people are not easy to astonish. But the power of an image is so great that the dramatic realism of seventeenth-century art continues to astonish even when we would expect it to pale in comparison with photographs of current events astonishing and painful beyond belief. Perhaps that is the clue to the effectiveness of baroque realism: it is *not* beyond belief. It brings the event close to us, makes us part of itself, in a way that idealism does not. We may strive for the ideal but we have experienced the real.

The seventeenth century produced armies of painters who were under no technical limitations at all; painters who could draw any figure, from any angle, in any curious or distorted attitude, whether or not they had anything to say. It is not surprising that the age produced the absolute

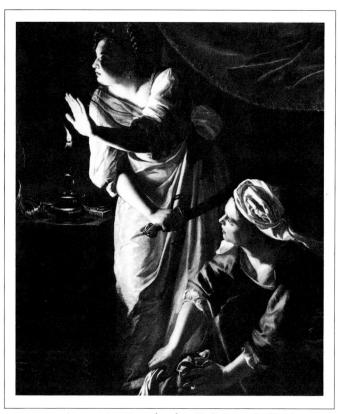

97. Artemisia Gentileschi. *Judith and Maidservant with the Head of Holofernes*. Early 1620's. Oil on canvas, 72½ by 55¾ inches. The Detroit Institute of Arts. Gift of Leslie H. Green.

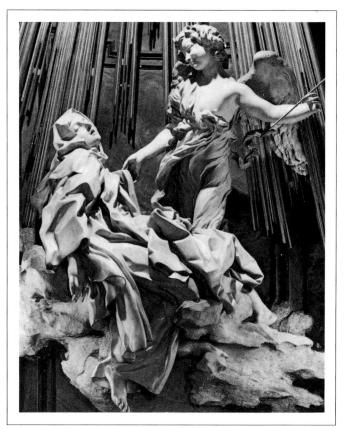

98. Gianlorenzo Bernini. *Ecstasy of Saint Theresa*. 1645–52. Marble, height of group about 16 feet 6 inches. Cornaro Chapel, Santa Maria della Vittoria. Rome.

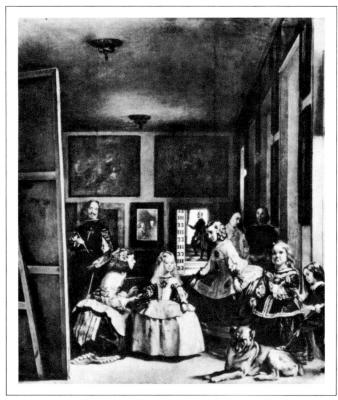

99. Diego Velázquez. Las Meñinas (The Ladies in Waiting). 1656. Oil on canvas, 10 feet 5 inches by 9 feet. Museo del Prado, Madrid.

100. Detail from The Ladies in Waiting.

realist of them all: Velázquez—Diego Rodríguez de Silva y Velázquez, who was content to pass his life as a vassal of the king of a declining Spain.

If ever painting, in its purest definition as the controlled application of paint to canvas, can be its own reason for being, it is so in the art of Velázquez. Las Meñinas (The Ladies in Waiting, 99) shows a little Spanish princess, surrounded by her court attendants while, to one side in the background, the painter himself is at work on the picture we are seeing. Further back, reflected in a mirror. the king and queen watch him at work (100). The painting gives the impression of being executed in realistic detail, but when we look at a section of it, we discover that is not true. Here is a new kind of realistic vision. Whereas van Eyck would have painted individual hairs. Velázquez paints not a single strand or even a definable mass. Velázquez is not painting hair; he is painting the light reflected onto the retina of his eye by a substance that happens to be hair. He translates this reflected light into pigmented tones, giving us only the impression of the color, texture, and form of hair in terms of light (101). He does the same with the ornament of ribbon at one temple and at the neck of the dress. We could not describe these objects in precise detail because we are not familiar with them as specific objects. We know them only as light reflected over the considerable distance between the painter and his model, a distance that reduces the objects to spots of color with concentrations of lighter and darker tones in highlights and shadows.

In this kind of painting we see more than the artist puts there. Cover the upper and lower parts of the nose and you will see that its bridge is not described as form. We supply the missing description, just as we supply the individual hairs because we know they are there; just as we supply the lower lid of the little girl's far eye because we know it is there, though hardly suggested; just as we supply the division between the neck and the jaw near the hair, although as far as descriptive painting of form is concerned, that area is largely blank. On the other side of the face, the dividing line between cheek and hair is so softened that in places it cannot be precisely determined—but again we supply it. Velázquez paints the light reflected by an object across the distance between him and the object; he does not paint what memory or close-range inspection tells him the object looks like. If he had been painting the city in the background of Saint Francis Receiving the Stigmata, he would have painted it in blurs and spots, which is all the eye can see of a city at such a distance. He would never have painted the individual bristles in the beard of the saint, even if he had been painting the head at life size, since the eye does not see such details clearly except at very close range. Velázquez paints detail only to the degree that it is visible from where he, and hence the observer, stands.

The beauty of Velázquez's realism is its consistency. As objects recede into the distance of his pictures and

become more vague, as they come into the foreground and become more sharply defined, every brush stroke, every tone, every modulation of color, is in perfect relationship—as a reflection of light—to every other.

All this sounds like the ultimate degree of mere imitation of nature, as if Velázquez were only a lens equipped with a paintbrush. But Velázquez the artist, as opposed to mere technician, selects, modifies, eliminates meaningless or confusing accidentals, slightly heightens or lowers intensities of light or shadow, to create a world of subtler visual harmonies than the one that serves him as a model. He creates a luminous world with its own abstract beauty in its order, its harmony, its consistency, its perfect relationship between every nuance of descriptive color.

Still, optical delight even at its maximum cannot explain the enduring appeal of Velázquez as expressive painter rather than supertechnician. Where does his expressive quality lie? It cannot be discovered in terms of Rubens's fleshly vigor or Caravaggio's miracles-on-earth. By these standards. Velázquez's religious paintings are meaningless collections of effigies, and his allegorical or mythological subjects end up as prosaic groups of patient models, beautifully painted. His expressive quality lies at the opposite pole: from Velázquez's world all passionate intensity, all mystery or symbolism, and all intellectual philosophizing have been distilled away as impurities. The images exist for themselves, always once removed from us, separated by an invisible barrier behind which they stand regarding us impassively, complete in their own being. When Velázquez paints an image of the Madonna we must accept it as the Madonna, just as literally as we accept, in The Ladies in Waiting, the room, the little princess, and her entourage. His art poses no questions and suggests no paths to solutions; it presents us with a fait accompli, as if the question having been asked and the solution found we need concern ourselves with neither; we must be content to accept without query the answer Velázquez offers without comment.

So far, in chronological sequence, as examples of different kinds of realism we have seen a Greek athlete, a Roman citizen, a mystical universe, the Virgin seated in a grotto, a Titan, a miraculous conversion, a Judaic heroine, a female saint's possibly hysterical vision, and a Spanish princess—all realistic images expressive of aspects of their centuries. After a list of such elevated subjects, the appearance of three apples, two pears, a mug, and a knife on a stone ledge might be taken to indicate that a new century has lost its sense of the grand and the noble. This is not so. In this picture the eighteenth century is discovering that nobility can exist in the commonplace.

The events of 1776 in our own country were a social manifestation involving the philosophical idea that nobility exists in the simplest things and the simplest people. Without exaggerating too much, we could argue that the Declaration of Independence and Jean-Baptiste-Siméon

101. Detail from The Ladies in Waiting.

102. Jan Davidsz de Heem. Still Life with Parrots. About 1646. Oil on canvas, 59¼ by 45¾ inches. John and Mable Ringling Museum of Art, Sarasota, Florida.

Chardin's Still Life with a White Mug (105, p.76) are first cousins under the skin.

Still-life painting is boring to many people; it is too often merely imitative. But a good still life can also be an expressive picture, and the range of expression can be fairly wide. It cannot compare with the range of landscape or the human figure, but even so it would be possible to tell the history of painting, on a reduced scale, in still life alone. Until Chardin, though, we would normally find still life either an incidental part of a larger picture or, when a picture in itself, an ornamental display of technical skill as in a canvas by Jan Davidsz de Heem, one of the most influential seventeenth-century still-life painters (102). With Chardin, still life becomes an independent expressive vehicle.

As far as accuracy of drawing is concerned, the objects in Chardin's still lifes are close to photographic, which of course is not enough. It is his way of painting them that transfigures surface facts into inner truths. Light and dark tones are adjusted, colors are modulated; even the rich, creamy surface of Chardin's paint is essentially a departure from exact imitation of nature. We commented on similar departures in Velázquez's way of working, but the two painters are not alike in effect. Velázquez was painting light; Chardin is painting form. Everything he does is directed toward one end, the expression of the weight, solidity, and repose that he feels in the objects he selects. The paint itself is heavier, richer, more firmly applied than Velázquez's, which by comparison is often only a veil of pigment.

The seven objects in our illustration are arranged very simply on the homely shelf, but very rightly. There are no set rules for this kind of pictorial composition, and thus no really good way to explain why one succeeds and another fails. The objects are placed in a kind of balance that cannot be calculated but can only "feel" right or wrong. The simpler such an arrangement is, and the fewer the objects included in it, the more difficult is the problem of adjustment of the parts to one another. Chardin's composition can be tested in much the same manner as we tested Harnett's (86), by imagining changes in the number or placement of the various objects. Take away the knife, and immediately the mug is divorced from the other objects. Or if we substitute another apple for the upright pear, or shift its position so that it leans toward the center of the picture rather than toward the left, we discover that we have to make other changes to compensate for the disturbed relationships.

In analyzing a Chardin in this way—as an exercise in formal relationships—we are seeing it from a twentieth-century point of view. In his own day in France (his dates are 1699–1779), Chardin's still lifes were admired for their illusionistic realism just as Harnett's were to be in nine-teenth-century America, and were purchased at moderate prices by the prosperous bourgeoisie, while his scenes from daily life, such as *The Governess* (103), were so highly regarded that they were purchased for royal collections all

the way from France to Russia. Chardin himself preferred still life, and painted nothing else during his last twentyfive years except when he would repeat one of his easily saleable early genre subjects to make a little money.

Within a few years of birth and death Chardin was a contemporary of François Boucher, his exact opposite, whose slick, artificial, frequently erotic art, exemplified by the Toilet of Venus (104), made him the reigning painter at the French court. That the same fashionable society should occasionally buy a Chardin genre scene like The Governess is less surprising than it seems; the attitude toward Chardin's subjects combined sentimentalism with a variety of semi-intellectualism in the appreciation of current concepts of the nobility of the common man propounded by the philosopher Jean Jacques Rousseau. Professed sympathy with the lower and middle classes took on a certain snob value among the aristocracy and its hangers-on; Boucher's paintings of shepherds and shepherdesses-sumptuously costumed in silks and satins-became as successful as his gods and goddesses, and were reflected in garden parties where dukes and duchesses came in similar pastoral finery. Chardin's scenes of bourgeois life were sentimentalized even by the upper bourgeoisie who, along with international royalty, collected them. When The Governess was reproduced as an engraving, it was accompanied by a verse to the effect that "Although this sweet-faced little boy pretends to listen obediently to the admonitions of his governess, I'll wager that he's thinking about getting back to his games," which demeans a painting that (as we see it today) is an affectionate reflection of respect for middleclass virtues, just as Chardin's still lifes celebrate the honesty of simple things.

It makes no difference whether or not "natural" man turned out to be as noble as the eighteenth-century philosophers hoped. We all know that near the end of the century in France noble heads were chopped off by the common man in a not very noble manifestation of his changed status. But the dignity of the common man was a noble ideal, it was in the air, and it found its way into Chardin's paintings of pots and pans.

The nineteenth century was, of all centuries, the practical one, the common-sense one, the respectable middle-class one. Whatever other qualities it had, its life was centered upon this substantial core. The eighteenth century's philosophical ideal of "natural nobility" became in reality frequently more vulgar than noble. In an age that was what we call "realistic about things" in its daily philosophy, realistic painting flourished over a range as wide as the century's own attitude toward the daily world: from crass to profound in its understanding of human life.

Jean-Léon Gérôme's The Duel after the Masquerade (106) is at neither the top nor the bottom of this range. We can begin to see just where it belongs by comparing its realism to Chardin's. When we say of the Chardin, "A pear on the left and a mug on the right binds three apples, another

103. Jean-Baptiste-Siméon Chardin. *The Governess* (alternate title, *The Nursemaid*, formerly *The Admonition*). Oil on canvas, 13% by 14¾ inches. The National Gallery of Canada, Ottawa.

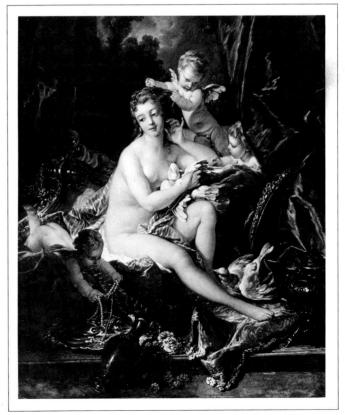

104. François Boucher. *The Toilet of Venus*. 1751. Oil on canvas, 42% by 33½ inches. The Metropolitan Museum of Art, New York. Bequest of William K. Vanderbilt, 1920.

105. Jean-Baptiste-Siméon Chardin. Still Life with a White Mug. Date uncertain. Oil on canvas, 13 by 16¼ inches. National Gallery of Art, Washington, D.C. Gift of the W. Averell Harriman Foundation in memory of Marie N. Harriman.

106. Jean Léon Gérôme. The Duel after the Masquerade. About 1867. Oil on canvas, 15¼ by 22 inches. The Walters Art Gallery, Baltimore.

pear, and a knife on a stone shelf," we have said little about the picture. Its meaning lies elsewhere, as we have tried to explain. But when we say of the Gérôme, "After a duel in a snowy open space within a park, a male figure costumed as a seventeenth-century burgher supports another costumed as Pierrot, who, wounded, collapses, while a third, costumed as an oriental potentate, examines the wound, and a fourth in a rich velvet cloak clutches his head in grief; to the right the successful duelist, costumed as an American Indian, leaves the field accompanied by his second, costumed as Harlequin," we have described the essence of the picture, if we add that technically it is a faultlessly performed exercise. The picture is an anecdote. The anecdote may be pathetic, but the picture is not interpretive. It neither enlarges nor intensifies our experience. We cannot find anything else for the picture to "say" unless it says, as we already know, that when young men get into a fight after a dance, someone is likely to get hurt. With the young men in costume there is an element of fantasy for frosting. In other words, the picture is superficial.

This does not mean that a duel after a masquerade could not serve as a subject for a moving interpretation of some aspect of life. The anecdotal quality is inherent in the treatment, not in the subject. As mighty a subject as the Crucifixion could be reduced to anecdotal level by similar treatment—and has been, more than once. Any meaning we read into *The Duel after the Masquerade* must come from our reaction to the anecdote; it is not implicit in Gérôme's telling of it. And in the words "telling of it" we indicate that the approach is essentially literary, rather than painterly. The picture is an illustration, taking second place to something else rather than existing as an independent creation.

The painting's shortcomings are typical of nineteenth-century academic painting, the painting of the popular, successful artist who pleased the public because his art was easily understood, undemanding. But in making all these objections, we are not insisting that every painting should be a great one. Painting at second level has its place too, if it does not pretend to be anything else. If we accept the Gérôme as a stunning technical rendering, a pleasant bit of decorative color, a graceful combination of attractive figures, then it is an enjoyable picture. It hangs in a gallery full of nineteenth-century paintings of very high caliber and easily holds its own among them.

The nineteenth century was the one in which art first found a mass audience eager for culture. The ambitious bourgeoisie liked to think of art as an elevating experience, which, indeed, it can be, but never before or since has this experience been so identified with sentimentalism. A thriving culture-consciousness in the United States was often combined with the artistic celebration of homespun virtues that were supposed to flourish with exceptional vigor on native soil. Thomas Hovenden's *Breaking Home Ties* (107) is a superior example of the type of anecdotal realism that capitalized on popular moralistic values. The young man,

107. Thomas Hovenden. *Breaking Home Ties.* 1890. Oil on canvas, 521/8 by 721/4 inches. Philadelphia Museum of Art. Given by Ellen Harrison McMichael in memory of C. Emory McMichael.

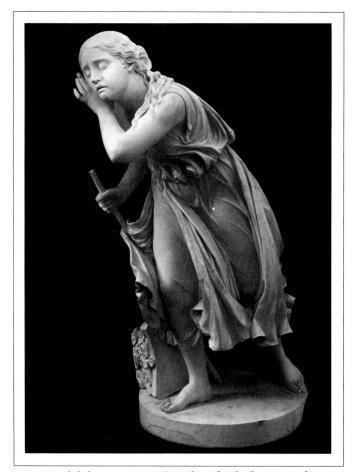

108. Randolph Rogers. *Nydia, the Blind Flower Girl of Pompeii*. 1856. Marble, height 55 inches. Museum of Fine Arts, Boston. Gift of Dr. and Mrs. Lawrence Perchik.

hat in hand, is leaving home for the first time; a male relative carries his bag toward the door at the right; the mother, concealing her grief in courageous recognition of the necessity of the situation, bids the boy goodbye, perhaps with a last word of advice. The grandmother sits stoically at the table; a young sister leans against the door; perhaps she will cry later. At one side another woman—a maiden aunt?—sits holding the boy's umbrella and a small package she has made for him. By her side the family dog is stoic in the prospect of bereavement.

When *Breaking Home Ties* was first exhibited in Philadelphia in 1890, people lined up to see it and, unlike the characters in the picture, were unable to restrain their tears. The picture's emotional force for its contemporary public is partially explained by a virtue still apparent: it is beautifully observant in the details of its setting, and beautifully painted in a firm, honest manner that bolsters the feeling of sturdy virtue, which is the picture's theme. If it no longer inspires tears, *Breaking Home Ties* can still inspire respect.

Anecdotal subjects were also popular in nineteenth-century sculpture, but time has been less kind to them than to pictures like *Breaking Home Ties*. Somehow the sheer tangible weight and mass of stone or bronze and the sheer physical labor of producing a work of sculpture accentuate the triviality of subjects that no longer seem worth the trouble. That a wide audience in the nineteenth century felt differently is proven by the popularity of *Nydia*, the *Blind Flower Girl of Pompeii* (108), by the American sculptor Randolph Rogers.

Nydia is the blind flower-seller heroine of *The Last Days of Pompeii* by the English historical novelist Edward Bulwer-Lytton. The book, published in 1834, was the *Gone With the Wind* of its day, and became so popular in America that Rogers virtually mass-produced copies of *Nydia*; nearly a hundred versions still exist. *Nydia* is the ultimate storytelling sculpture, totally dependent on a knowledge of the book. The volcanic eruption that destroyed Pompeii has blotted out the light in a city filled with smoke and ash; but Nydia, having always been blind, and knowing her way around the city in her own perpetual dark, is leading others to safety while she strains to hear the voice of her master, Glaucus. Our example was done in 1856, twenty-two years after the publication of the book, when Nydia's name was as familiar as Scarlett O'Hara's is today.

It is usually easier to explain what is wrong with a picture than to show what makes it good. The better a picture is, the more likely it is to communicate in terms that cannot be expressed as well in any other medium. This is true of other art forms, too. What Shakespeare says in Hamlet, for instance, has not been said as well in painting. Similarly, what Thomas Eakins says in his portrait Miss Van Buren (109) is said so completely in terms of a realistic image that when we come to discuss it, the temptation is to say no more than "Just look at it!" The picture is one of

those great ones whose meaning is as obvious as it is unexplainable in specific comment.

Eakins was a life-long Philadelphian who at the age of twenty-two in 1866 went to Paris and studied for three years under academic masters, including Gérôme, the slickly proficient painter of *Duel after the Masquerade*. Fortunately Eakins was protected by a natural immunity to infection by this master, and returned home to become his country's soundest, strongest realist and, by many critical judgments, our greatest painter in any classification.

Even though the total effect of the portrait of Miss Van Buren is greater than the sum of its parts, leaving its greatness, as we have said, unexplainable, some specific virtues can be defined. As a realistic drawing (that is, as the expression by lines and shadows of a three-dimensional form on a two-dimensional surface), it is superbly skillful. Eakins is completely master of the craft of realistic drawing, which he inherits from the centuries of artists who worked before him. As a realistic painting (that is, a drawing that includes the re-creation of the colors of the represented objects), the picture is equally good. As creative realism, in its selection and modification from the visual material confronting the artist, it employs some devices we can be specific about.

The sitter has, first of all, been posed in an attitude natural in effect and expressively characteristic. From this advantageous beginning, Eakins goes on to exaggerations of the natural contrasts between light and shade. Without getting theatrical he creates a spotlight effect, a formula used in portraits by hundreds of painters (Rembrandt used it most insistently). By its use Eakins directs our attention to the salient passages of his subject, intensifying their effect by displaying them brightly against other passages that are relatively blotted out. But he does this so subtly that we are not conscious of the exaggeration, as Rembrandt makes us conscious of intensification for a more emotionalized statement. Eakins does not want to emotionalize his subject; the mood is one of contemplation but not of mystery. This mood is stated in the color, too, which is modified away from unexpected combinations or full intensities.

But not one of these devices is original with Eakins; we could find all of them combined similarly in any number of pictures that are nothing but proficient demonstrations of technique. Is the Eakins a greater picture because it does the conventional thing but does it better? No. Eakins employs these familiar devices with maximum skill, yet there remains an intangible quality in the art of every great painter, one that makes the difference in Eakins's case between this image of Miss Van Buren, which is so vital, and an image that is lifeless.

Whatever this intangible quality is, with Eakins it has to do with honesty. Feature by feature Miss Van Buren's face is not a beautiful one (110). It is even rather plain. But she is neither glamorized nor flattered. In terms of the average portrait, where the purpose is to produce an ac-

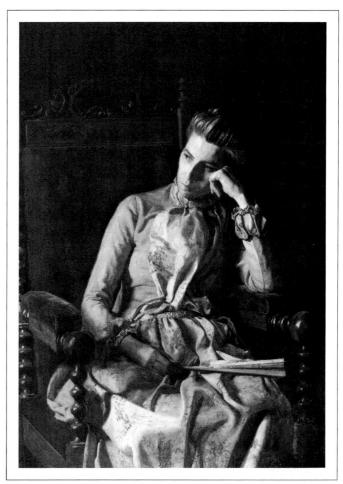

109. Thomas Eakins. *Miss Van Buren.* About 1889–91. Oil on canvas, 44½ by 32 inches. The Phillips Collection, Washington, D.C.

110. Detail from Miss Van Buren.

ceptably accurate likeness as beautified as possible, Eakins's picture would be mercilessly and pointlessly realistic. But a great Eakins portrait is a matter of neither cosmeticization nor documentation. It is a great painting finding within the substantial everyday world poetry of such strength that it needs no bolstering by prettification or ornament. Comparing this masterpiece with others we have been discussing, we see that it is not idealized (like the Leonardo), not dramatized (like the Rubens and the Caravaggio), not objective (like the Velázquez). Its everydayness is related to Chardin's; its greatest contrast is with Saint Francis Receiving the Stigmata. Whereas the painter of that wonderful little picture saw every fragment of the world taking on meaning as part of a great established scheme of things, Eakins sees that each fragment of reality must be accepted for itself, for whatever meaning it has in itself, independent of a divinely organized, an idealized, or a dramatized world. This idea was expressed more emphatically by a group of French painters—Eakins's contemporaries, but more experimental in their approach—who came to be known as the Impressionists.

Impressionism was a double revolution—an ideological one in which the chance moment became as interesting to an artist as were the eternal verities, and a technical one by which the "impression" of a chance moment was

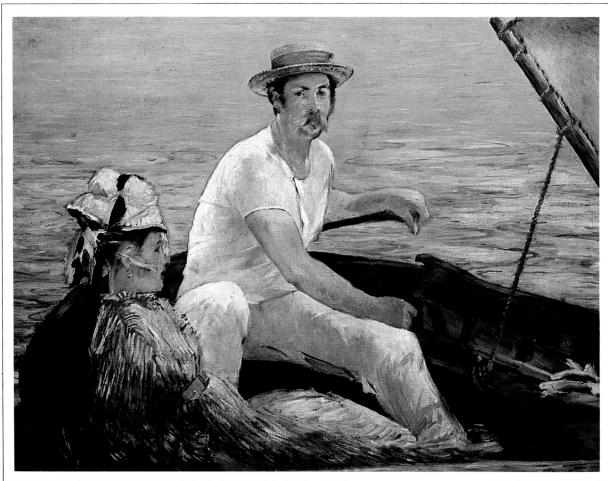

111. Édouard Manet. Boating. 1874.
Oil on canvas, 38½
by 51¼ inches. The
Metropolitan Museum of Art, New
York. Bequest of
Mrs. H. O. Havemeyer, 1929. The
H. O. Havemeyer
Collection.

recorded. In order to achieve an impression of the light and atmosphere of a particular time of a day that might be rainy, snowy, foggy, or sunny, colors were applied loosely, even spottily, to be blended by the eye into the appropriate effect of sparkle or mistiness. Claude Monet, in his land-scapes, epitomized this aspect of impressionism. But suggestion also took the place of exact statement in less systematic painting, going beyond the studious objective optical realism that we saw in Velázquez, to a kind of shorthand notation that approximates, rather than reproduces, what the eye registers at a glance.

Edouard Manet's *Boating* (III) is put together as if the subject had been caught by accident in a snapshot, as if it were a fragment of a larger composition. The effect is to increase our feeling of intimacy and participation in the scene. Harmonizing with this apparently offhand composition, the technique is sketchy; what we have already called impressionistic "shorthand" is used for the eyes and other features, for the details of clothes, particularly the hat and veil of the woman, for the expanse of water.

Living in a century when science had demonstrated that no one man can begin to know the universe, Manet was not interested in trying to make universal statements, ideal or otherwise. He seems to say: "Here is an instant in a day, to be accepted for what it is, without too much concern over its place in the vast, incomprehensible scheme of things." Thus Impressionist realism appeals because it so frequently discovers an idyllic quality in the commonplace and, above all, the transient. In the hands of trivial painters, the commonplace can be most trivial indeed; but in the hands of serious and sensitive painters like the great figures among the Impressionists, fragments of commonplace reality tell us that although the universal scheme of things may be beyond our comprehension, we can understand moments of it in terms of feeling and sentiment or enjoy their simple visual attraction.

The Impressionists fought their battles and won their victory—a total victory—in the last thirty years of the nineteenth century. But even as their century turned into the twentieth, a new generation was questioning their realistic premises. Expressionism and abstraction (the subjects of our next two chapters) fought new battles as the new century opened, followed by new victories. Shortly after World War II, with the triumph of a dazzling school of abstraction in the United States, it seemed possible to say that impressionism had been the last flower of realism, exhausting the possibilities of exploring alike the world of emotion and the world of intellect in terms of the world we see around us.

But this idea was mistaken. The 1970's saw a revival of realism in general, led by two extreme forms—photorealism and hyperrealism. (The term "superrealism" is also used; we are using the alternate "hyperrealism" to avoid confusion with "surrealism," which is an art of the fantastic

112. Isabel Bishop. *Two Girls*. 1936. Oil and tempera on composition board, 20 by 24 inches. The Metropolitan Museum of Art, New York. Arthur H. Hearn Fund, 1936.

and supernatural. We will encounter surrealism in a later chapter.

Realism had, in fact, persisted without interruption in the United States during the rise and triumph of abstraction. The Great Depression of the 1930's stimulated an approach called "social realism," marked by a sympathetic attitude toward the urban lower-middle class and the proletariat, who always bear the brunt of hard times. Artists discovered that the big city's subways, its park benches, its cheap movie houses, its hall bedrooms, and above all its business streets, were parts of a humanistic spectacle that had hardly been tapped as painters' material. Isabel Bishop's sensitive but unidealized observations of anonymous shopgirls and office workers (112) are among the enduring witnesses to the vitality of this twentieth-century American form of realism, while Edward Hopper's famous Nighthawks (113), in a different mood, plays a theme peculiar to our times the loneliness of individuals in an urban society, a loneliness all the more poignant because it persists within a crowd. Painters like Isabel Bishop and Edward Hopper continued their careers during the years of the rise of abstraction, but by the nature of the contemporary art world, which demands recurrent excitement and novelty, something unusual was necessary to proclaim that realism was reborn.

Photorealism proclaimed something unusual indeed. Artists had used photographs for reference ever since the invention of the camera, but artists had not insisted that the camera's eye held a truth to which the painter must be subservient. The pioneer photorealists even claimed that the painter's only function was to "transfer information from the medium of photography to the medium of painting," and sought to eliminate all evidence of the artist's hand, all additional interpretive function, from their reproductions of

113. Edward Hopper. *Nighthawks*. 1942. Oil on canvas, 30 by 60 inches. The Art Institute of Chicago, Friends of American Art Collection.

photographs. And the more ordinary the photograph, the more certain was the escape from interpretation.

This escape, of course, was impossible—as well as rather dull for the artist and unrewarding for the observer, who quite justifiably might find more interest in a photograph than in a painted reproduction of a photograph. Even the most devout photorealists cleaned up the photographs in the process of transferal—sharpening edges, emphasizing important details, eliminating others. Richard Estes's Supreme Hardware (114) of 1973, while nominally photorealist, is obviously interpretive beneath its apparent objectivity. For one thing, his city street is abnormally deserted, with a resultant effect of unnatural silence. For another, although he seems to have included every detail of the clutter of this side street, including garbage bags, everything exists with an unnatural clarity. Our eye is carried from one familiar detail to another, yet each has more independent interest than it would have if lost in the conglomeration of details either in reality or in a photograph.

In a later picture, Thom McAn (115), by the same artist, the reproduction of photographic reality is hardly more than a starting point for invention. Each detail is perfectly, legibly, acutely defined in the rendition of multiple reflections in glass panes and shiny surfaces. Yet if we give the painting more than a glance, we begin to confuse reality with the reflection of reality, what is real with what is illusion. Which objects and planes are in front of us, and which are reflections of those behind us or at either side of us? The final enigma, of which we may be unconscious even while it affects our response to the picture, is that while we, as observers, are obviously standing in a position where our image would be reflected and re-reflected, we are quite absent. We stand as if invisible, or atomized, within a commonplace setting that has become unreal. In such a painting, "photorealism" is no longer an appropriate term; the artist's eye has rejected the eye of the camera in order to perform the eternal function of realistic art—to reveal the familiar world in a vision that affects our experience of it.

"Hyperrealism," by a dictionary definition of the prefix, would mean "more-than-the-normal realism," and its function, in the view of its contemporary practitioners, is to make us more than normally aware of visual realities we are so habituated to taking for granted that we only half see them. In terms of comparative realism, a head by Chuck Close (116) is exactly the opposite of one by Velázquez. We saw that Velázquez painted only what the eye perceived at a certain distance in a certain light. Chuck Close's heads are painted an enormous size—up to about 8 feet high with proportionate enlargement of hairs, pores, small wrinkles, eyelashes, and all other details (117). It is as if our eyes had suddenly become powerful magnifying lenses; we become aware that we have never really seen a human face before, at least not in such explicit physicality. This is more-than-the-normal realism to an extreme degree, riv-

Supreme Hardware. 1973. Oil on canvas, 40 by 66 inches. Courtesy of Allan Stone Gallery, New York.

Thom McAn. 1974. Oil on canvas, 40 by 60 inches. Private collection. Courtesy Allan Stone Gallery, New York.

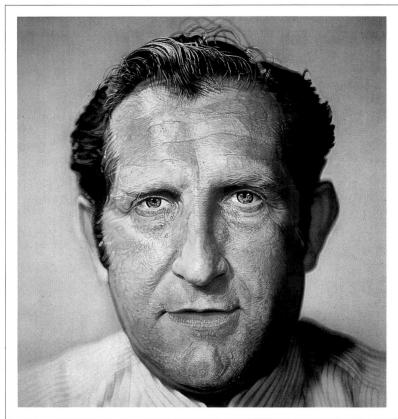

116. Chuck Close. *Nat.* 1972. Watercolor on paper, 67 by 57 inches. Neue Galerie, Aachen, West Germany. Ludwig Collection.

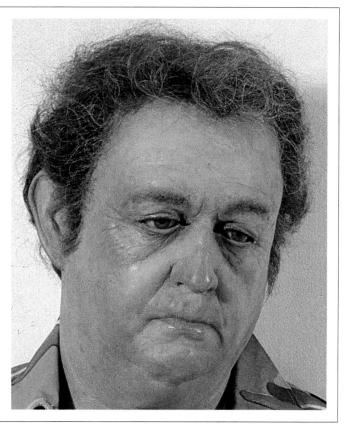

Shopping Bags. 1976. Polyester resin and fiber glass, polychromed in oil, with clothing and accessories, life size. Courtesy of O. K. Harris Gallery, New York.

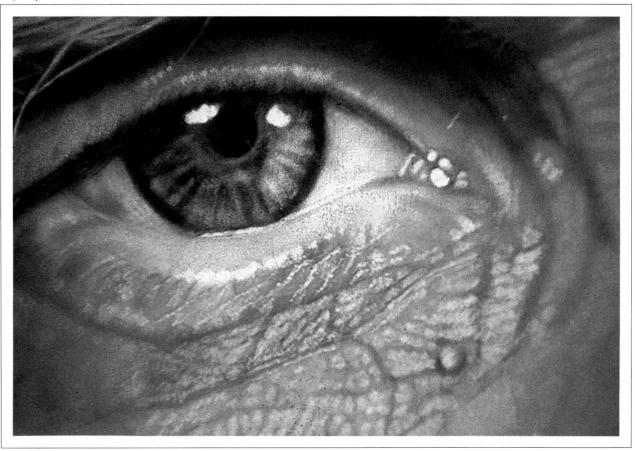

Wood, guilded and painted, life size. From the High Altar, St. Mary's, Cracow.

eting our attention on a facial landscape with all its erosions, cracks, ridges, and evidence of subterranean tensions.

The qualities that make hyperrealism a realism specifically of our time may be clarified if we juxtapose three realistically sculptured heads: first, that of Saint Peter (119) from the Cracow Altar, which was begun in 1477 by Wit Stwosz and remains in the Polish city where it was carved; second, a head of Saint John of God (120) by the seventeenth-century Spanish baroque sculptor Alonso Cano; and finally the head of the man (118, p. 85) from a two-figure sculpture group, Couple with Shopping Bags, by the contemporary American sculptor Duane Hanson. (The entire sculpture is illustrated and further discussed later on).

Saint Peter, carved in wood and painted in realistic colors, is only about forty years later than the painting of Saint Francis Receiving the Stigmata with which we discussed medieval realism. Saint John of God is contemporary with The Ecstasy of Saint Theresa and, like that sensational example, seeks to stir the observer by the tangibility of a religious image. Like Saint Peter's, the head of Saint John of God is carved in wood and painted, with the addition of real glass eyes. Originally it was part of an imagen de vestir, a type of statue popular in seventeenth-century Spain, clothed in real costumes, with real jewelry or other accessories, often symbols of martyrdom.

Hanson's twentieth-century martyrs to supermarket culture, an ordinary man and his wife, are cast from life in polyester resin. Their skins are painted with strict fidelity to nature; in addition to glass eyes and wigs for both, the man's arms are equipped with fuzz set into the vinyl hair by hair. Wearing real clothing and carrying real shopping bags filled with real products, here are examples of the *imagen de vestir* beyond anything previously seen—even in waxworks museums, for their fidelity to nature exceeds the most convincing of such effigies. With the exception of movement, the illusion of life is complete.

Saint Peter's seamed and wrinkled face, the pouches beneath his eyes, a small wart on the right side of his nose, the glint of upper teeth seen through the half-opened mouth, the curl-by-curl complexities of the hair and beard—here is an exaggerated and intensified realism that might have been called hyperrealistic if the term had been invented earlier. But everything is patterned with an eye to elegance that competes with the realism and, if we compare it with our twentieth-century shopper, triumphs over literal reality. And the spirituality of the saint's expression of compassionate concern is high drama, in contrast with the shopper's look of stultification and chronic despair.

It seems likely that *Saint Peter* is a portrait from life of some good citizen who lent his features (including the small wart) for the purpose. *Saint John of God* is a portrait of this Portuguese adventurer who turned to charitable works after his conversion—a portrait derived from paintings showing his traditional features. It is a strong face, making a first impression of great beauty that is accounted for, when we analyze it, more by the fineness of the noble, slightly

melancholy expression than by the features themselves. The beauty of color reminds us that the tinting of stone and wood statues had been common practice from antiquity on through the very late Middle Ages, when it was often entrusted to eminent painters as being of equal importance with the carving. (The great Jan van Eyck was not too proud to accept commissions to tint other artists' sculptures.) The pure white marble statues of the Renaissance were left uncolored under the misconception that ancient statues. which time had bleached of their color, had never been tinted. Under this influence color was gradually abandoned, but the art of Alonso Cano shows how vigorously it survived in seventeenth-century Spanish religious sculpture. Cano was equally skilled as painter and sculptor, and thought of color as an integral part of his statues rather than a secondary addition.

Since the goal of the sculptor-painters of these three heads was to create as vivid as possible a projection of the life and the individuality of the subjects, and since both of the earlier sculptors employed departures from literal reality to enhance that vividness, is Hanson's sculpture "anti-art" (as it has been called) in its deliberate and insistently literal reproduction of the subject, even to the extent, as we have said, of casting from life? That is a reasonable question, but it is answered by the fact that whether you call it art or anti-art, the image of a weary supermarket shopper makes an impression stronger than life. By reproducing the commonplace with such staggering verisimilitude, the artist makes us examine this bit of life in the way he reproduced it—pore by pore, hair by hair. Because we are amazed by the technique, we are spellbound by the image of a person of exactly the kind that we pass by on the street without a glance. Thus the hyperrealist sculptor forces us into a more-than-normal realization of the character of life. He breaks our habits of seeing, clears our eyes, and by forcing this typical member of our society upon our attention, by amazing and fascinating us by the illusion of reality, leads us to look at that reality anew, and to speculate upon the nature of the society that produced this typical specimen of humankind. As we will see later, the inferred comment is not a flattering one.

Turning once more to the dictionary, we find that the first definition of realism is "a tendency to face facts and be practical rather than imaginative or visionary." This does not altogether conform to the more flexible ideas of realism in painting and sculpture, but does supply an affirmative answer to a question that naturally arises: Is there such a thing as realism in architecture?

There is indeed. Under the term "functionalism," architectural realism demands that the "imaginative or visionary" aspects of designing buildings be extraneous to "facing facts and being practical," and must be eliminated to give full play to the primary consideration of seeing that a building is designed to perform its function with maximum efficiency.

120. Alonso Cano. Saint John of God, head. 1660–67(?). Wood, painted, life size. Museo Provincial de Bellas Artes, Granada.

121. Church of Saint-Nectaire (Puy-de-Dome). Begun about 1080. France.

122. Walter Gropius. Bauhaus. 1925–26. Dessau, Germany.

As a corollary to that premise, a building may automatically take on forms that are esthetically satisfying as a result of the dictum that "Form follows function." The dictum belongs to modern architecture, but the principle is not peculiar to it, having been demonstrated in the past without benefit of theory. The exteriors of medieval churches, when not encrusted with sculpture and other carved ornament, are simply the defining skins of interior spaces designed for specific functions; yet these skins tell as solid volumes that seem to have been arranged with regard for their beauty, resembling, in effect, monuments of abstract sculpture(121).

The theory of functionalism, however, is applied only to modern buildings, and the argument goes that if a building serves the purposes of our time functionally, it will necessarily assume new forms, the forms of a uniquely modern style, as a kind of spontaneous stylistic autogenesis. Added to the modernism of these formal innovations will be the textures of building materials peculiar to our time. A good example of early-vintage functionalism is Walter Gropius's Bauhaus, built at Dessau, Germany, in 1926 (122).

The Bauhaus, a state school of architecture, painting, and sculpture, was formed in 1919 with the thirty-six-year-old Gropius as director. In a Germany suffering from the defeat of World War I, art was reflecting the neurotic tension, the pessimism, and the social chaos of the times. (As an example, see Ernst Kirchner's Street Scene, in the next chapter.) Gropius called for an educational program that would reestablish the unity of the arts, which were to be led out of the wilderness by an architecture that was positive and rational in spirit, a twentieth-century architecture that would be of its time in its adaptation to industrial civilization.

The industrial age supplied industrial products for building-modern concrete, steel, and glass-that were employed in the Bauhaus undisguised by overlays of traditional materials and undeformed by adaptation to shapes inherited from the past. Economy and function as the determining considerations of design yielded clean, spare forms that allowed maximum space and light for the studios and offices of the school. Familiar today (overfamiliar, in fact, and often misused), these forms in 1926 were strikingly modern, and virtually unheard of as the forms of a state building, where architecture is always most conservative. The projection of the upper stories beyond the ground floor, the elimination of the cornice except for a thin, narrow band, the opening of the interior to full view from the outside, the exposed construction everywhere, the elimination of ornament-all of this meant the rejection of standard architectural vocabulary and the creation of a new one.

The Bauhaus design, more than fifty years later, remains unusually satisfactory. Its simple clarity is the first reason, but this design was not, after all, determined entirely by functional demands. Such details as the size of the divisions of the panes of glass, the variations in size from square to long-rectangular, the variations in size and proportion of

the interrelated blocklike units of the building's mass (if so open a building can be said to have mass), the purity of the long white bands of concrete, the play between solid structural elements and the voids between them—each of these was determined first by functional principles. But it is still true that every opportunity was taken to emphasize their inherent potential as elements in a controlled design. In its own way, this example of realistic architecture is an expression of an ideal, and an ancient one in architecture—the ideal of the rational spirit that has been persistent and recurrent ever since its consummate expression in the Parthenon twenty-five centuries ago.

The Bauhaus's twentieth-century ideal of absolute identification of form with function had been achieved in the middle of the nineteenth century by a building born of necessity in an emergency—the Crystal Palace (123 and 124), built to house England's Great Exhibition of 1851, the first international exposition. The requirement was for a vast building to house exhibits from around the world, with all the attendant problems of light, unencumbered space allowing for the construction of independent exhibition

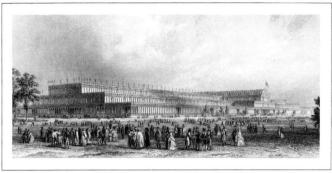

123. Joseph Paxton. Crystal Palace, exterior. 1851, destroyed 1936. Line engraving.

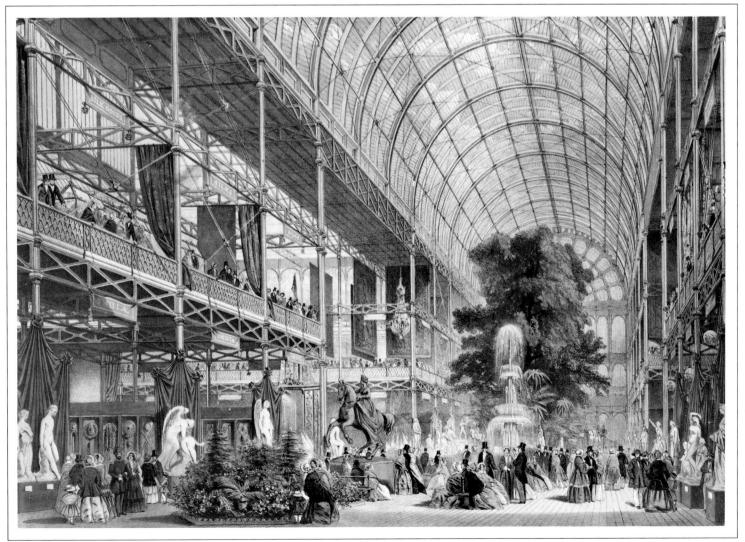

124. Crystal Palace, interior. After a color lithograph, 131/4 by 191/8 inches. From Dickinson's Comprehensive Pictures of the Great Exhibition. London, 1854.

125. Thomas Fuller. Parliament House. Ottawa. 1859–65. Chromolithograph by Burland, Lafricain & Co. Courtesy Public Archives of Canada, Ottawa.

126. Charles Garnier. Opéra. Paris.

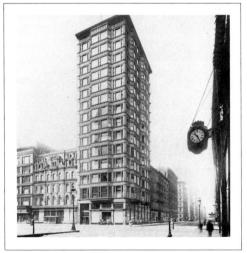

127. D. H. Burnham & Co. Reliance Building, Chicago. 1894–95. Photograph, about 1905, courtesy Chicago Historical Society.

areas, and the accommodation of great crowds—plus the desperately complicating factor of quick and economical construction.

The taste of the time was for elaborate buildings in eclectic styles. The opposite of functional in their complex ornamentation of forms that often were themselves more decorative than functional, these buildings could be ludicrous. But at their best they were brilliant studies in design. Two of the finest examples, both contemporary with the Crystal Palace, will serve us. Parliament House in Ottawa, shown here (125) before being rebuilt in somewhat simpler style after partial destruction by fire in the twentieth century, was a major achievement, unsurpassed even in England itself, as an exercise in the favorite English eclectic style, neo-Gothic. The Paris Opera House (126) was, and remains, the supreme neo-baroque building. But the Paris Opera House took six years to construct, and Ottawa's Parliament House, eight. Quite aside from the expense of buildings like these, London needed its exhibition hall within a matter of months. Architects were at a loss.

The solution was reached by Joseph Paxton, a garden landscapist and greenhouse builder who had no training in either engineering or architecture. His iron-and-glass building, whose area of 753,000 square feet made it one of the largest buildings of its century, was essentially a gargantuan greenhouse built of standard units (the term today would be "prefabricated") that could be rapidly assembled and just as rapidly disassembled after the exhibition was over. Virtually every foundry in England was set to casting the standard units of hollow iron tubes, while glass factories rolled out the glass panes. Every functional requirement was met, and the building was completed in less than six months. In retrospect, the Crystal Palace is a landmark in functional architecture and the use of modern materials. At the time it was a sensational success as a kind of fairytale fantasy. And indeed it was a fantasy, a transparent building within which you could stand under the great trees of Hyde Park, where it was built, and look up beyond them and through the roof and into the sky. Within the building the light shifted and changed according to the time of day and with the passage of clouds.

In the seventy-five years stretching between the Crystal Palace and the Bauhaus, circumstances made one imperative demand on architecture that had never been made before. As cities grew bigger and bigger, with their business districts compressed within a central area, buildings could grow larger only by growing upward instead of spreading outward—and the skyscraper was born. Its early history included a battle of styles in which Chicago architects made the most prophetic recognition of the skyscraper as a layered steel skeleton that required no supporting walls and thus offered opportunity for the elimination of exterior wall space in favor of windows (127). This realistic approach was opposed by a continuation of eclecticism in which all the styles of the past were then juggled, twisted, stretched, and

otherwise deformed in efforts to apply to an architectural form that was peculiar to the present.

The aspiring lines of the Gothic cathedral were best adapted to the skyscraper's verticality, and Cass Gilbert's Woolworth Building (128), built in 1913, must be called the masterpiece of skyscraper eclecticism. But following the lead of the Bauhaus and other forces that developed the spare, antiseptic, unornamented modern styles, the skyscraper assumed the form we now see repeated ad infinitum. that of a slab, frequently "walled" by only a glass curtain. The Seagram Building (129) is the most eloquent proof that exquisite attention to proportions in the linear divisions of the slab, plus the use of some of the most expensive square feet of real estate in the world as a plaza, can produce a beautiful commercial skyscraper and provide it with a beautiful site. For the most part, however, the skyscrapers that grew as thick as weeds (and almost as rapidly) in the post-World War II building boom were innocent of any serious esthetic considerations in their design. Design was determined by the builders' determination to make maximum commercial use of every square and cubic foot allowable under zoning regulations. This of course is "realism" of a definite kind, but hardly a desirable kind.

As early as 1950 the artist Saul Steinberg, whose satirical drawings of buildings in all styles are acutely perceptive critical judgments, anticipated other critics' disillusion in a prophetic drawing in which he used a sheet of graph paper as a skyscraper façade. Steinberg's prophecy was distressingly fulfilled during the next thirty years by building after building in what could be called Graph Paper Style, in which large glass boxes divided into the small, uniform squares of their steel skeletons became the monotonous norm for the skyscraper. What had once been modern had become rep-

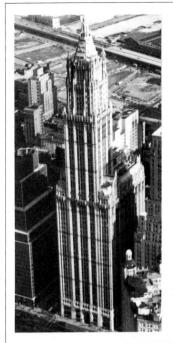

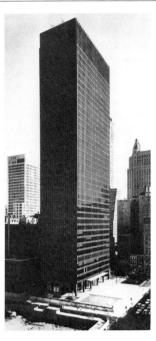

129. Ludwig Mies van der Rohe. Seagram Building. 1956–58. New York.

130. Abandoned missile-tracking station, North Dakota.

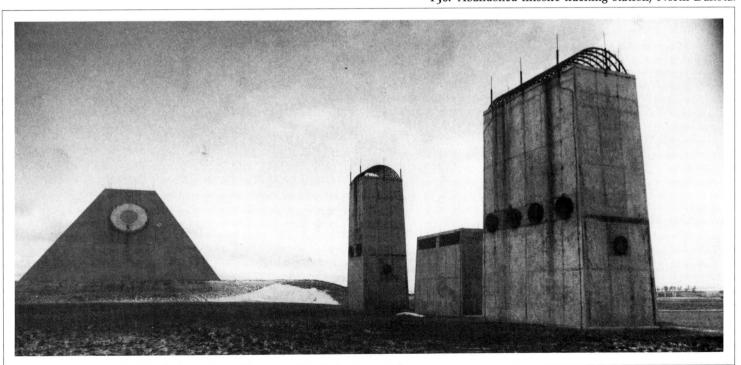

131. Welton Beckett Associates. Hyatt Regency Hotel and Reunion Tower. 1973–78. Dallas, Texas.

132. First floor plan. Opéra, Paris. From "Le Nouvel Opéra de Paris," 1878–80. Courtesy The Museum of Modern Art, New York.

etitious, mechanical, unimaginative, and dehumanized in spite of the uneasiness of thoughtful architects. In the mid-1960's, the critic Ada Louise Huxtable expressed her misgivings as to what was happening to New York in an article, "Slab City Marches On."

Architects, critics, and historians began to suspect that the most exciting and possibly most distinctive structures of our time might be those whose forms followed specific functions that were satisfied not by architectural design but by practical engineering, such as our great refineries with their complexes of forms that had never been approximated by architecture of the past. Functionalism, in such cases, was the mother of invention. Unfortunately, obsolescence is also the death of architectural record, and these projects will be lost to the future except in photographs. An example is the \$5.7 billion missile-tracking station in North Dakota (130), as eerie a group of structures as could have been imagined if fantasy and not science had dictated its forms.

Deliberate fantasy is an expensive indulgence in most building design, but efforts to create arresting effects in variations of the glass-box formula have been made when circumstances (which means financing) have permitted it. The Hyatt Regency Hotel and Reunion Tower in Dallas, Texas (131), by Welton Becket Associates, with its spaceage overtones, is an example. In this case, the sacrifice of maximum use of ground space (and for that matter, air space) is worth the attractions the design holds for a public that by its patronage must support the project financially.

Disenchantment with the functional ideal that had been so enthusiastically received in its youth was not limited to the skyscraper, which was only the most spectacular example of the malfunction of a legitimate theory. Buildings large or small, residential or commercial, raised the same doubts. Was the human spirit being starved by the impersonality of the new styles? Was the eye becoming bored by formulas that, even when applied with taste and discretion, were monotonous in their repetition? Such questions were declared officially permissible in 1975 when the Museum of Modern Art, which had been a powerful influence in the popularization of modern architectural theories. took a revolutionary step with a sympathetically presented exhibition of the very kind of architecture that had been most reviled by the modernists, an exhibition called "The Architecture of the École des Beaux Arts."

The name of the École des Beaux Arts, the official French school of painting, sculpture, and architecture, had been synonymous for close to a hundred years with conservative or reactionary approaches to the arts. The reputation was well deserved, but the Museum of Modern Art's unexpected exhibition suggested that even so there were virtues in the nineteenth-century eclectic styles that had been too quickly dismissed as vices. Perhaps architects who in the nineteenth century had been thought of as creative designers along with painters and sculptors, had sacrificed this position to one in which they were subservient to all

practical requirements. After all, the Paris Opera House, which exemplified the Beaux Arts style to perfection, was also a model of efficiency from a functional point of view. Even in skeleton outline, the Opera's plan and section (132) and 133) show that it accommodated one of the world's most beautiful auditoriums, with backstage arrangements for the most elaborately engineered spectacles, as well as offices, storage rooms, a multitude of foyers (we will see one doubling as a rehearsal room in Degas's painting, 261, and circulation areas that not only allowed for heavy traffic in and out of the auditorium but made those passages delightful for the audiences. The Opera's Grand Staircase (134) makes one's entrance and exit a pleasure in itself, as opposed to the more practical but hardly fascinating escalators that perform the function of moving modern audiences but perform it with no recognition of the individual as anything more than a certain number of pounds, occupying a certain number of square feet, that must be got in and out of the hall.

In the 1970's at least one eminent architecture critic, Peter Blake, a former proselytizer for modern styles, reversed his stand in a series of essays entitled *Form Follows Fiasco:* Why Modern Architecture Hasn't Worked. Here he attacked various "fantasies," as he called them, that in addition to "the fantasy of form" included fantasies of function, of purity, of technology, of the skyscraper, of the ideal city, of mobility, of zoning, and of housing. Everywhere, by his arguments, "The spirit of architecture seems to have been lost."

This extreme rejection may be a necessary counterweight to the extreme commitment of the Bauhaus generation, but it cannot be accepted without some modifying recognition of modern architecture's achievements, including certain beautiful office buildings where the squared lines and glass curtain walls that have become so monotonous are employed with imagination. Lever House (135), built in 1950–52, is such a building, with its directional play of one volume in counterpoint to another, and its main unit hovering as if weightless above a terrace. But there have been proposals to raze the building or to redesign it with additions that would make it more practical—that is, increase the amount of rentable space at the expense of the esthetic quality of a building that is one of the delights of New York's deteriorating cityscape.

Architecture has always, perforce, been an art upon which realistic values must be imposed to one degree or another; but only in modern architecture have these values been allowed to overpower humanistic values that are at least equally important. Perhaps, in the post-1970's, realism in architecture will be as flexible and as various as we found realism in painting to be, early in this chapter. We will not be building neo-baroque opera houses or neo-Gothic parliament buildings, but we may find ways of giving warmth and variety to new patterns of places where we live and work.

133. Longitudinal section. Opéra, Paris. From "Le Nouvel Opéra de Paris," 1878–80. Courtesy The Museum of Modern Art, New York.

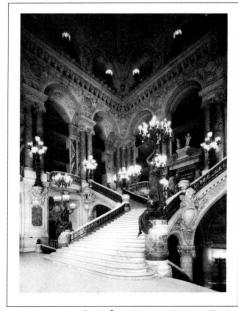

134. Grand staircase. Opéra, Paris.

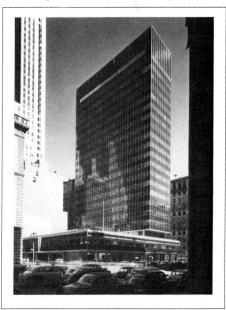

135. Skidmore, Owings & Merrill (Gordon Bunshaft). Lever House. 1950–52. New York.

136. Vincent van Gogh. The Starry Night. 1889. Oil on canvas, 29 by 36¼ inches. The Museum of Modern Art, New York. Acquired through Lillie P. Bliss Bequest.

Chapter Five

EXPRESSIONISM

o matter how much the realistic painters we have seen modified nature, we can still conceive of their painted objects existing in the real world. Harnett, Velázquez, and Chardin modified nature so subtly that at first glance their intentions seem only imitative. Others, like van Eyck, even when they are downright photographic from detail to detail, are not at all so in sum. And we found in every case that the *expressive* element of the realist's art comes from his modification of natural appearances rather than from his ability to reproduce exactly the look of the world around him.

Since this is so, it would seem reasonable that the less an artist is obliged to stick to the natural look of things, the greater his expressive range should be. This does not necessarily follow, but some artists have applied the principle, and this chapter is concerned with worjs of art where the modification of visual reality is so great that it reaches the point of distortion. We will see why the artists in question thought it necessary to violate the "real" look of things.

Our subject is expressionism, and the examples will be more intense and on the whole more personal than the ones we have seen so far. Every great artist has an individual style, but the expressionist's work is likely to be more sharply individualized than the realist's, more dramatically his own, sometimes to the point of eccentricity. Strong stylistic individuality is inevitable when an artist is more interested in probing his own soul than in reflecting the world of ideas, more interested in exploring a moody or tempestuous inner world than in revealing a basic harmony in the one around us. The expressionist may, in fact, be an individual who feels that the harmonies artists have always looked for beneath the chaotic surface of life have never existed, or have been vanquished by mankind's predilection for folly, and he cries out in resentment and horror. His world is one of intensified emotion, sometimes as a means of escape, sometimes as a means of release that brings personal salvation. In extreme cases, the very personal nature of expressionism may keep the observer from entering the artist's world because the artist may speak in terms perfectly clear to himself but puzzling to others.

As a working definition of expressionism, then: Expressionism is the distortion of form and color for emotional intensification. If we want to establish as neat as possible a dividing line between realism and expressionism, we can add to this definition that the distortions go beyond the point where we can accept the possibility of objects existing as the artist has represented them.

According to a dictionary definition, expressionism involves the "free" expression of emotions. We have been pointing out that all the forms in great art are organized into compositions that are far from free, if free means spontaneous and uncalculated.

137. Detail from The Starry Night.

So when we say that expressionist art is "free," we must still remember that what may look like a very free painting or sculpture may be a highly calculated one. A perfect example is *The Starry Night* (136) by Vincent van Gogh, painted in 1889 and now established as a classic of modern art.

The Starry Night appears to have gushed forth onto the canvas of its own volition; the whole picture swirls with a fierce, surging energy far removed from our ordinary associations with a starry night. The moon is as fiery as the sun (137), and the sky is filled with stars that seem to be whirling and bursting with the force of their own inner light. Through the center of this explosive firmament there winds a form that we cannot identify as a cloud or as the track of a comet or even as the Milky Way, which it is supposed to be. In such a sky, such a form really needs no explanation as a natural one. It is an expressive one, an invented one, far removed from the physical truth of whatever form may have inspired it.

The curling, rushing movement of this galaxy across the picture is repeated in an upward direction by the cypresses springing from the foreground as if they were tearing themselves free of the earth. Back of these trees, the fields and hills of the countryside surge and swell around the only quiet objects in the composition, a steepled church and some small houses, their windows yellow with lamplight.

The Starry Night is so highly charged with emotional fervor that it is tempting to think of it as the result of some kind of spontaneous creative combustion. Our knowledge of Van Gogh's life—his emotional torment, his unsuccessful search for peace with this world, his terrible loneliness—all this, as well as our awareness that he was subject to periods of irrationality, seems at first consistent with his having produced this fervid painting in an inspired frenzy or even in an almost hypnotic state.

The fact that we feel such immediacy in *The Starry Night* is a tribute to Van Gogh's genius for emotional expression. Our enjoyment comes in large part from our feeling of direct emotional communication with the painter. Although the picture is a personal revelation, it speaks in terms perfectly clear to the observer also. Van Gogh's paintings always seem to have come fresh from the easel; we seem to be in the painter's presence—even after we discover that this is a calculated picture, not a spontaneous production.

And very thoroughly calculated it is. For one thing, there is the way the upward twisting of the cypress forms is used as a counterforce, a kind of brake, to the forward rush of the comet-like form across the sky. Both forms benefit by the contrast since neither is allowed to overpower the rest of the picture, as either would have done without the balancing influence of the other. The most dramatic dark in the picture—again, the cypresses—is played in another balance against the most dramatic light—the fiery

moon—on the opposite side of the picture. (Imagine the difference if either the moon or the cypresses were shifted into the center.) Among secondary elements the church steeple helps unify the composition, first by echoing the form of the cypresses and also by interrupting the insistent line of the hills against the sky. The rushing line of the horizon might otherwise carry us too swiftly to the edge of the picture and out of it. This steeple-and-hills relationship is a restatement of the cypress-comet relationship, a repetition of the main theme, and is a major reason why a painting of such violent force is complete and self-contained instead of chaotic. And all the other elements in the composition, including the direction of each brush stroke, are caught up in the flow of movement determined by these major forms.

All the organization, its balance, contrast, echo, and rhythmic flow, was of course perfectly conscious on the part of the artist. He probably painted the picture rapidly; it is so vividly direct that it is hard to believe he reworked any part of it, but the composition is so skillful that we could not believe it was accidental or "inspired" even if we had no evidence to the contrary.

We do have this evidence. We have Van Gogh's preliminary drawings for various parts of the picture, and at least one earlier study of the same subject, as well as his letters over a period of months with references to his plans for developing it.

In his letters Van Gogh talks again and again about his plans for pictures, describing his progress toward the expression he wants. He once wrote to a friend who had admired the intensity of feeling in one of his pictures of some gardens:

... that was not accidental. I drew them many times and there was no feeling in them. After I had done the ones that were stiff, came the others.... How does it happen that I can express something like that? Because it has taken form in my mind before I start on it. What I am doing is not by accident but because of real intention and purpose.

As for his color, which is so right and seems so pure that we feel he had nothing to do but reach for paint ready at hand, he tells elsewhere in his letters of the trouble he had in determining exactly the kind of black (greenish or bluish, in relation to the surrounding colors) for painting cypresses. And although he frequently used certain colors straight out of the tube, for maximum intensity, he did so only after experiments in color relationships that were no less complicated for having ended in the desired effect of extreme directness.

And so Van Gogh, like all great artists, was a theorist and craftsman as well as an emotional human being. But this theorist also describes himself as working in a "dumb fury" at times and once, after painting all day without even stopping to eat, he wrote: "I shall do another picture this very night, and I shall bring it off."

There is nothing really contradictory in this combination of feverish creation and the application of theoretical principles. Expressionist art like Van Gogh's, by the nature of its intensity and its personal quality, reaches its pitch of achievement at times when the artist is so "inspired" (for want of a better word that his whole accumulation of knowledge and technical skill is at his command for immediate, as if spontaneous, use. But to think of an artist "inspired" to create a picture without preliminary spadework is as unreasonable as to imagine an actor giving an inspired performance without having learned his lines or a poet creating a masterpiece in a language he does not know. The Starry Night is an inspired painting if ever there was one, yet its creation was possible only because Van Gogh worked toward it for so long. (He wrote, "I wonder when I'll get my starry sky done, a picture that haunts me always.") The painting is so consummate an expression of Van Gogh's emotional nature that its creation must have been for him the most exalted and ecstatic release.

We have insisted that painting is an expression of its time. How does *The Starry Night*, as a work of modern art,

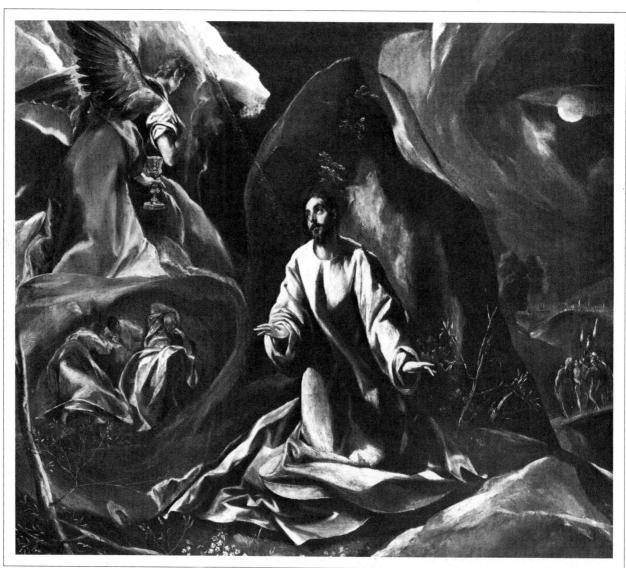

138. El Greco. The Agony in the Garden. 1590's. Oil on canvas, 40½ by 44¾ inches. The Toledo (Ohio) Museum of Art. Gift of Edward Drummond Libbey.

accord with this idea? We could say that in its extreme individuality it would not have been painted in a time other than our own, when individual freedom is a basic concept in our thinking. We could also say that in the need this lonely artist felt to communicate with his fellow man through painting, his art reflects the isolation of the individual that is a frequent corollary of his freedom. We could skate on very thin ice and suggest that in its violence, its agitation, its excitement, The Starry Night is a reflection of our age. All these arguments are at least partially valid; it is certainly true that stylistically (in its design, in its manner of paint application) The Starry Night cannot be imagined as belonging to any other time. But conceptually, as a personal expression, it is not much more of our time than of any other time—perhaps for the very reason that its creator was never able to become really a part of the life around him, as he so ardently desired to do.

Expressionism is a new term, usually thought of in connection with modern art, but the expressionist principle of distortion of form and color for emotional intensification appears in the art of some of the old masters also. El Greco's *The Agony in the Garden* (138), painted in Spain just three centuries before *The Starry Night*, is every bit as expressionist as the modern painting and even makes its effect through similar distortions.

As far as subject matter is concerned, El Greco is obliged to conform to the letter of the Bible story; but he treats it in an individual—and expressionist—manner. Christ prays on the mount, his eyes lifted toward the apparition of an angel. Rocks, robes, clouds, and diaphanous shafts and veils of light intermingle until, in spots, one cannot be distinguished from another. The most curious element in the picture is the cavelike or mirage-like form beneath the figure of the angel that encloses the sleeping disciples (139). They lie in odd, unnatural attitudes, not at all suggesting the relaxed quality of sleep, but rather an enchanted or magically transfixed state that removes them as witnesses of the divine events in progress nearby. At the extreme right, within a mystically luminous landscape, we see Judas approaching with the Roman soldiers (140).

Compositionally, *The Agony in the Garden* and *The Starry Night* employ surprisingly similar devices. The various forms in both pictures are tied together by swirling, eddying rhythms continuing without interruption between landscape and sky, uniting earth and Heaven in ecstatic harmony. Both pictures are painted in vivid colors. In both, the rhythmic flow of line is picked out in supernatural lights. The distortion in the cypress trees is even similar to that of the robed figure of Christ; both forms are elongated into conelike shapes, swirling and twisting in the intensity of their upward striving.

The composition of El Greco's *The Agony in the Garden* is more complicated than that of *The Starry Night*, but the main flow of line that knits it together can be traced around the strange form enclosing the sleeping disciples, on up

139. Detail from The Agony in the Garden.

140. Detail from The Agony in the Garden.

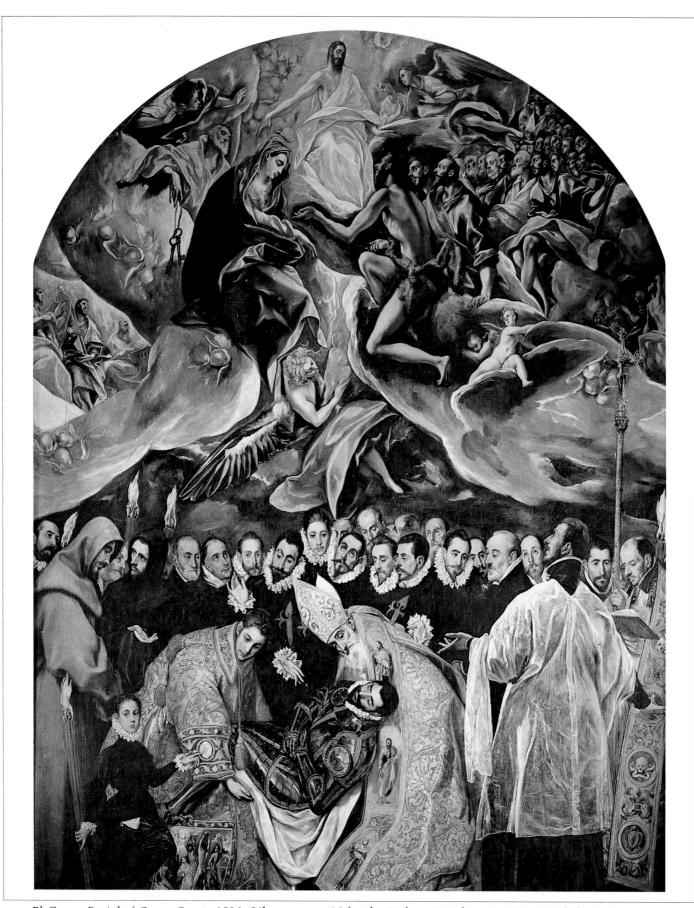

141. El Greco. Burial of Count Orgaz. 1586. Oil on canvas, 16 feet by 11 feet 10 inches. San Tomé, Toledo, Spain.

along the edge of the peaked boulder—the very summit of the mount—and then into the clouds that fill the upper right part of the picture. This sinuous line is very like the path of the Milky Way in the Van Gogh, although it is less obvious.

Behind all these surface similarities, however, the two pictures are totally different in the character of their emotionalism. Van Gogh's is a personal vision of overwhelming force. El Greco's intensity is somehow thinner, stretched to the breaking point. The El Greco has elegance—it makes its appeal in more sophisticated terms than the Van Gogh. Its mystical quality is the result of a colder and subtler calculation of staggering brilliance. This is a sumptuous painting, and although it is a religious one, its first appeal is through its sumptuousness, its elegance, its finesse, its intellectualism, and even its sensuousness. These comments are neither derogatory nor irreverent. The great art of El Greco makes sense in these terms as Van Gogh's would not.

El Greco is so individual a painter that the appreciation of his art has had a curious history as tastes have changed and ideas of what painting should be have shifted back and forth. In his own time, for that matter, one of his paintings was rejected by Philip II of Spain, who had commissioned it for an altar in the Escorial. But a select circle of intellectuals in and out of the Church recognized the mystical power of El Greco's style, and under their patronage he steadily increased the element of distortion, to the satisfaction of his aristocratic and ecclesiastical patrons.

Succeeding generations lost the understanding of El Greco's art until, not too long ago, he was either ignored or, at best, relegated to a minor place in art history as an interesting eccentric. His distortion was even explained as being the result of astigmatism, an absurdity that still pops up from time to time. If it is necessary to refute it, we can point out that astigmatic vision would not produce these distortions in the first place, and also that El Greco painted numerous pictures, particularly portraits, in which the degree of distortion is slight. In the *Burial of Count Orgaz* (141) he combines his more realistic style with his expressionistic one in the two parts of one picture.

The lower half shows the Count's body being placed in its tomb by Saint Stephen and Saint Augustine in the presence of surrounding relatives, friends, and dignitaries. There is a certain amount of elongation in the drawing of these thin-faced, melancholy aristocrats (142), but on the whole the figures in the lower half can be conceived of as existing in the form in which El Greco painted them.

In the upper half, however, we see first an angel who holds the soul of the Count in the conventional form of a naked babe, represented here as more shimmery and gauze-like than fleshly. The angel is more distorted than the human figures below it, and as we go on up toward the figure of Christ on his throne, the distortion becomes greater and greater. Saint John the Baptist, shown kneeling, is a fantastically elongated figure with a tiny head and

142. Detail from Burial of Count Orgaz.

odd swellings and contractions in the arms, legs, chest, and waist.

These distortions are repeated in the other celestial figures who surround the saint as he intercedes with Christ for the newly arrived soul. The scene takes place upon various levels made up of the same luminous, unidentifiable forms that twist through *The Agony in the Garden*. El Greco has harmoniously combined a realistic earthly scene and a visionary heavenly one, modifying his manner appropriately from realistic to expressionistic.

El Greco apparently developed his style objectively, calculating its effectiveness and making the most of it as a professional artist rather than as an emotional human being. With Van Gogh, expressionism was a personal release; with El Greco, it was an intellectual achievement.

The three expressionistic paintings we have seen so far are all visionary pictures, but the range of expressionism is wide. Our next illustration is at the opposite pole and brings us back to modern art. Georges Rouault's *Two Nudes* (144, p. 104) deals with brutal truth instead of rapturous hallucination, with degraded worldliness instead of elevated spirituality. It is the kind of picture that makes people say, "With so much that is beautiful, why paint something so ugly?" Not only the subject—two hideous, naked prostitutes—but the very look of the picture seems ugly to most people. The color, instead of being decoratively "beautiful," seems thin and acid, and the drawing coarse and heavy-handed.

Yet this is a painting by a man who on occasion draws with the most delicate precision, who has painted conventionally beautiful and reverent interpretations of mystical religious subjects, whose color frequently has the deep brilliance of stained glass. Why did he paint this "ugly" picture? If the man is a mystic, how can he choose this subject? And if he is an accomplished draughtsman, why does he draw like this?

Actually there is no paradox here. *Two Nudes* is noble in conception and its drawing is consistent with its message.

Two Nudes is an outraged cry against man's inhumanity to man, against corruption, meanness, and human degradation. In social and humanitarian terms it is a thoroughly moral picture. The painting is a condemnation, an accusation against a world that brutalizes and degrades. Secondarily, it is a condemnation in general of the animalism of lust.

Now, these ideas are impossible to present in a picture of conventional prettiness. Rouault slashes at his drawing in coarse, heavy lines expressive at once of his own anger and the brutishness of the women. He distorts the bodies into heavy, lumpy forms that are indeed ugly, as bodies. The color is scrubby, roughly applied, suggestive of fresh tints turned morbid, as if soured by the evil the painter reveals. And the answer to the question, Why paint this instead of something beautiful?, is that the whole world in any of its aspects is the painter's province. What he most

deeply feels, he must paint, in the most appropriately expressive way.

But, of course, Two Nudes is a beautiful painting. Technically, it is beautiful in the absolute control of drawing. For all the appearance of coarseness and license, the thick boundaries of the forms are expertly controlled and designed to describe these forms, and to describe them with appropriate emphasis or, if you wish, exaggeration. Even the distortions are beautiful in their powerful expressive quality. They could not have been created by an artist who had not passed through apprenticeship in the kind of accurate, detailed drawing that looks more difficult. Finally, above all, the subject is neither base nor vulgar. It is noble, if faith in man's goodness is noble. The subject is not presented lasciviously. (Could vice be made more unattractive?) Nor is it presented in cynical acceptance of evil. It is presented as a protest, and to protest against evil is to recognize the possibility of good. In all Rouault's work there is a fundamental faith in man's redemption through his recognition of evil and his rejection of evil.

It is this implication that gives *Two Nudes* its meaning. We are shown ugliness in terms of such violence that we must recognize it—and reject it. From any other point of view *Two Nudes* is only a repellent image of two grotesquely ugly dehumanized creatures.

From what we have said so far it appears that expressionism must always be associated with the morbid, the tragic, or the visionary. To a large extent this is true. "Distortion for emotional expression" suggests violence and intensity, although the whole emotional range, including feelings of peace and quiet joy, can be expressed by appropriate distortions of form (into simple, quiet shapes) and appropriate colors (subdued, soothingly harmonious ones). In practice, however, these quieter emotions are expressed by poetic realism. Expressionism is given the field when subjects are intense rather than serene, agitated rather than peaceful. For a painting using expressionistic devices to interpret a scene more cheerful and familiar than most, we can look at John Marin's 1920's water color of New York City, *The Singer Building* (145, p. 105).

A photograph (143) or a realistic painting of the subject must be dominated by the rigid parallel vertical lines of the Singer Building and adjacent buildings, with their flat walls regularly punctured in a rigid pattern of windows. If represented in correct proportion to the buildings, the crowded traffic of automobiles and people would be diminutive and, if visible at all, clotted into masses not suggesting their turmoil of movement. Rigid horizontals (the street and sidewalks) and verticals (the skyscraper) suggest quietness, orderliness, permanence; they are the standard framework for pictures of static character.

Now, this is the opposite of the impression a city makes; a city is busy, pushing, noisy, excited, crowded, confused. Above all, it is dynamic, and this dynamism is immediately relayed by Marin's painting. If we try, we can

143. The Singer Building, January, 1908, New York. Photograph from Byron Collection, Museum of the City of New York.

144. Georges Rouault.

Two Nudes (Filles).

About 1905. Oil on paper, 39 5/16 by 25½ inches. The Metropolitan Museum of Art, New York. Gift of Mr. and Mrs. Alex L. Hillman, 1949.

decipher in the lower part some shapes recalling streets, shops, and the rest (including the elevated railway, long since razed). But the important thing is that the sharp, strong angularities that interrupt one another, breaking and shifting to other angles, are expressive of action and excitement, in contrast with the static photograph (although this particular photograph is enlivened by parts of buildings under construction, and the smoke or steam issuing just above street level). Much of the fascination of photography is that it can freeze action—freeze a baseball in midair inches from the bat, hold an athlete forever in suspension as he clears a hurdle. But to freeze action is the opposite of expressing it, as Marin wants to do. In the end, his expressionist vision of what a city is is "real-er" than a photograph can be, although—or rather, because—some of the most expressive parts are not even identifiable as objects. In the lower half many of the sharp, emphatic lines are simply that—lines, lines of force perhaps, not parts of buildings or other objects. Above center right a wavering oval of pinkish color represents nothing at all but serves as a transition, a symbol of dissipating energy, from the hectic activity of the lower half of the painting to the relative quiet of the sky.

The transition from confusion to clarity is the most important but least conspicuous achievement in this cityscape. We are embroiled in the action, the excitement, the dynamism of street level, which is expressed in proportions altogether unrealistic. As the buildings rise, the excitement diminishes, the forms are less interrupted, there is less contrast of dark and light, the colors are more delicately washed in, until finally the peaks of the skyscrapers escape into the open sky. In reality the Singer Building was capped with a dome and lantern (under construction in our photograph) that performed the architectural function of terminating the tower as a capsule, a self-contained volume clearly defined to hold its own as a material unit within the amorphous space of the sky. If it had been represented in that way in Marin's vision of the city, it would have been altogether discordant. Hence he has left the dome form recognizable but has shattered and opened it to make it a part of the all-permeating vital energy that suffuses every bit and piece of his city.

A generation later, in 1953, another American artist responded in much the same way to his city. Franz Kline, a leader of the abstract expressionist school, painted *New York, N.Y.* (146), a giant of a painting in which this same vitality is expressed in a lunging pattern of black and white without specific reference to pictorial matter. In its raw power and large size, *New York, N.Y.* could almost be an enlargement of a fragment of the lower part of the Marin. As a matter of fact, Kline began his career as an abstract expressionist by isolating and enlarging areas of his own realistic works, on the theory that the idea of "city" could thus be intensified by concentration.

Marin, however, went further in his exploration. Compared with Kline's, Marin's idea of "city" is panoramic. Just

145. John Marin. *The Singer Building*. 1921. Water color on paper, 26½ by 21% inches. Philadelphia Museum of Art. Alfred Stieglitz Collection.

146. Franz Kline. New York, N.Y. 1953. Oil on canvas, 79 by 50½ inches. Albright-Knox Art Gallery, Buffalo. Gift of Seymour H. Knox.

147. Ernst Ludwig Kirchner. Street Scene. 1922. Color woodcut, 27¾ by 15 inches. The Museum of Modern Art, New York.

as the forms in *The Singer Building* are graduated from violent dislocation in the lower part to relative quiet above, so Marin's colors are graduated from reds and oranges, "hot" colors psychologically associated with action and excitement, to blues and greens, "cool" and associated with quietness. Marin makes the transition from the strong, exciting colors to the quiet ones in several steps—including, for instance, a change in the colors he quite arbitrarily chooses for the window openings in the buildings. This color transition goes hand in hand with the transition from broken, shifting shapes and angles in the lower half to the quieter shapes in the upper part.

(Leonardo da Vinci used this warm-to-cool color progression in the landscape background for the *Mona Lisa* [22], going from golden browns to silvery blues, although the yellowing of centuries of varnish has obscured the original contrast, making the cool passages much warmer than Leonardo painted them.)

Finally, we must remind ourselves that like any good picture, The Singer Building is an organization of line, shape, and color into a compositional unit. The angular lines that express the excitement and confusion of the city also tie the composition together by repeating, buttressing, and echoing one another. Again we see that objective skill and technical control are the means to an expression (not a description) of a subject so agitated that objectivity and control might at first seem out of place. Realizing this, Marin makes a point of retaining effects of spontaneity. He is a first-rate water-color technician and carries the medium far beyond the delicate tones usually associated with it. Some of his color is applied from a full, wet brush; in other places he capitalizes on the grainy quality of the rough paper where he has dragged a nearly dry brush across it. These contrasting textures are an important element in the picture's variety and excitement.

The Singer Building plunges us into the city and surrounds us with its stimulating sound and movement. It is essentially a cheerful, vigorous interpretation, full of the optimism and sense of youthful power and flourishing growth that we like to think of as typically American. It was painted in 1921 when an American boom was under way and the chastening years of the Great Depression had not become part of our national experience. At almost exactly the same time (1922), a German expressionist, E. L. Kirchner, shows us a contrasting idea of "city" in Street Scene (147).

The mood of a German city in 1922, only four years after the nation's defeat and humiliation in World War I, was the antithesis of the American mood of triumphant vitality. The terrible period of shock and dislocation in Germany was producing some of the most vicious social deformities in the history of our civilization. *Street Scene* is full of morbid introspection, of melancholy brooding, of sinister foreboding and the soul-sickness of a hopeless and groping society. There is a haunted quality in the figures

of the two women; their fashionable clothes have been turned into witchlike silhouettes, and although they are part of a crowd, we feel first of all their isolation in some private and unhappy world of disturbing preoccupations. The picture's colors are totally unreal, from the olive green of the skin to the brilliant red, blue, and yellow of the background. The angular treatment may somewhat suggest the angularities of Marin's city and may carry some of the same hint of noise and movement, but it is a very faint echo in a picture that, upon increasing acquaintance, relays a stronger and stronger feeling of unnatural stillness. The face of the central figure regards us uncomprehendingly, or suspiciously at best. She stands in an odd, half-crouched, retreating attitude. The strange little taxi behind her and the figures making up the crowd on the other side of the picture are as wooden and doll-like as toys, increasing the effect of unreality. The women are transfixed in a world without meaning, yet somehow threatening, filled with ominous portents of evil-exactly the opposite of the booming optimism of Marin's city.

Our present-day understanding of the art of children developed as a by-product of modern expressionism. Whereas children used to be taught to curb their natural exuberant expressiveness in painting, to "be neat," to "keep the color inside the lines," in short, to defeat every spontaneous release of their natural bent for putting ideas into pictorial form, they are now encouraged to paint exactly as they please, on the principle (quite sound) that they are unable to apply rule and theory in picturemaking but may have a natural response to psychological values of colors, lines, and shapes.

The nine-year-old who painted our third example of an expressionistic vision of a city (148) was no Marin, and as far as he was concerned, was simply painting a city the way it looks. Nor was the eleven-year-old who painted a hurricane (149) any Van Gogh. But the resemblance of these spontaneously invented forms to those in *The Singer Building* and *The Starry Night* is more than coincidental. The paintings say "city" and "hurricane" quite vividly because the children made direct translations of their feelings into images that seemed right to them. The adults have done the same thing, but not so innocently; their translations had to be conscious and studied, based on formal knowledge and theory that enabled them to distill the images from the depth and complexity of mature experience.

It is easy to overrate children's painting as artistic endeavor, which, of course, it essentially is not, and to credit many a lucky accident as an expressive intention. But at the same time it is good that we have learned that expression is often most effectively released through forms and colors that are not accurate transcriptions of nature, and that we have learned to understand the nature of painting done by children as well as the art of expressionism on this basis.

148. Nine-year-old child. City Street. Oil and crayon on paper, 14 by 19 inches.

149. Eleven-year-old child. *Hurricane*. Show-card color on paper, 14 by 19 inches.

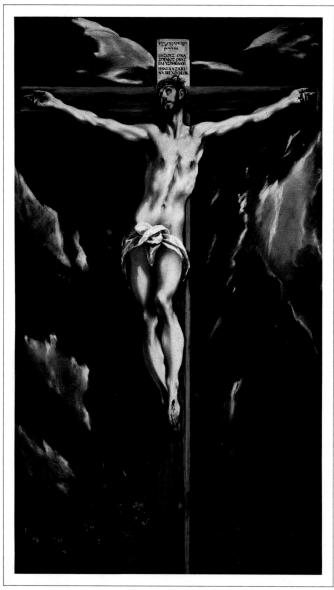

150. El Greco. *Christ on the Cross with Landscape.* About 1610. Oil on canvas, 74 by 44 inches. The Cleveland Museum of Art. Gift of Hanna Fund.

If what we have said so far about expressionism leaves the impression that any intensely emotionalized presentation of a subject is ipso facto expressionistic; or that mystical subjects demand expressionistic treatment; or that expressionism is always an art of individual invention on the part of artists who relay their personal responses to a subject in a personal style—then let us say clearly that these impressions are mistaken, as we can see by comparing three versions of the Crucifixion.

The first of these, Christ on the Cross (151) by Rubens, was painted in the seventeenth century by a master who was under no technical limitations whatsoever. The laws of perspective and anatomy and other elements of realistic representation had been discovered and codified long since. For Rubens their use was second nature. He had at his fingertips the whole range of knowledge for the creation of effects of light and shade, the various ways of giving illusions of depth, of making forms look round and solid. and he saw no reason to abandon these methods for experiments in expressive distortion even when treating the most intensely emotional subjects, such as Christ's agony on the Cross. From what we have already said about Rubens's Prometheus Bound (95), it should be clear why Rubens paints the scene as realistically as he does. He appeals to the emotions through our own experience with sensations of pain or pleasure—which, from an expressionist artist's point of view, could raise the question as to whether this Crucifixion is an interpretive picture at all.

Rubens gives us a magnificently painted male nude who is Christ only by association of ideas. There is little or nothing to supply the mystical connotations of the subject; we ourselves supply them by foreknowledge. As far as the painter's contribution is concerned, there is nothing inherently divine in this figure of a man nailed to a cross. It is not irreverent to say that if we didn't already know otherwise, this might easily be some Olympic champion undergoing torture or, more accurately, a well-muscled actor caught at a climactic moment of a fine performance. The whole production is effectively staged; the lighting, the backdrop with its illusion of storm and distance, are marvelously dramatic. And so real! They almost make us feel we are there—and that, of course, is the whole intention.

There is virtually no distortion—expressionistic or otherwise. The features are twisted in agony, the muscles of the arms and chest are strained tight, but none of this is a distortion of nature. It is, on the other hand, a kind of extreme naturalism under given physical circumstances. Not only is there no distortion, there is hardly, even, any exaggeration. Everything in the picture is represented at highest dramatic pitch, but there is nothing in it that could not have been reproduced directly from nature. This is, in short, an emotionalized presentation of a subject without recourse to expressionistic devices; it makes its effect today in very much the same terms as it did when it was painted more than three and a half centuries ago in the now vanished context of the Counter Reformation.

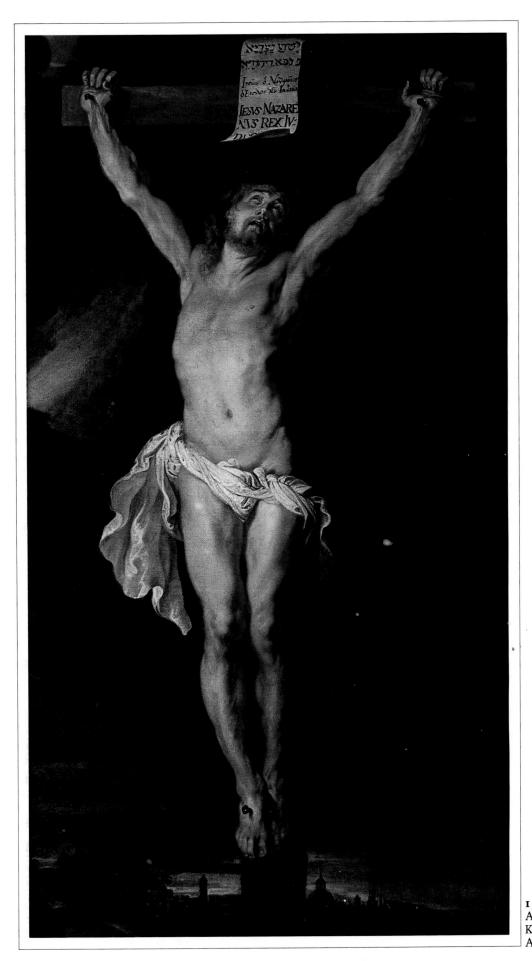

151. Peter Paul Rubens. Christ on the Cross. About 1610. Oil on canvas, 87 by 47 inches. Koninklijk Museum voor Schone Kunsten, Antwerp.

152. Detail from Christ on the Cross.

153. Detail from Christ on the Cross with Landscape.

Now, returning to El Greco, the great expressionist among the old masters, we find in his Christ on the Cross with Landscape (150, p. 108)—painted at about the same time and perhaps even in the same year as the Rubensthat he is not content to let us supply the mystical and miraculous spirit of the event while he serves as stage manager. He wants to make mystery and miracle inherent in his vision of the Crucifixion, and to do so he must depart from real appearances. He creates as background an otherworldly space, shot through with ambiguous forms and supernatural lights such as never existed on earth or, for that matter, on stage. We can easily imagine the human being who posed for Rubens's Christ-in fact, we don't have to imagine him; we see him. But if we had to imagine El Greco's Christ as an existing human being, he would be a monster of grotesque proportions afflicted with skeletal deformities that would make it impossible for him to stand or walk, in contrast with Rubens's superbly athletic model. But there is no temptation to see El Greco's Christ in terms of physical reality; this is a sensuous transfiguration. Nor does it bother us that the body does not actually hang from or seem actually nailed to the Cross; rather, the arms might be extended in a gesture of mystical appeal; the figure seems magically suspended. A comparison of the hands of these two Christs summarizes the physical reality of one, the spiritual mystery of the other (152 and 153). We have said that, confronted by the Rubens, we supply the mystical connotations by foreknowledge of the subject; if we did not already know the story of the Crucifixion, we would still be aware that El Greco's haunting picture is no ordinary scene of torture, but the transcription of a divine event.

Whether the Rubens or the El Greco is the better picture is not a question. Some people will be more moved or more interested by one, some people by the other, some people equally but in different ways by both, and some may prefer—if it is a matter of establishing preferences—to either of them a painted Cross (154) by a follower of an unknown master of the Middle Ages, an Italian active at the end of the thirteenth century who is given the name "Master of the Saint Francis Legend." Such crosses were produced in large numbers in Italy during the latter part of the twelfth century and in the thirteenth, varying in size and quality according to the size and wealth of the church for which they were originally commissioned. The large ones were put over the altar (sometimes suspended from the ceiling) where, within the shadows of the vaults, illuminated by the flickering gleam of the candles below, they must have had the quality of a vision.

The figure on the Cross certainly looked much more real to the people it was painted for than it does to us. They did not demand, or even conceive of, realistic painting as we know it. Giotto's revolution (275) was still a generation away. The painter has made some effort to round out portions of the figure in a naturalistic manner, and this effort is fairly successful in the small figures. But even so, realism in the terms we have been discussing was beyond

his conception. The loin cloth is primarily a decorative pattern in line (and a beautiful one); the hair is so highly conventionalized that it is out of the question to think that the painter tried for anything like realism; and the ear is snuggled in between the hair and beard like an afterthought (155). Nor is there any effort at realistic relationship between the various figures involved. There are four scales, descending in the order of the figures' importance. The largest is reserved for Christ alone; the Virgin and Saint John share the next largest; the two mourning angels at the ends of the arms of the Cross are a degree smaller; and finally the mere human being, kneeling at Christ's feet, is appropriately accorded the minimum size.

The figure of Christ, which would be merely inept in terms of realistic imagery, takes on a deeply moving spiritual quality precisely because it is not realistic, just as in the case of the El Greco; yet it is probable that this painter, a well-trained artisan but no revolutionary genius, was innocent of any idea of intensifying the emotional effect of the image by expressive distortions, and was being as realistic as he knew how. The apparent distortions are conventions inherited from generations of painter-craftsmen who were content to follow a set of patterns that had proven their effectiveness. But the rank and file of these journeyman painters turned out rather dry repetitions of studio formulas. This obscure follower of an obscure master has done more, within the indefinable area of creative art where we may feel the difference between one artist and another without being able to define exactly where that difference lies. It is possible that some of the effectiveness of this particular painted Cross among all the others came from this master's relatively advanced efforts to imbue the body of Christ with emotive power by exaggerating the angularities, as if the body had been broken on the Cross, and by striving for realism in such details as, for instance, the muscles of the abdomen. But need we worry about these questions. Except to the historian, do they make a great deal of difference? The artist's intention was to achieve an expression of the mystery of the Crucifixion, and he achieved it, by whatever means. The "distortions," whatever their origin, determine the character of the painting, and through them it speaks to us. We understand its visual language as well as we do today because our eyes have been attuned to it by modern artists who have expounded and demonstrated the principles of expressionism.

Expressionism in sculpture occurs less frequently than in painting, either modern or earlier. Perhaps this is because sculpture is so tangible an art that any drastic distortions are likely to become mere deformities when put into three dimensions. This is true of the *Venus of Willendorf* (36), that arch-ancestress of all sculpture, which, in spite of its towering anthropological importance, is unquestionably grotesque from any esthetic standard, expressionistic or otherwise. No painted fertility images comparable to the *Venus of Willendorf* are known; perhaps the same exagger

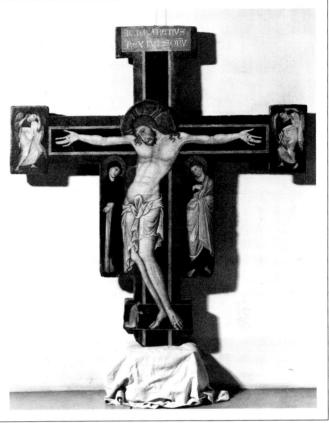

154. Follower of the Master of the Saint Francis Legend. Crucifixion. About 1280. Tempera on wood, 74 by 68½ inches. Philadelphia Museum of Art. Purchased by W. P. Wilstach Collection.

155. Detail from Crucifixion.

ations in two dimensions rather than the tangible third would have an advantage over this lumpy little object. In this respect we have already commented that El Greco's crucified Christ becomes grotesque only if imagined as a living body. Similarly, if translated into stone or bronze, it would be robbed of its ethereal, floating quality and would become monstrous. In addition, it is difficult to imagine a sculptural equivalent of the mystical, shifting lights in the background that account for so much of the mystical quality of the painting.

For a modern effort to create a sculptural monument calling on expressionist-related principles, there is Ossip Zadkine's *The Destroyed City* in Rotterdam, which is discussed later in this book in another context (386)—but its success is questionable. Expressionist distortions in sculpture are more successful at small scale, even intimate scale, as in a group of small German sculptures of the fourteenth century, where emotional intensification seems the product of a concentration of all the power of a large sculpture within an image only inches high.

As an example, the *Röttgen Pietà* (156), only 10½ inches high, and designed for private devotions, would be absurd enlarged to life size. At small scale the expressionistic exaggerations and distortions are poignantly affecting; the full range of expressionist devices can be employed. Christ's body seems to have come from the torturer's rack rather than the Cross; the neck is wrenched backward, the arms are frozen into rigid jointless rods, the chest protrudes as if paralyzed at the last moment of a supreme but impotent gasp for breath that leaves the mouth agape and the eyes half-closed. The blood has flowed from the five wounds in the body in rosettes like flowers.

But a Pietà is the Virgin's subject, dealing less with the pain and tragedy and glory of Christ's death than with his mother's human grief. To this end, the sculptor—in full control of his means—has concentrated on distortions that stimulate emotional response to the Virgin's agony. Realistic proportions have been discarded for expressive dimensions throughout; the Virgin's head is disproportionately large in order that her contorted features may tell to fullest effect, and the body of her son, which at normal size would distract from this effectiveness, is hardly larger than that of a boy. Each part and detail of this famous little sculpture is assigned its degree of emphasis in relation to the whole in order to complement a full dramatic realization.

If there are any questions as to the effectiveness of the expressionistic distortions in the *Röttgen Pietà*, they can be answered by putting it alongside another Pietà done about fifty years later, and not too far away, for the Seeon Monastery near Salzburg (157, p. 114). Comparing our comments on the *Röttgen Pietà* point by point, we see that Christ's body in the Seeon sculpture is peaceful and even comparatively graceful in death. The hands are gently folded, the eyes and mouth closed. The wound in the side, while realistic, is less effective for that reason; the blood has run, not gushed, from it, and the wounds in the hands

156. German, Middle Rhine. Röttgen Pietà. About 1370. Wood, painted, height without base 10½ inches. Rheinisches Landesmuseum, Bonn.

157. German, Salzburg. *Pietà* from monastery at Seeon. About 1420–30. Stone, painted, height 29½ inches. Bayerisches Nationalmuseum, Munich.

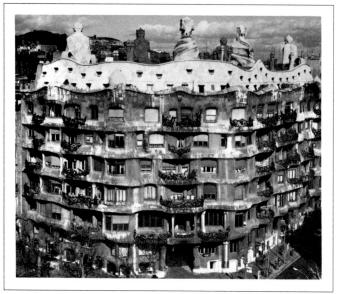

158. Antoni Gaudí. Casa Milá. 1905-10. Barcelona.

159. Arcade at street level. Casa Milá.

and feet are inconspicuous. The Virgin's pretty face in a head of normal size is unmarred by any agony of grief, although the corners of the mouth droop and the brow is slightly knit. The body she holds is also of normal size, with consequent difficulties. The Virgin's right arm has had to be unnaturally lengthened in order to support the corpse at the neck and shoulders, a deformation that is only awkward, not expressive. It is unconvincing as well; this delicate young woman could not support the body of the full-grown, if slender, man. Even the crown of thorns, to introduce another detail, is a spiked instrument of torture in the Röttgen Pietà that is reduced to an ornamental headband in the Seeon version. "Ornamental" is in fact a key word here, with emphasis on such incidental details as the lovely folds and fringed border of the scarf over the Virgin's head.

None of all this has to mean that the Seeon Pietà is inferior to the Röttgen. It is a matter of preference between contrasting styles or conceptions, and—such is the infinite variety of art—a devil's advocate could reverse our arguments in favor of a sculpture we have found wanting expressively.

Expressionism, involving as it does the willful distortion of form, is less compatible with architecture than with any other art. We have seen enough architecture so far in this book to know that architectural form at its most expressive is inextricably tied to the practical business of construction. As a primary example, the Gothic cathedral could never be called expressionistic, for all its originality and extreme expressiveness. The *invention* of forms is quite different from their arbitrary distortion. Rib vaults and flying buttresses were frequently ornamented, but they retained their strictly functional honesty undistorted beneath the frosting.

Early in the twentieth century, however, there appeared an architecture that can be called expressionist, growing out of a movement called art nouveau. Art nouveau was an effort to introduce into design the qualities of natural growth and movement in nature, the shapes of plants (particularly such sinuous ones as vines), the motion of water in the waves of the sea, and the eddies in the currents of streams or rivers. To design a solid building in terms of sinuous growth and shifting volumes is obviously an odd approach to architecture, exactly the opposite of what we called architectural realism in our last chapter, where form is disciplined by the practical demands of function.

The primary monument of art nouveau architecture is the Casa Milá (158), an apartment house in Barcelona by the architect Antoni Gaudí. Wavering, flowing forms are imposed not only on the exterior but also on the plan (160). The piers of the arcade at street level (159) are sculptured and roughened as if they were living stone entrances to grottoes. (The building is nicknamed "the quarry" in Barcelona.)

The Casa Milá was built in 1905–10. Later, in the

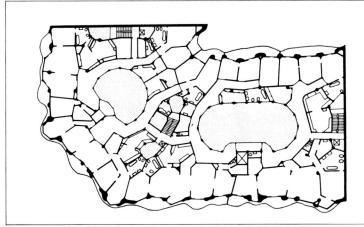

160. Plan. Casa Milá

1920's, corresponding to the rise of expressionism in German painting, there was a brief but lively growth of avowedly expressionist architecture, based on the idea that the form of a building should symbolize its function. (The important word here is "symbolize.") The design of the Einstein Tower at Potsdam (161), built in 1920, was rather indecisively connected with theories of relativity. It was also intended as a demonstration of plastic treatment of poured concrete in "sculptural" architecture—although, as things turned out, it had to be built of brick smoothed over with a skin of cement.

"Form symbolizes function" never became a popular idea, and the architect of the Einstein Tower himself, Erich Mendelsohn, soon abandoned it for a modern style closer to the realistic precept that form follows function. The triumph of functionalism reduced expressionist architecture to a trickle of small, special buildings—such as chapels—until suddenly one of the leading international designers of functional architecture, Eero Saarinen, temporarily reverted to expressionism in 1957-62 with a large commercial building, the TWA Terminal (162) at Kennedy International Airport in New York City. Using poured concrete, Saarinen sculptured the building in long, curved, flowing, and swelling forms like the wings of birds, forms that seemed buoyed up by the air beneath them, and managed at the same time to create interior spaces that satisfied the functional demands of an airport terminal the waiting rooms, the ticket counters, the baggage reclamation area, lunchrooms, and access to and from planes. The TWA Terminal is the most successful expressionist architectural project ever built to satisfy utilitarian demands, and it proved that expressionist architecture could accommodate them; yet it has the air of a tour de force. Its uniqueness affirms the associations with eccentricity and arbitrary estheticism that make expressionist structures more interesting as sculpture—and, frequently, as fanciful stage sets—than as architecture. The very strong theatrical element in expressionist architecture, combined with effects borrowed from expressionist painting, is familiar to anyone interested in the history of movies in the famous German film The Cabinet of Dr. Caligari (163).

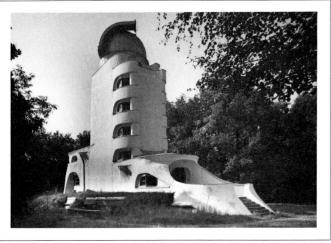

161. Erich Mendelsohn. Einstein Tower (destroyed). 1919–21. Potsdam, Germany.

162. Eero Saarinen & Associates. TWA Terminal (Flight Center). 1957–62. John F. Kennedy Airport, New York.

163. Production still from *The Cabinet of Dr. Caligari*. 1919. Germany. Walter Röhrig, Hermann Worm, and Walter Reiman, designers. Photograph courtesy The Museum of Modern Art, New York.

164. Jan Vermeer. The Artist in His Studio (Allegory of the Art of Painting). About 1665. Oil on canvas, 52 by 44 inches. Kunsthistorisches Museum, Vienna.

Chapter Six

ABSTRACTION

rom everything we have examined so far, it must surely be apparent that the basic premise of this book is that if a painting or sculpture is of any consequence, the accuracy with which it reproduces the look of a person or thing is at best only a clue to something more important—even when the reproduction is as exact as Harnett's painting of a violin, a horseshoe, and other objects in *Music and Good Luck* (86) or Duane Hanson's sculpture of a pair of supermarket shoppers (380). The premise, always valid, became a truism in our century when totally abstract art came into its own.

We say "totally" because there are degrees of abstraction. As an art term, "abstraction" always implies a focus on aspects subsidiary to representation; but these aspects may be hidden within straightforward representational images and their arrangement, or may be apparent in formal and coloristic manipulations that violate the representational aspects of the subject while leaving it recognizable, or, finally, representation may disappear entirely, leaving the field free for totally abstract adjustments of form and color. The terms "nonrepresentational" and "nonobjective" are often used to distinguish this final stage of abstraction from all other art. "Semi-abstract," with its suggestion of compromise, is sometimes used to designate middle-of-the-road paintings and sculptures.

To show that principles of abstract art are involved in traditional, representational art, we began by pointing out that Whistler's title for his most famous painting, Arrangement in Gray and Black (II), insists on the importance of abstract premises as opposed to sentimental values that the public, as things turned out, discovered for itself in a picture it rechristened Whistler's Mother. We also argued that Renoir, in his portrait of his wife (I7), transformed the image of a vital, blossoming young woman into a universal symbol by reducing natural forms to simple geometrical equivalents—an elementary kind of abstraction disguised, in this case, by an alluring realistic veneer.

Both of these paintings offer genuine rewards, but limited ones, when seen as nothing more than pictures of a sweet old lady and a healthy young woman. But when we come to Marin's *The Singer Building* (145), we find abstract elements dominating realistic ones. In the lower half Marin expressed the noise, the movement, the excitement and confusion of the city by a composition of slashing angles, lines, and colors that only half resemble the actual objects involved. Here we must recognize and accept abstraction to enjoy the subject at all. The artist seems to say that if a subject can be expressed through angles, lines, shapes, colors, arrangement, and other abstract elements, there is no reason why he has to depend any longer on even a ghost of reality. Is there then any reason to give us any recognizable images at all?

165. Pablo Picasso. *The Studio*. 1927–28. Oil on canvas, 59 by 91 inches. The Museum of Modern Art, New York. Gift of Walter P. Chrysler, Jr.

Perhaps abstract elements alone can tell the story. To carry the argument to its logical conclusion, why is it necessary even to have a subject? Why not just have forms, colors, and arrangement by themselves for their own sake?

This argument sounds reasonable enough, but it is also possible to contend that the abstract artist is defeating himself when he insists that recognizable images are of no importance in painting and should be left to the camera or (he might say) to those artists without enough creative imagination to get away from working like a kind of camera.

Without taking sides in this esthetic schism, we will examine some modern abstractions, comparing some of them with paintings by old masters or traditional artists who at first glance appear to be working almost photographically. We will begin by comparing two paintings of artists at work in their studios, one by the seventeenth-century Dutch master Jan Vermeer, *The Artist in His Studio* (164, p. 116), and another, *The Studio* (165), by Pablo Picasso, who hardly needs identification as the most conspicuous figure in the art of our century.

In Vermeer's painting we look into the cubelike space of an artist's studio, defined for us on all six sides. The back wall faces us directly. The front wall is expressed by the heavy curtain drawn aside to let us look within the space as if it were a stage. Without having to think about it or figure it out, we sense the windowed wall to our left by the flow of light onto the model and across the space of the room. The wall to our right is also defined by inference: the chandelier, which would be near the center of the ceiling, helps us locate it. The floor and ceiling we actually see.

Within this cube of space Vermeer arranges his figures and objects with exquisite care. We see the painter's back as he faces the canvas on his easel. He is using a mahlstick, an aid employed by painters to steady the hand while working on passages of fine detail. Without being able to see his other hand, we know that it holds his palette. He is glancing at the model, who is posed as an allegorical figure crowned with leaves and bearing a trumpet and a book. We see her across a table that holds, among other things, a cloth hanging off the edge nearest us.

The forms in this arrangement are not to be regarded as flat silhouettes, as it is possible to regard those in Arrangement in Gray and Black. They must be seen as solid volumes in three-dimensional space (the term is "spatial composition"). The little cube-shaped world is wonderfully self-contained; there is no feeling that the various objects are rigidly placed, but their relationships are so neatly adjusted that if we try to modify any one of them the serene balance of the picture is disturbed. We have said as much about still lifes by Harnett and Chardin (86 and 105); the difference is that the Vermeer is composed in space. Instead of playing from side to side and top to bottom of the picture area, as in the Harnett, or within the shallow depth of a shelf in the Chardin, the balances now

play back and forth, around and about, within the spatial volume of a room. Testing the composition with this in mind, would you, for instance, want the model to turn her head so that, in profile, she looks out of the window? This would be a small change, but it would disrupt the picture by tempting us to follow the model's gaze into the imagined world outdoors, instead of remaining happily within the defined space of the studio. It would also tend to divide the picture down the middle, since the psychological connection between the painter and the model would be weakened. This connection is like a unifying structural element in the composition. If you can imagine the model looking out the window and the painter turned to regard us, thus divorcing the painter and the model and bringing the painter, so to speak, outside the room into the area on our side of the heavy curtain, you will see that the whole structure falls to pieces.

Other changes would be less disastrous, but any change would mar the picture's balance. Would you want to push the artist and his easel further back into the picture space? Or move them nearer to us, so that they become larger in perspective, leaving more depth between the artist and the model? Would you rather the objects on the table were tidied up, or removed, or added to? Would you like to see the curtain hanging in straight folds, rather than bunched as it is? Would you like to eliminate the series of beams that terminate the picture at its upper part with their succession of strong horizontal lines, and substitute a flat, eventless ceiling?

None of these changes except the elimination of the ceiling beams would make the individual objects any the less interesting. The picture would still be an assemblage of magnificently rendered textures bathed in light. We could still sense the brassiness of the chandelier, the nap of the curtain, the silkiness of the model's robe, the smooth, cool surface of the floor. But the perfection of the picture is not the sum of its wonderful details any more than the beauty of a musical composition is the sum of its individual notes. Its perfection lies in the harmonious union of these details as arranged in space, just as the beauty of music is the harmony of notes combined and arranged in time.

Our second picture, Picasso's *The Studio*, is such a close parallel to the Vermeer that it might almost have been painted to demonstrate how an old master can be translated into modern abstract terms. We have to begin by accepting Picasso's rejection of realistic imitation, and the first question is why he chooses to work in a way so radically different when perfection like Vermeer's can be achieved through an approach almost photographic in individual details.

Actually, the similarities between the two pictures are as great as the differences, and just as important although less obvious. The painter stands to the left in the Picasso; he sits at the right in the Vermeer. Picasso constructs the figure of the painter in a few dark lines played against the

166. Detail from The Artist in His Studio.

bright yellow of the canvas he is about to work on; Vermeer constructs the figure of his painter as a dark silhouette, also played against the field of his canvas, upon which he has just begun to work (166 and 167). Both painters hold their brushes in a moment's pause. The "brush" in the Picasso is the short diagonal line terminating the "arm" that projects horizontally toward the right. Whereas Vermeer's artist has just stayed his hand to glance at the model, Picasso suggests by the extended line that his artist is sighting along his brush—a common practice in drawing—to measure the proportions of the object he is painting.

Picasso's painter's "head" is a long gray oval upon which is imposed an irregular white shape bearing three eyes arranged in a vertical row. Whether or not it was the artist's intention, we may hazard the guess that the painter is given this extra eye as a kind of symbol of the particularly acute, analytical vision developed by an artist in comparison with that of the rest of us, who see more casually.

The painters in both pictures hold palettes, although we see neither of them. In the Vermeer we sense the palette. In the Picasso it is symbolized by its thumb hole, a small circle just to the left of the painter's shoulder.

Vermeer's painter is working from a posed model; Picasso's from a still-life setup composed of a white sculptured bust (perhaps marble, perhaps a plaster cast) and a bowl of fruit on a table. A red cloth hangs from the side toward us, as in the Vermeer. The irregular white quadrangle is the base of the sculpture. Within the white oval of the general mass is a six-sided shape defined by a black line and bearing two eyes and a mouth—or perhaps two normal eyes and a "blind" one, suggesting the smooth blind eye of a sculptured face, arranged in the same way as the three eyes of the painter. The fruit bowl is reduced to two triangles, the fruit represented by a single green circle in the upper one. All four legs of the table and the round feet are visible, although they are placed arbitrarily, without regard to perspective. The red cloth, with its main lines accentuated by a wide hem, "hangs" in stiff angular folds reduced to flat patterns.

Flanking Picasso's painter on the side of the picture opposite him, there is a window or glassed door corresponding to the unseen window in the Vermeer, and on the back wall hang a framed picture and a dark mirror, rectangles only slightly more regular than the one of the decorative map hanging on the corresponding wall in the Vermeer.

These details add up to a close similarity between two apparently unlike paintings, even granting some leeway to their interpretation in the Picasso. The final similarity, and a most important one, is that each of the compositions is tied together by an invisible element—a cord of interest vibrating between the painter and the model. We have already commented on this in the Vermeer, saying that if the model looked out the window or if the painter turned his head to look at us, the beautiful integration of the cube of space would be disrupted. In the Vermeer, this connection between model and painter goes back into the depth of

space. In the Picasso, it plays across the surface of the picture between the dominating lines and shapes abstracted from the figure of the painter and his still life.

But why has Picasso chosen to paint this way, instead of following a tradition that satisfied painters for so long? Picasso was something of a child prodigy. In his teens he had already mastered the conventional techniques of painting and drawing. Why did he abandon them? He had to sacrifice a great deal in order to work abstractly. First of all, he sacrifices the interest inherent in the objects making up the picture, an interest on which Vermeer capitalizes. Next, he sacrifices the fascination and variety of natural textures. He sacrifices the harmonies of flowing light, the satisfaction of building solid forms out of light and shade.

What has he gained?

He has gained complete freedom to manipulate the forms in his picture. He need not bother with the true proportions of objects or their parts. If for the sake of design or expression he wants to make a head three-quarters the size of the body beneath it, he may do so. He may adjust every shape within his picture area quite arbitrarily. If he has sacrificed the advantages of perspective, which would have permitted him to create an illusion, he has also gained freedom from its limitations, which would have forced him to show the table legs, the bust, or any of the other objects according to a rigid system. For perspective is after all only a systematic geometrical distortion by which objects are shown larger or smaller and in different relative proportions from their true ones in order to represent their position within a third dimension, all of this according to strict rules. Picasso's distortion is his own; abstraction has freed him from an imposed geometrical system, allowing him to improvise his own from one painting to the next.

But all these sacrifices and gains are only part of a means to an end. What is the argument in favor of the end Picasso has in view?

The abstractionist would argue that the enjoyment of a picture like Picasso's The Studio is more intense because it is purer than the enjoyment we take in the Vermeer. We more fully enjoy pure form, pure color, and pure arrangement because we are less diverted by incidental matters. In the Vermeer we are diverted by our interest in the map on the wall, by our curiosity about the details of the model's costume, by our surprise at the novel cut of the painter's blouse, and by all the other items that are curious or interesting in themselves. The traditional painter would argue that the enjoyment of the Vermeer is richer for the very reason that it may be enjoyed simultaneously on the double score of its abstract foundation and its associative overlay. But such discussion eventually boils down to the conclusion that a great painting is a great painting, regardless of its means.

Abstract art, which has been with us now for the better part of a century, continues to induce in some people the uncomfortable feeling that it is too easy because the painter

167. Detail from The Studio.

is not obliged to demonstrate a high degree of craftsmanship. The Vermeer, if considered as craftsmanship alone, would remain a gem. Technically and in details it is an extremely complicated picture, but in this very complication there is a degree of safety that is denied to the abstract painter. The Picasso is so simplified that any faulty relationship would be more glaring than one in the Vermeer. A second-rate picture along the lines of the Picasso is simply no good at all.

By examining the structure of the Picasso we can discover, if we have not felt it from the first, that the picture is as tautly constructed as Vermeer's is exquisitely arranged. It cannot be read in depth the way we read the Vermeer (although it is possible to discover some shallow recessions and projections of its flat planes), but we can apply something of the familiar test of shifting or changing forms and colors. The most obvious element tying the picture together is the repetition of strict verticals and horizontals. Then there are other parallels or near-parallels, such as the left edge of the red cloth, which parallels the right line of the main triangle of the figure of the artist, and the top left line of the plaster bust, which parallels the right side of the fruit bowl. The line of the artist's "neck," if continued downward, meets the intersection of two other lines and forms one side of a suggested square. The top of the fruit bowl, continued to the right, would meet the point of balance of the bust on its pedestal. A dozen similar relationships can be discovered; they form a kind of secondary, concealed but important, supporting structure. As in the Vermeer, every element affects every other one. The thumb hole of the palette, to take an example at random. seems just the right size and in just the right spot. Raised, it would seem to float; lowered, it would seem to be sinking—an observation we also made concerning the brass match holder in Harnett's Music and Good Luck (86). A change in color would affect the shape's psychological weight and would have to be compensated for by shifting its position, or changing its size, or both. This is bringing things down to a fine point, but a picture like The Studio depends on fine points. It leaves no room for accidental or unconsidered elements.

It would be fruitless to argue that the Picasso is better than the Vermeer or that the Vermeer is better than the Picasso. Both are superb achievements. You may prefer one or you may prefer the other, but to accept one and reject the other is to understand neither. Either picture, enjoyed through full understanding, increases our enjoyment and understanding of the other.

Having compared one realistic masterpiece with an abstract one, stressing their similarities, we will compare another realistic traditional painting with an abstraction to show how violently they can differ. About 250 years separate Vermeer's painting from the Picasso we have just seen, yet we found in them a fundamental kinship. Only seven years separate John Singer Sargent's *The Wyndham Sisters* (168, p.

124) from Picasso's Les Demoiselles d'Avignon (169, p. 125), which in terms of the chronological span of art history means that they were painted at the same moment. Yet they could hardly be more different.

The Wyndham Sisters, painted in 1900, is a stunning technical display celebrating aristocratic fashions. Sargent, an American expatriate in London and wildly successful internationally, was one of the most facile painters who ever lived; these yards and yards of satin, these geysers of flowers, these opulent glints of gold in the shadowy depths of a mansion, these delicately boned faces, and these graceful figures with their languorous hauteur and easy elegance, all are brushed across the surface of the canvas as if effortlessly. Everything is very cool, very expensive, and just a little patronizing in its suggestion that this privileged refinement is on display for us to look at, to marvel at, to admire, to envy, but not to touch. It is as if the ladies, having opened their mansion for charity, have had the further graciousness to incorporate themselves into the décor for the afternoon. Without this little seasoning of condescension the picture would not be the consummate expression of Edwardian fashion that it is.

The Wyndham Sisters is an extremely attractive picture, but it is virtually without abstract interest if we discount the pleasure we may take in Sargent's lithe acrobatics with his brush. The composition is casual—skillful enough, but not rewarding in itself, in no way comparable to the beautifully organized complexity of the two paintings we have just seen. The brushwork is breathtaking, in the same sense that it is breathtaking to see a magician pull a rabbit out of a hat. The painting's real interest, its real reason for being, lies in its stylish presentation of stylish subjects. There is no point in hunting for hidden depths, no point in exploring beneath immediate appearances. The merit of the picture lies not in its profundity, but in its finality; this is the fashionable portrait to end all fashionable portraits, a reflection rather than an interpretation of an attitude toward life. It is intended to be visually pleasing rather than emotionally stimulating or intellectually satisfying, and within that intention it is an unqualified success. It is a picture we may enjoy wholeheartedly for its obvious attractions, as we could not do if it pretended to offer anything more.

The Wyndham Sisters represented the apogee of fashionable good taste at the turn of the nineteenth into the twentieth century, and by its standards Les Demoiselles d'Avignon, painted in 1907, is a perfectly ghastly picture. The women are ugly, there are no dazzling technical fireworks, the drawing is so bizarre that you can't even tell where some of the forms begin and end. Above all, the whole thing looks inept, if not perhaps insane, by Sargent's standards. The most generous thing one of the Wyndham sisters might have found to say about the picture is that it must be a joke. Or if the artist was serious, the poor fellow must have lost his reason.

But if Picasso was insane, he certainly holds the all-

168. John Singer Sargent. *The Wyndham Sisters*. 1900. Oil on canvas, 9 feet 7 inches by 7 feet. The Metropolitan Museum of Art, New York. Wolfe Fund, 1927.

169. Pablo Picasso. Les Demoiselles d'Avignon. 1907. Oil on canvas 8 feet by 7 feet 8 inches. The Museum of Modern Art, New York. Acquired through the Lillie P. Bliss Bequest.

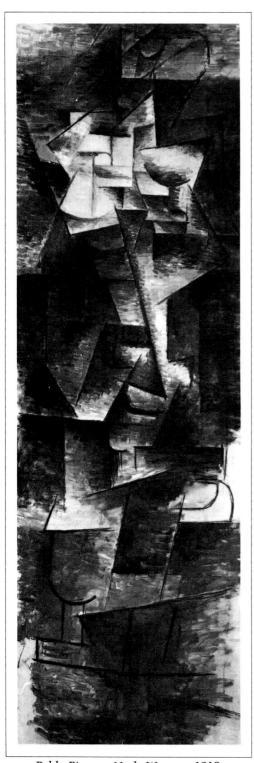

170. Pablo Picasso. *Nude Woman.* 1910. Oil on canvas, 73¾ by 24 inches. National Gallery of Art, Washington, D.C. Ailsa Mellon Bruce Fund, 1972.

time record for having remained conspicuously at large. And while there are still a few people who claim that modern art is an enormous hoax or a sensationalized bid for attention, *Les Demoiselles d'Avignon* single-handedly refutes such an accusation. This self-imposed labor of creative analysis was not even exhibited until thirty years after it was completed.

We have already said that while Picasso was still in his teens he had mastered the craft of drawing and painting as understood by Sargent's public. In his twenties he had already rejected it. Les Demoiselles d'Avignon was the prodigious effort of a twenty-six-year-old genius to discover new means of expression, not for the sake of their newness but for the sake of increasing the scope and intensity of the art of painting.

We need not pretend that Les Demoiselles is a completely successful painting. It is a masterpiece in the sense of being a landmark that everyone interested in painting should know, rather than a picture to be enjoyed out of historical context. It could hardly be a completely successful picture, for it was painted at the beginning of a revolution so great that it is still going on today. If we compare it with The Studio, which Picasso painted nearly thirty years later, we can sense that Les Demoiselles lacks the assurance, the final satisfying sense of completeness, of the later work. But it is still a painting of tremendous force and vigor. If it were not, it could not impress, irritate, and hold people as it does. What we must remember is that it is first of all an intellectual exercise in abstraction, an effort to evolve and apply new theories that were to crystallize as cubism, a new way of analyzing forms in painting.

Cubism was based on a double premise. The first of these was as old as art itself, that natural forms can be reduced or refined in the direction of geometrical equivalents, an idea that the Cubists forced to its extreme conclusion. The second, to which we have already referred in connection with sculpture (60 to 62), was that the "fourth dimension" of space-time should be recognized somehow in painting, allowing all aspects of an object to be seen at once. In Les Demoiselles d'Avignon the geometrization of the figures is surely too obvious to need pointing out, but the strangely broken geometrical forms of the head, shoulders, and arm of the seated figure at lower right have suffered less explicable dislocations. The nose and the eye to our right of it are a profile view of a face that is also seen frontally—an elementary space-time device—while the forms of the arm to our left break, change, and merge to the point of unrecognizability.

Recognizability all but vanishes in the full development of cubism's early stage, which was born with Les Demoiselles and is called analytical cubism. Analytical cubism continues the principles barely suggested in Les Demoiselles and is well exemplified by Picasso's Nude Woman (170), painted three years later. This extreme stage gave way to variations in which objects were represented with strong geometrical reductions but remained recognizable.

as they do in the much later Studio, which we compared with the Vermeer.

To return, now, to Les Demoiselles:

The flaw in this painting that—in spite of its towering historical position, in spite of everything—keeps it from being completely satisfying, is exactly the fault that the layman is first likely to find with it: we are never able to break away from the fact that these demoiselles are, after all, five exceptionally unlovely female figures. No matter how hard we try to argue ourselves into seeing them as satisfactory abstractions, they remain thoroughly unsatisfactory women. They have not been "abstracted" to the point where we can dissociate them from our perfectly legitimate and inevitable ideas of what a human figure should be. Abstraction has merely deformed them, and the deformations are not of a kind to clarify or, as we saw in the case of the deformations in expressionistic painting, to intensify our response.

When Les Demoiselles was painted, artists were just discovering African tribal sculptures as fine art rather than anthropological specimens. Picasso's borrowing is clearly shown by comparing the head of the woman at upper right with an African mask of a type he certainly knew (171 and 172). The vigor of tribal sculpture appealed to young artists like Picasso, who borrowed, or adapted, its forms to give a transfusion to art, which they felt had grown anemic in its conventions. And vigor Les Demoiselles certainly has, even though at this early point in his career the young experimenter was not able to resolve the conflict between reality and abstraction, as we saw the mature man do in The Studio, where the objects retain a very real importance yet have a fully realized abstract character.

Many artists and estheticians argue that paintings like Picasso's *The Studio* where forms are abstracted from visible reality but remain recognizable are compromises, and that if art is to be abstract at all it should be totally so, having no recognizable connection with the world our eyes know. Such painting is sometimes termed "nonfigurative" or "nonobjective" to distinguish it from the kind of abstraction that retains a tenuous connection with the world we see. Piet Mondrian's *Lozenge in Red, Yellow and Blue* (173) is a nonfigurative painting that is best explained by asking a series of questions of the kind a puzzled observer might ask, and answering them with quotations or paraphrases from Mondrian's own recorded statements of his theories:

Question: Why do you call this a painting when it is only some black lines and a few rectangles of color?

Answer: All painting—the painting of the past as well as of the present—is made up of lines and color.

Question: Yes, I know, but in the pictures I like, the line and color are used to describe forms of things I recognize and like.

Answer: But all those things you recognize and like actually exist in nature as solid objects. The painter has to

171. African, Itumba. Wooden mask. Height 14 inches. The Museum of Modern Art, New York. Purchased by Mrs. John D. Rockefeller, Jr., Fund.

172. Detail from Les Demoiselles d'Avignon.

173. Piet Mondrian. Lozenge in Red, Yellow and Blue. About 1925. Oil on canvas on fiberboard, 561/4 by 56 inches. National Gallery of Art, Washington, D.C. Gift of Herbert and Nannette Rothschild.

reduce them to the flat plane surface of his canvas. If we forget about natural appearances, we can free line and color on this plane surface.

Question: A lot of painters paint rather flatly. Whistler's Arrangement in Gray and Black, which everyone calls Whistler's Mother, is made up of essentially flat shapes, and Picasso's The Studio looks completely flat to me. But those pictures mean something. Yours doesn't.

Answer: Those were steps in the right direction. But art should be a *universal* expression. Whistler's Arrangement is not universal because you can identify the forms as individual objects and the old lady as an individual old lady. Picasso's forms are more universal because they are more abstract. But mine are completely universal because I have used only a single universal form: the rectangular area in varying dimensions.

Question: It looks to me as if there are some angles in this Lozenge that aren't right angles—45 degrees and like that

Answer: Ah! Yes, but you see this is a square picture hung diagonally stabilized by strict verticals and horizontals. The continuation and completion of the rectangular areas is sensed in adjacent space.

Question: The forms are still meaningless to me.

Answer: Not meaningless. Neutral. All associative values are annihilated, so line and color are completely freed.

Question: But it seems so cold, so mechanical.

Answer: I mean it to. I think that for the modern mentality, a work of art should have the appearance of a machine or a technical product.

Question: If you feel that way, I don't see why you wouldn't get more satisfaction out of being a mechanic rather than an artist.

Answer: I am not a mechanic. I am a living machine, capable of realizing in a pure manner the essence of art.

Mondrian has also stated that his art is not opposed to nature but quite the reverse, since he seeks a "dynamic equilibrium," which he calls the first law of nature. We can even discover that his nonfigurative painting developed from his early, fairly realistic works. His Landscape with Farmhouse (174) was painted about 1906. The house, and particularly its reflection in the canal, already gives a hint of his effort to find order by reducing forms to rigid, strongly defined rectangles (175). Also, the bare tree branches are beginning to resolve themselves into a tight pattern more interesting as pure pattern than as branches silhouetted against the sky (176). This means that his treatment is already half-abstract; he is well on his way to the much more abstract study Horizontal Tree (177), done in 1911. We can still find the general form of a tree in this abstraction, but it is the idea of tree, not the look of a tree, that he is analyzing here. Certainly the lines he has abstracted and combined express a rhythmic growth fundamental to the idea of a tree, part of nature's "dynamic equilibrium." In

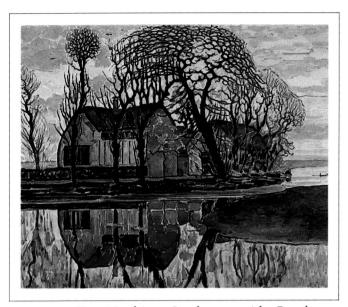

174. Piet Mondrian. Landscape with Farmhouse. About 1906. Oil on canvas, height 34 inches. Anonymous collection.

175. Detail from Landscape with Farmhouse.

176. Detail from Landscape with Farmhouse.

177. Piet Mondrian. *Horizontal Tree.* 1911. Oil on canvas, 29% by 43% inches. Munson-Williams-Proctor Institute, Utica, New York.

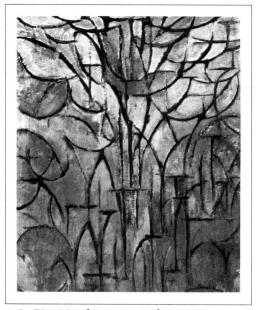

178. Piet Mondrian. *Tree*. About 1912. Oil on canvas, 37 by 27½ inches. Museum of Art, Carnegie Institute, Pittsburgh. Maillol-Mondrian Fund.

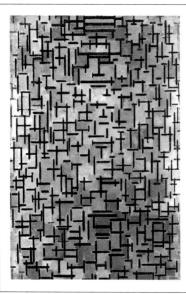

179. Piet Mondrian. Composition. 1916. Oil on canvas and wood strip, 47¼ by 29½ inches. The Solomon R. Guggenheim Museum, New York.

yet another *Tree* (178), done about 1912, the idea is abstracted in a vertical composition based on a tree's height rather than the spread of its branches.

When we follow through the idea in this way, Mondrian's abstractions are not puzzling at all—whether or not they are satisfying. The paradox in Mondrian's art is that his advanced theories produce paintings of an apparently elementary simplicity. The outcome of his logic, for the layman, is an art without content or structure, like the final stage of the tree sequence, his so-called plus and minus compositions, made up of short horizontal lines and small rectangular crosses that coincide with the forms of those two elementary arithmetical signs (179). We might read into this final reduction a philosophical premise or two concerning the basic and fundamental significance of plus and minus in life, thought, or what-have-you. Whether or not this deduction would be legitimate, it remains true that these plus and minus abstractions are the end result of an analytical process that began with the artist's response to the look of nature.

Mondrian was a member of the Dutch movement in painting, sculpture, architecture, and design called *De Stijl* (meaning The Style), pledged to an ultimate purity of form that would "serve a general principle far beyond the limitations of individuality." The group contended also that all arts are interdependent, with the result that their style, while limited, was one of the most closely knit in the history of art. Among sculptures, Georges Vantongerloo's *Construction of Volume Relations* (180) is self-evidently a three-dimensional equivalent of Mondrian's rectilinear planes.

It is more surprising to find that De Stijl's highly theoretical principles were applied successfully to the highly practical art of architecture. Gerrit Rietveld's Schröder house (181) in Utrecht, designed and built in 1924, was an early example of modern architectural style whose shock value at the time can hardly be appreciated today by people who have grown up with thousands of the Schröder house's legitimate and illegitimate modernistic descendants. Here Mondrian's planes and Vantongerloo's solid volumes are combined in an ingenious asymmetrical composition of rectangular slabs that interlock in space to create an interplay of hollow volumes. On the second floor, these volumes can be shifted in dimensions and relationships by sliding doors and movable screens.

There may be something chilling in the idea of living in a Schröder house surrounded by Vantongerloo sculptures Mondrian paintings and Rietveld chairs (182); the inhabitant of such an environment might soon be willing to sacrifice the ascetic purity and determined impersonality of De Stijl for a little chintzy, disorderly comfort—which may explain why De Stijl as an organized movement was short-lived. But we need only look at numerous examples of modern architecture, sculpture, painting, and furniture created since

then to realize that De Stijl played a vital part in the creation of the "modern" style.

In an earlier chapter, we contrasted a Cézanne (24) with a Durand landscape (23), saying that Cézanne sought to reveal an essential orderliness in nature (without suppressing nature's vitality), while Durand regarded nature as a manifestation of mysterious forces. If we had to put all artists into one of two groups, one group would be made up of those who tend to intellectualize and the other of those who tend to emotionalize their subject matter. This contrast is even more true in abstraction, where the artist, unhampered by the associative values of subjects represented more or less realistically, may go the limit in expressing his bent.

The abstractions we have seen so far in this chapter are intellectualized conceptions, but a glance at Wassily Kandinsky's *Black Lines* (183, p. 132) is enough to show that the artist is not working with the calculation, the analytical approach, apparent in our other examples. *Black Lines* was painted in 1913, an extremely early date for the kind of emotive abstraction—abstract expressionism—that it exemplifies. It appears to be, and in fact is, an improvisation, a free invention. We are not supposed to interpret the lines and areas of color as abstractions of any actual objects; if we tried, we might find suggestions of large anemone-like flowers with black stamens, or of sunset clouds, of butterflies or exotic insects, depending on what direction our imagination took. But this would defeat the painter's intention.

Then what is his intention? Why doesn't he at least give us a clue by a more suggestive title? If he is trying to express a certain mood by using certain shapes and colors, are we expected to play detective to discover what the mood or idea is?

Quite the contrary. The painting is not an emotional anagram. The artist's idea is that a painting should be a creation independent of any outside supporting factors. If it is possible to translate the various combinations of shapes and colors back into real objects or to translate their "meaning" into words, then the painting fails, because it would then have derived its meaning in the first place from ideas or emotions that can be described specifically in something other than pure form and pure color.

Of course, while the painter is at work, his choice of shapes and colors and the combinations he puts them into is presumably determined by whatever complex of emotions and thoughts is stimulating him to improvise in that particular way at the time. But it is a mistake to try to pin the meaning down. We all know that red suggests excitement, that blue suggests quiet or melancholy, that a jagged line suggests action, while a curved one may suggest relaxation, and a twisted one turbulence, and so on, through a long list of ideas associated with color, shape, and line. But we cannot take the different shapes in *Black Lines* and decide what each one "feels" like, list them, add them up, and then say that the painting is a mood synthesized from

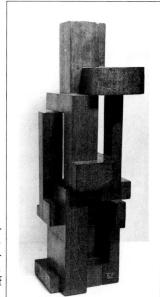

180. Georges Vantongerloo. Construction of Volume Relations. 1921. Mahogany, height 16½ inches. The Museum of Modern Art, New York. Gift of Silvia Pizitz.

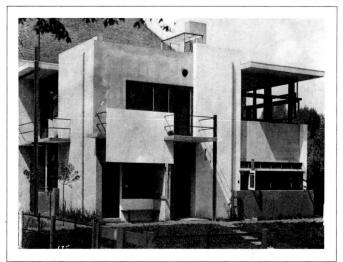

181. Gerrit Rietveld. Schröder House. 1924. Utrecht.

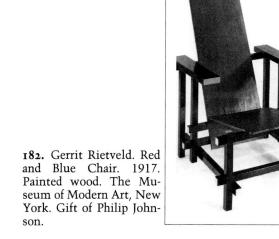

183. Wassily Kandinsky. *Black Lines, No. 189.* December, 1913. Oil on canvas, 51 by 51¼ inches. Solomon R. Guggenheim Museum, New York.

184. Willem de Koonig. *Woman IV.* Oil on canvas, 59 by 46¹/₄ inches. Nelson Gallery-Atkins Museum, Kansas City, Missouri. Gift of William Inge.

those factors. In his poem "Ars Poetica," Archibald MacLeish wrote:

A poem should not mean But be.

Similarly this Kandinsky is what it is. It is "about" itself. What you get from it depends on your sensitivity to its shapes and colors and their relationships to one another. Here we are only a step away from the "gestural" or "action" and other paintings of the school of abstract expressionism that developed in New York in the 1950's and captured leadership in the world of modern art from France for the United States.

We have already seen one of the leading painters of the New York School, Franz Kline, whose New York, N.Y. we compared with John Marin's earlier semi-abstract The Singer Building (145 and 146). In what we described as its "lunging" execution, the Kline could be called "gestural painting," a self-explanatory term. So could Woman IV (184), by another reigning figure of the New York School, Willem de Kooning. Although not totally abstract, Woman IV goes in and out of recognizability from passage to passage, and its impressive projection of almost feverish energy is largely the result of the gestural application of the paint; we feel from stroke to stroke the hand of the artist, as if he were improvising the painting before our eyes. Oddly enough, we have something of the same feeling when we confront a painting that could hardly be more unlike Woman IV in spirit— Sargent's The Wyndham Sisters (168), which is brought to life by the exhibitionistic skill of great sweeping brush strokes, although Sargent devotes each stroke to a kind of sleight-of-hand indication of form, while each of de Kooning's is an abstraction of energy.

The apogee of gestural painting is pure "action painting," exemplified best by the work of its most conspicuous performer and cornerstone of the New York School, Jackson Pollock. Pollock's loops, blots, splashes, and skeins of color in a painting like Convergence (185) are flipped, dripped, or thrown onto the canvas (laid out flat on the floor during execution), but with much less dependence on accidental effects than the observer may suppose. Each splash, drip, or splatter is a controlled accident, the result of the artist's sensitivity—developed through experience—to the combination of his own motion (of both hand and body) and the weight and degree of fluidity of the paint in determining the nature of its fall as he moves around the borders of the canvas interweaving colors and rhythms with one another.

But why can't just anybody improvise abstractions like Kandinsky's or Pollock's? To a limited extent anybody can, and unfortunately too many people have. But the amateur is in the position of a person who sets about to prepare an elaborate dinner without ever before having so much as scrambled an egg. We can supply him with all the ingredients and recipes in the most complete detail, but the dinner is going to be inedible. The "recipes" in art are the accumulated knowledge and experience that every good

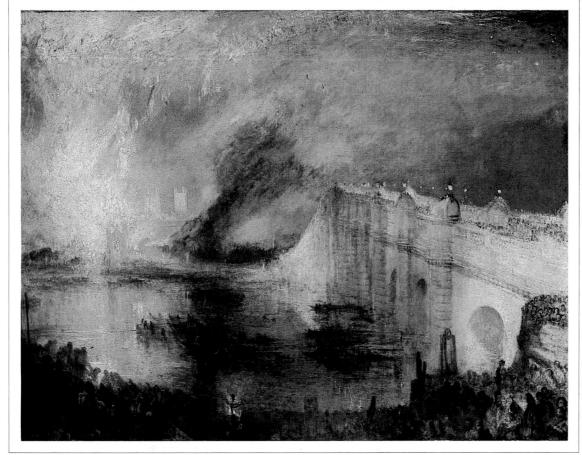

185. Jackson Pollock. Convergence. 1952. Oil on canvas, 7 feet 9½ inches by 12 feet 11 inches. Albright-Knox Art Gallery, Buffalo. Gift of Seymour H. Knox.

186. Joseph Mallord William Turner. Burning of the Houses of Parliament. About 1835. Oil on canvas, 36½ by 48½. Philadelphia Museum of Art. John H. McFadden Collection.

painter works from, whether he is modern, conservative, abstract, or whatever. For all its spontaneity, abstract expressionist painting is an application of this knowledge and experience. The paintings are often improvisations, but they are improvised from resources and disciplines that have become second nature to the artists.

In making comparisons between examples of realistic art and abstractions, we have been assuming that Vermeer's picture of a studio has wider appeal than Picasso's, that Sargent's fashionable sisters are more enjoyable to most people than Picasso's Les Demoiselles, and that any enjoyment of Mondrian's totally nonobjective patterns depends on knowledge of their ultimate sources in scenes from nature. However, abstract art has won such a large audience in the last twenty years or so that we find the reverse is true in some cases. J. M. W. Turner's Burning of the Houses of Parliament (186, p. 133), painted close to 150 years ago when abstract art was unheard of, was admired for its bright colors, which people always like, and because it was a representation of a spectacular event. But it has taken the pure colorism of paintings by abstract artists such as Mark Rothko (187, p. 136) to reveal what now seems quite obvious—that Turner, too, was at least as much abstract as he was realistic.

Turner's picture shows the conflagration that destroyed the Houses of Parliament in London in 1834. We see the spectacle from across the Thames. Crowds of spectators are eerily suggested; but the real play of interest is between the spectacular area at the left, its flames, smoke, air, and water, and the quieter, stabler form of the bridge on the right. As an illustration of an event, the painting is dramatic in the extreme. Everyone is fascinated by a good fire, and this one has the additional interest of involving an important place. We may be interested first by the fire and smoke because they are fire and smoke, and in the bridge because it is dramatically crowded—impromptu bleachers for the gigantic spectacle. But if we see the picture more than a few times, its enduring interest grows in other directions. Burning of the Houses of Parliament will always be a picture of a good fire. But it is a good picture of a fire because Turner has abstracted from the holocaust magnificent passages of pure painting, where incandescent yellows and oranges, purplish blacks and delicate grays, not only say fire, water, smoke, air, and stone, but can give pleasure in themselves as yellows, oranges, blues, and grays, in forms that range from solid, sharply defined ones to spreading, dissolving ones. This purely optical pleasure is a minor one; if Turner had done nothing more than turn a great fire into a passage of attractive color, he would have reduced a holocaust to an entertainment. Instead, he has transformed a specific incident of destruction into a cosmic vision of the elements in chaos, as if on the eve of the creation of the

At this point it would be easy to tie Turner's colorism to Rothko's by finding abstractions of fire and sunlight, or

the dark of night, of summer skies or storm clouds, of rain, earth, or what-you-will in Rothko's sometimes glowing, sometimes somber, fields of color. Even easier, his paintings can be enjoyed for their decorative effect, a considerable pleasure in itself. By the artist's stated intention, however, his paintings are humanistic ponderings; he wanted to deal, he said, with human emotion and human drama, but found the human figure impossible for his purposes, after struggling to find a way of his own to use it. Rothko's suicide in 1970, at the age of sixty-seven and at the apogee of his international fame, is usually regarded as the result of his own feeling that the ultimate expression he sought escaped him. By "human drama" Rothko meant, of course, an inner drama, not the drama of life around us and our active participation in it. We have seen that the other abstract artists we have considered arrived at their abstractions by way of the visual world. Rothko was dealing with abstractions in the first place—such abstractions as hope, fear, love, all human emotions—that great artists of the past, with Michelangelo as a supreme example, had dealt with by personifying them in human figures. A complicated philosophical premise is suggested here, to the effect that although an artist may arrive at abstractions from reality, or may give material form to abstractions, it is impossible to create abstractions from abstractions as Rothko wanted to do. But it is never safe to say that anything in art is impossible; what one generation has thought impossible has been achieved by the next too many times.

A revolution as extensive as the one that has produced such quantities of abstract art in the past sixty or seventy years must affect the way we see the art of the past. Our understanding of the old masters is not a static thing; from generation to generation, new ways of thinking and feeling show us new aspects of ancient art and blind us to ways that were the accepted ones a generation, a century, or centuries ago.

One old master who has come into his own as a result of our century's preoccupation with abstraction is the Italian Renaissance painter Piero della Francesca. Piero has always been regarded as an important artist, but it is only within the last twenty-five years or so that his name has appeared on most critics' and painters' lists of the greatest painters of all time. We are reproducing one scene and two details of it (188 to 190, p. 137) from his series of frescoes painted between 1452 and 1466 on the choir walls of the Church of San Francesco in the small city of Arezzo. The series tells the *Legend of the True Cross*. Our illustrations show the Empress Helena directing the excavation of three crosses, that of Christ and those of the two thieves, on the hill of Golgotha outside Jerusalem. Later (at far right) the legitimacy of the True Cross is proven when its shadow falls on a dead man and brings him to life. What raises this storytelling painting to the rank of a world masterpiece?

First of all, we should be able by now to enjoy the arrangement of forms in the same general way as in the

187. Mark Rothko. Orange and Yellow. 1956. Oil on canvas, 91 by 71 inches. Albright-Knox Art Gallery, Buffalo. Gift of Seymour H. Knox, 1956.

188. Piero della Francesca. Discovery and Proof of the True Cross, from Legend of the True Cross. About 1453–54. Fresco. Church of San Francesco, Arezzo, Italy.

189. Proof of the True Cross.

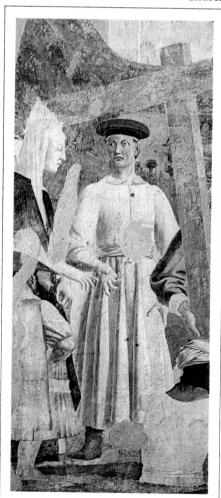

190. Figure from *Discovery of the True Cross*.

191. Henry Moore. *Internal and External Forms.* About 1953–54. Elm wood, height 8 feet 7 inches. Albright-Knox Art Gallery, Buffalo.

Vermeer. The "stage" this time is extremely shallow, but within its limited depth the figures are arranged as solid, three-dimensional forms, not as flat shapes.

But the spatial relationship of the figures, which accounted for the intimate appeal of the Vermeer, does not somehow fully explain the powerful expressive quality of *Legend of the True Cross*. The rest of the explanation lies in the created forms of the individual figures. Each one has the solidity, the dignity, the quietness of a great natural object or the abstract beauty of a superb architectural unit. Some of the figures, with the regular vertical folds of their robes, are as much like fluted columns as like human beings.

Now, the events pictured here are dramatic, exciting, full of action—the discovery of the crosses, the proof by miracle. Yet the figures show no agitation, no surprise, no movement. They seem hardly to be taking part in these astonishing events. Another painter would have twisted them into every attitude of amazement, would have filled the scene with movement and contrasts, would have picked us up and carried us along as participants, taking advantage of every theatrical element the story offers.

But Piero does not want to illustrate spontaneous human reactions to spectacular events. He does not regard these miracles as mere exciting anecdotes. He deliberately removes his narrative from the plane of worldly experience and invests it with solemnity, grandeur, and reverence. His figures are not first of all human beings; they are first of all pure form. They are, in a word, abstract. From them we can read the story of the pictured events—but not in human, worldly, or emotional terms. We are held outside, denied the observer's role as vicarious participant. If it were possible for us to enter the picture, we would wander around in it unseen, and certainly out of place, among these stately, motionless forms.

This stateliness, this abstract reserve, explains why the art of Piero seemed stiff, cold, and limited not many years ago when people looked first of all for sentiment and emotional drama in religious painting. We now see in his art an abstract majesty that lifts the events to an appropriately noble level. By comparison, some of the religious paintings that were most popular a generation ago look superficial or even irreverent.

In color as well as in form, Piero is subtly unreal. Every color is modified or slightly neutralized. Instead of pure greens, he gives us sage and olive; instead of pure reds, rust or brick or plum. His whites, modified toward pearly grays and creams, are as rich as his colors.

A painting like this one, tremendous in size and painted directly on the wall of a church, must lose more of its true quality than other illustrations even in the best color reproduction. An illustration in a book is of necessity so reduced in size that we see all of it at a glance. The original in this case is so large that as we stand before it, our eyes do not see the entire picture quickly but must travel across it. Sensitivity to the individual forms is increased as they reveal themselves to us gradually. For that reason, the

illustration may bring you closer to the original if you cover parts of it and study only a few details at a time, or if you move a sheet of paper slowly across from left to right, revealing the figures in sequence. In this way you may become more aware of their variety and even get a somewhat better impression of their size and dignity.

We have already commented on the importance of abstraction in modern sculpture and have seen examples by Gabo, Calder, and Schöffer (60, 61, and 62). We will see other examples further on in other contexts. For the moment, we will pause long enough to be certain that one modern concept is clear—the concept of negative volumes, which can apply also to architecture.

We have already mentioned, in connection with Bernini's David (47), the interpenetration of space in "open form." The concept of negative volumes goes a step beyond that, by which space is not a mere void between solid forms but has shape, just as solid volumes do. As an example from everyday experience: when we think of the size and shape of a room, we are considering it as a negative volume rather than as a void created incidentally by the walls, floor, and ceiling that define it. In grander terms, when we stand under a dome we are conscious not only of the inner shell

192. Henry Moore. *Reclining Figure.* 1965. Bronze, height 16 feet. Lincoln Center for the Performing Arts, New York. Commissioned through a grant from the Albert A. List Foundation.

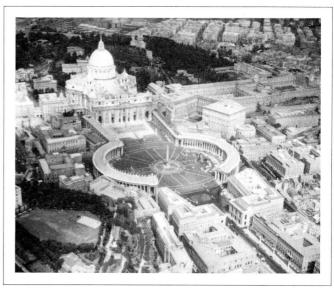

193. St. Peter's, Rome. Colonnade by Gianlorenzo Bernini, begun 1656.

of the dome above us but of the volume of the space it shapes. The main reason that a photograph of, say, the interior of St. Peter's in Rome cannot approach the experience of actually standing within it is that space cannot be photographed as a volume since all the enclosing architectural elements cannot be photographed at once.

As a sculptural example, if we see Henry Moore's Internal and External Forms (191, p. 138) only as an arrangement of solids, we are only half experiencing it. But whether or not we have ever heard of negative volumes, we are "seeing" the voids that interlock with the solid forms on a basis of equal interest. To use another Moore as an example, one of his many sculptures abstracted from reclining human figures (192, p. 139), here we have hollows, pits, and other irregular voids resembling the kind of negative volumes created by the action of wind and water, a hollowing-out process directly comparable to the sculptor's creation of sculptured space. A final comparison with nature is appropriate here, since Moore thinks of his sculptures in terms of association with nature and natural forces: in a great cave we are equally conscious of the space that nature has hollowed out and within which we stand, and of the shapes and textures of the cave walls. The same double pleasure is offered by Moore's *Reclining Figure*—the pleasure offered by the beauty of the solid volumes and their material, and the pleasure of the intangible yet visible beauty of the negative volumes.

As an architectural abstraction, the idea of shaped space is not easy to grasp, and indeed we must not make the mistake of thinking that a space is "shaped" simply because it is enclosed. We are speaking of architectural space as the conscious, not the accidental, creation of the architect, which makes him a kind of abstract sculptor on the grand scale.

On the grandest scale of all, he may mold the space of nature itself, as Bernini did with the embracing arms of the approach to St. Peter's. A view from above (193, p. 139) gives us some idea of the majesty of the conception, but does not relay the sensation of being a participant in this vast spatial creation with its changing perspectives as one walks through the plaza or within the curved colonnades.

Changing perspectives are even more important to our full realization of the architect's conception when we mount or descend the staircase of the Trinità dei Monti (familiarly called the Spanish Steps), also in Rome. Again seen from above (194), the curving patterns of the steps and intermediate landings show how we, as participants ascending or descending the steep rise between a busy city street at the bottom and the church at the top, embody the factor of motion that was planned in theory by the architect. The steps are best seen on a busy day when crowds of people flow in directed currents and contribute to the variety and stimulation of our own experience as we follow the shifting, curving course of the staircase with consequent shifting perspectives on the architecture of the staircase itself, the buildings around it, and the view across Rome.

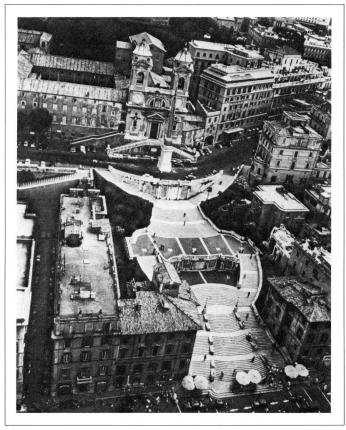

194. Francesco de Sanctis. The Spanish Steps. 1723–25. (Above them, the church of Trinità dei Monti, late sixteenth century.) Rome.

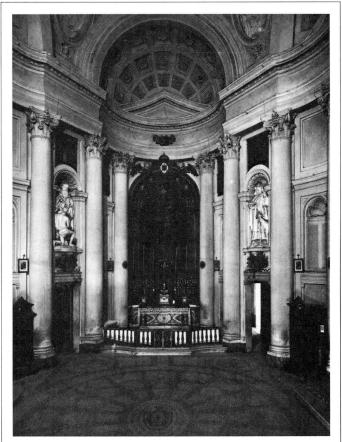

196. Interior. San Carlo alle Quattro Fontane.

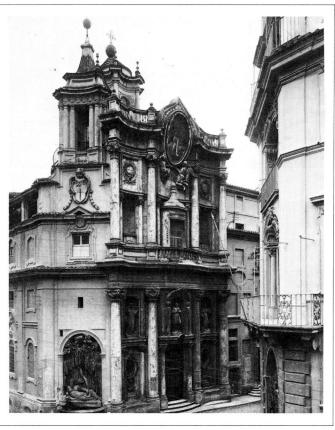

195. Francesco Borromini. San Carlo alle Quattro Fontane. Facade. 1665–67. Rome.

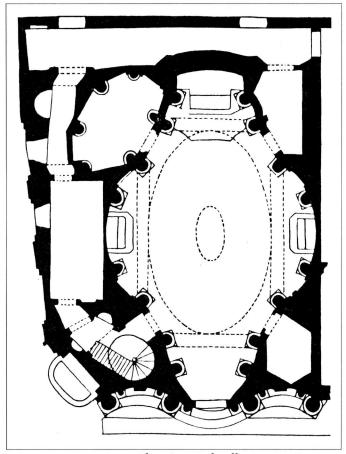

197. Plan. San Carlo alle Quattro Fontane.

198. Mi Fu. "Sailing on the Wu River." Late eleventh or early twelfth century. Handscroll, ink on paper, height 12¼ inches, length of entire scroll 18 feet 4½ inches. Collection John M. Crawford, Jr., New York.

199. Ping-shou. "The Path at Pine and Brook." 1813. Handscroll, ink on paper, height 13¼ inches, length of entire scroll 53% inches. Honolulu Academy of Arts.

With the idea in mind that actual, physical motion is important to the full experience of certain architectural spaces, perhaps we can understand the idea of implied motion in others. In the small Roman Church of San Carlo alle Quattro Fontane, the idea of dynamic space is so important that the interior space seems almost to have shaped its enclosing walls, rather than the other way around. The wavering in-and-out façade (195), bulging forward in the center and reversing this movement at the sides, is really only a curtain rather than a direct result of the interior shapes (196), but it echoes the pulsating forms of an interior based on a plan of intersecting ellipses (197).

This little church, taking its name from its location at a crossing with four fountains, one on each corner, is difficult to see even in situ. And—for the last time, let us hope—it is imperative to say that this, of all interiors, defies the camera. The reader must try to combine the plan with our photographable fragment of the very small interior and put his or her best imagination to work.

In discussing the medieval cathedral, we spoke of space as the symbol of God. Some such symbolism was also attached to space in the design of seventeenth-century Italian churches, but the idea of dynamic space as an architectural abstraction is a baroque conception. Baroque is a term of sprawling definitions, but for our purposes here it means the period of the seventeenth century, extending into the early eighteenth.

The fact that our discussion of abstraction led us finally into a baroque church and up, down, and around a famous outdoor staircase is indication enough that abstract values are all-pervasive in the enjoyment of art. Many people who think of themselves as indifferent to, or even opposed to, abstraction in general are more receptive than they know to the enrichments it offers. The fervent proselytizing for abstract art by eminent artists, critics, educators, and editors of popular magazines in the United States since 1950 has frequently been opportunistic; even so, it has been salutary in its effect on the public. Familiarity often breeds a degree of understanding without study, and the boom years of American abstraction—say, 1950 to 1965—generated an atmosphere that vastly widened our appreciative range.

Those same years saw an insurgence of interest in Oriental art, an arcane field until then. It is true that institutions like Asia House in New York—with its series of beautiful exhibitions devoted to creating a wider public for the arts of China, Japan, India, and related cultures—were the major force in this insurgence, but it is also true that the increased receptivity to abstract art was helpful in the program's success. Oriental art even at its most nearly realistic has always stressed abstract values more strongly than has the art of the Western world, partly because it is traditionally an art for connoisseurs.

Up until 1950, an exhibition of Chinese calligraphy in America would have been regarded as a project for a very small audience of scholars and students; but in 1971 such an exhibition, organized by the Philadelphia Museum of

Art and repeated at the Metropolitan Museum in New York, was a resounding success, crowded with people who. of course, could not read Chinese but stood absorbed by the abstract beauty of calligraphic handscrolls like the two illustrated here (198 and 199). Both are ink on paper, transcriptions of poetic nature subjects—"Sailing on the Wu River" in the late eleventh-century example, and "The Path at Pine and Brook" in the other, seven centuries later. Without knowing the poems, we can sense that the contrasting calligraphic styles—one so free, flowing, dashing, and joyous (in a style called "running script"), the other so determined, vigorous, emphatically defined-are as personal as painterly styles. To the literate, these Chinese characters do much more than transfer the words of the poems to paper; the styles are interpretive in themselves. The calligrapher recording the poem is comparable to an actor speaking the lines and investing them with whatever quality he thinks best. The remarkable thing about the success of the Chinese calligraphy exhibition is that the public, ignorant of this basic function of the calligrapher as "actor," enjoyed the interchange of purely esthetic ideas across seven hundred years between the art of calligraphers like Mi Fu and the "gestural" paintings of American artists like Jackson Pollock and Franz Kline.

We have said that Oriental art even at its most nearly realistic has always stressed abstract values. As an example, an eighteenth-century Japanese hanging scroll painted in color on silk (200), a compendium of plants and creatures of the sea, might have associative interest for a specialist in shells and coral but is essentially a combination of fascinating shapes and colors, which means that it is essentially abstract. We are very close here to an example of modern Western art in which the boundaries between East and West tend to disappear—Matisse's Beasts of the Sea, which figures in our next chapter (206). That chapter and the two following it are on the subject of composition the way works of art are put together. In effect these three chapters on the patterns, the internal structures, and the inventive devices that lie beneath the surface of works of art, are continuations of this chapter on abstraction—an inexhaustible subject in any attempts to answer the question, What is art?

200. Itō Jakuchū. Animals and Plants. Edo Period, eighteenth century. Hanging scroll, color on silk, approximately 56 by 30½ inches. Imperial Collection, Japan.

201. Benozzo Gozzoli. Journey of the Magi (portion). About 1459. Fresco. Palazzo Medici-Riccardi, Florence.

Chapter Seven

COMPOSITION AS PATTERN

In discussing realism, expressionism, and abstraction, we have been dealing with the artist's point of view toward subject matter. We saw the realists reflecting the Look of the world around them, but in different ways, according to what the real world, the visual world, has meant at different times and in different places. These differences aside, the realist, painting a tree, would give us a fairly accurate reproduction of the way the tree looks, leaving to us any emotional or intellectual reaction. The expressionist, in contrast, is less interested in reflecting the world around him than in revealing his responses to it; he explores these emotions in a personal and subjective way. Taking the same tree, he would distort its form and color as he pleased in order to tell us how he felt about it. The abstractionist has it both ways. Interested neither in reproducing the look of things, like the realist, nor in being specific about his emotional reactions, like the expressionist, he may be interested in the world as a complex of ideas and, if interested in trees at all, would ask himself what the idea of a tree might be, and would proceed to intellectualize a pattern revealing that idea. Or, if of an emotional bent, he might try to abstract from the idea of tree, rather than the look of tree, forms and colors that would express his response—which, we saw, would be a variety of abstract expressionism.

Of course these approaches are bound to overlap. The eye, the emotions, and the intellect all share in the creation of a work of art and in its enjoyment. All works of art of any consequence have an abstract element that many observers miss—their composition, the way they are put together.

Composition is so important that we began dealing with it in our first discussions. When we analyzed the reasons for the curious disposition of the elements in Degas's Woman with Chrysanthemums (21), where the subject of the portrait is pushed far toward one edge of the canvas leaving the most conspicuous position to a large bouquet of flowers, we were trying to show how one of the most skillful pictorial composers of them all went about saying what he wanted to say about his subject by compositional means. We discussed "Whistler's Mother" (11) as a combination of gray and black shapes arranged to create a mood. This is composition; what Whistler called Arrangement in Gray and Black could as well have been called Composition in Gray and Black.

Not every great painting is a great composition, but composition is so fundamental to the creation of pictures that a list of the world's greatest paintings would have to overlap a list of the greatest compositions in the majority of titles. Yet of all the elements in the art of painting, composition is usually the one least recognized even when it is playing a major part in one's reaction to a picture. By means of composition the artist directs the observer's eye, holds it on key areas, leads it away and back

again, takes it slowly across some areas, quickly across others. To a lesser degree, sculptors do the same thing. Architects, working under the difficulty of meeting practical demands at the same time, are composing when they adjust dimensions and volumes into harmonious proportions.

It is quite possible to enjoy works of art without being aware of their composition, but our spontaneous enjoyment of subject, color, and form is deepened when we can recognize their interplay on a compositional basis. In a general way compositions fall into two broad classifications, two-dimensional and three-dimensional, with every transitional stage in between. Two-dimensional compositions recognize the canvas or panel for what it is, a flat surface, and are limited to arrangements of lines and flat shapes on that surface. Three-dimensional compositions eliminate the surface, so to speak, opening up the space behind it and arranging objects within that space so that the painter's and sculptor's fields overlap. We saw this distinction when we compared Picasso's The Studio with Vermeer's The Artist in His Studio (164 and 165). We followed the composition of the Picasso, which is quite flat, straight across the surface, but we looked into the depth of the Vermeer, into a cube of space created by the artist and occupied by the three-dimensional forms he arranged within it.

What enters into a painter's decision to conceive his painting in two dimensions or three? Ordinarily he may decide for himself, but occasionally the choice is dictated by special circumstances. If he is commissioned to do a mural painting, for instance, a painting actually covering the area of a wall as opposed to an independent picture merely hanging on the wall, his obligation is to make his mural harmonize with the architecture and, usually, to respect the flatness and solidity of the wall, in order to avoid leaving us with the uncomfortable illusion that a heavy ceiling is left unsupported because the wall is painted out from under it. To avoid this illusion, some muralists create another by incorporating painted columns or arches that seem to support the ceiling while we look through them into the distance. Andrea Mantegna designed a complete architectural scheme of supports and a vault on the four flat walls and ceiling of the Camera degli Sposi of the ducal palace in Mantua, and was then free to dispose his figures at will, either within the spaces of the architecture or against vistas of painted landscape (202, p. 148). But more generally, murals lie flat on the wall-like tapestries, we might say. Benozzo Gozzoli's Journey of the Magi (201, p. 144) in the Medici Palace, Florence, is such a mural.

The Medici Palace is a heavy stone structure, and the chapel interior shares in the feeling of solidity imparted by the thick walls. Gozzoli accepts the wall for what it is, a solid supporting area, and treats the *Journey of the Magi* flatly and decoratively, as if it were ornamental wallpaper. The rock shapes and tree shapes are designed for their interest as flat decorative shapes, not for their interest as representations of real rocks or trees, and certainly not as

solid forms receding into and occupying space. Nominally this pictorial scheme begins with a procession immediately in front of us and goes back, back, and back across a fantasy landscape of rock ledges to a sky where clouds float. But nominally only. The distant forms are as clear, as precise and detailed, as those in the foreground. Ledges and figures, buildings and trees, grow smaller and smaller as we travel upward into the distance—but they are arranged in tiers as flat as sheets of paper, layer upon layer; they are not painted as solid forms receding into open space. In short, the painting respects the integrity of the wall.

A painter who composes in three dimensions would argue that it is as foolish for a painter to limit himself to two dimensions as it is for a composer of music to limit himself to a few instruments when he could write for a full orchestra. But another painter might respond that Beethoven said as much in his quartets as he did in his symphonies, and that Shakespeare said as much in the compact form of sonnets as Balzac did in all the volumes of La Comédie Humaine. And he would add that economy of means, the compression of subject into a quartet or a sonnet or a two-dimensionally conceived painting, results in greater clarity and greater purity, and thus intensifies whatever the artist has to say. It was some such argument that Mondrian was making about two-dimensional abstractions (179). And the French painter Maurice Denis, in a statement much quoted by other painters, once said: "Remember that a picture—before being a battle horse, a nude woman, or some anecdote—is essentially a plane surface covered with colors assembled in a certain order." The important words here are "plane surface." The implication is that there are both honesty and esthetic advantage in recognizing the limitations of a flat surface and capitalizing on them.

Two-dimensional composition includes the most elementary as well as some of the most sophisticated approaches to painting. The least experienced of us, given a piece of paper, a pencil, and a model, would place our image in the center of the space rather than in one corner. This is an instinctive recognition that a pictorial image needs a logical relationship to the flat area it occupies. We would also draw in two dimensions—necessarily, through ignorance of perspective and foreshortening and modeling, but also because the conception of space into the depth of a picture is a complicated one in itself. Yet even these unschooled approaches to the creation of a picture may produce a work of art when an artist's sensitivity is present, as in *Esther Tuttle* (203, p. 149) by Joseph H. Davis, a self-taught American painter of the last century.

In two-dimensional painting the artist's vocabulary is reduced to line, flat shape, and color. In each of these elements he must be inventive, but above all it is in their combination that he must be creative. Henri Matisse, generally recognized with Picasso as one of the twin fountainheads of modern art, once defined composition as "the art of arranging, in a decorative manner, the various ele-

202. Andrea Mantegna. Camera degli Sposi. Completed 1474. Fresco. Palazzo Ducale, Mantua, Italy.

ments at the artist's disposal." *Esther Tuttle* is a "primitive" painting—primitive in the art-sense of the word, meaning a painting by an untutored artist creating instinctively rather than working from a background of established theories, knowledge, and technical training. Primitive or not, the painter of *Esther Tuttle* has done a more than creditable job according to Matisse's definition of composition.

The rug, innocent of perspective, is drawn more like decorated baseboard than fabric lying flat on the floor. What difference does it make? Actually, a favorable difference: the rug's pattern is more vividly revealed for being free from the distortions that perspective would have introduced; the heavy curves are all the more effective in contrast with the crisp precision of the other forms. If we insist on photographic realism, we must admit that the artist has been unable to cope with the complications of the model's dress; but the important thing is that the simple bell-like shape

of the skirt is combined happily with the nicely calculated irregular puffs of the sleeves. The intricacy of the lace-trimmed collar is set off by being played in fullest detail against the broad, undetailed silhouette of the dress. And the wavering line of the bottom of the apron is one of the least conspicuous but most successful bits of design in the whole arrangement: its gentle movement relieves the stiffness of the lower part of the figure without competing in interest with the upper part, where the face, drawn in profile with skillful delicacy, has to hold its own against all this strong pattern. We have no way of knowing how accurate the drawing is as a likeness—it somehow looks convincing—but the line is beautiful in itself.

Are we giving Joseph H. Davis, an obscure painter, exaggerated credit for knowledge or talent or sensitivities that he possessed only in small measure, reading into this little painting qualities that are not there? Certainly we are not. Thousands of primitive paintings were produced in nineteenth-century America, and for every one of such merit as *Esther Tuttle* there are a hundred that are merely dull, inexpressive, and awkward.

There was probably very little conscious application of esthetic theory or rule in the making of this painting; but every detail is carefully considered as part of the total arrangement, every detail is important to the total effect, and the total effect is good—too good to be a fortunate accident. The design is creative, even if it is arrived at through a feeling for rightness rather than by proven rules of what is right. Even when the most highly skilled artist applies rules and theories, it is still the feeling for rightness that makes the difference between a successful exercise and a work of art.

The attraction of a really good primitive painting is that the innate creative sensitivity of the artist speaks directly and purely. It would be a gross exaggeration to call *Esther Tuttle* a great work of art, but it is an extraordinarily appealing one. The extreme smallness of the hands and feet may be the combined result of technical limitations and the artist's effort to show Esther Tuttle as a lady of refinement and delicacy. But anyone who looks at such a painting with as much perception as Davis employed in executing it will recognize that its merits lie deeper than attractive quaintness. This primitive painter has, indeed, shown himself to be an artist in "arranging, in a decorative manner, the various elements" at his disposal.

By comparing *Esther Tuttle* with three other portraits of women, we will see that the two-dimensional vocabulary of line, shape, and color is a flexible one. Each of the three is the work of a master of such impressive reputation that if Davis could have known of them he would have quailed at the prospect of having to stand alongside them. Yet it is easy to believe that these men would have appreciated Davis's artistry and, fully aware of its limitations, would have recognized its kinship with their own. One of these men is a seventeenth-century Japanese artist; another, a sixteenth-century European court painter; and the third, a

203. Joseph H. Davis. *Esther Tuttle*. 1836. Water color on paper, 11¾ by 9 inches. The New-York Historical Society.

204. Henri Matisse. *Lady in Blue*. 1937. Oil on canvas, 36½ by 29 inches. Philadelphia Museum of Art. Collection Mrs. John Wintersteen.

205. Stages in development of *Lady in Blue*, February 26 to April 6, 1937.

great revolutionary of modern art. Their names are Torii Kiyonobu I, Hans Holbein the Younger, and Henri Matisse, who has already supplied our working definition of composition.

The quality of sincerity in a technically limited painting like Esther Tuttle is easily recognized; but why some modern artists like Matisse, highly trained in the dominant tradition of painting things the way they look, should discard that tradition with its perspective, its mastery of three-dimensional modeling, and all the other devices of realistic representation, requires some explanation. As a young unknown, Matisse augmented his income by copying old masters in the Louvre. These copies were irreproachable, and Matisse was capable of doing original work of the same technical caliber. But for him, original work in the manner of the old masters was no more satisfying than making copies. He set about to find means of expression that would be his own, something beyond traditional technical dexterity. It was necessary for him to discard the past (or at least this aspect of it) not because the past was faulty but because its modes of expression, suitable in their own times, were out of key in ours. We look for certain things in Rembrandt, certain others in Matisse (and certain others in both). "I am unable to distinguish between my feeling for life and the way I have of expressing it," Matisse said. His feeling for life, in that case, is one of gaiety, of elegance. These qualities, seductive if not profound, are represented at their highly civilized best in his Lady in Blue (204, p.149).

The freshness and deceptive air of simplicity of Lady in Blue suggest that it must have been a spontaneous creation, easily achieved. But during its painting a day-today photographic record was kept of the stages through which it passed (205), showing that Lady in Blue began as a semirealistic impression, went through many transformations, and became the picture we now see only after a series of drastic readjustments of its shapes and colors. Describing this method of work, Matisse said: "Supposing I want to paint the body of a woman: first of all I endow it with grace and charm, but I know that something more than that is necessary. I try to condense the meaning of this body by drawing its essential lines. The charm will then become less apparent at first glance, but in the long run it will begin to emanate from the new image." When it was painted in 1937, the charm of Lady in Blue was not apparent to a mass public that was still absorbing the shock of an esthetic revolution; but for most people today the "long run" has worked, and the charm does emanate from the final combination of shapes and colors that satisfied the artist.

The point we are making is that the unschooled painter of *Esther Tuttle* and the highly trained painter of *Lady in Blue*, working from the opposite poles of innocence and sophistication, separated by a century of time and an even wider cultural gap, share an essential similarity. The model, the dress, and the accessories in both paintings are only raw material for flat pattern that is ornamental and ex-

pressive in its own way in each picture. In both of them the bell-like skirt is relieved by the uneven lines and masses of the blouse. The contrast between the intricate lace-trimmed collar and somber robe in *Esther Tuttle* is comparable to the same elements in the Matisse, substituting the jabot for the lace. Other similarities are apparent after a little examination. Whereas the primitive painter, unable to cope with the problem of perspective, worked by necessity in two dimensions, Matisse, who of course was a master of perspective, discarded perspective in order to capitalize on flat pattern.

The American primitive portrait is composed as a spotting of solid areas; the Matisse is this plus a balance of curves. The lyrelike yellow forms derived from the arms of a sofa are reversed in the curve of the light trim in the skirt. A series of arcs—the sides of the skirt, the edge of the red seat of the sofa, the black shapes in the background is tied in with these S-shapes. The hand holding the beads is startling in size, and at first it is not as easy to accept this bigness as it is to accept the equally exaggerated littleness of the hands and feet of Esther Tuttle. Yet if you cover up this hand, the picture looks empty. As a hand it would be grotesque; but it is not a hand, it is part of an arrangement of line and shape and color. Its extraordinary size and its conspicuous position in the center of the picture make it the major stabilizing element in this composition of curves and reverse curves. The picture, in its final effect, is static. It is tranquil. "What I dream of is an art of balance, of purity and serenity devoid of troubling or depressing subject matter," Matisse said. If ever he achieved that dream, he achieved it in Lady in Blue.

Matisse's stylistic history is a constant affirmation of the joy of life, expressed in vivacious patterns and exuberant colors with a constantly increasing emphasis on the twodimensionality of his arrangements. His Carnival at Nice (207), painted about fourteen years earlier than Lady in Blue, shows spectators on a balcony overlooking a street where a parade stretches off into the distance, with hints of sea and hills against the sky. None of this, however, is treated with serious recognition of distance; at best it compromises with three-dimensional space by granting a token acknowledgment of perspective that is immediately refuted. The overall pattern of dots of bright color makes no distinction at all between things near and far. Lady in Blue rejects even any token acknowledgment; then finally, in 1950, thirteen years after Lady in Blue and four years before the artist's death at the age of eighty-five, we have Beasts of the Sea (206), a collage of bright papers cut with scissors into essentially abstract shapes derived from sea life, and pasted on canvas, Matisse's ultimate celebration of the beauty of composition as the arrangement of flat areas of pure color.

Before looking at the next portrait of a woman for comparison with *Esther Tuttle* and *Lady in Blue*, we might examine parenthetically some Eastern examples related to

206. Henri Matisse. *Beasts of the Sea.* 1950. Collage, cut paper on canvas, 9 feet 8% inches by 5 feet 5% inches. National Gallery of Art, Washington, D.C. Ailsa Mellon Bruce Fund.

207. Henri Matisse. Carnival at Nice. About 1923. Oil on canvas, 26½ by 37½ inches. The Cleveland Museum of Art. Purchased by Mr. and Mrs. William H. Marlatt Fund.

208. Mahmud Muzahib or pupil. Bahram Gur in the Turquoise Pavilion on Wednesday. 1524–25. Tempera and gilt on paper, 12¾ by 8¾ inches. The Metropolitan Museum of Art, New York. Gift of Alexander Smith Cochran, 1913.

209. Attributed to Torii Kiyonobu I. Woman Dancer with Fan and Wand. About 1708. Hand-colored woodcut, 21¾ by 11½ inches. The Metropolitan Museum of Art, New York. Harris Brisbane Dick Fund, 1949.

our theme. Matisse was strongly influenced by Oriental art, and several resemblances between Ladv in Blue and the Persian miniature Bahram Gur in the Turquoise Pavilion (208) show the kinship. There is the same emphasis on silhouette rather than solid, rounded form; the same use of pure, ungraduated color; the same flattening out of perspective so that the tile-paved floor in the Persian miniature reveals its pattern without distortion, just as does the crisscross pattern on the couch in *Lady in Blue* and the rug in Esther Tuttle. Another resemblance: both Esther Tuttle. with its identifying legend in ornamental script at the bottom of the picture, and Beasts of the Sea, with its conspicuous title and signature written by the artist, introduce script harmonious with the rest of the picture, just as the Persian artist incorporates a section of decorative script in the horizontal band above the conventionalized archway. Or, going back to Gozzoli's Journey of the Magi, the Persian miniaturist also designs rather than imitates natural forms. and both pictures recede into the "distance" from bottom to top in layered areas as flat, we have said, as sheets of paper. Of all these Western pictures, however, only the Matisse was painted with knowledge (and admiration) of the conventions followed by the Persian miniaturist. A further difference is that Matisse alone cultivates an air of improvisation, while the Persian, the American primitive, and the Renaissance Italian have called into play all the precision that they could muster.

In discussing Picasso's Demoiselles d'Avignon (169), we said that abstract and realistic elements in the same painting may conflict to such an extent that our enjoyment of either may be marred by the other—a possible objection, in some eyes, to Lady in Blue. No such difficulty can arise in Woman Dancer with Fan and Wand (209) by Torii Kiyonobu I. Never having developed our Western preoccupation with photographic reality, Oriental art at an early stage reached such a satisfactory balance between representational form and abstraction that our own extreme expressions of realism and our corresponding extreme reaction into abstraction never took place, or at least not until total abstraction was borrowed from the West in our century. Until then, Chinese and Japanese artists, working within a tradition many centuries old, perfected the expressive virtues of two-dimensional composition in which pictorial subject matter and abstract values are mutually supporting, not competing.

The sinuous yet strong lines and shapes of *Woman Dancer with Fan and Wand* are a superb expression of the studied, flowing postures of traditional Japanese dance. Each line is interesting, whether we take it for itself or as part of the system of lines making up the whole figure. Long curving arcs come to a point and turn quickly into almost straight lines; a series of lines like those around the waist looks at first like a knotted convolution, but unwinds into a system of clear, simple elements. We look at no single line for very long; each one catches us up into a stream of lines that move quickly here, slowly there, like

flowing water or drifting smoke. The pattern of flowers and leaves on the sleeve is a delight in itself, but it too is like a line in its overall movement within a system of nearby lines. Some of the heavier forms act as weights or brakes to the quicker movement of others. Our constant and increasing pleasure in these patterns is fused with the idea of the dancer's movements; we have the double pleasure of an interesting subject and its abstract expression fused in indissoluble harmony.

If the picture is turned upside down, and especially if the face is covered, the design no longer represents a dancer's figure but becomes a purely abstract composition. It is quite changed, however, for it now billows upward into a climax of heavy forms. Right side up, the heavier forms lie in the lower half of the picture and curve up through lighter ones to the delicacy of the head with its terminating hat and the fillip of the orange bow. This is planned, of course; but the same thing happens, either by plan or by instinctive awareness of its rightness, in *Esther Tuttle*, where the delicate profile with its lightly painted bow at the neck and ornaments in the hair has a similar relationship to the heavier forms below.

As a brief aside before we see the Holbein, we can look at another Japanese woodcut, Torii Kiyotada's *Actor Dancing* (210). We do not need the grimace of the face, nor the paraphernalia of the swords that replace the fan and wand in the woman dancer's hands, to tell us that this is a dance of a contrasting character. We are told by line—sharp, angular line interrupted by other lines—and by shapes that are jagged and irregular instead of sinuous and flowing. The total silhouette has this same jagged character. The word "harmony" suggests, always, smoothness and grace. Actually, we have in *Actor Dancing* something like a harmony of conflicts—to be completely paradoxical—just as in music we may have a harmony of dissonances.

Compared with the extreme flatness and decorative conventions of the compositional patterns we have been analyzing, Holbein's realistic portrait of *Christina of Denmark, Duchess of Milan* (211) may seem to fall outside our two-dimensional bracket. But with its restrained modeling and shallow space, the composition is conceived more in terms of flat shapes than volumes. We are showing it in two versions, first as it was known before 1968, and then in its present state after cleaning, during which the oblong of white paper in the background was eliminated as a late addition and the background itself was discovered to have been varied, originally, by the cast shadow on the wall at the right.

Upon one of the occasions when Henry VIII was between wives, this habitual royal widower was considering as his fourth queen the eminently eligible and reputedly beautiful Christina, Princess of Denmark and recent widow of the Duke of Milan (she is still in mourning dress in the portrait). Henry sent Holbein to Brussels to participate in negotiations and to bring back a portrait of the princess.

210. Torii Kiyotada. *Actor Dancing*. About 1715. Hand-colored woodcut, 11¹/₄ by 6 inches. The Metropolitan Museum of Art, New York. Harris Brisbane Dick Fund, 1949.

211. Hans Holbein the Younger. Christina of Denmark, Duchess of Milan, before and after cleaning. 1538. Oil and tempera on wood, height 70 inches. National Gallery, London.

212. Head of Christina of Denmark.

213. Hands of Christina of Denmark.

Holbein executed a study, now lost, and brought it back to London, where it evolved into the portrait we are now examining. It charmed Henry as it has charmed everyone ever since, but Christina was less charmed with Henry's record as a husband, and the union never materialized.

Until the 1968 cleaning, the composition as we knew it was dominated by three light silhouettes: The oblong of white paper pinned to the wall, the oval of the face, and finally the hands—all played against an eventless dark blue background and the gentle rhythms of the robe with its furtrimmed edges and curving folds of the sleeves. The three silhouettes had a wonderful variety. The paper was a simple oblong; the hands, in contrast, an irregular flowering of curves and slender projections, while the oval of the face (212), terminated by the line of the cap and ornamented below by the lively frill of collar, blended the regularity of the oblong and the variety of the hands (213).

The three floating shapes were firmly anchored within the picture area on a horizontal axis established by the common center line of the face and the paper, and a vertical axis running through the center of the face and that of the hands. Coming at the intersection of these axes, the face was unequivocally established as the climactic focus of the picture—perhaps redundantly in view of its natural psychological dominance.

For anyone who had loved the picture in what proves to have been a modified state, the elimination of the white oblong was momentarily shocking. But it takes only a second look to see that the picture is even more subtly organized and more than ever revealing of personality by means of the original, and present, composition. We have more than ever the feeling that here is a real person, a person of great reserve, of acute intelligence—a subtle woman, a most attractive but not quite approachable one. The balancing function of the white oblong on the right, which counteracted the leftward lean of the figure, is now served, less intrusively, by the arbitrary band of cast shadow running along the margin at far right, leaving the lovely face and the lovely hands to tell even more effectively in their contrasting silhouettes.

Recalling the painting, even after having seen it frequently, most people would retain the impression that Christina is shown directly facing us in the center of the panel. If she had been so placed, however, the character relayed would have been that of a much more foursquare, more obvious, more everyday woman. As it is, the slight turn of the body and the variation from center constitute a removal from us, a reserve on the part of this beautiful woman that makes the direct gaze of the eyes all the more arresting. Composition, rather than the mere reproduction of a set of figures, accounts for our feeling that we are confronted by a fascinating personality.

To emphasize this point, we can compare the portrait of the Danish princess with *Anne of Cleves* (214), which Holbein painted the following year. The circumstances of its commission were the same: Henry, still shopping after

Christina's refusal, sent Holbein to portray this runner-up for the precarious honor of being queen of England.

It is an entrancing picture—possibly, in its elaboration of ornamental detail, more immediately attractive than the one of Christina. Presented with a different personality in his sitter, Holbein responds with a contrasting composition. Anne is presented in an absolutely frontal position, centered in the picture area, in a design as nearly symmetrical as possible without monotony. The sweet, prim, guileless, and unimaginative little mask faces us patiently, with a suggestion of gentle obedience (215). The hands are clasped in a meek and compact bundle (216), whereas Christina's were beguilingly patterned (213). Anne's elaborate robe, headdress and jewels, so different from the rich, subdued elegance of Christina's costume, manage to invest the ordinary little person with an air of circumstance; Anne's trappings are what we notice first, and remember best, while we remember Christina as a woman. As an expression of character, the portrait of Anne of Cleves is as successful a composition as the one Holbein devised to interpret Christina's more subtle personality; if it is less fascinating than Christina's, it is because it serves a less fascinating subject, showing us a sweet but unexceptional woman surrounded by and patiently accepting all the trappings of high position. These trappings flatter Anne. In a way, Holbein was too successful: Henry liked the portrait enough to contract the union but was so disappointed in Anne herself that he divorced her with indecent haste.

Now what are the rules for creating such compositions? There simply are none, except of the most general kind. Every artist knows that variety of shape makes for interest; that strong value contrast—that is, strong contrast between lights and darks—heightens dramatic effect; that a psychological balance can be created between a large, rather heavy area like Christina's robed figure and less conspicuous ones like the paper (or the shadow) on the wall back of her. But the final rightness of the disposition of the various elements in *Christina of Denmark* is the result of the same thing that made *Esther Tuttle* more than just another quaint primitive—the artist's individual sensitivity in applying general principles.

As we continue to analyze compositions we will find that certain rules, certain formulas, can be applied, but we can never set down rules and formulas that will entirely explain the power some paintings have to satisfy and move us while others that seem to follow the same formulas are nothing but dull and obvious products. From time to time some painter, critic, or esthetician sets out to discover the compositional secrets of the old masters and reduce them to a foolproof mathematical basis. The trouble is always that the systems work just as well when applied to commonplace objects and routine pictures as they do when tested on great sculptures and paintings. Precise theories derived from the beautiful shapes of Greek vases often work just as well when applied to ordinary coffeepots. In the

214. Hans Holbein the Younger. Anne of Cleves. 1539–40. Oil and tempera on parchment mounted on canvas, height 26 inches. The Louvre, Paris.

215. Head of Anne of Cleves.

216. Hands of Anne of Cleves.

same way, anyone who has taken a course in musical composition knows that it is possible to learn the rules of counterpoint and apply them correctly to produce a technically impeccable fugue that is downright ugly in sound. Composition in architecture, music, sculpture, or anything else is always a matter of creation, for which the rules are only a guide along tested paths.

We have analyzed the portrait of Christina as a two-dimensional arrangement because, in spite of the realistic modeling, it is so conceived. The modeling is slight, and although there is indication of shallow space, there is no great effort to create a spatial illusion, which is a different thing altogether. Logically explained, the piece of paper is pinned to the wall a foot or so back of the head, but compositionally the three light silhouettes perform on a single plane. However, we must always accept some ambivalence when a composition of modeled objects is conceived in what we might call "unmodeled space"; if you prefer to regard the picture in its shallow third dimension, the general analysis of its composition as we have given it can still be applied without very much modification.

In either case, Matisse—our spokesman in this chapter—could have been writing of Holbein's Christina when he said: "The whole arrangement of my picture is expressive. The place occupied by figures or objects, the empty spaces around them, the proportions—everything plays a part. All that is not useful in a picture is detrimental." For that matter, he could have been speaking of, or for, any number of artists who preceded him, but the emphasis he puts on "empty spaces" and his conclusion that anything not useful is detrimental call to mind one aspect of twodimensional composition as a flat pattern of shape and color that has to be mentioned with a word of tribute to the artist responsible for it—the art of the poster as revolutionized by Henri de Toulouse-Lautrec in the 1890's. His Aristide Bruant in His Cabaret (217, p. 160) is in fact the purest example of two-dimensional pattern reduced to a minimal vocabulary of shape, color, and empty space that we have seen in this discussion.

Bruant was a singer of popular ballads in cabarets that corresponded, more or less, to our nightclubs. In a costume of black boots, black wide-brimmed hat, voluminous cloak, and scarf and cane, he sang songs of bohemian life (and low life, frequently bawdy) in the argot of Montmartre. Lautrec captures the essence of Bruant's professional personality with a vivid image that explains why it was said of his posters that they "take possession of the streets"—but without disfiguring them. In their inescapability, their compelling design, and their pungent characterizations of theatrical performers, Lautrec's posters were commercially effective. But wherever commercial expenses are involved in anything as variable and as personal as a work of art, there will always be opposition to risking money on anything new. Lautrec usually designed his posters free for his friends among performers and even bore some of the costs of printing to assure that they would finally appear exactly as he had designed them. His posters were the earliest to come into museums as works of art rather than period pieces, and the principles upon which they were designed—clarity, expressiveness, and esthetic appeal—have served as models for poster designers ever since, through one change of style after another.

The compositions we have seen so far have been analyzed as patterns of shapes and colors. The ones we will now see could be similarly treated, but are more strongly tied together by another compositional element—line. By "line" here we will usually mean the bounding edges of forms, either the total form as separated from the background or the contours of the various secondary forms within a main one. Secondarily, "line" may mean the general stance, the general direction, of a form. A detail (218, p. 161) of the group, the Three Graces, in Botticelli's Primavera exemplifies the rhythmic interlacing of linear systems either way you want to regard them—specifically, as the bounding edges of forms ("outlines" if you wish), or more generally as the stance of a figure, the angle or curve with which a neck rises from the shoulders or a head balances on the neck; the lift of an arm within its linear boundaries; the flow of a mass of curls composed of smaller rhythms within the mass.

Botticelli, generally conceded by art historians to be the consummate master of linear design in painting, worked in fifteenth-century Florence when the greatest excitement and the most modern art centered upon developing the techniques of three-dimensional realism—perspective, accurate anatomical structure, and the placement of realistically modeled figures in space—and he followed and employed these developments. But not wholeheartedly. He was a stylist to the point of eccentricity, and his passion was for line to the extent that in spite of everything else his drawing and his composition are most appropriately analyzed two-dimensionally.

The linear grace of the detail we have chosen, the flowing lines of bodies, gauzy draperies, and masses of ringlets and escaping locks of hair—all of these lines intermingling, separating, and meeting again, all with their own grace and logic as they flow into and away from one another—these could be analyzed indefinitely, but to little point, since any eye must surely take pleasure in being carried along the paths and currents that Botticelli set down so clearly. The picture is a lyrical celebration of the grace, refinement, and sensitivity to the beautiful that was cultivated (along with more hard-headed studies in power politics) at the Medici court. We can use the same words to describe the quality of Botticelli's line: grace, refinement, sensitivity. And, we must add, strength. The firmness and gravity of long, slowly moving lines serve as foils to the more fluid, rapidly moving linear arabesques nearby. It is this interplay of strength and delicacy that differentiates Botticelli's line from that of his imitators, which turns flaccid in comparison.

217. Henri de Toulouse-Lautrec. Aristide Bruant in His Cabaret. 1893. Color lithograph, 54½ by 39 inches. The Metropolitan Museum of Art, New York. Harris Brisbane Dick Fund.

218. Sandro Botticelli. The Three Graces from Primavera.

219. Sandro Botticelli. *Primavera*. About 1478. Panel painting, 6 feet 8 inches by 10 feet 4 inches. Galleria degli Uffizi, Florence.

Line also holds the whole of the *Primavera* together as a unit that otherwise would break into three unequal divisions (219). The subject is an allegory that has been given various interpretations although the figures are individually identifiable. In the center stands Venus—a uniquely modest and maidenly conception of that goddess framed by a natural arch formed by boughs within a grove of orange trees dotted with bright fruit. In a group to our right the wind god Zephyrus, painted in chilly blues and grays, urges his wife, the nymph Chloris, toward fulfilling her transformation into Flora, goddess of Spring. She looks back toward him as if reluctant, but flowers are already issuing from her mouth. The third figure shows her fully transformed and scattering flowers, as Flora. The group alone would be a wonderful picture. The English poet Robert Herrick invoked the Chloris-Flora metamorphosis in "Corinna's going A'Maying," in which he admonishes his mistress ("sweet slug-a-bed") to arise and usher in the month of May:

Rise, and put on your foliage, and be seen To come forth, like the springtime, fresh and green, And sweet as Flora.

On the left, Mercury, who seems curiously uninterested in the events nearby, points upward with his caduceus. The

Three Graces, handmaidens of Venus whose function it is to make life delightful, dance in a ring. (They are Euphrosyne, representing the grace of mirth; Aglaia, that of splendor; and Thalia, that of bloom.) They are, for whatever reason, the targets of blazing arrows from the bow of blindfolded Cupid, who flutters above the scene.

Compositionally the picture builds up to a tentlike peak at the middle, reaching an appropriate climax at the head of Venus. The angle of Chloris's figure is continued by foliage and tree trunks up to the figure of Cupid, whose arm and arrow direct us firmly downward at a corresponding angle. Interrupted by the complications of the group of the Three Graces, the angle is restated by Mercury's forearm. A swaglike course running downward can be followed from the wind god's arm along the lowered arms of Chloris and Flora and then up along the curve of Venus's robe to her raised hand, uniting Venus with the right side of the picture. On the left the continuations are more tenuous; this is, on the whole, a much more loosely organized picture than some we will see where composition is a firm structural skeleton for the unification of a number of figures.

Composition can also be a means of expression, and we will anticipate our chapter on that subject with one emphatically linear example here. The name of the artist, William Blake, is assurance enough that the picture will be in a linear mode.

Blake's *The Wise and the Foolish Virgins* (220) is a storytelling picture, told superficially by the images that act it out, but fundamentally by the lines composing them. On the left stand the five wise virgins, their lamps glowing with flames from the oil they have been sagacious enough to save against the coming of judgment. Ranged in right-eousness, they reject the hysterical pleas of the five unwise virgins, who have squandered their oil and are now terrified by the sounding of the last trump in the darkened sky above them.

The two groups are characterized by contrasting lines. The lines of the wise virgins, followed from the left edge of the picture to the figure with the upraised arm, begin with the quite straight, almost rigid lines of the first two figures and gradually relax and curve until the fifth figure stands in a graceful arc, with a gown that flutters from the lower part of her body. Throughout the group the changing movement of line is steady, confident, and serene, as befits these women who by virtue of foresight now hold no doubts as to their salvation. But the lines of the group of the unwise five are wildly agitated, constantly interrupting one another, meeting at sharp angles and curling back upon themselves. The kneeling figure in front has a strong movement toward the left; the others move in contradiction to the right. The whole arrangement of the group expresses confusion and distraction.

Much of this story can be read purely in the attitudes assumed by the figures, although of course Blake invented the attitudes for the purpose of exploiting them in line. But the keynote of the narrative is that the unwise virgins

220. William Blake. *The Wise and the Foolish Virgins*. Water color with pen and ink, 141/8 by 131/6 inches. The Metropolitan Museum of Art, New York. Rogers Fund, 1914.

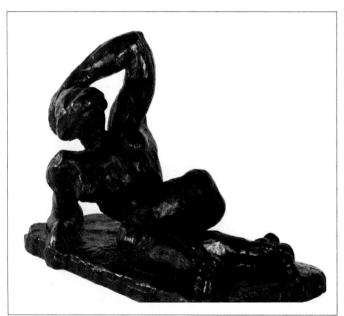

221. Henri Matisse. *Reclining Nude.* 1907. Bronze, height 13½ inches. The Baltimore Museum of Art. Cone Collection.

appeal to the wise to share their oil and are firmly refused; they must continue to suffer within their own foolishness. This idea is projected by line in the following way:

The kneeling figure appeals to the upright virtuous one, but this strong forward-rushing movement of appeal is turned back by the line of her own upraised hand, which swings us into the irrevocable line of the wise virgin's outstretched arm and back into the confusions of the group of unfortunates. There is no entering now into the fold of virtue; the foolish virgins are unequivocally rejected.

The paired linear systems, one serene, one agitated, are separated at their point of contact where the upward rush of the supplicating figure breaks against the standing figure and must return. In its arc shape, the upright figure seems to bend slightly as it receives the impact of the agitated rush, but does not yield. However, the picture must not be allowed to break entirely in half even though its two sides express opposing ideas. We cannot miss how the line of the supplicating hand is turned back along the extended arm, but, less conspicuously, this hand is also used to connect the two groups. The line of the hand is continued in the line of the wise virgin's scarf, though we must jump the barrier of the extended arm to follow it. The main line runs along the extended arm and back into the hysterical regrets of the foolish, yet through the secondary line we may reenter the linear system of the wise. Thus the two groups are united, as they have to be in a well-knit composition, but they are also divorced, as they must be to tell this particular story of wisdom and folly.

Matisse, whose ideas on pattern in painting have served us so well, was also a sculptor, and one who stood by what seems an obvious premise, that a three-dimensional art should not be approached in terms of a two-dimensional one (and vice versa). He declared this premise vigorously in sculptures where weight, solidity, and stress reverse the components we expect in his paintings—vivacity, grace, and charm. In his Reclining Nude (221) the parts of the body are violently distorted to express the counterbalance between load and support; the stress at the waist has all but wrenched the hip from the torso; the entire body is conceived in sections almost as if it had been built from raw boulders. There is nothing anywhere that can really be called a line. The smooth contours that allow for something like beautiful "line" in some sculptures we have already seen (38 and 42, for instance) have been rigorously avoided for rough surfaces and rugged forms that enhance the feeling of massive solidity.

In the field of low relief sculpture, however, the sculptor is frequently forced into an essentially two-dimensional approach. It is possible to create an illusion of depth in low relief sculpture just as it is possible to create an illusion of depth in painting, but the illusion is not always appropriate, as we have mentioned in connection with Gozzoli's *Journey of the Magi* (201). It would have been inappropriate in the Parthenon frieze (222), where it would have seemed to

weaken the structural reality of a band of stone uncompromisingly incorporated into the building's structural system. Originally running for 525 feet around the exterior of the sanctuary, 40 feet above base level, the frieze represented progressive stages in the Panathenaic procession, which every four years wound its way up to the Parthenon in celebration of the patron goddess. The section we illustrate shows maidens who will carry votive offerings being organized by stewards as the procession forms in the city below the Acropolis. The compression of three-dimensional figures into what could be called two and a half dimensions amounts to a hybrid between drawing and sculpture, where line is as important as volume, or more so. The arms of the maidens are virtually flat except at their edges. Everywhere, space and volume are indicated systematically, never imitated illusionistically.

To include an architectural example in a chapter on two-dimensional pattern and linear design may seem capricious, but the façade of the cathedral in Orvieto, Italy, is itself sufficiently capricious to justify its choice (223). With its sculpture in both full and low relief, its pictorial mosaics and their gold backgrounds, its marble colonnettes twisted like Christmas candies and banded with bright-colored mosaic patterns, also speckled with gold, and its fanciful carvings dividing areas from one another like elaborate picture frames—with all these, the façade is a single composition in what would be called mixed media today. In relation to the dimensions of the façade's beautifully unified total area, the relief of even the fully three-dimensional sculptures is much lower than that of the Parthenon frieze.

There is an inherent pretense in the design of this façade that, as with other Gothic façades, the decoration is subservient to architectural volumes that determine its divisions and subdivisions. But the pretense is exposed when the building is seen from the side—for the façade is a false front, a screen that has little architectural connection with the rest of the building except that it allows access to the comparatively severe interior. By the functional premises that underlie virtually all architectural esthetics to one degree or another, Orvieto's façade is a fib. But sparkling and gleaming against the blue Italian sky, it is one of the most joyful inventions in the history of buildings.

222. Greek, classical period. *Maidens and Stewards*, a fragment of the *Panathenaic Procession* from the east frieze of the Parthenon. Frieze completed 432 B.C. Marble, height about 43 inches. The Louvre, Paris.

223. Cathedral, Orvieto, Italy. Begun 1290. Facade by Lorenzo Maitani and others, begun 1310.

224. Leonardo da Vinci. *Last Supper*. 1495–97/98. Tempera or oil and tempera on plaster, height 13 feet by 9½ inches. Refectory, Santa Maria della Grazie, Milan.

Chapter Eight

COMPOSITION AS STRUCTURE

If any painting in the world is more famous than Leonardo da Vinci's Mona Lisa, which we have already seen (22), it is his Last Supper (224), a great painting with a religious subject. That is not exactly the same thing as a great religious picture—which the Last Supper is not. In any mystical sense it is a religious picture only by association of ideas. Nor did Leonardo intend it to be one. He conceived of the moment when Christ says to his disciples, "One of you shall betray me," as a moment of unparalleled human drama. It was the psychological atmosphere of that moment that fascinated Leonardo, and he directed every element of his composition toward its expression.

The drama as he conceived it is an interplay of three states of mind and spirit: that of Christ, who makes his announcement in foreknowledge that the events leading to his Crucifixion have been set in motion; that of the faithful disciples, who are filled with confusion, astonishment, and incredulity; and finally, that of Judas, who has already made the bargain of betrayal. The expression of the total atmosphere of this moment, of the three contrasting psychological states fused into a unified whole, is achieved through compositional structure. Every element is studied individually, but each takes on its full meaning only through integration with the rest of the picture. Leonardo analyzed each of the disciples as a personality, drawing on biblical history and what legends and surmises there were about them; he invented for each one a set of features that he thought to be characteristic; finally after long study he gave each one gestures and facial expressions that would complete the psychological description.

Now, plenty of other pictures have been constructed just as carefully as the *Last Supper*, but it would be hard to find another in which the construction is so clear and simple yet so unobtrusive and expressive. Let us insist that the compositional structure of the *Last Supper* does much more than hold together a picture of great size. It is itself an expressive factor and (with the picture in its present ruinous condition) the strongest one. The facial types and expressions that Leonardo developed with such care are now so blurred they are only half-decipherable, and the original color harmonies have faded, thus modifying the psychological force that Leonardo intended them to have. Yet the picture still says what Leonardo wanted it to say because the overall composition remains clear.

The Last Supper was painted across the full width of the end wall of a long room, originally a refectory. Simple one-point perspective continues the lines of the actual architecture of the room. More importantly, though, these perspective lines are a concealed compositional device. A diagram (225, p. 168) shows that, continued, they converge at the head of Christ, or, if you prefer, they radiate from his head like

225. Diagrammatic scheme of Last Supper.

rays of light. These lines are united by an arc, formed by the upper molding of a pedimented window above Christ's head. This arc, the only curved line in the painted architecture, is a segment of an invisible circle with its center on the point where the perspective lines converge. There are other relationships: two of the lines, those that follow the molding along the ceiling, pass through the ends of the arc, while the edge of the circle below the arc just touches the level of the horizontal line of the table on the side where Christ sits.

When we say that this invisible circle, with its center at the head of Christ, is like a halo, we do not mean to suggest that Leonardo had any such symbolism in mind. He has rather pointedly omitted the halos customary in paintings of the Last Supper, thus emphasizing the human drama rather than the divine mystery of his subject. But the fact that this circular form, the only one in the picture, does surround the figure of Christ tends to set him apart much as a halo would have done. If this was what Leonardo intended, however, he did not expect the observer to do this kind of detective work to notice it, any more than he meant that we should consciously follow the continuations of the perspective lines to Christ's head. He meant these lines to function structurally and psychologically as part of the total effect of the painting. And they do so, whether or not we are aware of them.

It might seem that once we have detected some of the devices the artist has used to create his drama, the drama itself would be rendered less affecting. This would be true if the *Last Supper* were nothing more than a kind of card trick. Once a trick is explained it has no further interest, since its only function is to puzzle us. But the *Last Supper* is not a card trick; it is a great painting. We may simultaneously enjoy its effect and the means that Leonardo has used to achieve this effect, just as we may be moved by great music and at the same time admire the musician's technique and be aware of the composer's inventiveness.

A second diagram (226) shows that the figure of Christ as it appears above the table is triangular in shape and closely integrated with the lines of the architecture. There could not be a more appropriate form: the triangle is the simplest, the most stable, and yet, with its apex, the most climactic of geometrical forms. This triangle, as a final, logical, and harmonious statement, is approximately equilateral. Its lines may be continued into the perspective lines of the floor pattern to form a larger triangle of the same proportions. (In addition, and Leonardo might have had it in mind, the triangle is a symbol of the Trinity.)

It is worth noticing that while the figure of Christ is closely integrated with the basic architectural scheme—the structural foundation of the picture—the figures of the disciples are not. This is one of several devices that not only draw attention to the figure of Christ but isolate him psychologically in this dividing moment of his life. Thus unified with the static architectural forms, Christ's figure

is invested with a divine calm that contrasts with the human agitation of the disciples.

The disciples are clustered into four groups of three each. The two groups on either side of Christ echo the central triangle without repeating it exactly. The groups at the ends of the table also repeat the triangle but echo it yet more faintly, as is indicated in our second diagram. If these groups were as purely triangular as the central figure, they would compete with it. As it is, they come to a climax in the figure of Christ: vaguely formed at the far sides of the picture, more definitely formed on either side of Christ, they culminate in the purely formed triangle of Christ himself.

This is part of a scheme to build the picture in a current of excitement that moves toward the center, where it reaches its greatest intensity, and breaks against the serenity of the central figure like waves against a rock. Thus Christ is set off, in his noble acceptance, from the weaker human excitement surrounding him. An accelerating movement runs through the disciples, along their arms and the folds of drapery, growing more agitated as it approaches the center, where it is turned back by an uplifted hand on the right and, on the left, by the figure of John, the beloved disciple, who turns away in grief.

In most paintings of the Last Supper, John the Beloved is shown leaning toward or on Christ and being comforted by him. Leonardo abandons this convention to isolate Christ in this moment at the beginning of the trial, conviction, and execution that he must bear alone. Leonardo also departed from convention in putting Judas among the other disciples instead of by himself on the other side of the table, where he would have been too conspicuous for Leonardo's conception of the scene. As it is, Judas appears, clutching his bag of silver, in the group to Christ's right, the only one of the disciples who is not protesting the prophecy of betrayal that Christ has just made. Symbolically, also, his figure is a break in the symmetry of the triangle.

This outline analysis of the Last Supper's composition could be enlarged to include any detail of it. For instance, the play of Christ's head against the light of the window is the strongest light-and-dark contrast in the picture. The hangings on the wall, because they diminish in perspective, are a series of vertical lines growing closer and closer together as they approach the center, just as the action of the figures grows quicker and quicker as it moves toward Christ. There are subtleties of balance at every turn. In the major one. Christ's head is bowed slightly off center to our right. Why? There are two reasons. The obvious one is that as an attitude it is expressive. But the head could have been bowed forward instead of to one side and been just as expressive. If it had, though, there would have been no relief to what would then have been a too rigid and obvious symmetry. The slight bending toward the right supplies the necessary relief. But it also creates a new problem. Such a variation in so conspicuous a spot must be countered

226. Diagrammatic scheme of Last Supper.

227. Raphael. Transfiguration. 1517. Panel painting, 13 feet 4 inches by 9 feet 2 inches. Pinacoteca,

228. Nicolas Poussin. Rape of the Sabine Women. Before 1637. Oil on canvas, 60% by 82% inches. The Metropolitan Museum of Art, New York. Harris Brisbane Dick Fund.

229. Detail from Transfiguration.

elsewhere if it is not to throw the scheme too strongly to the right. Hence, Leonardo's emphasis on the chief secondary figures, Judas and John the Beloved, on our left.

Think, then, how much is involved in a factor as small as the bending of a head: rigidity and monotony are avoided and a place is made for a narrative comment (on Judas) that would not otherwise have been balanced, since there is no incident of comparable importance to put on the other side of the picture—and yet we are aware only that Christ's head is bowed in an appropriately expressive way.

The beauty of the *Last Supper* as a compositional structure is that it is original without being eccentric, highly calculated without being complicated. In it pictorial structure and intellectual conception are consummately unified.

As a contrast to the unity of the Last Supper, since a failure can be as illuminating as a success, Raphael's Transfiguration (227, p. 170) is one of the most confusing compositions in the world. It is impossible to tell exactly where in the group of excitedly gesturing figures in the lower half we are being asked to look. The eye is told to move in a dozen directions at once. No sooner does it begin to follow any one of the emphatically indicated routes along a pointing arm and finger than it is peremptorily checked and told to follow another. Figures point this way and look that; first we are crowded off to one side, then swung across to the other; we see a patch of landscape in the distance but are denied access to it. Why is it there? Apparently only as filler. If we escape into the upper half, we are in an area of forms so obvious, so much weaker than those below, that our interest is not held, and we reenter the jangling confusion we have just left.

An attempt to diagram the composition would result in an incomprehensible and irrational web of lines stretching arbitrarily from point to point. Something like a warped triangle with the ascending Christ at its apex would emerge, but the only figure that really holds its own against all competition in this confusion is the kneeling woman who dominates the foreground—dominates, indeed, the entire picture (229).

This figure is beautiful in itself, in spite of the strained

artificiality of attitude and the draper's-display fall of cloth from one shoulder onto the ground. But this beauty is insufficient reason for the figure's prominence. As far as the miracles represented in the painting are concerned (Matthew 17:1–8 and 14–18), the figure is only an accessory, with no more significance than most of the others and with less than some. Its importance should have been given to the epileptic boy to the right, whose miraculous cure by Jesus so astonished the onlookers. In a sound, if obvious, bit of composition the woman points to the boy, but her

gesture is nullified by the stronger line of her glance in the opposite direction. In short, the composition fails because it lacks unity and focus. The spasmodic crisscross, the

abrupt turns and interruptions, could have served effectively to express the excitement and agitation of the moment if they had been organized toward an appropriate climax; as it is, they only confuse the observer and obscure the narrative.

It may be argued that to compare this composition with the *Last Supper* is unfair since Leonardo's subject was a quieter one involving only thirteen figures instead of twenty-seven. But the problems solved in the *Last Supper* only seem simpler because the solution is presented with such clarity that it appears to have been inevitable. For the sake of argument, however, the *Transfiguration* can be compared, still to its disadvantage, with an even more complicated, even more violent subject that involves even more figures, Nicolas Poussin's *Rape of the Sabine Women* (228, p. 171).

As in the Last Supper, but used toward a different end, literally every detail, no matter how small, is integrated within the whole of Rape of the Sabine Women. The composition is built upon a triple interlocking framework. First, there is the strong diagonal movement upward from right to left stated by the warrior in the right foreground, a linear continuation of the figure of the old man grappling with him. A young woman, her torso bent in conformity with the diagonal, completes the interlaced group, which forms a slanted triangle (230). The diagonal is repeated in the middle distance by a rearing white stallion, in the foreground center by the back of the crouching old woman, and in the upper left by the staff held by the heavily robed figure (Romulus) standing on the portico of a temple. A dozen other repetitions are discoverable at a glance. In sum, the diagonal is a neat 45 degrees from the vertical.

Second, this surging movement is countered by another, less vehement, in the opposite direction; some of the elements of this upward movement from left to right are the uplifted folds of Romulus's robe, the raised arms of two women who struggle against their abductors, two swords in the background, the fleeing figures that move out of the picture at the far right, and, again, many others. These two systems overlap; most of the figures and groups carry elements of both. For instance, the white stallion is integrated with the first system, while the woman who is being carried away on its back is part of the second. Her abductor in turn is part of a third system, which is a stabilizing repetition of horizontals and verticals, most apparent in the lines of the architecture. Also, Romulus stands vertically, and there are strong horizontals in the clouds, and verticals or horizontals in various arms, legs, and draperies, and in small details everywhere.

Upon this skeleton Poussin has constructed a composition in which there are various elements that can be better understood when we reach the end of this discussion. We will look at the *Rape of the Sabine Women* once more at that time, returning now to the point at which we left our discussion of the *Last Supper*.

230. Detail from Rape of the Sabine Women.

231. Pietro Perugino. Crucifixion with the Virgin and Saints. About 1485. Oil and tempera transferred from wood to canvas. Center panel 39% by 22¼ inches. National Gallery of Art, Washington, D.C. Andrew Mellon Collection.

When Leonardo used a triangle as the central element in the Last Supper, he was capitalizing on the most popular geometrical form in painting. A picture planned for a conspicuous central position in a building often demands a symmetrical composition that builds up to a climax at the center—and when we have said that, we have just about demanded the triangular form. This was so true during the Italian Renaissance, when altarpieces were the painter's stock-in-trade, that the triangular composition crystallized into a formula. The altar itself is the climax of the symmetrical scheme of a church. Everything leads inevitably to it, and thus, to the altarpiece. To cap the architectural scheme with a painting that would throw it off balance was unthinkable. The balance was usually achieved by symmetry. Perugino's Crucifixion with the Virgin and Saints (231) applies the triangular formula so purely that it could have been designed as a model demonstration.

Let us say immediately that an altarpiece is the kind of painting that suffers most by removal from its original location to a museum. Religious paintings lined up by the dozens along museum walls grow monotonous and sometimes we react by feeling guilty that they do. But we are quite right; installed in this way, they *are* monotonous.

Many paintings, especially modern ones, are executed with museum exhibition in mind. Each one is designed to compete for attention by its individuality. Each diverts us; each offers newer and more curious forms and combinations of colors. But an altarpiece never had and was never supposed to have the appeal of competitive novelty. Each one was painted to be seen by itself, not as part of a gathering of exhibition pieces. It was meant to be seen, frequently by candlelight, as part of the ensemble of a church or chapel.

Nor were altarpieces created in the knowledge that they would become items in a collection of historical specimens mounted for critical observation. That is exactly what most of them have become, and this is, of course, exactly the way we are treating Perugino's *Crucifixion* and Raphael's *Transfiguration* when we discuss their composition. But in so doing we should try to remember that altarpieces are particularly vulnerable when not seen as they were intended to be seen, as part and climax of a certain architectural scheme and emotional atmosphere.

The formula for the triangular composition, repeated hundreds of times in Crucifixions, Nativities, Madonnas with Saints, and similar subjects, calls for a central triangle with the picture's focal point at its apex and a secondary, weaker, inverted triangle to counter it. In his *Crucifixion*, Perugino uses the formula with particular grace (232). There is additional interest in that the formula unites three separate panels. Saint Jerome, in the left panel, forms one side of the triangle with the "line" of his upward glance directed toward the head of Christ. This line exists as strongly as if it were visible, like the dotted lines in old comic strips that lead from the eye of a character to the object he is looking at. This invisible but inescapable line

232. Diagrammatic scheme of Crucifixion with the Virgin and Saints.

not only forms a side of the triangle but unites the left panel with the center one by cutting across the dividing frame. The figure of Saint Jerome bends forward from the waist at the same angle.

In the right panel the Magdalene creates a similar line. Her body is not bent, but her head is tilted in the same direction as the line of her gaze toward the apex of the triangle. The forms of the rocks just behind her strengthen the line by echoing it, as does the fold of her robe from ankle to hip. The figure of Saint John, at the right of the Cross in the central panel, directs our eye to the apex in the same way. The Madonna, however, looks downward. (How repetitious and obvious it would be if she also looked upward.) But the head of Christ, bowed as if he were looking in her direction, suggests the missing line. The Madonna's bent head supplies a slight yet necessary variety among the four attendant figures and serves to single her out as the most important of them.

The inverted counter triangle is determined primarily by the landscape on either side of the Cross. It is also repeated in folds in the drapery of each figure and by Saint Jerome's staff. (The objects carried by saints in these pictures are always a great convenience to painters, who are free to tilt them this way and that for compositional purposes.)

There is nothing particularly original in the arrangement of this painting. Perugino is even notorious for the way he repeated his compositional devices from picture to picture, reassembling his figures from a stockpile. But he does satisfy beautifully the decorative demand for a painting that will not disturb the symmetry of an overall architectural scheme and the psychological demand for reverent peacefulness. There is even an agreeable clarity in the scheme's dependence upon the simplest and most apparent

233. Pablo Picasso. *Guernica*. 1937. Oil on canvas, 11 feet $5\frac{1}{2}$ inches by 25 feet $5\frac{3}{4}$ inches. Estate of the artist.

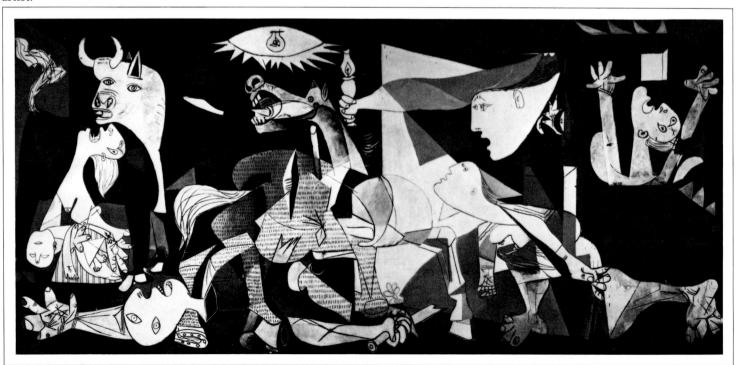

principles of arrangement. Virtually every element in the three panels ties in with either the major or the secondary triangle or with the verticals—the Cross, the towers, the delicate trees that rise so quietly and so serenely upward. Finally, the strong horizontal rectangle of the arm of the Cross is stretched firmly across the top of the central panel as an emphatic conclusion to the artist's note-perfect performance.

It would seem unlikely that anything having to do with a picture as quiet and tender as Perugino's *Crucifixion* could apply to a picture as violent and complicated as Picasso's *Guernica* (233), but compositionally the two paintings have an unexpected similarity. Perugino's altarpiece is a triptych, that is, it is made up of three separate panels, each side panel measuring half the width of the central one (because the side panels of triptychs often are hinged to fold over and protect the main panel). Picasso's painting is not actually divided into panels, but it also is composed as a central scheme with two "wings" of half its width divided from it by vertical lines, yet at the same time united to it, like Perugino's, by repeats and continuations of the main lines of a triangular formula. These the reader should be able to trace for himself.

Guernica is an extremely large painting (more than 25 feet wide), so large that one tends to look at it in sections. The triptych-like division makes the picture more decipherable section by section, since each section can be seen as a separate entity, but at the same time the three sections are a tightly knit unit when the picture is seen as a whole, as it is in our illustration, or at a sufficient distance from the original.

But the similarities between the two pictures end with their compositional skeletons. Whereas Perugino is serene, Picasso is violent; whereas Perugino is content to be conventional, Picasso is explosively original. Perugino, through realism, synthesizes an ideal beauty; Picasso, through distortion, creates an expressive brutality.

Guernica is a passionate indictment of a shameful incident that presaged the worst horrors of World War II. On April 26, 1937, market day in the peaceful village of Guernica, this ancient capital of the Basque people was bombed with high explosives, antipersonnel shrapnel, and incendiaries by German planes in the service of the Spanish Fascists in rebellion against the Republican government, to which the Basques were loyal. The bombing was part vengeful, part a cold-blooded experiment in the effectiveness of attack from the air—although Guernica was not in any way a military objective, and was defenseless. The painting is a carnage of dead, dying, and mutilated animals and human beings. In the right "panel" a figure is swallowed by a flaming ruin (234). On the left, a bull, symbolizing brute force, rises triumphantly over a woman who shrieks in grief as she cradles her dead child (235). In the lower part of the central panel a severed arm holds a broken sword, a traditional symbol of heroic defeat. The head of the horse

234. Figure from Guernica.

235. Figure from Guernica.

that rears from the center of the picture is grotesque, ugly, and, in a hideous way, ludicrous. But death by such violence is also grotesque, ugly, and even hideously ludicrous. *Guernica* is an overwhelming picture. There is every reason to believe that it will remain one of the half dozen masterpieces of twentieth-century painting.

Both Perugino's *Crucifixion* and Picasso's *Guernica* have as their subject social crimes of monstrous proportions. The difference is that the Perugino represents a social crime resolved into the divine blessing of man's salvation; hence it is painted with the serenity of divine confidence. But nothing can resolve the crime of Guernica into anything better than a staggering demonstration of viciousness and brutality—hence it is painted in terms that are as ugly and nightmarish as the crime itself.

Having seen the foregoing examples, we should immediately recognize the triangular formula in Antonio Pollaiuolo's Martyrdom of Saint Sebastian (236). The executioners' bows and arrows define the scheme like direction pointers. The arrows of the two men standing in the foreground point toward the apex of the triangle, while their bows, at right angles to the arrows, are part of the counter scheme, which is more conspicuously stated by the figures and arrows of the two executioners in center foreground.

But in this composition we have an important variation on the formula: here the composition demands to be read in depth, in three dimensions, if it is to be most effective. The executioners form a ring around the stake, and we read it as a ring. Thus, instead of a flat triangular composition, we have what would be better described as a tent-shaped or cone-shaped or pyramidal composition. It is as if the flat triangle had been spun on its pivot (the stake), and all the forms arranged in the spatial volume thus defined. Pollaiuolo insists on the spatial character of his composition by the sweep of his landscape, which opens into depth rather than hanging behind the bowmen like a tapestry on a wall.

He leads us into this depth by a series of transitions between the foreground, middleground, and background. A small plain with men and horses leads us to the river and hills, then into the horizon and the limitless sky. Admittedly the transition from foreground to middleground is rather abrupt. In dealing with a new concept of space in picturemaking, the unification of foreground and background in three-dimensional compositions was one of the most vexing problems painters had to solve.

Now, it may be asked why painters developed an interest in three-dimensional space when the possibilities of two-dimensional expression are so great; it could even be argued that a painter is working on a two-dimensional surface and should respect it as such, leaving three-dimensional design to the sculptor, the architect, the stage designer, and any other artist whose medium legitimately and unavoidably involves the third dimension. It may be asked why the Japanese and the Chinese, with their infi-

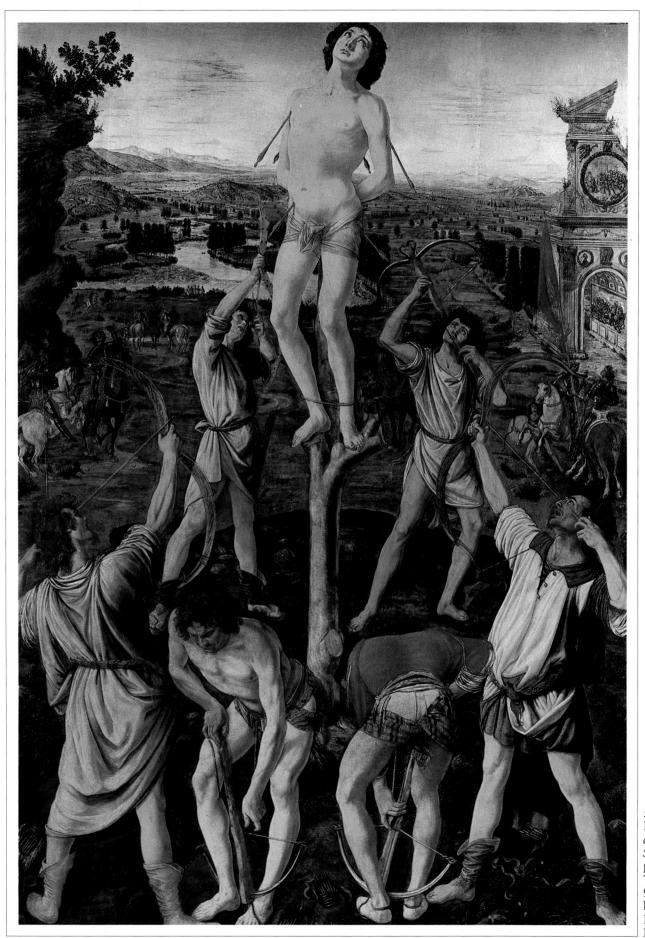

236. Antonio del Pollaiuolo. Martyrdom of Saint Sebastian. Completed 1475. Tempera on panel, 9 feet 7 inches by 6 feet 8 inches. National Gallery, London.

nitely cultivated traditions in painting, never felt the necessity of creating spatial illusions but were content to express entire mountain ranges in a few washes upon a surface that was allowed to maintain its integrity.

A proper answer to these questions would require a volume of philosophical and historical explanation. But somewhere within it would be an examination of this point: that the Western scientific spirit, which insists upon knowing the world by investigating its tangible realities, was born to all intents with the Italian Renaissance. Artists in harmony with their times were no longer content with pictorial symbols but sought instead to paint the world in images as nearly as possible real in a tangible sense. To this end they studied anatomy, invented perspective, and explored the laws of movement, light, and color. It is obvious that objects drawn and painted to express a third dimension, to look solid, could not compete successfully with the constant physical denial of a panel's (or a canvas's) twodimensional surface. Hence this surface was "done away with" to create space in which solid objects could exist. When this happened, the artist's problem as pictorial composer ceased to be one of arranging flat shapes on a flat surface and became one of arranging spatial relationships between objects in depth.

We have just said that in the *Martyrdom of Saint Sebastian* Pollaiuolo was unable to make an entirely satisfactory transition from foreground to middle distance. He compromised by placing the foreground action upon some kind of ambiguous promontory that terminates—not satisfactorily, not quite understandably—and breaks the background in half. How successfully later artists finally achieved the full integration of space is apparent in Jacob van Ruisdael's *Wheatfields* (237), painted in the mid-seventeenth century. The transition from foreground to infinity is easy and uninterrupted. As we enter the landscape and go deep into it, space is all about us—beyond us, behind us, to every side, and infinitely above. Space, rather than the objects within it, is the dramatizing and unifying component of the composition.

From the foreground, which we see as though we were standing upon a slight elevation, we are led down a road into a clump of trees, through them, and into the vast, cloud-filled sky. The trees, even though they partially obscure the horizon, are a zone to be entered and passed through, rather than a barrier. We are invited through natural alleyways between their trunks; we discover an area enclosed by an old wall, but it does not constitute an obstruction since we are faced by a wide opening (238).

As if to make certain that we feel free to enter and explore all this space, a man walks into the picture toward two figures in the middle distance, a woman holding a child by the hand. The forms of the landscape radiate around this pair like the spokes of a vast wheel around its hub, an effect emphasized by the outward lean of the trees at the right and by the dead branch in the left foreground.

237. Jacob Isaacksz van Ruisdael. *Wheatfields*. Date uncertain. Oil on canvas, 39% by 51½ inches. The Metropolitan Museum of Art, New York.

238. Detail from Wheatfields.

239. Piero della Francesca. *Madonna of Mercy*, center panel of triptych. 1445–55. Oil and tempera on wood, height about 57 inches. Communal Palace, Borgo San Sepolcro, Italy.

There is nothing particularly unusual about the fields and objects making up this landscape, nor is there intended to be. It is a rather ordinary bit of countryside, even more ordinary to the people for whom it was painted than it is to us, since time has given the costumes a fillip of the quaint and foreign. Space, the place these objects occupy, the infinite depth to the horizon and beyond it, the infinite upward reach of the sky, is the artist's subject. The earth, the trees, the clouds, exist more to create this space than for their own inherent interest.

You may remember that in an earlier chapter we compared two paintings, Cézanne's Mont Sainte-Victoire and Durand's Scene from Thanatopsis (23 and 24), commenting that Durand sought to create limitless expanses stimulating to the imagination, while Cézanne sought the opposite, a contracted and enclosed landscape that could be comprehended by the intellect. These are the two basic approaches to spatial composition, whether the subject is a landscape, a "roomscape" like the Vermeer of the artist's studio (164), or a figure composition. The picture we have just seen, Ruisdael's Wheatfields, belongs in the same group as Durand's imaginary landscape. Of course it is a gentler. more realistic scene, but like the Durand it suggests that space is infinite, not defined, extending on every side beyond the limits of the frame. Vermeer's roomscape, on the contrary, keeps us securely within a small, well-defined cube of space, where everything is so neatly disposed that a sense of order, harmony, quiet, and security is relayed to us.

These two contrasting space concepts can be called closed space and open space, or classical space and romantic space, comparable to closed and open form in sculpture. As an example of a close-knit composition in classical space, we will examine Piero della Francesca's Madonna and Child with Saints and Angels Adored by Federigo da Montefeltro (240), a formidable title for which we will substitute here the more convenient one of the Brera altarpiece, taking the name from the gallery in Milan where the painting now hangs.

The Brera altarpiece is so important that we will approach it through an earlier painting, *Madonna of Mercy* (239), in which the artist is working toward the kind of spatial composition he so magnificently achieves in the later example.

The *Madonna of Mercy* shows us the figure of Mary geometrized into a form approximating a channeled column, surmounted by a head and neck of even more geometrical character. She extends her arms to make a shelter of her cape for the figures at her feet. Considered in two dimensions, this is an impressive painting; its air of contemplation and gravity is characteristic of all Piero's art. But as a composition in three dimensions, its impressiveness is increased. The cape then forms a semicircular enclosure; we look into it as if it were a niche behind the column-like figure. Seen in two dimensions the worshippers on either

240. Piero della Francesca. Madonna and Child with Saints and Angels Adored by Federigo da Montefeltro (Madonna of the Egg). Tempera on wood, height 8 feet 2 inches. Brera Gallery, Milan.

241. Detail from Madonna and Child.

side are only rows of figures, but in three they form two half-circles into the depth of the picture, curving away from us into the niche of the robe. Thus the worshipful band surrounds the central figure instead of merely flanking it in clusters at either side.

This is a fairly elementary arrangement of forms, but in calling it elementary we must remember that Piero was a pioneer in three-dimensional composition. Also, the arrangement loses much of its three-dimensional effectiveness because the gold background is flat and tends to flatten the figures in front of it. Hence there is a contradiction between the three-dimensional arrangement of the figures and the two-dimensional background, a contradiction that could have been remedied by a background of painted forms harmonizing with the spatial forms in the foreground. Such a background could have repeated the column-like and niche-like forms to emphasize rather than nullify them.

This is exactly what has been done in the Brera altarpiece. Here, about twenty-five years later, Piero amplifies the virtues and corrects the shortcomings of the *Madonna of Mercy*. The Brera altarpiece is completely three-dimensional in conception, so much so that if we analyze it as an arrangement of surface lines and shapes, it is an indifferent composition—tending to divide into two parts, with its upper half occupied by an architectural background of some beauty but not much point.

But when the figures and background are regarded as a combination of solid objects and shaped space, the composition is firmly and beautifully unified in all its parts. We have to remember that the voids are as important as the solid forms. These voids are sometimes called negative volumes (as we have already seen in sculpture, where the concept is a bit easier to grasp).

The various forms, positive or negative as volumes, combine to create an impression of majestic repose. Again the Madonna is encircled by saints and angels, but this time the ring spreads out in the foreground so that in a ground plan the figures would be standing in an arrangement like the letter omega (Ω) . The niche in the background is thoroughly integrated with this curving plan; from its back the form of a shell curves outward toward us. An egg (often a symbol of resurrection) suspended from the tip of the shell is the solid core of a series of spatial volumes surrounding it (241). These volumes are defined and enclosed by the projecting canopy, the niche, and the arch above it. Two other arches at the sides curve toward us, suggesting limitations of space instead of leaving us free to wander beyond this compact scene. If one figure breaks from the scheme it is that of Federigo da Montefeltro, the armored man who kneels at the right. This divorce is intentional, for he alone among the congregation is neither saint nor angel but merely the patron of the artist, and it is right he should be a little separated from the holy band.

Compositionally, the Brera altarpiece is so much an exercise in solid and spatial geometry that it is no surprise to learn that Piero della Francesca was as interested in

mathematics as he was in painting. (He combined these interests to formulate the laws of perspective.) There are critics who feel that his late works, including the Brera altarpiece, are concerned too much with mathematics and too little with human sensitivities. Whether you agree will depend upon what you look for in painting. The Brera altarpiece does have an extreme reserve, but for those who respond to Piero's analytical approach, the geometrical forms suggest a nobility and a steadfastness appropriate in such a picture, lying beyond the too-human weaknesses and indecisions that harass all of us. This removal from the trivialities of daily life is expressed also in the curiously grave facial type that Piero repeats again and again (242).

When we say that the quality of this painting is architectonic, we are not referring to actual architectural elements like the niche and the arches that happen to be included in its composition. We mean the scheme is conceived and arranged in terms of structure. In this case the creation of spatial volumes, a primary conception in real architecture, does depend to a large extent upon the architecture in the picture; but the same architectonic attitude is present in the volumes created by the ring of worshippers, the egg, and the figures of the Madonna and Child.

Piero della Francesca's Brera altarpiece, which employs pictured architecture as an aid in creating architectonic values, may help us perceive architectonic values in Cézanne's *The Card Players* (243), which does not. Cézanne painted several versions of this subject with varying numbers of figures; all of them share the same solid and enduring quality so marked in this one. The direct comparison to architecture should not be pushed too far, but it is easy to see that the three men around the table, leaning forward over their cards, suggest domelike space, while the standing figure suggests the strength and stability of a column.

The Card Players lends itself to comparison with architecture, but with no loss of warmth. Where does this warmth, this human quality, come from, and how does it manage to exist in harmony with abstract values like the architectonic ones we have been talking about? Why is the quality of human warmth present here, while it has been distilled out of the Brera altarpiece, which we analyzed in much the same compositional terms?

Cézanne's idea was that the fundamental dignity of human life, the fundamental order that gives meaning to life, could be best expressed by geometrical forms of great solidity and simplicity arranged in organized space. In his paintings these forms are sometimes human beings, sometimes mountains, sometimes merely fruit and simple bowls and vases disposed on a tabletop. Ornate, precious, or unusual objects could have been used in the arrangements, but less successfully. (One critic, Sir Charles Holmes, commented that in a Cézanne, a crumpled tablecloth could take on the majesty of a mountain.) Cézanne's importance as the father of modern abstract art is so impressive that too little attention is paid to his subject matter. He may not be

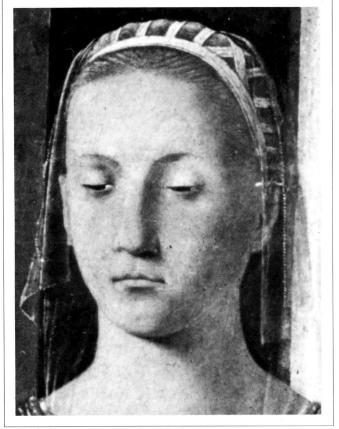

242. Detail from Madonna and Child.

243. Paul Cézanne. The Card Players. 1890–92. Oil on canvas, 25½ by 32 inches. The Metropolitan Museum of Art, New York. Bequest of Stephen C. Clark, 1960.

interested in his card players as personalities and he is not interested in them as members of a certain social class with certain problems; but it is important in this picture that the men are simple, earthy people. One of them wears a peasant's smock. The picture might be almost—but not quite—as effective if the players were doctors, lawyers, or successful businessmen. Cézanne chooses to make them simple people for the same reason that he painted apples and pears in his still lifes instead of rare exotic fruits.

The Card Players is not first of all a picture of four honest men of an unpretentious social level. It is first of all a structure of solid volumes that interlock with spatial volumes. But it is wrong to argue that the subject matter has no importance at all. Many contemporary painters do so argue. They try to eliminate subject altogether, dealing with pure forms, as we saw in our discussion of abstraction. But Cézanne is a major figure in the history of art because in pictures like *The Card Players* he achieved a perfect fusion of abstract and realistic values.

It is difficult today, even for those who dislike modern art, to understand why Cézanne was so viciously attacked in his own time as an incompetent or degenerate artist. The figures in *The Card Players* are downright realistic in comparison with abstraction today, but to Cézanne's contemporary audience they looked appallingly crude. Popular taste demanded slicked-up, semiphotographic images. Even the more liberally educated art public regarded Renoir's *Portrait of Madame Renoir* and Degas's *Woman with Chrysanthemums* (17 and 21) as pictures that had pushed modernism just about as far as it could go. Cézanne's spatial structure was beyond the understanding of more than a very few critics; it is still the aspect of his art least recognized by a public that has learned to enjoy him without analyzing his methods.

244. Caravaggio. The Musicians. 1594–95. Oil on canvas, 36¼ by 465% inches. The Metropolitan Museum of Art, New York, Rogers Fund, 1952.

245. Théodore Géricault. Raft of the Medusa. 1818–19. Oil on canvas, 16 feet 1 inch by 23 feet 6 inches. The Louvre, Paris.

The two paintings we have been comparing may leave the reader with the impression that three-dimensional compositional structures are always concerned with the majestic and the monumental. Let us, then, compare *The Card Players* with Caravaggio's *The Musicians* (244, p. 187), a seventeenth-century example. Like *The Card Players*, it is composed of a main group of three closely related figures, with a fourth, subsidiary figure in the background. The Cézanne is powerful; the Caravaggio, elegant. The Cézanne is concerned with the basic values of human life; the Caravaggio, with sophisticated ones.

Both pictures, however, are conceived as arrangements of volumes within a block of space. The forms of the Caravaggio weave in and out, back and forth, carrying us into little pockets of space and leading us out of them, offering us a series of sensuous delights in the rich fabrics, fine woods, ripe fruit, and handsome youths.

The Cézanne, on the other hand, does not lead us from form to form but focuses on the completed structure as a whole. We may examine either picture detail by detail, of course, but our interest in the details of the Cézanne does not last long; it is its wonderful completeness, its total unity, its cohesiveness, that gives *The Card Players* its monumental strength.

The clashing forms of Picasso's Guernica, for all their violence, are held within an evenly balanced scheme; they are motionless, as if revealed in an instant of blinding illumination. Pollaiuolo's Martyrdom of Saint Sebastian, which also illustrates a subject of some violence, is without movement. The archers are frozen at the precise moment when they are about to release their arrows or just about to complete the action of reloading their bows. We have commented on the wave of action in Leonardo's Last Supper. but the wave passes along a series of essentially static poses and goes only across the surface, not into the depth, of the picture. The Caravaggio Musicians has something of this same flowing quality except that, as we have seen, the flow is into and out of and around and about rather than across the surface. The musicians are not actually represented as being in motion, but the sinuous lines, which keep the eye moving within the picture, suggest motion.

How one painter solved the problem of composing a picture that is at once a firm structure and an expression of violent motion is demonstrated in Théodore Géricault's *Raft of the Medusa* (245, p. 187), painted in 1818, where the survivors of a shipwreck are crowded on a raft in a stormy sea with others who are dead or dying. The main path of action boils upward and across from the lower left to the upper right, where the figure of a young man, supported by a struggling group, waves a cloth in an attempt to attract the attention of a ship in the distance.

It is at once apparent that again we have a composition that builds up to a climactic figure by means of a triangle. The usual devices of outstretched arms, the direction of some glances, the disposition of draperies—all play their conventional roles. The difference is that the triangle is pushed off center so that it leans far to the right instead of resting in the center of the picture. This unbalance does not constitute action in the literal sense of the word, but the composition nevertheless creates the effect of action. You need only imagine the climactic figure at the top of a symmetrical triangle, centered in the space, to see that the effect, or impression, of motion would be lost or reduced, no matter how much the individual figures writhed and twisted in an attempt to create a feeling of movement.

This lopsided triangle leaves the picture overweighted on the right. Géricault brings it back into balance with a counter triangle leaning in the opposite diagonal direction, defined by the mast of the raft and the ropes that support it. This is a strong shape with echoes throughout the composition (the strongest one being the body of the dead youth in the foreground, which lies half off the raft), but the mass of struggling survivors holds our interest against the strong counteraction. To make certain that it does, the artist has weakened the counter triangle and strengthened the main one by a simple device: he interrupts the strongest line of the counter triangle by cutting the line of the rope against the sky with an arm that points toward the peak of the main triangle.

The result is a composition that creates an effect of action by its off-balance climax, but retains its strength as a pictorial structure by a neat counterbalance. And the whole scheme is a variation of a fundamental formula, the triangle and its inverted echo, that had been effective in one treatment or another for several hundred years.

The Raft of the Medusa is a conspicuous landmark in the history of painting because it became a battle cry for the famous romantic movement, which stressed emotionalism and individual invention instead of the intellectualism and observance of convention that dominated the arts at that time. We have already made the distinction between closed (or classical) space and the open space of romanticism. Actually, the Raft of the Medusa does not quite fit the romantic definition. The scene is played against open space but the figures are not united with it; they are arranged like an independent monument against a distant horizon. A later picture, Eugène Delacroix's The Abduction of Rebecca (246, p. 190), painted in 1846, is a fuller expression of romantic composition.

The Delacroix swirls from the foreground deep into the background, from the cyclonic forms of the horse, the abductors, and the victim to the excitement around the burning fortress, so that the principal figures are not only played against depth but also integrated with it. Can we analyze the tempestuous forms of the main group? Not with the same clarity as in our earlier, more static compositions. But we can see that the raging excitement is expressed by the constant turns, reversals, and interruptions of forms and their directions. The rider twists backward into the picture while the figure of Rebecca is thrust forward toward us. The horse is ready to charge in a third direction,

246. Eugène Delacroix. *The Abduction of Rebecca.* 1846. Oil on canvas, 39½ by 32¼ inches. The Metropolitan Museum of Art, New York. Purchased, Wolfe Fund, 1903.

and the rider's head is turned in the opposite one. Through the whole group lines snake and twist without rest. Color explodes in fragments over the turbulent forms.

This fragmented color is in direct opposition to the decisively confined color areas of Poussin's *Rape of the Sabine Women*, to which we are now ready to return. Several questions arise in the light of what has been said since we first saw this painting. Is it a composition in three-dimensional space? We analyzed its framework in two dimensions across its surface. What about the emotionalism of the subject and the apparently contradictory controlled definition of the arrangement? And what about this static composition for a subject of such violent action?—the mass abduction of the women of the Sabine people to supply wives for the womanless followers of the Roman Romulus.

The thing to remember about the Poussin is that it is in no sense an illustration, nor is it an emotionalized expression. It is an intellectual synthesis devoted to the classical idea of ultimate clarity.

The depth of the Poussin is a defined block of static space like that of the Cézanne and the Caravaggio, rather than a portion of swirling limitless space as in the Delacroix. The figures don't seem to move (247) as Delacroix's do; their passion, terror, and rage are not emotionalized for the observer, but objectified. We do not participate in the abduction of the Sabine woman as we do in the abduction of Rebecca. Instead of participating, we contemplate; instead of feeling, we reflect; instead of being in a world of action and conflict, we are in a world where all indecisions have been resolved. This is the classical world, where order has been imposed upon chaos, and to some temperaments it will always seem too static, a little cold, and impossible of reconciliation with themes of violence. But for others there is more satisfaction in this harmoniously disposed world of Poussin's, a world of complex balances and multiple relationships distilled from human experience. Poussin's composition says that all human experience is meaningful beyond its moment, that the moment may be overpowering in the immediacy of its joy or anguish, but there is an eternal order within which the moment is absorbed.

In looking at paintings in this chapter we have been dissecting them to discover their structural systems, sometimes only as the skeletons that hold them together (as in the case of Pollaiuolo's *Martyrdom of Saint Sebastian*) but usually, in addition, as an artist's means of interpreting pictorial subject matter, with Leonardo's *Last Supper* as an exceptionally clear example. It has been a matter of looking beneath surfaces for the increased pleasure that an understanding of a painter's methods can give us.

In sculpture and architecture the situation is often reversed. When structural systems are exposed and selfexplanatory, unencumbered by any overlay, they may become the immediate source of the pleasures we are offered.

Kenneth Snelson's Audrey I (248)—the title is a form

247. Detail from Rape of the Sabine Women.

248. Kenneth Snelson. *Audrey I.* 1965. Porcelainized aluminum and steel, height 7 feet 2 inches. The Cleveland Museum of Art. Gift of Kimiko and John Powers, Aspen, Colorado.

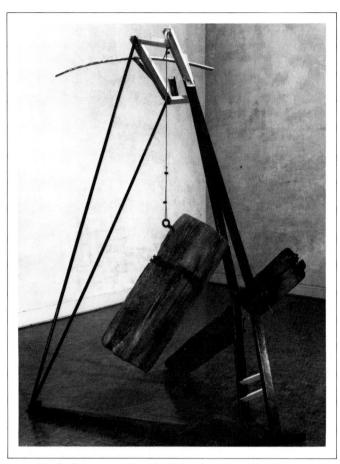

249. Mark di Suvero. Untitled. Steel and wood, 19 feet 11 inches by 6 feet 9 inches.Greenville County Museum of Art, South Carolina. Gift of Elaine de Kooning.

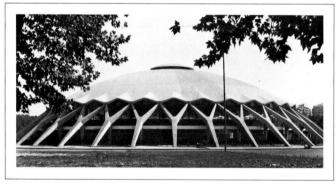

250. Pierluigi Nervi and A. Vitellozzi. Palazzetto dello Sport, exterior. 1956–59. Rome.

of dedication, not a subject, for the sculpture has no other subject than itself—is a structure of porcelainized aluminum tubes and steel wires held in a complex of interdependent balanced stresses. "Tensegrity" is Snelson's term for his form of engineering, and brilliant engineering it is. But it is engineering employed in the creation of sculpture of a very high order, coming close to full realization of the paradox of dematerialization declared as a sculptural goal back in 1920 with Gabo's "We deny volume as the expression of space... we reject physical mass as a plastic element." Gabo often called his sculptures "linear constructions," and we have seen one example (60). Snelson's tensegrity sculptures have been called line drawings in space, but he is in no way a follower of Gabo, who thought in terms of transparent planes. Snelson's aluminum tubes seem to float; contradictorily they are held in a system of extreme tension and compression. These static structures, filled with a sense of vibrant internal life, are defamed if compared to skeletons. They are more like nervous systems.

But to qualify as a work of art, this sculpture should "say" something beyond its amazing visual effectiveness as an engineered structure. Does it? Compare it with an untitled sculpture by Mark di Suvero (249). In contrast with Snelson's sleek, spare, hollow cylinders and thin wires, di Suvero's sculptures are compounds of ponderous, crude, found materials: heavy, weathered, scarred raw-cut beams. old chains, hawsers, cables, now and then such oddments as old tires or inner tubes. They seem (deceptively) to have been assembled on a semi-improvisational basis, one heavy piece added here to prop or buttress another there, a chain or hawser introduced as a provisional support that could be supplanted by another arrangement, one idea suggesting the next, in a process of asymmetrical growth that might change or continue, while Snelson's structure is finite. Di Suvero's structure is primarily a matter of weights; Snelson's entirely a matter of tensions. But regarded as expressive works of art, the two sculptures become more than contrasting structural exercises. They are expressions of the bilateral nature of all art, the reciprocal relationship between the intellectual and the emotional, between calculation and impulse, between what we call the classical and the romantic spirits. Both are wonderfully alive, with the difference that if we can compare Snelson's sculpture to a nervous system, di Suvero's has the character of muscles and tendons.

The biological metaphor of nerves, muscles, and tendons could apply to that form of building that has been recurrent in this book—the Gothic cathedral, where the structural systems of rib vaults and flying buttresses are fully exposed. We have also referred to the "exoskeleton" of the Pompidou Center (83), and have seen how structure, exposed and unornamented, was synonymous with fantasy in that landmark building, the Crystal Palace (123). These are conspicuous rather than isolated examples in the history of construction-as-architecture (a near-relative, but not identical with, form-follows-function), and of the architect-

as-engineer or engineer-as-architect. One of the latter who has had a strong influence on modern building is Pierluigi Nervi, who capitalized early on the innate architectural qualities of ferro-concrete construction. Unlike Saarinen, who, in his sculptured TWA Terminal (162), took advantage of concrete's plastic quality in a largely arbitrary design, Nervi, a purist, insistently observed the principle of making the most of the beauty natural to this form of construction. His Palazzetto dello Sport in Rome (250 and 251) is an example.

The engineering of bridges, whether from the vines and bamboo of primitive jungles or the girders and cables of today's suspension spans, has produced probably the most beautiful examples of nonarchitectural construction over the ages. One example of this form of civil engineering, where architectural principles of harmonious proportion and the practical solution of a problem are inseparably fused, demands our attention: the Pont du Gard near Nîmes in southern France (252), built by the Romans shortly before the birth of Christ as a viaduct combining the functions of roadway (in which capacity it is still sound) and aqueduct.

Modern engineering could have supplied pumps for this transfer of water, but the height of the Pont du Gard was determined by the necessity of observing a proper slope from the hills to the city, hence the two arched courses over the one supporting the roadway. The splendid second course is marked by protruding blocks of stone that supported scaffolding during construction and would ordinarily have been cut away; here they were left in case scaffolding was needed in the future for repairs. For the final course, the water channel proper, any crude stone casing would have done; but the architect-engineer terminated his design with the small arches, four to each of the large ones below, to make the Pont du Gard a masterpiece from the always fruitful union between structural engineering and architectural design.

Today we are more conscious of the Pont du Gard as architecture than as engineering because we are more accustomed to thinking of the stone arch as an ornamental form than as a functional structure. But we are also conscious of the beauty of a modern structure like the Verrazano-Narrows Bridge (253), even though its design and proportions were determined entirely by engineering in the service of practical demands. Between such structures and the structural schemes of paintings like Leonardo's Last Supper and others we have seen in this chapter, there could hardly be a wider difference in conception. Yet logical structure—whether in a purely functional bridge, the exposed engineering of a cathedral vault, the arbitrary balancing of weights and tensions in sculpture, or the abstract scheme that underlies and binds together the pictorial surface of a painting—has a profound psychological effect upon us as observers. Whether or not we realize it, we are being reassured that order can be distilled from the chaos of human experience, and this, by a definition we have already offered, is a primary function of art.

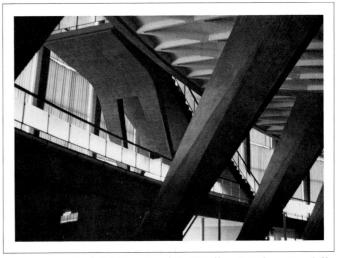

251. Pierluigi Nervi and A. Vitellozzi. Palazzetto dello Sport, interior forms. 1956–59. Rome.

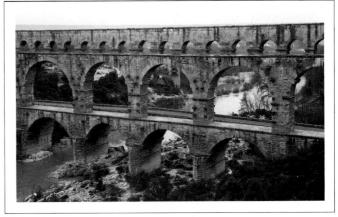

252. Roman. Pont du Gard. First century B.C. Near Nîmes, France.

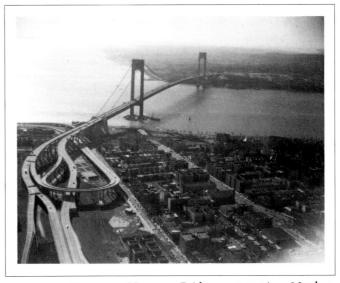

253. Verrazano-Narrows Bridge, connecting Manhattan and Staten islands, New York. Main span 4,260 feet, height of towers 690 feet above water. Construction started August 13, 1959; bridge opened to traffic November 1, 1964. O. H. Ammann, engineer.

254. Rembrandt. The Company of Captain Frans Banning Cocq and Lieutenant Willem van Ruytenburch (The Night Watch). 1642. Oil on canvas, 11 feet 5¾ inches by 14 feet 4½ inches. Rijksmuseum, Amsterdam.

Chapter Nine

COMPOSITION AS NARRATIVE

In analyzing pictorial compositions first as patterns, and then as structures, we have also been seeing composition as a means of expression. Leonardo's *The Last Supper* is one of the most logically constructed of all pictures, but the compositional system that binds the picture together as a firm structural unit serves composition's second and equal function of expression. The graceful, swinging arabesques that tie together the various figures in Botticelli's *Primavera* could never have served Leonardo as a substitute for the geometrical framework of the *Last Supper*, nor, in turn, could this framework have been anything but ruinous if the *Primavera* had been forced into its general lines. Yet both compositions, along with the others examined in the last two chapters, are built on general rules that apply to the majority of pictorial schemes where balances and counterbalances must be adjusted to give the desired relationships—psychological and structural—to the component parts of a picture.

Basic compositional rules have served artists for centuries without inhibiting invention or individual interpretation, but frequently an artist will depart from the rules or deliberately violate them to satisfy special demands. Degas's Woman with Chrysanthemums, one of the first paintings we discussed (21), is an instance of such violation. In this chapter we will see other instances remarkable for their ingenuity as means of expression or narration, as well as some less radical instances that will help to clarify the special examples—beginning with three paintings: Rembrandt's The Company of Captain Frans Banning Cocq and Lieutenant Willem van Ruytenburch, more conveniently if inaccurately known as The Night Watch; Charles Willson Peale's The Peale Family; and Degas's The Bellelli Family. Painted respectively by a seventeenth-century Dutchman, an eighteenth-century American, and a nineteenth-century Frenchman, they contrast strongly with one another. Yet they share a common problem in composition, which they solve in different ways. All are group portraits, and the group portrait is as vexing a compositional problem as a painter is ever required to solve.

In a group portrait each member must be awarded his proportionate share of interest and prominence. Obviously this condition limits the artist's freedom in arranging his material, since ordinarily he is free to assemble as many or as few figures as he wishes and to dispose them at will to build up whatever focal climax he wants. In a group portrait where all the members share equal interest and importance, his problem is to involve them in a composition that will be interesting in itself, rather than being merely a line-up of figures like, say, the usual graduating class photograph.

Rembrandt's problem in *The Night Watch* (254), as we will call it, was to catalogue the features of the individual members of an organization (which was

255. Rembrandt. *The Anatomy Lesson of Dr. Tulp.* 1632. Oil on canvas, 66¾ by 85¼ inches. Mauritshuis, The Hague, The Netherlands.

essentially social in spite of the military connotations of its name) and to create at the same time an inherently interesting picture. With some twenty figures to be included, he chose the device of showing them at the moment when they respond to the commander's order to get into parade formation. Individual psychological studies were not attempted, as being less appropriate here than in another kind of picture, say a call to arms in which every man would respond to the emotional moment in his own way. In an earlier and smaller group portrait, The Anatomy Lesson of Doctor Tulp (255), Rembrandt gave the individuals their own psychological identities as they react to the dissection, but in The Night Watch it was more reasonable to subordinate identity to activity. This was, in fact, the only feasible approach to such a large and complicated subject. The Night Watch is primarily a rendering of light and movement organized in space, and would be disrupted if our attention were called to a variety of psychological factors within it. For that matter, the call to parade formation would not stir a very interesting variety of individualized responses.

The Night Watch has been a much misunderstood picture. It was long obscured by coats of yellowed varnish and layers of dirt that reduced its color to a murky gloom punctuated by figures, some of them only half-visible, others revealed here and there as if by torchlight. Thus it acquired its inaccurate popular title—and the subject was thought to be a call to arms. It is not a night scene at all. During World War II the canvas was dismounted (it is a huge picture, more than 13 feet high) and hidden for safekeeping. After the war it was cleaned before being put back on exhibition. Cleaning revealed details in the background that had been obscured, brought minor figures into proper relation with the others, and above all brightened the yellow glow to reveal the members of the "night" watch occupying a spacious room in which cool daylight flows.

The members of the company are awarded varying degrees of prominence, but each is clearly visible. The fact that some of them had all but disappeared under layers of varnish and grime helped give rise to the legend that when Rembrandt completed the picture it was rejected by the company, ruining his career and beginning his long decline into poverty and relative obscurity after early success. This decline—in success, not at all in Rembrandt's power as an artist—did in fact take place. But the reasons for it must be found elsewhere; there are no factual circumstances to support the legend that The Night Watch was a disastrous landmark in the painter's career. The introduction of incidental figures, especially the girl so conspicuous in the pool of light to the left, was by the same legend arbitrary on Rembrandt's part. He was supposed to have used these figures as convenient elements in the creation of his dramatic composition, in spite of the fact that they had no justifiable relationship to the shooting company whose members had paid to have their likenesses recorded. But these figures are now believed to have emblematic significance.

256. Charles
Willson Peale. The
Peale Family. 1773
and 1809. Oil on
canvas, 56½ by
88¾ inches. The
New-York
Historical Society,
New York City.

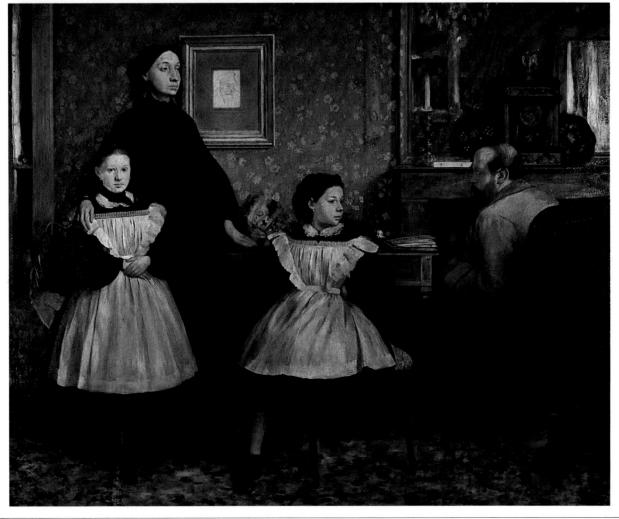

257. Edgar Degas. The Bellelli Family. 1859. Oil on canvas, 78¾ by 99½ inches. The Louvre, Paris.

However, if cleaning and historical reconsiderations have brought us back to a more proper understanding of the picture, it has suffered one irremediable disfigurement. The canvas was at some time cut down on both sides and at the bottom, crowding the figures at left and right in a way that is obvious at a glance, and making a less apparent but more serious shift in the relation of the two central figures to the rest. As the picture now exists, these figures are too obviously centered. Originally they were off center; this placement emphasized the feeling of movement and excitement of the composition, a device already familiar from previous discussions, especially in Géricault's *Raft of the Medusa* (245).

As a solution to a problem, *The Night Watch* was a skillful consolidation of a given number of figures into a group portrait and, under the conditions of this particular assignment, seems to have been satisfactory to the clients who commissioned it. In our two other examples, the Peale and Degas family groups, the drama and monumentality of *The Night Watch* would of course have been altogether inappropriate. Family subjects demand intimacy rather than dramatic excitement, an intimacy based on the psychological interplay between individuals whose lives are closely bound together. Yet the two family groups contrast with one another just as strongly as the pair of them contrast with the Rembrandt. In both pictures the painters employ composition to express contrasting psychological values.

Peale began work on the group portrait of his family (256) about 1773. Nine of the people in the picture are family members by birth or by marriage. The tenth is a matriarchal family nurse who stands in the background, hands folded, with all the dignity of a great natural monument. For good measure Peale includes three familial portrait busts on the shelf to the right, and as an afterthought adds the portrait head of a member who joined the family after the picture was half-finished, the dog Argus.

Argus, as a pup, was left to the Peales by a grateful old Revolutionary soldier who pulled him out from under his blouse in return for a free meal. The Revolution had come and gone since Peale began the picture. For many years he kept it unfinished in his studio as a kind of demonstration piece. In finishing it, he added the portrait of Argus, by then venerable, and the following inscription at center right: "C. W. Peale painted these Portraits of his family in 1773. wishing to finish every work he had undertaken—compleated this picture in 1809!"

A little arithmetic shows that the picture was completed thirty-six years after it was begun. This explains why Peale, who was sixty-eight years old at the time, appears in it as a young man of thirty-two. He stands to the left side, holding a palette and bending over to inspect a drawing on which his brother, St. George Peale, is at work.

The Peale Family is a delightful painting. John Adams, who saw it in 1776 in the painter's Philadelphia studio, wrote in a letter: "There was a pleasant, a happy cheerful-

ness in their countenances, and a familiarity in their air towards each other." And the intention of the picture is no more complicated than that. It presents an ideal façade of family life, informal, affectionate, harmonious, and secure. The canvas on the easel in the background, the picturewithin-a-picture upon which Charles Willson Peale has been at work, originally bore the phrase Concordia Animae as a clue to the meaning of the whole painting. But Peale later eliminated these words, "the design being," he wrote to his son, "sufficient to tell the subject," as indeed it is. A glance at *The Peale Family* is enough to show that the ten people in it are happily united as a group. They are pleasantly disposed and share the limelight without competing for it (although Argus, it must be confessed, remains what he was when he was introduced into the composition, a postscript).

Compositionally, the subjects are divided into two groups, six figures clustered at the left and three at the right side, or, if you include the nurse, four. She stands in a nicely selected relationship to the family proper, expressive of her position in the household, closely allied with the other figures yet slightly removed, painted as she is in more subdued tones and standing as she does in the only attitude not physically bound to the rest by contact of a hand or a shoulder.

If all the figures had been massed together, they would have looked crowded and monotonous. Hence the division into two groups. But this is a family, a harmoniously united family, so it is necessary that we also be conscious of the two groups as a unit. And we are: the two halves are united by a slight overlapping and by a scattering of fruit across the table, a trivial detail, yet an important one in binding the two halves together—as well as a pretty bit of still life gratuitously offered (258). The halves are even more strongly held together by the fact that St. George (extreme left), sketching his mother as she holds a grandchild (extreme right, glances toward her as he draws. This play of interest across the breadth of the picture is a psychologically effective tie, nullifying any feeling of disunity that might have been produced by the physical division into two groups.

Within this firmly knit composition each figure is pleasantly varied. We are conscious of each one as an individual, but we cannot look long at one without being led to another. The composition is not brilliant or complicated; it need be neither to fulfill the painter's conception, which is direct and simple.

Peale's style has a suggestion of dryness in it, like a pinch of salt in a dish that might otherwise have been too bland. There are occasional awkwardnesses in drawing—the hands of the sister standing at the left, one resting on the shoulder of Charles Willson Peale, the other on the shoulder of his wife, are a touch oversize. These hands are not quite as fortunately incorporated as the rest. They remind us that the picture is a group of separate studies synthesized into a whole. Also, the arm of the grandmother

258. Detail from The Peale Family.

cannot bear close examination. Instead of terminating as it should, it continues as a tubelike form and disappears into the shadows a moment too late to conceal from us that it is overlong, and handless. But these imperfections have their own appeal; they account for the suggestion of engaging provincialism that distinguishes the work of this early American painter from that of the facile English portrait painters he would have liked to emulate.

Pictures of this general type, which go by the name of "conversation pieces," are frequent in eighteenth-century and early nineteenth-century painting. Based on the assumption that life is a matter of agreeable surfaces, they are usually built around a theme with incidental reference to some pleasurable activity associated with the subjects, like the exercise in drawing that occupies St. George and Charles Willson here.

The picture is a happy interpretation of family life but not a very searching one, even for a pre-Freudian age. Families are more complicated than this. Family relationships produce frictions and irritations as minor evils, agonizing psychological conflicts as major ones. The brothers. sisters, and in-laws gathered around the Peale table were human beings, and certainly not immune to these difficulties. Just as certainly, in other aspects of their family life they rose to joys more intense than the casual affections so uniformly expressed in the group. Peale does not hint that these human beings have more than an agreeably tepid experience of life, nor does he make much effort, if any, to differentiate one from another psychologically. He was certainly aware of the psychological individuality of his sitters and of the crosscurrents of emotional relationships. but if it even occurred to him that it would be interesting to explore these in a painting, he rejected the idea as inappropriate in a family portrait.

The particular circumstances of individual relationships in all their psychological subtleties fascinated another artist, a young Frenchman who painted a family group in 1859 when he was less than thirty years old. This, you may remember, is younger than Peale was when he began his family portrait. But at that age this Frenchman, Edgar Degas, was already an urbane cosmopolite. He was a doubter, a speculator upon human nature, and basically a pessimist. He spent the better part of a year in Italy in spite of his father's repeated insistence that he return to Paris, for Degas had begun work on a large painting of his aunt, Baroness Bellelli, his two young cousins, and the Baron. In this family there was a less happy state of affairs than the one Peale would have us believe existed in his. Degas reveals it through a composition as original as any in the history of painting, and, as Peale said of his own, "sufficient to tell the subject." "Sufficient" is an understatement. Superlatives are dangerous, but there is less danger than usual in describing The Bellelli Family (257, p. 197) as the finest psychological group portrait ever painted. The temperament of each of the four members is individualized for

us, and, beyond that, their interrelationship is analyzed. Before you read the following paragraphs, you may want to ask yourself on the evidence of the picture what these people were like. In that case try to decide what the relationship of the father to the rest of the family might be, what the emotional tie of each of the little girls is to each of the parents, and what the difference is, temperamentally, between these two children. The chances are that you will learn as much from the picture itself as you will know when you have read the following summary, with the exception of specific historical facts.

From references in family letters we gather that the Baron was a man of uneven temperament, given to moods and, at least during the time Degas visited the family, conscious of frustrations and discouragements both in his personal life and in his career. His only son had died (the family is still in mourning in the portrait) and the Baron was marking time as a political exile from his native Naples. His disturbed life made him half a stranger in his own household, a condition aggravated by an increasing rift with his wife. Social conventions of respectability in the mid-nineteenth century placed limitations on a woman in the Baroness's situation. A reserved, intelligent, and patient woman—if we can accept the judgment of her young nephew—she seems to have shouldered even more of the responsibility for the home and the children than did the average wife of her time. Of the two little girls, the elder, Giovanna, was placid and closely attached to her mother, whereas the younger, Giuliana, was more energetic and restless, temperamentally sympathetic to her father but, by force of circumstance, more securely bound within the lives of her mother and sister.

The most casual observer must notice that in Degas's portrait the father is separated from the rest of the family by a series of vertical lines, which, violating normal compositional rules, separate a generous third of the picture from the rest. In addition, he sits unconventionally, with his back toward us and his profile in shadow. His features are painted less decisively than those of the other figures (259). He is the only one of the family who is not completely revealed to us as a person; we are left with the feeling that we do not know him as we know the mother and daughters. He has a life beyond this room; perhaps he leads a life more important to him than the life we are seeing here; he is an outsider.

But this vagueness, incompleteness, and isolation are reversed in the figure of the wife. She stands with decision, dignity, and forbearance, dominating the room by her quietness. Of all the figures, hers is the simplest and strongest in silhouette; that is why we return to her always, no matter how interesting the rest of the picture may be in its greater detail and variety.

Her right hand rests on the shoulder of Giovanna, the more placid daughter, who was like her and closest to her. This little girl is held within the larger silhouette of the mother's figure; her way of standing echoes her mother's,

259. Detail from The Bellelli Family.

as does her general silhouette—and she stands quietly. She is the only one of the family who looks at us, although the others are aware of our presence. She looks at us unquestioningly, content to stay within her mother's support and protection.

But the other child, Giuliana, partially breaks away from the pair. She occupies the side of the picture separated from the father, yet we feel strongly her connection with him. She is the only one whose glance could, and in a moment might, meet her father's. She sits restlessly, one leg tucked up under her, as if impatient with sitting for her artist-cousin, unable to remain still, the volatile member of the group. Just as she is divided in her loyalty to her mother and her father, so she does not belong wholly to either in the composition of the painting.

It is apparent, then, that Degas set about expressing a specific set of circumstances with the help of appropriate compositional means. When we know the circumstances, the picture takes on some peripheral interest; but it is a great picture because it is expressive of the interrelationships of four people, whether or not we know the specific circumstances. The picture has a life of its own beyond the immediate reasons for its creation. If the identity of the painter and the family were unknown to us, any meaning *The Bellelli Family* might lose would be of little consequence.

The Bellellis are not important to us as individuals. It makes no difference how they looked. Their troubles were never of any significance except to themselves. The relationships so brilliantly revealed were neither unique nor on the grand scale. The picture's greatness lies in its ability to stir us to thought beyond the limited considerations of a single family's not unusual circumstances. And it does so because Degas has crystallized his material into forms of perfect order, rid of all confusions, incidentals, vagaries, and distractions. In the resultant clarity our sensibilities and understanding may expand.

Degas was one of the greatest of all pictorial composers, and *The Bellelli Family*, an early painting, is only one (though one of the best) of a succession of startlingly original compositions. Degas is preeminent in this unconventionality without freakishness. Other great masters of pictorial composition time and again demonstrate their ability to use conventional devices more skillfully than their contemporaries. But Degas invents compositions without direct precedent, and each of these compositions is so special to its subject that none is directly useful to followers hunting a formula. The composition of *The Peale Family* might be adapted to any number of group portraits, but that of *The Bellelli Family* could not.

At the same time Degas was a master of what we call classical composition, although even here he was original in his use of traditional devices. We will compare Poussin's *The Funeral of Phocion* (260), a standard example of classical composition at its zenith, and Degas's *Rehearsal in the Foyer of the Opera* (261), an exceptional classical compo-

sition although it is seldom thought of as one. Beneath their surface dissimilarities, the pictures have much in common.

Poussin's masterpiece, painted in the seventeenth century, is an arrangement of architectural and landscape forms, completely imaginary, beautifully disposed in space, studded here and there with some small human effigies of no very great interest or individuality in themselves. On the other hand, Degas's Rehearsal is an arrangement of human beings drawn from life and sharply individualized, in an identifiable interior of the Paris Opera. The Poussin looks backward through centuries to the half-legendary world of classical antiquity for its subject, a subject involving the great and the mighty. Degas chooses a subject at hand, involving nobody more important than a few secondstring ballet performers, their rehearsal master, and the fiddler who supplies practice music. These people are not even involved in a performance with its attendant excitement and glamour; they are engaged in a routine rehearsal, and some of the dancers are apparently a little bored with the whole thing. Yet both pictures, for all their contrasts, are organized in terms of classical order.

Ultimately the subject of any classical composition is order. We have already seen that all composition is order of one kind or another, but in classical composition order is associated with the idea of repose and may exist almost for itself. What we call a classical composition is conceived in limited space, bounded space, rather than imaginative reaches into infinity. We made this contrast between Cézanne's Mont Sainte-Victoire and Durand's Thanatopsis (23 and 24). We saw other classical compositions in Poussin's Rape of the Sabine Women (228), taking place in architecturally bounded space, and Vermeer's The Artist in His Studio (164), where space was limited to a small room defined on all sides.

Poussin's *The Funeral of Phocion* is designed on the same principle: the satisfaction it gives us is based on the sense of order within a limited world. True, this is a panoramic landscape in contrast with the forum of the *Rape of the Sabine Women* and Vermeer's small room. But the sky is treated more as a backdrop terminating a stage set than as a continuation of space in nature. And even though we have no walls at the picture's sides, we are not offered temptations to wander beyond the frame. We may, however, wander at will within the landscape. Space exists all around the architectural and landscape forms. To enjoy the picture fully we must think of it in three dimensions, not as the flat surface of a canvas.

Actually, we do not wander: we are led. The contour of a hill, the angle of a low stone wall, the placement of a tree, the direction in which a cart moves—all these elements direct us as we explore this microcosm, this small, complete world. We are never allowed to escape from it, any more than we are allowed to escape from Vermeer's small room. Yet the elements composing the world are so harmoniously ordered that we do not feel imprisoned.

260. Nicolas Poussin.

The Funeral of
Phocion. 1648. Oil on
canvas, 45 by 69
inches. Collection Earl
of Plymouth, Oakly
Park, Leidlow,
England.

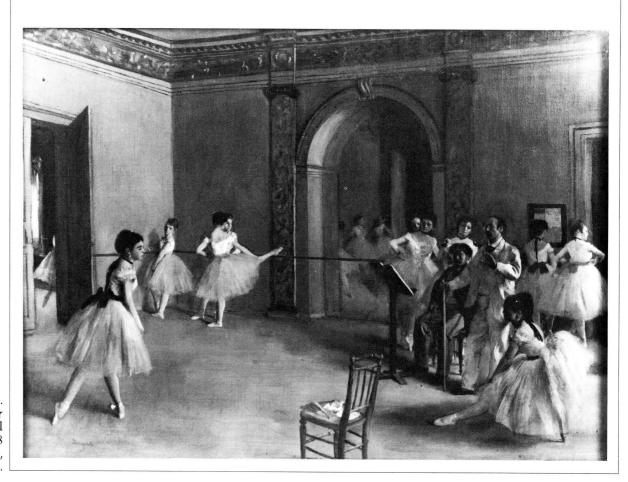

261. Edgar Degas. Rehearsal in the Foyer of the Opera. 1872. Oil on canvas, 12½ by 18 inches. The Louvre, Paris.

Such a picture is the result not of rules but of the artist's feeling for what is right. This feeling, of course, is developed through study, contemplation, and practice. If the means used to achieve its order were too obvious, the picture would be less satisfying. Some of these means, however, are definable and can be pointed out without marring our spontaneous enjoyment.

There is the device of "repetition of the picture plane." The picture plane is simply the plane defined by the frame or the surface of a canvas; it can be compared to the curtain of a stage. When the curtain is raised, the "plane" where the curtain hung still exists psychologically. On a stage this plane would be repeated by, let us say, a piece of furniture facing the audience directly rather than at an angle. Likewise it would be repeated by any actor who stands directly facing the audience. It would be repeated finally by the terminating backdrop or set wall.

In the Poussin the picture plane is repeated again and again as objects recede toward the final "backdrop," the sky. It is repeated by the facing surfaces of walls, by various buildings, and is suggested by long, low hills or mounds disposed across the picture space parallel to the picture plane.

A second series of planes at an angle to the picture plane is suggested first by the side plane of the stone wall at the right. We enter the picture from the lower left corner and move across it, but are kept from moving out by the tall tree at the right and by this plane of the wall, which is turned to deflect the "current" of our movement back into the picture. It is not noticeable that this plane is, in fact, a distortion of true perspective. In true perspective we would not see the side surface of a wall whose front plane parallels the picture plane, but Poussin turns this (and other planes that repeat it) slightly inward to create a series of checks to our movement, like objects placed on a stage to keep our eyes from wandering off toward the wings.

A corresponding but weaker set of planes serves the same function in the other direction. The rigidity of all these forms is alleviated by the curvings of streams or paths or pathlike areas winding backward and forward, around and about. Although the small figures represented as seated, standing, walking, riding, and carrying the sheeted corpse also turn us in directions in which the artist wants us to move, they themselves are not invested with motion. Essentially they are as static as the natural and architectural forms around them.

We commented in our discussion of Poussin's Rape of the Sabine Women that the static quality of figures represented as if in motion is the element in classical composition that, to many people's way of thinking, limits its effectiveness. Degas, with his customary ingenuity, finds a way to avoid this difficulty in his Rehearsal in the Foyer of the Opera. The figures in the Rehearsal are classically static and classically balanced, but at the same time they are convincingly engaged in an activity based on a premise of motion—dancing.

Degas resolves this contradiction by choosing an instant of repose in the midst of continuous action. The ballet master, in the white suit at the right side of the picture. has just held up his hand and tapped the floor with his stick. Responding to this command, the dancer (extreme left) whom he has been rehearing stops stock-still, holding the attitude of the moment as she listens for the comment or correction he is about to make. The violinist has lowered his bow, taking the opportunity for a moment's rest. Most of the other dancers, attracted by the tapping of the stick, pause to glance and listen, but others in casual attitudes chat with one another or stand waiting their turn for rehearsal. Thus the picture is full of life; it is, in a way, full of activity. But it is quite natural that every figure in it is perfectly still, and Degas is free to use each one as an object for disposition within a static, classical composition as if they were the walls, buildings, shrubs, and trees that served Poussin in The Funeral of Phocion.

Degas has also turned his space at an eccentric angle. To increase the effect of informality in a paradoxically formal arrangement, he abandons the picture plane idea. But his pictorial space is still precisely defined. The chair in the foreground, which appears to be so casually placed, repeats the angle of the walls, thus becoming a major factor in defining in the foreground the volume of space that the walls define in the background. The chair also serves as a barrier to keep us from entering the void in the center of the picture; it deflects us either to the ballet master and the group around him or to the dancer at the left.

To build a composition around a large central void is another eccentricity, but Degas is not interested in novelty for novelty's sake. In physically isolating the dancer from the ballet master, he is unifying them psychologically. The tension of interest that vibrates between them would be weakened by any interruption of the space. This is the same device, more inventively employed, that Peale used when he bound his family portrait together by the glance St. George casts toward the figure he is sketching.

By all the rules, Degas's Rehearsal is overbalanced on the right side, where a mass of figures occupies one end of a kind of compositional seesaw whose other end must be held down by the lone figure of the dancer. But the two sides are in what is called "psychic balance" (or "occult balance"). The dancer's isolation attracts our attention in a composition where the other figures, massed, compete with one another. The curious attitude of her legs and feet, opposed to the more ordinary gestures and attitudes of the several members of the group on the other side, also sets her apart. And finally, the "seesaw" is at the angle in space defined by the chair and the walls, so that the dancer's end of it is thrown nearer to us. Thus she is not only in a more conspicuous location but by reasons of perspective must be drawn larger than the figures she faces. For all these reasons she holds her own against superior forces.

The Degas is everywhere as neatly and beautifully balanced as the Poussin. Both painters set for themselves the problem of balancing static objects within defined space. They contrast in that Poussin invests his subject with majestic implications that seemed valid in a century that accepted the divine right of kings, while Degas, living in the century of the triumph of the bourgeoisie, accepts the authority of the commonplace. Yet both seek meaning through order. Neither one is much concerned with his apparent subject. The Poussin's sheeted corpse happens to be that of an Athenian general wrongly convicted of treason, and executed, who must therefore be buried outside the walls of the city. But the picture would not be much changed if the object on the stretcher were, say, the drum of a column being carried to a building site. The Degas has a much closer connection with its subject matter, yet the longer we know the picture, the more our satisfaction comes from the disposition of the objects rather than from our interest in who they are or what they are doing.

Degas admired both Poussin and Vermeer, and the gentle flow of light in the *Rehearsal* is similar to Vermeer's. Similar, too, is the device of implying a wall by showing objects illuminated by light coming from a window not seen but clearly sensed.

In arresting his figures between moments of action, Degas has a classical precedent in a Greek sculpture of the fourth century B.C., the *Discus Thrower* (262), which we know in several versions copied from a lost original by the sculptor Myron, representing an athlete engaged in violent action. The sculptor seizes the instant when the arm has reached the apex of the upward motion of its arc, the instant before it starts the downward motion that begins the act of throwing. This is also the instant when the body has reached the extremity of its twist in one direction and is ready to reverse this motion.

But every great work of art is new, no matter what its connection with the past. Other painters have imitated Vermeer, have imitated the *Discus Thrower*, have imitated Poussin. Degas imitated nobody. If we made a long catalogue of the sources of the art of Degas and an equally long one of the sources of the art of some mediocre painter, these sources might be the same; yet Degas would still be an original artist, and the other would remain an imitator, an eclectic.

Of all the paintings discussed thus far, only a few have told stories. When they did, as in the cases of Gérôme's Duel after the Masquerade (106) and Hovenden's Breaking Home Ties (107), we found them lacking in interpretive power. This is understandable since by its very nature the storytelling picture is likely to be a compromise between pictorial art and verbal art, or narration. You may argue that Rubens's Prometheus Bound (95), which pictures a classical legend, and Delacroix's Abduction of Rebecca (246), which takes its subject from Ivanhoe, and the various Crucifixions we have seen, which tell that great story, are all narrative paintings. This is true, on the face of it; but it is also true, and much more important, that these

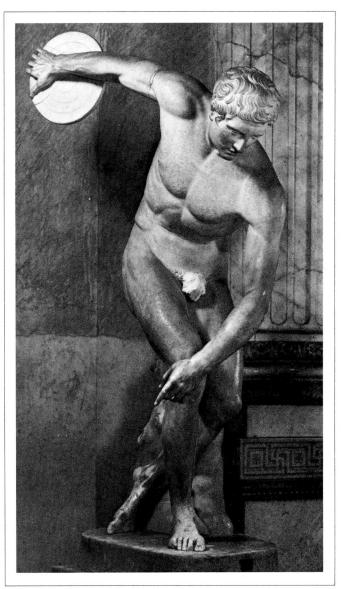

262. Myron. *Discobolus (Discus Thrower)*. About 450 B.C. Roman copy of bronze original, life size. Vatican, Rome

paintings are conceived as pictures of ideas. We do not have to translate them back into their original form of narrative in order to give them meaning. The medium of images is not playing second fiddle to the medium of words. When an artist wants to tell a story as vividly in images as it has been told elsewhere in words, his most vivid narrative device is composition.

Saint Anthony Tempted by the Devil in the Form of a Woman (263), painted by the Sienese artist Sassetta more than five hundred years ago, is as economical and expressive a bit of storytelling as can be found in any medium. Instead of showing us the incident as a kind of glorified snapshot of an actual happening (in the manner of Duel after the Masquerade), Sassetta creates a dramatic and psychological atmosphere through the abstract means of color, line, and arrangement. It might be objected that the temptation of Saint Anthony could hardly suggest a snapshot since the incident is a fantastical one, but an unimaginative painter could have treated it as literally as if it were the factual record of a commonplace event. Even such a painter might be able to tell the story clearly enough, but we all know that a story told effectively by one person may fall flat when told by another. In this little picture, it is not so much what Sassetta says as the way he says it.

What he says is that when the saint, who lives in the wilderness dedicated to a life of ascetic contemplation, returns to his cell one evening he discovers waiting near the door a woman, delightfully beautiful, who tempts him to the pleasures of the flesh. And the way he says it is this:

The saint, walking toward the door of his shelter, has just discovered the woman. In a wonderfully expressive attitude he hesitates, half turning toward her, his hand raised in a gesture of surprise that in the next moment can turn into a gesture of assent or one of rejection. He stands directly in the center of the picture, with the cell and the woman on either side of him like equal weights in a scale of which he is the pivot. The balance is emphasized by the fact that both objects offered him for choice are pink, the only bright color in the picture except the streak of light along the horizon. These pinks, however, clash with one another, the vermilion-pink of the shelter with the carminepink of the woman's robe. The woman is an exquisite little creature; the innocence of her pretty face and blond hair is denied by slits in her bodice and skirt; even her jeweled batwings are pretty, although they are hidden from the saint and revealed only to us. In contrast to the graceful and ornamental forms of the woman, the lines of the shelter are extremely severe.

The apparitional quality of the scene is created by the background, a never-never land of desert, its path sprinkled with stones to humiliate the flesh of the saint's bare feet, its odd rock-hills dotted with a few exotic trees that look like designs for jewelry, and its horizon so curved that it suggests the end of the world, the jumping-off place. Against this desolate isolation the temptress is all the more tempting.

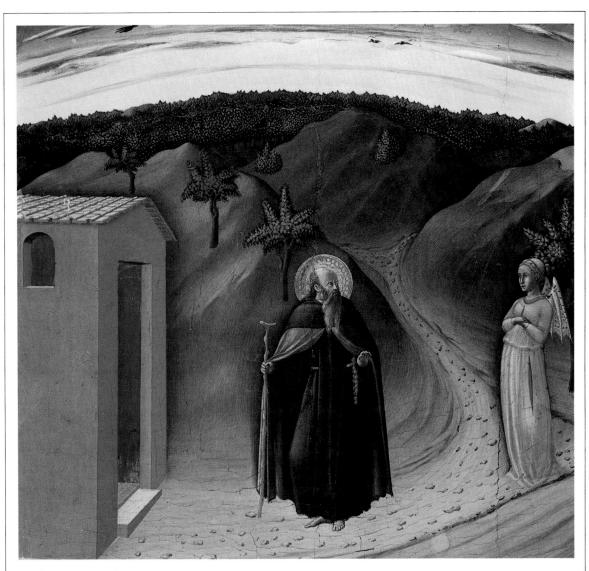

263. Sassetta. Saint Anthony Tempted by the Devil in the Form of a Woman. About 1430. Egg tempera on panel, 14% by 15¹³/₁₆ inches. Yale University Art Gallery, New Haven, Connecticut. University purchase from James Jackson Jarves.

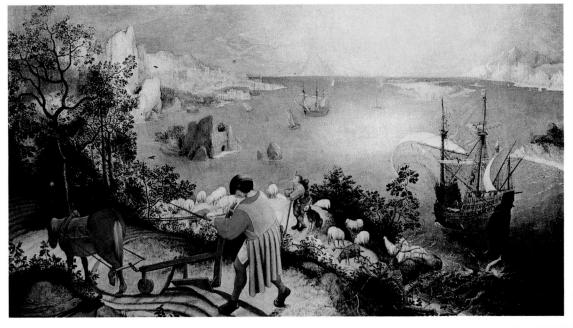

264. Pieter Bruegel the Elder. Landscape with the Fall of Icarus. About 1554–55. Oil transferred from wood to canvas, 29 by 44½ inches. Musées Royaux des Beaux Arts, Brussels.

265. Detail from Landscape with the Fall of Icarus.

This is not a complicated picture, and the story itself has been reduced to minimum terms. This minimum is reflected in the spareness of the objects represented. There are no parenthetical references, no hints of implications beyond the immediate subject. And that, of course, is where the picture might be said to fail in greatness, if it can be said to "fail" when it does not achieve something it never set out to achieve. The painting tells its little story in the most direct, succinct pictorial terms with utmost skill. Whatever else it is, or is not, it is utterly delightful—a joy.

To see how much a painter may say beyond the mere narrative of an incident drawn from a literary source, we will look at Landscape with the Fall of Icarus (264, p. 209) by the Flemish painter, Pieter Bruegel the Elder. According to Greek legend, the boy Icarus fell to his death in the sea when he flew too close to the sun on a pair of wings invented by his father, Daedalus. The wings were made of feathers and wax; the heat of the sun melted the wax in the boy's wings and they fell apart. Daedalus, also trying out his wings at a more cautious height between the sea and the sun, did not fall. The legend is given various meanings, most of them having to do with the vanity of pride or ambition.

Bruegel, however, finds its meaning in another direction. The composition of The Fall of Icarus carries this meaning by a kind of reverse emphasis. Whereas other compositions build every element toward a climax in the figure of the protagonist of the story, at first sight Icarus does not seem to be in the picture at all. The most conspicuous figure is a plowman, his head bent toward the soil, who is not even a part of the legend (265). Beyond him, looking up with mild curiosity toward an odd speck in the sky, a shepherd tends his flock. Stretching around these figures is a land- and seascape of intricate beauty. Ships move across the water, and in the cove below the plowman a particularly elaborate one is setting sail. When we have discovered this ship we have very nearly discovered Icarus at last. Our subject—or at least the small legs of our subject—is nearby, just disappearing into the water with a very small splash, lost among the details of more interesting patterns.

Bruegel's comment, then, has to do with the insignificance of personal tragedy in the great scheme of things. The death of this boy and the anguish of his father mean nothing at all in terms of a larger pattern. This could be a pessimistic conclusion, and the modern poet W. H. Auden made it one in his poem "Musée des Beaux Arts," inspired by this painting and others of the Flemish School where everyday events are combined with subjects like the Nativity and the martyrdom of saints:

About suffering they were never wrong, The Old Masters: how well they understood Its human position; how it takes place While someone else is eating or opening a window or just walking dully along;

How, when the aged are reverently, passionately waiting

For the miraculous birth, there always must be

Children who did not specially want it to happen, skating

On a pond at the edge of the wood:

They never forgot

That even the dreadful martyrdom must run its course Anyhow in a corner, some untidy spot

Where the dogs go on with their doggy life and the torturer's horse

Scratches its innocent behind on a tree.

In Brueghel's *Icarus*, for instance: how everything turns away

Quite leisurely from the disaster; the ploughman may Have heard the splash, the forsaken cry,

But for him it was not an important failure; the sun shone

As it had to on the white legs disappearing into the green

Water; and the expensive delicate ship that must have seen

Something amazing, a boy falling out of the sky, Had somewhere to get to and sailed calmly on.

We have here, then, a theme from literature, transformed in painting, with a consequent literary restatement. By this interpretation Bruegel used the Icarus legend to comment on human indifference to the suffering of others, the loneliness of the individual. But this idea is not in harmony with the look of Bruegel's picture. The pattern is of such depth and serenity, such calm beauty, such grandeur, that we may be consoled by the knowledge that our individual troubles are absorbed within a greater order.

In its serenity and elegance *The Fall of Icarus* is an exception in Bruegel's work. Typically, he combines the fantastic and the grotesque with the earthiness of peasant life, unlikely as the combination may sound. In *Flemish Proverbs* (266) he had a ready-made vehicle, since proverbs grow out of the life of the people but are expressed in terms of fantasy. The man who is enclosed in a crystal globe (at the very bottom of the picture just right of center) illustrates "I must stoop if I wish to go through the world" (*Ick moet my crommen, sae ick door de werelt commen*), and the man strewing roses before swine (*Desen stroyt roosen voor de vercken*), just above the globe and slightly to the left, is no stranger to us if we substitute pearls for blossoms.

Flemish Proverbs is conceived as a kind of drollery, although in the light of Bruegel's subsequent achievements critics like to believe that in painting it the artist intended a compendium of human folly. Compositionally it is not remarkable, although the job of tying together some eighty

266. Pieter Bruegel the Elder. *Flemish Proverbs*. 1559. Oil on wood, 45% by 63½ inches. Staatliche Museen, Gemäldegalerie, Berlin.

267. Pieter Bruegel the Elder. *The Parable of the Blind*. 1568. Tempera on canvas, 33½ by 60¾ inches. Museo di Capodimonte, Naples.

tableaux vivants simultaneously enacted upon a large stage is admirably accomplished. Flemish Proverbs is a fascinating picture; but in a later one devoted to a single proverb, The Parable of the Blind (267), we see Bruegel as a mature man and a mature artist doing a great deal more with the same kind of material.

The blind men are proceeding in single file across a bit of descending ground that ends in a ditch. The leader has tumbled in. The last man in line has no suspicion of what is happening. He will continue to follow, in complete docility, until he meets the catastrophe that the other men, in graduated stages, begin to suspect. The other figures are studies in the progressive emotions of uneasy suspicion developing into terrified certainty and culminating in frantic, helpless confusion as the men are finally caught up in the disaster they failed to anticipate when they placed their trust in another no better equipped than themselves to avoid it.

If this were only a picture of blind men falling into a ditch, it would be cruel. But it is a parable of human inertia, a comment on the weakness of people who follow blindly because it is too much trouble to find a way for themselves, who would rather shift responsibility for a course of action to someone else, just anyone, than make the effort to determine one for themselves. The blind men of the picture may be pitiable, but the "blind" men of the parable are not.

For expressive reasons, the picture abandons all usual ideas of balance and catapults downward into one corner. Each man's face reflects his state of mind; in this respect the faces are a superb series of inventions. But if they were blanked out, the story would still be vividly told, since it is in the design of the figures that Bruegel has concentrated the expressive force. The last man in line is drawn in simple masses; his cloak hangs in straight lines. In each successive figure this simplicity gives way more and more to complexity and agitation, until finally the figure in the lead is a tumbled silhouette, a tumbled mass. This is not because men tumbling or falling would happen to present such forms. They might, in fact, present quite simple ones. In newspaper photographs of people falling or jumping or lying on the pavement after an accident it is a rare instance when the victim presents a shape expressive in itself. Abstractly, that is, without the attendant evidence of blood or wreckage, the form of a man who has died a violent death is not likely to be much different from that of a man lying in a drunken stupor or even one taking a peaceful nap. Nor is the form of the figure of a man in physical torment or some violent action of a tragic nature likely to be very different, objectively regarded, from that of a man dancing or engaged in sport.

The point we are making is that Bruegel's blind men are not realistically represented. They may be realistic in detail, but taken as a whole they are abstract patterns of line and form, expressively designed. If they seem realistic, it is because of Bruegel's power as a creative draughtsman.

The rest of the picture is a peaceful landscape that,

268. Georges Seurat. Sunday Afternoon on the Island of La Grande Jatte. 1884–86. Oil on canvas, 6 feet 9 inches by 10 feet 8 inches. The Art Institute of Chicago. Helen Birch Bartlett Memorial Collection.

269. Detail from La Grande Jatte.

like the one in *The Fall of Icarus*, is in emotional contrast with the tragedy being enacted. The landscape in *The Fall of Icarus* was made elaborate and fanciful to suggest the unimportance of the single detail of the boy's legs. In *The Parable of the Blind* the landscape is as simple as the procession of men is complicated. Its lines are as straight and spare as those of the hapless men are knotted. By contrast the quiet landscape emphasizes the dramatic invention of the foreground figures.

It is hardly possible to exhaust the subject of pictorial composition, since it is limited only by the number of pictures, good or bad, that exist for discussion. In analyzing some standard examples and their variations (such as Perugino's Crucifixion and Picasso's contrasting Guernical, as well as the examples of uniquely expressive or narrative compositions that we have just seen, we have made incidental reference to the part that sheer painterly technique the method of applying the paint—may play in the structure of a composition. We saw that Poussin's Rape of the Sabine Women was tightly painted in a manner appropriate to the disciplines of classically static composition. In contrast, Delacroix's Abduction of Rebecca, a similar subject, is treated with romantic fervor in a turbulent composition where paint was so freely applied that one classically oriented critic called such brushwork the product of "a drunken broom." In the majority of our other examples there was less correlation beween painterly technique and the compositional unit, but to conclude our comments on composition we will look at a picture in which compositional structure and the sheer manual technique of paint application are interdependent to an extraordinary degree: Georges Seurat's Sunday Afternoon on the Island of La Grande Jatte (268, p. 214).

Seurat, who painted La Grande latte in 1884-86, was a Post-Impressionist, a term covering painters who, in different ways, departed from fading impressionism to seek new means of expression. (We have seen work by two other major Post-Impressionists, Van Gogh and Cézanne.) Cézanne once said that he wanted to make of impressionism "something solid and durable like the art of the museums." Seurat could have said the same thing and it would have been even more strictly to his point than Cézanne's. The Impressionists applied paint in short strokes of variegated tones and tints to increase the luminosity of the overall color. (They had an immediate ancestor in Delacroix and a remote one in Rubens.) Although impressionism thus approximated the vibration of color in light and air, the approximation was often achieved at the expense of form. which in extreme cases dissolved into rainbowed mists. Seurat stuck to the idea of using individual bits of color, but he built these bits into forms that were uncompromisingly defined. The color itself was applied with great precision instead of freely as in impressionism. A Seurat painting is composed of thousands upon thousands of individual flecks of pure color (269, p. 215), combined in semi-scientific

proportions with others that will be blended by the eye into the desired final color. Seurat preferred the term "divisionism" to describe his chromatic juxtapositions, but the more vivid "pointillism" caught on when a critic, Felix Fénéon, referred to Seurat's "peinture au point" in an article on *La Grande Jatte*.

Seurat died at the age of only thirty-one while still involved in a program that would have demonstrated his method by representing subjects both active and static in light both indoor and outdoor, natural and artificial, and of varying intensities. Yet if he had painted nothing but La Grande Jatte, the first of the series, his place would still be secure as an unchallenged master of modern art. His Sunday strollers enjoying a sunny afternoon on an island in the Seine near Paris, whether we read them in two or three dimensions—as flat shapes on the surface of the canvas or as solid volumes in pictorial depth—are defined by contours distilled to such purity that the quasi-geometrical forms approach abstraction. La Grande Jatte is, in fact, one of the very few paintings in which insistent abstraction and explicit description of the visual world meet on equal and harmonious terms.

The composition of this, among all paintings, can be tested by trying to imagine it with any shape changed, omitted, or shifted in position—backward, which would reduce the size of the shape; forward, which would enlarge it; or to either side or higher or lower on the surface. Poussin's Funeral of Phocion (260) can serve as a key (if one is needed) to studying the structure of La Grande Jatte. Both are entered from the lower left corner; both express distance by means of multiple receding repetitions of the picture plane; both include figures nominally in motion that actually serve as static direction pointers. The difference between the two is that the Poussin is more subtle, with secondary structural systems discoverable within the main one, while La Grande Jatte is severe and uncompromising in its diagrammatic, almost ascetic, purity.

The unity of Seurat's masterpiece lies in this severity in harmony with the rigidly disciplined pointillist technique. The area of the canvas is more than 67 square feet, with every smallest fractional inch testifying to the artist's absolute control of the process of creation. One question remains: Since this process allows for no relieving improvisational stroke of the brush, since inspiration is totally ruled out in favor of calculation, since every element of the composition is forever locked immobile in its spot, what then accounts for the feeling of life that, in spite of everything, emanates from a painting which has been subjected to disciplines that could have been expected to kill it? The explanation lies in the vibrant interplay of those tens of thousands or hundreds of thousands of points of color, the colors of light fractured by a prism. If there could be such a thing as molecules of light, Seurat's points of color would correspond to them in the living compound that, together, they compose.

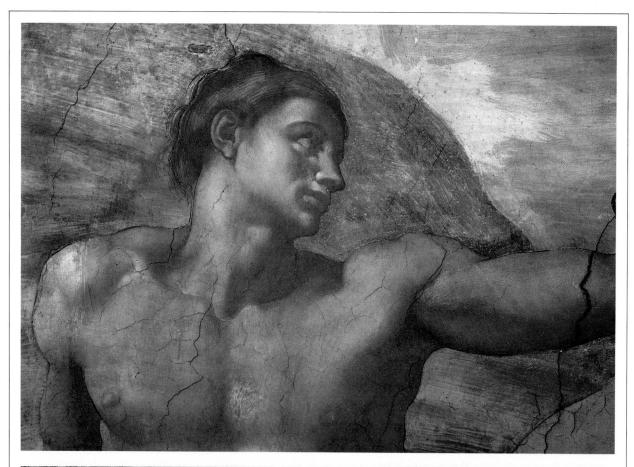

270. Michelangelo. Creation of Adam (detail above). 1511. Ceiling fresco. Sistine Chapel, Vatican, Rome.

Chapter Ten

THE PAINTER'S TECHNIQUES

In the course of the last several chapters we have enlarged on a number of answers to our original question, What is art? But we have made only incidental reference to one aspect of picturemaking that is apparent to everybody and understood by very few. This is the primary fact that a painting is a layer of pigment applied to canvas or some other surface in such a way that the manner of application becomes an integral part of the picture's expressive quality. If the application of paint were nothing more than a skilled manual procedure, there would be no point in discussing it here, any more than there would be in discussing finger exercises in an essay on music appreciation. But in a good picture there is no such thing as mere technique. The application of paint is more than a craft the artist learns in order to reproduce a tinted image.

In some cases the expressive quality of a painter's technique is so apparent that it need only be pointed out to be understood. (We have commented on *La Grande Jatte* in this respect.) Imagine, for instance, Whistler's *Arrangement in Gray and Black* painted in the thick, bold strokes of Van Gogh's *The Starry Night*. The image of the old lady could be presented just as accurately, and in the same harmony of quiet colors, in Van Gogh's bold style. But Whistler's paint is brushed onto the canvas so gently, so quietly, so tenderly, that the technique becomes an integral part of the expressive whole.

Likewise *The Starry Night* need not have been painted in heavy, violent strokes except as a means to its particular expressive end. The same surging pattern in the same vivid colors could have been washed onto the canvas in a diaphanous film or could have been as slick and smooth as enamel. But the dramatic texture of Van Gogh's thick, glistening swirls of paint is as expressive as the color.

Since we are going to talk about paints, pigments, and mediums, we had better define our terms. "Pigment" is simply coloring matter; a "binder" is any substance that holds pigment together and makes paint out of it; a "medium" is a modifying substance the artist may mix with his paint to bring it to the proper working consistency for his purposes. Often the word "medium" is used to cover the whole process of any kind of painting. The "oil medium" thus would cover the mixing and applying of oil paint in any of its variations. But in this chapter we will use "technique" for the whole physical process by which the painter sets down in visual terms his conception of a subject.

To illustrate our terms: The pigment called ultramarine, a magnificent dark blue with a purplish cast, is the semiprecious stone lapis lazuli ground to talcum-powder fineness. (At least it used to be; today it is usually synthesized chemically, like many other pigments.) This powdered stone could be mixed with water into a smooth paste

and applied to canvas like oil paint, or thinned out and washed onto paper. But in either instance as soon as the pigment dried, it would revert to powder and drop off the canvas or paper.

But if the powder is mixed with the proper kind of oil as a binder, the pigment becomes oil paint and will adhere to canvas and other surfaces. (Acrylic, a synthetic resin, is today a popular replacement for oil, with the difference that it is very fast-drying, which is sometimes an advantage. sometimes not.) If the pigment-powder is mixed with any one of several water-soluble adhesives (gum arabic is a standard one), it becomes water-color paint and will adhere to paper upon drying. Mixed with egg, pigment becomes tempera. Pigment mixed with chalk and an adhesive is also often called tempera, but strictly speaking this is inaccurate. These are the inexpensive paints called "show-card colors" used in elementary painting classes. In more dependable form, the mixture of pigment, chalk, and a water-soluble adhesive is called gouache; it is somewhat heavier in body than water color, and somewhat bleached in tone.

Paints as they come in tubes are usually too thick for use, and the painter thins them with the proper medium. In the case of oils, the medium is likely to be the painter's favorite mixture of (linseed) oil, a varnish, and turpentine, the proportions varying according to whether the paint is to be applied in a heavy layer or a thin one. The amount and kind of varnish will depend on whether the painter wants the picture to have a glossy surface, a mat surface, or something in between. A good craftsman will know which mediums are safe to combine, when he may use a fast-drying medium and when a slow-drying one, and which mediums may be applied over which others without danger of blistering or cracking. We will see one painter, Albert Pinkham Ryder (419), who was so careless in combining unsympathetic mediums that his pictures are in ruinous condition. There have been others. Even the great Watteau, who painted in the early eighteenth century when artists usually learned impeccable craftsmanship as the ABC of their trade, seems now and then to have used inferior or polluted oil as a medium, to the detriment of his work. And in the late eighteenth and early nineteenth centuries, when painters found that bitumen combined with oil gave shadow tones of exceptional richness, pictures with wonderfully brilliant lights and wonderfully velvety darks were produced, soon to become miserably blackened and cracked into great scaling patches like mudflats in a summer drought.

Each painting technique has its particular quality, its special limitations, its special adaptabilities. Oil is the most versatile, the most accommodating to the painter; tempera is the most precise and offers the greatest rewards to the meticulous craftsman; water color is the most vivacious and the most sensitive. But let us say flatly that true fresco, of all forms of painting, is the noblest. It is also the most difficult.

Asked to define a fresco, the average person would

define a mural. A mural is any wall painting, a fresco is a wall painting in a special technique, and a *true* fresco is even more special. A mural may be painted on a wall in any one of several techniques, of which ordinary oil and ordinary water color are two, but not the best. Most murals today are not painted directly on the wall but on canvas in a studio and are then glued to the wall. That makes them murals, they are far from being frescoes.

True or, as it is also called, buon fresco, which we will distinguish shortly from other fresco, is part and parcel of the wall. The painter, working with pure pigment dissolved in lime water (pure water is also serviceable enough), paints directly on a fresh plaster coating as it dries. He must time his painting carefully. If the wall is still too wet, it will not accept the pigment from his brush. If it is too dry the pigment will not enter the plaster and will powder off later. So the painter must complete his work during the few hours when the surface is just dry enough to suck the pigment in and just wet enough to combine its own moisture with the water containing the pigment. During those few hours the plaster will absorb the pigment to a tiny fraction of an inch below its surface and hold it there. The preparation of the wall is so vital a base for fresco painting that artists who work in fresco regard their plasterers more as colleagues than as assistants.

Everyone is familiar with the beauty of a freshly plastered wall—luminously white, with an eggshell surface neither glossy nor dull. The texture and the soft luminosity of this surface are produced by a next-to-microscopic crystalline film that forms as the plaster dries. This film is in effect the binder in fresco. The pigment is bound into the wall; it is the part of the wall we see; it and the wall are the same. This sense of the wall is psychologically a vital element in fresco painting, and it is a sense that is lost in reproductions.

Of all techniques, true fresco is the one that forces a painter into the most direct and uncompromising attack, with no room for experiment en route. As much of the wall as he expects to cover in one day is plastered, depending on the complexity of his design and his own speed and physical stamina. Michelangelo, whose Sistine Chapel ceiling (271) makes him the undisputed master figure in fresco painting, completed the 5,800 square feet of the ceiling in four years without employing assistants for minor passages as most painters, faced with that vast area, would have done.

The painter in oil is free to sketch in his entire picture tentatively and work it up gradually, making as many changes as he wants while the picture takes shape. The true fresco painter is not free to come back and make even a minor change. If the color of an area must be changed, there is nothing to do but chip off the offending area and begin over again. An additional complication is that the color changes as the plaster dries, growing lighter in key. (We all know that a damp spot on a plaster wall is darker than the surrounding area.) The fresco painter is always painting two pictures at once, one in the colors he sees as

271. Michelangelo. Ceiling of the Sistine Chapel. 1508–12. About 130 feet long. Vatican, Rome.

272. Michelangelo. Preliminary drawing for *Creation of Adam.* 1511. Red chalk on paper, 7% by 14% inches. The British Museum, London. Courtesy of the Trustees.

273. Piero della Francesca. *The Death of Adam*, from *The Legend of the True Cross*. 1452–66. Fresco. Church of San Francesco, Arezzo, Italy.

he paints, and the other in the colors he will see the next morning when the plaster has dried. He must bear this in mind. Picking up work in a newly plastered area, he must match yesterday's colors by trying to remember how they looked before drying, something impossible for most people to do and extremely difficult for even the most practiced artist.

The painter must work from preliminary studies at full scale (these are often called cartoons) or depend on the infallibility of his draughtsmanship. Before he can begin to paint, he must find a way to transfer an adequate guiding outline from his paper cartoon to the damp plaster. In the head of Adam from Michelangelo's Creation of Adam (270, p. 218) on the ceiling of the Sistine Chapel, these guidelines show up as gouges in the plaster. Michelangelo worked in one of two ways: either he took his full-scale drawing, held it against the damp plaster, and went over the outlines with some kind of point strong enough to press the design through the paper onto the plaster; or-incomparable draughtsman that he was-he established the general dimensions and then, enlarging from a small preliminary drawing on paper, incised the guidelines directly into the plaster, probably using the wooden end of one of his brushes.

We still have a small study for the figure of Adam (272), but there may also have been a full-scale drawing of the outlines. It wouldn't have occurred to Michelangelo to save the enlargement; such cartoons were ordinarily discarded after they had served their purpose; indeed, they were usually somewhat mutilated while serving it.

In Adam's head the gouges do not provide outlines in much detail, and Michelangelo has not followed them exactly. For example, he did not draw in the hair. You will see running through the hair a line that traces the contours of the skull as if it were bald; on this skull the hair was painted in freely. The lips have also been extended a little beyond the lines of the gouged-in "sketch," and anyone familiar with the drawing of heads will recognize that the backward tilt of this one has been increased by raising the eyebrow above the first rough indication.

Another, more meticulous way of transferring a drawing to plaster is to punch the outlines of the full-scale cartoon with a series of pinholes. (This is most speedily done with a small spiked wheel called a roulette.) The cartoon is then placed firmly against the plaster, and a powder of some sort, either charcoal or a dark pigment, is rubbed over the pinholed outlines. The powder goes through the pinholes and is absorbed by the plaster, leaving the outline in a series of dots when the paper is lifted away. This is called "pouncing."

The dotted outlines are ordinarily painted over, but occasionally they remain visible, as they do in another head of Adam, now an old man (274), by Piero della Francesca. This is a detail from *The Death of Adam* (273), one panel from the series telling the *Legend of the True Cross* in frescoes running the whole height of the walls of the choir in the Church of San Francesco in Arezzo. We have already seen another subject from the same series in the chapter on abstraction (188).

In the locks of hair at the old Adam's temple and around his ear you can see what looks at first like a peppering of random dark specks. But these follow the general outlines of the locks and are obviously the kind of guidelines we have been describing. The Piero frescoes are as rigidly controlled as Michelangelo's are tempestuous. Whereas Michelangelo improvised to some extent in his head of Adam, Piero has followed a detailed preliminary drawing with unusual precision. Here and there throughout the True Cross frescoes the dotted lines are visible, despite the careful, thin dark outlines that have been painted over them. They are especially evident as part of the outline around Adam's ear and can still be discerned along the nose. The Death of Adam is the topmost panel on a high wall and from such a distance the little specks don't tell. Nor, for that matter, do the gouges Michelangelo used in his head of Adam as a magnificent youth. In both cases, the illustrations bring us unusually close to the walls.

This noblest and most difficult of all forms of painting makes no concessions to the painter; it is merciless in its revelation of his shortcomings; it offers no refuge to me-

274. Detail from The Death of Adam.

diocrity. True fresco is, in short, thoroughly unaccommodating. It tolerates vivacity where vivacity is appropriate, but accepts sensitivity only as an element of strength. It reflects truth rather than precision. And as for highly developed craftsmanship, that is taken for granted.

It is quite true that there are plenty of frescoes where the conception is puny or pretentious. Fresco cannot ennoble the commonplaceness or the falsity of a mediocre artist, any more than the lines of *Hamlet* can inspire a noble performance in a puny and pretentious actor. But in the history of art, true fresco has offered great painters a fulfillment in expressive depth and power that is seldom equaled in other techniques.

Fresco in one form or another has been employed since prehistoric times, but it reached its most magnificent flowering in Italy in the fourteenth, fifteenth, and early sixteenth centuries. This of course was the Renaissance, a time when man stopped regarding himself as a soul temporarily imprisoned within vulnerable flesh pending salvation or damnation in the next world, and began examining himself as a being capable of intellectual nobility in his own daily world. We have referred to the "nobility" of fresco; this may be largely a matter of association with the nobility of the Renaissance conceptions that coincided with the flowering of fresco at this time.

About the year 1305, in Padua, Giotto di Bondone lined the Arena Chapel (279, p. 227) with frescoes that shifted the whole current of painting away from the manipulation of mystical symbols toward the passionate investigation of the world and man's place in it. His subjects were traditional mystical ones, the lives of the Virgin and Christ, in episodes that had been painted thousands of times in terms of medieval formulas. In Giotto's retelling of the old story, the divine effigies become human beings. The Virgin (277) from the Lamentation over the body of Christ (275) is first of all a mother in an anguish of grief and secondly the Mother of the Redeemer. As representational drawings, Giotto's figures are awkward and full of inaccuracies-but Giotto is a beginner in the process of discovering how to represent the world in realistic images. His realism, seemingly so faulty from this side of the perfected representations of later artists (and of the camera), must have appeared almost illusionistic to his contemporaries in comparison with any other work known at the time. Painters spent the next hundred years adjusting to his break with tradition, trying to go beyond him in the direction he had set, and not quite succeeding. It was not until the appearance of another genius, Masaccio, that Giotto's achievement was extended (which does not mean surpassed), with more accurate anatomical drawing of the nude body, more convincing fall of draperies when it was clothed, more realistic representation of facial expressions, and, above all, a mastery of the newly formulated principles of perspective that allowed Masaccio to place his figures in rational relationships to nature. In spite of early

training under obscure teachers, Giotto—dead for sixty-four years when Masaccio was born in 1401—was in effect Masaccio's true master, by example. After Masaccio's death at the age of only twenty-seven, his frescoes in the Brancacci Chapel in Florence (276 and 278) became the school for painters that Giotto's frescoes had been until then.

In the incredible century that followed, Italy produced artists with the prodigality with which we produce automobile mechanics today. Nor were they an army of hacks. In variety, vigor, invention, and profundity they topped one another's achievements, exploring every aspect of life and thought in search of the final synthesis of spiritual and intellectual perfections, whose ultimate achievement it never occurred to anyone to doubt. (We have seen Leonardo da Vinci as a towering figure of this century.)

The synthesis began to crystallize in the statuesque calm and abstract volumes of the art of Piero della Francesca; his Arezzo frescoes are the great monument of the Italian Renaissance as it neared its climax. Without being eccentric, Piero was the most individual colorist among fresco painters. It is difficult to describe any color in words, but we can try: smoky purples or lavender grays, dusty reds, pungent greens, and soft ivories dominate Piero's typical color schemes. Among these mutations, the occasional unmodified pinks and blues take on new clarity and purity.

No list of the great frescoes of the Renaissance can omit Raphael's in the Vatican's Stanza della Segnatura, of which the best known is The School of Athens (280). Raphael shares membership with Leonardo, Michelangelo, and Titian as the quartet of painters representing the moment of equilibrium called the High Renaissance, from about 1495 to about 1520, when the earlier Renaissance attained the final harmony for which it yearned. Of the four painters, Raphael comes closest to being the ideal example of the period's combinations of strength with grace, realism with idealism, and scientific principles with esthetic invention. His position in the history of art has remained unassailable for nearly five hundred years while other reputations have fluctuated, and it is customary to admire his frescoes in the Stanza della Segnatura without reservation. It is heresy, then, to suggest here that possibly these frescoes substitute grace for dignity, sweetness for elevation of spirit, facility for invention, and technical assurance for technical vigor. Perhaps it is just as well, yielding to the force of superior numbers among art historians, to let Raphael's citation as the perfect painter of the High Renaissance stand without further discussion. But even the most reverent historians concede that Raphael's harmonious synthesis is put to a severe test by the thundering frescoes that were being painted at the same time nearby in the Sistine Chapel, where Michelangelo's less optimistic message is to the effect that man in his imperfection is too vulnerable to achieve the benign harmony Raphael proclaims.

A summary of the dates for the frescoes we have been discussing might be convenient here:

275. Giotto. Lamentation. 1305-6. Fresco. Arena Chapel, Padua.

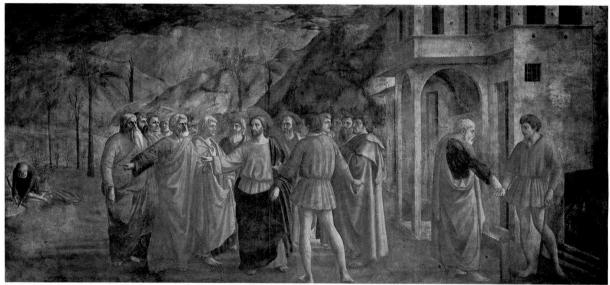

276. Masaccio. Tribute Money. About 1425. Fresco. Brancacci Chapel, Santa Maria del Carmine, Florence.

277. Giotto. Figures of Virgin and Christ from the Lamentation.

278. Detail from Tribute Money.

279. Giotto. Frescoes. 1305–6. Arena (Scrovegni) Chapel, Padua, Italy.

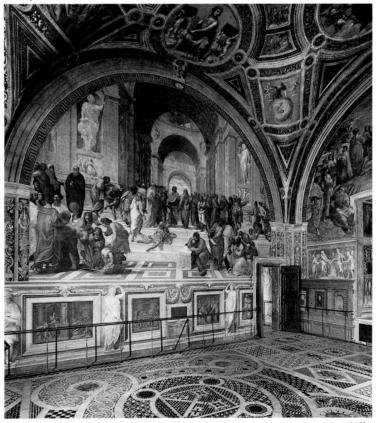

280. Raphael. *The School of Athens.* 1510–11. Fresco. Stanza della Segnatura, Vatican, Rome.

281. Cave painting. *Bison.* About 15,000–10,000 B.C. Lascaux (Dordogne), France.

Giotto's Arena Chapel, about 1305–6. Masaccio's Brancacci Chapel, about 1425. Piero's Arezzo frescoes, 1453–54. Raphael's Stanza della Segnatura, 1509–1511. Michelangelo's Sistine Chapel ceiling, 1508–1512.

It is time now to distinguish between true fresco and what is sometimes called, quite justly, false fresco. The proper term is *fresco secco*, which means dry fresco. The Italian words are always used instead of their English equivalent, although, contrarily, in this country "true fresco" is generally used instead of the Italian designation for that technique, *buon fresco* or, less frequently, *affresco*.

Fresco secco is painted on the dried plaster wall, which is slightly roughened to accept more readily the pigment mixed with an adhesive or binder. Since fresco secco is bound only to the surface of the plaster instead of being incorporated into that surface, it is likely to chip, peel, or powder off, and is also more vulnerable to scratching and rubbing. It can never achieve true fresco's luminosity nor its final degree of architectural integration, the "sense of wall." It can be beautiful in its delicate tonalities, and even its disadvantage is sometimes attractive: in very old fresco secco that has managed to survive, the powdering of the surface gives a soft, grainy texture that has its own charm.

Secco is frequently used to touch up true fresco. A highlight may be added here, or an awkward plaster joint covered there, or a mistake corrected the easy way instead of by chipping out and beginning again. But the dedicated true fresco painter avoids retouching on several scores: the dry additions have a different character from the surrounding true fresco areas and are likely to look like what they are, afterthoughts or corrections; these additions are likely to prove temporary; and most important of all, the true fresco painter is so conscious of the integrity of his technique and the grandeur of its tradition that, all other considerations aside, he regards recourse to fresco secco as an unworthy subterfuge.

Fresco (whether buon or secco) continued to be an important technique into the eighteenth century, but tended to give way to oil as the creative centers shifted from Italy to the North, where damp climates and radical changes of temperature were kinder to canvas than to plaster walls. There was a significant revival in Mexico in the 1920's, as we will see in another chapter, but we must conclude our comments here with glances at pre-Renaissance frescoes from three eras—prehistoric, classical antiquity, and medieval, plus an example from the Orient.

The oldest known paintings in the world are frescoes of a kind that can be called "true." These are the cave paintings found in France and Spain (281), where color was incorporated with the rock wall, without so much as an intervening skin of plaster, by rubbing the pigment into the rock. Where the natural rock is either convex or concave in a form suggesting an animal's body or a portion of it, the

cave artist frequently capitalized on this form as a beginning and adapted his drawing to its contours—which is one explanation for the wide variations in different photographs of the same cave painting. The natural relief is obliterated by the photographer's carefully equalized light, and shifting perspective varies the shape of the drawing in shots taken from different angles.

The pigments—browns, yellows, blacks, rusty reds—are natural mineral oxides that in some cases were probably the same as those that supplied earth pigments up until our own time. In some instances the original colors seem to have been intensified by the evaporation of moisture containing minute quantities of lime, which have imbedded the pigment within a crystalline film similar to the surface of true fresco. In other instances, unhappily, a different mineral content has obscured paintings under an opaque coating.

The tribal artists who decorated the walls of the ritual cave of Lascaux near Montignac in southern France must be included among the great painters of all time. Aside from their fascinating evocation of a life infinitely removed from ours—one they manage to bring overwhelmingly close when you are in their presence—these are great paintings. They would be great paintings if they had been done vesterday.

They swarm over the walls of the cave, magnificently alive. How passionately the artist has observed animals! He sums up the idea of "bison" in the most acute and economical way: the powerful forequarters, the small, taut hindquarters, the contrasting bony delicacy of hoofs and shins, the brutishness of the head, the menacing curve of the horns.

If there is any question as to whether or not the prehistoric artist who executed this expressive masterpiece was a creative painter in the most demanding definition of that term, his bisons need only be compared with a painting of a bull done in mid-thirteenth-century Japan during the Kamakura period, a time when technical mastery and esthetic sophistication produced corresponding masterpieces of Oriental art (282). The close stylistic resemblance across a gap of at least eleven thousand and perhaps as much as sixteen thousand years is more than a fantastic coincidence: it is accounted for by the fact that the prehistoric artist, whatever his expressive impulse and source of skill, and the Japanese artist, working within a highly developed tradition for an esthetically demanding audience, understood the essential quality of the subjects they were painting and expressed that quality by the most effective degree of selection and emphasis.

In ancient Greece and Rome, walls were often covered with rich painted decorations, generally referred to as frescoes, though it is not often possible to determine exactly what techniques were employed. The largest group of ancient wall paintings to have come down to us, many of them in good condition, are Roman, paradoxically preserved

282. Unknown Japanese painter. One of the Ten Fast Bulls. Kamakura Period (thirteenth century). Hanging scroll, ink and slight color on paper, 10³/₄ by 12⁵/₈ inches. The Cleveland Museum of Art. Purchased by John L. Severance Fund.

283. Unknown Roman painter. *Woman Playing the Kithara.* Before A.D. 79. Fresco from villa at Boscoreale, 73½ inches square. The Metropolitan Museum of Art, New York. Rogers Fund, 1903.

284. Early Byzantine. *Empress Theodora and Attendants*. About A.D. 547. Mosaic. San Vitale, Ravenna.

285. Master of Pedret, early twelfth century Spanish. *Virgin and Child Enthroned*. About 1130. Fresco, height approximately 11 feet. The Metropolitan Museum of Art, New York. Cloisters Fund, 1950.

286. Unknown Russian painter. *Saint George, Bishop.* Late sixteenth century. Tempera on wood, 43½ by 17 inches. Elvehjem Museum of Art, the University of Wisconsin, Madison. Gift of Joseph E. Davies.

by the cataclysmic eruption of Vesuvius in A.D. 79 that buried Pompeii and Herculaneum under volcanic ash. Paintings on any walls that withstood the disaster were safe from an even more destructive force—changes in fashionable taste.

As Pompeii and Herculaneum were provincial cities, it is unlikely that the very best Roman painters bothered to work so far from the capital. But even if that is so, we can deduce from the work of these painters of second rank the general character of classical painting elsewhere. Woman Playing the Kithara (283, p. 230), showing a seated woman holding a musical instrument while her daughter or handmaiden peers from behind the chair, is one of a series from a villa at Boscoreale, outside Pompeii. It differs from the Italian Renaissance frescoes we have seen in the intimacy and informality of its subject, as well as in its size, which is relatively small.

The woman and child shown here are probably portraits; certainly they are not identifiable as mythological or historical characters, and the painter has tried with some success to enliven and individualize them by casual poses. As portraits they fall somewhere between the classical formula for the ideal head and the subjects' own features. The formula calls for an oval face, a small, full mouth, a straight, high-bridged nose, a rounded chin, and perfect regularity of features. Here the variations from formula are slight, but the personality of the subject, whoever she was, is tantalizingly suggested. By current standards the image is somewhat ponderous and, accepting the probability of its being a portrait, not acutely individualized. But there is no denying the person's matronly force and dignity, the paramount virtues of a Roman wife prosperous enough to have a handsomely decorated villa at Boscoreale.

Certain formulas serve their purposes so effectively that they are not dulled by endless repetition. Virgin and Child Enthroned (285), an early twelfth-century fresco by an artist known as the Master of Pedret, follows one such formula. Originally it covered the semidome of the central apse of the Catalan Church of San Juan de Trédos; at present it is reassembled on a panel in the Metropolitan Museum, but thanks to modern technicians it could be reassembled at any time on a reconstruction of the original apse. If we imagine it in the church, with the Virgin—more than 10 feet in height—surmounting the vista of the nave, we may have some idea of the impressiveness of this representation of the Queen of Heaven.

Stylistically, this example is not much different from hundreds of other representations of the Madonna, Child, saints, and angels in frescoes, mosaics, altarpieces, panel paintings, and manuscript illuminations of the early Middle Ages. The conventionalized face with the black-rimmed, staring eyes, the angular patterning of the robes, the crisp linear contours and strong outlines everywhere, were repeated with local variations from generation to generation

from the sixth century into the twelfth, all the way from

Byzantium to England.

Considering that the ancient world had left to the early Middle Ages a legacy of realistic painting that could easily have been adapted to Christian subjects (and which we have seen exemplified in *Woman Playing the Kithara*), where did this very unrealistic style come from? It is not enough to say that in isolated parts of the early medieval world artists had no classical models to follow, or even that during the first centuries of confusion after the fall of Rome the arts declined. Both explanations can be supported to some extent, but this style flourished most vigorously in Byzantium, the greatest seat of money, power, and art at the time.

We owe the perpetuation of the stylistic formula in large part to a drastic theological schism, the famous Iconoclastic Controversy of the eighth and ninth centuries inspired by the Bible's specific injunction against the making of images in the Second Commandment: "Thou shalt not make unto thee any graven image, or any likeness of any thing that is in heaven above, or that is in the earth beneath, or that is in the water under the earth" (Exodus 20:4). The body of ecclesiastics called the iconoclasts—literally, "image-breakers"—not only forbade the making of images, either painted or sculptured, but destroyed existing ones, including scraping mosaics off the walls.

In 787 the Empress Irene convened an ecumenical council at Nicaea, in which it was declared that images were acceptable for veneration (as opposed to idolatrous worship) and were ordered restored to churches. But in the Eastern branch of the Church the iconoclasts remained stubborn for another century, and when they finally yielded they did so with a strong feeling of unease. Images were again tolerated, but the unease was assuaged if the images were unrealistic. The flat, bodiless, almost diagrammatic style of the Byzantine icon (286), which holds in the Eastern branches of the Church to this day, was a compromise with realism that, in addition, carried with it an otherworldly air that made it appropriate for holy subjects even in places where there was no objection to imagery.

Byzantine style reached its most opulent expression in mosaics. The technique of decorating walls or floors with patterns and pictures made from thousands of small pieces of colored marble was inherited from pagan antiquity. With the addition of gold and opaque glass "tesserae" of brighter colors (a tessera is any one of the small pieces used in mosaic work), the Byzantine mosaic became the most opulent form of wall decoration ever known in Europe and the Near East. The flat, severely outlined forms inherent in the limitations of picturemaking in mosaic were perfectly compatible with Byzantine conventionalizations. The Emperor Justinian took advantage of the hieratic grandeur of a style usually devoted to religious subjects to portray himself (with a halo) and his Empress Theodora in a pair of famous mosaics in the Church of San Vitale in Ravenna,

287. Head from Emporess Theodora and Attendants.

288. Head from Virgin and Child Enthroned.

Byzantium's Italian stronghold. The empress with her attendants (284, p. 230) could almost be the Queen of Heaven herself surrounded by her court of saints. If we compare the head of Theodora (287), done about the year 547, with that of the Virgin in the Catalan fresco (288) done nearly six centuries later, we see the continuation of a style from regal Byzantium to an obscure church in the Pyrenees. (The Master of Pedret had probably never seen a large mosaic, and mosaic workers in any case would not have been available in that part of the world to decorate the church; but in many churches fresco was used as a substitute for mosaic, which was extremely expensive even when available.)

It was natural that the Byzantine style, ubiquitous in one variation or another throughout the early medieval world, should make its most significant compromise with the realism of antiquity in Italy, where Roman art was still a visible influence even when in ruins. A thirteenth-century Enthroned Madonna and Child (289) now in the National Gallery in Washington is a fine example of the beautiful hybrids bred by the union of East and West, Byzantium and classical Rome. At first glance, the strongest inheritance is Byzantine, with the rich color and liberal use of gold. But the faces of the Virgin and Child are softly modeled—so much so that they rather break away from the rest of the picture—and the golden lights on the Virgin's robe, for all their Byzantine crispness, recall the naturalistic modeling of Hellenistic drapery.

At this point we are not far from Giotto's revolution. The rebirth of realism in Italian painting was anticipated by such immediate predecessors of Giotto as the painter Cimabue, but for our purposes we may compare the head of the Virgin by the Master of Pedret (288) with the one by Giotto we saw some pages back (277). The earlier painter accepts the mystery on faith and cuts directly through to it without question; hence he is satisfied with a conventionalized effigy not much different from hundreds of others. If the divine mystery is there without question, then an accepted symbol of it is sufficient as an object for our contemplation. But almost two centuries separate these two representations of the Virgin, and Giotto belonged to a time and an intellectual circle for which blind faith was no longer enough. It was necessary for him to search for the divine, which we can only sense, by way of the world, which we know. By bringing the Queen of Heaven down to earth and subjecting her to the agony of human grief, Giotto ennobled the human condition and made humanity worthy of divine compassion.

In China and India the tradition of wall painting stretches back until it is lost in hypothetical origins. We must include one example—from China—as a token representative of a vast, still inadequately studied field. Our knowledge of existing, ancient Oriental frescoes is often limited by their inaccessibility; through neglect or vandalism many have been lost, and many are still disappearing.

289. Byzantine school. Enthroned Madonna and Child. Thirteenth century. Tempera on wood, 51% by 30¼ inches. National Gallery of Art, Washington, D.C. Gift of Mrs. Otto Kahn, 1940.

Some of the earliest records of wall paintings in China tell that they were done on silk and then stretched on the walls, or hung there like tapestries. Wall painting could have originated as a substitute for these fragile and expensive decorations, just as fresco in the West was often a substitute for preferred but expensive mosaics.

Around the fourth century, when Buddhism became a powerful force in China, there was a strong development of mural decoration. Not only the walls but the ceilings of temples were completely covered with paintings of religious subjects in a conventionalized style based on flowing line and monumental, formalized silhouettes. Our example, which by coincidence happens to have been painted at about the same time as the Arena Chapel, is in fresco secco on a base of mud and sand, miraculously removed in sections from an ancient temple wall in Shansi Province and reassembled in the Metropolitan Museum (290). A detail of a head, if compared with the two we have just seen, is a miniature visual essay on comparative esthetics. The anonymous Chinese painter's absolute control of the brush line in describing forms with maximum economy and maximum sophistication is the inheritance of generation upon generation of artists who refined a tradition of decorative pictorial narration to the point of insuperable formal elegance. The play of color across this great wall, while softened by time and the slight powdering of the surface, gives us a hint of the full richness of a temple interior covered with a thousand multiplications and variations of the colors and rhythms of this fragment.

290. Unknown Chinese painter, Yuan Dynasty (1200–1368). Buddhist Assembly (detail of a head, opposite). Wall painting, water-color tempera on mud and sand. The Metropolitan Museum of Art, New York. Gift of Arthur M. Sackler, 1965.

291. Technician removing fresco from wall of the church of Santa Maria, early twelfth century, Tahull (Lérida), Spain.

We said that the fresco from Shansi Province was "miraculously" removed. The word is hardly too strong. Modern techniques account for the presence of frescoes that are now found in museums all the way across the world from the walls on which they were originally painted. James J. Rorimer, who was director of the Metropolitan Museum at the time the Chinese fresco was reassembled there, supplied the following description of the process:

The process of removing frescoes from old walls begins with the cleaning of the surface of the fresco; then canvas or some other cloth is applied to the surface with a paste that binds the fresco more closely to it than to the wall. The canvas and fresco are then cut and the fresco loosened from the wall with a knife or spatula and rolled [291]. A layer of canvas is attached to the back of the fresco, and the protecting canvas on the front is removed with a solvent which affects neither the fresco nor the paste of the lining canvas. The canvas with the fresco on the front is then ready for mounting in one of various ways, often being kept on a stretcher as in the case of a painting on canvas.

If fresco imposes a broad, vigorous, unhesitating execution, tempera is demanding in another way: it requires extreme precision, absolute control in minutiae, and patience. It is slow. It does not allow for suggestion; each fractional bit of the area of a large painting must be covered as meticulously as that of a small one. But tempera rewards the artist with its combination of adaptability to grand themes and of tolerance for statements of secondary importance. Most of the greatest pictures of the early Renaissance, aside from frescoes, were painted in pure egg tempera, but this is also, of all the periods of painting, the one in which minor masters appear to best advantage. Even the painter who did not have a great deal to say was likely to say his little bit with order and clarity. Even the painter with nothing to say, if he managed to become a painter at all, was able to turn out pictures that offer at least the satisfaction inherent in a well-made object.

To appreciate egg tempera painting as a technique, we must abandon the picture of an artist standing before his easel at work on a canvas, improvising as he paints, covering large areas rapidly with a stout brush, manipulating pigment as he pleases, smoothing it, blending it with other colors. applying it thickly or thinly as seems best. We must visualize instead a painter at a workbench applying color in small, thin strokes that dry immediately. And he is at work not on a canvas but on a panel whose preparation in itself demands conscientious craftsmanship. When he was an apprentice, the artist learned to prepare panels in the master's studio. As he proceeded in his training, he was allowed to work on more and more important stages of the many through which an egg tempera painting progresses on its way to completion. As he grew more proficient, he was allowed to paint some of the preliminary passages or even to execute some of the minor figures in the master's commissions. He would eventually paint entire pictures

under the master's instruction, and by these degrees would attain recognized status as a full-fledged painter, a member of the guild with his own studio in which he trained the next generation of painter-apprentices.

Several stages of the production of a large tempera panel painting are revealed in the *Madonna Enthroned Between Saints Peter and Leonard* (292), executed about the third quarter of the thirteenth century by a painter of the Tuscan School. (A very conservative painter, his work sticks to established traditional formulas and gives no hint of changes in the air that would produce Giotto's Arena Chapel in 1305.) In its present condition the panel is an exceptional examination piece in the craft of egg tempera technique from the very beginning—the preparation of the wooden panel—to the completed painting. The original panel is exposed in the lower part of the area; elsewhere there are bits of the completed painting in their original condition. Between these preparatory and final stages all the intermediate ones can be seen.

When it came into the possession of the museum where it is now exhibited, the panel had experienced the normal history of many very old paintings that have suffered from alternating periods of neglect and attention. Parts of it had disappeared and been restored with varying degrees of skill from time to time. Other parts had been repainted simply to freshen them. Modern laboratory methods, including X-

292. Magdalen Master, Tuscan School. Madonna Enthroned Between Saints Peter and Leonard. About 1270. Egg tempera on panel reinforced by linen, 41½ by 63 inches. Yale University Art Gallery, New Haven, Connecticut. University purchase from James Jackson Jarves.

293. Damaged area of Madonna Enthroned Between Saints Peter and Leonard.

rays and chemical analysis, can determine with a good degree of accuracy the difference in age between the original and the restored portions of such a panel. In this case the technicians removed, fragment by fragment, every bit of matter thought to have been added to the original. Film by film, the layers of varnish and dirt were cleaned away until what remained of the original object was exposed.

Normally the next step would have been an accurate rebuilding of the lost portions and a scholarly and technically accurate restoration of the surface, a process that in skillful hands can virtually recreate the original of a formula picture like this one from the clues remaining. In this case, however, the panel has been left unrestored as a study piece.

The detail illustrated here (293) shows the area below the hem of Saint Leonard's gown. The shred of linen visible on the right is a bit of the piece originally glued directly onto the wooden panel, not only to strengthen it but also to serve as a base for a layer of gesso, upon which the painting is done. Gesso is an extremely fine-textured, brilliant white substance, like plaster but finer and bound by glue instead of lime. It would be possible to gesso a wall instead of plastering it—possible but not practical. Gesso is not easy to prepare in large quantities and dries too fast for true fresco technique. Its virtue is that it gives the painter a wonderfully smooth, pure white panel upon which he can do work of great delicacy intended for the kind of close-range examination not ordinarily given to large surfaces of wall decoration.

Gesso is applied over the linen-covered wooden panel in several layers, which are allowed to dry between coats. It is brushed on like paint while in a warm, fluid condition. Since one of the ingredients is gelatin, it hardens upon cooling. When a thickness of one-eighth of an inch or so has been built up, the gesso is allowed to harden thoroughly, and is then sanded. The resultant surface is comparable to the smoothest eggshell and is a joy to paint on. It accepts paint readily but has just enough tooth to act as a slight brake that helps the painter control his brush.

If a tempera painting is to include a background or other passages of gold, as in Madonna Enthroned Between Saints Peter and Leonard, or to be painted on a panel entirely covered with gold, as in our example, a Sienese Virgin and Child (295, p. 242), the gilding is the next step once the gesso has been sanded to its perfect surface. Wherever gold is to be applied, the gesso is lightly covered with gilder's clay, which serves as an adhesive for the gold leaf and, more importantly, as a base for the necessary burnishing. Gilder's clay is brick red in color—handsome in itself. Applied like thin paint and built up in several filmy layers, it is allowed to dry, is burnished to a smooth gloss, and then dampened a bit. While damp, it is ready to receive the gold.

Gold leaf is the pure metal beaten into uniform tissuethin leaves that, touched with the finger, disintegrate into fine powder. But a skillful gilder, using a wide, flat, brushlike instrument called a gilder's tip, can pick up sheets as large as 3 inches square. The gold leaf is attracted to the hairs of the gilder's tip, but is more strongly attracted to the dampened surface of the red clay when brought close to it. If the craftsman is adept enough or lucky enough, the leaf goes on in one piece; more often, cracks or holes appear in it, one reason why several applications are necessary to get a solid coverage. Each layer is burnished with a smoothly polished agate tool before the next is applied.

With time the layer of gold partially evanesces and the reddish tint of the gilder's clay shows through. It is particularly apparent in the area around the aureole of the Virgin in our anonymous Sienese *Virgin and Child*. Fortunately the rich color of the clay is compatible with gold, and these reddish areas, which show through the surface of virtually all unrestored gilded panels as old as the ones we are seeing

here, have a handsomeness of their own.

With the leaf laid on and burnished to a satisfactory sheen, the panel is ready for whatever tooling it is to receive in halos, borders, or other areas. A detail (294) from the border of this very ornamental little picture shows that the tooled pattern is made up by recombinations of a few elements. The tooling, or punching, is done with small instruments, frequently carved from bone, a few inches long and comparable in other dimensions to knitting needles. One end has a pattern carved into it; it is rested on the surface of the gilded gesso and the other end is given a firm tap. Inexpertly delivered, this blow may chip the gesso, a disaster. Our detail shows that, at most, half a dozen simple shapes have been combined to create a variety of patterns. Identifiable are a hollow circle repeated seven times to make the center and the six petals of the flowerlike figure running along the central band, a half-circle and two arcs that are combined to make the lacy border along the inner edge, a simple blunt punch that produces a miniature crater, and perhaps one or two others. The tooling can, of course, be done after the painting is completed, but is usually done first because less is lost if the panel cracks.

Except for occasional minor details, egg tempera paintings are not improvised on the panels. Before the panel is touched by paint, a drawing at full scale is completed, finished in all its outlines, and modeled in its more important areas. To transfer the outlines to the panel, the usual practice is to scratch them lightly into the gesso surface. These scratched outlines generally become filled with paint, but you can see them now and then in a great many paintings if you look for them in a favorable light. They are more than usually apparent in the robe of the Virgin in this work by an unknown artist, which is one of several reasons we have chosen it for illustration instead of a more important painting.

Once the outlines have been scratched in, it is at last time to apply color. Egg tempera paint is composed of approximately equal parts of powdered pigment, yolk of egg, and water. White of egg is also used in some formulas. When used in the correct amount, egg is a perfect binder. If there is too little of it, however, the pigment will powder off when it dries. If there is too much, the paint is gummy and hard to work with and has an unpleasant sticky-looking

294. Indented patterns on gesso and gilt panel.

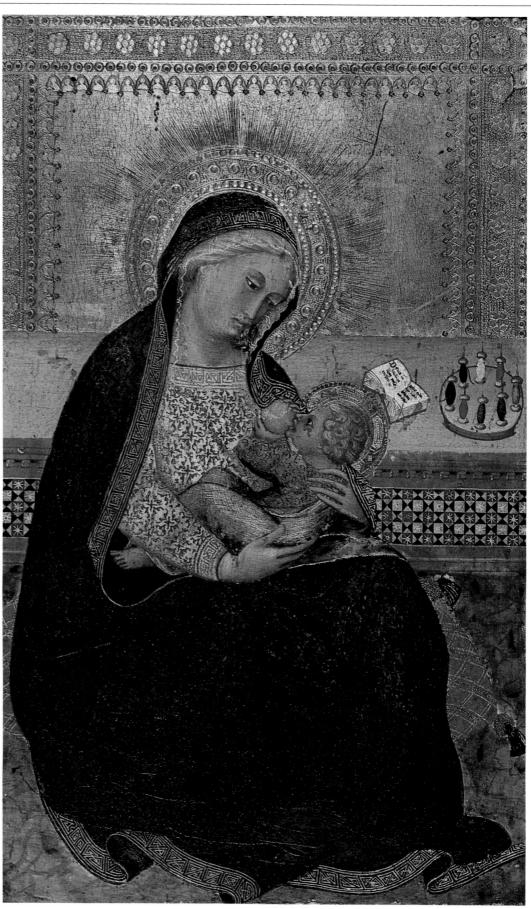

295. Sienese artist, late fourteenth century. Virgin and Child, left panel of a diptych Virgin and Child with St. Jerome. Tempera on wood, height 11¾ inches. Philadelphia Museum of Art, John G. Johnson Collection.

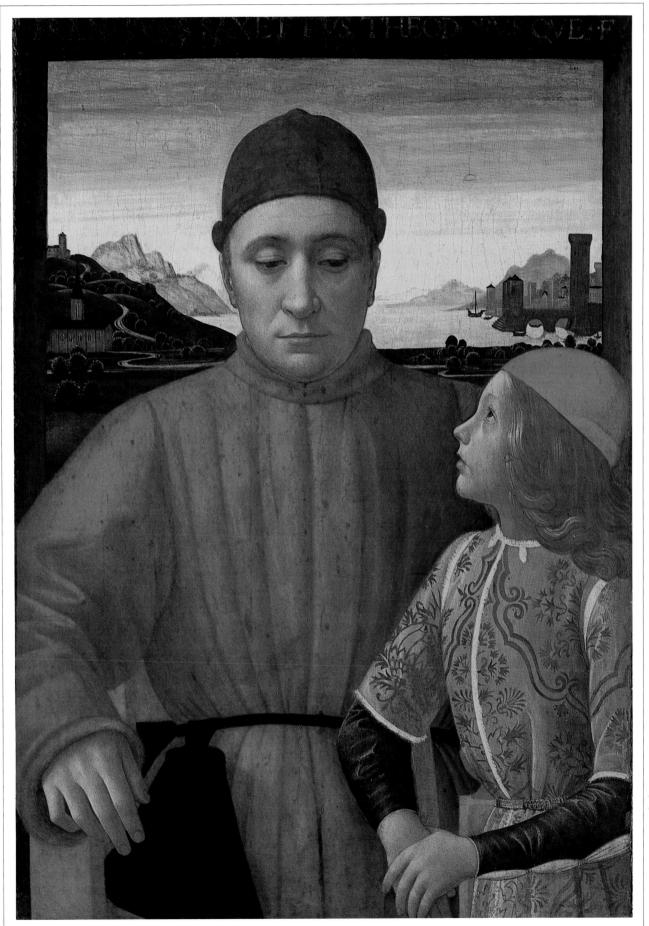

296. Domenico Ghirlandaio. Francesco Sassetti and His Son Teodoro. 1472. Tempera on wood, 29½ by 20½ inches. The Metropolitan Museum of Art, New York. The Jules S. Bache Collection, 1949.

297. Head of a boy from *Francesco Sassetti and His Son Teodoro*.

gloss when dry. An experienced tempera painter can tell when the mixture is right by stirring it with his brush. The paint is mixed in very small quantities, a few thimblefuls at a time, since not much is required to cover a surface and it tends to thicken in the dish.

Using small, pointed brushes, the artist applies the paint stroke by stroke, not in washes or broad areas, and often in hairlines. The paint dries instantly, at least as far as workability is concerned. The only way to apply a solid area of color is stroke by stroke until hundreds of criss-crossings produce a uniform flatness.

For some reason the flat blue of the Virgin's robe has not been modeled, a curious circumstance in a picture so wonderfully complete in other passages, but a convenient omission for our purposes here. The scratched-in guidelines that were to have served as guides in modeling the robe in tones lighter and darker than the local color can be seen in our reproduction.

Modeling, like flat color areas, must be built up little stroke by little stroke until the form emerges. But difficulties increase at this point. Whereas the solid tone can be built up by crisscrossing lines in any direction, the modeling must "follow the form." Dürer's famous drawing. Hands of an Apostle (298), explains this phrase. The hands are modeled entirely in the lines; without recourse to flowing, blending, or smudging, they describe the complicated form of hands, along with all the ins and outs of secondary forms (veins, tendons, creases, the wrinkled skin over knuckles), by appearing, as it were, to lie upon the forms they describe. The result is a double definition: once in terms of light and shadow, as the camera records form; and once in terms that can be called diagrammatic, with each line describing the surface it lies on. It is a powerful way of defining form, but a technically demanding one. A misplaced line would be immediately disfiguring, with the appearance of a piece of wire or string or a hair projecting from the form, instead of a diagrammatic line following it.

A painter may "follow the form" by cross-hatching as Dürer does (especially noticeable in the cuffs), or by using lines in only one direction, as Ghirlandaio does in the head of a little boy (297) reproduced here at close to full size from the double portrait Francesco Sassetti and His Son Teodoro (296, p. 243). The modeling is rather shallow; the forms are treated more like low sculptural relief in color than three-dimensional forms existing in full depth surrounded by air. The red cap especially is very lightly modeled, and the delightful design of curling hair is conceived as much as a linear pattern as a three-dimensional form, so that it falls somewhere between the two. In addition to modeling the forms in only one direction, Ghirlandaio has reduced them to their simplest bases, in contrast to the method Dürer used in his drawing of the hands, in which he sought out intricacies and revealed them in linear systems that constantly shift direction with the subtlest change in the hands' multiple contours.

The greenish cast so frequent in flesh passages painted in tempera comes from the base color showing through the superimposed modeling. The tempera formula for painting flesh tones is an exception to the rule that the entire area of a color is first covered with a flat base tone of the object's local color (as we have seen in the blue robe of the Virgin with its unmodeled ultramarine area). Tempera flesh tints modeled over a pink or cream base tone appear chalky and lifeless. Inasmuch as the dominant color in flesh tones is red, its complement, green, is used as the base tone because it has a maximum vibration in opposition to red. Minute bits of the green base showing through the flesh-colored modeling bring the passage to life. The green tone was frequently left showing fairly obviously along the "shadow edge" where the light tones give way to darker ones, but seldom to the extent evident in very old temperas. Over the centuries the top film of paint tends to evanesce or become transparent; in addition, very few old temperas have escaped varnishing, which also increases transparency. Finally, any cleaning that is carried a microscopic fraction of an inch too deep will remove some of the top film, so that in many old tempera paintings the flesh tones have taken on an unhealthy greenish pallor.

The Sienese Virgin and Child to which we have given so much attention is a very pure example of tempera

298. Albrecht Dürer. *Hands of an Apostle.* 1508. Brush, heightened with white, on blue-grounded paper. Albertina, Vienna.

299. Sienese artist, late fourteenth century. Virgin and Child with St. Jerome, diptych. Tempera on wood, height 11¾ inches. Philadelphia Museum of Art. John G. Johnson Collection.

technique and has the advantage of an unfinished section for elucidation, plus the great advantage of being small enough to reproduce without drastic reduction. It is sometimes attributed to Tommaso da Modena, himself very obscure if not quite anonymous. But why choose it instead of an example by a great master—Fra Angelico, for instance, whose temperas are of exquisite purity technically and are invested, as well, with deep spirituality? The very fact that our choice could not in any way be called a great painting is one reason for its choice here. Having already said that it was painted at a time and in a medium that allowed minor masters to appear to best advantage, we will extend that point to argue that there have been times in the history of art when technique in itself, and technique alone, can become a form of expression for an artist who has nothing particularly original to say.

In the light of this preamble, let us look again at this little *Virgin and Child*. It is the left half of a diptych (299) whose two parts are hinged to close together face to face like the pages of a book. Being a little less than I foot high, it must have been a portable shrine painted for some wealthy and devout person to carry with him on his travels, with his patron saint, Jerome, occupying the right half.

In neither of these figures—and certainly not in that of the Child, which is only a pretty manikin—has the artist exercised any particular originality, force, or emotional depth of conception. These are honest, respectably executed figures, invested with whatever qualities are appropriate to the Virgin and Saint Jerome, but they appeal more by readymade associations than by any special interpretation on the part of the artist. The Virgin bends over the Child in an attitude that is adequately tender but entirely within the formula of countless other Virgins painted by Italian contemporaries. The Child is thoroughly disappointing if we try to find anything inherently more profound than a dolllike prettiness. The little spindles of bright-colored thread are an engaging detail relating the Virgin to her household activities. Saint Jerome's lion, whose participation in such pictures is obligatory, is squeezed into a corner as an afterthought and resembles a tabby more than the king of beasts.

And yet the pictures are intensely expressive. They glitter with gold and precious pigments applied with an exquisite elaboration that becomes devotionally expressive in itself. The picture of the Virgin is as much a jewel as a painting; the craft of the jeweler, in fact, overlaps the craft of the painter in such a work. The richly tooled border with its multitude of indentations that catch the light is repeated in the halos, and around the Virgin's halo the aureole flames gently where the surface of the gold has been indented in a series of radiating lines. The gown beneath the robe is a sumptuous brocade, first modeled and painted, then scratched through to the gold in a pattern that, in turn, is tooled with minute indentations which not only increase its richness but, being delicate as threads, give the gold a brocade-like texture and differentiate it from the flat gold of the background. Otherwise it might appear that the background was showing through holes cut in a pasteboard figure. The Child's light blue robe is similarly patterned,

and in addition it is modeled over his thigh and along his back with tiny scratches, which once again reveal the gold background in strokes like those of a pen or fine-tipped brush, so that the robe takes form and turns golden simultaneously.

The picture is shot through with gold in hundreds of tiny details. Gold is conspicuous along the ornamental borders of the Virgin's robe, and sparkles less obviously in the band of mosaic behind her. It shines in small details such as the stripes on the cushion upon which the Virgin is seated and on the heads of the tassels. A gold filament runs through her veil; there is a highlight of gold on the bobbin of white thread. All this rich detail is more than ornamental; it becomes devotional in character. In its psychological effect—its expressive quality—it is remindful of shrines covered with offerings of jewels, flowers, and precious trinkets from grateful worshippers.

Tempera, for all its special beauties, is a technique that makes no concessions in certain quarters where the painter could otherwise extend his range of expression. Textures can be simulated only within a narrow range. The way a robe falls—in delicate, crisp folds or in large, ample ones may indicate that it is supposed to be of a light material like thin silk or a heavy one like thick wool, but tempera offers no really satisfactory way to simulate the difference between the sheen of silk and the nappy look of wool. While wonderfully adaptable to the description of form, tempera falls short when it comes to reproducing the quality of the light that falls on those forms, light caught and reflected in different ways by different surfaces. Flesh passages in tempera, no matter how skillfully executed, never quite take on the quality of flesh, but remain some harder, sharper substance tinted approximately the color of flesh. Fur (difficult to represent in any technique) is impossible in tempera. Individual hairs may be defined neatly, but the soft mass cannot be represented in a technique where the choice is between crisp line and mushy compromise. For instance, the lining of the robe worn by our Sienese Saint Jerome, showing at the collar and inside the sleeves, is recognizable as fur, but as for its texture, nobody is likely to grant the artist credit for more than a good try.

Tempera is an art of clearly defined edges; objects can neither fade into shadow nor loom from shadow into bright light. Tempera colors are most effective in the upper range; dark colors tend to grow heavy and turgid. And tempera is essentially an art of small scale. The large altarpieces painted in the fifteenth century may seem to refute this statement, but a large tempera painting is simply an accumulation of close-range material assembled upon a large surface, a large area of close-range painting. Dash, sweep, and free movement over large areas intended to make their effect from a distance are foreign to tempera's nature. Finally, the paint film is uniform over the surface of the gesso; the paint cannot be piled up dramatically to emphasize one passage, nor thinned out to throw another passage into the background.

For all these reasons, tempera does not appeal to many

300. Rogier van der Weyden. Portrait of a Lady. About 1455. Oil on wood, $14\frac{1}{2}$ by $10\frac{3}{4}$ inches. National Gallery of Art, Washington, D.C. Andrew Mellon Collection.

modern artists as a creative technique, no matter how much they may admire temperas of the past. Modern art usually demands the full value range from black to white and the full color range from the most brilliant primary colors (red, blue, and yellow) to sonorous secondary and tertiary mixtures. More often than not, the modern artist also wants to enhance the visual excitement of color and form by an agitated surface where uneven paint textures remain on record as witnesses to the swift passage of a brush in the hands of a skilled manipulator. Even when modern paintings are made up of flat colors held within sharply defined boundaries and within tempera's limited color range, tempera has the disadvantage of being a laborious technique outmoded by the bright, fast-drying mediums now synthesized chemically.

The most conspicuous exception to this rule among contemporary artists is Andrew Wyeth, who paints contemporary subjects realistically in the purest tradition of early Renaissance tempera technique as set down about the year 1390 by an artist named Cennino Cennini in a handbook of practical advice, *Il Libro dell'Arte*. At first glance, Wyeth's *Groundhog Day* (301) seems to deny what we have just been saying about tempera's limitations. Actually, it circumvents those limitations by making the most of tempera's special aptitudes.

First of all, Wyeth has painted a gentle flow of light across the landscape, into the quiet room, and across the objects on the table, apparently in direct contradiction to our having said that "tempera falls short when it comes to reproducing the quality of the light that falls on those forms." Light, indeed, is present in this tempera painting, is even its theme. According to an old tradition, the groundhog comes out of hibernation on Groundhog Day, February 2, and if he sees his own shadow, goes back to his hole for six more weeks of winter weather. The quality of the light in Wyeth's Groundhog Day is not only adaptable to tempera; it seems almost to demand it. The pale, cool, clear sunlight of late winter casts no strong shadows and is reflected in no brilliant highlights. In addition, Wyeth lets it spread across textures that are perfect for description within tempera's range—the cool, clean, eventless surfaces of paper, cotton or linen cloth, and lightly glazed china. Outdoors, individual twigs and blades of dry grass can be picked out by small strokes of the brush in a beautifully cohesive harmony of light, texture, and color that identifies the actuality of the scene with the magic of the technique that records and preserves it.

Tempera's characteristically dry, precise quality comes from the "lean," fast-drying nature of its binder and medium—egg and water. A "fat" medium dries slowly, allowing the painter to cover one area, brush another color into it while it is still wet, blur edges if he wishes, and to model by blending one tone into another with a soft brush instead of making the transition in a multitude of graduated tones. A fat medium can be piled thick or scrubbed thin, and can run the entire range from black to near-white without going murky in the darks or dead in the lights.

301. Andrew Wyeth. *Groundhog Day.* 1959. Egg tempera on composition board, 31 inches square. Philadelphia Museum of Art. Gift of Henry P. DuPont and Mrs. John Wintersteen.

302. Detail from Portrait of a Lady.

The standard fat medium is oil. Oil was used as a binder in heavy-duty paints (as for the exterior of houses) long before it was used by artists, largely because oils of sufficient purity not to discolor and deteriorate rapidly were difficult to come by. The "secret" of the earliest artists who used oil was the process of refining crude oils to a point that ensured their stability and in sufficient quantity to justify experiments.

Painters first employed oil not as an independent medium but as an adjunct to tempera. Oil's viscosity, allowing for easy manipulation of thin glazes over obdurately unmanipulatable tempera, added the advantage of easy transition between lights and darks to tempera's delightful precision, and its transparency allowed for greater depth and brilliance of colors in a wider range between black and white than tempera alone could yield. We do not know with any certainty the details of the combined oiland-tempera technique as exemplified by its supreme master, Jan van Eyck, whose Arnolfini Wedding Portrait we have seen (30). But we do know that the basic formula called for thin, transparent glazes of pigmented oil over an underpainting in a leaner technique, tempera or perhaps a tempera-oil emulsion. This underpainting defined the forms in considerable detail; then the brilliant transparent oil glazes were used to "dye" the forms in the desired color, either modifying or intensifying the undercolor. Obviously there was a great deal of manipulation of the oil films, but their brilliance and variety is accounted for by the fact that they could be used essentially as dyes over forms already established.

From North European workshops, some knowledge of the new technique spread to Italy, where similar but less successful experiments had been made. Oil's attraction for the Italians is apparent if we compare the tempera portrait we have just seen, Ghirlandaio's of the boy Teodoro Sassetti, with a Northern masterpiece painted about twenty years earlier, Rogier van der Weyden's Portrait of a Lady (300 and 302, pp. 248 and 249). Ghirlandaio was an expert technician, but the modeling and textural variations possible in oil were beyond the range of tempera even at its most flexible. Tempera's stroke-by-stroke rendering could have indicated that a filmy wimple was arranged to fall across the lady's brow and ear, but could not have recreated the delicate nuances in degrees of definition and color that tell us simultaneously of the texture of flesh and the texture of the diaphanous veil that modifies the look of what we see through it. From the crisp detail of the gold buckle and the almost stylized line of the eyelids, to the imperceptibly changing gradations in the modeling of the volumes of the face; and from the rich black of the robe to the white edge of the wimple, Rogier's Portrait of a Lady demonstrates the range of the new technique and the limitations of the old.

Oil painting as most people think of it—a freer application of paint, with visible brush strokes and a generally more eventful surface of varying thickness—developed gradually from the early oil-and-tempera hybrid. In Venice, particularly, the taste for luxuries on the grand scale during

the heyday of the hedonistic city was sympathetic to an effulgent style of painting unlike the small-scale, tightly controlled renderings we have been seeing. In the sixteenth century the development reached its apogee in the art of Titian and his followers.

Titian's Venus and Adonis (303, p. 252) is conceived to appeal first of all in sensuous terms. It relays the very feel of flesh, hair, silken gauze, jewels, foliage, and swirling balmy air, a textural symphony in which the texture of the canvas itself and the richly manipulated paint are fused with the simulation of textures in nature. The lusciousness of Titian's paint is part of the picture's expressiveness just as form and color are, and could have been achieved only in oil.

Titian's method continued to be based on underpainting that defines essential forms and overpainting in glazes to tint and develop them; but the underpainting is now brushed in freely on canvas of a natural brownish color with shadow areas defined in darker golden browns painted thinly with fluid pigment, and lights laid on in a heavy white paint that can be piled up to considerable thickness. When the underpainting was dry, the overpainting was built up in a series of glazes applied one on top of another. Orange might be produced by spreading transparent red over an opaque yellow. The resultant variety and brilliance was beyond anything that could be achieved by straight painting or by glazing in a single color over brown or gray underpainting. The uneven texture of piled-up light areas in the underpainting collects the fluid overpainting in its pits and shallows; a glaze may be applied over a large area and then rubbed off in spots. In "scumbling"—a technique in which a brush of thick, half-dry pigment is dragged over a dry, heavily textured area—the new color clings to the slightest roughness but allows the original color to show through in the shallows.

Underpainting has a function beyond its primary one as a preliminary definition of form. If executed in golden browns, it continues to affect the overall tonality of the completed picture in that direction; if in black and white, the tonality is cooler, more silvery. In either case it is always in the lights that pigment is built up and heavily worked; darks may remain hardly more than the canvas dyed by the original underpainting.

In this technique shadows have a luminosity and vibrancy, no matter how dark they are, that cannot be achieved in other ways. In contrast with these mysterious depths, forms may emerge into brilliant lights. Where Titian capitalized on the sensuous and dramatically ornamental potentials inherent in this contrast, Rembrandt found in it the means toward an opposite expression—of mystery, melancholy, and philosophical brooding. His *Aristotle with a Bust of Homer* (304) is typically Rembrandtian in the way forms emerge into warm, golden light from the obscurity of vibrant shadows.

The techniques of the old masters are not exactly lost, but after their abandonment it is not easy to pick them up

303. Titian. *Venus and Adonis*, with detail. Late 1560's. Oil on canvas, 42 by 52½ inches. The Metropolitan Museum of Art, New York. The Jules S. Bache Collection, 1949.

304. Rembrandt. Artistotle with a Bust of Homer, with detail. 1653. Oil on canvas, 56½ by 53¾ inches. The Metropolitan Museum of Art, New York. Purchased with special funds and gifts of friends of the Museum, 1963.

again even from descriptions in contemporary records. A variety of reasons account for their disappearance, including such simple ones as the appearance of oil paints readyground and emulsified with binder and purchasable in tubes, and commercially prepared canvases sold by the yard in art stores. Conveniences like these contributed to the demise of the idea of a painter's studio as a workshop where apprentices were trained, and to the abandonment of traditional techniques. Instead, we have the convenience of "straight" painting, where ready-made paint is applied directly from the palette to the ready-made canvas, without the preliminaries of underpainting and without any systematic glazing. Since effects of spontaneity and immediacy are typical of "straight" painting at its best, it was adaptable to the nineteenth-century Impressionist attitude of direct, unpretentious response to everyday subjects informally presented to the observer. For subject matter that was fragmentary in the first place, a style of painting dependent on suggestion rather than on detailed statement was appropriate and in harmony with a very direct attack. Manet's Boating (III) was discussed in this respect when we said that it offers us a kind of shorthand description. A detail of the woman's head (305) shows that the entire passage was certainly painted all at once, with the "details," if we can call them that, brushed and spotted into freshly painted areas instead of being built up over preliminary foundations by glazes, scumbling, and the like.

If we compare this head with another (307), a detail from Picasso's Woman in White (306), we discover that, surprisingly, the modern arch revolutionary draws more heavily from the past than Manet did. Woman in White is an arresting combination of paint textures involving building up in the lights of the face, glazing of a kind where the lower right section has been softened by an overscrub of white, and a free, fluid calligraphic line indicating the fall of hair—all this in connection with form as highly simplified and as sharply defined as those in a tempera painting. In a picture like Woman in White we can find a little bit of nearly everything: a little bit of the classical past, a little bit of the Renaissance, a little bit of impressionism, even a suggestion of Chinese painting in what we have called the calligraphic line of the hair and, of course, a great deal of Picasso and our own century.

Woman in White is not a piece of craftsmanship in anything like the sense of the earlier paintings we have seen in this chapter. It is typical, rather, of the anarchic technique of modern painting, in which individual invention takes the place of systematic procedures. Such experiments are all to the good and have tremendously enriched the painter's technical vocabulary in the twentieth century. Yet even the most experimental techniques must be based on a craftsman's knowledge of his materials. The old masters' strict observance of technical formulas in fresco, tempera, and oil was an assurance that their work would endure. Ironically, Leonardo's penchant for experiment made him an exception to the rule.

305. Edouard Manet. Head of a woman from Boating.

306. Pablo Picasso. *Woman in White.* 1923. Oil on canvas, 39 by 31½ inches. The Metropolitan Museum of Art, New York. Rogers Fund, 1951. Acquired from the Museum of Modern Art, Lillie P. Bliss Collection.

307. Head from Woman in White.

By definition water color is pigment with any one of several water-soluble gums used as a binder. It is a convenient technique, requiring no more accessory equipment than a brush, a piece of paper, and a container of water. It is also easy to clean up. For these reasons we meet water color in our first paintbox and continue to think of it as a technique for beginners. Actually, the proper manipulation of water color demands great dexterity and a sound command of the principles of picturemaking.

Water color's individuality lies in its extreme fluidity and transparency, which usually imply rapid, facile execution in pure, bright colors applied in broad washes and deft strokes with a fairly large, fully saturated brush. But water color can also be used with the precision of a pen or pencil, as John J. Audubon uses it in his combined pencil and water-color study of a family of brown rats (309)—probably the most attractive rendition ever made of these unpopular rodents, in which their not very lovely forms are caught in decorative silhouettes, and the natural growth patterns of pelt and whiskers are caught in fine individual strokes over a light water-color base tone.

A more arresting exploitation of water color's potential is made in paintings like Winslow Homer's Sloop, Bermuda (308). Here the preliminary drawing is limited to a few cursory pencil lines, a bare minimum indication of the picture's arrangement that leaves the forms to be described by the brush in "broad washes and deft strokes," as we have said. The effect is very "wet"; the very feel of the flowing brush is still present. The texture of the paper, which is an integral part of the effect, is revealed in two ways. In some areas, as in the sky, the pigment has been allowed to settle into the grain of the paper. (Certain heavy pigments, ultramarine blue among them, never go into complete solution, and when applied very wet they settle at the bottom of tiny puddles that form in the irregular surface of the paper.) Here and there a wavelet is defined by a relatively dry brushful of pigment dragged across the paper, leaving the grain showing as a speckling of white spots like flecks of foam or sparkles of light. Everywhere the paper is allowed to tell: in its own white brilliance beneath the transparency of the washes; in passages like the sails or the side of the sloop, where it may remain entirely unpainted or tinted with only the barest suggestion of color.

Water color thus applied has a freshness, spontaneity, and vivacity unique to itself. But the painter has no time to calculate or study, no opportunity to change or modify. Everything depends on his exact knowledge of what he is doing. He must work fast, so that passages intended to flow together may do so before the early ones dry out. The result of such speed and dexterity is a style depending on suggestion rather than complete statement, and carries with it the hazard that a painter may depend so much upon a standard bag of tricks that his water colors become sleight-of-hand performances rather than creative acts.

This was certainly not true of Homer. He thought of

308. Winslow Homer. *Sloop, Bermuda.* 1899. Water color on paper, 15 by 21½ inches. The Metropolitan Museum of Art, New York. Purchased by Amelia B. Lazarus Fund, 1910.

309. John James Audubon. *Brown Rat* (figures cropped from neutral background). 1843. Water color and pencil, full dimensions 24½ by 325/6 inches. The Pierpont Morgan Library, New York.

his water colors as incidental to his work in oil, and it was in the oil technique, deliberately and thoughtfully developed that his brisk water-color style was founded as we

his water colors as incidental to his work in oil, and it was in the oil technique, deliberately and thoughtfully developed, that his brisk water-color style was founded, as we may see if we compare Sloop, Bermuda with one of his most famous oils, The Gulf Stream (310), also a subject with water, a boat, and a figure. The water color is a brilliant summation, in a kind of pictorial shorthand, of principles that are fully and solidly elaborated in the oil.

The majority of painters who limit themselves to water color, no matter how technically expert they may be, fall into the trap of repetitious effects through a stock of shorthand devices. The resultant anemic productions account for the idea that the technique is without substance. To this unhappy generalization there are happy exceptions, with John Marin among the happiest. Marin is a water colorist first of all; his oils reverse the usual order and seem to be efforts to adapt to a less compatible technique what he learned about painting in water color. He used the unique advantages of water color to their fullest, forcing them to their very limits, investing the technique with a masculine force and creative originality unparalleled in its history until then.

Marin's Boat off Deer Isle (its rather unwieldy full title is Maine Series No. 9: Movement—Boat off Deer Isle, 311) is abstract and expressionistic according to principles discussed in earlier chapters. It is not our purpose to analyze it in that way now, but to point out its identification of

311. John Marin. *Boat off Deer Isle.* 1926. Water color on paper, 13 by 17 inches. Philadelphia Museum of Art. Alfred Stieglitz Collection.

312. Rosalba Carriera. *Personification of Europe*. Probably before 1720. Pastel on paper mounted on canvas, approximately 17½ by 13½ inches. The Cooper-Hewitt Museum, New York.

technique with expression. The elements we have mentioned in Homer's water color—the feel of the brush, paper, and water, the use of settling pigments, the revelation of paper texture by a dragged brush—all are present here, but with a difference. In the Homer, everything was directed toward suggesting the appearance of objects in brilliant outdoor light. In the Marin, realistic suggestion is no concern; the manipulation of water and pigment becomes a form of expression rather than a means of description. That is why it is difficult to imagine *Boat off Deer Isle* satisfactorily translated into oil, and why Marin has a claim to the title frequently awarded him as the finest and certainly the purest water colorist of them all.

Marin's water colors present the anomaly of an art combining spontaneity with a sense of complex and powerfully controlled organization. Boat off Deer Isle offers an unusually strong clue to the way Marin composed a picture, combining on-the-spot decisions with a general predetermined scheme. On the left side there is a strong vertical line where, apparently, a puddle collected at the bottom of the heavy, blackish stroke and then, breaking, ran down the paper. It may be taken for granted without too much risk that this was an accident that, in the ordinary water color and in most Marins, would have been ruinous. In this particular picture, however, we may deduce that Marin saw the possibility of incorporating the line thus created into his general composition, countering or echoing it with the series of five similar black strokes at the right side of the picture, and probably making adjustments in other elements that otherwise would not have had the same position or character. Admitting that the cultivation of such accidentals would hardly be a safe rule of procedure for Marin or anybody else, it is still true that in this case the result was successful. It is an exaggerated illustration of the extraordinary unity between creative invention and the manipulation of a technique in Marin's art.

Even more than water color, pastel is associated with ideas of the innocuous and the dainty. Pastel is only one of the hundreds of varieties of colored crayons made up of pigment combined with filler and pressed into stick form with enough gum to hold it together. This stick will vary in color intensity according to the proportion of pigment to the diluting filler; it varies in softness or hardness with the amount of gum. Since filler is less expensive than good pigment, the average commercial pastel is pale, sometimes having the loveliness of "pastel shades" at their best, sometimes being merely weak and flat.

Pastel may be used on any surface with enough tooth to take the crayon under light pressure. A slick paper is no good at all. There are very fine sandpapers especially prepared for pastel, and it can also be used on fine-grained canvas. If pastel is to have any life at all, the surface must have a grainy or powdery texture that accepts the pigment readily, even if this texture is close to microscopic. Beginners always overwork pastel, rubbing and smearing it to

death. A skilled pastelist may rub a tone lightly here and there, or even brush a whole area lightly, but not much. Every touch, once the pastel is applied, is dangerous; passages cannot be reworked because pastel is as unpleasant when overloaded with powder as when rubbed.

A completed pastel may be "fixed" with a light spray of diluted gum, but the fixative is only a help, not a real protection, to this most delicate of surfaces. If the fixative is applied heavily enough to hold the pastel firmly to the paper, it may also spot it, deaden it, or give it an unpleasant shine. Pastels cannot be cleaned. If they are to endure, they must be sealed under glass against all dust, dirt, and surface contact.

Pastel enjoyed its liveliest vogue during the eighteenth century as a portrait medium. Its powdery, feminine tints were especially compatible with fashionable taste in decoration and costume; even the powdered coiffures of the period lent themselves to the chalkiness of pastel description. The light touch, the intimacy, and the sensitive application of pastel harmonized beautifully with the light and graceful intention of the century's décor, as well as its special kind of cultivated social personality. The reigning pastelist was a woman, Rosalba Carriera, a Venetian as successful in France and Vienna as she was at home. Her light, graceful style (312) capitalized on her patrons' desire to be invested with the rather superficial delicacy cultivated in fashionable circles.

In sporadic appearances more recently, a few artists have shown that pastel's potential for more significant statements has been neglected. Manet's portrait of George Moore (313 and 314) is a brilliant example. George Moore was a bright, clever, rather shallow young man, given to superficialities of social intercourse rather than to great solidity or profundity of thought. It would not take much change to turn that description into a description of pastel technique. Moore's coloring, too, so very pale of skin and so pinkish-blond of hair and beard that he was set apart from everybody else in a group, could have come straight out of a pastel box. With a subject perfectly suited to the technique, Manet did one of the most wittily revealing portraits of his century, capitalizing to the full not only on the color and delicacy of pastel but also on its capacity for quick suggestion. There are not many portraits that bring us so immediately and so freshly (and perhaps so mercilessly) into the presence of the sitter, although there are a great many, including some by Manet, in which a less eccentric subject has given the painter opportunity to explore more significant nuances of personality. But for these explorations painters usually use the more solid technique of oil.

The great exception among pastelists is Edgar Degas. From what we have already said about him in other chapters in discussing his *Woman with Chrysantheumums* (21) and *The Bellelli Family* (257), both oil paintings, it is obvious that Degas is hardly in line with the pastel tradition of superficial delicacy. His vigor, his precision, and his intel-

313. Edouard Manet. *George Moore*. About 1879. Pastel on paper, 21¾ by 13¾ inches. The Metropolitan Museum of Art, New York. Bequest of Mrs. H. O. Havemeyer, 1929. The H. O. Havemeyer Collection.

314. Detail from George Moore.

lectualism are foreign to the generally innocuous run of pastels; nor was he content to turn to pastel as Manet did only for occasional use when a special subject could combine with the technique to produce an exceptional picture like Manet's of George Moore.

Still, pastel had certain advantages that attracted Degas. One of the greatest draughtsmen in the history of art, he was never altogether happy with oil paint. It is possible for a painter to draw with a brush, but a pencil or crayon is somehow closer kin to his hand and a degree closer to the surface upon which he works. In pastel Degas found satisfaction as a draughtsman, and he became the only major

painter to produce a large body of major works in the technique, giving it a strength and solidity hitherto foreign to it. This he did by building his pigment in successive layers. Ordinarily, as we have just said, such a way of working would have resulted in an unpleasant clotting of the pastel if, indeed, it were possible at all, since there is a limit to the amount of this powdery substance a surface can retain. Degas worked with a fixative prepared specially for him from a formula that he guarded closely and that is now lost. With this fixative, successive layers could be firmly secured without loss of brilliance or the blemish of shine. Using crayons with a maximum of pigment and a minimum of filler, he avoided the obvious and limited effects of traditional pastel. Woman Having Her Hair Combed (315) is the kind of picture in which he lifted pastel from its limbo of airy effects and sporadic brilliance to a firm place among the major techniques. An examination of a detail should show the powerful drawing—in firm, decisive strokes of the crayon—that he found more possible in pastel than in oil. In color, he juxtaposed one color at full intensity with another to enhance the strength of both, and often dragged one color across another so that their intermixture vibrates with light. Diaphanous suggestions give way to solid forms that emerge with the fullness and richness of oil or fresco.

315. Edgar Degas. Woman Having Her Hair Combed, with detail. About 1885. Pastel on paper, 291/8 by 237/8 inches. The Metropolitan Museum of Art. Bequest of Mrs. H. O. Havemeyer, 1929. The H. O. Havemeyer Collection.

316. Thousand Buddhas, portion of a large sheet. 1212. Ink stamped on paper, height of figure 1½ inches. Japanese National Treasure. North Octagonal Hall of the Kōfuku-ji.

Chapter Eleven PRINTS

rints, with woodblocks as the oldest form, began life humbly, not as works of art but as substitutes for drawings or paintings when multiples of a single image were needed, probably as long ago as the fifth century A.D. in China. It took another thousand years for the woodblock print to come into its own as a fullfledged independent art form, which it did under the sponsorship of the great Albrecht Dürer in Germany. Dürer performed the same service for engraving, the second oldest print form, and collectors began taking etchings seriously when Rembrandt produced his wonderful ones in the seventeenth century. All three print techniques, during their rise, still served as second-class citizens in their function as reproductions of original works of art, mostly as illustrations in books and magazines. This continued well into the nineteenth century, by which time lithography had joined the print family in the same kind of double life after it was invented about 1796 by Aloys Senefelder, a Bohemian. Only in our century have prints come fully into their own as works of art, with photomechanical reproduction processes taking over their former, original function. Today fine prints are coveted as intensely as drawings and paintings.

We will take up their history in chronological order of appearance: woodblocks, engravings, etchings, and lithographs, with any appropriate offshoots as they occur.

So far as we know, the numerical record for hand-printed multiples of a single image was set in the year 770, when the Empress Shōtoku distributed one million prints of a Buddhist charm to temples throughout Japan. Since one woodblock would wear out before that number, there were no doubt many repeats of the block itself. High artistic quality was not the first goal in such prints; repeated over and over and over again into the thousands of times, and frequently placed within hollowed-out statues of Buddha, they had something like the incantatory function of the chants in which devout Buddhists repeat the same phrase over and over again for hours at a time. Our illustration (316) is a section of a sheet of a thousand Buddhas, done in the year 1212 and found inside a statue of the bodhisattva Miroku. (A bodhisattva in Buddhist lore is a person who has attained moral and spiritual wisdom in assisting suffering mankind.) The height of the figures is 1½ inches. A related ancient form of charm-print has disappeared forever: Buddhist priests used to impress them on the wet sand of beaches, to be washed away by the tide, thus incorporating the charm with the eternal mystery of the sea.

Woodcuts did not come into wide use in Europe until the Middle Ages, when they were used in the earliest printed books, on broadsides, and sometimes as inexpensive souvenirs at religious fairs where the faithful could buy a crudely printed image of a patron saint for a few pence. In principle, the woodcut is the simplest print

317. Enlarged detail from Four Horsemen of the Apocalypse.

form—but not necessarily in execution. A drawing is first made in black ink on a smooth piece of hard wood. Then the uninked areas are cut away, leaving the drawing standing in relief, rubber-stamp fashion. Inked and printed, the block now gives, in reverse, a reproduction of the original drawing that is more or less accurate according to the skill of the craftsman who cut it. Certain characteristics of the drawing are inevitably sacrificed; even the most accurate cutting cannot entirely capture the freedom of the original. Gradations of tone are eliminated by the uniform inking and printing of the block. But in compensation, the denseness and uniformity of the printed version, and its feeling of rigidity, have their own attractions. Artists working for woodcut reproduction learn to anticipate these qualities in the original drawing.

A few artists in the early days of woodblock printing cut their own blocks, but most of them were content to put the drawing on the wood and leave the cutting to craftsmen who specialized in this work. The cutting of a fine block requires craftsmanship of excruciating precision; it is easy to draw a series of crisscrossed black lines on a piece of smooth wood, but not so easy to excise the areas between them. Dürer's Four Horsemen of the Apocalypse (318), shown here with an enlarged detail (317), is a woodcut conceived as a woodcut from the beginning. Hence modeling by cross-hatching (which we described in Dürer's famous drawing of praying hands, ...) was avoided in favor of lines describing the form in only one direction and so much easier to cut. The Four Horsemen, one of a series illustrating the Apocalypse according to the Book of Revelation, was an early print for which Dürer himself perhaps did the cutting. That he cut the blocks for his later prints is unlikely. For one thing, he could hardly have found time to cut the number of prints he designed when they became popular. For another, the form cutter's guild became so powerful not long after the Apocalypse series that these craftsmen could have confronted Dürer with restrictions amounting to something like union troubles today. Whichever the case, the Apocalypse series was a landmark that established the woodcut as an independent art form worthy of attention by leading artists and collectors.

The general term "woodblock" includes woodcuts, as we have just described them, and wood engravings. William Blake's illustration for the *Pastorals of Virgil*, a tiny gem of a wood engraving, is reproduced here at full size (319). In contrast with woodcuts, where, as we have said, the drawing is done in black ink on the smooth block, the surface of the block for a wood engraving like this one is first darkened and the cutting then done to reveal the drawing in whites. The difference takes a moment to grasp and may seem not very important—but it is. The woodcut is conceived in blacks against whites; the wood engraving in whites against blacks. This distinction is about as close as we can get without making dozens of reservations, and unfortunately the distinction doesn't hold at all when we

318. Albrecht Dürer. Four Horsemen of the Apocalypse. About 1497–98. Woodcut, 15½ by 11 inches. The Art Museum, Princeton University, New Jersey. The Laura P. Hall Collection.

319. William Blake. Illustration for Thornton's *Pastorals of Virgil*. 1821. 1% by 2% inches. The Metropolitan Museum of Art, New York. Harris Brisbane Dick Fund, 1921.

320. Erich Heckel. *Scene from Dostoevski*. 1912. Woodblock, 10⁵/₁₆ by 9⁵/₁₆ inches. The Metropolitan Museum of Art, New York. Gift of J. B. Neumann, 1924.

get to recent work. A modern print like Erich Heckel's illustration for a scene from Dostoevski (320) is obviously conceived in whites gouged out of blacks, but because they are gouged so vigorously, almost crudely, it is not by usual definition a wood engraving. Engraving always implies delicate execution with a very fine sharp point; Heckel's whites could have been hacked out with a pocket knife, and the print owes its power to this feeling of almost desperate urgency. We must be content to allow generous leeway in our definitions, especially since modern artists invent new techniques or experiment with variations on old ones every day.

Linoleum, easy to cut, has long been a substitute for wood. For purists, a linocut lacks the strength, the vigor, of the real thing, but Matisse and Picasso are among modern artists who have not disdained it. Linoleum's relative softness and its grainless texture allow for cutting more relaxed, flowing lines than are possible in wood. Matisse capitalized on this potential in a series of white-line linoleum engravings illustrating Henri de Montherlant's *Pasiphäé* in 1944 (321). From 1959 into early 1963 Picasso added one hundred linocuts to his always phenomenal record of production; his direct attack on the submissive linoleum was comparable to his most tempestuous manner in painting (322). For both Matisse and Picasso, however, these successful forays into the field of the linoleum print were temporary adventures.

So far as texture is concerned, in the scene from Dostoevski, Heckel has insisted upon what can only be called the "woodiness" of the block, and has capitalized on its gouged quality just as a water colorist might capitalize upon flow and transparency, or as a painter in oil might take advantage of glazing, scumbling, and all the other potentials of that technique. The pioneer in this contemporary attitude toward the woodblock was Paul Gauguin. Working in Tahiti, he admired the accidental irregularities of batiks and stamped tapa cloths, where the natives' primitive technical processes left their mark strongly on the finished product. He carried this idea into his woodcuts, frequently working on planks so rough that the grain reproduces in the printing. Instead of inking his blocks smoothly and printing them with uniform pressure, he allowed (or even cultivated) irregularities that printmakers before him would have regarded as defects. He was not always successful; some of his prints are blurred and smeared to the point of being indecipherable. But in many, as in Manao Tupapao or She Thinks of the Spirit (326, p. 269), these crudities are, by a sophisticated standard, appropriate to the primitivism of the subject. Certainly they bring us into the presence of the artist just as a painting does and as a technically perfect woodcut does not. We are close to him as he works, much closer than we are in woodblocks in which the artist has merely drawn on the surface and then left the job of cutting to an intermediary technician.

Before commenting further on Manao Tupapao, we should examine some traditional color woodcuts. Saint Christopher and Saint John the Baptist (325) is a page from a book printed with wooden type and woodcut illustrations. (The inscription in the upper left corner is handwritten.) As a further embellishment the illustrations were tinted by hand—rather crudely, since handwork took time and tended to cancel out the advantages of printing. In these early printed books there is a wonderful unity between type and illustration. Both were cut by hand from wood and thus shared an identity lost in much of modern bookmaking where the type has one personality and the illustration is simply introduced with no regard for the harmony of the page as a unit. Even the relatively crude hand-tinting in our example has a vigor and directness in keeping with the rather rough cutting. A delicately and meticulously tinted picture would be out of harmony—although this could hardly have been the consideration when some apprentice was given the job of filling in certain areas with color.

The next step in the use of color was to make additional blocks from which the color areas could be printed. An early Chinese print, Two Peaches on a Branch (324), reproduces a water color after the artist Ko Chung-hsüan. The imitation of classical Chinese water-color style is successful enough to be momentarily deceptive. The shading on the gray branches and the blending of the pink tip of one peach into its yellow body are especially convincing. There is considerable speculation but no certain knowledge as to exactly how these gradations were created on the block, as we know they were, before the block was pressed onto moistened paper. The deep green leaves with dark veins are less successful imitations of the quick manipulation of the painter's brush, but the accented outlines of the peaches, which not only thicken but also darken here and there, are so brushlike that they deny their print quality, as the craftsman meant them to do.

In the two Japanese prints that we saw in an earlier chapter (209 and 210), the block was cut to echo the shapes of brush strokes, but the artist made no other attempt to capture brush character. Whereas Two Peaches on a Branch is still more painting than print, the other two examples are already more print than painting. Before long the Japanese print flourished to the point where its merits as a print superseded its attractions as a pseudo painting, crystallizing during the eighteenth century into the exquisite form in which we know it best.

After fully polychromed prints were introduced about 1765, Suzuki Harunobu emerged as the leading master of the new form, both technically and expressively. The earliest Japanese prints were of actors, courtesans, or other subjects having to do with the world of public gaiety and entertainment. Harunobu, on the other hand, developed the print as a means for representing intimate domestic scenes of the utmost delicacy. Instead of beautiful courtesans he chose modest and well-bred young girls; instead of actors and dancers, mothers and children; instead of public places

321. Henri Matisse. Illustration for Montherlant's *Pasiphäé, Chant de Minos*. (Paris: Martin Fabiani, 1944). Linoleum cut, 12% by 9¾ inches. The Museum of Modern Art, New York. The Louis E. Stern Collection.

322. Pablo Picasso. *Seated Woman* (after Cranach). 1958. Linocut printed in yellow, blue, red, ochre and black, $25^{11}/_{16}$ by $21^{5}/_{16}$ inches. The Museum of Modern Art, New York. Gift of Mr. and Mrs. Daniel Saidenberg.

323. German. Saint Christopher and Saint John the Baptist. Fifteenth century. Hand-colored woodcut, height 9½ inches. The Metropolitan Museum of Art, New York. Bequest of James C. McGuire, 1931.

324. After Ko Chung-hsüan. *Two Peaches on a Branch.* 1633? Color woodcut, 10 by 11½ inches. Philadelphia Museum of Art. Purchased by Seeler Fund.

325. Suzuki Harunobu. *Drying Clothes*. Mid-eighteenth century. Color woodcut, 10% by 8½ inches. Philadelphia Museum of Art. Samuel S. White III and Vera White Collection.

327. Detail from *Drying Clothes* showing *gaufrage*, or blind printing.

328. Josef Albers. Solo V. 1958. Inkless intaglio, 6% by 8% inches. The Brooklyn Museum.

or famous scenic spots, the interiors of homes of good families and the secluded corners of their gardens, like the charming scene *Drying Clothes* (325). Surely never before or since has a household chore been made more attractive than in this print epitomizing the Japanese taste for poeticizing even the least poetic aspects of daily life—in this case through the pictorial means of subtle color combinations and exquisitely graceful line.

Each color in a print of this kind represents an individual block, cut with incredible nicety to register with the other blocks within the framework of the black one that establishes the drawing and is called the "key block." Again, it is impossible to reproduce here the noticeable depressions along these hair-thin outlines that add so much life and definition to the original. Patterns are stamped into the paper here and there. In the mounds of white blossoms on the bush, detail is picked out in relief, and within the gray pattern on the curtain to the right a secondary design is incised. There are also stamped patterns on the robes of the mother and the child. Some of these markings are apparent in the detail taken in a raking light (327). This "blind printing," for which the French term gaufrage is frequently used, is done from a separate, uninked block.

A colorless impression of the cut block itself, freed from the block print's close allegiance to the art of painting, should theoretically be the final and most dramatic demonstration that prints are a totally independent art form. By this theory, Harunobu's gaufrage would have a large family of twentieth-century descendants in the inkless prints made by modern artists. In these, the slight relief of gaufrage, which is the merest fraction of an inch, is increased until a pattern tells clearly in normal light in relief alone, unassisted by inked lines and color areas. This is done by pressing thick, strong white paper, dampened for flexibility, into a pattern cut deeply into a block. When the dried paper is removed, it retains the pattern in the form of a low relief-thus, it must be admitted, shifting the print's allegiance from painting to an even stronger allegiance to sculpture. Our illustration (328) is a classic example of the inkless print by Josef Albers, a German artist whose emigration to the United States in 1933 and position as chairman of the Department of Design at Yale University from 1950 to 1960 made him a major force in modern American art.

It is characteristic of traditional Japanese art that it depends upon exquisitely developed craftsmanship of the most demanding kind, and in this respect Albers is sympathetically allied to that tradition. But in most aspects of modern art, traditional craftsmanship has been sacrificed to individual expression. That is one strong reason why Harunobu's *Drying Clothes* and Gauguin's *Manao Tupapao* look so very different, although we are about to say that they are alike in their authenticity as prints. Technically they are at opposite poles, but the full enjoyment of each depends upon our recognition of the uses to which the artist has put his technique.

In different good impressions of the same Japanese

process is, after all, not a mechanical but a hand one. But these differences are nothing at all compared with those in prints by Gauguin, where each print is virtually independent of others from the same blocks. Instead of applying his color uniformly over a defined area, Gauguin would smear or rub it over an area or part of an area in any way he thought might be most effective, and these differences and irregularities were exaggerated by the varying pressures of unsystematic printing. *Manao Tupapao* is Gauguin's rarest print. At an early stage he ruined the block in making some additional cuttings, and only five impressions are known. Each of the five has wide variations from the others, but in all of them the block and the process of creation is vividly, immediately present.

print there will be certain minor differences since the

We may conjecture that Harunobu would have found Manao Tupapao unpardonably brutal, and so, in truth, Gauguin's prints seemed to most of his contemporaries. Japanese prints exerted a strong influence on Impressionist painters in the latter nineteenth century. Mary Cassatt, the American painter who joined the Impressionists in Paris, executed a particularly fine series of color prints in the manner, but not the technique, of Japanese woodblocks. The Fitting (329), executed in dry point, soft ground, and aquatint-techniques that we will explain a bit latershows how she adapted the patterning, the linear delicacy, and the intimate domestic subject matter of prints like the Harunobu to the kind of everyday modern subjects so dear to impressionism. The Cassatt is more realistic than the Harunobu, but in both cases each line is beautiful quite aside from its descriptive function, and is incorporated into a flow of rhythms that in its turn defines the integrated pattern of silhouettes.

If we look for similar qualities in Manao Tupapao, we can find them. The line and pattern are more obvious and more direct, vigorous rather than exquisitely subtle, but ultimately they were fathered by Japanese prints, which Gauguin knew and admired and which influenced him without serving as models for imitation. In his departures from convention he committed the heresy of adding spots of color with a brush, a practice that horrifles printmakers but can be defended here. Gauguin was not touching up mistakes, but simply carrying on the creative process of a picture that he thought of in terms as individual as those involved in the execution of a painting. He was creating as he went, rather than observing the mechanical niceties involved in reproducing uniformly a predetermined pattern. There is no such term as woodblock-painting, but it could be coined to describe work like Gauguin's, not because he actually painted into his print, which he sometimes did, but because the creative process continued and developed during the production of his prints, just as it does in painting on canvas. In his prints Gauguin was, in a way, painting by means of a woodblock instead of a brush.

Have we, then, come full circle back to Two Peaches on a Branch, which imitated painting? No, not at all, for

329. Mary Cassatt. *The Fitting.* 1891. Color print with dry point, soft ground, and aquatint, 14¾ by 10¹/16 inches. Museum of Art, Carnegie Institute, Pittsburgh.

330. Antonio Pollaiuolo. *Battle of Naked Men.* About 1465. Engraving, $16^{11}/_{16}$ by $24^{1}/_{6}$ inches. The Cleveland Museum of Art. J. H. Wade Fund.

this reason: whereas the craftsman who cut and printed *Two Peaches on a Branch* was imitating another technique, Gauguin's whole conception is stated in terms of the technique in which he is working.

Printing is ordinarily thought of in the terms we have been describing—the inking and stamping of surfaces in relief. But it is also possible to print by the reverse of this method, using the "intaglio" process, in which the drawing is incised into the surface instead of raised above it. This is the process in metal-plate engraving and in etching.

In engraving, the picture is cut into the metal plate in fine, sharp, shallow lines. (Hard metals, such as steel, are the most difficult to cut but repay the craftsman with the sharpest, cleanest lines and will yield more impressions than softer metals before wearing out.) The entire plate is then inked; special attention is given to forcing ink down into the lines. Then the plate is wiped clean on the surface, with care taken to leave the incised lines filled with ink. Next, paper is laid over the plate and put under pressure to force it down into the lines, where it picks up the ink. The drawing is thus transferred to the paper, and the plate may be re-inked and printed as long as it lasts.

Because the face of the paper is forced into the cut lines, each line is reproduced not only in ink but also in the form of a very slight ridge. This is the texture we feel when we run our fingertips over an engraved invitation or calling card, and it explains the particular character of engraved line. Properly cut and properly printed, the engraved line has a razor-sharp definition and a brilliance beyond anything that can be achieved by pen line or a line printed in relief process.

One of the finest of all engravings throughout the history of art is also one of the earliest: Pollaiuolo's Battle of Naked Men, done about 1465 (330). The reader may weary of being reminded that in reproduction the various print processes lose some of their character. But it is important to remember, because so much of the enjoyment of prints comes from an understanding of the way the artist has used the technique. The severity of Pollaiuolo's style, his passion for exact definition of anatomical contours, and the masculine force of his design are all heightened by the rigorous discipline of the burin, the pointed cutting tool used by engravers. In this great print Pollaiuolo attains maximum expression of the controlled ferocity that characterizes his art, a ferocity combined with ornamental elegance that makes no concessions to prettiness or even to grace. (We have already seen these characteristics in his Martyrdom of Saint Sebastian, 236.)

The friezelike background of *Battle of Naked Men* reflects Pollaiuolo's early training in the demanding craft of goldsmithery, which must have contributed a great deal to his exceptional skill as an engraver. *Battle of Naked Men* is the only engraving known to be by Pollaiuolo, but alone it places him high in the hierarchy of an art that demands complete unity between technique and image. The finest

331. Detail from Battle of Naked Men.

332. Albrecht Dürer. Magnified details from Melencolia I.

engravings (including wood engravings), unlike woodcuts, are not drawn on the plate for execution by assistants. Expert engraving technicians frequently translate paintings or drawings into the form of engravings, but these are approximate reproductions quite removed from the original artist's hand.

The engraver's burin is a sharp triangular gouge that cuts cleanly into the metal plate, excising with immaculate precision the tiny channel that becomes in printing a sharp inked ridge of a line. The depth and width of the burined line depends upon the degree of pressure the craftsman applies in the cutting. A skillful engraver can accent a line by thickening it or thinning it with varying pressure, but the range is narrow because too thick a line will not print sharply. This "shaded line" has the sparkle and contrast of all engraved lines plus a suggestion of flexibility.

In a detail at approximately full size (331) from Battle of Naked Men it should be apparent that each line is produced with absolute control and that any slip throwing a single line or portion of a line out of relation to the others would have been fatal. The metal plate, engraved and ready for inking, is a beautiful thing. Each line glistens with the same quality as engraved initials on silverware, which of course are incised in the same way. Theoretically, it would be possible to reproduce (always in reverse) the initials on ordinary tableware by filling them with ink in the way described and pressing paper into them. The art of pictorial engraving probably originated in some such way when the engravers of ornamental designs on armor or other decorated metal took impressions of their patterns for future reference.

Limited as he is to thin lines, the engraver who wants to produce varieties of gray tones must do so by a multitude of crisscrossings, or a series of straight lines close together, or a stippling of tiny short strokes or dots, as Dürer has done in another masterpiece among engravings of all times and places, his great *Melencolia I* (333). Enlargements of two areas (332) show how the different textures and tonalities were produced by different combinations of burin lines.

We are indebted to Dürer more than any other single artist for the elevation of prints to the status of high art. His woodcut of the *Four Horsemen of the Apocalypse* is one of a set of fifteen subjects from the Revelation of St. John that transformed the medium by unprecedented fineness of cutting combined with design as powerfully constructed as any heretofore reserved for painting. Although he had important precursors in engraving, Dürer's transformation of that medium is hardly less impressive. It is safe to call him the greatest engraver of all, and although there might be room for argument as to which is his greatest engraving technically, most authorities would agree that *Melencolia I* is the most profound.

The subject is a complicated allegory of the human dilemma of conflict between the imaginative world of art and faith and the realistic one of science and learning. Symbols of art, science, learning, and religion are strewn in

333. Albrecht Dürer. *Melencolia I.* 1514. Engraving, 9½ by 7⁵/₁₆ inches. The Metropolitan Museum of Art, New York. Harris Brisbane Dick Fund, 1943.

334. Giovanni Benedetto Castiglione. *Melancholia*. Mid-seventeenth century. Brush drawing in oil with red chalk on paper, approximately 11 by 16 inches. Philadelphia Museum of Art. Pennsylvania Academy of Fine Arts Collection.

disarray around a figure of Genius frustrated by the complexity of knowledge and skills that refute the world of faith yet leave the universe unexplained.

In his personal life Dürer himself, born at the point of change between the Middle Ages and the Renaissance in Germany, was torn between mystical faith and analytical intellectualism. We have said that Pollaiuolo's passion for exact definition (in a Renaissance world where science could be regarded as the source of ultimate realities) received perfect expression through control of the burin, a happy coincidence between stylistic preference and philosophical conviction. In Dürer's case, the engraving medium became almost an allegory of his personal struggle. The tortured complications of the artist's introspective agony are relayed to us by a kind of technical intensity in Melencolia I, with its thousands upon thousands of fine incisions engraved into metal, each one obsessively controlled as an infinitesimal unit in a design that has nothing less than the universe of the soul and the mind as its subject. If this is not immediately apparent in Dürer's print, compare it with a treatment of the same subject about a hundred years later in a drawing by the Italian artist Giovanni Benedetto

Castiglione (334). The same symbols, although in reduced numbers, are scattered around a figure of Genius similarly clothed and crowned and, like Dürer's figure, resting a cheek on one hand and holding calipers in the other. But the similarities mean nothing; the mood in this enchanting drawing is one of graceful relaxation.

The rigorous discipline of cutting a drawing into a metal plate rules out the quick, sketchy line of free drawing. This restriction is removed—not entirely, but to a large degree—in another intaglio process, etching. The plate is similarly inked, wiped, and printed, but the sunken line is produced in a different way.

To make an etching, the artist first covers a metal plate (usually copper) with a wax coating called "ground," which is impervious to acid. Using a fine stylus (needle) point, he can draw on this ground with a freedom approaching that of pen or pencil. The sharp point removes the wax where he draws, exposing the metal to the action of an acid bath that "bites" into the surface of the plate. The artist controls the width of the line by the depth of biting. Heavy lines are produced by longer exposure to the acid. Lighter ones are "stopped out" midway by removing the plate from the bath and re-covering that area with the impervious ground.

An etched line is quite different in character from an engraved one. It is softer, warmer, richer. Whereas the engraver's burin cuts precisely, the acid eats out a little chasm with microscopically uneven edges. Rembrandt's Christ Carried to the Tomb (335) and a magnification of a detail (336) can be compared with Battle of Naked Men and Melencolia I to show the resultant difference after printing.

An engraved plate is always inked and wiped with maximum care to clean the surface of every trace of ink, in order that the inked lines may tell as sharply and brilliantly as possible. Some etched plates are similarly wiped, but since an etched line is softer than an engraved one, some etchers increase the effect of softness by not wiping the plate quite clean. A little film of ink may be left where a tone is desired over a certain passage. Rembrandt, among others, utilized this trick of wiping; Whistler, at the end of the nineteenth century, used it to an unprecedented extent, employing it not only as "tone" but as a pictorial element. In an etching like his Nocturne (337) one of many to which he gave the same title, the light on the horizon, the twilight sky, and its reflection in the lagoon are all produced by wiping. In the history of etching, Whistler's revolution was not as great as Gauguin's in woodblock printing, but it increased the freedom of etching technique and had a wide influence.

Tonalities from filmiest gray to richest black can be bitten into a metal plate by a process generally used as an adjunct to etching—"aquatint." In this technique, the plate is dusted very thinly with powdered resin. When the plate is heated from the under-side, the microscopic granules melt and adhere to its surface. Like regular etching ground, the resin is impervious to acid, so that when the plate is

335. Rembrandt. *Christ Carried to the Tomb*. About 1645. Etching, 5³/₁₆ by 4⁵/₁₆ inches. The Metropolitan Museum of Art, New York. Harris Brisbane Dick Fund, 1923.

336. Magnified detail from Christ Carried to the Tomb.

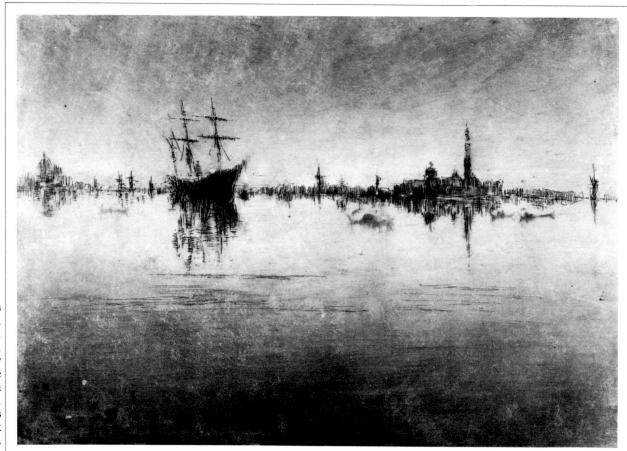

337. James Abbott McNeill Whistler, Nocturne. 1880. Etching, 81/8 by 113/4 inches. The Metropolitan Museum of Art, New York. Harris Brisbane Dick Fund, 1917.

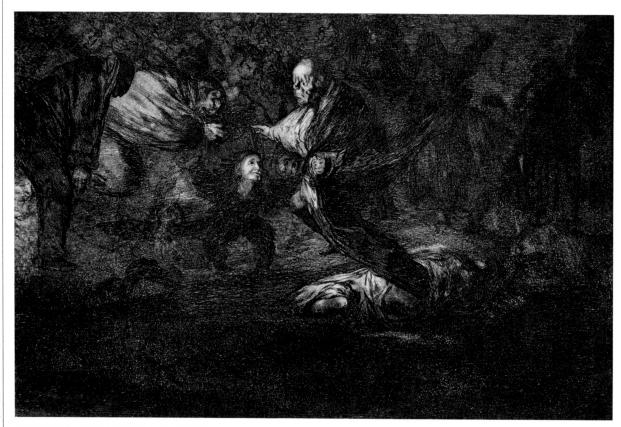

338. Francisco Goya. Old Man Among Ghosts (plate 18 from Los Proverbios). 1813–16. Aquatint, 95% by 13¹³/₁₆ inches. The Metropolitan Museum of Art, New York. Harris Brisbane Dick Fund, 1924.

put into the bath, the acid eats into the metal only in the tiny interstices between the granules and only, of course, in areas that have not been blocked out in preparing the design. The texture and darkness of the aquatinted areas are controlled by the thickness of dusting in the first place, and the time of exposure to acid in the second. Goya's Old Man Among Ghosts (338) was toned with aquatint after the drawing was completely bitten in. A magnified portion (339) brings us closer to the texture.

Another intaglio process, closely related to both etching and engraving, is dry point—a technique in which lines are dug directly into the metal plate with a stylus, without benefit of biting acids. The difference from engraving is that a line gouged or scratched into the plate with a stylus is softer and more flexible than one incised with the engraver's burin. A soft metal, usually copper, is employed for dry point plates, and the stylus, like a miniature plow, throws up a ragged ridge on either side of the gouge. When the plate is wiped, these "plowed up" edges, called "burr," retain additional ink that, under the pressure of printing, squeezes out and gives a softer or even a fuzzy edge to the line. The effect of dry point can be one of great richness. But very fine, delicate lines may also be produced in dry point by polishing away the burr.

Etching and dry point are frequently combined in a single plate, most often with dry point serving as a convenient retouching technique. The combination has never been employed with more originality than in Rembrandt's The Three Crosses (340). Rembrandt comes closest of any artist to holding in etching the position that Dürer holds so securely in woodcut and engraving; he regarded the plate as an area for free experiment in widening the medium's range of expression, much as he regarded a canvas for painting. In his late paintings, Rembrandt's figures loom into golden light from profound shadows, an effect that had not yet been approximated in conventional etching techniques. (Aquatint could have yielded the intense blacks Rembrandt wanted, but was not invented until late in the next century.) The Three Crosses represents the moment following the Crucifixion when supernatural darkness spread across the sky and earth. The print exists in several "states"—a state being a print pulled from the plate in order to serve as a guide for further work. Our detail (341) of the state illustrated shows that Rembrandt took a straight edge of some kind and scored the plate heavily with lines running across the etched figures to throw them in various degrees of shadow. In some areas where the lines are close together the burr holds so much ink that an area becomes solid black, while in other passages heavy black lines separated by brilliant white give the impression of sinister gloom penetrated by miraculous rays of light.

If Rembrandt had wanted to lighten, or even eliminate, the velvety black of the heavily burred areas in *The Three Crosses*, he could have done so with a burnishing tool that eliminated the burr or, by strenuous polishing, could even have brought the plate back to a smooth surface that would

339. Magnified detail from Old Man Among Ghosts.

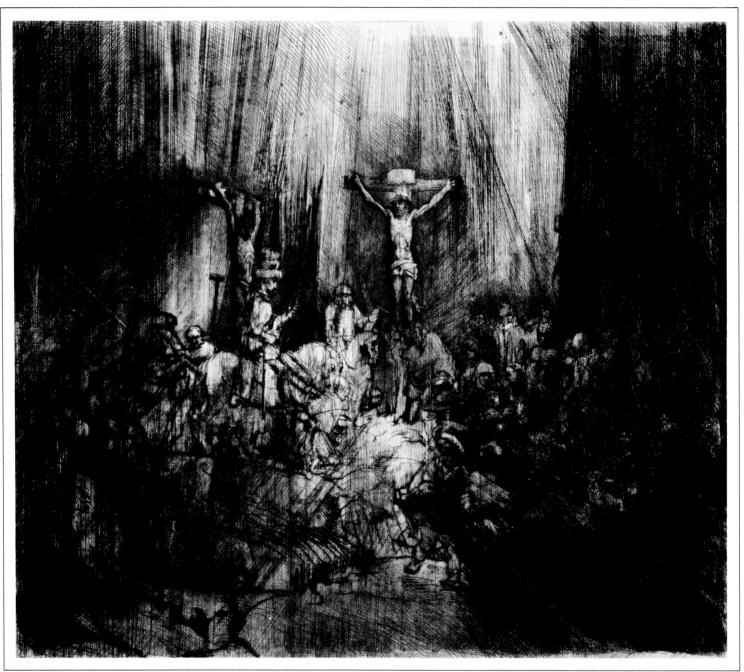

340. Rembrandt. *The Three Crosses* (4th state). 1653. Dry point and burin, about 17³/₄ by 15 inches. Museum of Fine Arts, Boston. Harvey D. Parker Collection.

print white. The erasure technique called "mezzotint" is an application of this principle. An entire plate is given a uniform, very fine burr (after which it would print solid black), and the picture is then created by polishing—erasing—to produce every tone from black to white. Mezzotint is a laborious process and has been most widely used as a reproductive rather than a creative medium.

Woodblock printing is a relief process; engraving, etching, and the variations we have described are intaglio processes; in between is the "planar" process, which prints from neither a raised nor a depressed design, but from a flat surface. Lithography—literally, "stonedrawing"—utilizes the simple principle of the incompatibility of oil and water.

A lithograph is first drawn with greasy ink or crayon

341. Magnified detail from The Three Crosses.

342. Käthe Kollwitz. *The Summons of Death.* 1935. Lithograph, 15 by 15 inches. Philadelphia Museum of Art. Print Club Permanent Collection.

on a slab of smooth, fine-grained limestone. (Zinc and other materials are sometimes substituted for the stone, but do not yield the same beautifully fine-grained print.) The drawing is then "fixed" on the stone with a preparation of gum arabic and nitric acid. To print, water is first applied over the entire surface. The greasy drawing repels water, but the porous stone absorbs it and remains damp. When a roller covered with lithographic ink, which has an oil or grease base, is run over the stone, the damp surface repels the ink while the grease drawing accepts it, and the stone is ready for printing. A sheet of paper is placed over it, and stone and paper are run through a press that exerts a scraping pressure. The drawing is transferred (in reverse, of course) from stone to paper, and the process can be repeated until the image on the stone breaks down from wear.

Käthe Kollwitz's *The Summons of Death* (342) could be mistaken for a crayon drawing as neither engravings nor etchings could be mistaken for pen or pencil; in lithographs we are particularly close to the artist as draughtsman.

As is apparent in *The Summons of Death*, lithography affords the entire range from the darkest, richest blacks to the pure white of the paper. The distinctive grainy quality of the grays comes from the texture of the stone. In the Kollwitz lithograph the drawing is exceptionally vigorous and direct. A lithographic crayon is square in section—about a quarter of an inch—and in the broad strokes at the left the various gradations within a single stroke were made by varying pressure. A stroke beginning wide and ending thin, and graduated from light to dark, like several in this example, is made in a single, sure motion, not only by varying the pressure but by turning the crayon to a different angle as it is pulled across the stone. At the opposite pole there are the delicate, tenuous lines of the hand coming into the picture from the right.

Color lithography is a rich field for the printmaker, coming closer than any other technique to the variety and flexibility of painting. Toulouse-Lautrec's lithograph of a popular Parisian clownesse, Mlle. Cha-u-ka-o (343), involves color as well as half a dozen different methods of applying the crayon, including its liquid form, which is called "tusche." In color lithography a different stone is prepared for each color, just as in woodblock printing. These are printed in sequence over one another. In woodblock printing two colors are sometimes printed over one another to produce a third—blue over yellow to produce a green, for instance—but the result is likely to be a little thick and heavy. In lithography, however, the grainy texture of the stone, with its peppering of tiny clear areas throughout, is wonderfully adapted to overprinting. The undercolor shows through the open spaces of the overcolor, giving an additional vibrancy to the resultant color as its two elements play against one another.

Here, the ruff, or collar, was painted on the stone with a soft brush and liquid crayon, and the spots on the floor were apparently dabbed in with the end of a stiffer brush less heavily loaded with tusche. The speckling over the

343. Henri de Toulouse-Lautrec. *The Seated Clownesse*, *Mlle. Cha-u-ka-o.* 1896. Color lithograph from the series *Elles*, 20% by 15¾ inches. The Metropolitan Museum of Art, New York. Stieglitz Collection, 1949.

344. Robert Rauschenberg. *Centennial Certificate*. 1969. Lithograph, 35% by 25 inches. The Metropolitan Museum of Art, New York. Gift of Joseph Singer, 1969.

entire stone was made by holding a stiff brush well above its surface and scraping the bristles against some rigid edge—or possibly by flipping them lightly with the thumb. This spattering was built up within certain definite areas—such as the bench and the wall back of the head—by protecting the rest of the stone with pieces of paper laid over it, stencil-fashion.

Toulouse-Lautrec's departure from conventional lithographic techniques corresponds to Gauguin's in the woodblock and is at least as important in the history of printmaking. Like Gauguin, he enlarged the scope of a limited print technique to the point where it became a flexible art form. In recent years lithography has been subject to innumerable variations, both in the studio and commercially. Other surfaces than stone have been widely adopted for convenience and, in the case of commercial printing, economy. The printing process called "offset" is an adaptation of the lithographic principle to photomechanical techniques. Lithography in all its variations, including posters and billboards, is the most ubiquitous of all print techniques today.

It has also become the most flexible as an artist's medium in which some of the commercial uses have been adapted. Robert Rauschenberg's Centennial Certificate, M.M.A., 1969 (344), commissioned in celebration of the hundredth anniversary of the Metropolitan Museum, is a lithograph by definition; but in effect it is a collage of photographs and reproductions superimposed transparently. as would have been impossible in true collage of objects in the museum's collections, plus a piece of graph paper with signatures of museum officials and a statement of the museum's ideals at top center. The print was made from two stones and two aluminum plates in red, yellow, blue, and brown, and has the special quality of being so directly the result of special processes (such as photosensitized aluminum plates) that it could not possibly be regarded as a substitute for painting or drawing. This insistence on prints as totally independent art forms, a development of the last fifteen or twenty years, is modern art's most important expansion of the print's function.

Another planar process, the silk-screen stencil or serigraph, the newest print process, is the only one executed in paint rather than inks, which is often thought of as an advantage but which nevertheless does not eliminate the mechanical look of multiple reproduction. The stencils are made by stopping out portions of a piece of thin silk tightly stretched on a frame, leaving open the areas that are to print in a single color. The stencil is placed on top of the paper (or other material), and paint is pressed through the open areas of the silk with a squeegee. Each color demands a separate stencil unless the paints are transparent enough to yield secondary colors by overprinting. Delicately manipulated, silk screen can yield subtle variations of tone and color; but it is best adapted to bold contrasts in large, simple areas. For this reason it is widely used for posters.

Its most conspicuous use in contemporary art has capi-

talized on this poster-like commercial quality in the hands of Andy Warhol and the numerous studio assistants in what he calls, appropriately, not his studio but his factory. A leader in pop art, Warhol is preoccupied with that aspect of pop that finds its material in the most familiar clichés of the contemporary scene, including advertising art. His multiple portraits of Marilyn Monroe (345), among subjects that include other celebrities, Coca-Cola bottles, and the famous Campbell Soup cans, are at once anti-art in the conventional sense and art-innovative in another.

One other planar process is as rare as lithography and silk screen are widespread. This is the monotype, which occupies an ambiguous position between paintings or drawings and prints. The process is simple enough: a painting, in either black and white or color, is done on a nonabsorbent plate of any kind strong enough to hold up under pressure, and is then transferred to paper either in a press or by rubbing by hand. Either oil or water color may be used; oil is more common. Textures vary widely, depending on the thickness of the paint (if very thick, it may squash out rather unpleasantly on the paper) and the texture of the paper. On the plate the paint may be manipulated in many ways—by a brush, of course, but it can also be worked by hand. The paint may be scratched out over areas that the artist wants to be pure white (if he is working on white paper).

The only major artist who has regarded the monotype as more than a novelty to be experimented with a few times was Degas, who did at least two hundred. He objected to the term "monotype," saying that his were "drawings done with greasy ink and printed." The monotype, as the term indicates, yields only one good print; a second, much paler, can sometimes be pulled, or even a third, very pale indeed. Ordinarily, the plate has to be touched up, refreshed, after

the first print is pulled.

Our example, The Ballet Master (346), was probably Degas's first experiment in monotype, but he was already investigating its full possibilities, scratching out white lines, "erasing" soft white and light gray areas, and, in the upper right and upper left, smearing the paint to suggest stage scenery, all, of course, on the plate before printing. When he pulled a second impression, Degas often touched up the weak passages on the paper, sometimes with pastel.

A monotype, by the very meaning of the word—"single print"—is unique, and hence has the rarity of a painting. We pointed out at the beginning of this chapter that prints owed their early development to the fact that they could be produced in multiples. This not only made them adaptable for use as illustrations or ornamentations in books but also gave artists a chance to produce a desirable low-priced product for people who could not afford such unique works as paintings or drawings. Originally regarded as second-best works of art for this reason, prints were given less care than paintings or drawings. Hence the few surviving examples

345. Andy Warhol.

Marilyn Monroe, diptych.
1962. Silk-screen enamel
on canvas, each panel 82
by 59 inches. Collection
Mr. and Mrs. Burton
Tremaine, Meriden,
Connecticut.

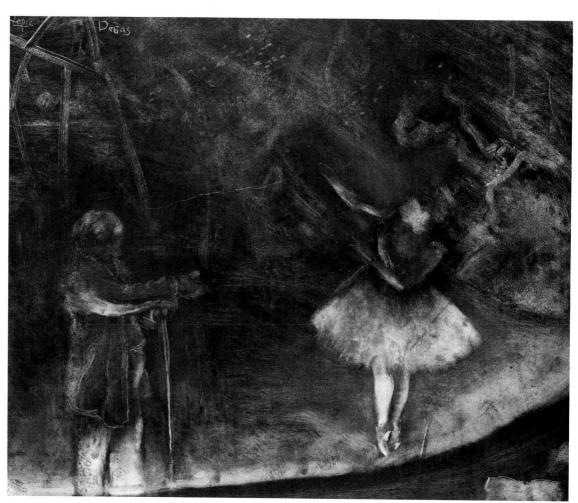

346. Edgar Degas. The Ballet Master. About 1874. Monotype in black ink, 22 by 27½ inches. National Gallery of Art, Washington, D. C. Rosenwald Collection.

of some fairly large printings now have rarity value for collectors. It is not known how many prints were pulled from Pollaiuolo's wonderful plate of the *Battle of Naked Men* (which, incidentally, is often found under the title *Battle of Ten Nudes*), but if one of the existing prints should come onto the market today, it would be competed for by every museum and collector in the field with enough money to make a bid.

Recognizing that prints could have rarity value, printmakers in the nineteenth century began limiting their editions. Instead of printing until the plate wore out, they deliberately destroyed the plate or disfigured it-for example, scoring the surface of an etching plate (347)—after pulling a predetermined number of prints. Prints thus arbitrarily limited in number (as virtually all prints are today) bear a notation, usually just below the lower left corner of the impression, consisting of two numbers, such as 20/75, which would mean that the print in hand was the twentieth pulled in an edition of seventy-five. In place of the numbers there may be the written words "Artist's Proof," which means that this is one of an undesignated number pulled in addition to the edition proper. Obviously, each artist's proof reduces the rarity of each of the numbered proofs, but there is no very good way of telling how many such additional proofs have been pulled.

Finally, this leaves us with the question, What is an "original print"? The term is a recent one, coined to distinguish between mere reproductions and prints like those we have been discussing, in which the artist either created the plate and printed it, or created it and supervised the printing by a technician. Unfortunately some reproductions are numbered, implying that this photographically manufactured product is the work of the artist's hand. Serious confusion is created in a few instances where artists have unwisely "OK'd" the quality of reproductions of their work by examining them for defects and then signing them. The amateur print collector must be wary; but with a little practice, his eye will soon learn the difference between a good impression of an original print, a poor one pulled after the plate had deteriorated, and the print that is not an original print at all but only a pretender.

347. Edgar Degas. *Portrait of Tourny*. 1857. Etching. Print from canceled plate, 9 by 5% inches. Courtesy Associated American Artists, New York.

348. Honoré Daumier. Rue Transnonain, April 15, 1834. 1834. Lithograph, 11½ by 175% inches. Boston Public Library, Print Department.

Chapter Twelve

THE ARTISTAS SOCIAL CRITIC

By popular conception the artist is an individual at odds with society (the artist as a rebel), or free from its conventions (the artist as a bohemian), or a dweller in some Cloud-Cuckoo-Land where he is less than half conscious of the world and its practical demands. He is ordinarily thought of as a person unconcerned with the social problems of the time.

In general the history of art bears out this last assumption. The most enduring paintings are not likely to be comments on the passing scene, simply because that is what it is—passing, and art is concerned with permanent values, not transient ones. Great art's ultimate statement is general, not specific, even when it is couched in specific terms. But spotted through the history of art there are instances when contemporary events associated with violent injustice and social cruelty have inspired artists to specific protests that, with time, have taken on the character of judgments on human folly in general. In this chapter we will see some of these instances, with the artists appearing in their least familiar guise, that of social critics and moralists.

What we call "social consciousness," the individual's awareness that he has a personal responsibility for the general good, is a relatively new idea. And it is not on the whole one that has inspired very much first-rate art, if by first-rate one means art that appeals universally instead of depending on topical subject matter for its meaning. How much a picture can change when its topical associations are no longer current is shown in Honoré Daumier's lithograph Rue Transnonain, April 15, 1834 (348), which appeared in Paris that same month. Neither the name of the street nor the date means anything to most people. Quizzed, perhaps the best they might do would be to guess that April is the month the chestnut trees come into bloom along the Champs Élysées, which is hard to connect with the scene in the picture, clearly the aftermath of some appalling violence.

A man and woman lie dead on the floor of a bedroom. There has been a struggle; furniture is overturned, blood is spattered here and there and trickles from the bodies. Under the man lies the body of a child; the head of another corpse, an older man, whom we take to be the grandfather, shows at the right. It is a sobering picture, but anybody who looks at it without detailed knowledge of the period will see first of all a sordid story of murder, unexplained.

On its appearance in 1834 with no other explanation than its title, the picture's association was entirely different. Workmen in Paris had been rioting in sympathetic demonstrations connected with a general strike called at Lyons. In this state of near-civil war, troops patrolling the streets were fired upon from a window or windows of number 12, Rue Transnonain. In retaliation the soldiers went through the building and killed every person in it, innocent or guilty. Thus to Parisians, still

349. Francisco Goya. *The Executions of the Third of May.* 1814. Oil on canvas, 8 feet 8¾ inches by 11 feet 3½ inches. Museo del Prado, Madrid.

shocked by this crime, the picture, when it appeared a few days after the event, was not the record of a sordid anecdote but a monumental accusation. And understood in this light the picture changes character for us; the very room in which the bodies lie seems to grow more quiet, the bodies themselves acquire the stature of martyrs.

Rue Transnonain, then, loses its original point if we don't know its story. But without the key to its subject the picture may gain even more, going beyond its topical reference to become a universal statement of our mortal vulnerability to anonymous violence.

A work of art may rise above topical limitations even when its subject is clearly defined. Goya's *The Executions* of the Third of May (349) is based on events that took place in 1808, the year of the Napoleonic conquest of Spain. The king and the army had hardly resisted the French invasion, which was accomplished with a maximum of pointless brutality, if we are to trust Goya's records of it, and the French occupation was regarded with a minimum of concern by an incomparably contemptible Spanish ruling class.

But then, in Madrid, the people learned that the son of the king was to be carried away to France. Whether he stayed or went made no practical difference, but to the people he was a symbol. Thus the Madrileños, protecting the monarchy whose members were doing their best to ingratiate themselves with Napoleon, attacked the invaders in the streets. This was the Second of May, the date that marked the beginning of Napoleon's expulsion.

The uprising of the Second of May was followed the next day by frightful reprisals. Civilians were executed in group lots without much regard for their guilt or innocence as participants in the fighting. Possession of a penknife was called carrying arms, and, according to one account, even the ownership of a pair of scissors was enough to establish guilt and bring a sentence of death.

Goya shows one of the civilian executions in *The Executions of the Third of May*, in which a group of Madrileños face the firing squad. At their feet sprawl human carcasses, while beyond them the next lot of victims stands in line. The scene takes place against a barren rise of ground; in the distance the outlying buildings of the city are spectral.

Now, while all these elements are historically identifiable, and while the scene is specific enough to be read as a political execution even without the historical background, the picture goes beyond the immediate circumstance to make a statement applicable at any time in history. For a Spaniard, the historical context no doubt endows the painting with particular excitement. Yet this context also imposes a limitation. If we know nothing about the Third of May as a historical event, the picture's dramatic power is at least as great. It is even more inclusive, for the picture's effectiveness is widened when the connotations are no longer tied to a single event or a single country.

The picture centers upon a young man who flings up his arms and thrusts his body forward as if to proclaim his vulnerability as an individual and yet to defy the soldiers with the jibe that this execution will not affect the cause for which he stands. He is the spirit of a revolt that will continue against all odds because it is beyond personal defeat or annihilation. At his shoulder a half-brutish companion senses this conviction. Half-comprehending, he too thrusts himself forward to receive the bullets. The other figures and those in line stare or hide their faces in various reactions of horror, despair, or resignation.

In contrast to the excitement, variety, and humanity of the figures of the victims, the executioners are ranged in identical poses suggesting automatons, their faces hidden so that they are further deindividualized. Thus they become figures of blind force, ultimately incapable of victory because they are not endowed with passion and perception.

If Goya had chosen to make us aware of the psychological state of each soldier as an individual, the point of the picture would be lost. If the soldiers were represented as a group of unmitigated villains, we would sense that the artist was stacking the cards. Soldiers selected as members

 ${\bf 350.}\,$ Sandro Botticelli. Calumny, Fraud, and Deception from Calumny.

of a firing squad are human beings also; they react in a variety of ways to the job at hand. But Goya wants no interplay of human emotions here. He is painting unquenchable passion for freedom in the face of any force attempting to stem it, and he does it by ranging human beings against symbols of insensate power.

Goya painted The Executions of the Third of May in 1814, six years after the event. Daumier published his lithograph of the massacre on the Rue Transnonain immediately following that infamy in 1834. As the nineteenth century progressed, "socially conscious" art appeared with increasing frequency, and then in the twentieth found vehement expression during and after the Great Depression of the 1930's in America, with artists becoming political activists. But if we trace in the other direction, backward from Goya and Daumier, the opposite is true. Art as social comment, except in terms of storytelling and picturesque scenes of poverty, gradually disappears. It is surprising, then, to find an indictment of political injustice painted at the end of the fifteenth century in Italy. We will compare this extraordinary picture with another on the same theme painted more than four hundred years later in America.

The first is Botticelli's Calumny (351), painted just before the year 1500 in Renaissance Italy. The second is a contemporary American picture, Ben Shahn's Passion of Sacco and Vanzetti (352) one of a series painted only a few decades ago, in 1931–32. On the surface the two pictures appear to have no similarities at all, yet they have unexpected parallels when examined more deeply.

Botticelli's *Calumny* is a curious picture and not altogether a pleasing one. The extreme complications of line are an exaggeration of Botticelli's earlier style, which we have already seen at its happiest in his *Primavera* (219).

In the center of the composition we see an innocent victim dragged by the hair to judgment by Calumny, who carries a torch, false symbol of her love of truth. Two other female figures flank her and twine roses in her hair. These are Calumny's attendants, Fraud and Deception. The standing male figure in this central group, dressed in rags, is Envy, who makes his false accusations to the Judge.

Although the Judge wears a crown and carries a scepter, he also has ass's ears. Ignorance whispers into one ear, Suspicion into the other, and he listens.

All these figures are snarled and knotted into groups with lines of such complication that the effect they create is finally—and appropriately—grotesque and disagreeable. They occupy the major portion of the picture space, filling it with masses of twisting draperies, writhing hair, and oddly jointed limbs; lines and masses weave in and out of one another like nests of serpents. If we compare the three female figures, Calumny, Fraud, and Deception (350), with those of the Three Graces (218) from the *Primavera*, we can see how tortured confusion replaces the rhythmic linear harmony of the earlier picture. But the artist uses this disturbing line only where it is appropriate.

In one figure he gives us again a line of great simplicity

351. Sandro Botticelli. *Calumny*. About 1494. Tempera on wood, height 243/8 inches. Galleria degli Uffizi, Florence.

and purity. This is the figure of Truth, who stands naked at the extreme left, ignored and all but crowded out of the scene, connected with the other figures only by the glance of one who turns and regards her with prophetic questioning. She is Remorse, an ancient crone in black rags.

The allegory follows the description by Lucian of a vanished painting by the ancient Greek artist Apelles. Several other Renaissance artists have given us their ideas of what Apelles's *Calumny* might have looked like, but it is improbable that Botticelli painted his version simply as an exercise in the reconstruction of a lost masterpiece. Classical allegory was frequently Botticelli's vehicle of expression and, for that matter, it was the most popular means at the time for propounding moral judgments. In his *Calumny* Botticelli may have been concealing a specific accusation against contemporary society in the guise of classical symbols.

One theory is that *Calumny* allegorizes the political attacks on the Medici family, Botticelli's great patrons, that resulted in their exile from Florence after they had ruled it for several generations. The crime the artist pictures takes place within a loggia of purest classical-Renaissance design embellished with works of art, a setting that could symbolize Florence at the apogee of its cultivation under Medici

352. Ben Shahn. *Passion of Sacco and Vanzetti*. From a series of 23 paintings. 1931–32. Tempera on canvas, 84½ by 48 inches. Whitney Museum of American Art, New York. Gift of Edith and Milton Lowenthal in memory of Juliana Force.

patronage, now defiled by the monstrous event being enacted there. The serenity of the sea and sky opening out beyond the noble arcade is a final contrast and rebuke to the hysterical violence of the false trial.

The Calumny is more often interpreted as a concealed protest against the trial, conviction, and execution of the priest Savonarola. Today Savonarola would be called a revivalist; his apocalyptic sermons against the vanities of life, the corruption of power, and the moral decay of Italy in general made him for a while the most influential man in the city-state of Florence. A scholar and a man of God, he was also a fanatic so zealous that his power waned through the sheer exhaustion of his followers, who were unable to sustain his pitch of intensity. A menace to the temporal power of the Church as well as to the State, Savonarola was tried for heresy on charges that may or may not have been trumped-up. He was convicted after confessions made following an ordeal that may or may not have included physical torture, and was executed by hanging and then burned in the main public square of Florence, where not long before he had achieved his most spectacular triumphs. His pyre was built on the same spot where he had held his famous "bonfires of vanities," burning great mounds of such irreligious objects as false hair, cosmetics, rich costumes, and works of art not dedicated to the highest moral principles, all delivered up to the fire by temporarily repentant Florentines.

Although Botticelli is known to have come under Savonarola's influence, it is not likely that *Calumny* is a reference to the martyred priest's trial, conviction, and execution, since most scholars believe that the picture was painted before Savonarola was executed in 1498. But the intensity of the painting does suggest an anguished protest against the spirit of the witch-hunt, the punishment of innocent people who are sacrificed to public hysteria. Therein lies its parallel to the twentieth-century painting we are comparing with it, a picture speaking of the trial, conviction, and execution of two men, Nicola Sacco and Bartolomeo Vanzetti.

As in the case of Savonarola, the guilt or innocence of Sacco and Vanzetti was the subject of vehement controversy. The painter believed that they were the victims of a miscarriage of justice. We are not balancing the scales here, but are examining the protest made in pictorial form by an artist in the light of his own belief, in order to compare it with a similar subject approached in a different way.

Botticelli's painting accuses the Florentine government of ignorance, suspicion, envy, calumny, fraud, and deception; depicts it as unworthy of the crown and scepter of authority; proclaims the victim's innocence; and prophesies the city's remorse—all this in allegorical concealment. The modern painting makes parallel accusations with no effort whatsoever at disguising the message. In the *Passion of Sacco and Vanzetti* (352) all subtleties and indirections are abandoned for an uncompromising indictment.

Nicola Sacco was a fish peddler and philosophical anarchist; Bartolomeo Vanzetti a shoe-factory employee and radical agitator. In 1920 they were accused of killing two men in a payroll holdup at South Braintree, Massachusetts, and found guilty. But for six years liberals everywhere campaigned for their release on grounds that prejudice had convicted the men; essentially, that they were being convicted as an anarchist and a radical agitator rather than as killers in a holdup.

A series of sensational appeals culminated in the appointment of a committee of three, headed by President Lowell of Harvard and including the president of the Massachusetts Institute of Technology and a former judge. The opinion of this committee was that the guilty verdict should be sustained. Sentence of death on Sacco and Vanzetti was carried out in the prison at Charlestown, Massachusetts, on August 22, 1927. But a large body of considered opinion continued to believe the two men innocent.

Calumny and the Passion of Sacco and Vanzetti have a very close similarity of pictorial procedure beneath their primary differences of style. In the Passion of Sacco and Vanzetti the victims are not shown dragged naked to false judgment but are revealed in their coffins after execution. It does not take a great stretch of the imagination to associate the half-caricatured figure in academic cap and gown with Botticelli's figure of Calumny. He is flanked by two top-hatted figures holding lilies in their hands. They are certainly parallels to Fraud and Deception, the female figures who twine roses in Calumny's hair. The roses and the lilies borne by the top-hatted figures are the same false symbols of purity.

The parallel continues. Botticelli's unworthily crowned and sceptered false Judge is repeated in Shahn's painting by a framed portrait of the sentencing judge in the Sacco-Vanzetti case, his hand raised in a gesture that combines the oath of truth and a gesture of benediction, both of which are desperately ironical. This portrait hangs in the hall of a neo-classical court building corresponding to Botticelli's allegorical Renaissance palace. The only element without correspondence is the group of Remorse and Truth—if, indeed, the lamp in the upper left corner of the modern picture is not intended to be some such reference.

The four pictures we have seen so far have taken their subjects from specific instances of social cruelty or injustice. In varying degrees they accepted or overcame the limitation that can prevent this kind of picture from being an independent expression—the limitation, that is, of the observer's being dependent on knowledge of the specific event for full understanding of the picture's meaning. Even without this knowledge, even if we are left to find for ourselves their general sense, these four pictures are works of art of interpretive power or, at least, of curious fascination.

As a contrast, we may compare these pictures with John Trumbull's *The Declaration of Independence* (353)—

353. John Trumbull. *The Declaration of Independence*. 1786–94. Oil on canvas, 21% by 31% inches. Yale University Art Gallery, New Haven, Connecticut.

at the risk of being unfair to this worthy and much-loved painting by putting it into company that makes it look even more pedestrian than it is. Trumbull shows assembled in a room of admirable colonial style a group of dignified gentlemen conducting themselves with extraordinary decorum. The features of each participant are as true to life as Trumbull could make them; but in spite of the general solemnity and the air of consequence they have assumed. there is not much indication that the gentlemen are present at a climactic moment in the history of the modern world. They could easily be doing nothing more important than granting a charter to some minor institution, or signing one of those bothersome expressions of esteem that corporations have a habit of preparing for retiring directors. The social idealism, the political conflict, the prescience of war and sacrifice, in short, all the significant historical and emotional elements of a great moment in the course of human events are not even hinted at. Reducing our criticism to irreverent terms, the shortcoming in Trumbull's depiction of the signing of the Declaration of Independence on the first Fourth of July is that he has omitted fireworks. What do these impassive effigies have to do with the glory and the spiritual magnificence of the birth of a great nation?

Does The Declaration of Independence fall short because it lacks the vehemence of The Executions of the Third of May, the nervous intensity of Calumny, or the high moral purpose of the Passion of Sacco and Vanzetti? Unquestionably, it does—as an independent picture out of its context. But the shortcoming can be condoned, and the picture somewhat enriched, if we consider it as a reflection of the time in history—American history—when it was conceived. The subject illustrated here was one of four that Trumbull was commissioned to repeat for the rotunda of the Capitol in Washington and which he completed in 1824 the other three being The Surrender of Cornwallis at Yorktown, The Surrender of Burgoyne at Saratoga, and Washington Resigning His Commission). The new nation, anxious to take its place with the established countries of the world, was more interested in proclaiming its dignity and solidity than its fire and imagination. The new Capitol was no country bumpkin of a building but a monument in the tradition of the great structures of ancient Rome, as revived and modified in the nations of the modern world. To maintain harmony with this architectural setting, it was necessary to select paintings that were imagined in the same faintly pompous spirit—a requirement that, it must be admitted, was perfectly compatible with Trumbull's shortcomings. Ideally, the four panels chosen to adorn the Capitol should have been conceived with a dignity and nobility that translated into visual terms Thomas Jefferson's masterpiece, the Declaration itself. But there was no artist in America with stature as a painter equal to Jefferson's as a statesman, and there was no European painter who could have thought and painted in terms of Jefferson's political idealism. As a result we have Trumbull's Declaration of Independence, a little dull and unimaginative if forced to

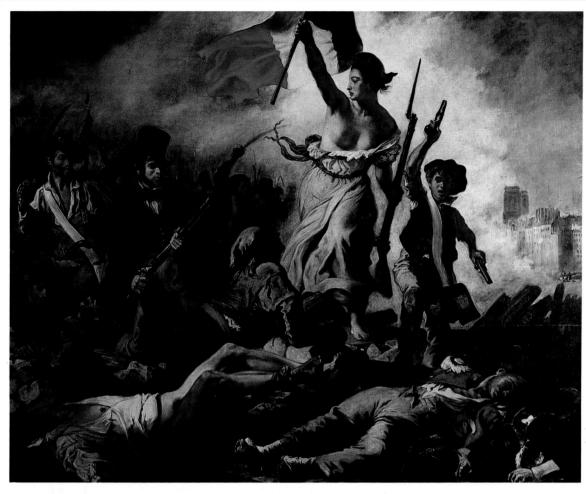

354. Eugène Delacroix. Liberty Leading the People. 1830. Oil on canvas, 8 feet 6 inches by 10 feet 8 inches. The Louvre, Paris.

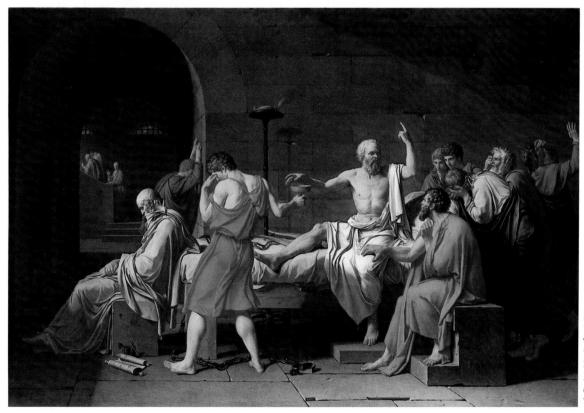

355. Jacques-Louis David. *The Death of Socrates*. 1787. Oil on canvas, 51 by 77¹/₄ inches. The Metropolitan Museum of Art, New York. Wolfe Fund, 1931.

compete with other pictures as a complete and expressive statement, yet possessing an appropriateness in the setting of its own time and of its own place that dignifies and enriches it.

Only six years later Delacroix painted his emotionalized Liberty Leading the People (354), a swirling, highly charged expression of the social ferment that led to revolutionary disorders in France in 1830. Both The Declaration of Independence and Liberty Leading the People are concerned with the same theme. If we try to imagine the Delacroix substituted for the Trumbull as an ornament for the national Capitol, however, it suddenly looks forced and high-flown, although no critic would seriously question its superiority over the American painting as the solution of a problem of expression.

What all this comes down to is that the essence of an event cannot be expressed simply by reproducing its circumstances. The painter with something to say about the history of his time may be wiser to forget factual appearances and depend on other ways of putting across his ideas. This is what Delacroix was doing when he painted *Liberty Leading the People*, and, less obviously, it is what Goya was doing in *The Executions of the Third of May*, which is an imagined, a created version of an actual event, not a reproduction of it.

An artist may comment on the contemporary scene without referring to it in the image he creates—and may even refer to it obliquely in images of the distant past. Jacques-Louis David's *The Death of Socrates* (355) is an instance. Although the subject is drawn from the ancient world, David's reference is to his own France. The old philosopher about to drink his cup of hemlock personifies the ideal of self-sacrifice for a principle. As a political allegory painted on the eve of the French Revolution, the picture declares that citizens who believe in the cause of liberty must accept the sacrifice of personal interests involved.

The Death of Socrates is a work of almost icy elegance, immaculately drawn and painted. Its surface is as tight and smooth as enamel, and the edges of its forms are sharp, clear, and uncompromising. In spite of a certain staginess, the arrangement is also severe—very severe in comparison with the esthetic tradition against which it revolted. A typical example of this tradition, Boucher's The Toilet of Venus, which we have already seen (104), shows why The Death of Socrates was a radically "modern" picture and why its technique was exemplary of a new social philosophy.

The Toilet of Venus was painted for an eighteenthcentury French court society in which women determined much of the policy and for which they certainly dictated the taste. Fashionable décor consistently suggested the boudoir, whether applied to a bedroom, a sitting room, a court hall, or a chapel. Paintings were liberally incorporated into these decorative schemes as ornamental panels. Boucher, with pictures like *The Toilet of Venus*, was an immense success because he developed a manner completely in harmony with the feminine delicacy of the style.

His typical female figure is a young girl of chubby proportions, with dewy lips, wide eyes, blond hair, and an air of perverse innocence suggesting more than anything else the mutual pleasures of seduction. In The Toilet of Venus she happens to be posed as the goddess of Love and Beauty, but even when Boucher painted milkmaids they were girls of the same cut, surrounded by the same opulent, fashionable swirls of taffetas, flowers, and ornamental paraphernalia. The Toilet of Venus suggests every feminine refinement of erotic pleasure; it is a perfumed, sweetflavored painting, at once as fresh as the blossoms strewn about in it, as expensive as the jewels of the goddess, and as calculated as the wiles of a professional courtesan. It is a superb, professional job created for a limited audience, an audience of specialized cultivation with the means to indulge itself in the acquisition of every accessory to this cultivation, from desirable partners to fine or fashionable works of art.

Indirectly, a picture like *The Toilet of Venus* is a social comment even though the painter had no trace of such an idea in mind. In earlier chapters where we have insisted that painting is inevitably an expression of its time, we examined a painting by one of Boucher's contemporaries, Chardin. His still life of simple homely objects (105) was conceived in a spirit the reverse of Boucher's slick and superficial one. The two painters represent opposing factors in eighteenth-century culture: Chardin, the new philosophical interest in the common man and the nobility of simple things; Boucher, the tag end of the Renaissance period of luxury and power concentrated in inherited position. It was this conflict, we know, that at the end of the century would tear France apart in the Revolution.

In the light of the burgeoning French Revolution, David's *Death of Socrates* begins to make new sense. The revolutionary spirit was a denial of every quality of the *ancien régime* summarized in *The Toilet of Venus*: it was a proclamation of new social standards. Masculine decision must dominate feminine sensitivity; self-sacrifice must replace self-indulgence. Moral force becomes the paramount virtue, opposing its parallel vice, the cultivation of sensuous pleasures. Opulence gives way to austerity, fashionable invention to philosophical order.

When The Toilet of Venus and The Death of Socrates are placed side by side, it should be apparent that The Death of Socrates, for all its elegance, proclaims these new ideals. Its revolutionary approach is more apparent if we know that as a student young David was greatly influenced by Boucher and even did a competition picture, The Combat of Minerva and Mars (358, p. 301), in a windy adaptation of Boucher's style. But as a fledgling painter in Rome he departed from this manner to develop the severe, highly disciplined style that helped make him one of the powerful figures in the revolutionary government.

356. Detail from The Death of Socrates.

357. François Boucher. Detail from *The Toilet* of Venus.

358. Jacques-Louis David. *The Combat of Minerva and Mars.* 1771. Oil on canvas, 45 by 55 inches. The Louvre, Paris.

Instead of the seductive adolescent goddess in her boudoir, David paints a philosopher surrounded by his loyal followers. But subject matter aside, the choice and delineation of forms in the two pictures contrast correspondingly. As an instance, some of the drapery passages in the David are of great beauty (356), but it is a beauty of discipline and order as opposed to the profligate gaiety of Boucher's taffetas (357). Compositionally, the antithesis continues. The Boucher is designed in swirls and graceful curves; forms play coquettishly in and out of the picture depth; objects are piled and strewn about with wanton abandon. But the David gives an immediate impression of absolute control. Each figure is placed uncompromisingly, posed almost rigidly, in a scheme where every detail is calculated to the last degree. The Toilet of Venus is just as skillfully and even more subtly organized; the point is that its organization is directed to give an impression of lightness and spontaneity, whereas The Death of Socrates insists upon formal order as a virtue and calls our attention to the fact that every element in the picture is subject to its unyielding discipline.

Compared with the half-illustrative, half-symbolical approach of the *Passion of Sacco and Vanzetti*, the social statement of *The Death of Socrates* seems to be made in a roundabout way. But in the long run—and art is always a matter of the long run—the *Passion of Sacco and Vanzetti*

359. Jean François Millet. *The Sower.* 1850. Oil on canvas, 39¾ by 32½ inches. Museum of Fine Arts, Boston. Gift of Quincy A. Shaw.

will grow more and more enigmatic, while *The Death of Socrates* will continue to speak of high idealism, dedication, and sacrifice, whether or not any connection is made between it and the events that once surrounded it.

We referred a few paragraphs ago to the eighteenthcentury philosophical conception of the innate nobility of simple things and the common man. In the nineteenth century this idea was given enough sentimental flavoring to make it palatable to a wide public in the art of Jean François Millet, whose *The Sower* (359) has come to be one of the best-known pictures in the world. The figure of a full-bodied peasant played against the light of a late afternoon sky is reduced to a near-silhouette. Details of dress and features are obscured in the interest of monumental breadth; this powerful mass fills the picture space and takes on an importance that the figure would not have if it were smaller in relation to the space or if objects in the immediate background were allowed to compete with it. If, for instance, the fields were shown stretching beyond the sower on every side, as of course they would in visual fact, leaving him isolated, surrounded by earth and sky, he could have become a symbol of man's smallness in the vastness of the world. As it is, the fields behind him suggest this vastness, but he dominates it, making us aware of the fundamental importance of the man who tills and sows and reaps, without whom the structure of society could not exist. Also, working in rhythm with the cycle of nature he is presumably closer to something of ultimate significance than the rest of us are. In "Saison des Semailles," a standard romantic poem that French schoolchildren are required to memorize, Victor Hugo eulogizes the peasant who throws the grain afar, dips his hand, throws again, and strides as rhythmically as the cycle of the seasons themselves across the plain in silhouette against deepening shadows that "seem to extend to the very stars the noble gesture of the sower."

The romantic ideal of the peasant as a kind of earth-symbol is all very well, but the lot of the nineteenth-century peasant was a little less than ideal when he was thought of as a human being. At close range, Nature's Nobleman had a distressing way of looking more like Society's Victim, a variation on Millet's theme that did not escape him even if he seldom dealt with it. In at least one picture, however, he showed the peasant as a creature brutalized by labor and poverty, the famous *Man with the Hoe* (360), which inspired another poet, Edwin Markham, to a comment different from Hugo's:

Bowed by the weight of centuries he leans Upon his hoe and gazes on the ground. The emptiness of ages in his face, And on his back the burden of the world. Who made him dead to rapture and despair, A thing that grieves not and that never hopes, Stolid and stunned, a brother to the ox? Who loosened and let down this brutal jaw?

Whose was the hand that slanted back this brow? Whose breath blew out the light within this brain?

Is this the Thing the Lord God made and gave To have dominion over sea and land; To trace the stars and search the heavens for power; To feel the passion of Eternity?

The position of the French peasant some hundred years ago was neither as desperate as that of *The Man with the Hoe* nor as pleasant as that of the rest of Millet's simple folk, but the position of the Mexican peon at the beginning of this century was without question subhuman. In *The Liberation of the Peon*(361), Diego Rivera commemorates the social rescue of the Mexican peasant by the Agrarian Revolution.

Rivera, a leader in the only significant revival of fresco painting in two centuries, was commissioned to paint a

360. Jean François Millet. *The Man with the Hoe.* About 1863. Oil on canvas, 32 by 39½ inches. Private collection, San Francisco.

361. Diego Rivera. *The Liberation of the Peon.* 1931. Variation of a fresco in Ministry of Education, Mexico City, 1923–27. Fresco, 74 by 95 inches. Philadelphia Museum of Art. Gift of Mr. and Mrs. Herbert C. Morris.

362. Courtyard, Ministry of Education, Mexico City. Murals by Diego Rivera.

series of murals for the Ministry of Education (362) in Mexico City, an undertaking he started in 1923. He conceived the murals as a combination of historical fact, ancient legend, and sociological and political propaganda a combination just as original but more harmonious than it sounds. The standard approaches for such commissions for the ornamentation of public buildings had crystallized into two familiar, threadbare forms. The more familiar was the obvious series of stuffy storytelling scenes in which historical figures stand around in costume like so many dummies in waxworks tableaux of famous events. The second approach might be called the routine-symbolical, in which groups of well-built male and female models are painted in decorative attitudes, holding cornucopias, shields, torches, scrolls, parts of machines (very advanced), and so on for the amount of wall space to be covered, and labeled Prosperity, Law, Justice, Art, Industry.

Rivera fell victim to neither of these bromides. His frescoes cover walls around open courts, where, read in sequence, they constitute a propagandistic textbook for the illiterate, who may read the history of Mexico in pictorial terms of agrarian-revolutionist ideology. The Liberation of the Peon symbolizes the end of an era of persecution and exploitation for the common Mexican, and the beginning of his liberation in the sense of political rights, land ownership, and education.

In the background, a hacienda of the oppressive landowning class is in flames. The revolutionists who have overthrown this régime are grouped around the peon, whose body is striped with whip marks. One man symbolically cuts a rope that binds the peon's wrists; another supports the body gently; a third covers its nakedness.

Rivera's murals are effective decorations aside from and often in spite of the insistent propagandistic fervor that sometimes defeats itself. It does so in *Dinner of the Millionaires* (364), where John D. Rockefeller, J. Pierpont Morgan, and Henry Ford are shown in caricature that overshoots the mark and gives us a newspaper cartoon rather than a work of art with expressive extensions beyond its immediate subject.

The Liberation of the Peon has these extensions. Compositionally, the scene is built along a sweeping line running diagonally through the picture along the limp body of the victim. This line is countered by the head and neck of the horse in upper center, which turns the line back and leads us again toward the right. On both sides the movement is stabilized by standing figures with strong vertical axes the horse on the left, the man holding a horse on the right. Within this framework there are secondary rhythms of highly geometrized loops made by the ammunition belts, the ropes, saddles, hats, and the simplified, rounded forms of the figures. In places this decorative geometry is strong enough to distract our attention from the whole, as it should not have been allowed to do. The pattern on the chest of the horse to the left, for instance, is too conspicuous for so incidental a detail; the crisscrossed loops of ammu-

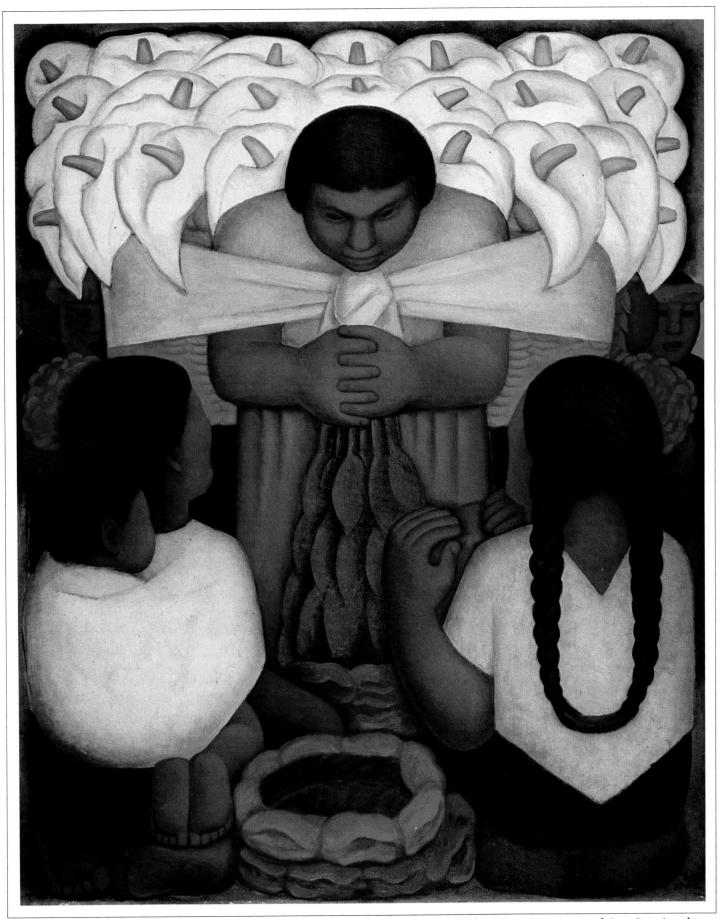

363. Diego Rivera. Flower Day. 1925. Oil on canvas, 58 by 47½ inches. Los Angeles County Museum of Art. Los Angeles County Funds.

364. Diego Rivera. *Dinner of the Millionaires*. 1923–27. Fresco. Ministry of Education, Mexico City.

365. Central Mexico. Standing Goddess. A.D. 250–650. Volcanic stone with traces of green and red paint over stucco, height 36 inches. Philadelphia Museum of Art. Louise and Walter Arensberg Collection.

366. Aztec. *Rattlesnake.* 1200–1521. Rhyolite porphyry, diameter 23¾ inches. Dumbarton Oaks, Washington, D.C. Robert Woods Bliss Collection.

nition around the neck and chest of the standing figure at the right, the knot in the shirt, the design of the ropes, are also attractive enough to exist for themselves rather than as adjuncts to the whole. But in singling these out, we are finding flaws in a generally successful arrangement.

In beginning the murals, Rivera experimented with the juice of a Mexican cactus plant as his medium, an idea with special attractions for this particular commission, but it was not successful. He employed instead the pure fresco technique of fourteenth- and fifteenth-century Italian painters, also borrowing heavily from their pictorial tradition; the forms and the composition of The Liberation of the Peon are directly comparable to those of Giotto's Lamentation (275) in the Arena Chapel in Padua, painted in 1305. But it is one thing to depend parasitically upon a great tradition like that of early Renaissance Italy and another to use it as a point of departure, as Rivera did. Rivera's stature has been drastically reduced by most critics during the years after 1923 when he painted the Ministry of Education frescoes; yet The Liberation of the Peon stands as a legitimate work of art, whatever its borrowings from the Italians and its reduction of the forms of ancient Mexican art to a decorative formula.

To Rivera's way of thinking, a revival of the forms of native Mexican art, the gods and symbols of the pre-Columbian cultures and civilizations destroyed by the Spaniards, would revitalize the spirit of independence in Mexico's oppressed majority—the peons, in which the Indian strain was ethnically dominant over the European, and often quite pure. Rivera's identification of social reform with esthetic principles had a good sound, but not quite so good a look. In Flower Day (363) the figure of the gentle Indian with his load of calla lilies reflects the stylistic symmetry and conventionalizations of not at all gentle Aztec gods of death and destruction (365), while the wreathlike form at lower center is a similarly sweetened echo of another frequent Aztec motif, the coiled rattlesnake (366). There is not much evidence that the Mexican peasants understood Rivera's implication that the great traditions of their ancestors were still alive and legitimate in everyday life. But the wealthy Mexicans and gringo millionaires who were excoriated in Rivera's socialistic murals were attracted by the decorative sophistication of his synthesized style and became avid collectors of his paintings and drawings. an unhappy backfire in the art of social consciousness.

The "Mexican Renaissance" of the 1920's and 30's is the only important instance of an art movement created by artists themselves, dedicated to propagandizing the ideals of a political system—unlike the official art of the Soviet Union, where artists have been obliged to adhere to themes dictated by the government or subsist as esthetic outlaws. Rivera and the two other leading Mexican artists of the day—José Clemente Orozco and David Alfaro Siqueiros—were strong individualists, so strong in fact that in spite of the didactic humanitarian goal that they shared, their "renaissance" was finally defeated by intramural squabbles.

367. David Alfaro Siqueiros. Proletarian Victim. 1933. Duco on burlap, 6 feet 9 inches by 3 feet 11½ inches. The Museum of Modern Art, New York. Gift of the Estate of George Gershwin.

368. José Clemente Orozco. *Law and Justice.* 1921–24. Fresco. National Preparatory School, Mexico City.

369. William Hogarth. *The Rake's Progress*. First episode: *The Young Heir Takes Possession of the Miser's Effects*. Engraved version, published June, 1735. 14 by 16 inches. Boston Public Library, Print Department.

A strong element of satire characterizes much of Orozco's work, and we will show here an early example. Law and Justice (with the reminder that Orozco's noblest works are murals fusing Aztec mythology with the history of the Spanish conquest in the formation of the Mexican people and nation). Law and Justice (368) is a ribald condemnation of legal corruption, in which a tipsy lawyer bearing all the earmarks of the prosperous bourgeoisie whom Orozco despised as enemies of the proletariat cavorts with an equally tipsy Justice. Her sword is broken, her scales are out of whack, and the blindfold over the eyes that assures equal justice before the law has slipped to one side. One may wonder which is more effective as propaganda, this bitterly amusing satire, or the pretentious Proletarian Victim (367) by Siqueiros, who more often than not weakened his point by melodramatizing it.

In 1732 the English painter William Hogarth published *The Harlot's Progress*, a set of six engravings following the misadventures of an innocent country girl from her seduction upon arriving in London through a career embracing prosperity, poverty, prison, disease, and finally death. Partly fiction with overtones of soap opera and partly social comment on evils of the day, the series was a financial success. Although Hogarth secretly regarded them as hack work, he published two more sets, *The Rake's Progress* and *Marriage à la Mode*, the latter detailing the misfortunes of a young couple in a loveless marriage arranged by selfish and ambitious parents.

These pictorial tracts have become classics in the history of art and cornerstones in the history of art as social comment. They are an amalgam of rather fuzzy moral preachments, lively satire, and explicit records of the contemporary scene, lifted to significance by the sudden appearance here and there of episodes castigating social cruelties. We will follow the eight episodes of *The Rake's Progress* in some detail.

The first scene, The Young Heir Takes Possession of the Miser's Effects (369), is worth examining closely as an example of Hogarth's narrative method. We are told what is going on by pictorial signposts such as letters, open diaries, and other written matter that we must actually read to understand the action. This method is a most unpainterly way of going about the job, as Hogarth very well knew, but he was working for popular response from a not very art-minded public, and he found the formula to be a successful one.

The signposts show us a very young man, Tom Rakewell, called home from Oxford by the death of his father. There are a dozen indications that the father was a miser who managed to save a considerable fortune, and just as many that Tom is getting ready to spend it. A strongbox full of silver has been broken open; beside it are heaps of securities—mortgages, bonds, and indentures. A diary (lower right), conveniently open at an appropriate page, tells us under the date "May 5th, 1721" of the old miser's

joy at having got rid of a bad shilling. The shabby furniture, the unused fireplace, and the contents of a dusty wardrobe, as well as a pair of old shoes resoled with leather from a family Bible, show that the father wasted no money. The young heir has hastened to change all this: at his direction a servant builds a fire, and a tailor measures Tom for new clothes.

The walls are being draped with black mourning cloth, disturbing a rotten molding that drops a fall of gold coins. Near the window the miser's escutcheon shows three vises clamped tight, with the motto "Beware!" The jack and spit, symbols of hospitality, have been carefully kept locked up in a cubbyhole (upper right).

Tom is arguing with an irate mother, who holds an apronful of his letters to her pregnant daughter, Sarah Young. Sarah, a good girl with whom Tom has had his way, weeps, holding his ring in one hand. Tom will pay her off with the sack of gold behind him, from which his lawyer filches a coin, a prophecy of the assaults he will make on the young rake's fortune on a larger scale after they get to London.

In the second scene, *The Levée* (370), Tom is in London holding a gathering in the French (and to Hogarth, everything French was contemptible) manner. He is cultivating all the fashionable graces; hence his entourage, with identifiable portraits of London figures, including a dancing master, a French fencing master who lunges with the shortsword, an English instructor in quarterstaff who looks on disapprovingly, a landscape architect, a professor of music at a harpsichord, a jockey with a trophy in the form of a silver bowl presumably won by one of Tom's horses, and in the background tailors, perukemakers, hatmakers, and a poet who hopes for Tom's patronage. Portraits of fighting cocks on the wall show that the young blade is also interested in that sport.

Skipping the third scene for the moment, we find in the fourth scene, The Arrest (371), that our rake has made the grade socially and is on his way to be received at court. Or at least we learn it if we identify the palace of Saint James in the background and if we recognize, as Hogarth's contemporaries would, two figures of Welshmen wearing enormous leeks, a symbol that fixes the day as March 1, sacred to the titular saint of Wales and one observed by a reception at court. (If this seems farfetched, think how easily today we would identify a date as March 17 if a picture included an Irishman appropriately displaying a shamrock emblem and, perhaps, lining up for a parade.) It is easier for us to identify a bailiff who stops Tom's sedan chair and threatens him with arrest for debt. Bankrupt, Tom is saved by Sarah Young, the girl he had wronged. Her reappearance at this particular moment, fortunate for Tom, is a plausible coincidence. We see by her costume that she is now a milliner and has come to observe the dress of the people arriving at the reception. She pays the bailiff from her own purse.

This is Tom's chance for repentance and redemption; but in the next scene, *The Marriage* (372), we find him marrying a hideous old woman, obviously rich, who has

370. The Rake's Progress. Second episode: The Levée.

371. The Rake's Progress. Fourth episode: The Arrest.

372. The Rake's Progress. Fifth episode: The Marriage.

accepted his proposal with such alacrity that her maid is still arranging her wedding gown at the ceremony. Tom is hardly able to hide his repugnance for his bride. Sarah, holding Tom's baby, stands in the background while her mother tries to battle her way into the chapel.

The story goes on with Tom's losing his new wife's fortune in a gaming house (373) and follows him to debtors' prison (374), where Sarah Young, unable to help him further, falls in a faint while his hag of a wife berates him. In the last scene, *The Madhouse* (375), Tom ends up in Bedlam, London's insane asylum, a maniac among maniacs, not even recognizing his faithful Sarah, who still stands by.

As a narrative, *The Rake's Progress* is lively enough; as a moral lesson, it is ambiguous because while vice is punished, virtue is not rewarded. As social comment, it is largely satirical; but in the last two scenes, the debtors' prison and especially Bedlam, the story rises above itself.

In debtors' prison Tom has tried to write a play to recoup his fortunes. A rejection note lies beside him on the table. Behind him the turnkey presses for his prison fees, and an errand boy refuses to leave a mug of beer Tom has ordered but cannot pay for. The other inmates are so picturesque as to confuse the issue somewhat. The man who helps support Sarah is identified by a scroll as one "I.L. now a prisoner in the Fleet" (London's notorious debtors' prison), who has been working on "a new scheme for paying the debts of the nation." And in the background another prisoner operates a chemical apparatus, possibly tied up with alchemy, while on the canopy of the bed (upper right) a pair of wings designed to be worn by a human being are a third symbol of visionary foolishness. In spite of these distractions, our attention is called to the squalor and hopelessness of the Fleet.

The scene in Bedlam (a corruption of Bethlehem) Hospital is more appalling. The inmates are a roster of standard insanities—the religious maniac, the naked man with delusions of grandeur, the hopeless depressive seated on the stairs, and various gibbering manic types. The two women in the background are visitors. Bedlam was open as a kind of sideshow for the public, and according to contemporary records was a notorious meeting place for sexual intriguers.

To what extent was Hogarth actually protesting against the cruelty of social institutions in these pictures of Fleet Prison and Bedlam? Although he reveals them in all their foulness, he does not do much more than record the actual state of things. But the state of things was so bad that any truthful record had to constitute a protest.

Although another artist might have treated these subjects humorously or with the morbid, callous curiosity of the two women visitors to Bedlam, it must have been quite possible for Hogarth's contemporaries to miss the point of his implied criticism of the institutions, for the pictures did not reveal any conditions not well known to everybody. If *The Rake's Progress* is a moral lesson, and if Fleet Prison and Bedlam, for all their horrors, are only the hells to which

373. The Rake's Progress. Sixth episode: The Gaming House.

374. The Rake's Progress. Seventh episode: Debtor's Prison.

375. The Rake's Progress. Eighth episode: The Madhouse.

376. Edward Kienholz. *The State Hospital*. 1966. Construction—plaster, neon, glass, fibers, metals, light bulb—approximately 8 feet high, 14 inches wide at front. Moderna Museet, Stockholm.

our sinner is legitimately damned, then Hogarth's social protest is confused with his moral warning that his rake is getting no worse than he deserved. But since Hogarth once said that he would rather have "checked the progress of cruelty than have been the author of Raphael's cartoons," we may take it that he had some such protest in mind.

We have omitted one episode from *The Rake's Progress*, which we will see in a moment, but first we might look parenthetically at a twentieth-century American artist's version of a madhouse to compare it with Hogarth's Bedlam. The eighteenth-century artist's social protest in the story of a foolish young man's career is adulterated by its lively appeal as a pictorial novelette and its confusion between personal morality and society's obligation to care for its wayward or incompetent members. But Edward Kienholz's *The State Hospital* (376) can leave no question in the observer's mind as to the horror of the situation represented and the brutal side of a society in which that situation can exist.

Kienholz worked in a mental institution in 1948. In 1964 he described his project of *The State Hospital*, based on his memory of cruelties and indifference to the suffering of inmates that he had witnessed, as follows:

This is a tableau about an old man who is a patient in a state mental hospital. He is in an arm restraint on a bed in a bare room. (The piece will have to include an actual room consisting of walls, ceiling, floor, barred door, etc.) There will be only a bedpan and a hospital table (just out of reach). The man is naked. He hurts. He has been beaten on the stomach with a bar of soap wrapped in a towel (to hide tell-tale bruises). His head is a lighted fish bowl with water that contains two live black fish. He lies very still on his side. There is no sound in the room.

Above the old man in the bed is his exact duplicate, including the bed (beds will be stacked like bunks). The upper figure will also have the fish bowl head, two black fish, etc. But, additionally, it will be encased in some kind of lucite or plastic bubble (perhaps similar to a cartoon balloon), representing the old man's thoughts.

His mind can't think for him past the present moment. He is committed there for the rest of his life.

Kienholz's "tableaux," as he calls his combinations of sculpture and real objects, are extensions of the "assemblage" idea that we have already seen used for esthetic purposes (70). In *The State Hospital*—which was executed in 1966 with a few variations from the concept written out in 1964—the combination of sculptured figures (cast from life) with actual paraphernalia accentuates the horror of a situation that would have been lessened if all the objects had been translated into sculpture.

The episode we omitted from *The Rake's Progress* is the third, an early station on Tom's road to ruin. Hogarth's engravings for the popular market were first created as

377. William Hogarth. *The Orgy*, third episode of *The Rake's Progress*. About 1733. Oil on canvas, height 24½ inches. Sir John Soane's Museum, London. Courtesy of the Trustees.

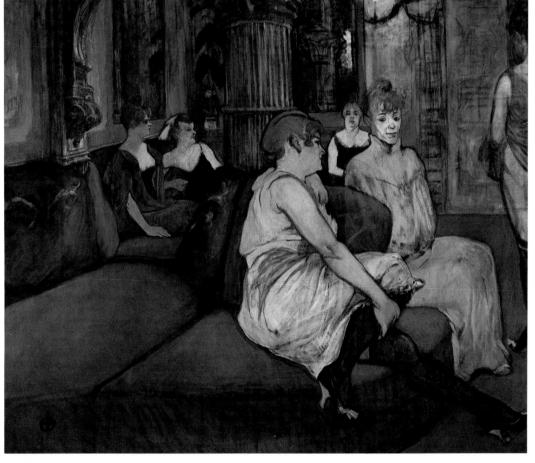

378. Henri de Toulouse-Lautrec. Salon in the Rue des Moulins. 1895. Oil on canvas, 43% by 52½ inches. Musée Toulouse-Lautrec, Albi, France.

paintings; we are illustrating the painting of *The Orgy* (377). The details are largely self-explanatory, except for the portraits of Roman emperors (each but Nero's with its head cut out) and the staff and lantern by Tom's chair (probably trophies of some drunken prank). The woman spitting gin across the table at her rival is not an invention. Hogarth witnessed the incident while visiting Moll King's Tavern with an artist friend, one Francis Hayman. Hogarth knew these brothel-taverns and their inmates well; if the bawds in the picture are not portraits, they are close to it.

The brothel scene is chosen for illustration to make a comparison with Toulouse-Lautrec's Salon in the Rue des Moulins (378), painted in 1895. Hogarth's painting, whatever its moral content in other ways, is unconcerned with his prostitutes except as accessories to the narrative of Tom's adventures. He tells us that loose company leads a foolish young man to a bad end, but does not indicate that the women are engaged in anything more distressing than a rollicking, profitable evening at Tom's expense. In other words, the human condition is not involved in this illustration of a social evil except in the most roundabout way.

But beneath its apparently callous objectivity as reportage on sordid aspects of Parisian life, Lautrec's art makes compassionate observations on contemporary social values—much more so than Hogarth's, of which the reverse is true. Salon in the Rue des Moulins, referring to a brothel frequented by the artist, is an intensely moral picture in spite of its "immoral" theme, and subjective in spite of its air of casual detachment from anything more profound than a bit of journalistic on-the-spot description. And indeed each figure in the painting is a portrait of an inmate of this particular maison close; the seated one facing us is the madam of the place. But instead of Hogarth's hilarious orgy, we have here an expression of infinite lassitude, a suggestion of stagnant air where the spirit languishes, a mood that has as little to do with hope as it does with hopelessness. Hogarth preaches that the wages of sin are madness and death; in Lautrec's world, they are infinite boredom, the desiccation of the human spirit, and stultification into brutish semiconsciousness.

Hogarth's "moral comedies" take place in the fashionable half-world of the early eighteenth century; Lautrec concentrates on Parisian bohemia at the end of the nineteenth. Both men are quite specific in their incidental references. (Lautrec's salon is now taking on the air of a period room, as Hogarth's interiors have long since done.) The difference we find in the painters, when we compare the brothel scenes, is that Hogarth is interested in people typed as social phenomena, while Lautrec is interested in people as individuals affected by the structure of society.

There comes a point where what we have been calling social consciousness merges with a more general consciousness of the human condition within the complexities of the world. Lautrec's *Salon in the Rue des Moulins* reaches this point; it would be difficult to say whether it is more

a comment on prostitution or more a comment on human beings who happen to be prostitutes. In that respect it stands midway between Hogarth's social observation and a disturbing comment on humanity painted by an American in 1929–30—Ivan Albright's Into the World There Came a

Soul Called Ida (379).

This mass of flesh, luminous with decay, pitted, scarred, and swollen with time, partially covered with bits of cheap imitation silk—this piteous image may or may not be that of a prostitute, but it is certainly an image of the mortality of the flesh and of the spirit. By the clothes, dressing table, and knickknacks, all of them shoddy machine products of the most painful ugliness and repellent vulgarity, this double mortality is linked to some evils of our civilization—its crassness and especially its exploitation of mediocrity. To that extent, the picture is a social comment whether it was intended as one or not. The picture is not a tragic one since the subject is without nobility, a pathetic creature mercilessly painted. But the social implications are no less disturbing for being inherent in the subject rather than propounded by the artist.

The theme of frustration and loneliness in individual lives within a society that is supposed to offer them everything—the theme that we called "the exploitation of mediocrity" in the case of the soul named Ida—has been a recurrent one in American art of our century. We have already examined the head of a sculpture by Duane Hanson as an example of extreme realism in presentation. But extreme realism is also typical of the effigies in waxworks museums. Just where does a sculpture like *Couple with Shopping Bags* (380) become something more than pore-bypore reproduction of nature? What is the social or human-

istic comment beneath this exaggerated realism?

Here are two people who must have been normally attractive in their youth, and normally high-spirited in their confidence of finding their place in the best of all possible worlds. In early middle age they are defeated—the woman sullen, the man despairing. Confronted by these faces, a poet could ask variations on the questions Edwin Markham asked about the Man with the Hoe. What turned youthful rapture to despair, what extinguished the light within these spirits? What has gone wrong? Economically, this couple is secure enough somewhere in the middle brackets of a society that has offered its middle class more material benefits than any other in the history of the world. They are dressed in wonder fabrics that they will wash in a wonder washing machine with the new wonder detergent that competes with other wonder products for their attention every night on the TV. Their shopping bags must contain food with what the manufacturer calls new wonder ingredients, and they are probably dosing themselves with new wonder cures for colds, aches, pains, and upset stomachs. The commercials on their set tonight will tell them of the latest new wonders available to make their lives dirtfree, care-free, and work-free, from cat food to automobiles. And yet nothing wonderful ever seems to happen for them.

379. Ivan Le Lorraine Albright. *Into the World There Came a Soul Called Ida |The Lord in His Heaven and I in My Room Below|*. 1929–30. Oil on canvas, 55 by 46 inches. The Art Institute of Chicago. Gift of the artist.

380. Duane Hanson. *Couple with Shopping Bags*. 1976. Polyester resin and fiber glass, polychromed in oil, with clothing and accessories, life size. Courtesy O. K. Harris Gallery, New York.

381. George Segal. *Subway*. 1968. Construction—plaster, metal, glass, rattan, electrical parts, light bulbs—90 by 114½ by 53 inches. Collection Mrs. Robert B. Mayer.

382. Peter Blume. *The Eternal City*. 1937. Oil on composition board, 34 by 47% inches. The Museum of Modern Art, New York. Mrs. Simon Guggenheim Fund.

The realization that American life is not perfect shattered our national complacency in the 1920's with the appearance of books like Sinclair Lewis's Main Street and Sherwood Anderson's Winesburg, Ohio. But the locales were small towns, implying that life in the cities, with their cultural advantages, was different. In 1949 Arthur Miller wrote one of the masterpieces of the American theater, Death of a Salesman, in which an honest man finds himself lost at the end of a career based on the false values promulgated as basic virtues in a materialistic consumer society. Hanson's people (it is easier to think of them as people than as sculptures) are the current victims of a society now, in effect, completely urbanized, yet as unrewarding to them as the small-town cultures of their grandfathers. Hanson calls up the couple with shopping bags as witnesses for the prosecution in his indictment of a persistent aspect of our society, which has failed to offer the inner satisfactions of human life that less advanced civilizations seem to have offered generously.

The theme of urban loneliness that runs through modern American art is all the more poignant because this loneliness persists in the crowd, seems even to be generated by the crowd. In George Tooker's The Subway (383), this most hectic area of New York is composed of interlocking prison cells; each person, for all the presence of others, is isolated, uncertain, fearful. Three men in telephone booths are clones of one another, symbolical of the conformity imposed on members of a supposedly individualistic society. In sculpture, George Segal brings an almost spectral loneliness to his subway passenger (381). We have already mentioned the American artist Edward Hopper as a painter of loneliness, and we may refer back to that brief passage (113). But there is a difference between Hopper and the artists we have been discussing here, which is that Hopper's interpretation of a commonplace city scene is his expression of a personal loneliness that permeates all his work, rather than a deliberate social comment.

With the exceptions of Botticelli's allegory and Tooker's nightmare subway, the paintings and sculptures we have examined as social comment or record have been on the whole realistic. Their realism has ranged from Shahn's near-caricature to David's neo-classical idealism, from Daumier's broad generalization of form to Albright's microscopic detail, from Trumbull's prosaic reconstruction to Rivera's decorative patterning. Their realism is not surprising, fantasy by definition should be useless to the artist as social critic. An exception is Peter Blume's *The Eternal City* (382), where fantasy and sociopolitical content are inseparable.

The painting was completed in 1937 after several years of work following the artist's visit to Rome in 1932. It was the heyday of Mussolini's power as Il Duce. His Fascist state was presenting every surface indication of Italian rejuvenation. Trains ran on time, as they had never done before in Italy. Tourists regarded this miracle a bit uncomfortably, finding the practical convenience rewarding in

spite of the brutality and violence they read of but never met face to face. The full Fascist potential had not yet been revealed by events in Germany that were to make Mussolini's Italy only an amateurish preface to Hitler's demonstration of man's full capacity for evil.

Blume's picture shows Mussolini as a scareface leaping out of a jack-in-the-box. Weightless upon its paper stalk, the head was inspired by a papier-mâché statue of the dictator seen by the artist in Rome. With brilliant green face and bright red lips it is a shocking dissonance (the painter's own word) in the color scheme. Blume writes: "It hurt me aesthetically to paint the head but . . . the question of harmony was superseded by other considerations."

What these other considerations are should be apparent in the surrounding elaborate fantasy-allegory. Anyone who has visited Rome—and most who have not—will recognize that The Eternal City is a composite of familiar elements: the underground corridors of the Colosseum, the pillared monuments of the Forum, the vaults of the catacombs, a late baroque shrine, and the bell tower of an early medieval church. These references to the past do not insist on Rome's grandeur; corruption and decay are everywhere, culminating in a pile of broken sculpture and architectural fragments in the foreground, where a miserable beggar sits. Yet all of it is more substantial than the Hallowe'en jack-in-the-box Duce springing from it. The luxuriant vines and the tree may symbolize the city's eternal vitality, its capacity for rebirth from age to age, just as the peaks in the background, which define Italy's geographical entity, suggest an eternity and indestructibility that reduce the Fascist régime to an affair of the moment.

383. George Tooker. *The Subway.* 1950. Egg tempera on composition board, 18 by 36 inches. Whitney Museum of American Art, New York. Juliana Force purchase.

Unfortunately fascism could not be taken that lightly. In April 1937, while Blume was finishing *The Eternal City*, Fascist planes bombed the Spanish city of Guernica and gave the world a sinister prophecy of what World War II was going to be like. This crime generated the most powerful indictment of war that our war-ridden century has produced, a painting worthy to stand with Goya's *Executions of the Third of May*—Picasso's *Guernica*, which, for convenience, we will repeat in illustration here (394).

In a landmark essay of the early 1920's, The Dehumanization of Art, the Spanish philosopher José Ortega y Gasset commented that the new forms of art, including cubism, were not adaptable to humanistic expression, but could only serve the pleasures of an élite class interested in art for art's sake. This seemed true until Picasso, in his anguish and rage after the bombing of Guernica, produced virtually overnight a painting in Cubist-derived forms that stands as a humanistic statement accessible to an audience innocent of any knowledge of esthetic theory and uninterested in—or even opposed to—modern art.

Suddenly the Cubist deformations were no longer formal exercises for analysis by estheticians but seemed to have been produced by the physical violence and emotional intensity of the subject. It was as if the whole history of cubism, since Picasso's innovational *Les Demoiselles d'Avignon* (169) thirty years earlier, had been directed toward this unexpected consummation, by which a form of horror peculiar to our century—bombing from the air—had been represented in a form of art invented to express it.

Confronted by *Guernica*, who can imagine this painting redone realistically? Earlier in this chapter we spoke of pictorial style as an element of social statement, citing David's iciness in *The Death of Socrates* and Boucher's playfulness in *The Toilet of Venus* as examples. If Picasso's *Guernica* stands in the future as the masterpiece of the twentieth century, as is quite possible, it will be because of the triple coincidence of a subject of profound significance, an artist passionately involved, and a formal style appropriate to the release of expression at full force.

After *Guernica*, it seems unfair to conclude this chapter with a painting that, although excellent, must bear comparison with Picasso's masterpiece as an ambitious treatment of a closely related subject, James Rosenquist's *F*-111 (395); but chronology dictates the necessity. During the twenty-eight years that elapsed between the two paintings, the technology of mass murder from the air produced the atom bomb, and Rosenquist's painting is a protest against the production of an experimental bomber, the *F*-111 (*F*-One-Eleven), highly publicized in the years of the "cold war" with Russia. Produced at vast expense, the *F*-111 proved faulty and was scrapped. Paradoxically, the best thing that came from the program was Rosenquist's painting protesting it.

Measuring 10 feet high and 86 feet long, F-111 was designed to be installed as a mural on three walls. Rosenquist was a prominent practitioner of pop art, the move-

384. Pablo Picasso. *Guernica*. 1937. Oil on canvas, 11 feet 5½ inches by 25 feet 5¾ inches. Estate of the artist.

385. James Rosenquist. *F-111* (central portion and portion at right of center). 1965. Oil on canvas with aluminum. Entire work, 10 by 86 feet. Private collection.

ment, then at its peak, that drew its images from the most commonplace mass-produced aspects of America's consumer society, everything from soap boxes to the standard formula for glamour girls. Routine advertising art of the magazine and billboard type was often adapted satirically in deadpan social comment. Rosenquist himself had worked as a signpainter on the gigantic billboards above Times Square. One passage in *F*-111 is adapted from advertising for canned spaghetti with tomato sauce. Rosenquist gives it a double meaning: juxtaposed as it is with a representation of an atomic explosion, the spaghetti becomes the bloody entrails of a bombing victim. (The "umbrella" of the atomic cloud is accompanied by the commercial image of a real umbrella, to less point.)

The pros and cons of the merits and shortcomings of *F*-III can be rationalized back and forth indefinitely, and we might reach the conclusion that in this case the means offered by pop art were inadequate to the magnitude of the theme. But *F*-III would remain an important work of sociologically oriented art even if we had nothing but the climactic image of the little girl under a hair dryer. There is another double reference here, first to the vulgarity of a culture that sends little girls to beauty parlors, and second to the horror of a civilization that murders little girls along with everybody else from the air—for the hair dryer is also the nose cone of a bomber.

Postscripturally, we might ask why the art of protest has inspired no monumental sculptures comparable to Guernica. One good reason is that monuments are not likely to be commissioned until years after the events they commemorate, and by that time the topicality of an event has faded. The victors, whether of war or some other social struggle, are more interested in celebrating the heroism of leaders or martyrs than in raging against forces that, after all, have been defeated. One recent sculpture of rage that must inevitably bear comparison with Picasso's Guernica, since the subject and intention are so nearly parallel, is Ossip Zadkine's The Destroyed City (386), in Rotterdam. The entire center of that city was destroyed by German air bombardment in 1940 several hours after the city had capitulated. In angular, twisted forms, less abstract than Picasso's, a figure shouts defiance to the sky, arms extended in a pose that recalls the defiant figure in Goya's Executions of the Third of May—but is less real.

Here a critic is on uneasy ground—or, at least, one who finds Zadkine's sculpture unequal to its theme must feel uncomfortable in saying that for all its admirable, even noble, intentions, he finds the statue little more than a mannered exercise in semi-abstraction, neither tragic nor wrathful. The total effect of rebuilt Rotterdam is deeply moving; it must depend on personal responses whether the monument is ennobled by association, standing as it does against that background, or whether it is not only an intrusion in the first place but an inadequate expression of its theme as well.

Somehow, in either case, the fire is gone.

386. Ossip Zadkine. *The Destroyed City (The Destruction of Rotterdam).* 1954. Bronze. Leuvehaven Quay, Rotterdam.

387. Giorgione. The Tempest. About 1505–10. Oil on canvas, 30¼ by 28¾ inches. Galleria dell'Accademia, Venice.

Chapter Thirteen

THE ARTISTAS VISIONARY

e have defined realism, expressionism, and abstraction, and have offered enough examples of each to indicate that the variations and overlappings of each classification may be infinite. We have analyzed composition as pattern, as structure, and as a relationship of forms determined by special problems of expression and narration. We have seen that the various techniques available to artists are not only the means of bringing a work of art into existence but may be in themselves elements of expression.

If these discussions have succeeded in their purpose, then anyone who has followed them should have found ways of looking at works of art to discover within them some meanings not apparent on the surface. But it should also be clear by now that in spite of the general principles we have outlined, formula must always take second place to invention for the artist—which means that formula must always take second place to perception for the observer. In outlining general principles, we have tried to give some kind of basis for the speedier development of individual perception. In the end, a work of art is a communication between artist and observer, in which a guide or interpreter is only in the way.

We have thought of these discussions as an introduction to art, but all acquaintance with art is an introduction to it, since each new work of art is a new experience. If by a miracle it were possible for one person to have universal knowledge of art up to this moment, everything he knew would be only an introduction to what will be created tomorrow, whether good or bad, false or sincere, conventional or revolutionary. Art is so various that once we have begun its exploration we are always in midstream.

Since we have been engaged in something like a course of study, it might seem reasonable to devote this last chapter to an exposition of some knottier problems than any we have tackled so far, basing the explanations on what we have learned from preceding examples. But this would suggest that the understanding of art depends more than it does on the application of rules and systems. Instead, we will be concerned with some subjects that are essentially unexplainable in any specific sense. Visionary, grotesque, fantastic, or mystical, they depend to the utmost on that communication between a work of art and its observer that may be facilitated by acquaintance with rules and general principles but is finally determined by the unique reaction of the individual to a unique image.

Giorgione's The Tempest (387) is—partly by accident—a perfect example of such a situation because, though its subject has been lost, the picture is so provocative that it must take on meaning of some kind for anyone with a grain of imagination. The meaning must be entirely personal; the title is an arbitrary one, since we have

388. Giorgione, attributed. *Pastoral Concert.* Before 1510. Approximately 43 by 54 inches. The Louvre, Paris.

no idea what Giorgione originally called it. (It is also sometimes called *Soldier and Gypsy*, a title that presumes more than we can actually know about the two figures.) The painting is beautifully composed; its individual elements are quite irrational and contradictory in any narrative or psychological connection that we can perceive, yet they are integrated into a perfectly unified pictorial whole.

To one side of the picture, a young woman suckles a child. She is nude except for a length of cloth draped across her shoulders. Her attitude is not particularly one of maternal tenderness; she seems rather to be engaged in some casual, indefinable reverie. Her presence in the countryside upon this grassy bank, amid luxuriant sprays and clumps of foliage, is unexplained yet appears inevitable. She seems unaware of the other figure or of the gathering storm; although she glances in our direction, she does so without any response to our presence. It is important to the extraordinary impression of isolation created around her that she is separated from us by a delicate filigree of leaves and branches springing from the rock in the immediate foreground.

The figure on the opposite side is a very young man, hardly more than an adolescent, sometimes described as a knight, sometimes as a shepherd, who carries a staff that is not quite appropriate to either. The figure is graceful and assured, alert in contrast to the half-meditative, half-enchanted young woman. He regards her attentively, and his position in the extreme foreground and his graceful pose suggest an awareness of the observer. He is the only element that invites our participation in the picture. We are barely admitted to the right foreground, and we are fenced out of the left, as soon as we have encompassed the figure of the youth, by a barrier of foliage, water, and architectural ruins, beyond which some buildings of a town or city rise in spectral illumination against a dark sky breached by a streak of lightning.

Giorgione, a Venetian, painted The Tempest about 1508. It is a typical Venetian Renaissance painting in its transmutation of sensuous luxury into pastoral idyllicism. In Giorgione's other paintings and in works by his contemporaries we find the same combination of soft golden flesh, tender foliage, gleaming velvets and satins, mellowed stones, the same sense of the touch of air, the same glowing lights and vibrant shadows. But The Tempest somehow remains outside the formula. There is no other picture anywhere quite like it. Compare it, for instance, with Pastoral Concert (388), a superb painting frequently attributed to Giorgione as a compound expression of the delights of the flesh and the senses that rises above salaciousness or vulgarity because it is conceived in the spirit of pagan worship of sensuous delight, rather than commonplace indulgence.

The difference between the two pictures, which has led some authorities to reject the attribution to Giorgione, is that in *The Concert* our curiosity is satisfied by the completeness we find in it. Its greatness lies there, in the

rich fullness of its statement. But the fascination of *The Tempest* lies in its atmosphere of lyrical mystery. Someday the subject may be discovered, but it seems probable that Giorgione deliberately invented a mysterious picture, a probability supported by the fact that X rays have revealed that the figure of the "knight" was originally that of another woman. Such a change would be difficult to account for if the picture illustrates a lost poem or an episode from an ancient Greek story, as has been conjectured. A more likely explanation is that the subject is an allegory, which would account for the curious combination of figures and setting but would change the picture from a poetic mystery into a didactic illustration.

Nothing, of course, could quite do that. No explanation, however precise and irrefutable, could transform The Tempest from a poetic masterpiece into the collection of symbols that make up an allegory. For the poetry does not lie in the objects themselves, nor does the mystery lie entirely in the strangeness of their combination. It is their unification as forms in light and their harmony as sensuous experiences that lift this collection of miscellaneous and itemizable elements to the level of an experience not to be explained in terms of the world. It would not be proper or safe to wonder whether The Tempest is a more expressive picture for having lost its subject. But it is probably a different picture. Its details remain explicit while the total statement Giorgione intended them to make remains mysterious, so that its meaning is of necessity a matter of personal response to all the suggestions involved. The Tempest may have begun as an allegory; it has become a dream. When we look at it the dream becomes our own, and our own interpretation of it becomes the legitimate one.

What is the image of a dream? By popular conception it is fuzzy, misty, half-formed, and wavering—no doubt because of the quickness with which dreams fade from memory, their elusiveness when we try to describe them. But in actual experience a dream may be and usually is acutely vivid. When painters set about exploring this otherworld, the best of them have usually chosen to do so in forms of exceptional clarity, sharper than reality, so that the fantasy and unreality of the visionary forms are intensified.

William Blake, the late eighteenth/early nineteenth-century English painter and poet whose *The Wise and the Foolish Virgins* we have already seen (220), wrote:

A spirit and a vision are not, as the modern philosophers suppose, a cloudy vapour or a nothing; they are organized and minutely articulated beyond all that the mortal and perishable nature can produce. He who does not imagine in stronger and better lineaments and in stronger and better light than his perishing and mortal eye can see, does not imagine at all.

Blake's "perishing and mortal eye" was frequently indistinguishable from his imagination. At the age of four

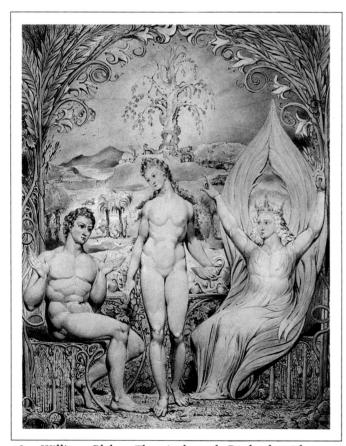

389. William Blake. *The Archangel Raphael with Adam and Eve,* illustration for Milton's *Paradise Lost.* 1808. 19½ by 15% inches. Museum of Fine Arts, Boston. Gift by subscription.

he told his parents that he had seen God's head at the window, an incident frequently related to indicate his visionary nature but one common enough in children at that age. But at the age of seven his vision of the prophet Ezekiel in the fields surrounded by angels in trees was more exceptional. The wings of the angels were "bespangling the boughs like stars." Even if this description, as quoted much later by his wife, has the benefit of hindsight, it is quite in the spirit of Blake's art and temper. From his wife, too, we have the description of Blake's death, certainly as jubilant a passing as has ever been recorded. He was seventy years old and confined to bed, where he worked on a set of drawings illustrating Dante. On the day of his death he called his wife and told her, "Kate, you have been a good wife; I will draw your portrait." He proceeded to do so for an hour as she sat by the window and then, according to her account, "he began to sing Hallelujahs and songs of joy and triumph, loudly and with ecstatic energy. His bursts of gladness made the walls resound," and then he died. This was a man who had suffered poverty and scorn and had been forced to live on the thinly disguised charity of friends.

Like many artists of extreme individuality, Blake must be accepted without question or completely rejected. His paintings and engravings are ecstatic and thrilling visions, or they are conscientious but obvious and labored illustrations based on forms cribbed from Raphael and Michelangelo. In everything Blake did, his naïveté is a primary characteristic. In The Archangel Raphael with Adam and Eve (389) there is not the slightest question that Adam and Eve are two specific human beings of exceptional beauty as Blake conceived of human beauty, in terms of Renaissance idealizations). They are receiving instructions from the angel Raphael in a Garden of Eden where twining plants and exotic trees of Blake's own invention are as real as his own small garden, where he was fond of impersonating, or of confusing himself and his wife with, Adam and Eve. To Blake the word "real" described what was most real to him. whether it was of this world or another world. He appears to have made little distinction between the world around him—at least that part of it which he was willing to accept-and the world of the Bible, Milton, Dante, and Shakespeare. The world he synthesized in his art drew from all these sources.

If Blake could have known Giorgione's *The Tempest*, he might have admired it as an unexplained vision; but he would have scorned it as an explained allegory, which, for him, would have turned it into nothing but a charade. "Fable or allegory is a totally distinct and inferior kind of poetry," he wrote. "Vision or Imagination is a representation of what actually exists real and unchangeably." That he recognized no boundary between tangible fact and visionary fabrication brings Blake close to lunacy by definition. He might indeed have ended as a confined lunatic if his wife had not combined unquestioning faith in his appointed role as a spiritual messenger with an un-Blakean capacity for

holding body and soul together. Kate has achieved her own special immortality in the history of art.

Blake's water colors and, of course, his engravings retain the strong lineaments in which he created them, but his tempera paintings have deteriorated to such a degree that some of them have turned to the "cloudy vapour" that so offended him as the conception of a dream or a vision. He used some form of glue tempera of his own concoction that has deteriorated badly, with much crackling and discoloration. Yet the effect is not altogether unpleasant, nor does it obscure the forms in paintings like Zacharias and the Angel (390). Apparently in his temperas the forms were originally even more substantial than in his water colors, even if they were not quite so sharply delineated. Zacharias and the Angel is filled with flame and light and smoke, filled with a spreading brilliance now visible through and exaggerated by the veil of crackling. We can guess that in their original condition these paintings, more than Blake's water colors, combined the conventional effect of apparitions in a miraculous light with the artist's insistence upon a strong and tangible image.

One modern artist who shared Blake's goal of giving reality to dreams was Odilon Redon, although his definition is frequently hazier than Blake would have tolerated. Sometimes, as in his Evocation of the Butterflies (391), a soft, wavering iridescence, formless or half-formed, covers the picture area; here even the butterflies scattered across such a background are only half defined. Large areas of a painting by Redon may suggest the shifting and transient glimmering of an oil film upon the surface of water. But it is a mistake to think that Redon ever composed in a haphazard manner or that his forms are insubstantial. He began as a student of architecture and later worked at sculpture, two arts in which the physical existence of three-dimensional form is, obviously, basic to the designer's conception. And when Redon said that he wanted to put "the logic of the visible to the service of the invisible," he was striking close to Blake's idea that organization and articulation are imperative to the creation of images of fantasy.

Redon's *The Chariot of Apollo* (392) bears this out. The god's chariot is drawn through an empyrean of clouds and fire dramatically expressive of flaming space. We are at the opposite pole from Blake's systematic linear rhythms, which carry us with inescapable definition from one point to another and back again over the surface of his pictures. But we can apply to a picture like this one the informal test of any composition: Can the picture's structure be changed without weakening or transforming its nature? Can we, for instance, cut down the right side, in which nothing happens, change the attitude of any one of the horses, make the chariot and Apollo larger or smaller, make the reins connecting the chariot to the horses more conspicuous or less so? The test could be pushed to the point of absurdity, but in general it is certainly true that the composition is as well articulated as one of Blake's, if less obviously, and that

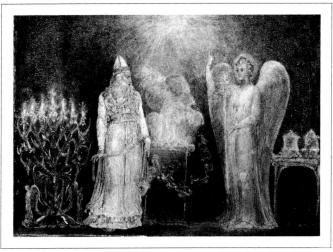

390. William Blake. Zacharias and the Angel. Date unknown. Tempera and glue size on canvas, 10½ by 15 inches. The Metropolitan Museum of Art, New York. Bequest of William Church Osborn, 1951.

391. Odilon Redon. *Evocation of the Butterflies*. 1898–1916. Oil on panel, 16 by 29¾ inches. The Detroit Institute of Arts. City purchase.

392. Odilon Redon. *The Chariot of Apollo*. 1898–1916. Oil on canvas, 26 by 32 inches. The Metropolitan Museum of Art, New York. Anonymous gift, 1927.

393. Eugène Emmanuel Viollet-le-Duc. *La Stryge.* Invention on medieval models. Gargoyle, mid-nineteenth century. Parapet of Notre Dame, Paris.

in the end it depends more on formal values than on ambiguous ones in its visionary description.

Blake's The Archangel Raphael with Adam and Eve was painted at the end of the eighteenth century, the Age of Reason, and Redon's Apollo at the beginning of the twentieth, the age of science, so both artists, as visionaries, fall outside the major currents of their times. But if we go back to the Middle Ages, we enter a period when reason was put into the service of the miraculous, and science was half fantasy. Hieronymus Bosch's Creation of Eve (307, p. 333) is as explicit as Blake's and as visionary, but he did not have to theorize about it. And his Hell (398) was quite naturally painted in detail as specific as that of any earthly landscape because Hell's existence was accepted, and its horrors catalogued and believed by medieval man, as easily as we may now believe a guidebook's descriptions of an exotic country we have never seen. The art of the Middle Ages abounds in fantasies—some of them symbolic, some of them accepted as literal truth, and some of them apparently the result of nothing more profound than a rollicking attraction to the grotesque. Cathedral portals were lined with statues of the saints, surmounted by Last Judgments, Resurrections, or Ascensions, and encrusted with the miraculous Christian story materialized into stone figures of unquestionable reality. And higher up on these buildings clustered the gargoyles (393), fantastic half-diabolic and half-humorous inventions as plausible to the medieval mind as any dog or cat in the streets. In manuscripts these little monsters appear in miniature with a kind of gaiety as part of decorative borders (395).

Bosch was the most terrifying of the medieval painters of the fantastic. He worked at the end of the Middle Ages, a changing time but one when, in the North at least, the conviction of sin and punishment continued to haunt men's minds in spite of all promises of forgiveness and bliss. In discussing realism, we described the infinite detail of Van Eyck's *Saint Francis Receiving the Stigmata* (90) and said that its microscopic description of natural objects took on spiritual meaning through the medieval conviction that every particle of matter in the world, no matter how small, was inherently significant because all existence was part of an orderly scheme created by the will of God. In Bosch's fantasies, this idea is reversed.

Bosch creates a universe as detailed as Van Eyck's, but it explores the depths of sin and evil and the damnation of the soul. Detail by detail he paints as explicitly and as naturalistically as Van Eyck; we recognize in his hellish figures parts of plants or machines or birds or animals, but these naturalistic parts are combined into outlandish and horrifying wholes. The horror of these monsters comes from their incontrovertible existence: they are true. Like Redon, Bosch puts "the logic of the visible to the service of the invisible," and, as Blake wanted to do, he organizes and articulates his inventions into something more vivid than the "perishing and mortal eye" can see.

394. Hieronymus Bosch. *The Garden of Delights*, center panel of the triptych. About 1505–10. Oil on wood, 86% by 76¾ inches. Museo del Prado, Madrid.

395. Jean Pucelle. Illuminated page with grotesqueries from the *Hours of Jeanne de'Evreux*. 1325–28. Tempera on vellum, 3½ by 2% inches. The Metropolitan Museum of Art, New York. The Cloisters Collection. Purchase, 1954.

396. Detail from *Hell*, right panel of the *Garden of Delights* triptych.

Bosch's *Creation of Eve* and *Hell* are the left and right panels of a triptych, wings that tell respectively of man's creation in innocence and his consequent damnation. The Garden of Eden, where we see the creation of Eve, is like Blake's in showing against distant crags an exotic garden where the animals of the earth wander at peace with one another. The prophecy of evil in Blake's garden is made by an outsize tree in the background around which the serpent is coiled. In Bosch's the prophecy is present in a subtler and more ominous way, in the suggestion of evil taken on by the monstrously unnatural forms of the foliage, the fountain, and the crags, and by the sinister shapes and activities of some of the animals, which are like spots of infection in the terrestrial paradise.

The large central panel between Eden and Hell shows The Garden of Delights (398). The pleasures of the flesh are extolled, but with full consciousness of the medieval connotations of the sinfulness of fleshly indulgence. At virtually the same time, in the more relaxed moral climate of Venice, Giorgione was able to transmute these pleasures into idyllic reveries, as we have just seen. But Bosch's garden is a nightmarish circus where swarms of lissome naked bodies are compounded with evil grotesqueries.

In the third panel, *Hell*, all delights are abandoned in a vision of evil where logic and illogic become indistinguishable from one another. Although this is a Hell where some physical tortures take place, they are the smallest part of a Hell where the real torture is spiritual, where corruptions, deformities, monstrous growths, mutilations, and agonizing transformations are the norm. The damned soul is wracked less by physical pain than by existence in a world where all reason and order have been grotesquely transmuted by some cancerous misdirection of divine will.

In a detail from *Hell* (396) the head of the central figure, a concoction of parts that must be called "figure" for want of any other word, has by legend been called Bosch's own portrait. This figure looks back over its—can we say shoulder?—from beneath a disk that suggests a hat brim. Resting on the disk is a bladder-like form, terminating in a musical pipe and a spout from which issue smoke and flame. This whole invention is surrounded, in turn, by demons leading naked, condemned souls by the hand, round and round. Whether or not the head is Bosch's portrait, its sly, halfdemonic, piercingly observant air suggests his spirit. The head grows from a huge eggshell-like body, hollow and broken open at one end, supported by leg-like growths. These "legs" stand in two small, rigged boats, and branch into the form of blasted trees with dead, pointed limbs that grow upward to pierce the body, whose hollow interior is infested with tiny figures, part human, part insect, that have turned this strange belly into a tavern.

In every fragment—and the scene is cumulatively effective as it is examined fragment by fragment—we are presented with a specific and concrete image of a Hell-form whose reality and whose impossibility are equally undeniable until, like the condemned souls themselves, we are

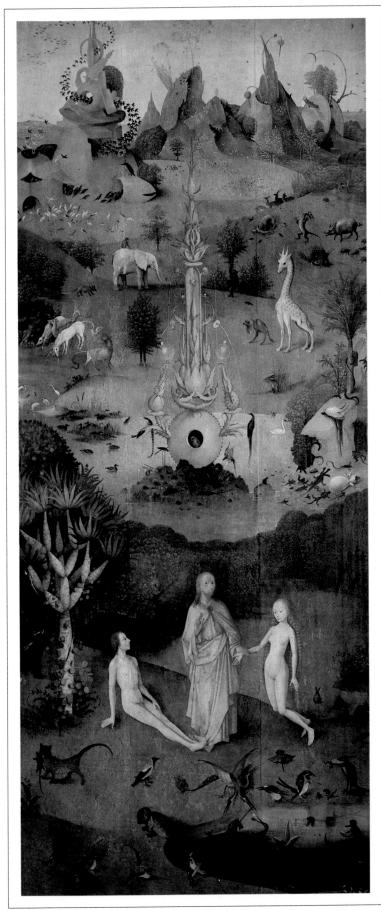

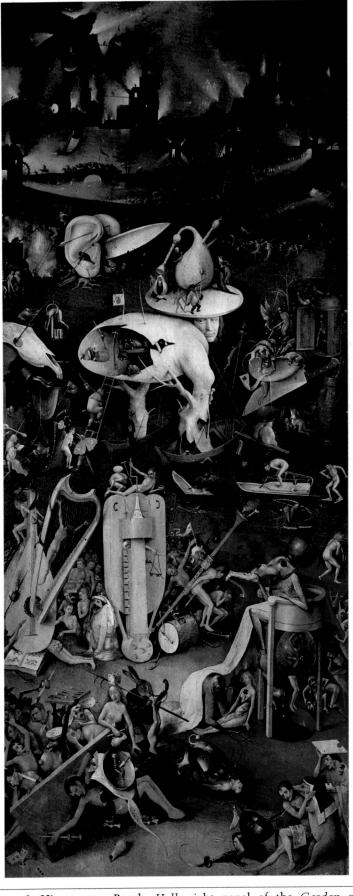

397. Hieronymus Bosch. Creation of Eve, left panel of the Garden of Delights triptych. About 1505–10. Oil on wood, 65% by 381/4 inches. Museo del Prado, Madrid.

398. Hieronymus Bosch. Hell, right panel of the Garden of Delights triptych.

399. Pieter Huys. *Temptation of Saint Anthony*. Third quarter of sixteenth century. Tempera and oil on wood, 43 by 59 inches. The Metropolitan Museum of Art, New York. Anonymous gift, 1915.

taken up by the force of unreason. Occasionally the figures of this mad-normal world are hideously comical. The little bird-headed, pigtailed demon walking near the front edge of the "hat brim" carrying a burning staff is such a one. These not-really-humorous figures are as horrifying as the more obviously monstrous ones; the humor is as devilish as the tortures.

Among Bosch's several followers or imitators was Pieter Huys. Although his inventions do not approach those of the master in hellish power, he is worth a parenthetical reference here to compare his *Temptation of Saint Anthony* (399) with Sassetta's treatment of the same subject, *Saint Anthony Tempted by the Devil in the Form of a Woman* (263), which might also have been included in this chapter for its dreamlike quality.

The temptation of Saint Anthony was a rich subject for the painters of diableries; Bosch himself did a large picture of this hermit saint whose mind was a battleground where his yearning to achieve grace through prayer and meditation was constantly under attack by the evil thoughts that obsessed him. Sassetta reduced the story to its essentials:

the symbol of temptation (the woman), the symbol of meditation (the hut), the dreamlike wilderness where the drama takes place, and the saint himself.

Contrastingly, Huys shows the saint within a crowded nightmarescape centering upon the lovely figure of a nude girl but flowering all round into evil forms. The girl holds a small owl (always a witchlike bird, associated with things dark and ominous), while behind her crouches a hag with a distaff, and beside her a female monster with a platter upon which she offers what appears to be a piece of carrion. To describe the picture further would only be to continue an enumeration of the hideous visions that torment the holy man. The harmonious serenity of Sassetta's version of the subject and the agonized complications of Huys's are offered here as a reminder of one of our opening definitions of what a painting is: a reflection of the personality of the man who painted it and an expression of the time and place that produced it. The contrast in this case lies particularly between the premise that dominates Italian painting, that in spite of its evils the world ultimately is good, orderly, and beautiful, and a premise met frequently in the North, that in spite of its joys and diversions the world is basically tragic, malevolent, and mysterious.

The world we have seen in Bosch and Huys is disturbing because it operates within a set of irrational laws to which we are subject when we enter their pictures. Jumping forward four and a half centuries and substituting Freudian theory for biblical prophecies of hellfire and damnation, we enter the world of the twentieth-century Surrealists, which operates in much the same way. The sinful hallucinations besetting Saint Anthony in his wilderness are the Freudian dreams of anybody anywhere today; from them the Surrealists created a nightmare world that borrows heavily from the earlier painters. The agonized creature rending itself in Salvador Dali's Soft Construction with Boiled Beans (400) is obviously a relative of the eggshell figure from Bosch's Hell. And the same Surrealist painter's Apparition of a Face and a Fruit Dish on a Beach (401) is an even more curious kind of dream or nightmare picture.

Apparition is, among other things, an exercise in the invention of double images. We are all familiar with the shifting and changing of the subjects in our dreams: "I was in our old house, in the living room, and then all of a sudden it seemed to be a cave instead. There were a lot of people there, and I didn't seem to recognize them, but at the same time I realized they were all people we know."

Just so, in *Apparition* the foreground is a smooth beach that changes by imperceptible degrees into a table covered with a cloth. The apparition of the head fuses with that of a compote full of fruit—a variation on the Boschian device in which a single figure is a composite of animal, vegetable, and mineral forms—and combines, too, with objects on the shore such as the jar that does double duty as an eye. The upper right quarter of the picture is a technically exquisite landscape, crowded with inventions of corruption and de-

400. Salvador Dali. Soft Construction with Boiled Beans: Premonition of Civil War. 1936. Oil on canvas, 39% by 39 inches. Philadelphia Museum of Art. Louise and Walter Arensberg Collection.

401. Salvador Dali. Apparition of a Face and a Fruit Dish on a Beach. 1948. Oil on canvas, 45 by 56% inches. Wadsworth Atheneum, Hartford, Connecticut. Ella Gallup Sumner and Mary Catlin Sumner Collection.

402. Marc Chagall. *Birthday*. 1915. Oil on cardboard, 31¾ by 39¼ inches. The Museum of Modern Art, New York. Acquired through the Lillie P. Bliss Bequest.

cay, stretching back into a distance of magical clarity where peaks rise against the enameled sky. But with a sudden reversal of scale and meaning, this landscape becomes a dog's head; a tunnel becomes his eye, and a viaduct his studded collar. The animal's body merges into the apparitional fruit dish, and his hindquarters materialize from the odd shape rising at the far left. A length of frayed rope and a bit of discarded cloth lying on the beach complete the picture. Perhaps these last have an obscure and personal symbolism for the painter himself. Or perhaps, as one suspects, they are there as a demonstration of his technical dexterity as much as anything else.

This taint of exhibitionism by the artist is the flaw in surrealism and constitutes the difference between its purportedly visionary nature and that of an artist like Bosch. There is a feeling that the Surrealist synthesis of forms is arbitrary and tricky, a stunt, whereas Bosch's combinations are purposeful. One reason is that the Surrealists, particularly the one who painted this picture, indulged in so much conspicuous zaniness during their heyday that their art became suspect for much of the public. As a defense, sensationalism and shock are inherent in surrealism. Their use is conscious, open, and hence legitimate up to a point. The Surrealist may indulge in behavior that is undignified, eccentric, or outrageous by conventional standards and yet be acting within his credo. The trouble is that this liberty has so often been extended to include publicity stunts that the lay public has difficulty in regarding surrealism as a serious and thoughtful art. (Nor is it always; no "ism" has been more prostituted.) The most generous attitude to take toward the more bizarre novelties of the Surrealists is to consider that, like most modern art, surrealism is an intensely personal expression; as such it cannot be expected to achieve the same force as the art of Bosch, who worked at a time when art was an expression of unified social forces rather than a personal response to isolated and specialized fragments of social experience.

We might point out that Blume's Eternal City, which we saw in the preceding chapter (382), has certain connections with Surrealist techniques that are unexpected in a painting in which the comment is sociopolitical. But if this is surprising, it is not nearly so surprising as the general resurgence of fantastic art in this century. This is the age that has made a fetish of science, yet our artists have been more prolific and varied in exploring the worlds of pure imagination than any artists since the Middle Ages, when the otherworld was a part of daily life. Blake was all but alone in his time as a visionary painter, and his audience was small. Our fantasts are public figures, and their audience is wide and receptive. The references in the art of Marc Chagall, as in Birthday (402), are quite personal; they speak of his life as a boy in Russia, stories he has been fond of, his love and marriage, anything that gives him delight. If ever a man painted for himself alone, Chagall does. His typical painting is a private reverie that he makes no effort to explain, yet thousands of reproductions of his work are

403. Giorgio de Chirico. *Melancholy and Mystery of a Street*. 1914. Oil on canvas, 343/8 by 281/4 inches. Private collection.

404. Giorgio de Chirico. *The Anguish of Departure.* 1913–14. Oil on canvas, 33½ by 27½ inches. Albright-Knox Art Gallery, Buffalo. Room of Contemporary Art Fund.

sold around the world. It may be that the world being too much with us these days we are especially glad to be taken out of it for a while, and that artists, for the same reason, find satisfaction in leaving this world for excursions into worlds of their own invention.

Giorgio de Chirico created one of the first of these invented worlds and one of the most enduring. As early as 1912, ten years before the term "surrealism" was invented, he anticipated many Surrealist devices minus surrealism's morbidity and sensationalism. Again and again he painted combinations and recombinations of a limited set of motifs that, for all their repetition from picture to picture, retain undiminished their sense of mystery and melancholy touched with an ominous foreboding but mitigated by a pervading serenity. The world he creates is at once desolate and intimate, empty but filled with suggestion, deserted yet full of mysterious presences, a world that is never explained and possibly for that reason never palls.

The elements in Melancholy and Mystery of a Street (403), for instance, and those in The Anguish of Departure (404), overlap, and both pictures overlap others, yet each is individual. In the same way realistic landscapes may be individual though composed of the same set of elements trees, hills, sky, and the other usual features. The collective mood of Chirico's dreamscapes is reflected by the titles he gives them; in addition to melancholy and mystery, anguish and departure, the titles repeat such words as "serenity," "surprise," "lassitude," "enigma," "delight" and "joy," "destiny" and "uncertainty," "torment" and "dream," "nostalgia" and "return." The words "scholar," "philosopher," and "poet" are also frequent; soothsaying and metaphysics and fatality have their visual counterparts in Chirico's repetitions of long arcades in unyielding perspective, statues in deserted squares, tiny distant figures dwarfed by their own extended shadows, towers, great isolated smokestacks, huge boxes, and wheeled vans unattended and unexplained.

The van in *Melancholy and Mystery of a Street* is empty. What was in it? Or what is it waiting to receive? In *The Anguish of Departure* the van doors are closed. What do they hide? We cannot rationalize the presence of the van nor the disposition and relationship of any of the objects in a Chirico on any kind of logical basis, yet their existence is inescapably real. The words "irrefutable logic" are familiar; in Chirico's dreamscapes there is something like an irrefutable *illogic* that accounts for the harmonious existence together in one picture of so many contradictory elements, at once so disturbing and so removed.

Chirico wrote that a painting should bring to the observer the "sensation of something new," something he had never known before. He wrote that "the strange sensations which a man can experience, faithfully reproduced by this man, can always give new joys to a sensitive and intelligent person." But in the pre-World War I years when Chirico first offered these "strange sensations" to the public

in paintings like the ones we have just seen, there were not many people, even among the "sensitive and intelligent" ones he mentioned, who were prepared to recognize the "new joys" of Chirico's imagined world. The most popular picture that came anywhere near to resembling that world had been painted in 1880 by a German artist, Arnold Böcklin; it is called *The Island of the Dead* (406, p. 340).

Böcklin held that extraordinary subject matter could best be represented in realistic images, a sound enough point of departure for an artist who can invest those realistic images with imaginative force. We have seen that William Blake held a similar conviction—that dreams should be represented in lineaments more sharply defined than nature's. But whereas Blake was a supremely imaginative artist, Böcklin's efforts at fantasy were often heavy-handed, as in this *Triton and Nereid*, where his power of invention is limited to adding stage props to models too obviously posed in the studio.

The Island of the Dead is more successful, and may make less surprising the fact that Chirico so admired Böcklin that during the years 1906–9 he adopted him as a kind of teacher by proxy (Böcklin had died in 1901), studying his paintings and even copying them. From our historical vantage point we can see the connection between two apparently dissimilar artists, but for Chirico's early audience there was no connection at all. The public's admiration for The Island of the Dead and its bepuzzlement in the face of Chirico's beautiful early work, followed by the dismissal of Böcklin's work and admiration for Chirico's a short generation later, is a succinct example of the turnabouts in taste that have characterized the last hundred years in art. New movements have grown so rapidly out of old ones (Chirico growing out of Böcklin, for one) that the public has suffered from a kind of esthetic jet lag.

Why did The Island of the Dead exert such a strong popular appeal? The best explanation is that while seeming to offer something new, it was understandable in terms of familiar experience. Unlike Chirico's deserted cities, which are both hauntingly familiar and disturbingly strange, Böcklin's island is not really strange at all. Nature is not transformed, merely somewhat refurbished. Somber and spectral the scene may be, but it could be created in hard fact, given a rocky site of the right size and an adequate body of water. It would not be difficult to pose costumed figures in a boat just as Böcklin has painted them here. In an evening light the scene would take on an appropriately eerie quality, especially if we happened to know that the island is a cemetery (just as we must know the title of the picture for it to make its full effect). Watching from the bank, as in essence we do when we stand in front of the painting, we might be stirred to certain thoughts of life, death, and afterlife, presumably the thoughts Böcklin intends to stir in us by creating a scene that never existed except as he invented it but that actually could exist, literally and concretely. Even the most practical down-toearth person can exercise his imagination sufficiently to

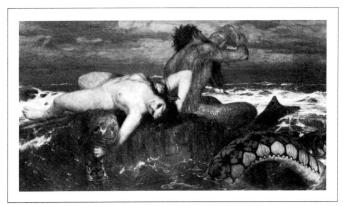

405. Arnold Böcklin. *Triton and Nereid.* 1873–74. Oil on canvas, 40¼ by 75¼ inches. Bayerische Staatsgemäldesammlungen, Munich.

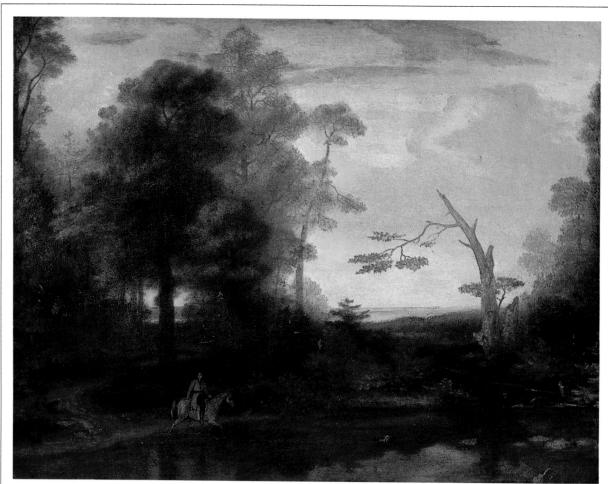

406. Arnold Böcklin.

The Island of the Dead. 1880. Oil on wood, 29 by 48 inches. The Metropolitan Museum of Art, New York. Reisinger Fund, 1926.

407. Washington Allston. American Scenery: Time, Afternoon with a Southwest Haze. About 1834–35. Oil on canvas, 18½ by 24½ inches. Museum of Fine Arts, Boston. Bequest of Edmund Dwight.

enter into the very slight exaggerations and deceptions Böcklin permits himself in this mild fantasy. With Chirico we travel in the same direction that we are taken by Böcklin, but we travel further, explore more deeply, and enter a new world instead of remaining within theatrical modifications of this one.

Böcklin was a late follower of the romantic movement that flared up early in the nineteenth century as a revolt against the desiccation of official painting. The emotionalization of romantic art ranged over a gamut of sensitivities from lyricism to violence. We have seen two of the great French romantics in Géricault and Delacroix (245 and 246). Géricault's Raft of the Medusa is a melodrama based on a contemporary event, and the emotion of The Abduction of Rebecca is more intellectualized than spontaneous. Neither picture can be called visionary in the sense of the pictures we have been examining, but the romantic spirit, which obviously moves toward visionary expression, produced some remarkable images we can call dreamscapes. These may appear unexpectedly, like passages of dream breaking through the more pedestrian course of a work, even a realistic one.

When Washington Allston, an American romantic, called one of his landscape paintings, American Scenery: Time, Afternoon, with a Southwest Haze (407), he certainly indicated his intention to reproduce specifically the look of a certain place, or type of place, under certain conditions. But by the evidence of the picture itself, he was painting from a deep emotional response that transfigured the subject. However specific the source of the picture may have been, it has little to do with one time or one place. Instead it becomes, with its horse and rider moving alone and silent through some golden otherworld, a vision of the isolation of the human spirit in a region 1 d time and place.

> century in America evocative paintings

n was inspired by

e as The Tempest es, the gleaming

are Venetian by of The Flight of

s of the Venetian

ich falls a small and mysterious

mpse of distant

bening through

whatever Allston

e of Allston's work. RATA vardness or naïveté tom of the page is Arnold Böcklin's lels, giving them a 06). The painting at the top is American Scenery (407).

rs should bear notice of copyright: of David Smith 1980

ot. Paris/S.P.A.D.E.M.

Rauschenberg 1980 ndy Warhol 1980

es Rosenquist 1980

menucu, ms slender, delicate-legged horse is motionless, as if magically transfixed, even to the regular waves of its flowing tail—as are the rider and her fluttering scarf. The Flight of Florimell happens to illustrate an episode from

408. Washington Allston. The Flight of Florimell. 1819. Oil on canvas, 36 by 28 inches. The Detroit Institute of Arts. City appropriation.

409. Thomas Cole. *The Titan's Goblet.* 1833. Oil on canvas. 193/8 by 161/8 inches. The Metropolitan Museum of Art, New York. Gift of Samuel Avery, Jr., 1904.

Spenser, but it is so complete in its own magical suggestion that there is little temptation to attach it to its subject. It is delightful to find in Allston's comments on the Venetians who inspired him that "the poetry of color gives birth to a thousand things which the eye cannot see," and that their pictures "leave the subject to be made by the spectator, provided he possesses the imaginative faculty." This is exactly what happens in *The Flight of Florimell*.

The Flight of Florimell is a fantasy; but American romanticism of the first half of the nineteenth century also produced a group of painters who, to an exceptional degree, revealed that a dream or a vision need not be shaped in fantasy but may exist in ordinary aspects of the world around us. This is shown in Thomas Cole's View on the Catskill, Early Autumn (410).

Cole was the leader of the group of American landscape painters called the Hudson River School. In commenting on one of these pictures, Durand's Scene from Thanatopsis (23), we noted its preoccupation with the mystery and grandeur of nature, in that instance expressed in terms merging with those of fantastic invention. Cole also painted in such terms some of the time. In one exceptional picture dated 1833, The Titan's Goblet (409), he even anticipated the Surrealist device of combining detailed realism with unrealistic reversals of scale: the goblet holds ships borne upon a vast lake.

410. Thomas Cole. *View on the Catskill, Early Autumn.* 1837. Oil on canvas, 39 by 63 inches. The Metropolitan Museum of Art, New York. Gift in memory of Jonathan Sturgis by his children, 1895.

411. Detail from View on the Catskill.

412. Detail from View on the Catskill.

But View on the Catskill shows Cole as less novel and more subtle, revealing the world of dream within the world we know. Without much question the landscape was painted with faithful reference to an actual panorama and might still be identifiable by its topographical features. Lyrical in a way familiar enough in landscape painting, it is more than a competent picture in this respect alone. But when we come close to it and examine it in detail as we do a Bosch, we discover something more: spotted in little openings between trees, in small valleys or upon little rises and promontories, and in a section of river emerging from concealing banks and foliage, there are human figures isolated from one another in small, intimate, enclosed worlds. A man chases horses that race through a field (411): another rows a boat across glassy water (412); a hunter approaches a fence (413). Ordinary enough in themselves, each little world-within-a-world grows magical because each is magically revealed. We see them as if gifted with superhuman vision; they are at once close to us and infinitely removed, at once intimate and inaccessible. Whether or not Cole held any such end or theory in mind is beside the point. The visions are there; if we want to explain their presence, we must suppose that they crystallized from the painter's innermost experience. It is this gift of crystallizing inner experience that differentiates an artist from a mere technical master, and sometimes such crystallization takes place through the chemistry of some power unwilled or even unsuspected by the artist. The most conspicuous manifestation of such a power occurs in the art of Henri Rousseau.

Henri Rousseau, usually called "Douanier" Rousseau in reference to his occupation as a French customs clerk, was what we would call today a hobby painter. An extremely simple man in his origins and in his way of life, having a next-to-incredible naïveté, he seems never to have doubted for a moment that he was a great artist. When he is called one today, it is for reasons that would hardly have pleased him. What he wrote about his pictures is often totally at variance with the impression they make. He would describe as a "genre scene" (that is, a subject from everyday life, realistically treated) a picture full of mystery and enchantment. This quality is peculiarly his own. On the surface he is one of those thousands of untrained "Sunday painters" who make pictures in their spare time for relaxation. His work bears every mark of the conscientious but inadequately trained beginner. In his Landscape with Cattle (314) we see them all: the flatness of forms intended to appear round, the labored detail, the meticulous but awkward finish, the stiffness, the inaccuracies of proportion and perspective, the trite subject (though a subject is trite only when tritely approached); in short, the Sunday painting's general air of naïveté, a natural result of technical limitations.

But the picture has something more. It has decorative flair (particularly apparent in the patterning of foliage), a pleasant if superficial virtue, and beyond that it hasinexplicably but irrefutably—an air of enchantment. The flat, rigid objects are transfixed within some magical suspension of time; every distracting banality has been distilled away. Rousseau could not so much as copy a picture postcard (as he sometimes did) without transforming its trite realism into his own distinctive unreality.

Rousseau's exceptional quality as a "modern primitive" may be more apparent if we compare him with another who also became famous, Grandma Moses, the delightful old lady who at the age of one hundred was still painting her recollections of life in a vanished rural America (415). These are scenes of great charm in their reflection of a happy innocence that we like to think of nostalgically as a native virtue of our recent national past. (Although history tells us that those times were neither as innocent nor as happy as Grandma Moses pictures them. Perhaps they were for her.) Her paintings, for all their "primitive" quality, are acutely realistic in intention. She records the details of every visual component of her happy world with an utterly charming faith in the obvious and an absolutely invulnerable innocence that eliminates any possibility of the magical, often disturbing transmutation of reality we find in Rousseau.

It is difficult to know to just what degree Rousseau can be said to have remained innocent. He was fortunate enough to receive from established painters whom he admired the good advice to avoid formal training even when he was in a position to take advantage of it. Emulating himself, he developed a style of great polish and assurance: he performed the unlikely feat of preserving the fly of his innocence in the amber of his technical sophistication. In pictures like the well-known The Sleeping Gypsy (416), exotic subject matter intensifies and makes more obvious the otherworldliness inherent in all his work. This is certainly one of the master dream pictures of all time, and one that follows most decisively Blake's admonition as to "stronger lineaments" than the "perishing and mortal eye" can perceive in nature—even though one may be left wondering just where Rousseau's inborn primitivism, or naïveté, ends and where it has been supplanted by a sophisticated consciousness of the decorative values and capricious attractions of a highly developed pseudoprimitive style.

The piquant combination of innocence and sophistication in a single manner is frequent in visionary or fantastic art, but it is seldom so neatly balanced as in Rousseau. Blake was first of all an innocent, for all his theories, and the balance between his innocence and the far-from-innocent Michelangelesque and Raphaelesque forms he borrowed as a pictorial vocabulary is so precarious that he frequently teeters on the edge of disharmony. Reversing this situation is Paul Klee, a German-Swiss intellectual fantast of the most exquisite sophistication whose pictorial vocabulary is largely developed from the innocent art of children, savages, and the insane.

Klee's art is immediately comprehensible to some people, never comprehensible to some others, and a mystery

413. Detail from View on the Catskill.

414. Henri "Douanier" Rousseau. *Landscape with Cattle*. 1895–1900. Oil on canvas, 20¼ by 26 inches. Philadelphia Museum of Art. Louise and Walter Arensberg Collection.

415. Grandma Moses (Anna Mary Robertson Moses). Coming Home for Thanksgiving. 1944. Oil on canvas, 26 by 22 inches. Private collection.

to be solved for many. He is not a formula painter, and no formula can be synthesized to explain him; but if a vote were taken among modern art historians and critics as to who might be the foremost visionary artist of all time, the title would probably go to Paul Klee with William Blake as runner-up. We will approach one of his paintings by way of three others on the same subject (the ship as a symbol) and take advantage of the four to summarize in conclusion some of the points we have made about visionary painting.

Shortly before 1500 there appeared in France a certain Shepherd's Calendar, called *Le grant kalendrier et compost des Bergiers*. Like others of its kind it was an almanac combining popular misinformation, accepted superstitions, astral diagrams and astrology, medical hints, and pious comments on virtue, vice, Heaven, Hell, and the culture of the soul. It was an everyman's version of the intricate compendium of medieval learning and was illustrated with woodcuts, of which we reproduce one (417). The picture is an allegory accompanied by an explanation that translates to this effect:

Mortal man living in the world is like a ship on the sea or a perilous river carrying rich merchandise which, if he can reach the desired port, will make him happy and rich. The ship from the moment of setting out clear to the end of the voyage is in great peril of being sunk or captured by enemies. Because there are always perils at sea. Thus is the body of man living in the world; the cargo which he carries is his soul, the virtues, and good works. The port is Paradise where all who arrive are wonderfully rich. The sea is the world, full of vice and sin.

(Homme mortel vivant au monde est comparé a navire sur mer ou rivière perilleuse portant riche marchandise, lequel s'il peut venir au port que le marchant desire, il sera heureux et riche. La navire quant entre en mer jusques à fin de son voyage est en grant peril d'estre noyee ou prinse des ennemys. Car en mer sont tousjours perilz. Tel est le corps de l'homme vivant au monde; la marchandise qu'il porte est son âme, les vertus et les bonnes oeuvres. Le port est paradis auquel q

riche. La mer est le

The picturization of explicit realistic desalizations in the service the captain, the mast will with convenient disregalis represented by convenient disregalis represented by convenientally as the man himodified for expressive per that must be "interpresaccompanying explanation into another for a foreign."

This little woodcut, as a work of art, but the

418. Thomas Cole. *Manhood*, from the series *The Voyage of Life*. 1840. Oil on canvas, 52 by 78 inches. Munson-Williams-Proctor Institute, Utica, New York.

rendered might be found in medieval manuscript illuminations. In either case, Blake would not approve, since "allegory is a totally distinct and inferior kind of poetry" to this visionary artist. In passing we might remember that if Blake's opinion of allegory were universally shared, we would never have had Dürer's supreme allegory, *Melencolia I* (333), or Botticelli's *Calumny* (351), among other masterpieces.

A more defendable objection to our example would be that the allegory of the ship and its pilot as symbols of everyone's passage through life is a weary one. It was certainly weary by the early nineteenth century when Thomas Cole, who also painted our admirable and genuinely poetic View on the Catskill, produced a set of four canvases called The Voyage of Life showing the passenger in childhood, youth, manhood, and old age in the company of his guardian angel, who serves as helmsman at the beginning and end and stands by on the outskirts of the drama during the two middle episodes. The third episode, *Manhood* (418), shows the passenger in circumstances almost identical with those in the medieval woodblock. Beset by storm, he is also threatened not by the Devil himself but by three of his representatives, the demons of lust, intemperance, and suicide, barely visible in the upper center of the picture, with God's emissary, the guardian angel, hovering in a spot of light above.

The Voyage of Life was so successful that Cole painted it in at least three versions and made a great deal of money from engraved reproductions. The pictures are generally regarded today with a degree of condescension as reflections of the taste of an American public awakening to culture but demanding that fine art be combined with high moralistic sentiment.

We are in an entirely different domain a century and a half later with *Moonlight Marine* (419) by Albert Pinkham Ryder, the mystical poet of American painting. Like Blake he was an eccentric, and even more than Blake a recluse. ("The artist cannot be a good fellow," he said.) He is frequently remindful of the Van Gogh of *The Starry Night* when he writes, "I am in ecstasies over my Jonah [he was working on a painting of Jonah and the whale]: such a lovely turmoil of boiling water and everything," or, "Exultantly I painted until the sun sank below the horizon, then I raced around the fields like a colt let loose, and literally bellowed for joy."

In Moonlight Marine specific allegory has changed to a mystical vision that is lessened in its effectiveness if we try to pin down its component parts as symbols. The tossing sea is not meant as a specific symbol of the hazards of life in the world; even less is the frail ship meant to suggest man's body charged with the cargo of his soul, to be protected from the waters of evil. There is nothing here but a vast sea, a vast sky, a moon, the unreal shapes of some clouds, and a small boat nearly obscured. Unlike Blake with his obsession for the sharp delineation of visionary forms, Ryder believed that "The artist should fear to become the slave of detail. He should strive to express his thought and not the surface of it."

A very strong difference between *Moonlight Marine* and the ship allegories we have just seen is that Ryder's vision of a mystical voyage carries with it a sense of exhilaration. If the picture is by association an allegory of man's journey through the world, we can imagine the voyager, so small in the infinite scheme of things, feeling not threatened by the elements but exultant in his security as he keeps his tossing boat on course over the water, beneath the clouds, by the light of the moon.

So where does this bring us as an introduction to Paul Klee's *Demon as Pirate* (420), an example of an art that we began by calling "immediately comprehensible to some people, never comprehensible to some others, and a mystery to be solved for many"? We have approached this picture of a ship in danger from a demon by looking at two specifically explainable allegories and one painting, Ryder's, where our response is primarily unanalytical even though we may force the picture as a kind of informal allegory. With Klee, all allegory—and any other specific scheme of reference—must be forgotten; our personal response to his very personal art is everything.

Demon as Pirate, although it is a great Klee, can hardly be called a great painting. Klee is in the extraordinary position of being a major painter who never painted a major

419. Albert Pinkham Ryder. *Moonlight Marine*. 1870–90. Oil on wood, 11¾ by 12 inches. The Metropolitan Museum of Art, New York. Samuel D. Lee Fund, 1934.

420. Paul Klee. *Demon as Pirate.* 1916. Gouache on paper, 11½ by 17 inches. Philadelphia Museum of Art. Louise and Walter Arensberg Collection.

picture to be pointed to as the summation of his genius. It is only in his total work that his scope and his expressive force become apparent. Individually his pictures may seem only witty; wit is a delightful element in all his work, and is particularly apparent in *Demon as Pirate*, but that is just part of the story. Klee's art is wider and deeper than any single one of his paintings hints; each Klee one knows enriches all the others, until eventually the individual fantasies share the psychological power of the mass. It is also true that the wider the observer's acquaintance with art in general, the richer his response to Klee's is likely to be—a good reason for putting Klee at the end of this book.

Any understanding of Klee's achievement must begin with the acceptance of two premises: first, Paul Klee is a highly trained painter of great technical skill and an esthetician of great subtlety and complication, no matter how slight his work may appear to be; second, this technical skill and this intellectualism are only the superficies of his art. To recognize them certainly adds to the interest of his pictures, but enjoyment will depend in large part on our

ability to respond unanalytically.

In Demon as Pirate there is much that can be pointed out in partial explanation: that the fish at the left is related to hieroglyphics or sign-symbols of the kind found scratched in rocks everywhere from the American Indian's West to aboriginal Australia; that the little animals in the boat have the same character plus humorous overtones; that as pure line the pattern of the two boats and the demon connects the picture with certain Oriental traditions. The composition could be gone into at some length—the ornamental subtlety of its color, the deft placement of the three flags, the forward-swooping line of the demon, its echo in the movement of the harpoons, its stabilization by the masts and the figure in the small tublike boat. But Demon as Pirate is no Raft of the Medusa, built on traditional compositional patterns. In the long run no explanation is going to explain the most important things about Demon as Pirate. It is a vision and a dream, but a waking one conceived with enormous zest by an artist drawing on the full range of his complex esthetic theories, and our response to it depends finally upon complex associations that we bring to it from deep within ourselves, associations that we might be at a loss to define.

Of course this is more or less true of every picture we see. It was true of Giorgione's *The Tempest*, with which we began this discussion. The difference is that *Demon as Pirate* has only the most tenuous relationship with the world we see, and hence depends upon associations of the most inward kind. It happens also to depend upon other associations of a highly cultivated kind, ranging over the whole field of the arts. Klee stands outside the human drama and its passions, but his comments on its refinements are endlessly delightful.

When we come to sculpture, examples of visionary art by our definition become scarce. Sculpture is rich in vision-

421. *The Vision of Saint John.* About 1120–25. Tympanum, Abbey Church of Saint-Pierre, Moissac, France.

422. Jean de Bandol (Hennequin de Bruges) and Nicolas Bataille. *The Fall of Babylon the Great City* from the Apocalypse tapestries. About 1381. Approximately 6½ by 10 feet. Musée des Tapisseries, Angers, France.

ary subject matter, but that is quite a different thing from sculpture created in a visionary spirit. We gave Bernini's *Ecstasy of Saint Theresa* (98) as an example of dramatic realism, although its subject is a miraculous vision following the detailed description as given by the saint herself. Bernini produced a hardheaded, supremely calculated, technically breathtaking three-dimensional illustration of that vision, that is all—and that is quite enough to make this sculpture a baroque masterpiece. We also said that Bernini created an illusion of tons of marble floating in the air. But this, too, was a technical tour de force. Illusionism is the creation of optical deceptions by technical means, and is unrelated to visionary inspiration.

If visionary subject matter were synonymous with visionary art, any work illustrating any part of the Revelation of Saint John would be visionary to the point of hallucination. The images in this last book of the New Testament are so vivid as verbal descriptions that they need only be approximated in another medium to carry with them a considerable degree of visionary force. The artists of the Middle Ages were called on to illustrate this book so often, in both painting and sculpture, that a summary of their second-hand visions would require a book longer than this one.

One of the most famous examples, The Vision of Saint John on the tympanum of the Church of Saint-Pierre in Moissac, France (421), is in fact a third-hand vision, a sculpture derived from a manuscript painting derived from the text (Revelation 4) describing Christ enthroned, surrounded by the signs of the four evangelists and adored by twenty-four crowned elders. Manuscript illumination was already a highly developed art when a surge of churchbuilding demanded quantities of sculpture unprecedented since ancient Rome, and stonecarvers became sculptors by adapting their craft to these demands, with manuscript illuminations among their models. The translation from manuscript to monumental sculpture at Moissac (originally including the bright colors and, perhaps, gold of the manuscript model) retains a visionary quality even though twice removed from Saint John's text.

The Fall of Babylon the Great City (422), from a series of late fourteenth-century tapestries of the Apocalypse, shows how the eerie and enchanted quality of Saint John's text is carried into another medium with, we can believe, more invention on the part of the "translator." The destroyed city—"Babylon the Great, the Mother of the Harlots and of the Abominations of the Earth"—is seen in miniature, its falling towers suspended forever in mid-air beneath trumpeting angels and the fierce, haloed eagle clutching in his beak and claws a scroll with the words "Woe, woe, woe." "And I saw," wrote Saint John, "and I heard an eagle, flying in mid heaven, saying with a great voice, Woe, woe, woe, for them that dwell on the earth, by reason of the other voices of the trumpet of the three angels who are yet to sound" (Revelation 8:13). Later (14:8) we are told that the second of the trumpeting angels says, "... Fallen, fallen is Babylon the great, that hath made all the nations to drink of the wine of the wrath of her fornication." Finally (16: 18–19), "There were lightnings and voices, and thunders; and there was a great earthquake, such as was not since there were men upon the earth, so great an earthquake, so mighty. And the great city was divided into three parts, and the cities of the nations fell; and Babylon the great was remembered in the sight of God, to give unto her the cup of the wine of the fierceness of his wrath."

In the tapestry the quake has torn the earth into chasms—one of them dividing the road leading into the city—with knife-edged walls, while flowers (an addition not mentioned by Saint John) continue to bloom, at an entirely different scale, on the carpeting of greensward. The saint himself, as if performing as narrator, stands at our right.

The precise definition of each visionary detail (which might have pleased Blake) may be partially a reflection of the linear manuscript style, but is primarily the enforced result of tapestry techniques of the time by which each pictorial element was woven separately from a master pattern and the parts then sewn together. Whatever the influences or borrowings involved, the Apocalypse tapestries remain, by the genius of their master designer and the unquenchable force of the Book of Revelation, one of the great visionary works in the history of art.

However, this tapestry has taken us back into the general field of pictorial art, leaving us with the question as to why sculpture has seemed ill-adapted to visionary expression. Perhaps the chief reason is that all painting offers in the first place a kind of magic in the reduction of three-dimensional images to only two, a transfiguration that is denied to sculpture by the absolute physical tangibility of three-dimensional images no matter how imaginatively conceived. Then, too, the sheer physical process of carving sculpture imposes an inflexible scheme in advance, while a painter may invent more freely as he goes, a process more compatible with imaginative wanderings.

In medieval sculpture the most popular subject for the tympanum of the main portal of a church or cathedral soon became the Last Judgment. The Last Judgment is a subject adaptable to visionary treatment if ever there was one, but it can also be treated didactically and usually was—a respectful, noninterpretive treatment of the facts as outlined in biblical texts. One of the earliest Last Judgment tympanums is an exception to this rule, in which the sculptor seems to have made the most determined effort to invest the subject with an appropriately supernatural atmosphere. This is the tympanum over the portal of the Cathedral of Autun, in France (423), by the sculptor Gislebertus, carved only a matter of five or ten years later than the tympanum at Moissac.

Gislebertus is one of the few medieval sculptors whose name we know. The fact that he signed the Autun tympanum is proof enough that he set out to create an individualistic work of art and that he recognized himself as an

423. Gislebertus. Last Judgment. About 1130. Tympanum, Cathedral at Autun, France.

424. Detail from Last Judgment.

425. Giambologna (Giovanni Bologna). *The Apennine*. About 1580. Villa Demidoff, Pratolino, near Florence.

artist rather than an exceptionally skilled craftsman, which was the status of the usual medieval sculptor. The extreme elongation of his tiny-headed figures, exceeding that of any other sculptures of the time, is the most obvious hallmark of his style. In addition he patterns these figures in expressionistic variations. On Christ's right hand (on our left as we face the sculpture) the Blessed, en route to a Paradise represented by an arched castle, are ranged in stable verticals, while the Damned on the other side, and the angel and the Devil struggling for their souls on either side of a balance, are in contorted attitudes that make the most of expressionistic angles and interruptions. On the band of the lintel, the Blessed are received by angels as they rise from their graves at the sound of the last trumpet; on our right the Damned suffer agonies of apprehension, and one unfortunate is clasped around the head by gigantic hands that lift him to judgment (424).

If there is anything like a school of visionary, fantastic, or demonic sculpture in Europe, it is garden sculpture of the latter sixteenth cetury. "Garden" in this context means the landscaped grounds of villas and palaces (later on to be peopled by marble gods and goddesses), which during this manneristic prelude were the playgrounds of imaginary monsters and personages of fantastic aspect. One of these is Giambologna's *The Apennine* (425), at once a symbol of the Apennine mountains that run from one end of Italy to the other, and of the mystical race of the peninsula's original inhabitants. The figure's identity with the stone from which it rises is intensified by the continuation of the rough-cut bank into the locks of the beard and hair—an effect of union with raw nature (in highly sophisticated terms, admittedly) that is exaggerated today by four centuries of weathering.

Modern sculpture with its extended range of materials is partially freed from the restrictions we listed a few paragraphs back that make sculpture ill-adapted to visionary expression. Alberto Giacometti's Surrealist The Palace at 4 A.M. is put together from wood, glass, wire, and string materials allowing for free improvisation as the artist develops an idea, elaborates it, simplifies it, changes the relation of one part to the others, working in part from esthetic principles he knows so well that they have become inborn, but also from impulses generated by the same subconscious or unconscious forces that generate our dreams. Here we are on dangerous ground, since it is presumptuous of us, the observers, to guess how much of such a work of art is the result of the artist's studied manipulation of his means and how much is impulsive especially in this case, where the artist by his own statement intended to leave no traces of that manipulation. But there the end product stands, dreamlike, all explanations aside.

Like most Surrealist paintings or sculptures *The Palace at 4 A.M.* needs its title for full effect, and as usual the title is enigmatic. What palace? Why 4 A.M.? But title or no title, esthetic manipulation or no manipulation, the dreamlike air, the here-but-not-here quality, comes largely from the palace's curious relationship with space. Rooms, cor-

ridors, towers: at first they seem defined for us as if this were a skeleton-palace with the walls removed for our convenience; but if we look again, there is no structural logic, no formal definition in familiar terms, no distinction at all between real space and dream space, leaving us with the choice of dismissing this fragile structure as a bit of entertaining frivolity or accepting our participation in its irreality. Looking back to the paintings we have seen, *The Palace at 4 A.M.* is most closely related to Paul Klee's *Demon as Pirate*, and most distant from Thomas Cole's *View on the Catskill*, which represent the poles of visionary conception.

Among modern art forms classified as sculpture because they are three-dimensional and fit into no other standard classification, are constructions like Joseph Cornell's, put together in shallow boxes from odds and ends (carefully selected odds and ends) of material that can include photographs, prints, stuffed birds, artificial flowers, machine parts, toys, bits of manuscript or newspapers and other printed matter, butterflies, shells, drinking glasses and glass jars, candy wrappers—anything. The term "assemblage" has been coined to apply to these and related forms of puttogether-from-bits-and-pieces art, but has not been accepted in wide usage as has the earlier "collage," which is the official term for paste-ups in two dimensions. Both collage and assemblage, but especially assemblage, have been subjected to outrageous degradation by amateurs who combine disparate objects simply because they are disparate without regard for associative effects or for the esthetics (frequently traditional) of formal composition that persist within the innovative medium.

Cornell's *Medici Slot Machine* (427) one of several by that title) is a small box 15½ inches high, 12 inches across, and 4% inches deep, with a glassed front that functions less as a physical protection for the objects within the box than as a psychological barrier that isolates those objects from the world outside and emphasizes their interdependence in the small world of which they have become the component parts. Cornell chose components with strong personal associations, combining things that delighted him as a child with others connected with his adult interests. How, then, the reader may ask, can we know what a Cornell is "about," since we don't have the same associations?

Obviously we cannot, but we have associations of our own that may be just as potent in generating the air of mystery that is fundamental to Cornell's work. Even in our own dreams we do not always understand why certain objects appear to us (although psychoanalysts may try to explain them to us) in what seem to be normal relationships until we awake and recognize their oddity.

Medici Slot Machine is an exceptional Cornell in having a strong theme identifiable to any observer—an evocation of Italy through fragments of its art. The young nobleman who occupies the central spot is a reproduction of a portrait by Sofonisba Anquisciola (now in the Walters Art Gallery, Baltimore); his head appears eight more times in shifting

426. Alberto Giacometti. *The Palace at 4 A.M.* 1923–33. Wood, glass, wire, and string, 25 by 28¼ by 15¾ inches. The Museum of Modern Art, New York.

427. Joseph Cornell. *Medici Slot Machine*. 1942. Construction, 15½ by 12 by 4% inches. Private Collection, New York.

relationships with itself in vertical bands at the extreme right and left boundaries of the construction. Fragments of other Italian paintings, including a Botticelli portrait repeated four times, appear elsewhere. The column-like vertical bands on either side of the main portrait—or segment of it, since the artist has severely trimmed it—are cut from a map showing the remains of the ancient Roman imperial palace on the Palatine Hill, and the words "Italie au XVme Siècle" appear on a scrap of printed paper adjacent to the "column" on the right.

But why the division into quadrants crossing at the boy's face? Why the compass—a real compass—centered below him between the two smaller boxes with mirrored backs that reflect miscellaneous objects including jackstones, one in each box? (A third appears in the vertical band at the extreme right.)

There is no point in wondering why. If everything were explainable, this magical box would become nothing but a catalogue of objects with specific psychological relationships to one another assembled in a pleasant manner, rather than what it is—a world of its own, where disparate objects are equalized on terms mysterious to us on the outside but obviously reasonable in their own self-contained world of dream.

All painting and sculpture, we are frequently told—at least all that is worthy of the name art-is a matter of transfiguration, which usually means transfiguration of the familiar into forms that "clarify, intensify, or enlarge" our experience. This is true of Cornell's boxes, although they demand an exceptional degree of receptivity from the observer. It is certainly true of another modern American sculptor, Louise Nevelson, whose raw material for transfiguration is wood picked up at wrecking sites-parts of moldings, balusters, railings, paneling, chair arms or legs and other bits of broken furniture, and any other pieces of wood in all the variety of shapes originally determined by decorative or structural function. As the title of Sky Cathedral (428) indicates, there is a strong architectural suggestion in these sculptures, which frequently cover large walls or even become total environments.

We said, concerning The Palace at 4 A.M., that it would have been presumptuous of us, the observers, to guess how much of such a work of art is the result of studied manipulation of means and how much is impulsive. In Nevelson's case, however, we know enough from recorded interviews to determine a balance between the analytical and the visionary in her creative approach. All her sculptures are either black, white, or gold, and each has for her its own mystique. Beginning with a general scheme in mind, she builds a sculpture placing this piece or that in the position that seems right, or that becomes right after adjustments. In a process where there can be no clear division between what "feels" right and what should be right according to esthetic theory and experience—esthetic discrimination attained through long study and practice the balance in Nevelson's case does seem to be on the side

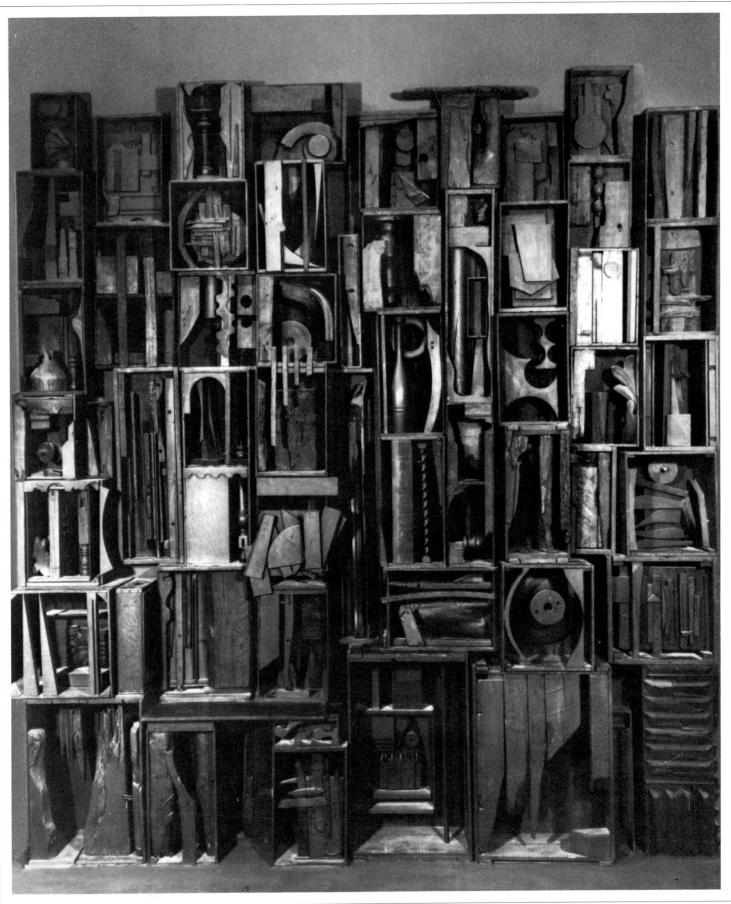

428. Louise Nevelson. *Sky Cathedral.* 1958. Assemblage—wood construction painted black—height 11 feet 3¼ inches. The Museum of Modern Art, New York. Gift of Mr. and Mrs. Ben Mildwoof.

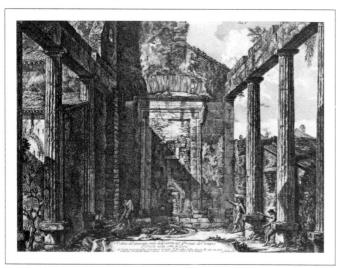

429. Giovanni Battista Piranesi. *Temple of Castor and Pollux.* 1746. Etching. The Museum of Fine Arts, Boston.

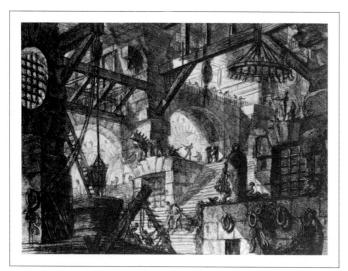

430. Giovanni Battista Piranesi. Imaginary prison, from the series *Invenzione Capricciosa di Carceri*. 1745–61. Etching, 161/4 by 211/2 inches. Museum of Fine Arts, Boston. Gift of Miss Ellen Bullard.

of instinctual response, which puts her on the side of the visionaries in opposition to the intellectualizers in the eternal dichotomy that runs through the history of art.

Can there be such a thing as visionary architecture? By any puristic definition of architecture, no. But architects have played with ideas on paper that they never expected to see materialized, have invented fantastic buildings or entire architectural worlds that they are free to imagine with no engineering problems involved, and have imagined extensions of contemporary engineering into realms theoretically possible even if totally impossible from any practical point of view.

Some of the most awesome architectural visions ever recorded are the Carceri d'Invenzione, a series of imagined prison interiors by the eighteenth-century Italian architect and printmaker Giovanni Battista Piranesi. The few buildings that Piranesi produced as a practicing architect are of no distinction; practical architectural disciplines were too demanding for his volatile, rather violent, temperament. His talents were better adapted to the romantic glorification of architecture in pictures, and here he excelled. The 137 large etchings of his Vedute di Roma, views of the modern city and its ancient ruins, published from 1745 onward, were internationally popular and still are (429). But it remained for his prisons (430) to give full play to his double nature as architect and visionary. These subterranean palaces for the confinement, torture, and execution of criminals guilty, surely, of unimaginable crimes, are labyrinthine confusions of arches, vaults, piers, terraces, and monumental staircases, some complete, some half-built, some fallen, combining the wildest dramatics of hallucination with contradictory effects of architectural solidity. Actually the structural relationships are too ambiguous to allow for the possibility of construction except in terms of lath and canvas—in which terms they have inspired innumerable stage sets.

The most impressive historical example of visionary architecture designed by a professional architect who held in mind the possibility of actual construction is Étienne-Louis Boullée's project for a cenotaph for Sir Isaac Newton (431). Although best remembered for his theory of gravitation, Newton also made important contributions to mathematics and astronomy, two themes that Boullée kept in mind in designing the cenotaph. Here he was able to apply a principle that he could only partially demonstrate as an architect of buildings devoted to everyday functions: the principle that buildings should be composed of pure, simple. unornamented geometrical volumes. The cenotaph is one gigantic globe rising from circular variations of terraces and landscaping, a direct and unequivocal mathematical reference, while Newton's astronomical investigations were symbolized by the globular void of the interior, which, approached through a long, dark tunnel, was illuminated only by holes like the moon and stars, placing the observer at the center of the astral universe.

Theoretically, this enormous building could have been

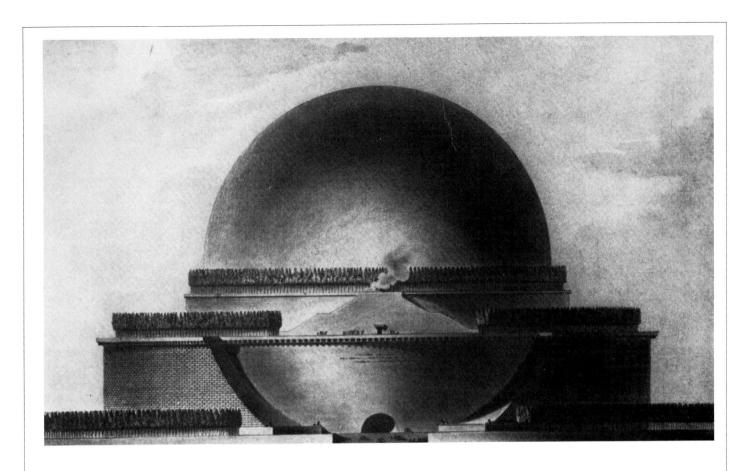

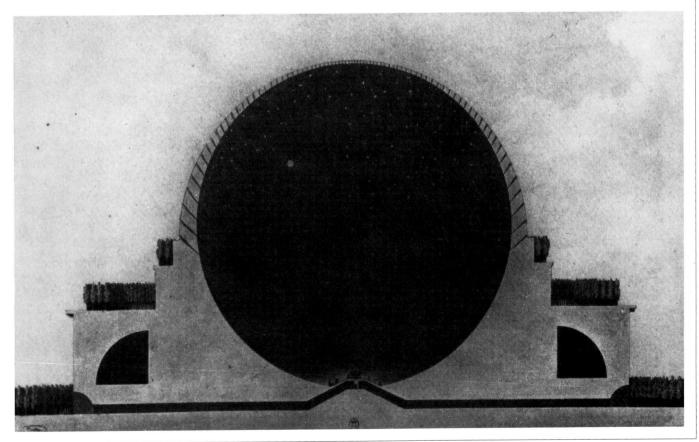

431. Etienne-Louis Boullée. Project for a cenotaph for Sir Isaac Newton, exterior and section, night effect. 1784. Bibliothèque Nationale, Paris.

432. U.S. Air Force Radome, Moorestown, New Jersey. Destroyed.

built at the scale Boullée indicated by tiny figures: certainly it could have been built at a smaller scale. Today it could be built at large scale as a concrete or opaque-plastic covered geodesic dome like Buckminster Fuller's for the United States Pavilion at Expo '67 in Montreal (433). But by an appropriate coincidence, the cenotaph now looks like a prophecy of the radomes, or tracking stations, whose pure geometrical forms, so like Boullée's, were developed not from any architectural premise but through the necessity of satisfying technological problems connected with the tracking of aircraft or missiles by means of radar systems (432). We call this an "appropriate" coincidence because the coincidence is not only one of form, but of form determined by modern scientific realizations that would have fascinated Newton the experimental physicist. If Boullée's cenotaph for Newton was an unintentional

If Boullée's cenotaph for Newton was an unintentional prophecy, architects have often indulged in prophetic speculations. Leonardo da Vinci made rough sketches for a city with two-level streets several centuries before modern conditions demanded overpasses and elevated highways. And in the lively field of theatrical invention, the German expressionist movie *Metropolis* multiplied the idea many times over in sets (434) anticipating the planetary space stations invented for *Star Wars* half a century later (435).

These stations look hardly more fantastic than the "arcologies" proposed by an Italian architect now working in the United States, Paolo Soleri, as serious studies in the relationship between architecture and ecology (whence the word "arcology"). By concentrating an entire metropolis within a single arcology and leaving uncontaminated countryside between arcologies, Soleri would eliminate the blight of urban sprawl and the contamination of nature by the messy, unorganized infestation of automobile graveyards, dumps, cheap building, and decayed townships that stretches across the countryside from coast to coast with our highways as carriers of the virus.

"Babel IIB" (436) is at once conceivable and impossible, if it is safe to say that anything in the future is impossible. In the meanwhile, it is the vision that counts. Just as visionary painting gives a degree of materialization to intangibles and thus opens new areas of consciousness for us, so visionary architecture on the magnitude of Soleri's arcologies can affect our ways of thinking about organizing our lives on the beautiful planet that, in a sense, we have invaded.

433. Buckminster Fuller. United States Pavilion, Expo 67. Montreal, Canada.

434. Still from *Metropolis*. Germany (Ufa). 1927. Art directors, Otto Hunte, Erich Kettelhut, and Karl Vollbrecht. Sculpture by Walter Schultze. Photo, The Museum of Modern Art, New York.

435. Still from *Star Wars*, Obi-Wan Kenobi (Alec Guinness) turning off the tractor beam in the Death Star. Twentieth Century-Fox, 1977. Production designer, John Barry. Photo courtesy The Museum of Modern Art, New York.

EPILOGUE

Something by way of epilogue may be in order now, at the conclusion of these discussions. But it should be brief; most of it should be said by a work of art. Daumier's *The Print Collector* (438) makes an appropriate statement.

As a picture "of" something, *The Print Collector* shows us an ordinary man pursuing a hobby. He is going through one of the portfolios of tens of thousands of miscellaneous prints that crowd Paris bookstalls. But he might be looking at pictures anywhere, and if we ponder one question, then the inner subject of *The Print Collector* becomes apparent. The question is, Why do pictures interest this man?

Why do pictures exist at all? Why do people look at them, respond to them, grow to love some and to dislike others, argue about them, defend and attack them, collect them, explore them, starve to paint them, build museums to protect them, cross oceans to see them?

In another Daumier, *La Soupe* (437), human creatures devouring food with animal intensity become symbols of the cycle of birth, life, death, birth—bound to the soil, nourished by it, and returning to it.

The Print Collector speaks of our other life. This ordinary man is not a human animal but a human being who thinks, wonders, and tries to explain. He is the creature who stopped being an animal and developed into a human being when it became necessary for him to explain to himself the existence of the world and to find a reason for his presence in it. He was rubbing this explanation with colored clays onto the walls of caves at least fifteen thousand years ago and fashioning magical figures out of bone or ivory. He was creating works of art, and is still creating them, and will continue to create them as long as he continues to be a human being.

This curious, unceasing activity of the artist is defined without being explained by the dictionary—art is "Creativity of man as distinguished from the world of nature," a definition we quoted at the beginning of this book. But the impulses that force us to create, and the search for some kind of fulfillment that accounts for art's fascination—accounts for Daumier's quiet print collector—these are not quite definable, and perhaps they don't even need explaining. It is enough to say that art is a fulfillment, whether for the creator or the observer, a form of communication with our time and all times, an extension of our experience of living, sometimes profound, sometimes entertaining. The only answer to the question, What is art? is that art, whatever its definition, is an inexhaustible enrichment of life.

437. Honoré Daumier. *La Soupe.* Latter nineteenth century. Wash drawing, 11 by 15¹/₄ inches. The Louvre, Paris.

438. Honoré Daumier. *The Print Collector*. Latter nineteenth century. Oil on wood, 13% by 10¼ inches. Philadelphia Museum of Art. Purchased, W. P. Wilstach Collection.

GLOSSARY

abstract art, abstraction. Generic, nonspecific terms covering art that in various degrees departs drastically from the natural appearance of things. At its extreme, abstract art makes no reference whatsoever to nature, an aspect sometimes called nonfigurative or nonobjective to distinguish total abstraction from degrees of abstraction where objects remain recognizable in spite of distortion or reduction to geometrical equivalents. The word "abstract" is never a noun in art terminology. "Abstracts" are summaries of books, court cases, and so on, but an abstract work of art is an abstraction, not an abstract.

abstract expressionism. Movement in modern art, especially painting, in which form and color alone are the emotive forces, without recognizable reference to nature. Abstract expressionism was the dominant school of painting in the 1950's and early 1960's, centered in New York but practiced internationally.

academy, academic, academicism. "Academy" originally referred to the French Academy, founded in the seventeenth century under royal sponsorship to establish rules and supervise acceptability in literature, the arts, and the use of the French language. It and other national academies still function. The adjective "academic" is now nonspecific, and usually perjorative, referring to art that depends on established conventions rather than creative individuality.

acropolis. From Greek words for "high" (acro) and "city" (polis). Any fortified upper part of an ancient Greek city. Capitalized, the Acropolis is that of Athens, where the Parthenon and other temples were built.

acrylic. Paint in which the binder is acrylic resin, a transparent thermoplastic substance that is also the basis of such products as Lucite, synthetic fibers, and so on. Acrylic in recent years has replaced oil as the favorite paint of many artists because it dries faster.

action painting. Term invented by the American critic Harold Rosenberg emphasizing the sheer physical activity involved in the creation of large, spontaneously executed abstract expressionist paintings like those of Jackson Pollock and Franz Kline, among others.

aerial perspective. See perspective.

affresco (Italian). See fresco.

allegory. A story, play, poem, painting, or sculpture in which the participating personages and objects are the disguised components of a hidden theme, usually moralistic.

- altarpiece. A painting or sculpture placed upon or behind an altar. When the subject is not a standard one such as the Crucifixion, it may be connected with the saint to whom the church or chapel is dedicated.
- alto rilievo. Italian for high relief.
- Apocalypse. The last book of the New Testament, Revelation, written on the island of Patmos about A.D. 85 by one John, probably Saint John, recounting his visions of the ultimate triumph of good over the forces of evil.
- apse. A recess in a building, usually semicircular and covered with a half dome. In a church or cathedral, the semicircular end of the choir. In early medieval buildings the apse was a favored spot for mosaic or fresco decoration.
- aquatint. An etching technique dating from the late eighteenth century by which tonalities approximating those of wash drawings may be produced. A plate is dusted with resin (occasionally sugar) and submerged in acid, which eats through tiny interstices between grains of the dust, biting a very fine stipple into the metal.
- Archaic period. Early period in Greek art, 600-480 B.C.
- architectonic, architectonics. Specifically, relating to architecture and its theories, but in general referring also to the structural quality of any art, including painting. Poussin's carefully constructed paintings are good examples of architectonic pictorial composition. (The term is also used in philosophy, where it means the systemization of knowledge.)
- arcologies. Term invented by the modern architect Paolo Soleri denoting his visionary schemes for mammoth structures enclosing whole cities with open countryside between.
- art brut. French term translatable as "art in the raw," invented by Jean Dubuffet to designate the art of very young children, psychotics, and the perpetrators of graffiti on public walls and monuments. Believing that spontaneous untutored art flows from basic sources more vital than timeworn standards of sophisticated, professional art, Dubuffet based his own paradoxically sophisticated style on these crude sources.
- artist's proof. An unnumbered print pulled by the artist in addition to the numbered set.
- art nouveau (new art). A style created in an attempt to break away from the art of the past and practiced from about 1880 to about 1910. With its sinuous lines and sharp definition it became primarily a decorative art form, but it also found expression in painting and architecture.
- assemblage (a·säm·blazh'). A three-dimensional work of art (as opposed to two-dimensional collage) made up of bits and pieces from various sources, usually found objects.
- baroque, baroque period. As a general term, baroque refers to elaborate, irregular, theatricalized forms, but the baroque period (roughly, the seventeenth century and the rococo sequel in the eighteenth) was also marked by schools of architecture and art based on classical models. In the same period the Netherlands produced the profoundly humanistic art of Rembrandt. Baroque cannot be given a single precise definition.
- barrel vault. A vault semicircular in section.
- bas relief. More frequently used than the equivalent "low relief," the term denotes sculpture in which forms are compressed from front to back into about one-quarter, more or less, of their volume in nature.
- Bauhaus. State school of art and architecture founded in Germany in 1919 and headed

- by Walter Gropius. Most important for its theory and teaching of architecture, in which science and technology became the basis for design.
- binder. The ingredient of paint that gives pigment the capacity to adhere to a surface. Binders include oil, egg (tempera), gum arabic (water color), acrylic, and others.
- Book of Hours. A prayer book used by laymen for private devotions. As an illuminated manuscript in the fifteenth century, the Book of Hours was a major art form.
- bravura. Bold, dashing technique that displays an artist's skill.
- burin. A small, pointed tool, triangular in section, used by engravers.
- burr. The uneven ridge of metal thrown up on either side of a line gouged into a plate, which collects ink and produces a soft, blurred line in printing.
- buttress. A masonry support built against a wall to counterbalance the lateral thrust of an arch or vault (engaged buttress or pier buttress). A flying buttress is an arch or series of arches carrying the thrust over the side aisles to the piers of a Gothic church or cathedral.
- calligraphy, calligraphic. Handwriting, and pertaining to it, especially beautiful handwriting as an art. In painting, often extended to include any freely executed linear inventions, such as Jackson Pollock's "skein" paintings.
- cantilever. A large bracket, block, or beam projecting from a wall to support an elevated structural form without the use of walls, columns, arches, or other supporting forms beneath.
- cartoon. A full-scale study, usually on paper, for a painting, either for reference or for transferring to the panel, canvas, or wall where the painting will be executed. Cartoons are also made for tapestries, stained glass, and other two-dimensional art forms that require a preliminary study.
- cathedral. Strictly, the main church of a bishop's see, but also applied to any large, imposing church, Gothic ones in particular.
- cenotaph. A monument or empty tomb honoring a dead person whose body is somewhere else.
- choir. The part of a church or cathedral reserved for the clergy and choir. It occupies the space between transept and apse.
- classical space. Concept of space as definable and measurable in harmoniously adjusted proportions, especially in painting.
- closed form. Primarily a term applied to sculpture, but applicable to painting and architecture, denoting the entity of a form displacing a volume of space yet not fusing with it. As an extreme example, Brancusi's *The Kiss*; as a moderate one, an archaic Greek kouros. Later sculptures like the *Diadoumenos* and many others, including modern ones, are essentially closed forms in spite of the separation of legs, arms, or other units of the mass.
- collage (ko·lazh'). French for "paste-up." Work of art made up wholly or in large part from bits of paper, cloth, or other material pasted onto a flat surface. The three-dimensional equivalent is assemblage.
- colonnette. A small column. Because of their delicacy, colonnettes are frequently more decorative than functional.
- complementary colors. In physics, any two colors of the spectrum that, combined, produce white light. In painting, however, the complementary colors (red and green; yellow and purple; blue and orange) when mixed produce browns or grays.

- When juxtaposed in the right intensities, complementary colors are mutually intensifying. The principle is important in impressionism and pointillism.
- composition. Arrangement; the art of arranging the component forms and colors of a painting or sculpture (sometimes architecture) in a harmonious, decorative, or expressive way.
- concept art, conceptual art. Extreme phase of modern art in which ideas are presented in diagram or in description rather than in conventional execution as a painting or sculpture.
- conversation piece. A group portrait of an informal gathering of relatives or companionable people disposed in their natural habitat, often a drawing room.
- cubism. With fauvism, the basic revolutionary movement in modern art, initiated in 1907 by Picasso's *Demoiselles d'Avignon*. Cubism is based on two premises: first, that all forms in nature can be reduced to geometrical equivalents, usually angular; and second, that it is possible to represent multiple aspects of a figure or object simultaneously (see *space-time*). These ideas were combined in cubism's early phase, called "analytical cubism". A second phase, "decorative cubism," capitalized on ornamental shapes and patterns suggested by the analytical exercises. Since then Picasso and others have invented freely in Cubist-derived manners.
- Dada. Nihilistic German anti-art movement (later French) in painting, sculpture, and literature, rejecting all established disciplines in reaction to World War I and its social upheavals. Nonsense, impertinence, and esthetic blasphemies were cultivated as a combination of protest and entertainment. The term "Dada" was selected by the poet Tristan Tzara. Marcel Duchamp remained Dada's living monument after its death in the early 1920's.
- De Stijl (The Style). Journal founded in 1917 by a group of Dutch painters, architects, and sculptors proposing and practicing a system of modern design limited to rectangular forms and the primary colors (red, yellow, and blue) plus black and white. The name De Stijl is also given to the group and its theories.
- diableries. Devilish inventions, sometimes half-homorous, frequent in Medieval manuscript illumination.
- diptych. A painting or low relief sculpture in two compartments hinged to close like a book. Diptychs are most frequently met as portable shrines.
- divisionism. Application of color in small spots or strokes to be blended by the eye as another color: for instance, blue and yellow to produce green, red and yellow to produce orange. The color may be applied loosely, as in impressionism, or semiscientifically according to optical rules, as in pointillism.

dome. See vault.

- donor. Patron who commissions and pays for an altarpiece (or other work of art) and is portrayed along with saints and other religious personages in the completed work as recognition of his generosity.
- drolleries. Grotesque or comical figures in manuscript illuminations.
- dry point. Print technique related to etching and frequently combined with it, by which the lines of a drawing are scratched directly onto the plate with a stylus.
- earth art. Form of art in which arbitrary changes with no useful reason for being are imposed on a countryside employing only the natural materials at hand. A trench a few inches deep may be dug for a distance of miles in a desert area, for instance. Basic to the ethos of earth art is a revolt against the commercialism of art galleries and the incarceration of art in museums.

- engraving. Print made from a metal plate into which the picture or pattern has been incised with a burin.
- exoskeleton, exoskeletal. As a biological term, the exterior skeletons of lobsters, turtles, and others. As an architectural term, exoskeletal refers to structural elements like flying buttresses exposed on the exterior of a building. The Pompidou Center in Paris is an extreme example of exoskeletal architecture.
- expressionism. Specifically, a movement in modern art in which distortions of form and color are employed for emotive effects. Can also apply where appropriate to works of art created long before the term was invented, for instance, the paintings of El Greco.
- façade. Usually the front of a building with the main entrance. Also, another side when given emphasis by architectural treatment.
- fauvism. With cubism, one of the two revolutions that shifted the course of art in the early twentieth century. Never an organized movement, fauvism was a spontaneous expressionistic impulse in the use of distorted form and intense color for emotive (and decorative) effects in a happier mood than other expressionist painting. Leading Fauves (meaning "wild beasts," originally a derogatory name for the school) included Derain, Vlaminck, and the young Braque, but Matisse, the most eminent, remained fauvism's exemplar.

ferroconcrete. Reinforced concrete.

fixative. Thin solution of gum for spraying over pastels or other drawings to hold them more firmly to the paper.

flattened relief. See rilievo schiacciato.

flying buttress. See buttress.

foreshortening. Perspective as applied to the representation of objects or, especially, the human figure, by which the lines of component parts are shortened to give the illusion of proper relative sizes.

"Form follows function." Basic premise of functionalism.

found object. Any object not originally intended as a work of art, usually fragmentary and discarded, which an artist finds of sufficient esthetic interest to be treated as a work of art or to be incorporated into an assembled work of art. Old machine parts and bits of wrecked buildings serve artists most frequently.

fourth dimension. See space-time.

fresco. In its pure form (buon or true fresco), wall painting executed in pigment and water on fresh plaster. Fresco a secco (dry, or false fresco) is executed in tempera on dry plaster.

functionalism. The theory that a functionally perfect object or building will automatically be inherently beautiful. Although thought of as a modern concept, the functionalist idea goes back to antiquity and received its most ecstatic statement in nineteenth-century America when Horatio Greenough, a sculptor, described the beauty of a sailing ship.

futurism. Modern art movement originated by an aggressively self-publicizing group of Italian artists and literati just before World War I, which advocated the destruction of traditional art and the creation of new forms expressing the speed, energy, and violence of modern times. The automobile, railroad train, and airplane were among its symbols.

- gargoyle. Strictly, a waterspout. (The word is derived from the Old French gargoul, "throat.") Medieval waterspouts were decorated with grotesque or monstrous heads, their mouths open to emit water. By extension, gargoyle means any grotesque projecting figure on a building.
- genre painting. Subjects or scenes from daily life painted realistically, often with quaint or homely overtones.
- geodesic. Form of architectural engineering in which structures are built of polygons formed by short, straight, lightweight bars. The method is particularly adaptable to the construction of large domes or globes.
- gesso. Extremely fine-grained plaster used over wooden panels as a surface for egg tempera painting or on furniture as a surface for gilding and other decoration.
- gestural painting. Painting in which the free action of applying paint remains apparent in the result. Not quite identical with action painting, gestural painting can be stretched to include such bravura techniques as John Singer Sargent's.
- glaze. A thin, transparent film of color applied over another color to intensify or modify it.
- Gothic. See Middle Ages.
- gouache. Water-soluble paint somewhat thickened and made more or less opaque according to the degree of admixture with white.
- grotesques, grotesqueries. Fanciful inventions combining human, animal, vegetable, mineral forms, usually of a humorous and decorative nature, but put to more serious use by certain late medieval Flemish painters.
- ground. In etching, the acid-proof varnish with which a metal plate is covered and through which the drawing is scratched. Soft ground is a resinous mixture that remains sticky after application. In a print it yields a softer line, comparable to pencil drawing in contrast with the penlike line of etching proper.
- gum arabic. A water-soluble resin obtained from several African acacias and used in medicines, candies, and various emulsions, including water-color paint, where it serves as a binder for the pigments.
- happenings. Impromptu performances staged by artists, creating bizarre and ludicrous situations in which audience participation was invited. Popular in New York for a brief period in the 1960's.
- hatching. A means of shading in drawing, engraving, or other graphic arts by fine lines either parallel, crossed, or systematized to describe the contours of the pictured shapes.
- high relief. The degree of relief in sculpture between medium relief and full round. The term is elastic, but high relief may be thought of as the compression of the full three dimensions into about three-quarters of the front-to-back volume.
- hyperrealism. Preferable to superrealism as avoiding confusion with surrealism. A movement of the 1970's in which naturalistic detail is rendered with acute fidelity, created in extreme reaction against abstraction. The term applies to both painting and sculpture.
- Iconoclasts. "Image breakers." A group of members of the Orthodox Eastern Church in the eighth and ninth centuries who opposed the use of images in religious painting and sculpture, to the extent of destroying works of art in which such images appeared.
- iconography. Representation of a subject, especially by interrelated symbols. See

- discussions of the Arnolfini wedding picture and Dürer's Melencolia I. Not the same as iconology.
- *iconology*. The study and interpretation of iconography. Iconology frequently involves a kind of detective work, for instance, the discovery that the apparently casual domestic details of the Arnolfini wedding picture are interrelated as symbols.
- illuminated manuscript. Manuscript decorated with pictures and designs. Initial letters and page borders are the most frequently illuminated spots, but independent miniature paintings are also encountered.
- *imagen de vestir.* Spanish sculpture realistically carved and painted, clothed in actual garments.
- *impressionism*. Major revolutionary art movement of the nineteenth century. Subjects from everyday life were sympathetically treated in "snapshot" compositions as if captured in momentary aspects. Effects of light and atmosphere were created by the free application of pure color in accord with loosely applied theories of physics.
- intaglio, intaglio print. Print made from drawings incised into a surface, usually metal. The incised lines are filled with ink, which is transferred to paper under pressure. Engraving and etching are the major forms of intaglio prints.
- *jamb*. The side piece of a framed opening such as a doorway, important in medieval art as the location of major sculptures, as at Chartres.
- Jugendstil. German term for art nouveau.
- Kamakura period. A.D. 1185–1333. One of the two foundation periods in Japanese art, preceded by the Heian (A.D. 794–1185). The city of Kamakura was at its most splendid during the period now given its name.
- kouros (plural, kouroi). Greek for "young man," used in art to designate the standing nude male sculptures of the Archaic period. The female counterpart is the kore (maiden).
- *liberal arts.* In art history, the medieval quadrivium (arithmetic, geometry, astronomy, and music) and the lower trivium (grammar, logic, and rhetoric). Symbolic figures of the seven liberal arts occur frequently in medieval painting and sculpture.
- linear perspective. See perspective.
- *linocut, linoleum cut, linoleum print*. Relief print from linoleum; otherwise same as woodblock, woodcut.
- *lintel.* Horizontal supporting beam spanning an opening, frequently carved when on medieval portals.
- lithograph. Print made from a drawing in wax crayon on special limestone (or substitute material in recent variations) by a process invented by Aloys Senefelder in 1798.
- low relief. See bas relief.
- manifesto. A public declaration of principles and intentions. Manifestos became popular with avant-garde groups of artists in the early twentieth century; the Italian Futurists made the most dramatic use of this form of publicity by scattering printed sheets from bell towers.
- mannerism, mannerist. As a general term, refers to a distinctive, usually affected, mode of style or behavior. Specifically, the sixteenth-century movement in which artists departed from the ideal classicism of the High Renaissance in favor of sometimes bizarre and often neurotic stylizations.

Medieval period. See Middle Ages.

medium relief. See mezzo rilievo.

- megalith. A huge stone, especially in prehistoric or ancient monuments, as at Stonehenge, but the term is also applicable to any large column, obelisk, or other architectural unit carved from a single stone.
- Mexican Renaissance. Nationalistic art movement dedicated to propagandization of the Mexican Revolution, flourishing in the 1920's under the leadership of Rivera, Orozco, and Siqueiros.
- mezzo rilievo. Italian term more frequently used than its English equivalent, medium relief, to denote sculptural relief where form has been compressed from front to back to about half the depth of nature's three dimensions.
- mezzotint. Method of engraving by which a metal plate is uniformly roughened with an edged tool (roulette or rocker), after which it would print solid black. Smoothed with a burnisher, areas will print lighter in tones up to pure white. Mezzotint was widely used in the eighteenth century and into the nineteenth as a means of reproducing paintings, a function now served by photographic processes.
- Middle Ages. The centuries between the dissolution of the Roman Empire and the Renaissance, subdivided by art historians (with vague and overlapping dates) into early Middle Ages (about 1000 to middle or late eleventh century), Romanesque (mid-eleventh century to latter twelfth), Gothic (latter twelfth to end of fourteenth) and, in the North, late Gothic (fifteenth century).
- minimal art. Painting or sculpture conceived according to the modern adage "less is more," originally applied to architecture. The ultimate minimalist painting is a canvas of a single color, of which there are numerous examples; the ultimate sculpture, a simple cube, this having been demonstrated by the American artist Tony Smith.
- *mobile.* A sculpture constructed of movable parts that change relative positions either in air currents or when motorized. Alexander Calder invented the form; Marcel Duchamp named it.
- monotype. A variety of printmaking by which a painting in black and white or color is executed on metal or another nonabsorbent surface and transferred to paper under pressure. "Mono" indicates a single transfer, but a weaker second print may be pulled in some cases, or the original painting may be retouched for further impressions, all, of course, differing.
- *mosaic.* A picture or design made by bits of stone, glass, or other material set into a floor, wall, or ceiling.
- mural. A wall painting. Murals may be painted directly onto the wall or onto canvas that is then attached to the wall.
- narthex. A porch, portico, or vestibule on the west end (main entrance) of a church. Penitents or others not admitted to the church itself were allowed in medieval times to enter the narthex; hence it was sometimes the size of a hall to accommodate bands of pilgrims.
- naturalism. This term has been an ambiguous one in varying uses since its invention in the late seventeenth century to apply to followers of Caravaggio, who rejected idealization for the representation of people as they (more or less) are. As a literary term in the nineteenth century, naturalism was identified with the novels of Zola and with Flaubert's *Madame Bovary*, in which observation of human behavior in contemporary society was supposedly objective. In art today the term is loosely

- used, but basically it denotes forms of realism in which personal interpretation is avoided, such as hyperrealism and photorealism.
- nave. From navis "ship", an early symbol of the church. The main part of a church, between the chief entrance and the choir, separated from the side aisles by piers or columns.
- negative volume. Spatial volume defined by solids, but not to be confused with "void." Voids are automatically created by forms that enclose space; negative volumes are conceived as shaped spaces that are creatively introactive with the defining solids and may even be conceived as having defined those solids, as the action of natural forces can hollow out a cave. "Negative volume" refers to sculpture but is inherent in good architectural design.

Niké (Nī'-kē). In Greek mythology, the winged goddess of Victory.

nonfigurative. See abstract art.

nonobjective. See abstract art.

- offset printing. A photographic adaptation of the lithographic process by which the image is set on a rubber-covered roller and then transferred to paper.
- op (optical) art. A classification of abstract painting utilizing geometrical patterns that create illusions of formal displacement or motion, often in black and white, as well as chromatic juxtapositions that set up illusory color changes and pulsating vibrations.
- open form. Term primarily associated with sculpture but applicable also to architecture and painting, denoting conceptions by which volumes cease to be self-contained (closed form) and, instead, project into space around them.
- original print. An etching, engraving, lithograph, or other kind of print from the artist's hand rather than from mechanical reproduction. Ideally an original print is not only created by the artist on the plate or block or stone, but is also printed by him. However, printing is often left to professional craftsmen, whose work is done under the supervision of the artist, or is subject to the artist's final approval.
- pastel. Finely ground pigment mixed with a gum binder and formed into a short, pencil-like stick. Pastel differs from most crayons in its dry, powdery texture, in contrast with the waxy texture of others.
- pediment. The triangle (gable) at the end of a building, formed by the sloping roof. The pediment form is also applied decoratively, over windows and doors.
- perspective. The art of picturing things or scenes on a two-dimensional surface in ways that represent them in three dimensions as they appear to the eye. Perspective is of two kinds, linear and aerial. In *linear perspective*, lines that are parallel in nature converge as they recede into the distance (railroad tracks being a standard example) and objects of the same size in nature become smaller in proportion to their distance from the eye. *Aerial perspective* takes into account the softening effect of distance, the diffusion or loss of detail, diminished value contrast, and the bluish color of distant scenes, all the result of atmosphere intervening between the eye and the thing or scene viewed.
- photorealism. Art form of the 1970's in which artists reproduced photographs as paintings, often with maximum fidelity, at other times with certain refinements or simplifications that added a note of interpretive intent to the absolute objectivity of the earliest photorealists.
- piazza. In Italy, an open public square, usually surrounded by buildings and sometimes with an architectural structure designed specifically to enclose it, as at the piazza of St. Peter's in Rome.

- picture plane. The plane of the surface of a painting, most easily comparable to the glass in a framed picture, behind which the picture "recedes" in depth, often with frontal planes that repeat the picture plane.
- Pietà. A representation of the Virgin Mary mourning over the body of Jesus, held upon her lap, after the Crucifixion.
- pigment. The coloring matter of paint, formerly obtained from natural sources, today largely synthesized chemically. Combined with a binder (oil, egg, acrylic, gum arabic, and others), pigment becomes paint.
- pointillism. Method of painting in small juxtaposed dots of chromatic colors that may be fused by the eye, at a distance, into other colors of which they are the component parts. Pointillism differs from the broken color (divisionism) of impressionism in its precision and semiscientific application of the laws of optics.
- polyptych. A set of more than three panels, usually painting but sometimes carving, hinged or otherwise bound into a unit. Most frequently an altarpiece.
- pop art. From "popular art." Term coined by the English critic Lawrence Alloway in the mid-1950's to denote the "vernacular culture" of comic strips, advertising, movies, and aspects of urban culture not ordinarily thought of as art. The term is expanded to include the art of painters and sculptors who have employed these motifs in commenting on the contemporary scene.
- porch. An architectural structure set in front of the entrance to a building. In Gothic architecture, where it was most highly developed, the porch became as deep, wide, and high as an independent building. Heavily encrusted with sculpture and ornament, porches were dramatic introductions to the soaring vaulted cathedral interiors, as on the transepts at Chartres.
- post-impressionism. Theory and practice of artists who at the end of the nineteenth century departed from impressionism in order to rectify, each in his own way, what they regarded as its shortcomings. Cézanne and Seurat rejected the free, spontaneous character of Impressionist technique for formal disciplines based on impressionism's divided color, while Van Gogh and Gauguin rejected its happy objectivity for intense personal expressionism.
- predella. The base of an altarpiece, often divided into panels with paintings of subjects relating to the main subject above.
- primitive art. The art of primitive societies, usually tribal.
- primitive artist. Self-taught artist who has not mastered such standard means of representation as perspective, foreshortening, and the like, but who, as a result, may develop an expressive individual style.
- print. A drawing or design in black and white or colors made from a master original by one of several means. Intaglios are printed from metal plates with lines incised either directly (engraving, dry point) or with acid (etching). Relief prints are made from lines or areas left standing on a master block, the blanks having been cut away (woodcut, woodblock, linoleum cut). Planar processes, from a flat surface, include lithography. Silk screen is a stencil process. See also original print.
- psychic balance, psychological balance. Balance in a pictorial composition created by mental factors such as the degree of interest or emphasis given an element that otherwise would not hold its own in terms of size or other purely visual factors.
- quadrivium. See liberal arts.
- realism. The representation of things and people as they actually appear. Realism does not rule out personal sensitivity and acute perception, as the art of Rembrandt

- and Eakins among many others proves, but stops short of expressive or idealistic modifications or distortions. See also *naturalism*.
- refectory. Dining hall, particularly in convents and monasteries, where the Last Supper was the standard subject for Renaissance mural paintings; Leonardo da Vinci's is the most famous.
- reinforced concrete. Concrete masonry strengthened by interior steel bars or mesh.
- relief. A work of sculpture in less than full three dimensions of nature. The degrees, in lessening order, are high relief (alto rilievo), medium relief (mezzo rilievo), low relief (bas relief), and flattened relief (rilievo schiacciato).
- relief print. Print from a raised surface. See print.
- rib. A masonry arch, usually molded, forming the framework of a vault.
- ribbed vault. See vault.
- rilievo schiacciato. Extremely low sculptural relief, barely rising above the surface, adaptable to the most subtle atmospheric effects. The English translation of this Italian term, "flattened relief," is seldom used.
- rococo. Developing from the baroque and frequently included as its last phase, rococo was a style of extreme elaboration and delicacy. Ornamental motifs were derived from flowers, foliage, shells. (The term originated from the French rocaille, meaning shell work or stone work.) Paintings of similar character were widely incorporated into rococo decorative schemes.
- Romanesque period. See Middle Ages.
- romantic movement, romanticism. An international mid-nineteenth-century surge of creative energy in all the arts, with personal, emotive, and freely inventive creative approaches in rebellion against the formalized dictates of the neo-classical establishment. As contrasting examples see David's neo-classical *Death of Socrates* and Géricault's romantic *Raft of the Medusa*.
- romantic space. Concept of space as limitless, mysterious, often turbulent.
- roulette. A small wheel edged with sharp points that may be rolled along the outlines of a drawing on paper to puncture them, after which the outlines may be transferred to another surface by laying the punctured drawing on it and dusting with dark powder, usually charcoal.
- scumbling. Heavy, rather dry paint dragged from a brush across the rough surface of another painted area so that bits of the second color adhere to the irregularities of the first. Scumbling enriches surface texture and can result in interesting color effects. Glaze is often applied over dry scumbling for further enrichment.
- serigraph. A term as reasonable as "lithograph" that failed to catch on widely as a replacement for silk screen print.
- show-card color. An inexpensive, opaque, water-soluble paint frequently but not quite correctly called tempera, popular in classes for beginners, especially children.
- silk screen print. Print made by pressing paint through fine silk stencils onto paper. Silk screen stencils are also used on fabrics, plastics, and various other surfaces, frequently in mass commercial production.
- social realism. Realism directed toward political or social comment. Nineteenth-century examples include Daumier's *Rue Transnonain* and much of his and other artists' representation of the contemporary scene, but the term is most closely associated with American painting of the period between World Wars I and II when artists cast a sympathetic eye on the anonymous members of the urban proletariat.

- soft ground. See ground.
- space-time. Concept in modern physics by which space and time are indissolubly united, the three dimensions of space being joined by the fourth of time. In art the concept is basic to cubism, in which different aspects of the same object are represented simultaneously.
- state. A proof pulled at a way-point in the development of an etching, engraving, or other print, by which the artist determines what he has so far set down on the plate. States are called first, second, third, and so on, as work continues.
- stigmata. Wounds or marks on a person resembling the five wounds on the body of Christ at the Crucifixion. Saint Francis of Assisi was the first stigmatist.
- straight painting. The direct application of pigment to canvas in creating a picture with little or no preparatory study or guidelines.
- stylus. A needle-like instrument. In art it applies to the instrument used in ancient times to incise letters, figures, or designs on clay tablets, or to the needle used by etchers to scratch their drawing into the ground on the plate.
- superrealism. See hyperrealism.
- surrealism. Movement in modern art and literature also described by its adherents as a way of life, with manifestos in 1924 and 1929 by the French poet André Breton. Surrealism in painting, where it received its widest expression, is an art of paradox where the exact pictorial description of objects and figures is paired with their irrational combination.
- symbol. Something that stands for something else, especially a physical object that stands for an abstraction, such as the small dog in the Arnolfini wedding picture, symbolizing fidelity. A combination of symbols used to tell a story constitutes an allegory.
- symbolism. A movement in reaction against realism based on the essential principle, proclaimed in the Symbolist Manifesto of 1886, that ideas must be "clothed in sensuous form."
- tableau. French for "picture," but applied by the American artist Edward Kienholz to his verbal outlines for proposed works.
- tempera. An emulsion of pigment with any of several gluey substances as a binder, yolk of egg being traditional. Egg tempera was the standard technique for panel painting in the Renaissance before the development of oil.
- tensegrity. Term invented by the American artist Kenneth Snelson to denote the engineering principle of balanced tensions and compressions in suspension employed in his sculptures.
- tessera (plural, tesserae). A small piece of stone, glass, or other material used in making a mosaic.
- thrust. The outward force exerted by an arch or vault.
- tight. Semicolloquial term denoting meticulous, smooth-surfaced execution of a painting.
- *tracery.* Ornamental stonework decorating a window and holding the glass in place. Typical of Gothic buildings.
- transept. The arm of a cruciform church at right angles to the nave.
- triptych. A painting or carving in three compartments side by side, or three independent panels hinged so that the lateral sections, or wings, each half the width of the central panel, can be closed over it.

- tympanum. The space over a doorway enclosed by the lintel and the arch.
- underpainting. Preliminary stage of a painting, in which the forms are defined, usually in monochrome, for subsequent development in color and greater detail. Underpaintings may be in tempera, oil, or any other stable paint. A warm underpainting (browns and tans) lends a golden tone to the finished picture; a cool one (grays and whites) can yield a silvery tone.
- value. The equivalent lightness or darkness of a color in terms of black and white. Yellow, for instance, tells as a light value; purple, as a dark one. Generally speaking, a black and white photograph on properly sensitized film translates color into values.
- vault. An arched ceiling of stone, brick, or concrete. A barrel vault is semicylindrical. A groined vault is formed by two barrel vaults intersecting at right angles. A ribbed vault consists of light masonry supported by a framework of ribs. A dome is a hemispherical vault.
- vedute (singular, veduta). Italian, meaning "views." Accurately detailed paintings of important city views, especially of Venice, popular in the seventeenth and eighteenth centuries.
- wing. In painting, one of two panels of equal size flanking the central panel of an altarpiece and hinged to close over it.
- woodblock, woodcut, wood engraving. Woodblock prints are of two kinds: woodcuts, in which the whites are cut away to leave black lines and areas standing in relief for printing, like a drawing in black ink; and wood engravings, in which the cutting is extremely fine and the picture is conceived in terms of white against black rather than black against white.

Photo Credits

Alinari/Editorial Photocolor Archives: 425 Foto Jorg P. Anders: 266 © Arch. Phot. Paris/S.P.A.D.E.M.: 5, 7, 52, 54, 422 Art Reference Bureau: 141 The Bettmann Archive: 106, 298 British Tourist Authority: 79 Courtesy Leo Castelli Gallery: 345, 385 Chevojon Frères: 134 Geoffrey Clements Photo: 39 Cliché des Musées Nationaux, Paris: 11, 14, 22, 222, 245, 257, 261, 358. Courtesy of the Cooper-Hewitt Museum, the Smithsonian Institution's National Museum of Design: 312 Photo François Darras: 83 EAST Photo: 119 Alison Frantz, Princeton, New Jersey: 3, 47 French Embassy Press and Information Division: 53 French Government Tourist Office: 121, 126, 393, 421 Galerie Denise René, Paris: 62 Golden Spike Empire: 8 Greek Press and Information Service: 42 The Solomon R. Guggenheim Museum, New York: 427 Italian Government Travel Office: 194, 250, 251 Alain Keler/Editorial Photocolor Archives: 252 © 1979 F. L. Kenett, London: 156 Balthazar Korab Photo: 131 Joseph Martin/SCALA: 142 Photo MAS, Barcelona: 158, 291 Robert E. Mates: 179, 183 Photo Services, Minneapolis Institute of Art: 66 Courtesy Museum of Fine Arts, Boston, © 1972: 407 Courtesy Museum of Fine Arts, Boston, © 1979: 340, 341, 359, 389 Collection, The Museum of Modern Art, New York: 122, 181 The Museum of Modern Art/Film Stills Archive: 163, 434 Reproduced by courtesy of the Trustees, The National Gallery, London: 30, 31, 32, 94, 211, 212, 213, 236 Courtesy The Pace Gallery, New York: 116, 117 Philadelphia Convention and Visitors Bureau: 85 Photograph by Philadelphia Museum of Art: 67, 148, 149 Photo Researchers, Inc.: 159 Press and Information Service, The Netherlands: 386 © Cervin Robinson 1979: 161 © Charles E. Rotkin: 9, 10 (© 1966), 77 (© 1964), 84, 128 (© 1971), 193 (© 1967), **253** (© 1965) SCALA/E.P.A., Inc.: 2, 6, 46, 48, 57, 59, 64, 76, 92, 93, 96, 188, 189, 190, 195, 196, 201, 202, 218, 219, 223, 224, 225, 226, 227, 229, 239, 240, 241, 242, 260, 262, 264, 265, 267, 270, 272, 273, 274, 275, 276, 277, 278, 279, 280, 281, 284, 287, 350, 351, 354, 387 SCALA/E.P.A., Inc., Photo Hubert Josse: 214, 215, 216 SCALA New York/Florence: 98 The Trustees of Sir John Soane's Museum, copyright Sir John Soane's Museum: 377 Ezra Stoller © ESTO: 79, 80, 129 (© 1958), 135, 162 (© 1962), 192 Courtesy Allan Stone Gallery: 115 Photo by John Tennant: 1 Courtesy of Twentieth Century-Fox: 435 U.S. Air Force Photo: 432 Copyright Johan Maurits van Nassau: 255

David Wallis/NYT Pictures: 130

Alfred J. Wyatt: 326, 334

Bernard Pierre Wolfe/Photo Researchers, Inc.: 159

INDEX

Animals and Plants (Jakuchū), 143

118–20, 120, 138, 182, 203

Artist's proof, 266, 287

Anne of Cleves (Holbein the Younger), 189-91, 190, 207, 341 156-7 Abstract expressionism, 105, 145; improv-Anti-art, 87, 285; and Dada, 48 isation in, 132, 134; and "meaning," Apparition of a Face and a Fruit Dish on a Beach (Dali), 335, 336, 337 Abstraction, 117–43; in architecture, 140–2; Appenine, The (Giambologna), 354 Cézanne as father of, 186; and cubism, 126-7; defined, 35, 117; degrees of, 117; Aquatint, 271, 277, 278, 279 Archangel Raphael with Adam and Eve, De Stijl, 130-1; and hyperrealism, 370; The (Blake, William), 328 intellectualization vs. emotionalization, 131, 145; Mondrian's rectilinear planes, Architectonics: Brera, cf. Cézanne, 185–6; Nevelson's Sky Cathedral, 356 127-30; and perspective, 121; Piero's fig-Architecture, 53-7; abstract values, 140-2; ures, 135, 138–9; and Oriental art, 142–3, architectonic values, 185; arcologies, 361; 154; proselitizing of, 142; cf. realism, bases for judgment, 54; Bauhaus, 88-9; 62-3, 119-26; rise of, 81-2; Rothko and, De Stijl, 130-1; and engineering, 192-3; 135; in sculpture, 33, 35, 139-40; Seurat's exoskeletal, 56–7, 192; expressionist, 114–15; façades, 165; functionalism, 87–92; geodesic, 360; materials, 54–5, Sunday Afternoon, 217; and Turner, 134. See also Abstract expressionism Acropolis, 7, 165 Acrylic, 220 88-91, 115, 193; and mural painting, 146; negative volume, 139-42; Parthenon, 3, Action (motion) in art, 188-91, 205-7 5, 7-8; Renaissance churches, 66; sky-Action painting, 132 Actor Dancing (Kiyotada), 155 scrapers, 90-2; triangular form, 167-9, 175-6; union with sculpture and painting, Advertising art, 285, 322 9, 37-9; visionary, 358-61. See also Gothic African, Itumba: wooden mask, 127 period Age of Bronze, The (Rodin), 45–6 Arcologies, 360, 361 Agony in the Garden, The (El Greco), 98, Arena Chapel, Padua, Giotto frescoes, 224, 99, 101 Albers, Iosef, Solo V. 270 226, 227, 228, 234, 236, 239, 306 Arezzo frescoes. See Legend of the True Albright, Ivan Le Lorraine, 315–16, 318; Cross Into the World There Came a Soul Called Aristide Bruant in His Cabaret (Toulouse-Ida, 315, 316 Lautrec), 158, 160 Allegory of Deception (Queirolo), 44 Allegory of Man's Life, from Le grant ka-Aristotle with a Bust of Homer (Remlendrier et compost des Bergiers, 347 brandt), 251, 252 Arnolfini wedding picture (van Eyck). See Allston, Washington, 340-1, 343; American Marriage of Giovanni Arnolfini and Giov-Scenery, 340, 341; The Flight of Florimell, anna Cenami. 341, 343 Arrangement in Gray and Black, No. 1, Alto rilievo (high relief), 38 (Whistler), 10, 12, 13, 15, 19, 117-18, 129, American Scenery (Allston), 340, 341 145, 219, 277 Amiens Cathedral, choir vaults, 7 Art brut (art in the raw), 51 Analytical cubism, 126, 368 Artemis of Ephesus, 51 Anatomy Lesson of Doctor Tulp, The (Rembrandt), 196 Artist in His Studio, The (Vermeer), 116,

Abduction of Rebecca, The (Delacroix),

Anecdotal realism, 77-8

Anguish of Departure, The (Chirico), 338

Assemblage, 46, 312, 355-6 Athenodoros, Laocoön, 36 Audrey I (Snelson), 191–2 Audubon, John J., Brown Rat, 255, 256 Autun Cathedral tympanum, 353 Babel IIB (Soleri), 360, 361 Bahram Gur in the Turquoise Pavilion on Wednesday (Muzahib), 153, 154 Balance and counterbalance, 151, 191, 195; Last Supper composition, 169, 172; and motion, 36, 189-91, 198; 205-7; psychic, 206; solid forms in, 33-5, 118-19 Ballet Master, The (Degas), 285, 286 Balzac (Rodin), 46, 47 Bamboo arch: New Guinea davi, 55 Baroque period: Bernini's David, churches and dynamic space, 142; dramatic realism, 70-1, 352 Bas relief (low relief), 38–9; sculpture, 164–5 Bataille, Nicholas, Fall of Babylon, 352-3 Battle of Lapiths and Centaurs (Greek, early classical), 36-7 Battle of Naked Men (Pollaiuolo), 272-3, 277, 287 Bauhaus (Gropius), 88–9 Beasts of the Sea (Matisse), 143, 151, 152, 154 "Beaubourg." See Pompidou Center Beaux Arts, École des, 92–3 Becket Associates, Hyatt Regency, 92 Bellelli Family, The (Degas), 195, 197, 200-2, 201 Bernini, Gianlorenzo: David, 36-7, 45; Ecstasy of Saint Theresa, 71, 86, 352; Saint Peter's Colonnade, 139, 140 Binder, 219; egg, 241; in fresco, 221; and pigment, 220 Birthday (Chagall), 336, 337–8 Bishop, Isabel, Two Girls, 81, 82 Black Lines (Kandinsky), 131–2 Blake, Peter, Form Follows Fiasco: Why Modern Architecture Hasn't Worked, 93 Blake, William, 327-30, 339, 345, 347, 349; Archangel Raphael with Adam and Eve,

Art nouveau, 114-15, 366

Blake, William (cont.)

328, 332; illustration for Pastorals of Virgil, 264, 266; The Wise and the Foolish Virgins, 163-4, 327; Zacharias and the Angel, 329

Blind printing, 270

Blume, Peter, The Eternal City, 318-20, 337 Boating (Manet), 80, 81, 253

Boat off Deer Isle (Marin), 257

Boccioni, Umberto, 44; Unique Forms of Continuity in Space, 41-2

Böcklin, Arnold, 341; Island of the Dead, 339, 340; Triton and Nereid, 339

Books, and prints, 266-7, 286

Borromini, Francesco, San Carlo alle Quattro Fontane, 141, 142

Bosch, Hieronymus, 334-5, 337, 344; Creation of Eve, 330, 332, 333; Garden of Delights, 331, 332, 333; Hell, 330-2,

Botticelli, Sandro, 31; Calumny, 292-6, 293, 318, 348; Primavera, 159, 161, 162-3, 195, 292

Boucher, François, Toilet of Venus, 75, 298-9, 300, 301, 320

Boullée, Etienne-Louis, cenotaph for Sir Issac Newton, 358-60, 359

Brancacci Chapel frescoes (Masaccio), 225, 226, 227

Brancusi, Constantin, The Kiss, 32, 33-5; Torso of a Young Man, 35

Braque, Georges, 369; Musical Forms, 59-60, 62-3

Breaking Home Ties (Hovenden), 77-78,

Brera altarpiece (Piero). (See Madonna and Child with Saints and Angels.

Bronze, sculptural, 42–6

Brown Rat (Audubon), 255; 256

Bruegel the Elder, Pieter, 209, Flemish Proverbs, 211-12; Landscape with the Fall of Icarus, 209, 210-11, 216; Parable of the Blind, 212-13, 216

Brunelleschi, Santo Spirito, 66

Brushwork: de Kooning, 132; Marin's dragging of, 106, 255, 258; Sargent, 123, 132 Buddhist Assembly (unknown Chinese painter), 236-7

Buon fresco (true fresco), 221-8, 232, 369; crystalline film, 221, 229

Burial of Count Orgaz (El Greco), 100, 101 - 2

Burnham, D. H., & Co., Reliance Building,

Burning of the Houses of Parliament (Turner), 133, 134

Burr, 279–80, 367

Byzantine style, 231, 232-4, 235

Cabinet of Dr. Caligary, still from, 115, Calculation vs. spontaneity, 23, 96-8, 107, 192

Calder, Alexander, Little Spider, 42 Calligraphy, 142-3, 253

Calumny (Botticelli), 292-6, 293, 318, 348 Camera degli Sposi fresco (Mantegna), 146, 148

Canaletto, Clock Tower in the Piazza San Marco, 5-6

Cano, Alonso, Saint John of God. 86-7 Cantilever (Wright house), 54

Caravaggio (Michelangelo Merisi), 73; Conversion of Saint Paul, 70; Musicians, 187, 188, 191

Card Players, The (Cézanne), 185-8, 186 Carnival at Nice (Matisse), 151, 152

Carriera, Rosalba, Personification of Europe. 258, 259

Cartoon, 222-3

Casa Milá (Gaudí), 114, 115

Cassatt, Mary, The Fitting, 271

Castiglione, Giovanni Benedetto, Melancholia, 276-7

Cathedral. See Gothic period

Cave paintings, 228

Cennini, Cennino, Il Libro dell'Arte, 249 Cenotaph: Boullée's project for, 358-9

Centennial Certificate (Rauschenberg), 284 Centennial Exposition, Philadelphia, 48–51, 49-50

Cézanne, Paul, 26, 31, 186, 191, 216; Card Players, 185-8, 186; Mont Sainte-Victoire, 23, 24, 26, 131, 182, 203

Chagall, Marc, Birthday, 336, 337-8 Chardin, Jean-Baptiste-Siméon, 73-5, 77,

118; Governess, 74-5; Still Life, 74, 76, 299

Chariot of Apollo, The (Redon), 329-30 Chartres Cathedral, 7, 39-40

Children's art, 107

Chirico, Giorgio de, 337-9, 341; The Anguish of Departure, 338; Melancholy and Mystery of a Street, 337, 338

Christ Carried to the Tomb (Rembrandt). 277

Christina of Denmark, Duchess of Milan (Holbein the Younger), 155-8, 156

Christ on the Cross (Rubens), 108, 109, 110 Christ on the Cross with Landscape (El Greco), 110-11, 108

Cimabue, 234

City Street (nine-year-old child), 107 Classical composition, 202, 203; motion

and static figures, 191, 205-7; painterly technique, 216

Classicism, ideal, 66-9, 191, 232, 371 Clay, 44-6, 240

Clock Tower in the Piazza San Marco (Canaletto, 5-6

Close, Chuck, Nat, 83, 85, 86

Cole, Thomas, Manhood from Voyage of Life series, 348-9; The Titan's Goblet, 342, 343, ill. 342; View on the Catskill, 343-4, 345, 355

Collage, 46, 355; and lithography, 284; Matisse's Beasts of the Sea, 151, 152, 152

Color: application of, 81, 134; change, and fresco painting, 221-2; Mondrian's freeing of, 127, 129; Piero and, 137, 226; and two-dimensional composition, 147-58; warm-to-cool progression, 105-6; value of, 377

Colorism, 134–5

Colossal Head of Balzac (Rodin), 46

Columnar forms, 40, 182, 184

Combat of Minerva and Mars, The (David), 299, 301

Coming Home for Thanksgiving (Moses), 345, 346

Common man theme, 298-303

Commonplace subjects, 73-5, 81, 207 Company of Captain Frans Banning Cocq

and Lieutenant Willem van Ruytenburch, The (Rembrandt), 194, 195-8 Composite work of art, 8-9

Composition, 12-13, 15; Brera masterpiece, 185-6; Card Players, 185-8; classical. 173, 191, 202, 203-7; Degas, 20-1, 202, 206-7; function of, 145-6; group portraits, 195-202; Guernica, 177; Last Supper, 167–9, 172, 175, 188; linear, 159, 162–4; as narrative, 195-217; as pattern, 145-65; pictorial, 202, 216, 258, 306; pyramidal, 178; Raphael's Transfiguration, 172-3; rules for, 157-8; Seurat's pointillism, 217; sculptural and architectural, 191-3; spatial, 118–19, 180–4; storytelling pictures, 207-16; as structure, 167-91; testing, 12-13, 15, 61, 74, 122; triangular formula, 175–8, 188–9; two-cf. three-dimensional, 146-7; unbalance and motion, 188-91, 205-7; women's portraits compared,

Composition (Mondrian), 130

15 - 23.

Concept art: Kienholz's State Hospital, 312 Construction (Stankiewicz), 46, 47, 51

Construction of Volume Relations (Vantongerloo), 130, 131

Constructions, 355-8; linear and spatiodynamic, 41-3, 47

Convergence (Pollock), 132, 133

Conversion of Saint Paul, (Caravaggio), 70 Cornell, Joseph, Medici Slot Machine, 355–6 Cot, Pierre Auguste, The Storm, 29–31, 30 Couple with Shopping Bags (Hansen), 85.

86-7, 315, 317, 318

Craftsmanship and skill, 6, 30, 351; abstraction and, 121-2, 126, 132, 134; Cézanne. 26; Cot, 30; Gérôme, 77; Hicks, 27; and buon fresco, 224; Japanese art and Gauguin, 270-1; Marin, 106; Matisse, 150; Renoir, 17-18; and tempera, 238; Van Gogh, 97-8. See also Draughtsmanship Crayons, 258, 282. See also Lithography:

Pastel paintings Creation of Adam (Michelangelo), 218, 222 - 3

Creation of Eve (Bosch), 330, 332, 333

Cross-hatching, 244, 264

Crucifixion, 28; old masters compared, 108 - 11

Crucifixion (Follower of the Master of the Saint Francis Legend), 110–11

Crucifixion with the Virgin and Saints (Perugino), 174, 175-8, 216

Crystal Palace (Paxton), 89-90, 192 Cubi VII (Smith), 35-6

Cubism: analytical, 126; defined, 126; humanistic art, 320; Les Demoiselles, 123-7; space-time concept, 40, 126

Dada, 48

Dali, Salvador, Apparition of a Face, 335, 336, 337; Soft Construction, 335

Daumier, Honoré, 288, 292, 318; Print Collector, 362, 363; Rue Transnonain, 288, 289-90; La Soupe, 362

David, Jacques-Louis, 297, 318; Combat of Minerva and Mars, 299, 301; Death of Socrates, 297, 298-9, 300, 301-2, 320 David (Bernini), 36-7, 45 David (Donatello), 66

Davidsz de Heem, Jan, Still Life with Parrots,

da Vinci. Leonardo. See Leonardo da Vinci Davis, Joseph H., Esther Tuttle, 147-51, 149, 154, 157

Death of Adam, The (Piero), 222, 223 Death of Socrates, The (David), 298-302, 320, 297, 300

de Bandol, Jean, Fall of Babylon the Great City, 352

Declaration of Independence, The (Trumbull), 295-6, 298

Degas, Edgar, 20-1, 145, 195, 202, 206-7, 259-61, 285; Ballet Master, 285, 286; Bellelli Family, 195, 197, 200-2, 201; Portrait of Tourny, 287; Rehearsal in the Foyer of the Opera, 202, 204, 205-6; Woman Having Her Hair Combed, 261; Woman with Chrysanthemums, 19, 20-2, 145, 186, 195

de Kooning, Willem, Woman IV, 132 Delacroix, Eugène, 216; Abduction of Rebecca, 189-91, 190, 207, 341; Liberty Leading the People, 297-8

Demoiselles d'Avignon, Les (Picasso), 123, 125, 126-7, 154

Demon as Pirate (Klee), 349, 350, 351, 355 Denis, Maurice, 147

Depth, 146-7, 178, 180

de Sanctis, Francesco, Spanish Steps, 140, 141

De Stijl, 130-1

Destroyed City, The (Zadkine), 112, 322,

Diableries, 332-5

Diadoumenos (Polykleitos), 34-5, 40, 45,

Dinner of the Millionaires (Rivera), 304, 306 Discobolus (Myron), 207

Discovery of the True Cross (Piero), 137 Distortion: in architecture, 114–15; abstraction, 61-3; El Greco's, 101, 110; expressionism, 95-7, 99, 103, 107, 114, 145, 177; medieval Crucifixion, 111; Ruben's Crucifixion and lack of, 108; in sculpture, 111-14; and violence, 103, 177-8

di Suvero, Mark, untitled sculpture, 192 Donatello, David, 66; Saint George and the Dragon, 40, 41

Dramatic realism, 69-71, 108, 352

Draughtsmanship, 102-3, 222, 260, 282

Drawing: art brut, 51; full-scale, egg tempera painting, 241; monotype and, 285; on woodblock, 264. See also Intaglio prints Dreamscapes: American, 341–4, 348–9;

Blake, 327–30; Chirico, 338–41; Dali, 335, 337; Klee's *Demon*, 351; Rousseau, 344–5 Drying Clothes (Harunobu), 269, 270-1 Dry point, 279

Dubuffet, Jean, Nourrice Profuse, 2, 3, 5, 51 Duchamp, Marcel, "ready-made" sculpture, 46-8

Duel After the Masquerade, The (Gérôme), 75, 76, 77, 207-8

Dufy, Raoul, Yellow Violin, 59, 61-2

Durand, Asher B., Scene from Thanatopsis, 23-6, 24, 25, 131, 182, 203, 343

Dürer, Albrecht, Four Horsemen of the Apocalypse, 264, 265, 274; Hands of an Apostle, 244, 245; Melencolia I, 274-7, 275, 348; and woodblock prints, 263-5

Eagle-Headed Winged Being Pollinating the Sacred Tree (Assyrian), 38

Eakins, Thomas, Miss Van Buren, 78-80,

Eclecticism, 90–1

Ecstasy of Saint Theresa (Bernini), 71, 86,

Egg tempera, 220. See also Tempera painting Eiffel Tower (Eiffel, Gustave), 8, 56, 57 Einstein Tower (Mendelsohn), 115

El Greco, 31, Agony in the Garden, 98, 99, 101; Burial of Count Orgaz, 100, 101-2; Christ on the Cross, 108, 110-12; expressionism of, 99

Empress as Donor with Attendants (Chinese), 39

Empress Theodora and Attendants, 230,

Engineering: and functional structures, 92; architectural construction, 56, 192–3; Gothic cathedrals, 6-7

Engraving: use of burin in, 272, 274, 276; defined, 263; Dürer and, 274-7; gray tones, 274; and intaglio, 272

Enthroned Madonna and Child (Byzantine school), 234, 235

Estes, Richard, Supreme Hardware, 83, 84; Thom McAn, 83, 84

Esther Tuttle (Davis), 147-51, 149, 154, 157 Etching: defined, 263; and dry point, 279; cf. engraving, 277; and ground, 277; and intaglio, 272; original print, 287; stylus use, 279

Eternal City, The (Blume), 318-20, 337 Evocation of the Butterflies (Redon), 329 Executions of the Third of May, The (Goya), 290-2, 296, 320, 322

Exoskeletal architecture, 56-7, 192 Expressionism, 81, 95-115; in architecture, 57, 114-15; color distortion, 95, 97, 99, 107; distortion, 61-3, 95, 103, 111, 145; free vs. calculated, 95-8; and sculpture, 111-14

"Falling Water" (Wright), 54 Fall of Babylon the Great City, The (Bataille; de Bandol), 252-3

Fashion and taste, 28-31, 57, 68-9, 77, 90, 95; and Beaubourg, 56; pastels, 259; reaction to Cézanne, 186; Rockwell popularity, 11-15; Sargent's portraits, 123

Ferroconcrete, 369; Nervi construction, 193, 51

Figure with Raised Arms (Wotruba), 35 Fitting, The (Cassatt), 271

Fixative, 259, 261

Flatness, 146-7, 149, 158 Flattened relief (rilievo schiacciato), 40

Flemish painting, 210–11, 330–5 Flemish Proverbs (Bruegel the Elder), 211-212

Flesh tones, 244-5, 247, 250

Flight of Florimell, The (Allston), 341, 343

Florence, 66, 146, 159, 293-4 Flower Day (Rivera), 305, 306 F-111 (F-One-Eleven) (Rosenquist), 320, 321, 322

Foreshortening, 147

"Form follows function," 88-9, 115

Forms, 26, 74; in abstraction, 121; and cubism, 126; "follow the form" modeling, 244; Mondrian's universal, 129; ovals, 18, 22–3; Piero's abstractions, 138–9; Seurat, 216-17; solid volumes, 33, 35-6; spatial composition, 118-19; tempera painting, 247; underpainting and, 251. See also Composition; Distortion; "Form follows function"; Geometrical forms

Found object, 46, 48, 192

Four Horsemen of the Apocalypse (Dürer), 264-5, 274

Fourth dimension, sculptural, 41-2; and space-time, 40, 126

Fra Angelico, 246

Francesca, Piero della. See Piero della Francesca

Francesco Sassetti and His Son Teodoro (Ghirlandaio), 243, 244, 250

Freedom from Want (Rockwell), 11, 12 Fresco: Byzantine, 234-6; Oriental, 234-6; Piero's, 135, 138, 222-5, 228. See also Buon fresco; Fresco a secco

Fresco a secco, 228; Chinese, 236 Fuller, Buckminster, U.S. Pavilion, 360

Fuller, Thomas, Ottawa Houses of Parliament, 90

Functionalism, 87-92, 91 Funeral of Phocion, The (Poussin), 202-7, 204, 217

Futurism, 41

Gabo, Naum, Linear Construction, Variation, 42, 192

Garden of Delights The, triptych (Bosch), 331 - 3

Gargoyle, 330

Garnier, Charles, Paris Opéra, 90 Gaudí, Antoni, Casa Milá, 114, 115 Gaufrage, 270

Gaugin, Paul, 374; Manao Tupapao, 226, 269, 270-2; woodblock prints, 277, 284 Gentileschi, Artemisia, Judith and Holofernes, 71

Geodesic method, 360

Geometrical forms, 18, 23, 117; architecture and, 53; architectonic values, 184-6; cylinders, 35; and Gothic vaulting, 6-7; and sculpture, 33; triangle, 168-9, 175-8, 189. See also Forms

George Moore (Manet), 259-60

Géricault, Théodore, Raft of the Medusa, 187, 188-9, 341, 351

Gérôme, Jean-Léon, Duel After the Masquerade, 75, 76, 77, 79, 207-8

Gesso, 240, 242, 247, indented pattern

Gestural painting, 132, 143

Ghirlandaio, Domenico, Francesco Sassetti and His Son, 243, 244, 250

Giacometti, Alberto, Palace at 4 A.M.,

Giambologna (Giovanni Bologna), The Appenine, 354

Gilbert, Cass, Woolworth Building, 91 Gilding, 240-1, 242, 245, 246-7

Giorgione, Pastoral Concert, 326-7, 332, 341; Tempest, 324, 325-8, 341, 351

Giotto di Bondone, 110, 224-5, 228, 234, Arena Chapel frescoes, 224, 227; Lamentation Over the Body of Christ, 224, 226, 227, 306

Gislebertus, Last Judgment, 353

Glaze, 251, 253

Gold leaf. See Gilding

Gothic period, 114; cathedrals and churches, 6-8; exposed structure, 192; exteriors, 88; façade, 165; flying buttresses, 7, 56, 114; frescoes and mosaics, 110; gargoyles, 330; interiors, 142; cf. New Guinea davi, 54-5; Orvieto façade, 165; painted crosses, 110; sculptures, 7, 39-40, 353.

Gouache, 220

Governess, The (Chardin), 74-5

Goya, Francisco, Executions of Third of May, 290-2, 296, 320, 322; Old Man Among Ghosts, 278, 279

Gozzoli, Benozzo, Journey of the Magi, 144, 146-7, 154, 164

Gropius, Walter, Bauhaus, 88

Grotesques, 325; Bosch, 330–5; Bruegel, 211; Dali, 335; expressionist sculpture, 111–12; illuminated page with, 332 Ground, 277

Groundhog Day (Wyeth), 249 Guernica (Picasso), 176, 177-8, 216, 320,

321, 322 Gulf Stream, The (Homer), 257

Gum arabic, 220, 282 Gum fixative for pastels, 258-9

Hagesandros, Laocoön, 36 Hands of an Apostle (Dürer), 244-5 Hansen, Duane, 118; Couple with Shopping Bags, 85, 86-7, 315, 317, 318 Harlot's Progress, The (Hogarth), 308 Harnett, William Michael, 95, 117-18; Music and Good Luck, 58, 59-63, 117, 122 Harunobu, Suzuki, 267; Drying Clothes,

269, 270-1 Hatching, 370

Heckel, Erich, 264; Scene from Dostoevski,

Hell (Bosch), 330-333

Hicks, Edward, Peaceable Kingdom, 27 Hogarth, William, Harlot's Progress, 308; Marriage à la Mode, 308; Orgy, 313; Rake's Progress, 308-14, 309, 311, 313

Holbein the Younger, Hans, 150; Anne of Cleves, 156-157; Christina of Denmark, 155-8, 156

Homer, Winslow, Gulf Stream, 257; Sloop, Bermuda, 255, 256

Hopper, Edward, Nighthawks, 82, 318 Horizontal Tree (Mondrian), 129, 130 Hours of Jeanne de'Evreux (Pucelle), 332 Hovenden, Thomas, Breaking Home Ties, 77-8, 207

Hudson River School, 25, 343-4

Human body, 34-5, 40, 63, 66; Masaccio drawing of, 224; Rodin's bronze, 45; Rothko and, 135

Hurricane (eleven-year-old child), 107 Huys, Pieter, Temptation of Saint Anthony, 334

Hyatt Regency Hotel and Reunion Tower. Dallas (Becket Associates), 92

Hyperrealism, 81; function of, 83, 86–7; and Hansen, 86, 315

Ideal realism, 63, 298-302 Il Libro dell'Arte (Cennini), 249

Illuminated manuscript, 232, 348, 352; Hours, 332

Illusionism, 60–1, 352; mural painting, 146-7; photorealism, 83

Illustrations, for books, 264, 266-7, 285 "Image breakers," 233

Impressionism, 80; painterly techniques, 81, 216, 253

Individualism, 95, 98-9, 108, 270-1; and visionary paintings, 328, 330

Ingres, Jean-Auguste-Dominique, Madame Leblanc, 14, 15-16, 19, 23

Inkless print, 270

Intaglio prints, 272-80

Internal and External Forms (Moore), 138, 140

In the Meadow (Renoir), 17, 18

Into the World There Came a Soul Called Ida (Albright), 315, 316

Invenzione Capricciosa di Carceri (Piranesi), 358

I. P. Morris Blast Engine, 48, 49 Iron, 46, 51

Island of the Dead, The (Böcklin), 339, 340 Ivory sculptures, 43-4

Jakuchū, Itō, Animals and Plants, 143 Jefferson Memorial (Pope), 52, 53 Journey of the Magi (Gozzoli), 144, 146-7, 154, 164

Judith and Maidservant with the Head of Holofernes (Gentileschi), 71

Kamakura period (Japanese art): bull painting, 229

Kandinsky, Wassily, Black Lines, 131–2 Kienholz, Edward, State Hospital, 312 Kinetic art, 9, 42

Kirchner, E. L., Street Scene, 88, 106-7 Kiss, The (Brancusi), 33-5, 367

Kiyonobu I, Torii, 150; Woman Dancer, 154 - 5

Kiyotada, Torii, Actor Dancing, 155 Klee, Paul, 345, 347; Demon as Pirate, 349, 350, 351, 355

Kline, Franz: action painting, 143; New York, N.Y., 105-6, 132

Ko Chung-hsüan, after, Two Peaches on a Branch, 267, 269, 271-2

Kokoschka, Oscar, Tempest, 29-31, 30, 61 Kollwitz, Käthe, Summons of Death, 282 Kouros, 34, 40, 63

Lachaise, Gaston, 44, 51; Standing Woman, 32, 33; Torso, 32, 33 Ladies in Waiting. See Meñinas, Las

Lady in Blue (Matisse), 149, 150-1, 154 Lamentation Over the Body of Christ (Giotto), 224, 226, 227, 306

Landscape, 81, 129; classical composition, 203-5; Hudson River School, 343-4; romantic vs. classic, 23-6, 131, 180-2, 344 Landscape with Cattle (Rousseau), 344-45 Landscape with Farmhouse (Mondrian). 129

Landscape with the Fall of Icarus (Bruegel the Elder), 209, 210-11, 216

Laocoön and His Two Sons (Hagesandros, Polydoros, Athenodoros), 36

Lascaux cave paintings, 228

Last Judgment (Gislebertus), 353-4 Last Judgment (Michelangelo), 4, 5

Last Supper (Leonardo), 167-9, 172-3, 191, 193, 195; diagrammatic scheme, 166, 168, 169

Law and Justice (Orozco), 308

Legend of the True Cross (Piero), 135, 137, 138–9, 222–3, 225, 228

Leonardo da Vinci, 225, 253; architectural sketches, 360; cf. Caravaggio, 70; Last Supper, 166, 167-9, 168-9, 172-3, 191, 193, 195; Mona Lisa, 21-3, 106, 167; Virgin of the Rocks, 66–8, 67, 80

Lever House (Skidmore, Owings & Merrill),

Liberation of the Peon, The (Rivera), 303-4,

Liberty Leading the People (Delacroix),

Lichtrequisit (Moholy-Nagy), 42

Light and dark: in abstraction, 121; Blake and, 329; Cezanne and, 26; in Degas' Rehearsal, 207; "follow the form" modeling, 244; in impressionist paintings, 371; and Moholy-Nagy sculpture, 42; Rembrandt and "spotlight," 79, 279; tempera painting, 247, 249; tenebroso, 70-1; colors used in underpainting, 251; value of color, 377; Velazquez, 72-4

Line: Blake and Botticelli analyzed, 159, 162-4, 292; engraved, 272; etched, 277; Mondrian's freeing of, 127, 129; "shaded" in engraving, 274; two-dimensional composition and, 147-9, 154-5, 159. See also Triangular formula

Linear construction, 41–2, 192

Linear Construction, Variation (Gabo), 42, 192

Linear perspective, 40

Linoleum cut print (linocut), 266

Lithography: method, 280, 282; offset printing, 284

Little Spider (Calder), 42 Low relief. See Bas relief

Lozenge in Red, Yellow and Blue (Mondrian), 127, 128, 129

McArthur, Jr., John, Philadelphia City Hall, 57

Machinery, 48-51, 49; and sculpture, 46 Machinery Hall, Philadelphia, 48, 49 Madame Leblanc (Ingres), 14, 15-16, 19, 23 Madonna and Child with Saints and Angels Adored by Federigo da Montefeltro (Madonna of the Egg) (Piero), 182, 183-5 Madonna and Nativity paintings, 175-6

Madonna Enthroned Between Saints Peter and Leonard (Magdalen Master), 239–40 Madonna of Mercy (Piero), 182, 184 Maidens and Stewards (Parthenon), 165 Manao Tupapao (She Thinks of the Spirit) (Gauguin), 266, 269, 270–2

Manet, Edouard, 31; Boating, 80, 81, 253; George Moore, 259–60

Manhood (Cole), 348-9

Mannerism, 31

Mantegna, Andrea, Camera degli Sposi, fresco, 146, 148

Man with the Hoe, The (Millet), 302–3 Marilyn Monroe (Warhol), 285, 286 Marin, John, Boat off Deer Isle, 257–8;

Singer Building, 103, 105–7, 117 Marriage à la Mode (Hogarth), 308

Marriage of Giovanni Arnolfini and Giovanna Cenami (Van Eyck), 27–8, 29, 250 Martyrdom of Saint Sebastian (Pollaiuolo), 178, 179, 180, 191, 272

Masaccio, 224, 228; Tribute Money, 225, 226, 227

Master of Pedret, Virgin and Child Enthroned, 231, 232, 234

Material values, 315, 318, 322

Matisse, Henri, 369; Beasts of the Sea, 143, 147–8, 150–1, 152, 154; Carnival at Nice, 151, 152; Lady in Blue, 149, 150–1, 154; illustration for Pasiphäé, Chant de Minos, 266, 267; Reclining Nude, 164

Medici family and palace, 146, 293–4 Medici Slot Machine (Cornell), 355–6 Medicyal art. See Middle Ages

Medieval art. See Middle Ages

Medium, 219-20, 249

Melancholia (Castiglione), 276, 277 Melancholy and Mystery of a Street (Chirico), 337, 338

Melencolia I (Dürer), 274–7, 275, 348 Mendelsohn, Erich, Einstein Tower, 115 Meñinas, Las (Velázquez), 72–3

Metal plates: dry point, 279; aquatint tonalities, 277, 279; engraving, 272, 274; etching, 277

Metropolis, still from, 361

Mexican Renaissance, 228, 303–4, 306 Mezzo rilievo (medium relief), 38–9

Mezzotint, 280

Michelangelo, 135; Creation of Adam, 218, 221–3, 222; Last Judgment, 4, 5; Sistine Chapel ceiling, 221–2, 225, 328

Microtemps (Schöffer), 42-3

Middle Ages: faith, 6–8; fantasies and grotesqueries, 325, 330–5; and human body, 34; journeyman painters, 111, 238–9; mystical realism, 64–6, 330; panel painting and altarpiece formula, 232–3; Shepherd's Calendar, 347; unrealistic images, 233–4; visionary sculpture, 352–4; woodcut images, 263. See also Baroque period; Gothic period

Mies van der Rohe, Ludwig, Seagram Build-

ing, 91

Mi Fu, "Sailing on the Wu River," 142, 143 Millet, Jean François, Man with the Hoe, 302–3; Sower, 302

Miniature paintings: Persian, 154; van Eyck's Saint Francis, 64–5

Minor masters, 238, 246

Miss Van Buren (Eakins), 78-80, 79

Mobile: Calder's, 42, 51; motorization of, 42

Modeling, 147, 150, 158; by cross-hatching, 244, 264; "follow the form," 250

Modena, Tommaso da, 246

Modern art, 11, 23; anarchic techniques, 253; anti-art, 48, 87, 285; concept art, 312, 368; expressionist movement, 98–9; found objects and machinery, 43, 46, 48, 51, 192; and prints, 284; Seurat's place in, 217; straight painting, 253; and tempera technique, 249. See also Abstraction; Abstract Expressionism; Cubism; Futurism; Surrealism

Moholy-Nagy, László, Lichtrequisit, 42; System of Dynamo-Constructive Forces (manifesto), 42

Mona Lisa (Leonardo), 21-3

Mondrian, Piet, 129–30, 134, 147; Composition, 130; Horizontal Tree, 129, 130; interview with, 127, 129; Landscape with Farmhouse, 129; Lozenge in Red, Yellow and Blue, 127, 128, 129; Tree, 130

Mondsee Gospels, 44, 45

Monet, Claude, 31, 81

Monotype, 285

Mont Sainte-Victoire (Cézanne), 23, 24, 26, 131, 182, 203

Moonlight Marine (Ryder), 349, 350 Moore, Henry, Internal and External Forms, 138, 140; Reclining Figure, 139, 140

Mosaic, 232-4, 236

Moses, Anna Mary Robertson (Grandma), Coming Home for Thanksgiving, 345, 346

Motion. See Balance and counterbalance Motorized sculpture, 42–3

Mural paintings, 7, 146–7, 221; Chinese, 236; Rivera, 304

Murals (Rivera), Ministry of Education courtyard, 304

Musical Forms (Braque), 59–60, 62–3 Music and Good Luck (Harnett), 58, 59–63, 117, 122

Musicians, The (Caravaggio), 187, 188, 191 Muzahib, Mahmud, Bahram Gur, 153, 154 Myron, Discobolus, 207

Mystical realism, 64-5, 330

Mystical subjects, 66, 108-11, 325

Naïveté, 328, 344-5. *See also* Primitive art *Nat* (Close), 83, 85, 86

Naturalism, 60-1, 63, 108

Nature, 42, 140; and art nouveau, 114; classic vs. romantic landscape, 25–6, 343; "dynamic equilibrium" of, 129–30; transformation of, 8–9, 95

Neo-classical style: David's Death of Socrates, 298–302

Neo-Gothic style, 90

Nervi and Vitellozzi, Palazzetto dello Sport, 192, 193

Nevelson, Louise, Sky Cathedral, 356–8, 357

New Guinea *davi* (ceremonial house), 54–5 New Testament, 70; Book of Revelation, 264–5, 352–3

New York, N.Y. (Kline), 105, 132 New York school, 132 Nighthawks (Hopper), 82, 318 Night Watch, The (Rembrandt). See Company of Captain Frans Banning Cocq. Nike of Samothrace (Winged Victory), 41–2 Nîmes, 193

Nineteenth century, 7–8, 11, 37, 123, 200; in America, 25–6, 77–8, 341; architectural styles, 92–3; common and practical themes, 19–20, 75, 320; demolition, 57; French Academy and, 30–1; and machines, 48, 51; socially conscious art, 289–92

Nocturne (Whistler), 277, 278

Nonobjective (nonfigurative) art, 117, 127–30, 134

North Dakota missile-tracking station, 91, 92

No Swimming (Rockwell), 11, 12 Nourrice Profuse (Dubuffet), 2, 3, 5, 8, 51 Nude Woman (Picasso), 216 Nydia, the Blind Flower Girl of Pompeii

(Rogers), 78

Objective optical realism, 72–3, 80–1 "Occult" balance, 206
Oil painting, 220, 250–3

Old Man Among Ghosts (Goya), 278, 279 Old Testament, 27

One of the Ten Fast Bulls (unknown Japanese painter), 229

Open form, 36–7, 41–2, 139 Opéra, Paris (Garnier), 8 90, 92, 93

Optical realism, 72-3, 80-1

Orange and Yellow (Rothko), 134–5, ill. 136 Order, 22, 26; out of chaos, art function, 3–9, 64, 193; and classicism, 191, 203

Orgy (Hogarth), 313

Orozco, José Clemente, 306; Law and Justice, 308

Orvieto Cathedral, 165

Ottawa Houses of Parliament (Fuller), 90 Overpainting, 251

Paint: ready-made, 253; silk-screen stencil, 284. See also Oil; Tempera

Painterly techniques, 74, 216–17, 219–20; buon fresco, 221; with oil, 250–1; with tempera, 238–9. See also Brushwork; names of artists

Painting: and artist's personality, 11, 15, 37–8, 335; cartoons, 222–3; changing ideas and taste, 28–31; emotion *vs.* intellect, 23–6; as expression of its age, 5–8, 11, 15, 30–1, 335; journeymen and apprentices, 111, 238–9; at second level, 77–8; symbolism and disguise, 27–8; union with architecture and sculpture, 9 *Palace at 4 A.M., The* (Giacometti), 354–5 Palazzetto dello Sport (Nervi and Vitellozzi), 192, 193

Panel painting, 232, 238–40

Parable of the Blind, The (Bruegel), 212-13, 216

Paris, 8, 48, 57; Opera House (Garnier), 8, 90, 92, 93; Pompidou Center, 54–7; Rue Transnonain, 289–90

Parthenon, 3–5, 7–8, 44; Athenian procession from frieze, 39, 164–5

Pasiphäé, Chant de Minos, illustration for (Matisse), 266, 267

Passion of Sacco and Vanzetti (Shahn), 292, 294, 295–6, 301–2, 318

Pastel paintings, 258-61

Pastoral Concert (Giorgione), 326-7, 332, 341

Pastorals of Virgil, illustration for (W. Blake), 264, 266

"Path at Pine and Brook" (Ping-shou), 142, 143

Pattern, 145–65; of line, 159, 162–4; of shapes and colors, 146–59

Paxton, Joseph, Crystal Palace, 89, 90 Peaceable Kingdom, The (Hicks), 27

Peale, Charles Willson, *Peale Family*, 195, 197, 199, 198–200, 206

Peale Family (Peale), 195, 197, 199, 198–200 Pediments, 36–7, 38

Persian painting, 154

Personification of Europe (Carriera), 258, 259

Perspective, 6, 140, 147–8, 159, 185, 205; and abstraction, 121; beginnings, 224; in *Last Supper*, 167–9

Perugino, Pietro, Crucifixion with the Virgin and Saints, 174, 175–8, 216

Philadelphia City Hall and Tower (Mc-Arthur), 57

Photographic art techniques, 263, 284 Photography, 5–6, 105; vs. abstraction, 118; capturing of space, 140, 142

Photorealism, 82–3 Piazza San Marco, 5–6

Picasso, Pablo, 11, 147; Demoiselles d'Avignon, 123, 125, 126–127, 134, 154; Guernica, 176, 177–8, 216, 320, 321, 322; linocuts, 266; Nude Woman, 126; Seated Woman, 267; Studio, 118–22, 121, 126–7, 129, 320; Woman in White, 253–4

Picture plane, 205–6
Piero della Francesca, Death of Adam, 222–3; Legend of the True Cross, 135, 137, 138–9, 221–3, 225, 228; Madonna and Child, 182, 183–5; Madonna of Mercy, 182, 184

Pietà, 112-114, 113

Pigment, 219, 374; cave paintings, 228; and mixing, 219–20; tempera, 241, 244; in water color, 255, 258

Ping-shou, "Path at Pine and Brook," 142, 143

Piranesi, Giovanni Battista, Invenzione Capricciosa di Carceri, 358; Temple of Castor and Pollux, 358

Planar process, prints, 280–5 "Plane surface," 147, 205

Plaster: drying of, 221, 229; cf. gesso, 240. See also Buon fresco

Plus and minus compositions, 130

Pointillism. See Seurat

Pollaiuolo, Antonio del, Battle of Naked Men, 272, 273, 274, 276; Martyrdom of Saint Sebastian, 178, 179, 180, 191, 272 Pollock, Jackson, 132–4; Convergence, 132, 133

Polydoros, Laocoön, 36

Polykleitos, *Diadoumenos*, 34–5, 40, 45, 63 Pompeiian wall painting, 229–32 Pompidou Center, 54–7, 192 Pont du Gard, Nîmes, 193 Pop art, 285, 322

Pope, John Russell, Jefferson Memorial, 52 Portals, 39–40

Portrait Head of a Man, Roman, 63–4 Portrait of a Lady (van der Weyden), 248–9, 250

Portrait of Madame Renoir (Renoir), 16–23, 17, 30, 33, 186

Portrait of Tourny (Degas), 287

Portraits: pastels, 259; of women compared, 15–23; Miss Van Buren, 78–80, 79

Poster art, 158–9, 284 Post-Impressionism, 216–17

Pouncing, 223

Poussin, Nicholas: Funeral of Phocion, 202-7, 204, 217; Rape of the Sabine Women, 171, 173, 191, 203-5, 216

Première Pose, La (Roberts), 48, 50, 51
Primavera (Botticelli), 159, 162; "Three Graces" from, 161, 162–3, 195, 292
Primitive art, 148; Esther Tuttle, 149–50

Print Collector, The (Daumier), 362, 363
Prints, 263–87; development of, 263–4, 284–5, 287; limited edition, 287; original, 287. See also names of various techniques, i.e., Engraving; Etching; Lithography
Proletarian Victim (Siqueiros), 308, 307
Prometheus Bound (Rubens), 69–70, 207

Propagandist art, 304, 306, 308 Psychic balance, 206

Pucelle, Jean, Hours of Jeanne d'Evreux. 332

Quadrivium, 371

Queirolo, Francesco, Allegory of Deceptipn, 44

Radome, U.S. Air Force, 360

Raft of the Medusa, The (Géricault), 187, 188–9, 341, 351

Rake's Progress, The (Hogarth), 308–314 Rape of the Sabine Women (Poussin), 171, 173, 191, 203–5, 216

Raphael, 312, 328; analysis of, 225; School of Athens, 225, 227, 228; Transfiguration, 170, 172–3, 175

Rattlesnake (Aztec), 306

Rauschenberg, Robert, Centennial Certificate, 284

Ready-made paint, 253

"Ready-made" sculpture, 46-8

Realism, 59–93; cf. abstraction, 60, 62–3; anecdotal, 75–8; architectural, 57, 87–93; and Byzantine style, 233; commonplace themes, 73–5, 79–80; dramatized, 68–71; cf. expressionism, 59, 61–2, 95; Giotto frescoes, 219; hyperrealism, 83, 86–7, 315, 318; ideal, 63–4, 177; illusionism, 60–1, 74; impressionism, 80–1; mystical, 64–5, 110–11; objective, 72–3, 83; photorealism, 82–3; Renaissance, 66–8; sculptural, 86–7; See also Social criticism and realism

Reclining Figure (Moore), 139, 140 Reclining Nude (Matisse), 164 Red and Blue Chair (Rietveld), 130, 131 Redon, Odilon, Chariot of Apollo, 329–30; Evocation of the Butterflies, 329 Refectory, 375

Rehearsal in the Foyer of the Opera (Degas), 202, 204, 205-6

Reliance Building (Burnham & Co.), 90 Relief, 38–40

Relief print, 263-71, 280

Rembrandt, Anatomy Lesson of Dr. Tulp, 196; Artistotle with a Bust of Homer, 251, 252; Christ Carried to the Tomb, 277; Company of Captain Frans Banning Cocq, 194, 195–8; etchings, 263, 277, 279–80; humanistic art, 11; realism, 70; "spotlight" effect, 79, 279; Three Crosses, 279–280, 281

Renaissance, 9, 175, 306, 372; frescoes, 224–5, 232; High, and painters of, 71–2; ideal classicism, 22, 66–9; tempera panel paintings, 238–45; three-dimensional composition, 180. See also Baroque period; names of artists

Renoir, Pierre Auguste, 31; In the Meadow, 17, 18; Portrait of Madame Renoir, 16–23, 17, 33, 117, 186

Reproductions, 15, 78, 284, 372; bronze sculpture, 44; literal, 87; original prints, 287. See also Prints

Resin, 277, 279

Restoration technique, 239-40

Rietveld, Gerrit, *Red and Blue Chair*, 130, 131; Schröder House, 130

Rilievo schiacciato, 40

Rivera, Diego, 303; Dinner of the Millionaires, 304, 306; Flower Day, 305, 306; Liberation of the Peon, 304, 306; murals, 304, 306, 318

Roberts, Howard, La Première Pose, 48, 50,

Rockwell, Norman, Freedom From Want, 11, 12; No Swimming, 11, 12; and Whistler's Mother, 12–13, 15

Rodin, Auguste, Balzac, 46, 47; Colossal Head of Balzac, 46; The Age of Bronze, 45–6

Rogers, Randolph, Nydia, 78

Romantic movement (Romanticism), 23, 189–92; in America, 25–6, 341–3; peasant ideal, 302

Romantic space, 182; Abduction of Rebecca, 189

Rome: architecture, 8, 140–2; Blume's Eternal City, 318–20

Rosenquist, James, F-111, 320, 321, 322 Rothko, Mark: colorism, 134–5; Orange

Röttgen Pietà, 112–14, 113

and Yellow, 136

Rouault, Georges, Two Nudes, 102–3, 104 Rousseau, Henri "Douanier," Landscape with Cattle, 344–5; Sleeping Gypsy, 345, 346

Rubens, Peter Paul, 73, 80; Christ on the Cross, 108, 109, 110; Prometheus Bound, 69–70, 108

Rue Transnonain, April 15, 1834 (Daumier), 288, 289–90

Ryder, Albert Pinkham, 220; Moonlight Marine, 349, 350

Saarinen, Eero, TWA Terminal, 115, 193 "Sailing on the Wu River" (Mi Fu), 142–3

Saint Anthony Tempted by the Devil in the Form of a Woman (Sassetta), 208-209, 334-5 Saint Christopher and Saint John the Baptist, German hand-colored woodcut, 267, 268 Saint Francis Receiving the Stigmata (Van Eyck), 64, 65, 68, 72, 80, 86, 330 Saint George, Bishop (Byzantine, unknown Russian painter), 231 Saint George and the Dragon (Donatello), 40, 41 Saint John of God (Cano), 86-7 Saint Matthew (Mondsee Gospels miniature), 44, 45 Saint-Nectaire Church, 88 Saint Peter (Stwosz), 86 139, 140 vaulting, 6 Lautrec), 313, 314 romini), 141, 142 Santo Spirito (Brunelleschi), 66 132, 134

Saint Peter's, Rome, 7; Colonnade (Bernini), Saint Peter's Cathedral, Beauvais, choir Salon in the Rue des Moulins (Toulouse-San Carlo alle Quattro Fontane, Rome (Bor-Sargent, John Singer: and gestural painting, 132, 134; Wyndham Sisters, 122-3, 124, Sassetta, Saint Anthony Tempted by the Devil, 208–209, 334–5 Savonarola, 294 Scene from Dostoevski (Heckel), 266 Scene from Thanatopsis (Durand), 23-6, 24, 25, 131, 182, 294, 343 Shöffer, Nicholas, Microtemps, 42-3 School of Athens (Raphael), 225, 227 Schröder House (Rietveld), 130, 131 Script, ornamental, 154 Sculpture, 33–51; Baroque theatricality, 71; closed vs. open forms, 34-7, 139; composition, 146; constructions, 42, 192, 355-8; degree of relief, 38-40; De Stijl, 130; expressionist, 111-14; fertility symbols, 33-6; found objects, 46, 48, 192; fourth dimension, 40–2; "garden," 354; Gothic cathedrals and, 7, 38–40; Greek and Roman, 34–5, 63–4; Hansen, 86–7; low relief and two-dimensions, 164-5; mobiles, 42–3, 51; modern vs. traditional, 42-51; negative volumes, 139-40; of protest, 322; Renaissance, 66; with sound, 43; surrealist, 354-5; visionary, 351-5; woods and stone used, 43-4. See also Relief; Realism (Toulouse-Lautrec), 282, 283

Seagram Building (Mies van der Rohe), 91 Seated Clownesse, Mlle. Cha-u-ka-o, The Seated Woman (Picasso), 267 Seeon Monastery Pietá, 112, 114 Segal, George, Subway, 318 Semi-abstraction, 117, 322 Serigraph. See Silk-screen print Seurat, Georges, 374; Sunday Afternoon on La Grande Jatte, 214, 215, 216-17 "Shaded line," 274 Shahn, Ben, Passion of Sacco and Vanzetti, 292, 294, 295-6, 301-2, 318 Sienese Virgin and Child, 240-1, 242, 244, 245, 246-7

Silk-screen print, 284–5

Singer Building (Marin), 103, 105-7, 117 Siqueiros, David Alfaro, 372; Proletarian Victim, 307, 308 Sistine Chapel ceiling (Michelangelo), 5, 225, 328 Skidmore, Owings & Merrill, Lever House, Skyscrapers, 9, 90-1, 93 Slab architecture, 91-2 Sleeping Gypsy, The (Rousseau), 345, 346 Sloop, Bermuda (Homer), 255, 256 Smith, David, 46, 51; Cubi VII, 35; Volton XV, 47 Smithson, Robert, Spiral Jetty, 8 Snelson, Kenneth, Audrey I, 191-2 Social criticism and realism, 289-323; American urban loneliness, 82, 292, 312, 315. 318: in France, 289-90, 298-301, 302-3, 314; Germany, 106-7; Hogarth's Rake's Progress, 308–14; injustice, 292–8; Mexico, 303-8; politics and war, 290-2, 318-22; morality and prostitution, 102-3, 310, 312, 314–315 Soft Construction with Boiled Beans: Premonition of Civil War (Dali), 355 Soleri, Paolo, Babel IIB, 360, 361 Solid volumes: interpenetration of, 41–2, 184; Card Players, 186, 188; De Stijl, 130; spatial composition and, 118–19. Solo V (Albers), 270 Sound sculptures, 43 Soupe, La (Daumier), 362 Soviet art, 306 Sower, The (Millet), 302 Space: architectonic values and, 185-8; classical, 182, 189, 203; closed form, 33-4, 36-7; depth and three-dimension, 147, 180, 182; fourth dimension, 40-2; dynamic, 142; negative volume, 139-40, 184; open form, 36-7; romantic, 182, 189; shaped, in architecture, 140-2 Space-time concept; and cubism, 126; in sculpture, 40-3 Spanish Steps, Rome (de Sanctis), 140, 141 Spatial composition, 118–19, 180, 182, 184-6, 188 "Spatiodynamic" construction, 42, 43 Spiral Jetty (Smithson), 8 Spotlight effect, 79 Stained glass, 7, 367 Standing Goddess (Aztec), 306 Standing Women (Lachaise), 32, 33 Stankiewicz, Richard, Construction, 46, 47, Starry Night, The (Van Gogh), 94, 96-9, 101, 219, 349 Star Wars, still from, 360, 361 State Hospital, The (Kienholz), 312 Steinberg, Saul, 91 Stencil, 284 Stigmata: Saint Francis painting, 64-65 Still-life painting, 73–5, 118 Still Life with a White Mug (Chardin), 74, Still Life with Parrots (Davidsz), 74 Stone drawing. See Lithography Stonehenge, 52, 53, 55 Storm, The (Cot), 29-31, 30 Storytelling paintings, 207-16

Street Scene (Kirchner), 88, 106-7

Stryge, La (Viollet-le-Duc), 330 Studio, The (Picasso), 118–22, 121, 126–7, 129 Stwosz, Wit, Saint Peter, 86 Stylus, 277, 279, 376 Subway (Segal), 318 Subway, The (Tooker), 318, 319 Summons of Death, The (Kollwitz), 282 Sunday Afternoon on the Island of La Grande Jatte (Seurat), 214, 215, 216-17 Superrealism, 81 Supreme Hardware (Estes), 83, 84 Surrealism, 81-2, 335, 337; Giacometti's Palace, 354-355; realism with fantasy, Symbols: Arnolfini wedding picture, 28; Botticelli's Calumny, 293; Dürer cf. Castiglione, 276-7; in Goya's Executions, 292; medieval, 142, 347; Renoir's universal, 18, 21 Tableau, 312 Taliesin East (Wright), 54 Tapestries, 7, 146; Chinese, 236; Fall of Babylon, 352-3 Tempera painting, 249, 329; preciseness and technique, 220, 238-50 Tempest, The (Giorgione), 324, 325-8, 341, Tempest, The (Kokoschka), 29-30, 61 Temple of Castor and Pollux (Piranesi), 358 Temptation of Saint Anthony (Huys), 334 Tenebroso, 71 Tensegrity, 192 Tessera, 233 Textures: and aquatints, 279; Braque's use of, 62; Harnett's illusion of, 60; Marin and water color, 106; monotype print, 285; and oil painting, 250; of paper, water color, 255, 258; for pastel, 258; Picasso, 7, 121, 253; swift brushwork and, 249; in tempera painting, 247 Theatricality, 115. See also Dramatic realism Thom McAn (Estes), 83, 84 Thousand Buddhas (Japanese), 262, 263 Three Crosses (Rembrandt), 279-80, 281 Three-dimensional composition, 146, 150-1; Brera altarpiece, 184-5; Caravaggio and Cezanne cf., 185–8; depth in space, 178, 180, 182, 184; techniques of, 159; triangular composition, 178; vs. two-dimensional, 147, 184 Three-dimensional relief, 38, 40 Time, 56; and space, 40 Titan's Goblet, The (Cole), 342, 343 Titian, Venus and Adonis, 251, 252 Toilet of Venus, The (Boucher), 75, 298-9, 300, 301, 320 Tooker, George, The Subway, 318, 319 Torso (Lachaise), 32, 33 Torso of a Young Man (Brancusi), 35 Toulouse-Lautrec, Henri de, Aristide Bruant, 158, 160; lithographs, 284; pos-

ters, 158–9; Salon in the Rue des Moulins,

313, 314; Seated Clownesse, Mlle. Cha-u-

ka-o, 282, 283

Transfiguration (Raphael), 170, 172-3, 175 Transparent sculpture, 42, 192

Tree (Mondrian), 130

Triangular formula: altarpieces, 175; Guernica, 177; Last Supper, 168-9, 175; Martyrdom of Saint Sebastian, 178; offbalance and motion, 189; Perugino's Crucifixion, 175-7

Tribute Money (Masaccio), 225, 226, 227 Triptychs, 177, 182, 331, 332, 333 Triton and Nereid (Böcklin), 339

Trivium, 7

Trumbull, John, Declaration of Independence, 295-298

Turner, J. M. W., Burning of the Houses of Parliament, 133, 134

Tusche, 282

TWA Terminal (Saarinen), 115, 193

Twentieth century, 11, 270; American artists, 82-7, 106-7, 292, 312, 315, 318; Guernica, 278, 320; New York as composite work of, 8-9; sculptural materials, 43; Van Gogh's Starry Night, 98-9; visionary art, 337-43

Two-dimensional composition, 146-65; linear design, 159, 162-5; Oriental, 154-5; portraits compared, 149-58; primitive, 147-9; shift from, 178, 180

Two Girls (Bishop), 81, 82 Two Nudes (Rouault), 102-3, 104 Two Peaches on a Branch (Ko Chunghsüan), 267, 269, 271-2 Tympanum, 352–3

Underpainting, 251, 253 Unique Forms of Continuity in Space (Boccioni), 41-2 Unmodeled space, 158 U.S. Pavilion, Expo '67 (Fuller), 360

Van der Weyden, Rogier, Portrait of a Lady, 248-9, 250

Van Eyck, Jan, Marriage of Giovanni Arnolfini, 27-8, 29, 250; Saint Francis Receiving Stigmata, 64, 65, 72, 80, 86-7, 330

Van Gogh, Vincent, 216, 219; Starry Night, 94, 96-9, 349

Van Ruisdael, Jacob, Wheatfields, 180, 181, 182

Vantongerloo, Georges, Construction of Volume Relations, 130, 131

Vaults: bamboo davi, 54-5; and buttresses, 56-7; engineering of, 6-7

Velázquez, Diego, 74, 80-1, 83; Las Meñinas, 72-3

Venus and Adonis (Titian), 251, 252 Venus of Willendorf, 32, 33, 35-6, 46, 51; grotesqueness of, 111-12

Vermeer, Jan, 207; Artist in His Studio, 116, 118-22, 120, 138, 182, 204

Verrazano-Narrows Bridge, 193

View on the Catskill, Early Autumn (Cole), 343-4, 345, 355

Violence in art, 289-92

Viollet-le-Duc, Eugène Emmanuel, La Stryge, 330

Virgin and Child Enthroned (Master of Pedret), 231, 232, 234

Virgin and Child with Saint Jerome (Sienese artist), 240-1, 242, 244, 245, 246-7

Virgin Mary, 111, 374; Giotto and, 224, 234; Pietà sculptures, 112-14. See also Madonna and Nativity paintings

Virgin of the Rocks (Leonardo), 66-8, 67, 80 Vision of Saint John, The (Saint-Pierre Church Tympanum), 352

Visionary paintings, 325-61; Bruegel, 211-13, 216; Klee, 345, 347, 349-51; Middle Ages and, 330-5; Surrealists, 335, 337, 354-5. See also Dreamscapes

Vitellozzi and Nervi, Palazzetto dello Sport, 192, 193

Void, 139-40, 184

Volton XV (Smith), 47

Warhol, Andy, Marilyn Monroe, 285, 286 Water-color painting, 220, 254, 255, 257–8; Water-color painting (cont.) Blake, 329; and Chinese woodcut, 267. See also Marin, John

Watteau, Jean Antoine, 220

Wax: and bronze, 44; and etching, 277 Wheatfields (van Ruisdael), 180, 181, 182 Whistler, James Abbott McNeill, Arrange-

ment in Gray and Black, 12, 15, 19, 117-18, 129; composition, 10, 13, 145; painterly technique, 219; Nocturne, 227, 278

Whistler's Mother. See Arrangement in Gray and Black, No. 1

Winged Victory, 41-2

Wise and The Foolish Virgins, The (Blake), 163-4.327

Woman Dancer with Fan and Wand (Kiyonobu I), 154-5

Woman IV (De Kooning), 132

Woman Having Her Hair Combed (Degas),

Woman in White (Picasso), 253-4

Woman Playing the Kithara (unknown Roman painter), 230, 232-3

Woman with Chrysanthemums (Degas), 19. 20-2, 145, 186

Woodblock prints, 154-5, 263-72; color development and Gauguin, 267-72; Dürer and, 264; medieval allegory, 347-8

Woodcut and wood engraving, distinction,

Woolworth Building (Gilbert), 91

Wotruba, Fritz, Figure with Raised Arms, 35

Wright, Frank Lloyd, "Falling Water," 54: Taliesin East, 54

Wyeth, Andrew, Groundhog Day, 249 Wyndham Sisters (Sargent), 122-3, 124, 132

Yellow Violin, The (Dufy), 59, 61-2 Young Horseman (classical Greece), 38

Zacharias and the Angel (Blake), 329 Zadkine, Ossip, Destroyed City, 112, 322,

			·
		*	
	¥		

A Note About the Author

John Canaday was born in Fort Scott, Kansas, and educated at the University of Texas and Yale University. He has taught art history at various universities. For six years he worked as an administrator and lecturer at the Philadelphia Museum of Art, where he directed the Division of Education. From 1959 to 1976 he was the art critic for *The New York Times*. In 1977 he toured South America lecturing on North American art for the State Department. He is the author of fourteen other books, including *Mainstreams of Modern Art* (1959), *Embattled Critic* (1962), *Culture Gulch* (1969), and seven mystery novels published under a pseudonym. He lives with his wife in New York City.

A Note About the Type

The text of this book was set in *Trump Mediaeval*. Designed by Professor Georg Trump in the mid-1950's, Trump Mediaeval was cut and cast by the C. E. Weber Typefoundry of Stuttgart, West Germany. The roman letterforms are based on classical prototypes, but Professor Trump has imbued them with his own unmistakable style. The italic letterforms, unlike those of so many other typefaces, are closely related to their roman counterparts. The result is a truly contemporary type, notable both for its legibility and versatility.

This book was composed by Monotype Composition Company, Inc., Baltimore, Maryland, who also shot the black-and-white illustrations. The color reproductions were separated by Offset Separations Corporation, New York and Turin, Italy. The book was printed and bound by the Kingsport Press, Kingsport, Tennessee.

Typography and binding design by Robert Aulicino.

Kidney Disease

From advanced disease to bereavement

SECOND EDITION

Edwina Brown

Consultant Nephrologist Hammersmith Hospital, London, UK, and Honorary Professor of Renal Medicine, Imperial College London, London, UK

Fliss Murtagh

Consultant and Clinical Senior Lecturer in Palliative Care King's College London, London, UK

Emma Murphy

BRC Clinical Research Training Fellow Biomedical Research Centre at Guy's, King's and St Thomas' School of Medicine King's College London, London, UK

Series editor

Max Watson

Consultant
Northern Ireland Hospice, Belfast
Honorary Consultant
Princess Alice Hospice, Esher
Visiting Professor
University of Ulster, Belfast

OXFORD UNIVERSITY PRESS

Great Clarendon Street, Oxford OX2 6DP, United Kingdom

Oxford University Press is a department of the University of Oxford. It furthers the University's objective of excellence in research, scholarship, and education by publishing worldwide. Oxford is a registered trade mark of Oxford University Press in the UK and in certain other countries

© Oxford University Press 2012

The moral rights of the authors have been asserted

First Edition published in 2007 Second Edition published in 2012

Impression: 1

All rights reserved. No part of this publication may be reproduced, stored in a retrieval system, or transmitted, in any form or by any means, without the prior permission in writing of Oxford University Press, or as expressly permitted by law, by licence or under terms agreed with the appropriate reprographics rights organization. Enquiries concerning reproduction outside the scope of the above should be sent to the Rights Department, Oxford University Press, at the address above

You must not circulate this work in any other form and you must impose this same condition on any acquirer

British Library Cataloguing in Publication Data Data available

Library of Congress Cataloging in Publication Data Library of Congress Control Number: 2011945378

ISBN 978-0-19-969569-0

Printed in Great Britain by Ashford Colour Press Ltd, Gosport, Hampshire

Oxford University Press makes no representation, express or implied, that the drug dosages in this book are correct. Readers must therefore always check the product information and clinical procedures with the most up-to-date published product information and data sheets provided by the manufacturers and the most recent codes of conduct and safety regulations. The authors and the publishers do not accept responsibility or legal liability for any errors in the text or for the misuse or misapplication of material in this work. Except where otherwise stated, drug dosages and recommendations are for the non-pregnant adult who is not breast-feeding.

Links to third party websites are provided by Oxford in good faith and for information only. Oxford disclaims any responsibility for the materials contained in any third party website referenced in this work.

To Jo Chambers who inspired the first edition of this handbook and contributed greatly to the development of UK renal palliative care Person Stambers who papers and constitution of the standard process of the sta

Foreword

Health care has changed from the 20th century cure paradigm many of us were trained and grew up in to a 21st century chronic disease management model of care. This is a cause for celebration. Many of the epidemic killers of earlier generations have been tamed or at least subdued. Now non-communicable diseases, often with multi-morbidity, are outstripping infectious diseases as our major challenge. The shift from exclusively cure to care has expanded our focus from the kidney to the person, the carers and the family of those with kidney disease. The authors of this monograph have been at the forefront of this transformation and together have an unrivalled knowledge and experience of their subject area. They provide an invaluable guide to the science of advanced kidney disease, which is accessible to the whole kidney care multiprofessional team.

Transplantation and dialysis have been a huge success but increasingly we recognize that choosing conservative kidney care, the no dialysis option, is a good choice for a minority of those who reach end-stage kidney disease. Many such individuals will live two or more years before their terminal phase. Mortality in those who opt for dialysis is higher than for many cancers. The one-year unadjusted survival on dialysis has improved to 80% but 10 years survival remains only 10%. Corresponding figures for kidney transplant recipients are 95% survival at 1 year and 62% at 10 years. Palliative care is, therefore, not just confined to conservative kidney care. It is not just about a good death, it is also about effective symptom control of advanced kidney disease and other comorbidities, understanding individual personal goals and helping patients achieve these, reaching the best possible functional status, avoiding unnecessary no added value admissions to hospital, and ensuring that the experience of care is positive. So palliative care is a core part of renal medicine making this specialist handbook an essential read for all the kidney care multiprofessional team and a valuable reference source for primary care and others providing support to end-stage kidney disease patients and families.

This paradigm shift has brought shared-decision making into focus. Shared-decision making is a fundamental part of care planning and promotes the best choice in what otherwise can be a complex and overwhelming situation. The care team communicates to the patient personalized information about the options, outcomes, probabilities, and scientific uncertainties of the various treatments. The patient communicates his or her values and the relative importance he or she places on the potential benefits and harms. The patients need time, digestible relevant information, and support; the health care system and individual health care practitioners need systematic tools such as patient decision aids and cause for concern registers, consultations skills particularly active listening and the detailed clinical knowledge to manage the specific and at times complex and competing challenges of the many facets of advanced kidney disease. This book is a source of that knowledge and when used in conjunction with

FOREWORD

viii

experiential training, reflective practice, and multiprofessional working will provide an insightful, confident, and well-informed work force that will be able to make a real difference to the populations and individual patients they care for.

Dr Donal O'Donoghue National Clinical Director for Kidney Care

Preface

We have written this handbook to try and provide a compact but comprehensive guide to management of patients with kidney disease at the end of their life. There is increasing awareness among renal healthcare professionals about the need for good supportive care at the end of life and therefore increasing involvement of palliative care teams. The authors include a renal physician, a palliative care physician, and a palliative care nurse completing her PhD in renal palliative care.

During our day to day management of dying patients and their families, we have come to realize the need for a practical book that gives basic renal information to palliative care professionals and guides renal professionals through the communication skills and knowledge needed to provide palliative care to their patients. We hope this book will fill this role. It is aimed primarily at doctors and nurses in the renal and palliative care teams, but should be of use and interest to all other healthcare workers involved with the dying patient—pharmacists, dieticians, counsellors, social

workers, and psychologists.

The book starts with basic information about the renal patient at the end of life—what they die from and what symptoms to expect and why. It then continues with guidance on controlling pain and non-pain symptoms followed by suggestions to help professionals recognize when the renal patient is dying. Practical ways of enhancing patient, family, and team communication are discussed leading on to a description of supportive and palliative care including how and when it might be accessed. Ethical and legal considerations are discussed before a detailed chapter on end of life care. Spiritual care and care for the carers conclude the book. As a practical guide to management, the book is didactic and represents our own clinical practice. We have therefore used case histories to further illustrate such management in practice. We have left plenty of space for the reader to add their own notes and observations.

This second edition includes the many new guidelines which have been developed in the recent years and the changes in practice which have evolved as a result of the increasing research output in the area of renal palliative care.

We are especially grateful to Wendy Lawson, senior pharmacist at the Hammersmith Hospital, who helped write the drug guidelines throughout and authored Chapter 16. We would particularly like to acknowledge our patients and their families who have taught us so much.

435 9MS

and thoretone inclears an environment of partitioner care, rained the authors, include a record flow over the patterned care partitions are much coallings over a

. The book same will instead of major a just sue remains the take er oferrer men non bus and still comes no sacretist, it was sufficient rack Guidered by suggestions of tools professional recognizes when the renal basiness of dying Treatest succeeds a considering potent samily what feature of life care. Solution lairs and consistency are sures reaction the books Agrae. Product products on that women by the books to those deciration of representational.

Contents

Detailed contents *xiii*Contributor *xix*Symbols and abbreviations *xxi*

1	End-stage kidney disease	1	
2	Comorbidity	15	
3	Complications of end-stage kidney disease	39	
4	Causes of death in end-stage kidney disease	65	
5	Health-related quality of life in end-stage		
	kidney disease	77	
6	Symptom assessment and trajectories	91	
7	The management of pain	103	
8	Non-pain symptoms in end-stage kidney disease	137	
9			
	palliative care	171	
10	Recognizing dying	185	
11	Communicating with patients and families	199	
12	Ethical and legal considerations	225	
13	Management of the last few days	253	
14	Spiritual and religious care	297	
15	Caring for the carers	315	
16	Drug doses in advanced chronic kidney		
	disease by Wendy Lawson	325	
17	Audit and research in renal end of life care	347	
	Appendix: Resources	359	

Contents

	Commence with a second second commence of the second secon	
	та при во	
	like are the variety and past forms	
en de la companya de An al companya de la	ाण गर्माण स्वतिक विषया	
	Completion	
	Complicacions of each stage kilding right of	
	Chresiot central end stage kidner director	
	् वयुष्टा है कि तो भी कि शतिकार में स्वाक्त की तिल्ला है।	
	and the state of t	
	ระบบสมาชิกเกมีย์ เกมาะ รัสดุสนักวิจะ และกับสมาชิกเลย	
	The mysechem of pain	N
9269	ly a paint symptoms in orderstock littlery dis-	3
	How ad deliver the best supportive and	
in a	philipping care	
23/	भूगार्था उत्पादने विद्यालय	
pok.	Contributions with patients and ramifles	
	Liscoland legal bonsiden cons - way us a	21
September 1	Planagement of the last few days	81
101	Spurfueland reflerensical assessment	
	Caring for the carers of a second	
	Drug do es in advaiscad du aniciadirey	
Ar	mown Library vices 26	
ShC	Audit and research in renal end of the care.	
CALL TO	Appendix: Rescurtes	

Detailed contents

	Contributor xix
	Symbols and abbreviations xxi
1	End-stage kidney disease
	Chronic kidney disease 2 one make a settle protection of the control of the contr
	Causes of kidney failure 4
	New patients on dialysis 8
	Patients on renal replacement therapy 10
	Choice of modality of renal replacement therapy 12
	23 all to properties of the contract of the co
2	Comorbidity
	Introduction 16
	Diabetes 18 comothejimu land anisameters on training a
	Cardiovascular disease 22
	Ischaemic heart disease 24
	Peripheral vascular disease 26
	Amputation 28
	Cerebrovascular disease 30
	Malignancy 32
	Infection 34
	Old age and frailty 36
	Complications of end-stage kidney disease
	Introduction 40
	Uraemia 42
	Electrolyte disorders 44
	Anaemia 46
	Fluid overload 48 and a large supplied the large Charles
	Calcium/phosphate disorders 50
	Poor nutrition 52
	Neuropathy 54
	Complications of haemodialysis 56
	Complications of peritoneal dialysis 58
	Compliantian of the last to

4	Causes of death in end-stage kidney disease	٠.
	Mortality 66	
	Causes of death 68	
	Cardiac arrest 70	
	Stopping dialysis 72	
	Conservative care 74	
-	Predicting the end of life 76	- T
5	Health-related quality of life in end-stage kidney disease	7
	Introduction 78	
	Measures of HRQOL 80	
	HRQOL of dialysis patients 82	
	Factors affecting quality of life 86	
	Quality of life at the end of life 88	
24	Conclusions 90	2 6
6	Symptom assessment and trajectories	9
	Introduction 92	
	Symptom prevalence 94	
	Symptom assessment 96	
	Symptom trajectories 98	
	Further reading 102	
7	The management of pain	10
	Introduction 104	
	Causes of pain 106	
-015	Types of pain 108 A Sell of Middle and the first the line of the l	
	Assessment of pain 110	
	What hinders pain management? 112	
	Principles of management: the WHO analgesic ladder 114	
	WHO analgesic ladder: steps 1 and 2 116	
	WHO step 3: opioids for moderate–severe pain + non-opioid ± adjuvant 118	
	Summary: WHO analgesic ladder 124	
	Managing opioid side-effects 126	
	Adjuvant analgesia 128	
	44.004.404.004.004.004.004.004.004.004.	

Episodic, movement-related, or incident pain 130 Chronic pain clinic referral and anaesthetic procedures 132 Referral to the palliative care team 134 Further reading 136 8 Non-pain symptoms in end-stage kidney disease 137 Introduction 138 Pruritus and dry skin 140 Fatigue, daytime somnolence, and weakness 144 Anorexia and weight loss 146 Dry mouth and thirst 148 Nausea 150 Constipation 154 Insomnia 156 Restless legs syndrome (RLS) 158 Symptoms from long-term complications of treatment of ESKD 160 Symptoms related to comorbid conditions 162 Dialysis-related symptoms 164 Other symptoms 166 Summary 168 Further reading 170 has disconnected and the second 9 How to deliver the best supportive and palliative care Introduction and definitions 172 was transported to many days to Advance care planning 176 Cause for concern registers 178 Preferred priorities of care 180 Referral and joint working 182

10 Recognizing dying

185

Introduction 186
Recognition of the need for supportive and palliative care 188
Gold Standards Framework 190
Recognition of the terminal phase 192
Listening to the patient and their families/carers 194
The nephrologist's perspective 196

11 Communicating with patients and families

Choosing conservative (non-dialytic) care 200

Introducing palliative and hospice care 204

Helping with decision-making 206

Withdrawal from dialysis 208

Raising awareness and improving communication skills 212

Sharing bad news 214

Responses to difficult questions 216

Communicating with family members 218

Communicating on issues around sexuality and intimacy 220

Communicating within teams and information sharing 222

12 Ethical and legal considerations

Principles of ethical decisions 226

A process of ethical decision-making 232

Choosing conservative management of ESKD 234

Renal replacement therapy and the elderly 238

Truth telling and collusion 240

Legal considerations: consent and capacity 242

Lasting power of attorney and court-appointed deputies 246

Advance decisions to refuse treatment 248

Multicultural issues 250

13 Management of the last few days

Introduction 254

Key issues to consider before cessation of dialysis 256

Where death is expected 260

Quality in end of life care 262

Domains of care 264

Symptoms at end of life 266

Symptom management: pain 268

Management: dyspnoea and retained secretions 272

Management: agitation, delirium, and neurological problems 274

Management: nausea and vomiting 276

Symptom management: syringe drivers and anticipatory prescribing 278

225

3.

End of life symptom control guidelines 280
Dialysis at end of life 284
Preferred place of care 286
The nursing perspective of end of life care in the renal setting 288
Summary: main principles of end of life care 292
Integrated care pathway for end of life care 294
Spiritual and religious care
Introduction 298
Assessing spiritual and religious needs 302
Cultural issues and spiritual support 306
Religious practices of different faiths in relation to end of life care 308
Caring for the carers 315
Introduction 316
Support for carers 318
Caring for the professional 320
Caring for the bereaved 322
Drug doses in advanced chronic kidney disease
by Wendy Lawson 325
Drug handling in advanced chronic kidney disease 326
Dosages of commonly used drugs in advanced chronic kidney disease: introduction 328
Drug dosages in CKD5: analgesics 330
Drug dosages in CKD5: antimicrobials 332
Drug dosages in CKD5: antidepressants/anti-emetics/antihistamines 334
Drug dosages in CKD5: antipsychotic and antisecretory drugs 336
Drug dosages in CKD5: anxiolytics/hypnotics 338
Some drugs not requiring dosage alteration in CKD5 with or without haemodialysis 340
Some drugs to avoid in CKD5 with or without haemodialysis 342
Notes on analgesics 344

Further reading 346

DETAILED CONTENTS

17	Audit and research in renal end of life care
	Why audit and research are important 348
	Linking audit and research to existing expertise 350
	Data sources 352 the same and to be a source as a source of source of the same and the same as a source of the same and the same as a source of the sa

Challenges in end of life research 356

ensurated giller bres family age 359

Appendix: Resources

Further reading 358

Patients and carers 360
Professionals 364

Index 367

Contributor

Wendy Lawson

Department of Pharmacy Hammersmith Hospital Du Cane Road London W12 0HS, UK

Contributor

Wendy LAwson

Department of the made in a water first that Du Comments

Symbols and abbreviations

cross-reference in this book
AA Attendance Allowance

ACE angiotensin-converting enzyme

ACP advance care planning
ADLs activities of daily living

AIDS acquired immune deficiency syndrome

AKI acute kidney injury

APD ambulatory peritoneal dialysis APKD adult polycystic kidney disease

ASA acetylsalicylic acid

ASN American Society of Nephrology

AV arteriovenous

B3G buprenorphine-3-glucuronide

bd twice a day

BDI Beck Depression Inventory

BP blood pressure BUN blood urea nitrogen

CABG coronary artery bypass graft
CAD court-appointed deputy

CAPD continuous ambulatory peritoneal dialysis CCPD continuous cycling peritoneal dialysis

CKD chronic kidney disease
CMV cytomegalovirus
CNS central nervous system

COPD chronic obstructive pulmonary disease
CPAP continuous positive airway pressure
CPR cardiopulmonary resuscitation

CPR cardiopulmonary resuscitatio
CRF chronic renal failure

CRN community renal nurse
CVD cardiovascular disease
DLA Disability Living Allowance
DOH [UK] Department of Health
DSI Dialysis Symptom Index
ECG electrocardiogram
ED erectile dysfunction

eGFR estimated glomerular filtration rate

SYMBOLS AND ABBREVIATIONS

EPA enduring power of attorney

EPS encapsulating peritoneal sclerosis

ERA European Renal Association
ESA erythropoiesis-stimulating agent

ESAS Edmonton Symptom Assessment Scale

ESF established renal failure ESKD end-stage kidney disease

ESKF end-stage kidney failure
FSH follicle-stimulating hormone
GABA gamma aminobutyric acid

GAS general adaptation syndrome
GFR glomerular filtration rate

GHRH gonadotrophin-releasing hormone

GI gastrointestinal GM glomerulonephritis GP general practitioner

h hour(s)

H3G hydromorphone-3-glucuronide HAART highly active antiretroviral therapy HADS Hospital Anxiety Depression Score

Hb haemoglobin

HCG human chorionic gonadotrophin

HD haemodialysis

HIV human immunodeficiency virus
HLA human leukocyte antigen
HRQOL health-related quality of life
5-HT₃ 5-hydroxytryptamine 3

ICD International Classification of Diseases

ICP integrated care pathway

IDDM insulin-dependent diabetes mellitus

IHD ischaemic heart disease
IM intramuscular(ly)
IOM Institute of Medicine
IV intravenous(ly)

KDOQI Kidney Disease Outcomes Quality Initiative

KDOQL Kidney Disease Outcomes Quality of Life Questionnaire

KPS Karnofsky performance score
LCP Liverpool Care Pathway
LH luteinizing hormone
LPA lasting power of attorney

LV left ventricle/ventricular

LVEF left ventricular ejection fraction

M&M morbidity and mortality
M3G morphine-3-glucuronide
M6G morphine-6-glucuronide

MDRD modification of diet in renal dosage

MDT multidisciplinary team

MI myocardial infarction

MOAls monoamine oxidase inhibitors

NCHSPCS National Council for Hospice and Specialist Palliative

Care Services

NCPC National Council for Palliative Care

NECOSAD Netherlands Cooperative Study on Adequacy of Dialysis

NHP Nottingham Health Profile
NHS [UK] National Health Service

NICE National Institute for Health and Clinical Excellence

NKF National Kidney Foundation

NMDA N-methyl-D-aspartate

NNH number needed to harm

NNT number needed to treat

nocte at night

NorB norbuprenorphine

NPT nocturnal penile tumescence

NSAID non-steroidal anti-inflammatory drug

NSF National Service Framework
NTDS North Thames Dialysis Study

OOH out of hours

PCF Palliative Care Formulary
PD peritoneal dialysis
pmp per million population
PMTs pain measurement tools
PO by mouth (her as)

PO by mouth (per os)
POSs [renal] Patient Outcome Scale—symptom module [renal]

PR rectally (per rectum)

prn as needed

PTH parathyroid hormone

PTLD post-transplant lymphoproliferative disorder

PVD peripheral vascular disease QALY quality adjusted life year

qhs at bedtime

SYMBOLS AND ABBREVIATIONS

qod every other day qds four times a day RBC red blood cell

RCT randomized controlled trial

rHuEpo recombinant human erythropoietin

RLS restless legs syndrome

RPA Renal Physicians Association [of the USA]

RPCI Renal Palliative Care Initiative RRT renal replacement therapy

SC subcutaneous(ly)
SCr serum creatinine

SF-36 Medical Outcomes Study Short Form-36

SIP Sickness Impact Profile

SLE systemic lupus erythematosus ('lupus') SSRIs selective serotonin re-uptake inhibitors

STAI State Trait Anxiety Inventory

stat immediately TB tuberculosis

TCA tricyclic antidepressants

TENS transcutaneous electric nerve stimulation

tds three times a day
UK United Kingdom

USA United States of America
USRDS US Renal Data System
Vd volume of distribution
WHO World Health Organization

WHOQOL World Health Organization Quality of Life [Assessment]

WNERTA Western New England Renal and Transplantation

Associates

End-stage kidney disease

Chronic kidney disease 2
Causes of kidney failure 4
New patients on dialysis 8
Patients on renal replacement therapy 10
Choice of modality of renal replacement therapy 12

Chronic kidney disease

Chronic kidney disease (CKD) is a major public health problem. As the prevalence of diabetes and obesity increases, and as the population ages, the prevalence of CKD will continue to increase. This is reflected not only in the increasing incidence and prevalence of patients with end-stage kidney disease (ESKD) requiring dialysis, but also in the substantial comorbidity found in such patients. Many patients are therefore not going to be suitable for transplantation. Despite the improvements in dialysis care, these patients will experience significant mortality and morbidity and an impaired quality of life.

Definition of CKD

The internationally accepted definition is based on that proposed by the National Kidney Foundation—Kidney Disease Outcomes Quality Initiative (NKF-KDOQI) workgroup:

• The presence of markers of kidney damage for 3 months, as defined by structural or functional abnormalities of the kidney with or without decreased glomerular filtration rate (GFR), manifest by either pathological abnormalities or other markers of kidney damage, including abnormalities in the composition of blood or urine, or abnormalities in imaging tests; or

The presence of GFR <60mL/min/1.73m² for 3 months, with or without

other signs of kidney damage as described above.

Staging of CKD

- Stage 1 disease is defined by a normal GFR (>90mL/min/1.73m²) and persistent albuminuria.
- Stage 2 disease is a GFR between 60 and 89mL/min/1.73m² and persistent albuminuria.
- Stage 3 disease is a GFR between 30 and 59mL/min/1.73m².
- Stage 4 disease is a GFR between 15 and 29mL/min/1.73m².

Stage 5 disease is a GFR <15mL/min/1.73m² or ESKD.

The majority of patients with stage 5 CKD will require renal replacement therapy (RRT), i.e. dialysis or transplantation. Patients with stage 4 CKD will have many of the complications of kidney failure and have a greatly increased mortality risk, particularly from cardiovascular disease. The pharmacokinetics of renally excreted drugs will be markedly affected in both groups, thereby making end of life care difficult.

Prevalence of CKD

Studies in the USA and UK suggest a similar prevalence of CKD, with approximately 11–13% of the population having CKD. Data from the National Health and Nutrition Examination Survey (NHANES) of 1999-2004 in the USA show that:

• 0.35% of the population have stage 4 CKD.

 2.4% of the population have stage 5 CKD (includes those on dialysis or transplanted).

 People with hypertension, diabetes, vascular disease, or obesity are at increased risk of having CKD.

- Overall prevalence of CKD stages 1 to 4 has increased significantly in the period from 1999–2004 compared with NHANES data for the period from 1994–98 (13.1% versus 10.0%, respectively).
- The prevalence rate for stage 5 CKD (ESKD) has doubled over same time period.
- CKD is more common in the elderly.
- A study in the Netherlands found that over 40% of individuals
 >85 years of age had an estimated GFR (eGFR) >60mL/min/1.73m².
 - Data from NHANES shows that prevalence of CKD stages 3–5 is 25% in the general population over the age of 70 years and 30% over the age of 80 years.
 - · This is reflected in patients developing ESKD.
 - Median age of starting dialysis in the UK is around 65 years.
 - 23% of patients starting dialysis in the USA are >75 years old.
- There is huge variation in incidence and prevalence of ESKD in different ethnic groups.
 - Incidence of ESKD in South Asian and Afro-Caribbean people in the UK is 3-4-fold higher than in the general population.
 - In the USA, compared with Caucasians, the incidence of ESKD in other ethnic groups is also increased: ×4 in American Africans, ×1.5 in Asian Americans, and ×2 in Native Americans.

CKD and microalbuminuria/proteinuria

- There is increasing evidence that the presence of microalbuminuria or proteinuria is an added prognostic risk factor for progression of kidney disease to ESKD or associated cardiovascular disease.
- It is very likely that a revised classification of CKD will be developed that includes the presence or absence of microalbuminuria and/or proteinuria.

4 CHAPTER 1 End-stage kidney disease

Causes of kidney failure

There are many ways of classifying the causes of kidney failure. In the context of this book, i.e. end of life management in kidney disease, the majority will have CKD, but some patients will have presented with acute kidney injury that has not recovered. As the symptoms of any associated disease have to be managed at the end of life, it is useful to list the causes of kidney failure with the underlying disease process.

Vascular disease

- People with hypertension, cardiac disease, peripheral vascular disease, or cerebrovascular disease (so-called 'arteriopaths') are at greatly increased risk of developing CKD.
- Kidney damage due to hypertension, renovascular disease, or ischaemic nephropathy.
- Hypertension represents 25% of all primary diagnoses in the USA, but is less frequent (around 9–10%) in Europe.
- · Cholesterol emboli:
 - Occur after arteriography or vascular surgery; more rarely spontaneously.
 - Present as a multisystem disorder associated with acute kidney failure.
 - · Usually kidney function does not recover.

Diabetes

- Commonest cause of kidney failure in the USA where 44% of new patients starting dialysis in 2008 had diabetes.
- Around 20% of patients in the UK starting dialysis have diabetes; more common in South Asian ethnic populations than in Caucasian populations.
- More common in northern Europe (accounts for around 40% of patients starting dialysis in some parts of Germany) than in southern Europe where around 12% of new dialysis patients have diabetes.
- Over 90% will have type 2 diabetes.
- The majority will have vascular comorbidity.

Glomerular disease

- Several types of glomerulonephritis can cause ESKD, but the original histological diagnosis does not affect outcome at this stage (unless of the type that recurs in transplant, e.g. focal glomerulosclerosis).
- More common as a cause of ESKD in younger patients.
- Disease process can be over many years, thereby allowing the vascular complications of hypertension to develop.

Autoimmune disease

- Examples are lupus (SLE), vasculitis, scleroderma.
- Relatively rare cause of kidney disease.
- Often multisystem involvement because of the nature of disease.
- Patients will often have had treatment with immunosuppressant drugs for prolonged periods of time.
- In some patients, the disease process is very rapid so they present with acute kidney failure that may or may not respond to treatment with immunosuppressants.

Familial disease

- The most common type is polycystic kidney disease, which is an autosomal dominant condition.
 - · Kidneys can be very large resulting in marked abdominal distension.
 - Bleeds into cysts can be very painful.
 - · Frequently cysts in the liver, which can also be painful.
- · Rarer types.
 - Alport's syndrome: hereditary nephritis associated with neural hearing loss and cataracts; variable inheritance.
 - Tuberous sclerosis: autosomal dominant; associated with skin lesions, kidney and cerebral tumours, epilepsy, and mental retardation.
 - Von Hippel-Lindau disease: autosomal dominant cystic kidney disease associated with a variety of tumours including renal clear cell carcinoma, angioblastomas including retinal angiomas, phaeochromocytoma.
 - · Metabolic disorders such as cystinosis, oxalosis, Fabry's disease.

Malignancy

- Renal carcinoma requiring bilateral nephrectomy.
 - · At risk of metastases even after removal of original tumours.
 - · Renal tumour in single functioning kidney.
- Urinary tract or pelvic tumours causing obstruction.
 - · Primary tumours, e.g. prostate, bladder.
 - Secondary tumours causing bilateral ureteric obstruction, e.g. from rectal, cervical, or ovarian carcinomas.
 - · Management primarily urological.
 - Dialysis not usually considered for long-term treatment unless patient young and to 'buy' time to allow other treatments to work.
- Haematological malignancies.
 - Myeloma.
 - · Primary amyloid.
 - Presence of kidney failure complicates treatment with cytotoxic drugs.
- · Complication of nephrotoxic cytotoxic drugs.
- Radiation nephritis.

Infections

- Worldwide, infections are a very important cause of kidney disease.
- Human immunodeficiency virus (HIV)-related kidney disease most common type of kidney disease in high-risk areas, e.g. sub-Saharan Africa.
- Other infections causing chronic kidney disease are hepatitis C and hepatitis B.
 - · These are endemic in some parts of the world.
 - Intravenous (IV) drug abusers are at high risk of such infections.
- Acute post-infectious glomerulonephritis, e.g. due to streptococcus.
 May result in ESKD at first presentation, though uncommonly.
 - Slow deterioration in kidney function after initial episode.
- Subacute bacterial endocarditis.
 - Commonly will resolve after treatment with antibiotics, but not always.

6 CHAPTER 1 End-stage kidney disease

Miscellaneous

- · Reflux nephropathy.
- Sickle cell disease.
- Analgesic nephropathy.
- Drug-induced:
 - Ciclosporin-related kidney disease following solid organ transplantation, e.g. heart, lung.
 - Chinese herb nephropathy.
- Secondary amyloid associated with chronic inflammatory conditions, e.g. rheumatoid arthritis, ankylosing spondylitis.
- · Toxins, e.g. lead, mercury.
- Congenital and acquired obstructive uropathy.
- Chronic interstitial disease, e.g. due to sarcoid.
- Haemolytic uraemic syndrome.

Transplant rejection

- Chronic rejection is a common reason for patients starting dialysis.
- Patients have a disease burden associated with long-term use of immunosuppressant drugs, cardiovascular risk of kidney disease.
- May have difficulty with vascular access because of previous dialysis.
- Can be considered for another kidney transplant if medically fit, though this may be difficult if there are high levels of cytotoxic antibodies.

Unknown

- The cause of kidney disease is unknown in about a fifth of patients starting on dialysis treatment.
- This is more common in people who present late with advanced kidney disease (stage 4 or 5 CKD).
 - · No obvious history of hypertension or proteinuria.
 - Usually kidneys are small on kidney ultrasound, so technically difficult to biopsy.
 - If kidneys are biopsied, histology consistent with ESKD (sclerosed glomeruli, interstitial fibrosis), but no indication of original cause.

New patients on distrais

and in the set Reight for the region of gives the data for publics and 1975 in the U.S. of the U.S. of

Acceptance race is a model of surried in 2011 unit at 17 la 24.06. This
gives no acceptance rate of 1.48 ner million population (princ).

CNCD is may promised a man comediate was 130 and for come or all flacts of a content.

Change in gradeure rate time or cytes warsk un incress or the seen. \$ 200 get in the seen in the seen

sun a visio ero sevorom

Figure 3 and purpose of garages particularly stide bett following consequences are remarkables to accommodate the second second

hjede, i paje of pe usita kina fire 8,85 i autor Uki sydija ke usi i i e 15. Parmie princijanjesi Kilipateobe to gas otder

Project is stated and the project of the countries of the

ariese de ella se greena que l'Alle not VV not de la collège de la collè

By Bella.

Proposed to control of the proposed to the control of the proposed posted to the proposed to the pr

w.Disagnosist respondance else indutions of glaterary and disagnosis are specification of patients such a final part of the specific and sole in the specific and sole in the specific and specific a

Dealy and a productive As 20 th a product of the productive and productive and a productive and

Wald - warpingow services unused to glass from 4270 VB Letter or queries here.

e migratega ya saka wasi arabi kasa 1999, kasa 1999, kata wa wasa ka mana sa 1990, kata wa 1994, ka 1999, ka m

20 99 99,0 to attended of 120 mp and pure the other processing to the processing of the processing of

New patients on dialysis

The 2010 UK Renal Registry Report¹ gives the data for patients on RRT in the UK during 2009. Figures below are for the whole of the UK; there are some (mostly small) differences between the constituent countries. More striking, are the often large variations between individual units.

Acceptance rate: 6639 patients started in RRT in the UK in 2008. This

gives an acceptance rate of 108 per million population (pmp).

Acceptance rate is unchanged from 2007.

 ESKD is more common in men; annual acceptance was 135 pmp for men and 82 pmp for women.

 Change in incidence rate: the progressive rise in incidence rate seen since 1982 seems to have slowed or stopped in the last few years. This could be due to:

improved pre-dialysis care;

 increasing proportion of patients, particularly older ones, selecting conservative management rather than dialysis.

Median age of patients starting RRT in the UK is 64.1 years. Patients

starting on dialysis continue to get older.

· Patients starting in England are the youngest of the four countries of the UK; this reflects the higher percentage of ethnic minorities who make up the population in England.

Median age of incident UK non-White patients is only 56.1 years.

- Acceptance rate is highest in 75–79-year age band—408 pmp in England.
- There are large differences in median age of incident patients between centres from <60 years to >70 years. Possible explanations include age structure of underlying general population, variations in ethnic mix, and local attitudes to conservative care.
- Diagnosis. Percentage distributions of primary renal diagnosis by age and gender in patients starting dialysis in 2008 are shown in Table 1.1.
 - Diabetes remains the most common primary renal diagnosis.

 Incidence of diabetic kidney disease higher in centres with greater percentage of non-White patients.

 Dialysis modality. At 90 days after starting RRT, 68% patients were on haemodialysis (HD), 20% on peritoneal dialysis (PD), and 5.9% were transplanted; six patients had died.

Wide variation between renal units, ranging from 42% to 95% of

patients being on HD at day 90.

· HD is more frequently the first treatment in Wales and Scotland

than in England.

 Age is major factor: 84% patients on RRT >65 years of age were on HD at 90 days compared with 71% of patients <65 years of age.

Table 1.2 Primary kidney disease in prevalent RRT patients by age and gender on 31 December 2009¹. Data provided by the UK Renal Registry

Primary diagnosis	% aged <65 years	% aged ≥65 years	Inter-centre range (%)	M:F ratio
Unknown	18.4	24.5	6.3-37.4	1.6
Glomerulonephritis	18.8	10.6	7.5–22.3	2.2
Pyelonephritis	13.5	8.6	3.8–18.7	1.1
Diabetes	13.7	16.8	6.7–25.2	1.5
Polycystic kidneys	10.0	8.9	4.3–17.0	1.1
Hypertension	5.0	7.2	0.9–14.1	2.3
Renovascular	1.1	7.8	0.8–13.2	1.9
Other	16.4	11.5	9.5–23.5	1.3
Not sent	3.1	3.7	0.1–46.1	1.5

Reference

¹ UK Renal Registry (2010) 13th annual report of the Renal Association, Available at: http://www.renalreg.com/Reports/2010.html.

Choice of modality of renal replacement therapy

As described in this chapter, Patients on RRT, pp. 10–11, use of the different RRT modalities depends on patient age and individual renal centres and has changed over time. Ideally, choice of modality should be made as part of a shared decision-making process with individual patients taking account of overall prognosis, likely effect of modality choice on patient well-being and lifestyle, and patient barriers to specific modalities. Several studies have shown that after appropriate education, and if given freedom of choice, 50–60% of patients will choose a home dialysis option. As this does not happen in most units in reality, other factors affect the decision regarding RRT modality:

 Healthcare system: use of HD is higher where physician salary is related to type of dialysis modality or where there are financial pressures to ensure a profit is made from HD centres.

 Physician bias: many nephrologists are unfamiliar with use of home HD or PD so are reluctant to recommend this to patients.

- Patient education: to ensure choice, patients need access to comprehensible, unbiased education about different modalities.
 Older patients with cognitive, vision, or hearing problems and patients from ethnic minorities have specific learning issues which are often not addressed.
- Unplanned start: 20–30% present with ESKD <3 months prior to starting dialysis. Most are started on HD with no prior education and are then not given any opportunity for subsequent education and choice of permanent treatment modality.

RRT in the elderly

The majority of deaths in ESKD occur in older patients, either in patients who start developing ESKD at an older age or in those who started RRT when younger. Older patients, particularly those with comorbidities, are unlikely to be transplanted and have relatively short survival; quality of life on dialysis is therefore particularly important.

Transplantation

- Age itself is not a contra-indication to transplantation, but only 25% starting RRT >65 years of age will receive a transplant.
- Comorbidity is principal barrier to transplantation—it is essential to exclude and/or treat underlying ischaemic heart disease (IHD).
- A shortage of deceased organ donors makes transplantation by this route less likely as organs are usually preferentially given to younger recipients unless from older donor.
- Older patients are therefore more likely to receive a kidney from a 'marginal' donor with lower likely success rate and higher risk of complications. This is often not discussed in depth with patients.
- Living donor transplantation is becoming more common for older patients often from a spouse whose lifestyle is equally affected by dialysis. Children and even grandchildren also donate, though many patients do not want this option.

Haemodialysis

- This is the most commonly used RRT modality in older patients.
- Vascular access can be a problem; co-existing vascular disease complicates formation of arteriovenous (AV) fistulas so there is a high use of central lines with associated risk of infection.
- · Haemodynamic instability can result in hypotension, arrhythmias, and angina on dialysis.
- Many will require transport to and from dialysis unit.
- · Many feel 'washed out' by HD session.

Peritoneal dialysis

- Older patients are less likely to use PD than younger ones despite the obvious advantages of this treatment:
 - Treatment is done at home thereby avoiding transport problems.
 - · Flexibility of treatment enables patient to maintain their lifestyle in terms of social activities, travel etc.
 - Continuous treatment, thereby lower risk of haemodynamic complications.
 - Avoids use of vascular access.
- Studies show the same or better quality of life for older patients on PD compared with HD.
- Older patients can find a home-based treatment difficult to perform independently—reduced physical mobility, cognitive problems, impaired vision and hearing, social isolation.
- Assisted PD using family members or paid healthcare workers (nurse or healthcare assistant) can increase access to PD for new patients and can help maintain patients on PD who would otherwise have to change to HD:
 - Largest and longest use of assisted PD is in France using community nurses; in many regions of France, older and frailer patients are preferentially treated with assisted PD.
 - The availability of assisted PD has been shown to increase eligibility for PD and therefore choice of PD by patients.

Silly Harmon A

ารเกิดสายเดือน เพลิสตินตัว โดยได้ข้อมี เมื่อสายกล้อย วากาย สำเ

or nearly religious. Emission controlled a service respect religions

riginus vis promos estimates e estici premi responsación de transcribente. Autoparti de la mesta assimblyadem, estica de des

A periody are controlling aware the differential or agreem that we entered the experience of the control of the c

The power of our beat to are a property of

was to the the ten to the leaf with

Podern record as the part of the County County County of the County Count

A property of the restriction of the property of the property

serms of a real stripped in the service of the service real for the service real feet in the ser

and weeks and the last the Wall

A consist of \$100 bill cates and interest allow of the complete policy as a consistency of the consistency of the latest c

C. Burnabents Conflict of the nect and near year all cities (E.g.) you indeed the conflict of the conflict of

And the second state of the second of the se

gapter of the Constitution of the Constitution

ari de la estaca de anuamento especial de la estaca de la ligidad de la composición del composición de la composición de la composición de la composición del composición de la composición del composición de la composición del composición del composición del composición del composición del composición del composición

Comorbidity

Introduction 16
Diabetes 18
Cardiovascular disease 22
Ischaemic heart disease 24
Peripheral vascular disease 26
Amputation 28
Cerebrovascular disease 30
Malignancy 32
Infection 34
Old age and frailty 36

Introduction

Not only is comorbidity a powerful predictor of early and late mortality in patients with ESKD, but the severity of comorbidities in individual patients will also have a powerful effect on their quality of life. Many patients with ESKD, particularly in older age groups, will have one or more comorbidities. These can be divided into:

- Cardiovascular disease (cardiac, peripheral, or cerebrovascular) which is much more common in patients with kidney disease than in the general population.
- Diabetes—as primary diagnosis or coincidental, i.e. not the cause of kidney disease.
- Coincidental disease, e.g. malignancy, chronic lung disease, liver disease,

The UK Renal Registry does attempt to collect comorbidities in patients starting on dialysis, and published a summary of the data collected in the period 2008-09 in the 2010 report.1

- These data (Table 2.1) show that two-thirds of patients starting dialysis >65 years of age have at least one comorbidity.
- Multiple comorbidity is common.
 - 12.7% of patients had two recorded comorbidities, 7.6% had three and 2.4% had five or more comorbidities.

Factors affecting comorbidity

- Age: the frequency of all comorbidities increases with age, apart from being a smoker.
- Diabetes: there is a higher prevalence of all types of vascular disease amongst diabetic compared with non-diabetic patients.
- Timing of referral to a nephrologist: patients with peripheral vascular disease (PVD) were more likely to be referred to a nephrologist early and patients with malignancy were more likely to be referred late.
- Ethnicity: distribution of comorbidity varies according to ethnic group (Table 2.2).
 - Diabetes is more common in each ethnic minority population than in the White population.
 - · At all ages, incident White RRT patients have more comorbidity than incident South Asian or Black patients despite a much higher prevalence of diabetes in these ethnic groups.

Reference

1 UK Renal Registry (2010) 13th annual report of the Renal Association. Available at: http://www. renalreg.com/Reports/2010.html.

Table 2.1 Percentage of new patients with comorbidity starting RRT 2008–09¹. Data provided by the UK Renal Registry

Comorbidity	Percentage of patients	
	Age <65 years	Age ≥65 years
Any comorbidity present	44.2	69.8
Angina Angina	8.3	18.6
MI in past 3 months	1.9	3.3
MI >3 months	7.3	16.3
CABG/angioplasty	6.7	11.8
Cerebrovascular disease	6.4	14.8
Diabetes not primary disease	6.0	12.7
Diabetes as primary disease	26.9	20.4
COPD	4.5	10.3
Liver disease	3.7	2.0
Malignancy	6.9	19.8
Claudication	5.2	9.9
Ischaemic/neuropathic ulcers	4.3	2.8
Angioplasty/vascular graft	1.8	5.1
Amputation	2.3	5.5
Smoking	14.6	10.0

Table 2.2 Percentage of patients with comorbidities amongst South Asian, Afro-Caribbean, and White patients starting RRT 2008–09¹. Data provided by the UK Renal Registry

Comorbidity	Percentage of patients of ethnicity		
	South Asian	Black	White
Ischaemic heart disease	22.6	8.6	29.2
Cerebrovascular disease	10.5	8.9	10.0
Peripheral vascular disease	13.1	5.3	11.3
Diabetes not primary disease	8.6	6.9	9.8
Diabetes as primary disease	21.8	28.4	39.8
Liver disease	2.6	4.4	3.7
COPD	7.9	2.5	3.5
Malignancy	14.2	5.8	4.4

Diabetes

Diabetes (mainly type 2) is an increasingly common cause of ESKD in all countries, accounting for almost 50% of dialysis patients in some parts of the USA, and 20% in Europe. In the UK, percentage of ESKD with diabetes depends on numbers of ethnic minorities, particularly South Asians, living in the catchment area. Patient morbidity and mortality are much worse than for non-diabetic patients as many of the non-renal complications of diabetes will continue to progress after initiation of dialysis (Table 2.3).

Macrovascular complications

- Coronary artery disease: present in around a third of diabetic patients starting on dialysis.
 - Presents as angina, acute coronary syndromes, arrhythmias, or sudden death.
 - Complicates HD because of chest pain, hypotension, and/or arrhythmias during dialysis sessions.
 - Commonly silent; diabetic patients are at particular risk of major coronary artery disease with no symptoms of chest pain until a major coronary syndrome or sudden death occurs.
 - Prevents or delays transplantation; coronary investigations are essential before transplantation followed by appropriate interventions.
 - · Often not amenable to endovascular or surgical treatment.
- Cerebrovascular disease: present in approximately 15% of diabetic patients starting on dialysis.
 - Clinical presentations include transient ischaemic attacks, stroke, vascular dementia.
 - · Can be related to carotid artery disease.
 - · Potentially a major cause of morbidity.
- PVD: about a quarter of diabetic patients starting on dialysis have PVD.
 - PVD is a major independent predictor of poor outcome on dialysis.
 - Often silent until critical limb ischaemia develops.
 - Often complicated by neuropathy and infection—'diabetic foot', a major cause of morbidity resulting in:
 - lower limb amputation, often bilateral;
 - upper limb ischaemia, particularly of fingers;
 - severe pain;
 - prolonged hospitalization;
 - difficulty in creating fistulas for vascular access;
 - poor nutrition.

Other complications

- Retinopathy: >90% of patients with type 1 diabetes and around 80% patients with type 2 diabetes will have diabetic retinopathy.
 - Patients must continue attending diabetic eye clinics regularly even after starting dialysis.
 - Often patients develop ESKD as a result of poor follow-up and/ or management of their diabetes; they are therefore at greatly increased risk of poorly managed diabetic eye disease.
 - · Poor vision will have major impact on quality of life.

- Increases chance of being on hospital rather than home dialysis therapy.
- · Risk of retinal haemorrhage exacerbated by anticoagulation on HD.
- Other eye complications:
 - cataracts;
 - glaucoma—can be extremely painful and may require enucleation of the eye;
 - · macular degeneration.
- Peripheral neuropathy: a major debilitating complication occurring in the majority of diabetic patients with ESKD:
 - · burning pain in the feet that can be very severe;
 - neuropathic ulcers on feet that can become infected—'diabetic foot';
 - · Charcot joints—particularly at the ankles;
 - · mononeuritis multiplex, i.e. isolated peripheral nerve lesions.
- Autonomic neuropathy: less common than peripheral neuropathy, but occurs more commonly in type 1 diabetes. It causes:
 - postural hypotension; this can be so severe that patients cannot walk without fear of collapsing;
 - impaired bladder functioning with urinary retention;
 - · diarrhoea.
- Gastroparesis: usually occurs in patients with significant autonomic neuropathy.
 - · Can cause severe vomiting.
 - · Contributes to poor nutrition.
 - Difficult to treat (see (Chapter 8).
- Infection: all types of infection are more common in diabetic patients.
 In particular:
 - vascular access infection, particularly of central lines or graft;
 - infection of vascular grafts used for management of PVD;
 - · development of osteomyelitis complicates 'diabetic foot'.
- Sexual dysfunction: in men, impotence is particularly common.

Table 2.3 Percentage of patients with or without diabetes who have comorbid conditions other than diabetes1. Data provided by the UK Renal Registry

7.4	Diabetics 32.5
	02.0
8.4	14.1
8.0	20.7
2.4	12.4
7.3	6.8
4.8	9.4
2.8	2.7
	8.0 2.4 7.3 4.8

Reference

¹ UK Renal Registry (2010) 13th annual report of the Renal Association. Available at: http://www. renalreg.com/Reports/2010.html.

and the property of the	
	and the first of the second of the second
	afficiency of the second
	The second of the second of the second
The second secon	

Cardiovascular disease

Cardiovascular comorbidity is the most common comorbidity in patients with ESKD and is responsible for approximately half of all deaths on dialysis regardless of age, gender, ethnicity, nationality, or primary kidney disease (Table 2.4). The risk of dying from a MI in a 40-year-old man on dialysis is approximately 100-fold greater than the risk for a man of the same age and with normal kidney function.

CKD and cardiovascular disease (CVD) share many of the same risk factors. It is therefore not surprising that patients with CKD have a greatly increased risk of having CVD and that patients with CVD have a greatly

increased risk of having CKD. Clinically, CVD presents as:

- · IHD:
- · PVD:
- cerebrovascular disease.

Individual patients with any one of these are at greatly increased risk of developing one or both of the others.

General risk factors	Risk factors with increased prevalence in kidney failure	Risk factors unique to kidney failure
 Age Male sex Smoking Family history Thrombogenic factors Obesity 	Hypertension Diabetes Physical inactivity Left ventricular hypertrophy Cholesterol Lipoproteins(a) Homocysteine Inflammation	Anaemia Hyperparathyroidism Uraemia Hyperphosphataemia Malnutrition AV fistulas Volume overload Kidney impairment

economist heart diseasons

The relative above Qualifier was a result of QHill's vaccinification and experience of the death of the street of the second of

Climical manifestations

a talehqi e relaced aqeida sayatlar iq patilons, with nor rail, i drev.

na gaziene dekruse of biede compressive eigen Control to the control of the contr

https://energincom.com.com/energineers/americanther Commenter Service asserts Summit Networks and secret Comment and Commenter and Commenter Comme

The Parameter of the Control of the

the or and shall the mathematic bases, the engineers of the control of the suggestion and the control of the co

Stemengormati Februarini exportmente dia 23 militaria.

- Estema grasportività titi, servica siatroni micropisudren greute.

14.6 mare supercodicitation conocci.

non state discovered the control of the control of

Macconstant to the first speciment of solution in the Processing Street Stree

Cadiac intervention.

Specially American respons

metricine de la completación de la Seus de la completación de la comp Completación de la completación de

97/04 (774)0 in the doubtout his doubt on the view of the select of the first when the control o

Chippy, which they control to sold in appropriate and the partition of the partition of the sold with a partition of the sold with a partition of the sold of the

Ischaemic heart disease

The natural history of IHD in patients with ESKD tends to be more progressive than in the general population. Patients with CKD have an increased mortality after an acute coronary syndrome. Intervention—both coronary angioplasty and coronary artery bypass grafting (CABG)—also carries a higher mortality risk. Patients with CKD, particularly stages 4 and 5, are much more likely to die, predominantly from IHD, than to eventually require RRT.

Clinical manifestations

- Exercise-related angina: similar to patients with normal kidney function.
 - Some patients, because of other comorbidities, e.g. PVD, stroke, etc., may not exercise sufficiently to develop chest pain.
 - · Exertional dyspnoea and/or arrhythmias may also occur.
- Angina and/or arrhythmias during dialysis: commonly associated with episodes of dialysis-related hypotension.
 - Hypotension is more common in patients near their dry weight or in patients with large weight gains between dialyses (so needing more fluid removal during dialysis).
 - Development of chest pain on dialysis therefore minimizes fluid removal during dialysis.
 - Patients at risk, therefore, of developing chronic fluid overload resulting in left ventricular (LV) dilatation and impaired LV function.
 - Chronic hypotension on and off dialysis develops as a result of impaired LV function. This makes fluid removal on HD even more difficult.
- Silent myocardial ischaemia is common in dialysis patients.
 - Patients present with MI, serious arrhythmia, or sudden death.
- Acute myocardial infarction.
 - Often presents atypically with just shortness of breath or arrhythmias.
 - Electrocardiogram (ECG) changes may be difficult to interpret because of pre-existing LV hypertrophy.
 - Serological diagnosis is also more difficult because creatine kinase and troponin T are often mildly elevated in patients with ESKD.

Cardiac interventions

Coronary angioplasty + stenting

- Increased risk of complications compared to patients with normal kidney function.
- Can achieve better survival than standard medical therapy in selected patients as in the general population.
- Can be technically difficult because of calcification of coronary vessels.

Coronary artery bypass grafting

- Typically three or four vessels require grafting.
- Increased post-operative mortality compared with patients without kidney disease.

- Increased peri-operative morbidity due to wound infection (sternum and vein graft sites), problems related to fluid and electrolyte balance problems, pain control, etc.
- Pre-existing LV dysfunction related to chronic fluid overload increases risk.
- Cardiopulmonary bypass is a major haemodynamic insult that commonly precipitates ESKD in patients with lesser degrees of kidney impairment.

Peripheral vascular disease

PVD as a predictor of survival

Analysis of factors affecting survival on dialysis shows that PVD is the worst predictor of outcome.

- Most patients with PVD also have other vascular disease, so are at high risk of IHD or cerebrovascular disease.
- More difficult to achieve vascular access for HD.
- Limits chances of successful transplantation as anastomosis on to the iliac artery may be technically difficult or may cause critical limb ischaemia.
- Diagnosis is often made late when critical limb ischaemia has already occurred.
 - Patients may not exercise sufficiently to get claudication, so no warning features.
 - · Arteries are often heavily calcified making non-invasive investigations, such as Doppler studies and ankle-brachial pressure ratio, inaccurate as the arteries cannot be compressed.
- Arterial disease is predominantly distal making bypass surgery technically difficult.
- Often associated with poor nutrition.

Clinical features

- Dialysis patients (diabetics and non-diabetics) may present with more diffuse and distal disease compared with those having normal kidney function.
- Pre-existing lower limb ischaemia may worsen after creation of permanent HD access in that limb, or after transplantation.
- Perception of claudication can vary from severe debilitating discomfort at rest to minor pain of little consequence.
 - · Severity of symptoms depends upon the amount of stenosis, collateral circulation, and amount of exercise.
 - Location of pain depends upon the location of vascular disease. Patients can present with buttock, thigh, calf, or foot claudication.
- Ischaemic rest pain typically occurs at night and involves the forefoot and toes. Pain may be more localized in patients who develop an ischaemic ulcer or gangrenous toe.
 - Precipitating factors include trauma superimposed on an area of borderline perfusion.
 - · Pain may be relieved by hanging feet over the edge of the bed or walking round the room.
- Ischaemic neuropathic pain is related to chronic tissue ischaemia and is described as throbbing or burning often with superimposed severe shooting pains up the limb.
 - Associated with ulcers on lower limb or diabetic foot.

Limb-threatening ischaemia

Limb-threatening ischaemia presents with rest pain, ischaemic ulcers, or gangrene. It usually inexorably progresses to amputation unless arterial perfusion can be improved, e.g. by angioplasty or arterial reconstruction.

- Rest pain is brought on or made worse by elevation of the leg and made better by lowering the leg. It is therefore often experienced only at night or when sitting with the legs up.
- Ischaemic ulcers are usually dry and are found most commonly at the lateral malleolus, tips of toes, metatarsal heads, and the bunion area.
 - Ischaemic ulcers involving the foot can become infected and lead to osteomyelitis.
- Gangrene is characterized by cyanotic, anaesthetic tissue associated with or progressing to necrosis. It can be described as dry or wet.
 - Dry gangrene has a hard and dry texture and commonly occurs at the distal ends of toes and fingers; there is a clear demarcation between viable and necrotic tissue. The involved digit is often allowed to auto-amputate, though this can take a long time.
 - Wet gangrene is an emergency and will often result in amputation.
- Acute ischaemia is caused by distal embolization from a proximal atheromatous plaque to digital vessels or occlusion of larger arteries by embolic or thrombotic events. Presentation includes:
 - blue toe syndrome: sudden appearance of cool, painful, cyanotic toe or forefoot often in the presence of foot pulses;
 - sudden onset of pain in a limb accompanied by pallor, coolness, and absence of palpable pulses.

Management

- Angioplasty is often not indicated or is not successful as the arterial disease is predominantly distal.
- Management of limb-threatening ischaemia in ESKD patients can be difficult for various reasons:
 - · poor wound healing;
 - high rate of infection;
 - poor nutritional state;
 - high operative risk;
 - vascular calcification can make arterial surgery technically difficult.

 Studies also attacked to the control of the cont
- Studies show that, after surgical revascularization, patients with ESKD have shorter survival, less subjective improvement, lower limb salvage rates, and lower graft patency than non-ESKD patients.
- If revascularization fails or is not technically feasible, amputation of digit, forefoot, or limb is required.

Amputation

Dialysis patients have a very high rate of lower limb amputation compared to the general population.

- Predicted survival is very poor after amputation; reports have been as low as 30% for 2-year survival among Medicare ESKD patients undergoing amputation.
- Prolonged hospitalization is often needed after amputation:
 - · poor wound healing;
 - · difficult pain control;
 - · poor nutrition;
 - · increased infection risk;
 - slow rehabilitation in patients who frequently have a long history of physical inactivity.
- High risk of developing critical ischaemia in the other limb resulting in bilateral amputation.
- Major social aspects and effects on quality of life, particularly after bilateral amputation.
 - If on PD, may have to transfer to HD as no longer able to cope with a self-care dialysis modality.
 - Will need assistance with transport to HD facility.
 - May need rehousing or major changes to accommodation.
 - May no longer be able to live independently and therefore have to transfer to a nursing-home.
 - Prolonged hospitalization with high risk of depression, poor nutrition, social isolation, etc.

Gernell Telligayondaya

The services of the College of the C

na a wendaya saa ii ng qaa aan CH ro anoonni oo asoog ba

e Petganism or or researched, with book a confoliability out areas.

is the residence of the control of the residence of the residence of the control of the control

Trianger on the life in ways

a wilk is being karolin both briend a dust nick kinga eine and driftinger in epakar beingeretag forden in

Taining a

salm per out a construir de la construir de la

can had wardings or call to the first and the United the section to the

And a set place is all many constraints are all a set of the first place is a set of the first place in the first place is a set of the first place in the first plac

Here is 51, but to imprem insteam should by made importance with more inspections. The importance is the penal of the importance of the second of the second

To improve company to partering Contest that is supported to the

Cerebrovascular disease

Stroke is more common in patients with ESKD as hypertension is the major risk factor for cerebrovascular disease.

- Hypotensive episodes on HD can also precipitate cerebrovascular events.
- · Patients at most risk are those with poorly controlled hypertension, diabetes, the elderly, smokers, and those with other vascular disease.
- Patients on HD appear to be at increased risk of cerebral haemorrhage—they are more liable to rapid changes in blood pressure (BP) and are anticoagulated on dialysis.

Presentation and management

- Presentation is the same as in the general population and includes:
 - · transient ischaemic attacks;
 - stroke:
 - · multi-infarct dementia.
- Increased risk of haemorrhage into area of cerebral infarction in HD patients using anticoagulation.
- Management of HD can be difficult after a cerebral haemorrhage because of the risk of anticoagulation.
- Transferring a patient to PD (if possible) may avoid further events related to hypotension on dialysis.
- No decision on the long-term outcome should be made immediately, as the prognosis is very variable, as in the general population.
- Important long-term sequelae of stroke in a patient on dialysis include:
 - · loss of social independence;
 - · difficulty in continuing to perform PD unless there is support from a carer;
 - · poor nutrition;
 - · depression.

Tantangias M

Linderful Bedicty Jabelsunger, that House As of principle CS Years and and the Socretarised White Endstrands makeholds whites an dialog Lindens Special develops a new materials, auchor their times of ANT This White begins have a control inspect on tabled as research.

 Pair composition organizated in patients with a dipay dipases, assessing Chapter 7).

a Parants Michaeldve and a vincy constitute a kidney unitablem

energiese un arrege une estat sur excepción de la companya paga la paga de la companya paga la companya paga d O companya de la companya de la companya de la companya de la companya paga de la companya paga de la companya

and see the control of the control o

* Turner or extra system or an area of the secret with controlled * There is no copyress on may use too be reduced to tenduple of secretariate the metal of the secretariate of a celebratic secretariate.

e Passeria e Pari de Como, se enpre californista da cal

alignator in course of hidrory failure

Soveral กรุศแต่ ประกอบสูกเล่า การสาราช

Thous requires on the addistrated to

where the bridge of the company of the contract of the contrac

District of the process of the post of the control of the process of the post of the post

or they conducte traguetic bilaces reprict until the corosts of a section of the corosts of a section of the corosts.

 Tan pocar deniera liprature i Janetys and it eji carde onta lavore, adher mich sizes the medither of the veloping one of the Phanes of the Phanes of the

Scotter group on the despite on the mission of the control of the

Premaraby place mough consists of the Calculus and the construction of the American state of the Property of the construction of the American state of the Calculus and the American of the Calculus and the Calcu

energiet taking vigtaget om Divergiples er ex

A A COUNTY OF THE

Complications of malignancy and or creeting the

EPRELO STINGYEL -

TO WAR Elevi year of a

e tosulations elchégo terapis alegit comm

beauth and tongs attribute set as the spourement soul. It

Malignancy

UK Renal Registry data suggest that around 6% of patients <65 years old and 15% >65 years old will have a history of malignancy when starting on dialysis. Patients can also develop a new malignancy during their time on RRT. This will obviously have a major impact on individual patients.

Malignancy is a poor predictor of survival.

- Pain control is more complicated in patients with kidney disease (see Chapter 7).
- Patients with active malignancy cannot have a kidney transplant.
- Management is often more complex than in the general population.
 - · Patients with ESKD have a high surgical risk.
 - · Many cytotoxic drugs are excreted by the kidneys so their dose has to be altered.
 - Timing of cytotoxic therapy around HD sessions is often complex.
 - Immunosuppression may have to be reduced in transplant recipients, thereby increasing the risk of rejecting the kidney.
- Patients can become severely malnourished.

Malignancy as cause of kidney failure

Several types of malignancy can cause kidney failure.

Obstruction to the urinary tract

- Bladder outflow obstruction, e.g. prostate or bladder cancer.
- Ureteric obstruction by pelvic tumours, e.g. cervical or rectal cancer.
- Obstruction of ureter of a single kidney by transitional cell carcinoma.

Kidney tumours requiring bilateral nephrectomy or removal of a single functioning kidney:

- Can occur de novo in native kidneys; renal cell carcinoma in one kidney increases the likelihood of developing one in the other kidney.
- Increased risk of kidney cell carcinoma in genetic disorders associated with cystic kidneys, e.g. tuberous sclerosis, von Hippel-Lindau syndrome.

Haematological malignancies can cause ESKD because of kidney involvement. Prognosis is related to the underlying malignancy and is worse than for patients with ESKD alone and for patients with the malignancy but normal kidney function. Examples are:

- myeloma;
- primary amyloid.

Complications of malignancy and/or treatment

- Hypercalcaemia.
- Tumour lysis syndrome.
- Tubular toxins in chemotherapy, e.g. platinum.
- Focal glomerulosclerosis and nephritic syndrome induced by pamidronate.

Coincidental tumours

Patients with ESKD can develop any tumour. The risk of malignancy is increased in ESKD, particularly after kidney transplantation, because of reduced immunosurveillance as kidney failure is associated with a reduced immune response. The natural history of such tumours is the same as in the general population, with the provisos mentioned at the beginning of this section.

Infection

Various types of infection can cause kidney disease and patients with kidney disease can have a coincidental infection. In both instances, outcome on ESKD will be affected by the natural history of that infection.

Hepatitis B

- Hepatitis B can cause membranous glomerulonephritis, which can lead to ESKD.
- More commonly, patients with kidney disease are carriers of hepatitis B. This is particularly common in:

IV drug abusers:

- patients from countries with a high prevalence of hepatitis B.
- Many patients with chronic hepatitis B are asymptomatic with a very low risk of cirrhosis or hepatocellular carcinoma.
- Risk of liver damage or carcinoma is increased with immunosuppression, e.g. for treatment of underlying kidney disease or transplantation.
- · Treatment with antiviral drugs, e.g. lamivudine, may be successful, enabling patients to be transplanted.
- Patients who are hepatitis B antigen positive need to be isolated while on HD to prevent transmission of infection to other patients.

Hepatitis C

- · Can directly cause kidney disease, predominantly membranoproliferative glomerulonephritis associated with cryoglobulinaemia.
- As with hepatitis B, more commonly patients with kidney disease are carriers of hepatitis C. This is particularly common in:

IV drug abusers;

- patients from countries with high prevalence of hepatitis C.
- Disease has long indolent course but leads to cirrhosis and hepatocellular carcinoma.
- Risk of liver damage or carcinoma is increased with immunosuppression, e.g. for treatment of underlying kidney disease or transplantation.
- · Treatment with antiviral drugs, e.g. interferon and ribavirin, is associated with more side-effects in patients with kidney failure, but may be successful, enabling patients to be transplanted.

HIV

- Causes both acute and chronic kidney disease; several types of histology are found on kidney biopsy.
- Patients can also be carriers of HIV infection; this is particularly common in:
 - IV drug abusers;
 - · patients from countries with high prevalence of HIV infection, e.g. sub-Saharan Africa;
 - patients with high-risk sexual behaviour.
- Use of combination antiretroviral treatment has revolutionized outcome to the extent that patients with negligible viral load are now being given kidney transplants.

Tuberculosis (TB)

- TB is more common in kidney failure and in ethnic minorities, most of whom also have an increased incidence of TB.
- Increased risk in patients with HIV.
- Extra-pulmonary involvement is common.
- Should always be considered if unexplained fever not responding to conventional antibiotics.
- Diagnosis often only made by using trial of antituberculous drugs.
- Doses of drugs have to be altered in the presence of kidney failure.

Old age and frailty

With a median age of starting dialysis of around 65 years, many patients on dialysis are old and frail. Both factors are associated with increased comorbidity and mortality. Furthermore, old age and frailty both have major impacts on a patient's ability to cope with dialysis and its complications.

Old age

The chronological cut-offfor old age used in the UK Renal Registry is 65 years. This arbitrary approach negates the individual response to mental and physical ageing. Not all patients on dialysis >65 years old have the characteristics commonly thought to be features of old age. However, with increasing age, it is important to consider medical and psychosocial features associated with ageing as these will affect well-being on RRT, decisions regarding choice, and changes in RRT modality and quality of life. These include the following:

Increased risk of comorbidity related to ESKD

· Impaired physical functioning

 The majority of older patients on dialysis will need some assistance with daily living.

· Often related to co-existing arthritis.

Deteriorates with time on dialysis and after hospital admissions.

Use of walking aids related to poorer survival.

Impaired cognitive function

Often unrecognized.

· More common in patients with CKD and more rapid rate of decline than in the general population.

· Related to increased cardiovascular risk.

· Affects day to day living and ability to make treatment-related decisions.

• Falls

Related to impaired physical functioning.

- Frequently under-recognized so appropriate prevention strategies not instituted.
- · Increased risk of fractures.
- · Predictor of reduced survival.

Fractures

 Underlying renal bone disease increases susceptibility to fractures after falls and impedes rate of bone healing.

 Increased complications—bleeding, infection, delayed surgery and rehabilitation to fit in dialysis needs.

Predictor of reduced survival.

Impaired vision and hearing

Eye problems more common in diabetics.

Macular degeneration associated with vascular disease.

Both will impact on decision-making round healthcare needs.

Poor nutrition

· Loss of muscle mass is a feature of ageing in general.

- More common in ESKD—impaired appetite, inflammatory state, comorbidities.
- · Predictor of poor survival.

Depression

- · Often not recognized.
- 20-30% of patients on dialysis are depressed.
- · Associated with worse adherence to treatment regimes.
- · Associated with increased mortality.

Social isolation

- · Common with increasing age.
- Often associated with loss of spouse leading to associated depression, poor nutrition.
- Potential barrier to home dialysis modality unless carer available (see Chapter 1, Choice of modality of renal replacement therapy, pp. 12–13).

Frailty

Frailty is a predictor of poor survival. It is not constrained by chronological age and can occur in younger age groups. Frail individuals are often thought of as those being at high risk of falls, disability, morbidity, and mortality. There are many definitions of frailty, but the easiest to use clinically is that proposed by the British Geriatric Society where frailty is diagnosed by someone having two or more of the markers in Box 2.1.

Box 2.1 Markers of frailty

- Inability to perform one or more basic activities of daily living (ADLs) in the 3 days prior to admission
- A stroke in the past 3 months
- Depression
- Dementia
- A history of falls
- · One or more unplanned admissions in the past 3 months
- · Difficulty in walking
- Malnutrition
- Prolonged bed rest
- Incontinence

Source: Reprinted with permission of the British Geriatrics Society

maissonne (T

- diten not recovered
- seems took one very on no allegate the 2017-2012
- у Азграмед и пределение в ответение и пределение и
 - that one basse doubtey betalooseA.

... folialezhanez e

- Fathly gazes of gall seekers lock to short this porthagest and the
- nidisky teres zadne všligo to překloh unadov strad kopřek t

First year edition of investments in the parconage paid by a respectable of a part of the forest distribution of the parconage of the part of the parconage of the part of the parconage of the p

effuelt, a even til material

- te bedra in to the list of the control of the control of the model of the control of the control
 - The transfer of the second of the second of the
 - - Legislay mountains
 - to be contracted to
 - echogolic (
 - ใน เขาเดอร์ จะ โดยเหติ และสิติ ละที่ได้แล้วให้เคย ของ และและที่ ความ V

Complications of end-stage kidney disease

Introduction 40
Uraemia 42
Electrolyte disorders 44
Anaemia 46
Fluid overload 48
Calcium/phosphate disorders 50
Poor nutrition 52
Neuropathy 54
Complications of haemodialysis 56
Complications of peritoneal dialysis 58
Complications of transplantation 60

Introduction

There are many complications of ESKD, as shown in Table 3.1. They can be divided into those directly caused by the abnormal metabolic state of kidney failure and those related to the treatment modality used. They contribute significantly to the morbidity and mortality associated with kidney disease.

Table 3.1 Complications of kidney failure

Metabolic complications	Complications related to RRT
Uraemia Electrolyte disorders Anaemia Fluid overload Hypertension Cardiac disease Calcium/phosphate regulation Renal bone disease Vascular calcification Calciphylaxis Poor nutrition Neuropathy Vascular disease	Haemodialysis: Vascular access failure Central venous occlusion Line infection Dialysis amyloid arthropathy Kidney cysts and tumours Peritoneal dialysis: Ultrafiltration failure Peritonitis Encapsulating peritoneal sclerosis Transplantation: Rejection Infection Malignancy Drug side-effects Cardiovascular disease Osteoporosis Sensitization

Uraemia

Uraemia is the complex of symptoms that develop with severe kidney failure; they are summarized in Table 3.2. For patients followed in a renal clinic, RRT (dialysis or pre-emptive transplantation) is commenced before severe uraemic symptoms develop. The level of kidney function at which uraemic symptoms appear varies from individual to individual with some complaining of tiredness with GFRs as high as 30mL/min and others denying any symptoms with a GFR as low as 5mL/min. Patients on dialysis often continue to have some uraemic symptoms of varying severity.

More severe uraemic symptoms develop in the following situations:

- When GFR approaches >8mL/min.
- · At end of life:
 - · patients who opt for conservative care and do not dialyse;
 - · patients who discontinue dialysis.
- Underdialysis.

Table 3.2 Uraemic symptoms

Early symptoms start when GFR <20–30 mL/min; become more severe as GFR declines:

- Fatigue
- Anorexia
- Pruritis
- Sleep disturbance
- Muscle cramps
- Feeling cold

Late symptoms start when GFR <10mL/min

- Nausea and vomiting
- Lethargy, apathy
- Weight loss
- Peripheral oedema and dyspnoea
- Pulmonary oedema
- Nocturia and polyuria
- Bleeding tendency
- Metabolic flap
- Myoclonic jerks
- Restless legs

Symptoms towards end of life start when GFR ~5mL/min

- Neuropathy
- Proximal myopathy
- · Severe pruritis (sometimes with skin excoriation)
- Pericarditis
- Fits
- Cognitive impairment
- Confusion
- Coma

Electrolyte disorders

The most common electrolyte disorders found in patients with ESKD are:

- hyperkalaemia;
- hypokalaemia;
- hyponatraemia.

Hyperkalaemia

The causes of high plasma potassium in patients with ESKD include the following:

- · Dietary intake from, e.g., fruit, vegetables, chocolate.
- Underdialysis.
- Drugs:
 - angiotensin-converting enzyme (ACE) inhibitors or A2 receptor blockers:
 - · spironolactone;
 - · potassium supplements.
- Breakdown of blood products releasing potassium from red cells:
 - blood transfusion;
 - · gastrointestinal (GI) bleeding;
 - · absorption of blood from a haematoma.
- Metabolic acidosis.

Symptoms

- · Often none.
- Cardiac arrhythmia—ventricular or atrial.
- · Cardiac arrest.
- GI symptoms—abdominal pain, diarrhoea.

Hypokalaemia

Low plasma potassium is less common.

- Usually associated with poor nutrition, and therefore a low potassium intake.
- Can occur in patients on high doses of loop diuretics, e.g. furosemide, bumetanide for fluid control:
 - pre-dialysis or conservative care patients;
 - PD;
 - · transplant with poor function.
- Increased risk of cardiac arrhythmias, particularly in patients on HD.
- Can exacerbate symptoms of fatigue and lethargy.

Hyponatraemia

Low plasma sodium is not uncommon in patients on dialysis or with ESKD.

- Usually associated with fluid overload with proportionately more water than sodium in extracellular fluid.
- Occurs in patients with high water intake and poor oral intake of sodium.
- Increases symptoms of fatigue, lethargy, nausea, confusion.

el management

par que la propesad la ESECE demanda de acapación de la partir de la faction de la partir de la faction de la partir dela partir de la partir de la partir de la partir de la partir dela partir de la partir de la partir de la partir de la partir dela partir de la partir de la partir de la partir de la partir dela partir de la partir de la partir dela part

ik gi idenski indifysky dro editived filo vivose fratski indicava nemse i gluber nemio i zaprod salacilik ing vendeski siculačio, versimi e jodyteni i udov si sind diecelepa remio Azolaje 90-495, od orešelatoga, jed kin a vellurecium

ianlam of rigosio signi krit 4,455) a i ga gitta amerikipotosi yirili igi dagal difirosografia signi kritiki sografia

yen opojetin sejerance.
Si o condor scieda de lifecta se ente la como de tre adolte.

mon at a factor of the control of th

ARROW CAN THE

nder besse liefger Her search etgel guit, e.g. hybriddysp<mark>hysia</mark> Califer

Turk, a country of a machine onestally a to guivery liberares.

una cons und medito gano

bendy has

Anaemia

Anaemia is universal in ESKD, primarily due to a relative lack of erythropoietin. There is a strong association between haemoglobin (Hb) and risk of death in ESKD. Increasing Hb causes major improvements in many uraemic symptoms, including exercise capacity, cognitive function, nutrition, and sleep patterns. Around 80-90% of patients on dialysis will require an erythropoiesis-stimulating agent (ESA) and iron therapy to maintain their Hb in the range of 10.5-12g/dL.

Erythropoietin resistance

This is common at end of life and is related to many of the problems common at this time:

- Concurrent infection/inflammation.
- Hyperparathyroidism.
- Malignancy.
- Malnutrition.
- Inadequate dialysis.
- Bone marrow disorders, e.g. myelodysplasia.
- Blood loss.

Difficulty in treating anaemia and therefore failure to achieve Hb targets will result in:

- increased fatigue;
- · anorexia:
- worsening of heart failure;
- · increased ischaemic symptoms, e.g. angina, claudication;
- increased dependence on blood transfusions—red cell antibodies are reasonably common in these patients increasing the difficulty in obtaining blood.

Residence State

Find Grovesch in the standish for a common problem in ESKT pagneters and call the standish made to with the fixes of breath at the end of The Vangus action coarround to his government.

The figure factor of the second of the secon

travial many mention accommo

Claims well and your blacks are an early and type while the notice of

Terest de valor es dos de la Oral de Para de la calcia en La constante de la calcia del calcia de la calcia del calcia de la calcia del calci

ว เรียกเลวารอบสมสมา สาร (ที่ 14 องเวศอลราวเลด ระบามา (กอร์เลก)

ราสาร์ขะของสลุขาบ อาการสารสาช ชุดภัยรัส โดยของกร €

legur Jesão, feir bear mont a

the course was belieff from a making on a collection of the collection of the collection of

The contribution of a factor page of the first angles of the continue poor cardinal and continue poor cardinal and continue page of the continue page of the

Fluid overload

Fluid overload is, not surprisingly, a common problem in ESKD patients and can cause significant distress with shortness of breath at the end of life. Various factors contribute to its development:

- Difficulty in restricting fluid intake.
- · Inadequate fluid removal on dialysis:
 - poor ultrafiltration and loss of residual kidney function on PD;
 - · difficulty with vascular access for HD;
 - hypotensive episodes on HD requiring infusion of saline thereby making fluid removal difficult.

Oedema associated with fluid overload also causes problems:

- impaired healing of ischaemic or venous ulcers;
- increased risk of cellulitis.

Vicious circle of heart failure and fluid overload

Chronic fluid overload results in LV dilatation with resulting poor cardiac function and hypotension, which then increases the difficulty of removing fluid on dialysis.

CIODICTA OF TECHNICAL

Typeshare thyruldism

Fig. 36 from a production of the first call that are prospered to reduce up.

rrandyddiselad Charleynau'r hellur Obde oeilog tollyndiadae 1,28 dloyddyy

Tables of the second of the se

and it brains and on incompanies and a marketic bounds companies extensioned in the companies of the extension

aimsolampodensola

bes enviloped with the property of the property of the services of the property of the propert

not each in a real to to one

The secure confer to -

reform executed and a section of

a de la companya de la co

A Albertana O Tale

date of prosphit standers (and operations with the use).

Renal bout d'agrad

At ggt with size 2.012 ft. 2000 is enableded disnoon by green unto they require a clarks in receiver of varying sectoring (2.5% for a 2000) seed, to compare they out the content of the

- สุราบาลส์ราก กลีเกิด

AL AR SHOUND THE PROPERTY AND A CARTEST TO A CARTEST TO A CARTEST AND A

ieroj,

ing Relited to assorbe about their metabolism.

Wooleds by care of he sisk

r punt _samps - After Andesphears as a stavoging envertion by Referentist Archen - green **man**n (Cordism sportpall)

racings - muse of pervisority warm Displacer.

levalor West presiden

acresings blim *

Calcium/phosphate disorders

Hyperparathyroidism

- · Hyperparathyroidism is the key to calcium and phosphate disorders in kidney disease.
- Primary cause is failure of the kidney to synthesize 1,25-dihydroxy vitamin D₃ (calcitriol), which is the active metabolite of vitamin D.
- · As a result, intestinal calcium absorption is reduced leading to hypocalcaemia which stimulates parathyroid hormone (PTH) secretion.
- The raised PTH acts on the bones releasing calcium and phosphate and thereby restoring plasma calcium levels towards normal but at the expense of hyperphosphataemia.

Hyperphosphataemia

Phosphate levels are an independent predictor of survival on dialysis and start rising when GFR falls below 30mL/min/1.73m². Factors determining phosphate levels include:

- level of residual kidney function;
- · dietary intake of phosphate;
- degree of secondary hyperparathyroidism;
- · use of vitamin D metabolites, e.g. calcitriol, alfacalcidol;
- · adequacy of dialysis;
- dose of phosphate binders (and compliance with their use).

Renal bone disease

All patients with ESKD have renal bone disease by the time they require dialysis, though of varying severity (Box 3.1). Dialysis is not a cure but merely a prolongation of the state of kidney failure. Renal bone disease therefore progresses and is not cured when patients are on dialysis.

Clinical features

Symptoms do not develop until an advanced stage of renal bone disease, and often patients do not complain of bone pains unless specifically asked, or after suppression of raised PTH by parathyroidectomy or treatment with cinacalcet (a calcimimetic). Symptoms can be divided into different groups.

- Related to calcium phosphate metabolism:
 - pruritis (calcium phosphate deposition under the skin);
 - soft tissue calcification leading to tender lumps under the skin;
 - · calcification of tendons leading to acute joint problems;
 - symptoms of hypercalcaemia if present (i.e. nausea, vomiting, constipation, confusion).
- Related to bone pathology:
 - · joint pains—often widespread and only commented on by patients when hyperparathyroidism treated;
 - · bone pains;
 - fractures—particularly of pelvis with vitamin D deficiency (osteomalacia).
- Related to raised PTH level:
 - mild depression.

Box 3.1 Factors contributing to renal bone disease

- Hyperparathyroidism
- Acidosis
- Low vitamin D levels (in certain groups of patients)
- Suppressed parathyroid activity (after treatment)
- Aluminium accumulation (now rare)
- Osteoporosis in elderly patients
- Osteopenia caused by steroids used to treat initial disease or for transplantation

Vascular calcification

- · Common in ESKD.
- Can be very obvious on plain X-rays, which may look like an arteriogram.
- Important underlying factor causing CVD in patients with ESKD.
- Includes heart valves.
- Multiple predisposing factors:
 - hyperparathyroidism;
 - hyperphosphataemia:
 - · inflammation:
 - calcium loading from calcium-containing phosphate binders (calcium carbonate, calcium lactate), particularly in the presence of oversuppressed parathyroid glands (low-turnover bone disease).

Calciphylaxis

- A syndrome of vascular calcification and skin necrosis occurring rarely in patients with ESKD.
- Associated with hypercalcaemia, hyperphosphataemia, hyperparathyroidism, vitamin D treatment, and IV iron, but precise cause unknown.
- High mortality (60–80%); mostly from sepsis from infected necrotic skin.
- Lesions are very painful, usually occur on the legs, develop suddenly, and progress rapidly.
 - Start as erythematous papules; then become necrotic or even bullous.
- More common proximally on thighs, buttocks, and lower abdomen, but can occur distally.
- Vascular calcification is a constant feature, but distal pulses are usually present.

Poor nutrition

Over a third of patients with ESKD are malnourished. This is associated with increased infection, poor wound healing, muscle wasting, and increased mortality. Poor nutritional status prior to initiation of dialysis is also associated with poorer outcomes on dialysis and increased mortality. Malnutrition is caused by inadequate dietary intake or unmet increased nutritional requirements (Box 3.2).

Diagnosing malnutrition

- Clinical features:
 - · weight loss:
 - · muscle wasting;
- anorexia;
 - · fatigue on exercise.
- Biochemical features:
 - reduction in plasma creatinine over time indicating reduction in muscle mass;
 - low plasma urea (<15mmol/L) indicating inadequate protein intake;
 - hypokalaemia suggesting poor nutritional intake as potassium is found in a wide range of foods;
 - hypophosphataemia also indicates overall poor food intake;
 - · low plasma cholesterol.

Consequences of poor nutrition

- · Increased risk of infection.
- Anorexia, nausea.
- Low plasma albumin.
- Oedema associated with hypoalbuminaemia.
- Muscle fatigue—reduced exercise tolerance.
- Depression.
- Feeling cold.
- Increased mortality.

Box 3.2 Factors causing malnutrition in ESKD

Factors increasing nutrient requirements

- Metabolic abnormalities:
 - Metabolic acidosis.
 - Inflammation—increased cytokine activity.
 - · Leptin activity.
- Concomitant disease:
 - · Cardiovascular disease.
 - Sepsis.
 - MIA syndrome: malnutrition, inflammation, atherosclerosis.

Factors decreasing food intake

- Anorexia:
 - · Nausea, fatigue, taste changes, anaemia.
- Gl disturbances:
 - Phosphate binders, antibiotics, uraemic and diabetic gastroparesis.
- Psychosocial and socioeconomic:
 - Depression, anxiety, ignorance, loneliness, alcohol or drug abuse, poverty.
 - Impaired physical and/or cognitive function—difficulty in shopping, cooking, motivation for eating.

Neuropathy

A peripheral polyneuropathy develops in advanced kidney failure or in patients who are underdialysed. It is more common in men and affects mostly the lower limbs.

Clinical manifestations

- Sensory symptoms (paraesthesiae, burning sensations, pain) occur before motor symptoms.
- Sensory symptoms improve rapidly on starting or increasing dialysis.
- Motor involvement resulting in muscle atrophy, myoclonus, and eventual paralysis is not reversible.

Sensory syndromes

- Restless leg syndrome—a persistent and uncomfortable sensation in lower extremities that can only be relieved by movement of the legs. More prominent at night and may interfere with sleep.
- Burning foot syndrome—severe pain and burning sensation in distal lower extremities.
 - · Can be due to thiamine deficiency as this vitamin is water soluble and well dialysed.
- Paradoxical heat sensation—application of low-temperature stimuli evokes sensation of high temperature.

Complications of basemoniclysis

Vascular actions Cillum

- week for an east in the Arthur the other) and the Affrodrik Affrodrik Common. Sub-on-the Common spanious copies subsections used the October 10 to the Sub-on-
- Removed to the common to the common and the second to the

 - Water to the state of the state of the
 - Avadish als topone ()
- THE COLD AND TETRO VIEW.

 No. 14 AND THE PROPERTY OF THE PROPE
 - A STATE OF THE STA
 - id a suburt

 - Lateurances auditor of transposition in The
 - Transmission as wh

The complications of all year of occess of a prominent and officers of a second of the conduction of t

- yr om i ar i ny izony i a unavin, a aariah a maasiy ya maanaa astan w
 - The Artifact of Africe Legislanding of the Art of the sample
 - State Comment of Parallel State Deliver of State State

che et annous accomprima, unes navelmuch belieb all line into accomprime the transition of the following for the first and the constant accomprise to a constant accomprise the constant accomprise to a constant accomprise

medicano conney is an il

i et et reterior et avvermittet veix tom en endet tret internet et 10 eksemble. Veix 1 teleparte et et tombred, per notat abbiet eign interfolk die talk Veir autori obsis intersonalisticht och tombreds did die treta for

- Table 2015 Translation of the Visit of the 1261 A
- o 1935 or golden i hen for inture VAV fistire for mun Michael of the Community of the community with the community of the com
 - A system of a memoral various occlusion occurs of the system of the system occurs occurs on the system occurs of the system occurs occurs on the system occurs of the system occurs occurs on the system occurs occurs on the system occurs occurs on the system occurs occur
 - reministration and remaining the second seco
 - witego arfaretti ekonik entidi devidib w
 - Pandruuga naliku kanali. waxanomo na verenin mni ga nalikwa a Marka

Complications of haemodialysis

Vascular access failure

Vascular access is the Achilles heel of HD; without it patients cannot be put on HD. The various types of access used include the following.

- Native arteriovenous (AV) fistulas. Choices of location (in order of preference) are:
 - · radiocephalic (wrist);
 - · radiobasilic (wrist);
 - · brachiocephalic (elbow);
 - · brachiobasilic transposition (involves freeing and transposition of basilica vein);
 - · thigh.
- Prosthetic grafts, usually using Goretex:
 - · upper arm;
 - · thigh.
- Tunnelled central venous catheters:
 - · jugular vein;
 - · subclavian vein.

The complications of all types of access are predominantly thrombosis and infection. These occur less frequently with native AV fistulas, but these fistulas are less likely to be successful in patients with vascular disease. After the standard sites have been used or if they are not feasible, various other access sites can be used:

- grafts connecting distant arteries and veins, e.g. across the chest from axillary artery to vein, or from axillary artery to femoral vein;
- central venous catheters placed into femoral or lumbar veins.

These various access procedures have much higher failure rates, are more likely to thrombose, and are therefore unlikely to last longer than a few months.

Central venous occlusion

Catheterization of any central vein can result in occlusion of that vein when the catheter is removed, even in the absence of infection or catheter thrombosis. The clinical consequences of this include:

- loss of that vein for future access;
- loss of ipsilateral arm for future AV fistula formation (particularly with subclavian vein thrombosis) because of reduced venous return;
- swollen arm if central venous occlusion occurs with functioning AV fistula because of high venous pressure;
- swollen face and neck if bilateral central venous occlusion;
- dilated veins across anterior chest wall;
- swollen leg from femoral vein thrombosis with risk of pulmonary embolus.

Line infection

Bacteraemia is a major complication of the use of central venous catheters for HD. It is more common with temporary catheters but not insignificant when using tunnelled lines. Complications include:

- need to remove catheter (and therefore loss of vascular access) if temperature does not settle within 2–3 days of starting antibiotics, or if recurrent infection;
- endocarditis, particularly in patients with pre-existing valvular disease;
- discitis with epidural abscess and resulting paraplegia (fortunately rare);
- embolic abscess formation at other sites, e.g. joints.

Dialysis amyloid arthropathy

This is a complication of long-term dialysis and becomes increasingly more common after 10 years; it is due to β 2-microglobulin amyloidosis. The incidence of this complication has reduced with improvement in biocompatibility of dialysis membranes.

Clinical features

- Carpal tunnel occurs first. Most patients who have been on dialysis for more than 20 years are affected and will have needed surgery; usually affects both hands.
- Joint pains and stiffness, usually bilateral, starting in the shoulders and extending to other joints. Pain is often worse at night and during HD.
- As the disease progresses, joint movements become restricted, particularly the shoulders.
- Chronic tenosynovitis of the finger flexors causes restricted movement, pain, and trigger fingers. Can become incapacitating.
- Very rarely, extra-articular accumulation of amyloid results in lumps, e.g. in the tongue or subcutaneously (SC) near joints.
- Destructive spondyloarthropathy, usually of the cervical spine.
- Rarely, amyloid may be deposited in the epidural space causing spinal cord compression.
- Pathological fractures, particularly of the femoral neck, due to amyloid cysts weakening the bone.

Kidney cysts and tumours

- Kidney cysts are common in patients on dialysis. They are usually asymptomatic. The important associated clinical features are:
 - haemorrhage into the retroperitoneal space—this can be lifethreatening and can cause significant hyperkalaemia;
 - erythropoietin production—patients may no longer need exogenous erythropoietin administration and can become polycythaemic;
 - · risk of malignancy.
- Kidney tumours (predominantly kidney carcinomas) are more common in patients with ESKD, particularly those on dialysis.
 - Predominantly a complication of long-term dialysis with increasing frequency after 10 years.
 - Mostly associated with cystic kidneys and can present with retroperitoneal haemorrhage.
 - Often no symptoms until presenting with metastases.

Complications of peritoneal dialysis

Ultrafiltration failure

Ultrafiltration is key to the success of PD, particularly once patients have become anuric. The methods used to increase ultrafiltration include the use of hypertonic dextrose dialysate, use of icodextrin (a glucose polymer), and use of ambulatory peritoneal dialysis (APD) in patients who have rapid transport membrane characteristics. As the peritoneal membrane transport tends to become more rapid with time on PD, some long-term PD patients develop ultrafiltration failure. They are then at risk of developing fluid overload and ideally should discontinue PD and transfer to HD.

Peritonitis

Peritonitis is a major cause of morbidity in patients on PD. The overall peritonitis rate in most units is 1 in 20–30 patient months. Some patients seem never to get peritonitis, while others have recurrent episodes. This can be due to patient technique, particularly with Gram-positive infections (Staphylococcus epidermidis and Staphylococcus aureus). Gram-negative infections are often associated with underlying bowel disease, and are therefore more common in elderly patients because of the presence of diverticular disease.

Clinical features

- Abdominal pain.
- Cloudy fluid.
- Fever in more severe cases.
- 80% cure rate with intraperitoneal antibiotics.

Complications

- Failure to respond to treatment necessitating catheter removal.
 - · More common with Gram-negative infections.
 - Patient then needs urgent transfer to HD with central venous catheter (unless pre-existing fistula).
- Clostridium difficile infection as a consequence of using broad-spectrum antibiotics for treatment of peritonitis.
- Worsening nutrition because of increased peritoneal protein losses.

Predictors of peritonitis

- · Poor patient technique:
 - social issues, e.g. housing;
 - cognitive problems;
 - depression.
- Exit site and tunnel infection.
- Active bowel disease, e.g. diverticulitis.
- PD being done in hospital:
 - · patient unwell so not so careful with technique;
 - nurses often inexperienced at PD particularly if high turnover and not receiving regular education about technique.

Encapsulating peritoneal sclerosis

This is also known as sclerosing peritonitis. Encapsulating peritoneal sclerosis (EPS) is a devastating complication of long-term PD. Prevalence is 2-5% in patients on PD for 5 years and 20% in patients on PD for more than 8 years. The condition consists of a thick-walled membranous cocoon that wraps itself round loops of bowel causing intestinal obstruction and subsequent malnutrition.

Clinical course

- Symptoms of full-blown EPS are:

 - vomiting;
 abdominal pain;
 - · intermittent small bowel obstruction;
 - ascites—often massive; can be haemorrhagic.
- Clinical symptoms of bowel obstruction more commonly occur when patients stop doing PD. Thus patients can appear well on PD but develop the syndrome within a short time (sometimes only weeks) of transplantation or transferring to HD.
- transplantation or transferring to HD.
 Course can be more insidious with symptoms developing after several months or even a year or two after transferring to HD.
- Can be precipitated by episode of peritonitis even early in the time span of PD.
- There is no proven treatment, though steroids, immunosuppressive drugs, and surgery are all occasionally used. Some patients appear to respond to tamoxifen, which has anti-fibrotic actions, but there is no randomized trial to support this observation. At least tamoxifen has no major side-effects.
- Mortality is high with 30–50% of patients with EPS dying within a few months of diagnosis, usually from malnutrition.

Complications of transplantation

One-year graft survival rates of 90–95% are now readily achievable for first grafts with the use of current immunosuppression regimes. Transplantation is therefore being offered to more 'marginal' candidates, i.e. older individuals, diabetics, and patients with IHD once it has been treated with angioplasty or surgery. Although the number of cadaveric organs is not rising, a dramatic increase in transplantation rates is being achieved by encouragement of living donor transplantation, often from unrelated donors, particularly spouses. In many UK units, over 50% of new transplants are from living donors. It is not surprising that, with an older recipient population, there is a higher rate of complications.

Rejection

Acute rejection is now relatively rare. Most transplants are lost during the first year because of surgical complications. Chronic rejection is the most common cause of graft failures after the first year. This is an incompletely understood process, which is also known by various other names such as transplant glomerulopathy or chronic renal allograft nephropathy.

Clinical diagnosis is suggested by slowly rising plasma creatinine,

increasing proteinuria, and worsening hypertension.

Important to rule out transplant artery stenosis causing deterioration in

kidney function.
 Changing immunosuppression may have some effect on slowing down

rate of progression.

 Important to control BP and cholesterol as some of damage is due to progressive glomerulosclerosis.

 At risk of developing other complications of ESKD, e.g. anaemia, hyperparathyroidism, as kidney function deteriorates.

 Over 25–30% of people on waiting lists for a kidney transplant have had one or more previous transplants.

Infection

Infection is a problem at all time points after transplantation.

- There is an increased risk of all types of infection, including:
 - common, community-acquired bacteria and viruses;
 - TB, particularly in those from at-risk ethnic groups, e.g. South Asian;
 - uncommon opportunistic infections that occur only in immunocompromised individuals, e.g. pneumocystis, nocardia, aspergillus, cytomegalovirus (CMV), etc.
- Urinary tract infection. Major risk factors are:
 - · indwelling bladder catheters;
 - handling and trauma to kidney and ureter during surgery;
 - anatomical abnormalities of native or transplanted kidneys (e.g. reflux, stones, or stents);
 - · neurogenic bladder.
- Chronic viral infections. These can have either caused the kidney disease, or the patient may be a carrier.
 - · Hepatitis B or hepatitis C.
 - · HIV.

Malignancy

Post-transplant lymphoproliferative disorders (PTLDs) are the most common malignancy complicating the chronic immunosuppression used for transplantation.

- More than 50% of patients with PTLD present with extranodal masses, e.g. in stomach, lungs, skin, liver, central nervous system (CNS), and allograft itself.
- Around 25% will have CNS disease.
- Involvement of transplanted kidney can result in kidney failure.
- Principal risk factors are degree of overall immunosuppression and Epstein–Barr virus status of the recipient.
- Incidence is highest in the first year when immunosuppression dosage is at its highest.
- Reducing immunosuppression increases risk of rejection but, if done carefully, can result in a high response rate and low rate of rejection.
- Can also be treated with chemotherapy and radiotherapy.
- Mortality can be high with rates of up to 80% reported.

Skin cancers post-transplantation Chronic immunosuppression is associated with increased incidence of skin cancers.

- Squamous cell carcinomas occur over a 100 times more commonly in transplant patients, with the highest risk in patients with a history of high sun exposure.
- Incidence of basal cell carcinoma is increased 10-fold.
- Skin cancers are often multiple and more than one type can occur in the same patient.

Skin tumours are more aggressive and are more likely to recur after resection in patients with transplants than in the general population.

Solid tumours, particularly squamous cell carcinomas are more common in transplant recipients because of reduced immunosurveillance. Compared with the incidence in the general population, the following tumours particularly are more common in transplant recipients:

- · Kaposi's sarcoma;
- non-Hodgkin's lymphoma;
- · renal cell cancer;
- · vulvovaginal cancer.

Immunosuppression drug side-effects

All immunosuppressive drugs have side-effects other than those related to the immunosuppression itself.

Steroids

- Cushingoid appearance.
- Obesity.
- Diabetes.
- Thin skin with easy bruising.
- Poor wound healing.
- Hypertension.

62 CHAPTER 3 Complications of ESKD

- · Bone disease:
 - osteoporosis;
 - osteopenia;
 - · avascular necrosis.
- Gastric erosions.

Ciclosporin

- Diabetes.
- Hypertension.
- Nephrotoxicity.
- Drug interactions due to metabolism by cytochrome P450 enzymes in the liver.
 - Drugs causing raised ciclosporin levels include diltiazem, fluconazole, erythromycin, lansoprazole, cimetidine, allopurinol.
 - Drugs causing decreased ciclosporin levels include rifampicin, phenytoin, orlistat.
- Hirsutism.
- Gingival hyperplasia and gingivitis.
- Tremor
- Metabolic abnormalities:
 - hyperkalaemia;
 - hyperuricaemia and gout.
- Bone disease—increased bone turnover leading to bone loss.

Tacrolimus

- Not as well studied as ciclosporin, but range of side-effects is very similar.
- Early studies suggested that diabetes is more common than with ciclosporin, but this is probably not so when mycophenolate given as well.

Azathioprine

- Bone marrow suppression.
- Skin malignancies.

Mycophenolate

- · Diarrhoea.
- Hypertension.
- Peripheral oedema.
- Insomnia.

Sirolimus

- Bone marrow suppression.
- Raised cholesterol and triglycerides.
- · Diarrhoea or constipation.
- Haemolytic uraemic syndrome when used in combination with ciclosporin.
- Interstitial pneumonitis; this is reversible on withdrawing sirolimus.
- Skin problems are common:
 - · delayed wound healing;
 - · acne;
 - · scalp folliculitis;
 - · oedema;
 - · aphthous ulceration.

Cardiovascular disease

Risk of CVD after kidney transplantation is reduced compared with the risk in patients on dialysis. This is only partly due to the fact that patients are screened for CVD and/or appropriately treated (e.g. with stents or surgery) before transplantation. CVD, nevertheless, remains much more common in transplant recipients than in the normal population and is the most common cause of death in transplant recipients.

Factors contributing to CVD in transplant recipients include:

- · hypertension;
- diabetes;
- obesity;
- pre-existing CVD;
- length of time on dialysis pre-transplantation;
- deteriorating kidney function post-transplantation;
- immunosuppressive drugs—steroids, cyclosporin, tacrolimus (see above);
- · physical inactivity.

Bone disease

Osteopenia and bone fractures are common after transplantation.

- Rapid bone loss occurs in first 6 months after transplantation.
- Patients start life with a transplant with hyperparathyroid bone disease or low turnover bone metabolism from overtreated hyperparathyroidism.
- Steroids and cyclosporin/tacrolimus contribute to bone loss (see above).
- Acidosis related to poor kidney function and/or use of cyclosporin contributes to altered bone metabolism.

Sensitization

Patients are at risk of developing human leukocyte antigen (HLA) antibodies after a failed transplant.

- It is important to avoid the same HLA antigens in subsequent transplants.
 This makes matching more difficult and therefore may entail a longer wait for a kidney.
- Patients can become sensitized to a broad range of antigens, particularly
 if given blood transfusions. This can make it very difficult to find
 suitable donors.

Gardiovasch betwoibus.

No. 25 C V.) Interestables are successful according to the polygopal of mission relation parameters are drop in a control of the control of the parameters are controlled as a control of the control of

inenanasyn e

21.79001

LY Suiters on

the section and the forest

nograma, garaga at a caracter section of the caracter of the c

e in minor subjects distributions. See this construction of the distribution of the see above.

Bene diseasi

e to groon a lijib is to a bakaciyinsi are dolmicoga lateli grankplastatilin. Babil oo ya too baday shalafa a moosee kana baka waxay saa a

sense transfer and the manufacturer state and back and back

FIRST DELIGN EXTRACE BOTTO SERVICE SERVICES AND OUT OVER 11, 1965 ETT.

 Latinas Inflict laspon can palents continuos to hor a los sessonas e Activisto related to part keineralamendos, que o les caspones

- dalmastragað

forests unlet was the strawelloping heaven, residently establiget of \$1.55 pm (5.55). The first first of the strain

A company of the second se

n e e se com e est com e e extente por e engal e en activa e en en en en Els militares en els estados presentados en el secretare e mercantal e conservada e Local el mesa.

traduciero, regularo en a arcelor recuenta a percenta percenta de la Composito de la Composito

Causes of death in end-stage kidney disease

Mortality 66
Causes of death 68
Cardiac arrest 70
Stopping dialysis 72
Conservative care 74
Predicting the end of life 76

Mortality manage to 28

Mortality rates for patients with ESKD are worse than for most cancers with an overall median survival of less than 6 years, though this does vary with age. UK Renal Registry data¹ show that 5-year survival after starting RRT is:

- >90% for 18–34-year-olds;
- 70% for 45–54-year-olds;
- 30% for 65-74-year-olds;
- <20% for >75-year-olds.

These 5-year survival rates are much lower than in the general population. The mortality rate for 45–54-year-olds with ESKD is about 18 times that for people of the same age in the general population. This is also true for the elderly: the mortality rate for >75-year-olds with ESKD is about 4-fold higher.

Predictors of increased mortality risk

Having one or more of the comorbidities or complications mentioned in \square Chapters 2 and 3 will increase the risk of morbidity and mortality. The list below summarizes some of these. These various factors do, however, interrelate, so multivariate analyses in most studies show that the key predictors of poor survival are age, comorbidity, and poor nutrition. Predictors of increased mortality include the following:

- · Being on dialysis compared to having a functioning transplant.
- Age.
- Vascular comorbidity:
 - PVD has been shown to be the most important predictor of poor survival in many studies;
 - · IHD:
 - · cerebrovascular disease.
- Dementia.
- · Diabetes.
- · Poor nutrition.
- Malignancy.
- Low plasma albumin.
- · Poor control of calcium and phosphate levels:
 - · hyperphosphataemia;
 - · hypercalcaemia;
 - · raised calcium-phosphate product.
- Impaired cardiac function:
 - · LVH:
 - · LV dilatation;
 - hypotension.
- Anaemia:
 - erythropoietin resistance.
- Infection:
 - · chronic viral infections, e.g. hepatitis B, C, HIV;
 - · recurrent dialysis-related infections.
- Poor compliance.
- Poor vascular access.

- · Lack of pre-dialysis kidney care.
 - 25–30% of patients are referred less than 1 month before needing to start dialysis—so-called crashlanders.
 - The mortality rate for such patients increased by 15–30% in several studies.
 - Detrimental effects of late referral are summarized in Box 4.1.

Box 4.1 Detrimental effects of late referral

- · Lack of interventions that might slow progression of kidney failure
- Failure to plan for RRT
- Failure to plan vascular access with consequent increased reliance on central venous catheters and risk of infection
- Failure to provide psychological and social support
- Increased hospitalization rate
- · Lower quality of life

Reference

1 UK Renal Registry Report 2009.

Causes of death

Causes of death are related to pre-existing comorbidity and complications of ESKD.

Cardiac causes

Cardiac causes account for over 50% of deaths.

- MI accounts for less than 10% of these deaths.
- Heart failure with LV dilatation is more common—often related to chronic fluid overload.
- About 60% of cardiac deaths are sudden due to arrhythmias related to electrolyte disorders or impaired cardiac function.

Peripheral vascular disease

- Amputation.
- · Sepsis—gangrene, osteomyelitis.
- Often associated with poor nutrition.
- Associated cardiac disease.

Cerebrovascular disease

- · Stroke.
- Complications of stroke—poor nutrition, depression.
- Associated cardiac disease.

Infection

- · Accounts for around 20% of deaths.
- · General infections, e.g. pneumonia.
- Dialysis-related—septicaemia (HD), peritonitis (PD).
- Transplant-related—general + opportunistic infections.

Malignancy

- One-sixth less common than cardiac disease.
- More common in transplant recipients.

Stopping dialysis

• Usually in association with one or more of the above.

Cardiac arrest

Causes

Sudden death has many causes and cannot be simply ascribed to 'cardiac' factors:

- large electrolyte swings (particularly potassium);
- · volume overload;
- · arrhythmias;
- aortic dissection;
- · intracerebral haemorrhage;
- subdural haematoma;
- · cerebrovascular disease;
- infection.

Outcome of cardiac arrest

Commonly occurs on dialysis unit as well as outside the hospital. This raises issues of cardiopulmonary resuscitation (CPR), and 'do not resuscitate' orders, which should be discussed in advance with patients and their families. A number of studies have looked at outcome of cardiac arrest in dialysis patients.

- The outcome is worse than in the general population: only 8% of resuscitated dialysis patients leave hospital compared with 12% of the general population
- In one study, 80% of patients who initially responded to CPR were dead within 4 days

Patients and families have a much more optimistic attitude towards CPR. Education and advance planning are therefore important.

Stopping dialysis

UK Renal Registry data¹ show that up to 25% of deaths in patients on dialysis are due to withdrawal of treatment, particularly in older patients. In the majority of instances, this decision is made when death is close and inevitable. Less commonly, a patient may decide to stop dialysis because of a gradual decline in their health. Examples of both are given in Box 4.2.

Suggestion of withdrawal of dialysis is often made by the physician but is also commonly made by the patient or a family member. Frequently the patient may make the request to their dialysis nurse or a nurse on the ward rather than to a doctor directly. Such requests should be followed up with discussions with medical staff, counsellors, social workers, and the

family (see A Chapters 11 and 12).

Time to death after withdrawal of dialysis depends on coexisting illness and residual kidney function. Death will usually occur within 2 days in the presence of severe illness. In patients established on HD, time to death after stopping dialysis is a median of 8–9 days in almost all studies. Some can survive longer if there is significant residual kidney function. This is more common in patients who have only recently started dialysis.

Box 4.2 Withdrawal of dialysis

Patient 1

SS was an 86-year-old man who had been on PD for 5 years. He originally had coped very well but over the years became shorter of breath because of underlying chronic obstructive airways disease. It became increasingly difficult for him and his wife to cope with dialysis at home, and, a year before he died, an attempt was made to change to HD. He tolerated this very poorly and had a cardiac arrest on the second dialysis. The family therefore decided to continue with PD at home. One year later he was admitted with a gangrenous leg. He was in severe pain, hypotensive, and confused. After discussions with the medical team, the wife and son felt he would not want to go ahead with an amputation. Dialysis was stopped and he died peacefully 2 days later.

Patient 2

Julia was a 35-year-old woman who had been on PD for 8 years following haemolytic uraemic syndrome associated with pregnancy. The first 5 years had gone well. Julia had managed to work as a teacher and accompany her husband when he travelled for work to Europe. Having initially been not keen on transplantation, she then accepted a kidney from her husband. Unfortunately, this failed immediately because of renal vein thrombosis. She subsequently continued on PD but accepted she would have to convert to HD as she was losing ultrafiltration. However, three attempts at fistula formation failed.

One weekend she was admitted with her first episode of peritonitis. This failed to resolve and the catheter had to be removed. At laparatomy extensive fibrous adhesions were found between the bowel loops and a diagnosis of encapsulating peritoneal sclerosis (EPS) was made. HD, however, did not go well; catheters only lasted a few days because of clotting problems. She also had continuous abdominal pain and was going to need parenteral nutrition as she did not tolerate any oral fluids. Although her prognosis was poor, there was a possibility that, with parenteral nutrition and eventual formation of definitive vascular access, she would be able to leave hospital, though after a prolonged admission. After many discussions with the healthcare team, she decided that she would rather discontinue dialysis when her current venous access failed. This happened during the next dialysis. Treatment was then stopped and she was given appropriate pain relief and eventually sedation. She died a week later.

Reference

1 UK Renal Registry Report 2009.

Conservative care

With increasing awareness of the poor outcome on dialysis for older patients with multiple comorbidities, the option of no dialysis is increasingly becoming a standard component of pre-dialysis education. Around 8% of the pre-dialysis patients in London select conservative management.

Conservative management

It is important that patients continue to be actively managed, even when they decide that dialysis is not for them.

Survival depends on kidney function and comorbidity; median survival

once GFR is <10mL/min is around 8 months.

- Several studies suggest that survival of elderly patients with multiple comorbidities is the same in those who choose conservative care as in those who start dialysis.
- Correction of anaemia with erythropoietin improves symptoms and quality of life.
- Correction of hypocalcaemia to prevent seizures.

Careful monitoring of fluid status:

Use of diuretics to prevent pulmonary oedema.

- Avoidance of fluid depletion which can result in hypotension and deterioration in kidney function, particularly in patients taking ACE inhibitors or angiotensin receptor blockers.
- Appropriate referral to community services and palliative care.

Re-offering the option of dialysis when patients become more

symptomatic.

 Clear records should be available in hospital notes and in primary care of the patient's decision not to have dialysis.

Quality of life

Although there are no studies comparing quality of life of patients who have chosen conservative care and those on dialysis, clinical observations suggest some advantages for frail patients with multiple comorbidities.

Symptoms and physical function usually remain stable until the last

weeks of life.

 Patients having conservative care spend fewer days in hospital—both for dialysis and for inpatient stays.

A higher proportion of patients die at home or in a hospice.

Causes of death

- Often patients will die from their comorbid diseases, e.g. cardiac or vascular disease, malignancy.
- Death will also occur from uraemia.
 - · Increasing drowsiness and confusion.

 - Arrhythmia related to hyperkalaemia causing sudden death.
 - Pulmonary oedema.

See also Chapter 13.

Conservative care

Patient '

Mr M was a 78-year-old man who was being followed in the renal clinic with CKD and hypertension. He had never married and lived with his nephew. During an admission with an acute coronary syndrome, he decided he did not want active cardiac treatment or dialysis when needed. At that time his plasma creatinine was 350µmol/L and Hb 8.2g/dL. On discharge, he was started on erythropoietin treatment and his Hb was subsequently maintained around 12g/dL. Over the next 2 years he was reasonably well and lived independently; plasma creatinine continued to rise, but slowly, and reached 450µmol/L. He continued to state that he did not want dialysis when needed. Two years after the initial coronary event, he was again admitted with severe chest pain and hypotension. On discussion, he stated that he did not want resuscitation if needed. He died from a cardiac arrest 2 days later.

Patient 2

Mr C was an 85-year-old man who was referred to the renal physicians having had a seizure in the urology clinic that he was attending for management of urinary retention. He was a practicing Scientologist and had resisted referral to hospital until he went into acute retention. Blood results showed: creatinine 834µmol/L; urea 45mmol/L; Ca 1.5mmol/L; phosphate 2.6mmol/L; potassium 5.6mmol/L; Hb 5.2g/dL. Renal ultrasound showed two small kidneys. Discussions were held with him and his wife. Both were adamant that they did not want dialysis. He was started on erythropoietin treatment and given supplies of alfacalcidol and calcium supplements but he did not take them. He continued to have intermittent seizures and generally deteriorated. His wife was also elderly and fairly frail and could not nurse him at home. At the end, he was admitted to hospital where he gradually went into coma and died 2 days later.

Predicting the end of life

Predicting the end of life in patients with advanced kidney disease is often difficult. Doctors tend to be over-optimistic about prognosis and the likely success of interventions. We all remember the individual patient who has survived despite the odds. The more common scenario, though, is for general deterioration after acute events, so that although the patient 'recovers', he or she fails to return to previous levels of functioning. This is discussed in more depth in \(\subseteq \text{Chapter 6.} \)

The simplest tool to predict the end of life is the 'surprise question'.

The surprise question

Would you be surprised if the patient died in the next 12 months?

- Studies have shown that patients with the answer 'No' to the surprise question have a poorer survival, though many will still be alive at 12 months.
- The accuracy of predicting mortality within the next 12 months can be increased by adding in other predictors of poor survival, e.g. dementia, PVD, low plasma albumin.

Dementia and PVD are particularly associated with poor survival.

 Decline in physical function as evidenced by poor mobility, falls, slow walking speed, and need for assistance with activities of daily living have all been shown to be associated with increased mortality.

The surprise question can be a useful start to that difficult conversation

about approaching the end of life:

 'If I ask myself whether I would be surprised if you were no longer with us in 12 months time, the answer is "no". However, that does not mean that the end will definitely come in the next year-but it does mean that we should start talking about whether you have ever thought about the end and what your wishes would be. . . .

Health-related quality of life in end-stage kidney disease

Introduction 78
Measures of HRQOL 80
HRQOL of dialysis patients 82
Factors affecting quality of life 86
Quality of life at the end of life 88
Conclusions 90

Introduction a battalayed lise if

'The quality, not the longevity, of one's life is what is important'

Dr Martin Luther King, Jr

Quality of life has many definitions; it is a concept that relates to an overall sense of an individual's well-being. It includes an individual's satisfaction with their life and relates to their ability to take pleasure in everyday activities. Health-related quality of life (HRQOL) extends this definition to include the way a person's health affects their ability to carry out normal social and physical activities. It is increasingly recognized that patient outcomes are strongly associated with HRQOL measures. HRQOL is often more important to patients than survival, particularly near the end of life.

Components contributing to HRQOL

Various overlapping components contribute to HRQOL:

Physical components:

- · Level of physical activity.
- · Sense of physical well-being.
- · Overall health.
- Energy/vitality level of patients.

Psychological components:

- Cognitive and emotional functioning, e.g. depression, anxiety.
- Social components:
 - Societal functioning.
 - ADLs.

Treatment-related components:

- Impact of a specific therapy on the patient's life.
- · Satisfaction with care.

Measures of AROU.

reace are many measures of the 1900 Objects and source, we many reaches are accepted to the control of the cont

source outrionly used the groups

- onor from 1810 (1916), the rement in the several remembers of the sever
- ejegülner payara iromana payareal ünit mannaga ün mittaliin, duc
 roothyseli haraili geniyet, kalta naranyan iqilgamlandin anangam.
- domining committee of the committee of approximation of the solution of the committee of th
- and saroty starting they have been accessed by market and both and they are the properties of the same and they are they are the same and the same and the same and they are the same and the
- gsware Crisia in normalis. Pray to result (), cy sit Hall RDOON artisses ha na offspuorficilis. Pratti vito vito work Voltages.
- Diagrams in abuda wook of strong goaling of soons, interpretsions in proceed on the following strong of features in the same of the features of solveral mostly and so for confidency disease (objects from the following strong of the features).
 - problem issues the second of the speciments of t
 - ad at memoral or of times as possible statement of the control of
- and the Control of the State of
- The scholar of the majorate of the promise could be deputed to the second excellent from the second of the second
 - Diagnosicol efinical depression remisere surficience interview.

Measures of HRQOL

There are many measures of HRQOL. Objective measures are more scientifically valid; subjective measures are better at capturing patient experience (e.g. patient-reported outcomes) but can be difficult to interpret.

Some commonly used measures

 Short Form-36 (SF-36): this is a generic measure developed for use in the general population. It therefore does not focus on problems related to kidney disease or its treatment.

 Measures physical domains (physical functioning, role limitation due to physical health, general health perception, and pain) and mental domains (energy/fatigue, social functioning, emotional well-being, and role limitations due to emotional problems).

 Physical and mental domains are summarized in physical and mental component scores. The score for each of these in the general population is 50; the higher the score, the better the performance.

 The physical component score of SF-36 is lower in dialysis patients compared with the general population. Mental health scores are usually closer to normal.

Kidney Disease Quality of Life (KDQOL) assesses domains specifically

for patients with kidney disease.

- Domains include work status, quality of social interactions, burden
 of kidney disease, social support, cognitive function, sexual function,
 sleep, effects of kidney disease (overall health) and symptoms/
 problem list.
- Scores are aggregated and transformed to a 0–100 range; higher scores indicate better status.
- Symptom-specific questionnaires elucidate symptoms known to be associated with ESKD and its treatment.
- Depression screening, e.g. Hospital Anxiety Depression Score (HADS), Beck Depression Inventory (BDI).
 - These determine the presence of symptoms related to depression, e.g. feeling hopeless, changes in sleep, etc.
 - Diagnosis of clinical depression requires a structured interview.

HRQOL of dialysis patients

Dialysis treatment is promoted as a means of maintaining or improving a patient's quality of life and well-being. This inevitably results in patients electing to commence dialysis in the expectation that their lives will be

significantly improved as a result of undergoing treatment.

However, studies based on the Karnofsky performance score (KPS), KDQOL, and SF-36, a patient's self-assessment quality of life health survey questionnaire, would indicate that the physical quality of life of both HD and PD patients is substantially impaired in comparison with the general population. Research suggests that HD patients experience lower levels of quality of life than PD patients in relation to physical functioning, role functioning, emotional and mental health, and pain, though such observations need to be adjusted for the lower comorbidity burden and younger average age of patients on PD. Comorbidities, low haemoglobin, and low residual kidney function are all contributing factors to a poorer quality of life, as can be living alone with little or no support locally.

HRQOL for PD patients

PD patients cite:

- feeling bloated;
- itching;
- · feeling cold;
- · lacking concentration;
- fatigue and difficulty mobilizing.

They also complain of:

- · fear of infection;
- fear of having to convert to HD;
- anxiety about sexual intimacy;
- negative impact on sporting activities;
- negative impact on social life due to PD regime;
- feeling socially isolated;

However, PD patients:

- usually find it easier to book holidays and short breaks as their dialysis fluid can be delivered to their holiday address or—if they are holidaying in the UK—they can often take their supplies with them;
- feel more in control of their lives and value their independence.

HRQOL for HD patients

Some HD patients cite:

- ongoing fatigue;
- reduced physical activity and stamina;
- sleep disturbance;
- restless legs;
- leg cramps;
- itching;
- feeling cold;
- dizziness;
- · headaches;
- · nausea and vomiting;

- poor concentration;
- access problems;
- anxiety, panic attacks, and depression;
- erectile dysfunction.

They also cite feeling frustrated when trying to:

- arrange holidays or spontaneous short breaks;
- negotiate more flexible dialysis slots;
- avoid delays in being put on a machine;
 avoid unacceptable waiting times for hospital transport;
- maintain their role in the family.

HRQOL for both HD and PD patients

For the great majority of people there is the hope of a transplant and continued disappointment as the wait continues.

It is perhaps not surprising to learn that, for some patients, the rigours of dialysis are barely tolerable. They struggle to integrate it into their lives and complain that having treatment has not in any way enhanced their quality of life.

Loss of control

Frequently mentioned in quality of life questionnaires is personal loss of control over one's own life and facing an uncertain future—a concern that is also shared by partners and family members.

I am finding this whole thing so difficult and had I known it was going to be like this, I don't think I would have elected to have dialysis. I have to get up at an unearthly hour to be ready for transport. I invariably feel quite nauseated on the journey to the unit. I have to wait for up to an hour to be put on the machine and am then told off for having put on too much weight. Then I have to hang around waiting for transport to take me home by which time I am so tired I just flop into bed. What life is that? And the non-dialysis days are not much better as I still lack energy and 'get up and go'. It's not much fun for me and I know my family is suffering too. I feel such a burden—my husband has to do everything for me and, although he doesn't complain, he looks worn out. If I had known it was going to be like this, I would never have started it'

Expectations

It can be seen that some patients feel short-changed—that their expectations have not been met and that life on dialysis is not living. For other patients, the euphoria of being thrown a life-line can turn to despondency and despair as they recognize that their hopes of an enhanced quality of life were unrealistic. This is particularly so with patients whose underlying systemic disease was responsible for causing the ongoing progression of kidney failure.

Joanna was such a patient. She had cystic fibrosis and was diabetic, but a successful heart/lung transplant some 15 years previously had transformed her life. She had married and was able to hold down a full-time job until her heart/lung anti-rejection drugs caused her kidneys to fail. She was also diagnosed with vasculitis and, as the disease progressed; she was readmitted to hospital where she underwent surgery to amputate first several of her fingers and then 2 weeks later above-knee amputations were performed. From being a totally independent and fully functioning person, in the space of just 8 weeks she became reliant upon nursing staff and family for her most basic needs. 'I can't even pick my own nose' she jokingly said, but as the weeks passed, she became more and more dependent and despairing, saying 'Can you imagine what it's like having to ask a male nurse to wipe and wash your bottom?'

Whilst dialysis supports life, it does not necessarily improve quality of life, and current research would indicate that the majority of dialysis-dependent patients rate HRQOL as being less than 'good' as deteriorating health impacts on the amount of time they can spend at work and on other activities—to say nothing of the impact it has on family life.

factors affecting quality of life

out mouse the distance of the particle of the standard of the particle of the

Pariett Cattents, Companie

deprivation of allows except to the continue of

And the method in the first and afford contain and the first and the fir

Find and the above of the first of the security of the securit

The first response of the second of the seco

consistence actionists

and the contract of the design of the contract of

the first exist of mentality activities. Tackle outside the self-

ann in 1996, Agus Bailtean (1997) ann an taigir ann an t-Airean (1997). Taigir an Taigir Bailtean (1997) an taigir an t-Airean (1997) ann an t-Airean (1997).

A service that the rest and a dependent series benefit and

Carrier Practice

Set son ception, see Wor with seal to the designation of the plant of the cold of the plant of t

Factors affecting quality of life

Fluctuating health and the rigours of dialysis impact on a patient's ability to be fully functioning.

Younger patients' complaints

- Being dependent on dialysis sets them apart from their peers and accentuates 'difference'.
- Access surgery is 'mutilating' and affects perceptions of body image, which can deter patients from establishing meaningful relationships or initiating sexual activity.
- Fluid and dietary restrictions are difficult to reconcile with lifestyle and younger patients often find it easier to withdraw and isolate themselves from their peer group rather than risk participating and being labelled 'different'.
- Sometimes a desire to be socially included results in younger patients taking negative risks such as drug or alcohol abuse, disregarding dietary and fluid restrictions, or not attending for dialysis sessions.
- Parental involvement increases at a time when healthy separation should be occurring. This can lead to resentment, recriminations, and difficult family dynamics.

Older patients' complaints

They may be experiencing difficulty in:

- establishing and/or maintaining their role within the family;
- securing and/or sustaining employment;
- meeting existing financial commitments;
- fully participating in family activities, social events, and holidays;
- remaining sexually active;
- managing family dynamics and interpersonal relationships when all energy is invested in just trying to integrate dialysis into an existing daily routine.

They may find that they are more dependent upon family members.

General factors

Self-perception, self-worth, and self-esteem can be adversely affected by being dependent on dialysis, which can lead to relationship difficulties and in some cases relationship breakdown as the pressure of adjusting to dialysis becomes too difficult to manage. It can be a time when patients complain of feeling unsupported and not understood by their partners, carers, or indeed their physicians, and it is not uncommon for patients at this stage of their kidney journey to consider withdrawal of treatment.

Opadicy of life at the eye of life

Quality of life at the end of life

As discussed throughout this book, the end of life phase is the stage in the ESKD pathway where palliative care—symptom, emotional, and social support—becomes more important, while active interventions have limited benefits and indeed can do harm. Quality of life is particularly important at this stage. Not surprisingly, studies show that measures of HRQOL are affected adversely by symptoms, particularly pain. Discussions about end of life care—advance care planning (ACP), determining preferred place of care—can alleviate emotional distress for many patients. Again, it is therefore not surprising that studies are beginning to show that such discussions can also improve quality of life at end of life.

Studies of HRQOL at end of life

There are now several studies that have measured HRQOL at end of life, though mostly not in kidney patients. It is reasonable to extrapolate the findings to patients with ESKD; there is no evidence that patients with ESKD behave differently from patients with other chronic conditions.

Evidence from randomized controlled trials (RCTs):

- An Australian RCT of advance care planning (ACP) in 309 general medicine inpatients >80 years old showed greater satisfaction of patients with their care in those who took part in ACP.¹
- In patients with metastatic non-small-cell lung cancer, the group randomized to early palliative care had better quality of life and fewer depressive symptoms. Interestingly, although the palliative care group had less active interventions at the end of life, they lived longer than the patients who did not receive palliative care (11.6 vs 8.9 months, P = 0.02). Both groups received the same initial chemotherapy. The palliative care group also received symptom and psychosocial support and were involved in decision-making round goals of care.²

References

- 1 Detering KM, Hancock AD, Reade MC, Silvester W (2010) The impact of advance care planning on end of life care in elderly patients: randomized controlled trial. BMJ 340, c1345.
- 2 Temel JS, Greer JA, Muzikańsky A, et al. (2010) Early palliative care for patients with metastatic non-small-cell lung cancer. New Engl J Med 363, 733.

Conclusions

The impact of RRT will vary with the treatment modality used and from patient to patient. What is essential, however, is not to forget the importance of quality of life in assessing someone who is receiving dialysis and always to seek to see if there are ways it can be improved. Some factors such as transport, cited above, could be improved with better use of resources; others, particularly those that relate to comorbid conditions or complications of kidney disease, may be irreversible. It is then important to strive to alleviate symptoms and provide all possible social, psychological, and spiritual support. This, the philosophy of palliative care, underpins the kind of care that we should endeavour to provide for these patients and their families and can be practised by any and all healthcare professionals, whatever the setting.

Symptom assessment and trajectories

Introduction 92
Symptom prevalence 94
Symptom assessment 96
Symptom trajectories 98
Further reading 102

Introduction

Patients with ESKD are among the most symptomatic of any chronic disease group.

Solano et al. (2006)1

Patients with ESKD are very symptomatic. This may be from comorbid conditions more than the kidney disease itself, but nevertheless, symptoms impact adversely on quality of life, and need active management. In addition to disease-related symptoms, RRT may itself cause symptoms. Dialysis provides major survival benefit and some relief of symptoms but, conversely, it may also add to symptom burden.

Identifying and controlling symptoms is a high priority for patients and their families, and can improve quality of life substantially. For these reasons, excellent symptom assessment and management is important.

The challenge of recognizing symptoms

In kidney disease, symptoms are infrequently assessed and often poorly recognized.² Patients themselves are uncertain about how to attribute their symptoms, and may not identify them spontaneously to professionals. In addition, symptoms may be long-standing. These factors militate against symptoms being discussed, and so renal professionals may underestimate symptom presence and severity in their patients.

There are several reasons why recognizing symptoms is so challenging: Symptoms may be due to comorbidities, not kidney disease itself.

- Patients may have experienced symptoms for weeks, months, or years, and come to accept them as routine, though unpleasant and distressing.
- Patients do not know what is causing their symptoms, and feel uncertain about raising them.
- There is often a clinical focus on blood results and renal management; symptoms may take second place in a busy clinical setting.

References

1 Solano JP, Gomes B, Higginson IJ (2006) A comparison of symptom prevalence in far advanced cancer, AIDS, heart disease, chronic obstructive pulmonary disease and renal disease. J Pain Symptom Manage 31, 58-69.

2 Weisbord SD, Fried L, Mor MK, et al. (2007) Renal provider recognition of symptoms in patients on maintenance hemodialysis. Clin J Am Soc Nephrol 2, 960-967.

Symptom prevalence

Symptom research is increasing, and much more is now known about prevalence of symptoms. Individual symptom prevalence is dependent on a number of factors, including: (a) how advanced the kidney disease is, (b) whether a patient is on dialysis or not, (c) what comorbid conditions they have, and (d) how symptom prevalence is measured (particularly how a symptom is defined and the time period over which symptoms are sought).

In general, physical symptoms such as fatigue, itch, drowsiness, pain, and dyspnoea are highly prevalent, occurring in 50-70% of patients. Prevalence is lower in earlier stages of disease. Low-level psychological symptoms are also relatively common, especially in certain subgroups (for instance, conservatively managed patients) and at certain times (for instance, around adjustment to changes in management or focus of care and towards death). However, severe psychological symptoms are generally infrequent.

Not all symptoms have the same impact. Certain symptoms, including fatigue, pain, and dyspnoea, are disproportionately distressing to patients. Renal-specific symptoms, such as restless legs and itch, are also unduly distressing, and may interfere with sleep. The prevalence of individual symptoms in different ESKD populations is summarized in Fig. 6.1.

Patients with advanced kidney disease have a high prevalence of individual symptoms, but also considerable total symptom burden. It is important to consider overall symptom burden. A symptom such as pain, for instance, is much more distressing for a patient who is also experiencing sleep disturbance, restless legs, and low mood at the same time.

The average symptom burden is moderate, with a mean number of symptoms of 15 among conservatively-managed patients, but with a wide range (from five to 30).1 This is similar to the least well among dialysis patients.² Some dialysis patients who are doing well will have a much lower symptom burden. Whatever subgroup of the ESKD population is considered, there is considerable diversity; some individual patients experience very few symptoms, while others have a very high overall symptom burden. This has implications for services: a 'standard' approach is unlikely to be optimal, but instead a 'tailored' or targeted service, which is responsive to (and varies in level of input according to) the individual patient's level of symptoms and related distress, is more likely to be effective.

References

- 1 Murtagh FE, Addington-Hall J, Edmonds P, et al. (2010) Symptoms in the month before death for stage 5 chronic kidney disease patients managed without dialysis. J Pain Symptom Manage 40, 342-352.
- 2 Weisbord SD, Carmody SS, Bruns FJ, et al. (2003) Symptom burden, quality of life, advance care planning and the potential value of palliative care in severely ill haemodialysis patients. Nephrol Dialysis Transplant 18, 1345-1352.

Fig. 6.1 Proportion (%) of patients with common symptoms in advanced kidney disease: (a) patients on dialysis; (b) patients with conservatively managed stage 5; CKD; (c) patients withdrawing from dialysis (last 24 h of life). Reprinted from E. Joanna Chambers, Edwina Brown, and Michael Germain, Supportive Care for the Renal Patient, Second Edition, 2010, p. 106 with permission of Oxford University Press, Inc.

Symptom assessment

It is important to routinely assess symptoms without waiting for the patient to raise them, and this can be done effectively and well integrated into regular nephrology care. The most important consideration is to use an appropriate, clinically relevant, and valid instrument to capture symptoms, and ensure the patient is asked to complete it, either regularly or when they experience any change in symptoms.

Assessment tools

Formal symptom assessment tools validated in ESKD patients include:

- The renal version of the Patient Outcome Scale—symptom module (POSs renal).1
- The Dialysis Symptom Index (DSI), developed from the Memorial Symptom Assessment Scale by Weisbord.
- The modified Edmonton Symptom Assessment Scale (ESAS).³

These were developed in the UK (POSs renal), the USA (DSI), and Canada (ESAS), respectively. All are patient-completed tools, and they are very similar; DSI is longer and may be slightly more suited to research than routine clinical use. Both POSs renal and DSI ask about the level of distress associated with a range of symptoms common in kidney disease, while ESAS uses a visual analogue scale for the patient to score common symptoms. The UK tool can be downloaded for use from http://www.csi. kcl.ac.uk/pos-s.html.

The use of clinical tools to assess symptoms is not, of itself, sufficient. Social and practical concerns, for instance, will not emerge from a symptom measure. Use of an assessment tool will help flag symptom concerns, and will signal the importance of these issues, but cannot be a substitute for more detailed elucidation of symptoms and other concerns within the clinical consultation, where more complex or less easily elicited, issues need to be identified and explored.

References

- 1 Murphy EL, Murtagh FE, Carey I, Sheerin NS (2009) Understanding symptoms in patients with advanced chronic kidney disease managed without dialysis: use of a short patient-completed assessment tool. Nephron Clin Pract 111, c74-c80.
- 2 Weisbord SD, Fried LF, Arnold RM, et al. (2004) Development of a symptom assessment instrument for chronic hemodialysis patients: the Dialysis Symptom Index. J Pain Symptom Manage 27, 226-240.
- 3 Davison SN, Jhangri GS, Johnson JA (2006) Cross-sectional validity of a modified Edmonton Symptom Assessment System in dialysis patients: a simple assessment of symptom burden. Kidney Int 69, 1621-1625.

Symptom trajectories

Symptom prevalence is often studied cross-sectionally, at one point in time, but this is not how patients experience their symptoms. Symptoms begin, evolve over time, and may subside or fluctuate. A trajectory is a pattern of change over time. Understanding symptom trajectories is key in planning care and delivering good symptom management, in order to anticipate and plan for changes in symptoms over time.

Work evaluating symptom trajectories in conservatively managed

patients¹ shows:

symptoms markedly increase in the last 2–3 months before death;

 individual patients showed considerable variation in their symptom trajectories.

Changes towards death

Symptoms change as patients approach death. On average, symptoms increase steadily in the 2-3 months before death. Professionals should be alert to increasing levels of symptom distress, and be aware that it may precede decline towards death. Although teams may wish to focus symptom management resources into this last 2-3 months to provide maximum benefit, it is not yet clear whether targeting symptoms before they increase is more effective or not. It is likely that a combination of targeting of symptoms before they worsen, and increased pro-active management in the last months when symptoms are more prevalent and severe is needed.

As death nears, the physical symptoms that were previously common become almost ubiquitous, and the associated levels of distress reported by patients are high. Dyspnoea is particularly dominant and distressing, especially for those with cardiac or respiratory comorbidity, and needs to be actively managed (see A Chapter 13). Psychological symptoms, although still less dominant than physical symptoms, become much more

prevalent, with associated increase in severity.

There continues to be, even close to death, considerable diversity among patients, ranging from relatively little symptom burden and related distress, up to very high levels of burden and distress from symptoms. Close to death, quality of life is impaired across both physical and mental domains, with physical aspects most affected, but psychological quality also notably impaired. The final illness itself may be short, and this highlights the need for rapidly responsive services, particularly community services if the preferred place of care is home (a proportion of renal patients prefer hospital, as they often know renal staff well and are familiar with the inpatient renal unit).

Individual variations in symptom trajectory

Three different patterns of symptom trajectory have been described (Fig. 6.2):1

steadily increasing symptoms over time;

 fluctuating symptoms over time (the unpredictability of which was highly distressing for patients);

stable symptoms which do not change over time.

Fig. 6.2 Individual trajectories of symptom distress. Reprinted from Murtagh FEM, Sheerin N. Addington-Hall J. Higginson IJ. Trajectories of illness in Stage 5 Chronic Kidney Disease: a longitudinal study of patients' symptoms and concerns in the last year of life. CJASN 2011: 6, 1580-1590.

This diversity indicates that services need to be flexible and highly responsive to individual needs. Those with a fluctuating pattern of symptoms may have the greatest need, not only in terms of symptom control, but also in terms of psychological and social support, as patients and families struggle with uncertainty and an unpredictable course.

'The worst of it is, I never quite know how I'm going to be. Sometimes I can get up and I'll be fine, it will be a good day, and that will carry on for a bit, and then out the blue, it all goes, like I've run out of petrol or something, and there's nothing in the tank. I can feel unwell for days then.'

Patient with CKD stage 5, fluctuant symptom trajectory

In developing and providing services, these patterns of symptoms should be recognized and anticipated. Detailed and skilled management of

symptoms is important, and is addressed in \square Chapter 8.

A further consideration is the frequency with which assessment of symptoms should be undertaken, especially if symptom assessment tools are being routinely administered to increase pro-activity and improve identification of symptoms. These patterns of change over time suggest that such assessment should not be dictated by clinical attendance if symptoms are assessed every 3 months, for example, then the worsening symptoms and concerns in the 2 months prior to death may be missed. Symptom scores could be triggered by a patient's own concern that there is a notable change and/or by monitoring mild symptoms that may worsen, in addition to administering routine symptom assessment at follow-up clinic or home appointments. The relatively small numbers of patients following a fluctuant symptom trajectory will need intermittent symptom interventions and fluctuating levels of involvement of services throughout their illness trajectory; again, a 'standard' approach is not ideal for accommodating the care of these patients.

CHAPTER 6 Symptom assessment and trajectories

Given the relatively short terminal decline, patients and families also need to be able to call on renal or palliative services for help at short notice, and often find it helpful to have a single point of contact 24 h a day, 7 days a week, if feasible. This is especially useful in the last few weeks of life.

Reference

1 Murtagh FEM, Sheerin N, Addington-Hall J, Higginson IJ (2011) Trajectories of illness in stage 5 chronic kidney disease: a longitudinal study of patients' symptoms and concerns in the last year of life. Clin J Am Soc Nephrol 6, 1580-1590.

enthan reading

Further reading

Chambers EJ, Germain M, Brown E (2010) Supportive care for the renal patient. Oxford: Oxford

Murtagh FEM, Addington-Hall JM, Higginson IJ (2011) End-stage renal disease: a new trajectory of functional decline in the last year of life. J Am Geriatr Soc 59, 304-308.

The management of pain

Introduction 104 Causes of pain 106 Types of pain 108 Assessment of pain 110 What hinders pain management? 112 Principles of management: the WHO analgesic ladder 114 WHO analgesic ladder: steps 1 and 2 116 WHO step 3: opioids for moderate-severe pain + non-opioid ± adjuvant 118 Summary: WHO analgesic ladder 124 Managing opioid side-effects 126 Adjuvant analgesia 128 Episodic, movement-related, or incident pain 130 Chronic pain clinic referral and anaesthetic procedures 132 Referral to the palliative care team 134 Further reading 136

Introduction

Even thinking about pain is like tapping at a high voltage wire with the back of your finger to see if it's live.

Christopher Wilson-Gleave

The growing number of patients on RRT or conservative management of ESKD, many of whom have multiple comorbidities, means that there are many patients living with the consequences of their disease, one of which is a prevalence of pain similar to that experienced by patients with advanced cancer. It is imperative that this is recognized by those caring for them and that pain is pro-actively assessed and actively managed to improve quality of life. Pain may well be related to comorbidities, rather than kidney disease itself, but it still needs active management. Management is made more difficult by the impact of kidney disease on prescribing.

Incidence of pain

Studies indicate that between 47% and 67% of patients on dialysis experience significant pain^{1,2} and a similar proportion (53%) of those managed without dialysis have pain.3

- Pain is moderate or severe for up to a half of those with pain.
- Significant numbers of patients are on no analgesia despite pain.
- Where the pain management index has been measured it indicates inadequate pain relief for three-quarters of patients.
- The mean duration of dialysis-related pain is 24 months:
 - · it occurs more often than once a week:
 - the mean duration of each episode is 2h.
- The mean duration of pain not associated with the dialysis procedure is also 24 months.
- Some studies report an association between incidence of pain and length of time on dialysis.
- The mean pain score for both dialysis and non-dialysis pains shows that moderate to severe pain is experienced for both types.
- There is an association between pain and depression in ESKD.

Impact of pain

Using the Brief Pain Inventory scoring system to show how pain impacts on activities of every day reveals that it significantly affects:

- general activity;
- normal work;
- enjoyment of life;
- other aspects of life, such as walking ability, mood, and sleep.

References

- 1 Murtagh FEM, Addington-Hall J, Higginson IJ (2007) The prevalence of symptoms in end-stage renal disease: a systematic review. Adv Chronic Kidney Dis 14, 82–99.
- 2 Davison SN (2003) Pain in haemodialysis patients: prevalence, etiology, severity and analgesic use. Am J Kidney Dis 42, 1239–1247.
- 3 Murtagh FEM, Addington-Hall JM, Edmonds PM, Donohoe P, Carey I, Jenkins K, et al. (2007) Symptoms in advanced renal disease. J Palliat Med 10, 1266–1276.

Causes of pain

The causes of pain in the ESKD population can be divided into categories. In some instances, this will help the clinician determine the best management strategy.

Concurrent comorbidity

This is the most common cause of pain in this population.

- Diabetic neuropathy.
- · PVD.
- · Chest pain.
- Arthritis.
- Decubitus ulcers.

Primary renal disease

A group of less common causes of pain, but may be a considerable challenge to relieve.

- Adult polycystic kidney disease (APKD):
 - · pain from bleeding into or rupture of renal cysts;
 - pain from liver distension from liver cysts;
 - pain from infected liver cysts;
 - back pain from lumbar lordosis caused by long-standing abdominal distension from enlarged liver.
- Renal calculi.

Complications of kidney failure

Some of these are the consequence of longevity achieved through successful RRT. It may not always be possible to distinguish the precise cause of bone and joint pains, many of which are caused by comorbid arthritis; musculoskeletal pain from whatever cause constitutes the commonest single type of pain. This is important because it can also be a difficult group to treat as pain is often movement-related (see this chapter, Episodic, movement-related, or incident pain, p. 130).

- Renal osteodystrophy.
- Gout and other crystal arthropathies.
- Dialysis amyloid arthropathy.
- Calciphylaxis.

Infection

- Septic arthritis.
- Discitis with epidural abscess formation.
- Peritonitis in PD patients.

Dialysis-related pain

- 'Steal syndrome' from AV fistulas.
- · Cramp.
- Headaches.
- Abdominal pain in PD patients.

Types or nate

Aur me numbered management. If neinful executegorith, each tree

alefterer der w

te i tre esta a la companio de la c

with Course for a constant and a

Self-valiet so tempo por esta come pero o estado albado relibe e

Nacioagrive pain entire per user a terre langer in survey only a opport any gest, the costrere of a besing readed will decord on the event of the plant.

Neuropaeth manussalvines sent conditionary burdens of a mover of the condition of the condi

Incidenti no moyentetto nelaced pain a circ come to bose se par famage, art i en en dicircto contratto han eus se to gaide. Eus us inclues pain ta contrat contrat participament in anapeta, et es codo ou occomes very case en contrata in requires for a cyto of anticas such characteristics on an equable and effections grant y are quees. It are a art or or when the ottom has no case.

รางกระทำ และ รายการกระทำการที่สามารถกระทำการที่สามารถกระทำการกระทำการที่สามารถกระทำการที่สามารถกระทำการที่สามา เกาะสามารถกระทำการที่สามารถที่สามารถที่สามารถกระทำการที่สามารถที่สามารถที่สามารถกระทำการที่สามารถที่สามารถที่ส

Types of pain

For the purpose of management it is helpful to categorize pain into:

- nociceptive;
- neuropathic;
- mixed nociceptive and neuropathic;
- incident- or movement-related;
- other specific pains, e.g. colic, which may be of renal or gut origin.

Nociceptive pain or the pain due to tissue damage is usually responsive to opioid analgesia; the strength of analgesia needed will depend on the severity of the pain.

Neuropathic pain usually has some opioid sensitivity but the doses required to relieve pain may cause unacceptable side-effects. Adjuvant analgesics (this chapter, Adjuvant analgesia, pp. 128-129) are therefore usually used with non-opioid and opioid analgesia. Many of the pains experienced in ESKD are a mixture of both nociceptive and neuropathic pain, e.g. the pain of peripheral ischaemia. These therefore need a combination of opioid and adjuvant.

Incident- or movement-related pain is often caused by bone or joint damage, and is more difficult to manage than most other pains. This is because pain is absent at rest when no or minimal analgesia is needed, but becomes very severe on movement requiring high levels of analgesia. This could lead to unacceptable side-effects, particularly sleepiness, if given at times when the patient has no pain.

Other specific causes It is important to diagnose other specific causes of pain, such as colic, since there may be specific remedies to relieve them.

Assessment of paint

Part of Monte of the Part of t

tour pento

FO Print American Conference of the Conference o

y end Window gas w

According to the control of indexing the representation of the fields by the control of the cont

Introduction plan and basevon pe

at a school gribman coop congress

Signification of the control of the

and the second s

Aperic og could bender dustak.

r sandar and sandar sanda

Taiddisk gamus 2.3 mins to great a construction of an artist title.

Manager of the now one depicts of the deal of the dea

eri da mangeo et (2 PA) Oc) menvas i melambama vene di francol Richardena non motali man atil eti basako ini digirin mina emin

Assessment of pain

- · Pain is what the patient says it is
- It can be profoundly affected by mood and by the meaning of the pain to the patient

It seems to me that pain in itself, though a pretty nasty piece of work, wouldn't have half the street cred if it wasn't like all bullies joined at the hip with that cringing lickspittle, fear.

Christopher Wilson-Gleave

Assessment of pain prior to initiation of management not only helps by determining, if possible, the cause of the pain, but also establishes a relationship with the patient. This relationship contributes to pain management through an ongoing partnership between physician or nurse and the patient. Pain relief is often not achieved at the first intervention but by initiating a plan of management, monitoring it, and adjusting it according to its effect on the patient. This ongoing commitment by the clinician to assess, reassess, and adjust gives the patient confidence that in itself will contribute to pain relief.

Areas covered by a pain assessment

- · Site of pain.
- Duration of pain including whether it is:
 - · constant;
 - · intermittent;
 - day or night and whether it disturbs sleep.
- Provoking factors.
- · Relieving factors.
- · Radiation of pain.
- Intensity could be recorded as:
 - · 'none', 'mild', 'moderate', or 'severe'; OR
 - using a numerical rating scale 0–10 where 0 = no pain and 10 = pain as unbearable as you can imagine.
- Nature of pain, e.g. burning, stabbing.
- Presence of abnormal sensation.
- Mood (to exclude depression).
- Meaning of the pain to the individual.

Figure 7.1 gives an example of a system (SOCRATES) to capture all the areas which should be covered in the pain history. Formal symptom assessment tools are discussed in A Chapter 6.

- Site of pain: Where? Any radiation? Numbness where pain felt? Pattern of joint/muscle involvement?
- Onset: When did it start? How did it start? What started it? Change over time? History or injury?
- C Character of pain: Type of pain—burning, shooting, stabbing, dull etc.
- R Radiation: Does the pain go anywhere else?
- A Associated feature
- Timing/pattern: Is it worse at any time of day? Is it associated with any particular activities?
 - E Exacerbating and relieving factors
- Severity: Record especially if the pain is chronic and you want to measure change over time, consider a patient diary. Ask about:
 - Pain intensity e.g. none-mild-moderate-severe; rank on a 1–10 scale.
 - Record interference with sleep or usual activities.
 - Pain relief e.g. none-slight-moderate-good-complete.

Fig. 7.1 Example of a pain assessment system. Reprinted from Karen O'Reilly, Max Watson, and Chantal Simon, *Pain and Palliation*, 2010, p. 7 with permission of Oxford University Press.

What hinders pain management?

Clinical factors

A combination of clinician and patient factors contributes to poor pain recognition and management in this group of patients. Some of these are listed below.

Clinician factors

- Primary focus on maintaining residual kidney function and preventing complications of kidney disease, with limited time/priority for symptom management.
- Associated lack of recognition of the problem and therefore failure to assess in the clinic.
- If pain is reported, uncertainty as to how to manage it because of lack of training in pain management.
- Failure to monitor the effect of treatment and therefore adjust according to response.
- Fear of causing toxicity from opioids.
- Fear of using strong opioids for non-cancer pain.
- Complex pain management because of more than one cause of pain.

Patient factors

- Underreporting of pain in the clinic, particularly chronic and long-term
- Cause of pain not directly due to kidney function and therefore not seen as the role of the nephrologist to help it.
- Analgesia not taken for fear of side-effects.
- Analgesia stopped because of side-effects but without request for review.
- Unfounded fear of addiction.
- Unfounded fear of tolerance and loss of effectiveness in the future 'when stronger pain killers might be needed'.
- Delaying amputation leading to a longer period with limb ischaemia pain.

Drug handling in kidney failure

Many drugs and their metabolites are excreted by the kidney through glomerular filtration, which, when reduced significantly, affects the clearance of those drugs and their metabolites. Where metabolites are active and retained, as is the case for morphine, the likelihood of toxicity is high. Other factors also contribute to difficulty in prescribing analgesia effectively.

- Bioavailability varies more in patients with uraemia than in patients with normal kidney function.
- Distribution:
 - increased in oedematous states;
 - decreased in dehydration and muscle wasting; reduced plasma protein binding (especially acidic drugs, e.g. phenytoin) may lead to increased toxicity from greater availability of free drug.

Metabolism:

- in the liver is affected by high levels of urea; some types of metabolism such as hydrolysis are slowed and others such as glucuronidation are not affected.
- Kidney excretion (falls as GFR declines):
 - dependent on molecular size and protein binding of drug.
- Pharmacokinetics:
 - usually worked out by plasma drug/metabolite concentrations after one-off dose modelling;
 - application of this model to chronic dosing is limited;
 - guidelines for dose adjustments in handbooks can therefore only be regarded as useful approximations, and often conflict.
- Dialysis losses:
 - difficult to predict as many factors affect removal not just molecular size.

Further reading

Vidal L, Shavit M, Fraser A, et al. (2005) Systematic comparison of four sources of drug information regarding adjustment of dose for renal function. Br Med J 331, 263–266.

Principles of management: the WHO analgesic ladder

Use of the WHO analgesic ladder (Fig. 7.2) to manage pain caused by cancer is recommended worldwide. Where pain is constant, as for many ESKD pains, a similar method of pain control can be used, with modifications to take account of the effect of poor kidney function. This method of working has been supported by recent studies indicating the likely efficacy of the WHO analgesic ladder in ESKD patients. 1,2

The principles are as follows:

- By mouth—where the patient can swallow and absorb.
- By the clock—if pain is constant, medication must be given regularly.
- By the ladder—adopting these steps in response to pain.
- Provide 'as needed' or prn medication for when pain breaks through.
- Tailored to the individual.
- With attention to detail:
 - frequent assessment for efficacy and toxicity;
 - · dose adjustments according to assessment;
 - active management of side-effects.

Initial analgesia is selected according to the intensity of pain. When a visual analogue scale of 0–10 is used, the following convention may be followed:

- Mild pain, scores 1—4:
 - step 1 on the WHO analgesic ladder.
- Moderate pain, scores 5–6:
 - step 2 on the WHO analgesic ladder.
- Severe pain, scores 7–10:
 - step 3 on the WHO analgesic ladder.

At all stages appropriate adjuvant treatment can be added. If pain is not adequately controlled at one step, then move up to the next step of the ladder or, if already on step 3, titrate the strong opioid upwards to pain relief (as long as adverse effects do not intervene).

References

- 1 Barakzoy AS, Moss AH (2006) Efficacy of the World Health Organization analgesic ladder to treat pain in end-stage renal disease. J Am Soc Nephrol 17, 3198-3203.
- 2 Launay-Vacher V, Karie S, Fau JB, Izzedine H, Deray G (2005) Treatment of pain in patients with renal insufficiency: the World Health Organization three-step ladder adapted. J Pain 6, 137–148.

Fig. 7.2 The WHO analgesic ladder. Reprinted with permission from the World Health Organization from http://www.who.int/cancer/palliative/painladder/en/.

WHO analgesic ladder: steps 1 and 2

Step 1: non-opioids ± adjuvants

Paracetamol

Metabolized by the liver; metabolites do accumulate but are accepted to be safe at normal doses.

Recommended: paracetamol 1g four times a day (qds)

Non-steroidal anti-inflammatory drugs (NSAIDs)

- Should be avoided if residual kidney function.
- Increase in non-renal side-effects.
- May be used in patients on dialysis.
 - Caution needed in PD patients with residual kidney function.
- May be considered at end of life if best way of relieving pain.
- ± Adjuvants as indicated (see this chapter, Adjuvant analgesia, pp. 128-129).

Step 2: opioids for mild to moderate pain + non-opioid ± adjuvants

Codeine

- Metabolized to codeine-6 glucuronide and morphine.
- Significant increase in half-life in kidney failure.
- Accumulation of metabolites can cause drowsiness and confusion.
- Idiosyncratic response with prolonged narcosis in some individuals.
- If used, use in separate preparation from paracetamol and at reduced dose with careful monitoring.
- It is poorly dialysed.
- Avoid in stage 5 CKD and those on dialysis.

Dihydrocodeine

- Reports of CNS depression.
- Little information in kidney failure—Avoid.

Tramadol

- Agonist at µ opioid receptor.
- Metabolized in liver to O-desmethyltramadol.
- 90% excreted by kidney.
- 30% unchanged.
- Dose reduction recommended in kidney failure:
 - use immediate release (not modified release) preparations;
 - patients on dialysis 50mg three times a day (tds);
 - patients not dialysing 50mg twice a day (bd).
- Watch for recognized side-effects—confusion and sedation.

WHO step 3: opioids for moderatesevere pain + non-opioid ± adjuvant

Recommended: tramadol immediate release 50mg bd (no dialysis); 50mg up to qds (dialysis) + non-opioids + adjuvants as indicated (see this chapter, Adjuvant analgesia, pp. 128-129).

Morphine

- Metabolized to morphine-3-glucuronide (M3G) and morphine-6glucuronide (M6G).
- M6G is a more potent analgesic than morphine.
- M3G and M6G accumulate in kidney failure, not removed on dialysis.
- M6G thought to be the cause of significant toxicity with sedation, confusion, and myoclonic jerks with chronic dosing.
- Avoid—not recommended for chronic use in kidney failure.

Hydromorphone

- Synthetic
 µ agonist; when used orally 4–7× as potent as oral morphine.
- Metabolized to hydromorphone-3-glucuronide (H3G) and other metabolites.
- Hydromorphone does not accumulate in ESKD, nor is it removed appreciably by dialysis.
- H3G accumulates in kidney failure but is removed by dialysis. However, it is neurotoxic if injected intraventricularly in rats.
 - Two cases are reported of severe toxicity in patients, both of whom went into acute kidney failure while taking doses of 1003mg hydromorphone parenterally daily (>5000mg morphine equivalent) and 144mg orally (~20mg morphine equivalent), respectively.
 - However, a further report, which demonstrated a high H3G to hydromorphone ratio in a patient with an estimated GFR of 19mL/min, describes the patient's cognitive function as normal.

Retrospective review and expert consensus suggest the following for dialysis patients.

- Hydromorphone immediate release 1.3mg 4–6 hourly plus 1.3mg as needed if pain breaks through; can safely be used to titrate if step 3 analgesia required providing:
 - · immediate release (not modified release) preparations are used;
 - · the patient is monitored carefully;
 - · the total daily dose kept low by using transdermal fentanyl when >6mg/day needed.
- Accepted practice is to substitute transdermal fentanyl 25mcg/h patch when more than nine doses of hydromorphone 1.3mg used in 24h and pain continuous.
- Hydromorphone is continued for breakthrough pain, increasing the breakthrough dose in line with the total 24h opioid dose (Table 7.1).

Oxycodone

- A semi-synthetic µ agonist with similar profile to morphine. 90% of the drug is metabolized in the liver with active metabolites.
- Single dose study shows prolongation of elimination of both oxycodone and its main metabolite noroxycodone in patients with kidney failure prior to transplant.
- Some anecdotal evidence of sedation and CNS toxicity.
 - Limited evidence for oxycodone use even in low doses in chronic kidney failure; therefore it is not recommended for long-term use.
 - However, oxycodone can be useful to titrate against pain in the short term, before switching to an appropriate transdermal preparation for longer-term pain management.
- In this circumstance, use:
 - oxycodone immediate release 2.5mg 6–8 hourly regularly, plus 2.5mg as needed if pain breaks through, and titrate carefully upwards to address pain;
 - once stable pain control achieved, switch to an equivalent dose of transdermal fentanyl (see Table 7.1).
 the patient needs to be monitored carefully during titration because of individual variation in response to oxycodone and risk of accumulation, and beyond because of risk of accumulation of fentanyl.

Buprenorphine

- A partial μ agonist/ κ antagonist; sublingually 30–60× as potent as oral morphine.
- Metabolized to buprenorphine-3-glucuronide (B3G) and norbuprenorphine (NorB) in the liver. Both accumulate significantly in kidney failure. Some (15%) biliary excretion.
- B3G is inactive.
- NorB has minor analgesic activity and causes respiratory depression in rats.
- A study of low-dose transdermal buprenorphine in 10 HD patients who could tolerate the drug did not show excessive levels of NorB after a week.
 - There is a lack of evidence about longer term use in ESKD.
 - However, there are theoretical reasons why it might be a good choice in kidney disease, and expert consensus is that it can be used cautiously, particularly the low-strength transdermal preparations.
 - Older patients experience a high level of adverse effects such as nausea and dizziness.
 - Transdermal preparations should not be used for titration (see next section on transdermal fentanyl).

Fentanyl

Potent synthetic µ agonist 50–100x as potent as morphine.

1000x as lipophilic as morphine and therefore suitable for transdermal

Available for injection (IV or SC) or as a transdermal preparation.

 Metabolized in the liver to norfentanyl, which is inactive; therefore accumulation not clinically important.

<10% excreted unchanged in the urine.

 Preferred opioid for SC infusion at end of life, except where doses >600mcg/24h required as volume required too large for portable syringe driver (see A Chapter 13, Symptom management; syringe drivers and anticipatory prescribing, pp. 278-279).

 Preferred opioid for titration using prn SC administration at end of life even if alfentanil is being given via syringe driver as it has a longer

duration of action than alfentanil when given SC.

 Transdermal fentanyl can be used for stable, continuous pain in ESKD once the patient's opioid requirement has been titrated with an immediate release preparation and patient shown to tolerate equivalent opioid dose to patch prescribed (see Table 7.1).

Patient should continue to be closely monitored.

Important considerations when using transdermal fentanyl

Not appropriate for uncontrolled pain.

Effective analgesia not reached until 24h after patch applied.

 When starting the first patch continue reducing dose of immediate release medications for first 12h and ensure patient knows further doses may be needed while the dose of fentanyl from the patch builds up in the blood.

 A normal immediate release strong opioid such as hydromorphone or oxycodone must be available for breakthrough pain.

 Maximum analgesia may not be reached until 72h so patch dose should not be increased until time for patch change.

 A depot of fentanyl remains under the skin for 24h after patch removal. If naloxone needed to reverse narcosis, a 24h infusion may be

needed.

 If pain relieved by another means, such as a nerve block or palliative radiotherapy, important to remember potential for toxicity from prolonged fentanyl action.

 Patients should be monitored closely. There is evidence that fentanyl does accumulate over time in patients with renal impairment, so keep dose under review and be prepared to reduce the dose if adverse effects supervene.

Table 7.1 To show equivalent doses of oxycodone or hydromorphone, according to fentanyl patch strength*

Fentanyl patch strength (mcg/h)	fentanyl	4-hourly prn oral hydromorphone (mg)	morphine	4-hourly prn morphine equivalent (mg) [†]	6-8 hourly oxycodone equivalent (mg)
12	300	No equivalent dose	30	5	Up to 5
20	000	1.3	60	10	
30	1200	2.6	120	20	
13	1000	3.9	180	30	20.05
100	2400	5.2	240	40	35-40
125	3000	6.5	300	50	35 -4 0

*All conversions are approximate and clinical judgment should be used at all times, especially in view of the wide interpatient variability seen in opioid response. Always start cautiously, provide prn doses, and titrate upwards if frequent prn doses are needed.

†Opioid equivalent doses are taken from PCF3 (Palliative Care Formulary, 3rd edn). See http://www.palliativedrugs.com/ for details. (Note: the 4th edition was published in book form in September 2011—this will provide the most up to date information. The information on the website is taken from the 3rd edition.)

Alfentanil

- · A derivative of fentanyl.
- It is one-quarter to one-fifth as potent as fentanyl but approximately 10× more potent than SC diamorphine or 15× as potent as SC morphine.
- It is extensively metabolized in the liver with largely inactive metabolites.
- Useful for continuous SC infusions because of greater solubility than fentanyl.
- Short duration of action when given SC so not useful for titrating opioid against pain relief (use fentanyl).
- But useful for short episodes of predictable pain, e.g. procedure-related
- Buccal or nasal alfentanil can also be used for procedure-related pain. Rapidly acting buccal, mucosal, or oral preparations are now available, although these are not appropriate for chronic pain.

Methadone

- Synthetic opioid active at µ opioid receptor.
- Thought to have some activity as an N-methyl-D-aspartate (NMDA) receptor antagonist and therefore a possible role in neuropathic pain.
- It is excreted mainly in the faeces, but also metabolism in the liver to inactive metabolites
- In the anuric patient, excretion is almost exclusively faecal.

CHAPTER 7 The management of pain

- Methadone titration for pain control with normal kidney function needs specialist experience because of its prolonged pharmacological action—up to 60h—and acute and chronic phase dosing requirements, with risk of late accumulation.
 - Characteristics suggest methadone may be safe in patients with ESKD but only in the hands of those experienced in its use for pain control in patients with normal kidney function.

Parenteral opioids

- Preferred route SC.
- Preferred strong opioid for titrating and breakthrough pain: fentanyl.
- Suggested doses 12.5–25mcg SC prn 2–4 hourly (titrate to higher dose if needed).
 - For doses greater than 600mcg/24h use alfentanil.
- For full details see

 Chapter 13 and this chapter, Summary: WHO analgesic ladder, pp. 124-125. See also (La Chapter 16.

1 near-opioid + eploid for randorape-devere pain 1

Summary: WHO analgesic ladder

General points

· Assess the patient's pain.

Choose the appropriate step.

Give drug regularly plus prn for breakthrough pain or incident pain.

Monitor for toxicity and efficacy.

Adjust and move up a step or increase dose as needed.

Remember psychological, social, and spiritual distress will impact on pain.

Step 1: non-opioid ± adjuvants Paracetamol 1g qds ± adjuvants, including NSAIDs if safe and indicated.

Step 2: non-opioid + opioid for mild-moderate pain ± adjuvants

Paracetamol 1g qds + tramadol immediate release 50mg bd (no dialysis) to 50mg qds (dialysis) ± adjuvants, including NSAIDs if safe and indicated.

Step 3: non-opioid + opioid for moderate-severe pain ± adjuvants

Patient able to swallow oral medication

Paracetamol 1g qds +

1 EITHER Hydromorphone immediate release 1.3mg orally 4 hourly, converting to transdermal fentanyl 25mcg/h if pain is controlled by 1.3mg 4 hourly after 48 hours.

OR Oxycodone immediate release preparation 2.5mg 6-8 hourly, converting to transdermal fentanyl 12mcg/h if pain is controlled by

2.5mg 6-8 hourly.

2 If pain not controlled in 1, titrate upwards cautiously using either hydromorphone or oxycodone until analgesia effective or adverse effects supervene (increase slowly and review patient frequently in this phase). Once pain is controlled, convert to an appropriate dose of transdermal fentanyl (see Table 7.1).

3 Continue to titrate upwards in similar manner if pain not controlled.

± adjuvants as indicated.

Patient unable to swallow oral medication See also 🔲 Chapter 13 and Fig. 7.3.

Opioid naïve

1 Fentanyl 12.5–25mcg SC prn up to hourly available whether pain present or not.

2 If >2-3 prn doses needed in 24h set up SC syringe driver.

3 Dose in syringe driver depends on previous requirements, but suitable starting dose is 100-150mcg/24h.

4 Plus SC fentanyl 12.5-25mcg prn hourly.

Already on strong opioids See also (Chapter 13, Table 7.1, Fig. 7.3.

1 Convert to dose equivalent SC fentanyl in a syringe driver.

2 If >600mcg fentanyl required, use alfentanil.

3 Increase dose according to previous day's prn doses and add to the regular dose (do not include doses used for specific movement or incident-related pain, e.g. dressing change or washing).

4 Plus prn SC fentanyl; approximately one-tenth of the 24h fentanyl dose,

prn hourly.

At end of life analgesia should always be prescribed by an appropriate route in anticipation of symptoms; the preferred parenteral route is subcutaneous The WHO analgesic ladder can be used in renal patients drug and dose modification suggested for use in renal failure Note: this is a guide and analgesia should always be tailored for the individual patient.

TD fentanyl HD/PD: 12 or 25 microgram/hr q72h based on previous opioid dose if pain continous Fentanyl 12.5–25 micrograms pm hourly: can be used to ttrate or for painful procedures such as dressing change if patient already on TD fentanyl or by Hydromorphone HD/PD: 1.3mg 4-6 hourly + 1.3 mg pm; convert to Oxycodone 2.5 mg 6-8 hrly HD/PD: use low dose for short courses if necessary: consider gastric protection e.g. Ibuprofen 200mg tds HD/PD: 10-25mg at night then titrate gradually Alfentanil use when SD contains > 600micrograms fentanyl/24 hours Alfentanil is 1/4 as potent as fentanyl; pm doses are very short lasting Adjuvants: can be used at all levels Renal impairment: dependent on GFR .useful for incident pain, e.g. dressing change but not for titration. Maintenance 200-300mg post HD Conservative pathway: AVOID PD: 300mg alternate days Starting syringe driver (SD) doses for the opioid-naive: fentanyl 100-150 micrograms/24 hours HD: loading 300mg, Amitriptyline PO ²rm alfentanil dose is 1/10th the 24 hour dose Gabapentin PO orally, convert to fentanyl for long-term use Subcutaneous: fentanyl see box above Conservative pathway 50mg bd Step 3: Oral: HD/PD:15-30mg qds syringe drive: the pm dose is approx 1/10th the 24 hour dose Step 1: Paracetamol PO/IV/PR 1g qds HD/PD: 50 mg qds Parenteral drugs prescribed in anticipation of pain: Tramadol Codeine Step 2: 3. Opioid for moderate-severe pain ± adjuvant 2. Opioid for mild-moderate pain ± non-opioid ± adjuvant ± non-opioid 1. Non-opioid ± adjuvant ± adjuvant

Dictolenac 25mg tds

Consult your local pallative care team for adivce where pain difficult to control or for dose conversions

Fig. 7.3 Guidance on the use of analgesics in kidney patients, including end of life care.

Managing opioid side-effects

Many side-effects from opioids are predictable. This should be explained and appropriate measures taken. Others are less predictable but clinicians should assess for unwanted effects and attempt to alleviate them. Many side-effects mimic the symptoms from uraemia and it can be difficult to distinguish them; opioids are frequently stopped when confusion, sedation, or agitation occurs. When the clinical situation has been assessed it is important not to leave the patient without adequate analgesia, and to re-titrate using immediate release oral preparations of hydromorphone, oxycodone, or SC fentanyl.

If a patient who was on a stable dose of analgesia without toxicity becomes toxic it is likely there has been a change in the clinical situation that

needs considering and managing such as:

- infection:
- dehydration;
- other electrolyte disturbance;
- worsening of poor kidney function;
- myocardial infarction.

Side-effects

- Nausea and vomiting:
 - occur in approximately a quarter of patients, but possibly a greater proportion of kidney patients;
 - may wear off after 10–14 days;
 - make anti-emetic available when starting opioids (see
 Chapter 8).
- Constipation:
 - · nearly universal;
 - provide all patients with regular laxatives once they are on Step 3 opioids(see Chapter 8).

CNS effects

- Drowsiness:
 - more common when first starting opioid or increasing the dose;
 - · may reduce after 72h;
 - · if continues consider alternative opioid, or alternative means of pain control.
- · Confusion:
 - occurrence as for drowsiness;
 - · more likely with morphine;
 - exclude correctable associations (see start of section);
 - · reduce dose;
 - consider alternative opioid or means of pain relief.
- Myoclonic jerks:
 - most commonly caused by morphine;
 - · stop morphine;
 - · substitute alternative.
- Respiratory depression is not a problem if:
 - · dose of opioids titrated upwards against pain because patients become tolerant to the respiratory depressant effect;
 - · short-acting preparations are used for titration;

- dose titration takes place prior to placement of a fentanyl patch;
- pain is suddenly relieved by a procedure such as nerve block and systemic analgesia is stopped and re-titrated.
- Respiratory depression can occur, however:
 - when the clinical situation changes;
 - pain is reduced but analgesia is not;
 - if patient is not carefully monitored.

Adjuvant analgesia

Adjuvant drugs, the prime indication for which may not be pain, are used in specific clinical situations to relieve pain and are often more effective than opioids in those situations and therefore less likely to cause toxicity. Many need modification to their doses in kidney failure (see 🛄 Chapter 16).

Pain syndromes

Neuropathic pain Many pains in ESKD are neuropathic in nature or mixed nociceptive and neuropathic. These usually need a combination of opioid and adjuvant for optimal effect.

- Antidepressants:
 - good evidence for tricyclic antidepressants;
 - number needed to treat (NNT) = 3;
 - number needed to harm (NNH) = 22;
 - · side-effects, particularly dry mouth and sedation, usually limit the dose achievable;
 - titrate slowly from very low doses, i.e. start amitryptyline at 10mg at night (nocte).
- Anticonvulsants:
 - NNT = 2.9;
 - NNH = 8;
 - gabapentin—doses must be reduced in kidney failure (see Fig. 7.3);
 - · clonazepam—useful as easy to titrate, rapid response (see Chapter 13);
 - carbamazepine—may be difficult to use because of drug interactions and patients are usually on multidrug regimens.
- Topical methods: see next section.

Colic-bowel obstruction

- Hyoscine butylbromide
 - give parenterally 20mg SC prn 2 hourly; OR
 - in syringe driver: dose required varies from 80 to 120mg/24h SC.

Renal colic

- NSAIDs first choice unless absolute contraindication.
- Hysocine butylbromide second choice.
- May need opioids: first choice is SC fentanyl.

Muscle spasm

- Benzodiazepines:
 - diazepam if able to swallow;
 - midazolam at end of life;
 - clonazepam single dose nocte.
- Baclofen.

Topical methods of analgesia

Opioids

Opioids may be effective topically where the skin is broken and there is inflammation as opioid receptors migrate to areas of inflammation. Most experience relates to morphine in a hydrogel such as Intrasite® gel, though other opioids such as fentanyl and diamorphine have been used. As the effect is local and relatively low doses are used it is thought that there is little effect from systemic absorption.

- - ischaemic leg ulcer that is painful between dressing changes;
 - decubitus ulcer for which treatment is palliative and healing not expected.
- Possible prescription:
 - morphine (for injection) 10mg in Intrasite® gel applied to the ulcer daily.

Capsaicin cream

Capsaicin is a chilli alkaloid that depletes substance P. There is evidence for benefit when it is used for post-herpetic neuralgia, diabetic neuropathy, and osteoarthritis, though a significant proportion of people will not tolerate it as it causes burning prior to relief. Possible uses:

- localized areas of neuropathic pain from diabetic neuropathy (NNT, 4);
- osteoarthritis (NNT, 3);
- it may also be considered if there is localized pruritus (see Chapter 8, Pruritus and dry skin, pp. 140-142).

Topical NSAIDs These may be useful for localized joint pain, with nonulcerated skin and when systemic NSAID is contraindicated (NNT, 3).

Buccal, nasal, or sublingual alfentanil or fentanyl

Reasonable bioavailability and good solubility mean that a sufficient dose of alfentanil or fentanyl can be given buccally or nasally to achieve shortterm (10-20min) analgesia to cover painful procedures or planned painful activities. A variety of new preparations have been recently released, and use/choice of preparation may depend on local formulary requirements. Prescribing these preparations is best discussed with a specialist palliative care or pain team.

Episodic, movement-related, or incident pain

These terms describe pain that occurs despite regular analgesic medication. They can be divided into the following.

Spontaneous episodes of pain

- Usually neuropathic.
- May be short-lived but severe.
- Shooting or burning in nature.
- No precipitating factors.
- Consider neuropathic agent for pain relief.

Breakthrough pain occurring during dose titration

Background analgesia inadequate.

Occurs at end of dosing period indicating a higher dose is needed.

Explain to patient and continue dose titration.

- Dose of breakthrough medication related to the 24h opioid taken: for hydromorphone, morphine, and oxycodone: 1/6th 24h dose;
 - for fentanyl and alfentanil: 1/10th 24h dose titrating up to 1/6th if ineffective.

Movement-related or incident pain

- Patient pain-free at rest but severe pain on movement or dressing change.
- Gradually titrate background opioid to highest level tolerated by the patient.
- Use short-acting opioid prior to planned activity, e.g. dressing change. Choose drug and route depending on patient's condition and length of procedure:
 - oral hydromorphone or oxycodone: onset 30min, duration 4–6h;
 - SC fentanyl: onset 5–10min, duration 1–2h;
 - SC alfentanil: onset 3–5min, duration about 30–60min;
 - buccal/nasal/sublingual alfentanil and fentanyl: onset 10min, duration 20-30min.
- Entonox[®] (inhaled nitrous oxide) may have a role for episodes of care in those who are not too frail.
- Look for local means of relieving pain, e.g. joint immobilization.
- Consider nerve blocks or anaesthetic procedure.

Chronic pale clinic referral and

Chronic pain clinic referral and anaesthetic procedures

In some situations severe chronic pain management can be exceedingly difficult and the patient may be helped by referral to a chronic pain management team where they may benefit from management by their multidisciplinary pain team.

Anaesthetic procedures may be indicated in some of the following

situations:

severe neuropathic pain where spinal analgesia could be an option;

 incident pain, such as that from a fractured hip where patient not fit for surgery, for local anaesthetic block;

sympathetically mediated pain;

 difficulty in achieving satisfactory pain control despite escalating analgesia or because of unacceptable toxicity when analgesia is achieved.

Referral to the palliative care team

When pain is difficult to manage or there are other distressing symptoms or psychological or social issues, referral to your local palliative care team may give the opportunity for a holistic assessment and review with improvement in symptoms. The presence of severe pain when part of disease progression and patient deterioration often indicates that prognosis is reduced or short. It should therefore act as a trigger for referral to a palliative care service. This can occur even if prognosis is uncertain, as good symptom relief and support should improve quality of life. It may also enable discussions about future care to be started. See also Chapter 11.

Further reading

Dean M (2004) Opioids in renal failure and dialysis patients. J Pain Symptom Manage 28, 497–504.
Ferro CJ, Chambers EJ, Davison SN (2004) Management of pain in renal failure. In Supportive care for the renal patient (ed. EJ Chambers, M Germain, E Brown), pp. 105–153. Oxford: Oxford University Press.

Kurella M, Bennett WM, Chertow GM (2003) Analgesia in patients with ESRD: a review of available evidence. Am J Kid Dis 42, 217–228.

Murtagh FEM, Chai MO, Donohoe P, et al. (2007) The use of opioid analgesia in end-stage renal disease patients managed without dialysis: recommendations for practice. J Pain Palliat Care Pharmacother 21, 5–16.

Non-pain symptoms in end-stage kidney disease

Introduction 138 Pruritus and dry skin 140 Fatigue, daytime somnolence, and weakness 144 Anorexia and weight loss 146 Dry mouth and thirst 148 Nausea 150 Constipation 154 Insomnia 156 Restless legs syndrome (RLS) 158 Symptoms from long-term complications of treatment of ESKD 160 Symptoms related to comorbid conditions 162 Dialysis-related symptoms 164 Other symptoms 166 Summary 168 Further reading 170

Introduction

Patients with ESKD are one of the most symptomatic groups of patients with chronic diseases. A systematic review of the prevalence of symptoms in patients undergoing dialysis revealed that fatigue/tiredness, pruritus, and constipation occur in more than half of dialysis patients and over 40% experience anorexia, pain, and sleep disturbance. A study of symptoms among patients who have chosen the conservative pathway shows a broadly similar incidence of fatigue/tiredness, pruritus, anorexia, and sleep disturbance, but pain seems to be experienced by a greater proportion of patients.

Assessment in a busy clinic is time-consuming, but, before a clinical appointment, patients can be asked to complete, simple symptom assessment tools, such as the dialysis symptom index, POSs renal or the ESAS (see Chapter 6 for details of these tools). This is an effective way of focusing limited clinic time on the symptoms that are causing most distress, and highlighting to the patient that their symptom concerns are

important and need to be reviewed.

The high prevalence of symptoms in this group of patients is due to the combination of those from chronic uraemia, those from the other comorbid conditions, many of which are responsible for their kidney disease, and those that are the result of RRT. Pain in chronic dialysis patients is as common as for patients with metastatic cancer with 40–55% of patients suffering from moderate to severe pain. Of non-pain symptoms in dialysis patients:

- mean number of symptoms per patient = 9;1,2
- worst symptoms are
 - · tiredness;
 - · lack of well-being;
 - · poor appetite.

In patients on conservative management:

mean number of symptoms = 6.3

The overall effect of this symptom burden is reduced quality of life, which correlates with higher symptom burden in a group of dialysis patients with high comorbidity.

Causes of the common non-pain symptoms

These can be divided into:

- those directly related to uraemia or to complications of kidney disease;
- those caused by comorbid conditions;
- those directly related to the dialysis procedure.

Important management considerations for all patients

Ensure:

- adequate dialysis;
- optimal anaemia management;
- sufficient treatment of iron deficiency.

Table 8.1 Symptom burden in ESKD patients on dialysis and those managed conservatively

Symptom	Pre	evalence (%) in patients
	On dialysis ³	Treated conservatively ^{4,5}
Fatigue/weakness	71	70
Pruritus	55	55
Anorexia	49	49
Pain	47	62
Sleep disturbance	44	39 7 20 20 20
Anxiety	38	34
Dyspnoea	35 35 35 45 45 45	39
Nausea	33	27
Restless legs	30	28
Depression	27	28

References

- 1 Davison SS, Jhangri GS, Johnson JA (2006) Cross-sectional validity of a modified Edmonton symptom assessment system in dialysis patients: a simple assessment of symptom burden. Kidney Int 69, 1621–1625.
- 2 Weisbord SD, Fried LE, Arnold RM, et al. (2005) Prevalence, severity and importance of physical and emotional symptoms in chronic haemodialysis patients. J Am Soc Nephrol 16, 2487–2494.
- 3 Murtagh FEM, Addington-Hall J, Higginson IJ (2007) The prevalence of symptoms in end-stage renal disease: a systematic review. Adv Chronic Kidney Dis 14, 82–89.
- 4 Murtagh FE, Addington-Hall J, Edmonds P, Donohoe P, Carey I, Jenkins K, et al. (2010) Symptoms in the month before death for stage 5 chronic kidney disease patients managed without dialysis. J Pain Symptom Manage 40, 342–352.
- 5 Murtagh FE, Addington-Hall JM, Edmonds PM, Donohoe P, Carey I, Jenkins K, et al. (2007) Symptoms in advanced renal disease: a cross-sectional survey of symptom prevalence in stage 5 chronic kidney disease managed without dialysis. Palliat Med 10, 1266–1276.

Pruritus and dry skin

Pruritus occurs in more than 50% of HD and PD patients, with about half of affected patients rating it as moderate or severe. In a study of 1773 HD patients, 25% scored itch >7 on a visual analogue scale (0-10). This was confirmed by a more recent study showing 46% rating it moderate or severe.² Pruritis is a very unpleasant symptom associated with reduced quality of life.

Characteristics of pruritus in ESKD

- No relation with the type of dialysis, either HD or PD.
- Some studies report a relationship between the timing of the appearance of pruritis and receiving dialysis, but reports are conflicting and the following have been reported about the symptom:
 - · increases in incidence while dialysing;
 - peaks in the period preceding dialysis;
 - lowest incidence immediately following dialysis.
- However, it may occur all the time or be transient in nature.
- May be localized or generalized.
- · Is often worse at night.
- Of those who rate it severe, three-quarters experience sleep disturbance
- Severe pruritus is more common in males, though itch overall may be more common in women.
- Skin appearance ranges from normal to severe xerosis with or without secondary skin changes from repeated scratching.
- · High levels of urea, calcium, and phosphate, and low levels of ferritin and albumin associated with increased incidence.
- · Reduced incidence associated with low calcium levels.
- · Exacerbating factors include: heat, rest, dry skin, and sweat.

Pathophysiology of pruritus in ESKD

The pathophysiology is complex and multifactorial. The relative importance of different aetiological factors will vary from patient to patient, so an individual assessment of likely key causes may help guide management plans. The perception of pruritus is probably mediated through more than one pathway. It is useful to note that:

- · Specific itch pathways (mediated through C fibres) which respond to mechanical stimuli (but not histamine) have been identified.
- The histamine-sensitive pathway seems to play a minor (or negligible) role in chronic itch.
- In chronic itch, central and peripheral sensitization occurs, so that noxious stimuli like heat or scratch (and possibly normal stimuli such as touch) produce a hypersensitive response and pathological modulation in the pathways which mediate itch

Likely mechanisms which initiate and sustain itch include the following.

- Dermal mast cell proliferation.
 - · Associated with increased histamine, serotonin (though no clear relationship between levels and severity), and cytokines all released by mast cells.

- Possible interaction between mast cells and C fibres (i.e. a form of neuropathy).
 - This may be associated with abnormal pattern of cutaneous innervation.
- Other theories include:
 - · pro-inflammatory state, with imbalance of Th1 cytokines;
 - imbalance of endogenous opioids;
 - · secondary hyperparathyroidism;
 - · possible low-grade sensitivity to dialysis products.

General management

For nearly all ESKD-related non-pain symptoms an important aspect of their management includes optimal management of the following:

- dialysis prescription;
- · nutritional status;
- · anaemia;
- · calcium and phosphate product.

Management strategies for pruritus

A multitude of diverse therapies has been tried for uraemic pruritus. Evidence for some is conflicting. This is probably because studies have been small and the condition is multifactorial. The effectiveness of treatment will depend on aetiology. Where this is known, appropriately directed therapy can be instituted.

General measures

- Exacerbating factors, which will vary for individuals, such as hot baths and alcohol, should be avoided.
- Maintenance of skin moisture by means of:
 - · emollients with high water content;
 - · avoiding soap;
 - · use of emulsifying lotions in the bath.
- Light clothing. Non-synthetic may be better than some synthetics.
- Discourage scratching—short nails, gloves at night.
- Showers, both hot and cold, help some individuals.
- Improve sleep.

Topical treatments

- Capsaicin cream, has been shown to be helpful for some patients:
 - likely to be most useful in localized itching;
 - some patients cannot tolerate it because of the burning it causes.
- Tacrolimus ointment. A prospective study of 27 patients showed a significant reduction in pruritus score with no systemic effects. However, time to response is not recorded and four patients withdrew.
- There is no evidence for the use of topical steroids and their potential side-effects weaken any argument for using them.

Specific measures

The following have been shown to be effective for some patients. Treatment decisions will be taken on an individual patient basis depending on circumstances, burden of treatment, requirement for monitoring (e.g. thalidomide), or potential for adverse effects. Time to efficacy has not been reported for all treatments and this will be a crucial consideration for patients near the end of their life:

- Ultraviolet B phototherapy. Consistent evidence for effectiveness, but offset in this population by burden of treatment.
- Antihistamines. Little evidence but continue to be used by patients. It is simple to use them and to monitor benefit and adverse effects.
- Gabapentin. One study of 25 patients using thrice weekly gabapentin after dialysis showed a significant reduction in pruritus score.
 - In patients on dialysis, a 300mg dose can be given after each dialysis session, but for those with an estimated GFR <15 not on dialysis the suggested dose might be 100mg on alternate days, monitoring carefully for toxicity because of the very high risk of accumulation.
- Thalidomide. Cross-over RCT of 29 patients: half the patents
 had significant reduction in pruritus; none responded to placebo.
 Prescription, controlled handling (due to major teratogenic side effects,
 with risk even from handling this drug), risk of neuropathy, and sedative
 side-effects may make this difficult to use, although it may be beneficial
 in selected patients.
- Mirtazapine. This is a selective neuro-epinephrine re-uptake inhibitor, with limited evidence of efficacy in ESKD
- Nalfurafine. This is a relatively new κ-opioid receptor agonist, given by IV infusion, which has been shown to be effective in an RCT of 144 HD patients. It remains to be seen if it will be useful for other ESKD patients, and if it will become available in other formulations.

Initial reports of benefit from ondansetron, naltrexone, and erythropoietin have not been confirmed and larger studies are needed to determine their place in the management of itch. Where vomiting, which is not otherwise controlled, is also a problem, ondansetron might be considered but its use is offset by headache and constipation and other anti-emetics may be more effective.

References

- 1 Narita I, Alchi B, Omori K, et al. (2006) Etiology and prognostic significance of severe uremic pruritus in chronic hemodialysis patients. Kidney Int 69, 1626–1632.
- 2 Davison SN, Jhangri GS, Johnson JA (2006) Cross-sectional validity of a modified Edmonton symptom assessment system in dialysis patients. A simple assessment of symptom burden. Kidney Int 69, 1621–1625.

Frigue, daytime covera knee, and

Processor sensor compressor expension of the compressor of the com

200 Single Comments to the second sec

The state of the first service and the particle of the state of the st

The series for this principles and the court of series building and a series of the court of the

b in orant factors contributing to the networking. of retherey

e are supplied to the supplied

in the self-digrephen provided by the state of services that in the selfend and suggests that the self-digrephen self-digrep

trodes a vi generalis a sa P San a sa sagata

ATEUR CONTRACTOR TO SPECIAL PROPERTY OF THE TOP OF THE PARTY OF THE PA

The second state of the second second

The state of the s

Fatigue, daytime somnolence, and weakness

This common symptom complex is experienced by:

- over two-thirds of patients before the onset of dialysis;
- a similar proportion after starting dialysis;
- · one-third of conservatively managed patients.

Poor sleep, discussed below, is associated with daytime somnolence and reduced quality of life.

- 45% of 507 dialysis patients rated drowsiness as moderate or severe.
- Muscle weakness itself will contribute to fatigue and reduced mobility and activity.
- This may lead to further reduction in activity and hence further muscle weakness with the potential for a spiral downwards of function if not actively managed.

Important factors contributing to the development of lethargy

- Inadequate dialysis.
- Uraemia.
- Anaemia:
 - iron deficiency;
 - · low erythropoietin levels.
- Biochemical abnormalities, particularly hyper- or hypokalaemia, hypomagnesaemia, hyper- or hypocalcaemia, hyponatraemia, and hypophosphataemia.
- Poor nutritional state.
- Poor quality sleep.
- Depression.
- Renal bone disorders leading to reduced activity because of pain.
- · Pain.

Impact of fatigue and weakness

In the dialysis patient this symptom complex has a major impact on quality of life. Reduced levels of physical functioning will impair social activities and may prevent the ability to work or run the household; this has an ongoing effect that spreads beyond the patient to those close to them. Loss of role, such as bread winner or household manager, leads to loss of self-esteem with the potential for depression and psychological distress. As physical functioning decreases, the need for hospital transport to and from dialysis sessions with associated stress and frustration leads to further reduction in quality of life.

By the time many patients with ESKD consider stopping dialysis their performance status is very low with increasing need for assistance with ADLs. This may be one of the factors that precipitates discussion about cessation of dialysis. Function will worsen as a result of stopping and the

need for considerable care can prevent patients dying in their place of choice, if such care is unavailable at short notice either at home or in a nursing home.

Fatigue, like pain in the ESKD patient, is associated with depression, itself difficult to diagnose in the presence of chronic physical disease with many similar symptoms.

Post-dialysis fatigue

Some patients experience severe fatigue immediately post-dialysis. This may relate to rapid changes in fluid volume, an effect on BP, or depletion of specific substances during dialysis. There is an expectation among patients that they will feel better when dialysis starts; for the frail and elderly the reverse may happen and they may actually feel worse. These are important considerations when decisions are being made about whether or not to start dialysis. See also \(\to \) Chapters 9, 11, and 12.

Management

The management of fatigue and weakness will depend on the stage of the person's illness. What is appropriate when the prognosis is measured in months or years is unlikely to be appropriate in the last weeks and days of someone's life.

General non-drug measures

Will include optimizing dialysis (if relevant), the medical management of the patient's other medical conditions, anaemia correction, and attention to patient's nutritional status as possible and appropriate.

- Physiotherapy and gentle rehabilitation programmes are associated with improved exercise tolerance and reduced fatigue, but may not be appropriate.
- As disease advances, social care to optimize support for everyday living and later nursing care are likely to be needed by many patients.
- Ensuring a good night's sleep if possible.
- Acupressure. Two studies from Taiwan suggest acupressure is helpful
 in reducing the severity of fatigue, though this may not either be
 available or applicable to patients at the end of life.

Specific and drug measures

- Optimal anaemia management should continue until the last few days
 of life. There is good evidence that treating anaemia in dialysis patients
 reduces fatigue.
 - Erythropoietin;
 - · Iron therapy.
- Screen for and treat depression if present.

Anorexia and weight loss

Clinical protein/energy malnutrition is common and is associated with raised inflammatory markers. It is strongly associated with increased mor-

bidity and mortality.

About one-half of patients on dialysis and a similar proportion of those managed conservatively without dialysis experience significant anorexia. Causes are multifactorial and the following may all have a bearing in some patients:

· Chronic nausea.

• Dry mouth, with or without superimposed mouth infections.

Altered taste

- Delayed gastric emptying from diabetic neuropathy, or medication such as opioids.
- Restricted ESKD diet limiting food options, leading to reduced intake.
- Lower bowel abnormalities, such as constipation, diabetic enteropathy, or ischaemic bowel symptoms.
- Fatigue exhausting the patient so too tired to eat food they have prepared.
- Social isolation. Eating alone can lead to reduced intake.
- · Depression.
- Under-dialysis.
- · Uraemia.
- Hypokalaemia resulting from poor nutrition.
- Abdominal discomfort and swelling from PD.

Management

All the conditions described above that can be reversed or partially reversed should be attended to. The advice of a renal dietician should be sought. The goals of this advice will change when RRT is discontinued and the aim is comfort. The liberalization of diet that ensues may be helpful to the patient. Some aspects of the attention to detail that follows may be helpful to patients.

• Treat mouth infections, particularly thrush.

 Review drugs for those that cause dry mouth to see if any can be discontinued.

Manage dry mouth actively where it is a problem (see this chapter, Dry

mouth and thirst, pp. 148)

- Trial of metoclopramide (in the absence of nausea or vomiting it may help by increasing the rate of gastric emptying and reducing early satiety). NB. Most effective if taken 20–30min before meals.
- Tempt the patient with small, well-presented meals that they have chosen or are known to like.
- Unless the patient wishes to eat alone, eating in company is associated with a greater intake.
- Reduce fatigue during eating by thoughtful presentation or help with eating.
- Treat depression.

Appetite stimulants

Steroids such as dexamethasone 2—4mg daily may temporarily increase appetite and sense of well-being, though there is no evidence for muscle weight gain.

- Effect is of short duration; defined course should be prescribed with a specific aim and with review of efficacy.
- Possible short-term ill-effects such as fluid retention must be balanced against any potential gain.

Dry mouth and thirst

Both dry mouth and thirst are common accompaniments to ESKD and dialysis. Objective studies have shown a clear relationship between thirst and xerostomia as measured by salivary flow.

Most patients will have devised their own strategies for minimizing and alleviating this symptom with common sense strategies, such as keeping out of the sun, limiting salt in food, and the avoidance of commercial drink outlets.

There are no good studies to guide management but some evidence for:

- chewing gum (small cross-over study);
- · artificial saliva;
- pilocarpine (observational study).

SPELLER

and the state of t

abyeaved charlespect effection) on emange and

2016 THE STATE OF STATES OF STATES AND STATES AND ASSOCIATION OF STATE

a preside that necessis nor they who how we will find a first tree.

า เราะเทองการ การสู่สมมากการการผู้สามมาโดก และกระ

a Place and electrolyce a less

curt in a secure of the control care of the control of the control

that so the adain and official formers

continuo anti y chiasa see see appropriate superiore.

remagnessing with general control of the control of

THE STATE OF THE S

and the second of the second

La sere remedate a la 1700 ment i de conselhe i collectivo and, maned apprativien, Vomitori Ginos comercia i gregori con essuas mercicalistica.

Management of named and condition Lable C.C.

The four state adjusted in Experience and a point to another and about the state of the second and the state of the state

the place of water the following

e Consider particol à sitte

s Select despression are and extended

Timbusca en consule entreality especients in the resultant of the full Cone A

 men he concretagi to men me additional mentro i productive energy windring cregative to be for such as with expension

Temper Temper & Walter the more leading to the training and the second of the second o

Ai jeto fi ali peleksi

Dress on to ask of management falls

CANTAGO PLAN GUINGE DE NAME CO

This first girl Tallah !

a dang lost brouge voraits;
 a zi dagen gabsorbeit

table out the sixture a public of a

Nausea

- Present for up to a third of dialysis patients.
- It is thought mainly to relate to uraemia; however:
 - it is likely the body develops a degree of tolerance to the emetic effect of urea and other toxins;
 - it is possible that nausea is more likely when there are sudden rises in urea.

Other relevant factors include the following:

- · Fluid and electrolyte changes.
- Concurrent medication can contribute to nausea in two ways:
 - · chemical stimulation, e.g. antibiotics, opioids;
 - delayed gastric emptying, e.g. amitriptyline, opioids.
- · The presence of infection.
- Delayed gastric emptying from other causes such as diabetic enteropathy.
- · Constipation.

Causes unrelated to ESKD must of course be looked for and treated appropriately. Vomiting is not commonly present unless there are other medical complications at the time.

Management of nausea and vomiting (Table 8.2)

Many of the general measures that apply to anorexia also apply here and can be used in conjunction with Table 8.2, which lists possible causes, suggested first-line drugs with additional prn medication, and second-line drugs where available. It aims to help the tailoring of anti-emesis to the putative cause. These suggestions are largely empirically based as there is little evidence, though the underlying scheme is widely accepted in palliative care.

Principles of anti-emetic prescribing

- Consider probable cause.
- Select appropriate anti-emetic.
- If nausea or vomiting constant, prescribe medication regularly up to full dose.
- It may be necessary to prescribe additional medication prn if nausea or vomiting break through the regular anti-emetic.
- Review effect and reconsider cause or adequacy of route if ineffective.
- If unable to swallow or vomiting oral anti-emetics or at end of life,
 - use SC route and, if symptoms constant, use syringe driver.

See also 🔲 Chapter 16.

Questions to ask if treatment fails

- Is anti-emetic appropriate to cause?
- If oral administration:
 - is drug being taken?
 - · is drug lost through vomiting?
 - is drug being absorbed?
- Is drug at maximum safe dose?

When those factors corrected for, consider the following

- Adding second-line drug; OR
- changing to second-line or broad-spectrum anti-emetic (Table 8.2); OR
- changing to 24h SC administration (this can be a temporary solution to break the cycle of vomiting and if patient is well enough return to the oral route).

If nausea is intractable and all treatment only partially effective, the addition of dexamethasone at doses of 2–6mg/day may enhance the effect of other anti-emetics. Whether this is due to a reduction in the blood–brain barrier or other undefined mechanism is not known. This can be given once daily, either orally or as a SC injection.

_
\Box
ESKD
₽.
CS
eti
Anti-emetics
P
nti
A
8.2
8
le
able
-

Site or mode of action and neurotransmitter(s)	Direct stimulants First-line	First-line	Use in ESKD	pm drug	Second-line
CTZ D2, 5HT ₃	Chemicals: uraemia, drugs	Chemicals: uraemia, Haloperidol 0.5–1.5mg No dose reduction drugs	No dose reduction necessary	Haloperidol 0.5mg up to 5mg/24h	Haloperidol 0.5mg up to Levomepromazine 6mg PO or 5mg/24h 2.5–5mg SC prn up to 8-hourly
Vomiting centre Autonomic affere stimulated indirectly by abdomen, thorax CTL higher centres, and vestibular afferents Ht, SHT ₂ , Ach _m		Autonomic afferents: Cyclizine 50mg 8-hourly No dose reduction, but Levomepromazine abdomen, thorax 6mg PO/SC prn up. Avoid in acute or 8-hourly chronic coronary disease	No dose reduction, but increases dry mouth. Avoid in acute or chronic coronary disease	Levomepromazine 6mg PO/SC prn up to 8-hourly	Levomepromazine 6mg PO or 2.5–5mg SC pm up to 8-hourly
Cerebral cortex	Fear, anxiety, pain	Benzodiazepine: lorazepam 0.5–1mg SL, diazepam 2mg	Caution with repeated doses: metabolite accumulation	Additional 1st-line drug, but accumulation with increasing doses	Levomepromazine 6mg PO or 2.5–5mg SC prn up to 8-hourly
Vestibular apparatus H ₁ , Ach _m	Tumours, motion	Hyoscine hydrobromide No dose reduction TD 1mg/72h or cyclizine 50mg 8-hourly	No dose reduction	Cyclizine 50mg prn 8-hourly	The alternative 1st-line drug

Specific drugs or effects required	Causes or indications	First-line	Use in ESKD	prn drug	Second-line
Prokinetic D2 Gastroparesis gastro- oesophageal reflux caused by	Drugs: opioids, NSAIDs, TCAs; diabetic neuropathy	Metoclopramide 10mg 50% normal dose; PO/SC tds before meals maximum 40mg/24h	50% normal dose; maximum 40mg/24h	Haloperidol 0.5mg up to 5mg/24h	Haloperidol 0.5mg up to Domperidone 20mg tds or 5mg/24h 30mg PR bd
Antisecretory drugs	Bowel obstruction, colic	Bowel obstruction, Hyoscine butylbromide No dose reduction colic	No dose reduction	Hysocine butylbromide maximum 240mg/24h	
5HT ₃ receptor Chemo- or antagonists.* Present radiotherapy CTZ and vomiting postoperative centre	Chemo- or radiotherapy postoperative	Granisetron 1–2mg od, Discontinue ondansetron 4-8mg bd, after 3 days tropisetron 5mg od	Granisetron 1–2mg od, Discontinue if ineffective ondansetron 4-8mg bd, after 3 days tropisetron 5mg od		May be enhanced by steroids. Late chemotherapy nausea or vomiting, consider levomepromazine as above

Note that levomepromazine 6mg tablets have limited availability on an un licensed, named patient, basis; if they are not available, then a quarter of a 25mg tablet can be used (6.25mg). Abbreviations. Ach., muscarinic, cholinergic; CTZ, chemoreceptor triger zone; D2, dopamine receptor, H1, histamine type 1; od, once a day; PO, oral; pm, as required; TCA, tricyclic antidepressant; SL, sublingual; SC, subcutaneous; SD, syringe driver; TD, transdermal; tds, three times a day, SHT2, 5-hydroxytryptamine 2; SHT3, 5-hydroxytryptamine 3.

NB. Use and route for haloperidol outside terms of licence though widely used and recommended in palliative care practice. *5HT3 receptor antagonists licensed for post-operative and chemo- and radiotherapy induced vomiting only

be prescribed concurrently. (2) You should not use two antimuscarinic drugs together. (3) Antimuscarinics relax the lower oesophageal sphincter and, if possible, should be avoided in Cautions. (1) Antimuscarinics block the final common (cholinergic) pathway through which prokinetic agents act the two types of drugs, e.g. cyclizine and metoclopramide, should not patients with symptomatic acid reflux.

Constipation

- Is also common.
- Multifactorial in origin. The following contribute in many patients:
 - · Low-roughage diet.
 - · Reduced fluid intake.
 - · Poor mobility.
 - · Medication, e.g. oral iron, phosphate binders.
 - · More common if on PD.

Management of constipation

General measures will be used according to appropriateness of the clinical situation.

- Increased fluid intake.
- High-fibre diet.
- Increased mobility.
- · Privacy and comfort during defecation.

Laxatives

Generally classified as stimulant or bulk forming, both are usually needed in the multifactorial origin of constipation in this population. Individual dose titration to benefit usually necessary.

- Stimulants:
 - · Senna.
 - Bisacodyl.
 - · Danthron (available as co-danthramer and co-danthrusate with softener—cause discoloration of the urine and should be avoided if incontinence because both urine and faeces can cause skin excoriation). Only licensed for the terminally ill in UK.

Stimulants must be accompanied with a softening laxative if stools are hard; these include osmotic agents.

- Softening agents:
 - · Docusate, often used in conjunction with stimulant such as senna or combined preparation such as co-danthrusate.
 - · Macrogols such as polyethylene glycol. Contain the necessary water within the dispensed agent, so do not necessitate further water consumption, which may be difficult at end of life.
 - The sodium content of polyethylene glycol is safe for renal patients as it is not absorbed, but remains in the bowel.

Impaction can be treated with up to eight sachets/day of polyethylene glycol. However, this is unlikely to be tolerable for someone at the end of life and rectal measures may be less exhausting and more comfortable.

Rectal measures

May be necessary to initiate return to regular bowel function.

- Glycerin suppository is stimulant and provides a faecal lubricant that aids evacuation through softening the stool.
- Bisacodyl suppositories are stimulant. They should touch the rectal mucosa and have an effect within about an hour.

- Enemas will be needed for more intractable constipation or faecal impaction.
- Arachis oil enema is used to soften the stool. It is often given overnight followed by a phosphate enema in the morning. (NB. Arachis oil contains peanuts.)

Insomnia

Sleep disturbance and poor sleep probably affect up to half of dialysis patients though many will not mention it unless specifically asked. Sleep may be disturbed by other symptoms such as restless legs, pain, or cramps. In addition, patients may have sleep disorders such as sleep apnoea. Someone who is lethargic and inactive by day is likely to find it harder to sleep at night. Poor sleep and increased daytime sleepiness is known to be associated with reduced quality of life, emphasizing the importance of trying to help patients with this symptom. Characteristically the patient may complain of difficulty initiating sleep, early morning waking, or feeling unrefreshed in the morning. Insomnia is likely to be associated with many other symptoms, some of which may contribute to the cause and others that are a consequence of it, though the relationship can be difficult to unravel in symptoms such as daytime sleepiness.

Associations with insomnia

- · Pain.
- Restless legs.
- · Cramps.
- Depression.
- Lethargy due to anaemia, poor dialysis prescription, electrolyte disturbance.

Management considerations

- Consider and treat any reversible conditions:

 - other non-kidney specific symptoms impacting on sleep;
 - · itch:
 - restless legs;
 - · anxiety, depression;
 - · anaemia.
- Encourage good sleep hygiene.
- Psychological support possibly with relaxation techniques.
- Hypnotics.
 - Use at end of life should not be restricted, though earlier in the course of illness greater attention should be given to other means of improving sleep.
 - Increased sensitivity to benzodiazepines in renal patients suggests one uses the shortest-acting hypnotics to try to prevent daytime sleepiness the following day.
 - Zopiclone and zolpidem recommended. Half-life 2–5h; act on the same receptors as the benzodiazepines though they are pharmacologically different.

Restless lags syndrome (RLS)

Also professional as it seems to paint a width a begin tions and extremely professionalists to so july secretion in the juwish factor. It is not a 10 to the internation of the professional professional secretion with the professional pro

indidence

estimates in the short problem was as an include of Section of the service sections of the service of the servi

Part to hydiology

in preference fill, se not telly reported our put integral to inverse the inverse deficiency reported and promoved by the production of the sense production of the sense production of the prod

50 19 On Sunday the between the color

- Charles to a read of the about A of A
 - A A A A
 - meterative of 1
 - A THE TON A PARTY
- The state of the s
 -

 - No A
 - Attlish Later 10 a
- a Prediction of the recompletion of the property of the property of

2/19 To spania

It is not control with the purple destination of the properties of the destination of the control of the purple destination of the control of the purple destination of the pu

Canada and engineering of the confidence from the Confidence of th

- CAPACONICE TO A VAID ALLESS A R
- Carbaranda ha sandan A
- 1497 B 17 1000 T 17

Restless legs syndrome (RLS)

RLS is defined as a sensory syndrome with a persistent and extremely uncomfortable 'crawling' sensation in the lower limbs. It is more prominent at night-time, may be sufficiently intense to interfere with sleep, and can often only be relieved by moving the extremities. The diagnosis is based on the patient's history.

Incidence

Estimates in the general population suggest an incidence of 2–15%, while studies of patients with ESKD show an incidence of 20–30% of patients with the lower incidence in the more rigorous studies. Primary RLS has a genetic origin; that seen in ESKD is secondary to a number of factors.

Pathophysiology

The pathogenesis of RLS is not fully worked out but appears to involve dopaminergic dysfunction, iron metabolism, and abnormalities in supraspinal inhibition. It is postulated that RLS may be a form of uraemic neuropathy in ESKD patients.

Factors associated with its incidence

- · Number of comorbidities.
- Anaemia.
- · Low ferritin.
- Low PTH levels.
- Inadequate dialysis.
- · Longer period on dialysis.
- · Pruritus.
- · Age.
- Diabetes mellitus.
- Medication, e.g. tricyclic antidepressants, caffeine, neuroleptics.

Effect of RLS

It is associated with poor sleep and daytime lethargy, an impaired quality of life, and an increased risk of death. There is a suggestion in one study that it is associated with premature cessation of dialysis, though this may be due to its other associations rather than a direct relationship with RLS. Vigorous management is important to try to restore sleep and an improvement in quality of life.

General management considerations

- Adequate dialysis if appropriate.
- · Avoidance of precipitating medication.
- Treatment of anaemia, as appropriate to stage of illness.

Pharmacological treatment

There are very few studies comparing different drug regimens with each other in patients with ESKD. Careful dose titration needs to take place for each patient. The rank in which drugs are tried will depend on stage of disease.

- Dopamine receptor agonist therapy, including pramipexole, ropinirole, pergolide, or cabergoline, may be considered as the first-line treatment for RLS. All need slow titration, however.
 - Adverse effects such as daytime sleepiness and augmentation may limit their use particularly at the end of life.
- Benzodiazepines may give more immediate relief, are easy to titrate, and are more appropriate at end of life.
 - · Useful if RLS is causing sleep disturbance.
 - Clonazepam suggested starting dose: 500–1000mcg nocte.
 - Must monitor benzodiazepines because of increased sensitivity.
- Anticonvulsants such as gabapentin have been used—must remember appropriate dose adjustments (see Table 16.3).
- Opioids; some emerging evidence in non-renal patients; the usual opioid restrictions would apply but may consider their use in refractory cases.

Symptoms from long-term complications of treatment of ESKD

The long-term complications of treated ESKD lead to renal-specific complications such as the deposition of amyloid, particularly in joints, or renal osteodystrophy. Sexual disorders occur in many other conditions but there are factors in kidney failure that lead to the high incidence in many renal patients. Cramps, too, are common in the general population but of increased incidence particularly during dialysis. Joint and other pain management is considered in \square Chapter 7.

Calciphylaxis

Calciphylaxis is a syndrome where there is calcification of small arteries and SC tissues, as a consequence of secondary hyperparathyroidism. This can lead to severe pain from ischaemic skin ulceration. It is associated with a very poor prognosis and has a high mortality. The patient often has a reduced performance status with a gradual physical deterioration. Other effects of ischaemia may also be present with complications of PVD.

Management considerations

- The main symptom from this extremely unpleasant complication of ESKD is pain both in the ulcerated area and increased sensitivity of affected but as yet unbroken skin. Pain management is considered in detail in (a) Chapter 7. Pain is usually both nociceptive and neuropathic in nature, requiring intense management particularly as the patient's clinical condition may change frequently with overall deterioration.
- Management of skin ulceration (see this chapter, Symptoms related to comorbid conditions, pp. 162–163).
- Psychosocial support to someone with increasing dependence and physical disfigurement requiring painful dressing changes and whose prognosis is severely limited.
- It is important to enable patients to have a discussion about the prognostic implications of this diagnosis in a supportive environment.

Cramps

Muscle cramps, defined as an involuntary and forcibly contracted muscle, are extremely common, particularly in the elderly. They occur more frequently in dialysis patients both in relation to the dialysis procedure or immediately after it with a frequency in one study of greater than 50%.

Cramps are associated with imbalances of water and electrolytes (particularly sodium, calcium, magnesium, and potassium). The exact aetiology in relation to dialysis is not fully understood but it seems reasonable to assume that it is a secondary effect of the removal of water and solutes. There seems to be a direct relationship between the volume of fluid removed and the development of dialysis-related cramps. In addition, in the person with normal kidney function they are known to be associated with muscle fatigue.

Management strategies

Physical help with muscle stretching or application of warmth may be sufficient. Drug therapy if needed will depend on stage of disease.

- If on dialysis:
 - adjustment of dialysis sodium and potassium;
- carnitine during dialysis.
- End of life:
 - · quinine;
 - vitamin E 400IU orally.

Sexual disorders and problems

Both men and women with CKD experience sexual dysfunction with both experiencing decreased libido and reduced sexual arousal and reduced fertility. Men commonly report erectile dysfunction and women pain during intercourse and difficulty achieving orgasm. The severity of symptoms does not relate to duration of CKD or type of dialysis, and some symptoms pre-date the diagnosis.

The causes relate both to hormonal changes, such as reduced testosterone or ovarian failure in women, and to patients' underlying diseases such as diabetes and PVD.

At end of life these symptoms may reduce in significance but may have affected physical intimacy earlier on in the illness. This may impact on the relationship between patient and their partner at the end of life. It is essential to remember the importance of privacy for patients at the end of life to enable there to be intimacy if wished, as many will not ask.

Symptoms related to comorbid conditions

Neuropathy (non-pain manifestations)

The commonest cause of neuropathy in CKD patients is diabetic neuropathy, usually manifesting itself as either gastroparesis or enteropathy or both.

Diabetic gastroparesis

Delayed gastric emptying is common in CKD, with several other contributing factors including drugs and kidney failure itself. Gastric emptying studies are needed to confirm the diagnosis of diabetic gastroparesis, which leads to anorexia, early satiety, nausea, vomiting, and weight loss.

Management

Optimal management of diabetes.

· Frequent small meals, minimizing hyperglycaemia (may not be appropriate at end of life).

Prokinetic agents (see Table 8.2).

- · Erythromycin only in cases of intractable symptoms where potential for ill-effects is counterbalanced by possible efficacy.
- Acid suppression may also be considered either with proton pump inhibitor or H2 blocker.

Diabetic enteropathy

A disorder characterized by diarrhoea alternating with constipation. The former may be painless, watery, occur without warning, and cause incontinence. Probable pathogenic mechanisms include abnormal motility and bacterial overgrowth.

Management

At end of life treatment is geared to relief of symptoms. Codeine is best avoided in view of possible toxicity.

- Symptomatic treatment of diarrhoea with loperamide.
- Supportive management of incontinence.

Other autonomic symptoms may occur such as loss of temperature regulation, sweating, and hypotension. Some of these symptoms will become less prominent at end of life but others need to be kept in mind when caring for the dying patient as symptomatic treatment may need to continue to maintain comfort.

PVD

This is described in detail in Da Chapter 2. The main symptoms are pain from skin ischaemia, claudication, or ischaemic ulceration and phantom limb pain if amputation is necessary. When these complications start to occur this is often an indication that prognosis is short. See A Chapter 7 for pain management and below for treatment of ulceration.

IHD

This is described in \square Chapter 2. Symptoms such as angina, flash pulmonary oedema, and hypotension may continue in the terminal phase and need ongoing management.

Other skin problems

Diabetic foot

The common combination of PVD and diabetes with peripheral neuropathy and reduced sensation in the foot can lead to severe symptoms from gangrene or non-healing ulcers, both of which can be very painful. Ongoing consideration of this to ensure maximum comfort at the end of life will be important.

Decubitus ulcers

Factors that predispose to pressure ulcers include:

- · immobility:
- · poor nutritional status with low albumin;
- · infection;
- incontinence;
- oedema.

These factors are present in many ESKD patients as they approach the end of their lives and their effect is added to by uraemia and the necessity of transportation and manual handling for dialysis. Prevention is the most important aspect of their management, which requires excellent nursing care. The occurrence of ulcers despite proper skin care reflects the advanced state of ill-health and may be indicative of closeness to death.

Management

Is geared towards comfort. It is unlikely that healing will be achieved, but it is important to prevent extension of ulceration where possible and ensure comfort. Details of care will depend on the presence or absence of:

- exudate:
- · bleeding;
- necrotic tissue;
- · odour:
- infection:
- cosmesis.

Pain management during dressing change is extremely important and considered under procedure-related pain management and topical opioids in Chapter 7.

Skin and ulcer care

Will depend on the stage of illness and includes:

- establishing the goal of treatment, i.e. comfort or cure;
- attention to pressure-relieving mattress;
- · good skin hygiene;
- prevention of pressure from overlying bed clothes;
- · assess and record of type of wound.

Dialysis-related symptoms

Cramps

Discussed in this chapter, Symptoms from long-term complications of treatment of ESKD, pp. 160-161, these can sometimes be extremely severe during dialysis. For some patients they occur during most dialysis sessions.

Hypotension

Hypotension may occur both early and late during haemodialysis and leads to unpleasant symptoms that make the procedure difficult for the patient to tolerate. It is always important to assess the fluid status of the patient and give fluids if the patient is thought to be hypovolaemic. Hypotension on haemodialysis is more common in patients with large weight gains requiring greater fluid removal during dialysis, and in patients with poor cardiac function. The use of haemodiafiltration in patients with poor cardiac function may result in less hypotension. There is a significant risk of cardiac arrest in patients who are hypotensive at the start of dialysis and this may be a reason for considering withdrawal of dialysis (if there are no reversible features).

Other symptoms

Depression

Depression is common in ESKD patients. Its prevalence is difficult to quantify as many of its symptoms are similar to those of CKD. However, it is thought that up to one in five ESKD patients suffers a major depression and about twice that number have depressive symptoms. It is associated with pain, insomnia, fatigue, and anorexia and it is not always possible to determine which symptom came first as all the associated symptoms have a high incidence in renal patients. Diagnosis may be difficult because the somatic symptoms may have other causes. Where there is difficulty in making a diagnosis, use of the Cognitive Depression Items within the BDI may be helpful as this concentrates on guilt, sadness, and difficulty in making decisions rather than somatic symptoms. Key stages of disease progression or increase in complications, including the recognition that the end of life may be close, in someone's renal history, are likely to be times of increased risk of depression. For someone who has been struggling with dialysis and who has recognized and accepted their own mortality, the cessation of dialysis may also bring some relief.

Management issues at end of life

- Psychosocial and spiritual support to the patient and family in combination with drugs targeting the main manifestation of the depression will be needed at end of life.
- If anxiety chief manifestation then anxiolytic therapy (see below) may give rapid relief.

· Similarly it may be used for agitated depression.

- Insomnia should be addressed vigorously as improvement may lift
 - · Tricyclic antidepressants may be used for hypnotic effect if also indicated for neuropathic pain.

Antidepressants

May not have time to be effective. Most are fat-soluble, easily pass the bloodbrain barrier, are not dialysable, are metabolized primarily by the liver, and are excreted mainly in bile. Consequently, the majority of these drugs can be safely used in this population.

- Tricyclic antidepressants are as effective as in the general population but may be contra-indicated because of side-effect profile. However, may be considered for their hypnotic effect or for severe depression. They should be started at low dose and titrated upward according to response and if no toxicity.
 - · Amitriptyline: dose modification not necessary but side-effects likely to limit use and dose achievable.
- Shorter acting serotonin re-uptake inhibitors (SSRIs) can be used cautiously without dose modification, including citalopram, and sertraline. In keeping with the general approach to avoid longer-acting preparations where possible, fluoxetine is used less often, and (when used) the dose interval increased to 48-hourly.

Anxiety

Anxiety is also common. It is to be expected that its presence and severity will fluctuate during the course of the renal illness, as patients adjust to a different set of norms for their own functioning and dependence. Again symptoms may mimic those from uraemia. It is important for staff to recognize anxiety and stress, to allow time for their expression which may be therapeutic, and to refer on those whose symptoms are very severe or disabling.

Pharmacological management

May be necessary where symptoms are severe or disabling. The mainstay of treatment is benzodiazepines, though SSRIs may be used for panic or general anxiety disorders.

 Diazepam. Ordinary doses can be used, but it accumulates in normal kidney function and active metabolites in ESKD, so monitoring and

dose reduction will become necessary.

Midazolam given SC is useful for rapid onset and short duration at
end of life. It can also be given in a syringe driver for more prolonged
use (see Chapter 16). Dose reduction is necessary because of
prolongation of half-life in the over-60s and because active metabolites
accumulate in kidney impairment.

 Lorazepam can be given PO, SL, or IV but not SC. It has a rapid onset of action, and is useful for panic attacks. However, it too accumulates in

kidney failure so care should be taken with repeated doses.

Symptoms associated with end of life

The occurrence and management of symptoms such as dyspnoea, confusion, and agitation that are more commonly associated with the terminal phase are described in \square Chapter 13.

Summary

Extremely ill dialysis patients, those who opt not to dialyse, and those who stop dialysis have a significant symptom burden that impacts on their quality of life. Many of these patients may benefit from more aggressive treatment of their symptoms, which could include support from a palliative care team while continuing under the care of their nephrologist to ensure optimal management of the renal condition. Recognition of the problem through the use of simple assessment measures with guidelines to promote good practice may improve the overall care of these patients and particularly those approaching the end of their lives.

Further reading

Chambers EJ, Germain M, Brown E. (2010) Symptoms in renal disease. In Supportive care for the renal patient, Ch 7. Oxford: Oxford University Press.

Murtagh FE, Addington-Hall JM, Donohoe P, et al. (2006) Symptom management in patients with established renal failure managed without dialysis. EDTNA ERCA J 32, 93–98.

Weisbord SD, Carmody SS, Gruns FJ, et al. (2003) Symptom burden, quality of life, advance care planning and the potential value of palliative care in severely ill haemodialysis patients. Nephrol Dial Transplant 18, 1345–1352.

How to deliver the best supportive and palliative care

Introduction and definitions 172 Advance care planning 176 Cause for concern registers 178 Preferred priorities of care 180 Referral and joint working 182

Introduction and definitions

You matter because you are you, and you matter to the end of your life.

Dame Cicely Saunders, 1919-2005

The active total care of patients whose disease is not responsive to curative treatment. Control of pain, of other symptoms, and of psychological, social, and spiritual problems is paramount. The goal of palliative care is achievement of the best quality of life for patients and their families. Many aspects of palliative care are also applicable earlier in the course of the illness in conjunction with conventional care for the renal patient.

Modified from the WHO definition of palliative care¹

The modified WHO definition of palliative care above describes the essence of supportive and palliative care. It can be applied equally to those with kidney disease as to the cancer sufferers for whom it was originally written, as it encompasses all domains of care, includes the family and carers, and recognizes the need for such care earlier in the disease than is frequently recognized currently for patients with ESKD. This type of care is sometimes separated into supportive care and palliative care, which are described below.

Supportive care

The National Council for Palliative Care (NCPC) defines supportive care as follows.

Supportive care helps the patient and their family to cope with their condition and its treatment—from pre-diagnosis, through the process of diagnosis and treatment, to cure, continuing illness, or death and into bereavement. It helps the patient to maximize the benefits of treatment and to live as well as possible with the effects of the disease. It is given equal priority alongside diagnosis and treatment.

Supportive care should be fully integrated with diagnosis and treatment. It is part of a team's overall service provision, and will be provided at times during a patient's illness as part of the patient's holistic care. Other specialists may be brought in for particular aspects of care.

The NCPC goes on to describe what it encompasses:

- · self-help and support;
- user involvement;
- information giving;psychological support;
- psychological suppo
- symptom control;
- social support;
- rehabilitation;

- · complementary therapies;
- · spiritual support;
- · end of life and bereavement care.

Providing supportive care for the patient is part of the renal team's holistic care of their patients; it is provided by different members of the team at different times. Other specialists and disciplines may be brought in when needed to contribute to that care.

Palliative care

This is defined by the National Institute for Health and Clinical Excellence (NICE) as follows.

Palliative care is the active holistic care of patients with advanced progressive illness. Management of pain and other symptoms and provision of psychological, social, and spiritual support is paramount. The goal of palliative care is achievement of the best quality of life for patients and their families. Many aspects of palliative care are also applicable earlier in the course of the illness in conjunction with other treatments.

It aims to:

- affirm life and regard dying as a normal process;
- provide relief from pain and other distressing symptoms;
- integrate the psychological and spiritual aspects of patient care;
- offer a support system to help patients live as actively as possible until death;
- offer a support system to help the family cope during the patient's illness and in their own bereavement.

General palliative or supportive care is provided by all doctors and nurses who provide day to day care of patients. Specialist palliative care is provided by a multidisciplinary team which has specialized in the discipline and which may practise within a specialist palliative care setting or in an advisory role either in hospital or the community.

Working alongside

Palliative care provides a philosophy of care that accompanies the patient whatever setting they are in. Specialist palliative care services are complementary to those of the renal team. Team members work alongside their renal colleagues, except for hospice inpatient end of life care, when care of the patient will be assumed by the palliative care team. In all other settings the two teams need to work in tandem, so the patient continues to receive the expertise of the renal multidisciplinary team plus the additional knowledge of specialist palliative care, thus providing the best possible care for the patient. When the patient is at home the primary care team will lead the patient's care but be able to utilize the expertise of either team as required.

Why is palliative care needed?

The morbidity and mortality of patients with ESKD has been described in the preceding chapters. It is recognized that they experience the following.

- Multiple symptoms.
- Multiple losses:
 - · employment;
 - · role in family and at work;
 - appearance changes;
 - · increasing dependence, which may lead to guilt;

 - · financial.
- An incurable condition.
 - · Even with a transplant previous morbidity may persist and antirejection drugs are lifelong and often have significant and even life-threatening side-effects.
- Relentlessly increasing comorbidity.
- Increasing dependence.

As more attention is paid to these aspects of the care of this group of patients so the importance of their supportive care during ongoing management and more intensive palliative care at times of crisis or as end of life approaches is recognized.

Provision of specialist palliative care services in UK

Specialist palliative care services are provided in a number of ways.

- Specialist inpatient facilities either in hospice or hospital.
- · Hospital advisory teams.
- Home support:
 - · advisory teams working alongside the general practitioner (GP) and district nurse:
 - · intensive home nursing or 'hospice at home' services for end of life
- Day hospice.
- · Bereavement care.
- Education and training.

Most palliative care services will accept referrals of patients with ESKD, though not all may be able to accept patients into specialist palliative care beds, usually due to the relative shortage of these beds. A few voluntary organizations may only accept certain categories of patient, such as just cancer patients. This distinction is gradually being reduced as the needs of non-cancer patients are increasingly being recognized.

Further information

Further information can be found on the NCPC website: http://www.ncpc.org.uk/site/ professionals/explained.

1 WHO (2002) National cancer control programmes: policies and managerial guidelines, 2nd edn. Geneva: World Health Organization.

Advance care planning

The restrict of the control of the c

The state of the s

magnic in statement of the account of the Agricultural Conduction of the Value of the Salaria Conduction of the Value of the Salaria of the Agricultural Conduction of the Agricultural Co

Advance care planning

What is it?

There is often some confusion between advance care planning and advance directives or statements.

Advance care planning is planning ahead to anticipate care, and is particularly important when health is declining towards death. Without good advance care planning, a crisis will arrive, and decisions may be made in the heat of crisis which do not concur with the patients priorities and preferences, Best practice in advance care planning includes:

 Discussing preferences and priorities for care with patient (and family, according to patient wishes).

 Considering together situations which may arise and planning care for those situations.

· Defining the limits of the advance plans, for instance when and what might cause a change of mind about the plan.

Documenting this clearly, including when the plan will be revisited.

 Communicating the plan to all relevant care providers (this includes primary care and out of hours (OOH) services).

 Understanding that preferences and priorities for care are a dynamic process, and providing for review and change as health and care needs change.

Advance directives or statements are oral or written expressions of preferences for future care by the patient, made in order to anticipate loss of capacity, and these should be brought into consideration when loss of capacity occurs.

Car se for concern resignations

fredt hamely?

Cause for income tregisters have been into liven as a way to the and only a great diagram was to be those took likely 1001 as distance by ceath to enhance the area of a second to the unconfinite in the second and makes the distance of make of the confinite and the second a

Declaration to install register was are as most fall of deciding nearly as the Box 1.1.

 Introduce a systematic way to undertake a set termb, and complete a expension for the resident.

If a first bear a constant of the stranger of the left in all representations of the constant of the stranger of the constant of the stranger of the stranger

4. The content is a relative of 60 of the control of 10, or in the 100 of the 100 of

in the that the legitine in your meadark is there if it is a will write in three do.

Quantity (a) The context of the partition of

which is passal, and v_1 position for a substitution with the contribution v_2 and v_3

a digital kenya asa usan didikalakan galahingan are sa k ndigital kenya asar sa majar sa majar paganan pagingana

The definition of the many seasons are the more than the seasons of the seasons o

Cause for concern registers

What are they?

'Cause for concern' registers have been introduced as a way to try and ensure that the care needs of those most likely to have deteriorating health are anticipated and met well. Several steps are undertaken in creating and using a cause for concern register:

- Decide how to identify those who are at most risk of declining health (see Box 9.1).
- Introduce a systematic way to undertake this identification and place people on the register.
- Once the register is in place, ensure it is easily accessible and that all relevant professionals know why it is there and how to use it.
- Entry onto the register should trigger additional checks and reviews beyond the usual, in order to anticipate and deliver appropriate supportive and palliative care.
- Ensure that the register is reviewed regularly to check it is achieving what it intends.
- Communicate the concerns raise/addressed by the register to the patient and family sensitively, and in keeping with their preferences for information and involvement in decisions.
- Communicate the additional concerns raised by the register to all relevant care providers (this includes primary care and OOH services).

Box 9.1 Identifying those ESKD patients most at risk

The surprise question 'would I be surprised if this patient died within the next 6 months (or 12 months)?'.

Gold Standards Framework A similar national register has been introduced to general practice, which is intended to identify and register all those likely to be in last year of life (with whatever diagnosis). For this reason, some renal units have called their cause for concern register by a similar name, such as the 'Gold' or 'Gold Standards' register.

Preferred priorities of care

Alesto nebishoo xiffW

Federal Jaumes in the People won to include the province to include and formation to include to the toylong standard or the control of the people won to include the people (before or the control of the people) and the people of the control of the

Autorope A

the country of the country of the speak of the gappy 2000, but that it is country in the gappy of the property of the country of the country

Preferred priorities of care

Why consider this?

Preferred priorities of care is an important public and government priority towards the end of life. People wish to be cared for (and to die) in the place of their choice, and this has been adopted by as a policy priority. Most people (between 50% and 70%) prefer to die at home but ESKD patients more commonly die in hospital., especially when compared with other conditions, with almost 70% of those dying with chronic kidney failure in England dying in hospital.1 This may in part be because these patients are well known to renal units over some time, and prefer to be cared for by familiar professionals near the end of life But it may also reflect limited planning ahead to enable home death when this is preferred. It is important therefore to ask about the preferred place of care during advance care planning discussions, and to document this as part of the advance care plan. National documents have been developed to help facilitate and support this (see http://www.endoflifecareforadults.nhs.uk/ tools/core-tools/preferredprioritiesforcare). Good advance care planning can help facilitate care and death in the preferred place, but it is important to remember that preferences are dynamic and may change in the face of advancing disease.

Reference

1 Deaths from renal diseases in England, 2001 to 2008. Report published in 2010 on the National End of Life Care Intelligence Network at http://www.endoflifecare-intelligence.org.uk.

wall arow into the firms bill

In incretions, he have a confine which we draw so viscos party party or party or subject or subject

 Cope comproved the disposition round and statement acting the pressing approximation of the statement where within excellent times.
 Presant Response to the control of the cont

remaix visite i issecolice selvativa nunspeniana e un scalinariea with the remainant entities catalactus.

er tourist and the second of t

ia Pute is vito filodonali ilgiliare e vi ceadagare e contrata viuledi garringe e vito ce di aresti in egeneri er alla e e e e vito ce e vilodore della

ger in de france de la companya de l

50 Section 2015

The state of the s

Lors during the market and audience

and the present (191) specific that the removable set is

เรียง และ กา<mark>สมอธิ โดย</mark>การกรที่โดย อังคุณการปลายการ เลือกให้น ก

s seem of more reflective participals consideration to the seed

Referral and joint working

Indications for referral to palliative care services

Many patients will not require referral to a palliative care service; rather they will receive palliative care from their renal and primary care teams. For some, the symptoms from their disease and its complications, or the severity of psychological, social, or spiritual issues may be sufficiently severe to require referral for help in their management. Other patients may request end of life care in a hospice or palliative care unit setting. Possible points in a patient's disease when specialist palliative care may enhance the care of the renal patient are listed below.

- Severe symptoms that are difficult to control and affecting quality of life.
- New significant diagnosis of a life-limiting illness while receiving RRT.
- Increasing symptoms from comorbid conditions, such as: · diabetic neuropathy;
 - · PVD:
 - · arthritis.
- At the onset of conservative management:
 - · in conjunction with the renal and primary care team;
 - · to ensure optimal symptom management.
- Falling performance status or other parameters identified in Chapter 8.
- · Recognizing dying, which leads clinicians to believe prognosis less than a year.
- Patients who develop kidney failure as a consequence of other life-threatening condition or its treatment, e.g. cancer.
- Around the decision to stop dialysis:
 - · for psychological support;
 - symptom control; · family support;
 - · help with planning re preferred place of care;
 - · bereavement support.
- Terminal care—where there are difficult symptoms or complex psychological needs.

Joint working

There are many ways in which renal and palliative care teams can work together to improve patient care.

- Develop a supportive care group of renal and palliative care professionals to lead in improving care by initiatives such as:
 - · guidelines for end of life care;
 - · guidelines for symptom control; use of an integrated care pathway (ICP) for end of life care;
 - · written information for primary care;
 - notification of conservative management decision on database;
 - · written information for patients—choosing not to dialyse;
 - improved physical facilities for inpatients.

- Joint education programmes.
- Change ways of working by:
 - · joint renal/palliative care clinics;
 - · preparative discussions with community palliative care services.
 - integration of nursing and psychological assessment notes;
 - · identification of key worker;
 - · critical event debriefing;
 - · use of advance directives;
 - open door policy to support for bereaved family;
 - open culture in discussing death and dying during pre-dialysis meetings.

- Approving to establish folder

 - we will all and the track of
- with the same and the same and
- the property of the control of the c
 - - Taken at the second second
 - The same policy in against whether present at a same
 - ลงเครื่องราชการเหมือดเหยื่นคราชภาษีสุดสินเวลเร็วและเกิดเปลดสุดราช

Recognizing dying

Introduction 186
Recognition of the need for supportive and palliative care 188
Gold Standards Framework 190
Recognition of the terminal phase 192
Listening to the patient and their families/carers 194
The nephrologist's perspective 196

Introduction

In order to provide the best possible care for someone at the end of their life it is important to identify that they have reached an irreversible stage in their illness. This is particularly difficult in people with a chronic illness who experience a slow decline. It might be helpful to address it in two stages:

- · recognition of the need for supportive and palliative care;
- recognition of the terminal phase—meaning the last days and weeks of life.

Recognition of the need for appartive and patting recore

The state of the s

Recognition of the need for supportive and palliative care

There are a number of markers that will help a clinician realize that their patient is in need of supportive and palliative care, particularly if one uses the 'renal' modification of the WHO definition of palliative care given in Chapter 9, Introduction and definitions, pp. 172–173.

One helpful way to raise awareness in one's own practice is to ask the question 'Would you be surprised if this person were to die in the next 12 months?' If the answer is 'no', the clinician should be considering whether such a person has palliative care needs. Recent evidence has shown the surprise question to be a more accurate predictor of prognosis than previously proposed variables such as plasma albumin. Prognostication is a very inexact science. However, we know that clinicians overestimate prognosis more frequently than the converse. Therefore, if in doubt, the chances are the person does have a prognosis of less than 12 months and may benefit from the early introduction of supportive and palliative care. In the UK a general practice initiative called the Gold Standards Framework (GSF) can help both identify patients and then improve their care.

Cold Standards Francescook

The sine out of the control of the end of the practical of the state of the control of the second of the control of the contro

The data of the fact has the profession of the data of

i inderessi i kirker geter et da ser Inderessi kan juditan da diwiki da di ini investi dan menjiki dan

nd negrous and displaying gains a way full says. A car miss a sustilipsort and supplied and carps Wiredian provide continual.

LANCE AND THE LANGE OF THE TRANSPORT AND THE

Caraco - 1

In the first state of the first of the second of the secon

To be the area of own fill to be about the first section of the se

Comments where the COH is remarkable of the COH Comments of the control of the co

o e la como el 1 des aux Europe. El magraca a considerado de el como el el como el Pare Na el como el como

Gold Standards Framework

The aim of the GSF is to provide one 'gold standard' for all end of life care. It is a programme for community palliative care, practice- or localitybased. It has a common sense framework that was initially developed for cancer care but is now recognized to be relevant to all with supportive and palliative care needs aiming to optimize the organization of and the quality of care. The principles of the GSF can be integrated into the routine management of all renal patients regardless of modality. The key elements all involve communication and are patient-centred:

- Identify patients in need of palliative/supportive care.
- Assess their needs, symptoms, and preferences.
- Plan care around needs.

The goals of care are that the patient:

- is symptom-free or at minimum has symptoms addressed;
- identifies their preferred place of end of life care;
- feels secure and supported by means of:
 - · ACP:
 - addressing information needs;
 - knowledge that planned care will lead to fewer crisis admissions.

For carers and staff the gains are as follows.

- · Carers are supported, enabled, and empowered to provide optimal
- Staff gain confidence through team working.

The seven Cs

The GSF identifies key tasks, known as the 'seven Cs':

- Communication within primary care which includes:
 - · a register of all patients with palliative care needs;
 - · all such patients discussed at a multidisciplinary meeting;
 - · improved discussion with patient to include ACP.
- Coordination of care with nomination of a co-coordinator.
- · Control of symptoms, which should be:
 - · assessed:
 - · recorded:
 - · acted on.
- Continuity, which includes OOH:
- · systems put in place for OOH care.
- Continued learning by primary care.
- Carer support.
- Care of the dying phase:
 - diagnosing dying;
 - could use the ICP (see A Chapter 13, Integrated care pathway for end of life care, pp. 294-295);
 - must use anticipatory prescribing.

Prognostic indicator

A prognostic indicator guidance paper was introduced in 2005 (revised September 2008), focusing on three groups: (1) cancer, (2) organ failure (including kidney disease), and (3) frailty and dementia. The guidance paper aims to help clinicians to identify and support more patients nearing their end of life, regardless of diagnosis. Specific clinical indicators for identifying renal patients in the last year of life include the following.

General predictors of end-stage disease

- Comorbidity is increasingly the biggest predictive indicator of mortality and morbidity. Also:
- Weight loss: greater than 10% weight loss over 6 months.
- General physical decline.
- Serum albumin <25g/L.
- Reduced performance status/Karnofsky performance score (KPS) <50%.
- Dependence in most ADLs.

Indicators specific to kidney disease

- Conservative care: patients with stage 5 CKD who are not seeking dialysis or are discontinuing it and are not for kidney transplant. Reasons include:
 - personal choice;
 - frailty or the presence of too many comorbid conditions.
- Patients with stage 4 or 5 CKD whose condition is deteriorating and for whom the '1-year surprise question' is applicable, i.e. overall you would not be surprised if they were to die in the next year.
- Clinical indicators:
 - CKD stage 5 (estimated GFR <15mL/min);
 - symptomatic kidney failure (anorexia, nausea, pruritus, reduced functional status, intractable fluid overload).

Indicators are taken from GSF prognostic indicator guidance.¹

Reference

1 The Gold Standards Framework NHS End of Life Programme: http://www.goldstandardsframework.org.uk/.

Recognition of the terminal phase

Clinical practice

In the context of patients (HD, PD, conservative management, or transplant) seen in outpatients or on the renal wards there are a number of factors that lead clinicians to recognize the approach of end of life.

- A rapid change in performance status with:
 - · increasing dependence;
 - · more time spent in bed.
- · Weight loss with cachexia in the absence of malignancy.
- Multiple admissions with complications of treatment.
- · Increasing difficulty with access for dialysis.
- Irreversibility of comorbid conditions such as:
 - worsening PVD not amenable to corrective surgery and leading to amputations;
 - ongoing complications of vasculopathy, either cardiac, cerebral, or gut ischaemia.
- Calciphylaxis—usually associated with a poor prognosis.
- Persistent hypotension related to poor cardiac function, particularly if this limits fluid removal during dialysis.
- · Recurrent infections.
- Increasingly severe symptoms, needing more complex management.
- Patient withdrawal from interest in the world around them. This may take various forms:
 - · refusal of food and drink:
 - · refusal of medication:
 - · refusal of basic nursing care:
 - · irritability with staff who are trying to help them.

If a patient chooses to be managed conservatively or to withdraw from dialysis it is important to check their understanding of the meaning and implications of their decision. It is likely that patients who request to withdraw from dialysis have been considering this option for some time, particularly in the presence of increasing frailty, comorbid conditions, and symptom burden. It is crucial that a series of sensitive discussions take place at the patient's own pace to explore the reasons underpinning the decision to withdraw.

Refusal of other care but not dialysis is often a cry for help, perhaps by someone who cannot verbalize their feelings, and it should be seen as an opportunity for gentle exploration to determine the patient's wishes and fears, and also to exclude depression or another cause that might be responsive to treatment.

Clinicians will always wish to ensure that no reversible causes of some of the above factors are missed. However, it is often helpful to discuss with the patient to what lengths they wish to go with investigations if the cause of decline is unclear. Without taking away hope it is possible to share with the patient your concern that not all illnesses are reversible and then to ask their view on how far they wish to be investigated balancing the burden against benefit. There will be some who: (1) have recognized that their prognosis is limited and acceptance of the approach of end of life,

(2) have weighed up the burdens of dialysis against the benefits and actively choose to withdraw, (3) are unable to make the decision themselves to withdraw, and (4) wish you to use all reasonable resources to try and improve the situation.

Ascertaining patient priorities and preferences earlier in the disease trajectory will allow the team to tailor their care accordingly.

If a patient is experiencing pain or other distressing symptoms, whatever the uncertainty about their prognosis, it is important to provide meticulous symptom control. If that person dies, you have provided the right kind of care for their end of life. If they survive, you will have improved their quality of life during a difficult time.

Listening to the patient and their families/carers

As well as the patient recognizing that they are approaching the end of their life, often the family or carers suspect or are concerned that their relative is moving towards the final stage of their illness. It is vital that patients, families, and carers feel able to express their concerns to any member of the renal team, who should ensure that there are opportunities to look at the whole situation for an individual not just the care necessary for their kidney disease. These opportunities can be provided in a variety of ways such as access to non-medical members of the team who can feed back to a multidisciplinary meeting. A regular overall assessment at dialysis attendance could include an open question asking how things are, which would give patients the opportunity to say if they are struggling.

The patient and family perspective

I thought I would walk out of here on two feet but now I am not so sure

Patients come to the realization that they are dying in their own time and in their own way with a range of emotions and coping strategies accompanying this recognition. Worden's work on loss in the context of mourning explains the emotions patients experience as they are confronted with their own mortality and their passage through overlapping stages of coping from the time that they become aware of their prognosis until their actual death.1 In order to be of help, we must first appreciate the enormous psychological impact dying has on the terminally ill patient and his or her family. Insight into the nature and range of coping mechanisms patients employ to manage the many powerful and sometimes conflicting emotions elicited by the prospect of death is paramount, as only by understanding this model of grief are we able to share the patient's unique journey and offer the most appropriate intervention. Patients express loss in different ways, rarely if ever progressing systematically through the stages of mourning but more frequently dipping in and out as they process newly acquired information. At such times it is helpful if their behaviour and emotions can be normalized within the framework of someone who is grieving not just for what they have lost, but also anticipatory grief for what they are about to lose.

Most commonly expressed emotions at this time are:

- · denial:
- anger and despair that, if internalized, can manifest as depression;
- difficulty in making decisions about future care pathways;
- sadness that life is to end and goodbyes need to be said;
- · fear about the process of dying;
- anxiety about those left behind and any business left unfinished;
- ambivalence;
- guilt and self-reproach—wondering if a change of lifestyle could have prevented progression of the disease;

- isolation, often self-imposed, as a sense of 'aloneness' encompasses them;
- helplessness and powerlessness—at not being able to change the inevitable course that their illness will take:
- yearning for what was and what will never again be;
- relief that the struggle will soon be over;
- · acceptance that death is inevitable.

Reference

1 Worden JW (1991) Grief counseling and grief therapy. Springer, New York.

The nephrologist's perspective

It is as important to diagnose and appropriately manage the terminal phase of the patient's illness as it is to diagnose and treat a chest infection. Nephrologists, however, often find this difficult. There are various reasons for this.

- Patients can often be temporarily 'rescued' by yet another vascular access procedure.
- · Patients are often referred from other teams when they develop acute kidney injury as a complication of other severe illness or after surgery.
 - · There is often an expectation from the referring team, patient, and/ or relatives that 'something can be done'.
 - · Tendency to focus on 'here and now' and not long-term situation.
 - · Difficult to be the person to say 'no' to further intervention when the referring team should have recognized the futility of escalating
- Many nephrologists are not adequately trained to share bad news with patients and are therefore hesitant about having such conversations.
- Historically nephrology has been very diseased focused.
- The powerful focus of technological care in the face of advanced disease provides a care culture, which can be difficult to change when death approaches, and patient and family needs are quite different.
- In many renal units, patients are admitted on to the wards under the care of a nephrologist different from the one responsible for their usual care on the dialysis unit or in the transplant clinic. Understandably it is difficult to have 'end of life' discussions between a patient and an unknown doctor.
- Having such conversations is time-consuming.
- Many patients with ESKD are from ethnic minorities and speak poor English; this makes communication difficult.
- Nephrologists often work in rotation, i.e. may be 'on the wards' for a fixed period of time and then hand over to a colleague. In such a system, it is easy not to confront the difficult decisions.

Difficult questions about dialysis at end of life

- Is resuscitation always appropriate?
- Is transfer from PD to HD in the weeks leading to death appropriate?
- Is perseverance with HD in patients tolerating dialysis poorly justified?
- Are multiple attempts at catheter insertion appropriate at end of life?

Clinicians should bear these questions in mind as they care for the very sick patient who may be near the end of their life and use this as an opportunity to raise their concerns sensitively with them.

Withdrawal of dialysis

- Difficult area to explore with patients but it is not uncommon for patients to recognize futility of treatment.
- Indicated if there is a high risk of patient having a cardiac arrest during a dialysis or dying while on the machine.
- Effectively necessary if no further dialysis access is possible.

Provide to swift y

The many of the second of the

Communicating with patients and families

Choosing conservative (non-dialytic) care 200 Introducing palliative and hospice care 204 Helping with decision-making 206 Withdrawal from dialysis 208 Raising awareness and improving communication skills 212 Sharing bad news 214 Responses to difficult questions 216 Communicating with family members 218 Communicating on issues around sexuality and intimacy 220 Communicating within teams and information sharing 222

Choosing conservative (non-dialytic) care

Good communication is the bridge that spans the gap between the mind of the doctor and the patient.

Anna Tharyan

Margaret was a 61-year-old married patient with type 2 diabetes, partial vision, neuropathy, and CKD. Her quality of life had been substantially affected by her deteriorating kidney function and she was dependent upon her husband for assistance with personal care and ADLs. Her own child had died 3 years previously from CKD having asked to be withdrawn from dialysis and Margaret's decision not to initiate treatment was based on her daughter's negative experience of RRT, her unwillingness to integrate another health regime into her daily routine, and fear of becoming a further burden on her husband who had his own health problems. This, combined with issues around unresolved grief in relation to the death of her daughter, made her feel that the future held nothing for her.

Whilst the case studies (as above) in this chapter raise a number of important issues, the aim is to focus predominately on decision making components.

Introduction to conservative management

Conservative management is now a recognized treatment modality in nephrology, with more than 20% of the UK pre-dialysis population selecting this option. As nephrology clinicians we are experienced in introducing and discussing RRT options; however, it can be far more challenging to describe the conservative care pathway to patients. In many cases the patient will ask 'how long will I live [without dialysis], what symptoms can I expect?'. Insight into the most likely course of illness the patient might expect can be informed by considering the clinical picture (biochemistry, comorbidity, age, and functional status) together with the patient experience. This will guide your answers to these frequently asked questions and enable you to reach the best outcome with the patient and family (see A Chapter 4).

The decision-making process

Conservative (non-dialytic) management may be appropriate if (1) the patient feels the burdens of dialysis therapy will outweigh the benefits and/ or (2) it is advised medically in view of declining health with rising comorbidity and poor functional status. In both instances it is essential that we are reassured that the patient and family fully understand what it means to be managed conservatively without dialysis. Asking your patient 'what do you understand about how your disease will progress should you elect not to have dialysis?' enables the professional to know what the patient's understanding is and is also a stepping stone to discussions around end of life care. It is worth bearing in mind that for some patients, despite severe

renal impairment, you may be the first clinician to introduce the concept of conservative, palliative, and end of life care. Set realistic goals for each consultation including:

- Describing the conservative care pathway versus dialysis treatment options: consider potential prognosis and quality of life with and without dialysis.
- Clarifying and establishing patient priorities for care in the context of their disease severity.
- Establishing a plan of care based on individual needs: include crisis/ exacerbation and ACP.
- Revisiting decision making, particularly as illness progresses and symptom burden increases, helping prevent crisis admissions and inappropriate decision to initiate dialysis.

Taking the conversation forward

There is good evidence that renal patients welcome the opportunity to plan in advance and discuss end of life care: having these discussions in a timely and sensitive manner can positively enhance hope rather than removing it. 1 Renal patients themselves have identified honest, open discussions as a priority in end of life care. Ask your patient:

Are you the type of person who would like honest, open discussions about your illness and future care?

Having ascertained that the patient would like honest open discussion you can then take the conversation forward to include discussion about sources of support and preferences for end of life care.

Choosing to be managed conservatively means you will receive ongoing management of your kidney disease to keep you as well as we can, including treatment for any symptoms. As your kidney function deteriorates and you become less well, you may agree to have some local support in addition to the renal clinic, such as the local community palliative care service.

The options you might want to consider and discuss with your family include remaining at home, being cared for in hospital, or hospice admission. Although it is difficult to accurately predict when this will be, talking about these things now will help us plan things to try to ensure your wishes are carried out.

Saying this reassures the patient that they are not going to be abandoned as a result of choosing the conservative care option and empowers them to participate in decisions regarding end of life care and their preferred place of death.

Knowing what to ask and when is very dependent upon the relationship that has been built up with the patient or family member but, by active listening, cues can be picked up from the patient as to whether they are ready to 'hear' what is being said. It should be remembered that when a patient makes a decision not to have dialysis, they could still live for several months. Patients may not be ready to face end of life discussions

CHAPTER 11 Communicating with patients & families

and may find it difficult to grasp the severity of their advancing disease (particularly if they maintain functional status and are relatively asymptomatic). Looking at end of life care and preferred place of death may not be uppermost in the patient's mind, for they still consider that they have a life to live. However, for patients facing death more imminently, i.e. those withdrawing from dialysis or late referrals with no time to consider their options, these issues have to be gently raised.

Reference

1 Davison SN, Simpson C (2006) Hope and advance care planning in patients with end stage renal disease: qualitative interview study. Br Med J 333, 886.

Introducing palliative and hospice care

It should be borne in mind that many patients regard hospices as 'somewhere you go to die' and there is often resistance to onward referral for hospice end of life care. This can be helped by introducing such care through the more generic term 'palliative care' and then explaining that hospice care is part of palliative care, having explained a little of the philosophy of palliative care. Take time to explain that the palliative care team should work together with the renal team to provide the best care and outcomes.

Depending on where the patient is in their understanding, it can be useful to say the following:

I want to reassure you that I am not raising the subject of palliative care because I have concerns about your immediate health, I just want you to be aware that we often make early referrals to hospice and palliative care services because they offer a different dimension to the care we can give you. Nurses can visit and advise on symptom management and are available as a resource, particularly if you want to take advantage of the day-care facilities and therapies they offer. They also provide emotional support, not only to patients but also to family members, and maybe this is something you would find useful at some time in the future.

Educating patients as to the resources that are available within hospice and palliative care services can address verbalized resistance and lead to the terminally ill patient and family members benefiting from local support services. See also (Chapter 10.

wal from dialysis

ment to death is a process that cannot be rushed.

from dialysis

-sustaining treatment for >47,000 patients with ESKD in th patients with multiple comorbid conditions, risk of deat r is higher than with most cancers. Quality of life remain disease and there is significant treatment burden associate he rising incidence, changing population, and recognition of dialysis mean more patients are likely to be advised withdraw from dialysis prior to death. Dialysis withdraw ered acceptable practice, with more than 17% of all U attributed to withdrawal of treatment (see A Chapter s a relatively predictable phase of a patient's manageme post-withdrawal is 8 days) the evidence and clinical expe ggest that it is a phase that is not managed well. As rer much of our energy is devoted to detailed technologic of quite problematic disease, providing a care culture th range when death approaches, and patient and family nee ent.

cision-making regarding stopping dialysis

dialysis withdrawal is usually raised by

I team, when dialysis is no longer seen as maintaining quality of life, or the patient is deteriorating additional

may raise the issue of withdrawing from treatment

scussions with the medical team and family members shot splore the reasons behind the medical concerns or patie ether any changes in treatment might improve quality of litom control before a final decision is made about stoppi imperative that any questions raised by the patient as are honestly addressed in order that informed decision d future care plans put in place.

for patients to understand the following:

ision-making will be respected.

nest dialogue will take place with the medical staff acting if the patient is experiencing difficulty discussing this amily members.

cal assessment may be required:

sion to withdraw is made for solely emotional reasons;

ridence of depression that could be treated with n or counselling, which might change the patient's e;

Helping with decision-making

A number of patients postpone making decisions regarding future treatment plans based on their assertion that they are not symptomatic and therefore there is no urgency. It is important to emphasize the unpredictability of kidney disease, whilst kidney function may remain stable for some time it is difficult to accurately predict when their function may 'tip'. Recent evidence and clinical experience has shown that renal patients may experience a more rapid decline than cancer patients. Whilst not wanting to pressure ambivalent patients, it can be helpful to say the following:

I can see that it is difficult to make a decision about future treatment options when you are not experiencing any symptoms, but sometimes, despite being closely monitored, things change suddenly and then immediate decisions have to be taken as to whether or not to start dialysis. This could lead to you being treated in a way you would not have chosen. So if you are able to make a firm decision you are ensuring that the care you receive will be in line with your wishes.

However, it is also important to reassure patients that we recognize that they may change their minds when the clinical situation changes. Emphasize that this is not a 'one off' discussion' and needs revisiting. This can be acknowledged by reassuring them as follows:

We recognize that sometimes when circumstances change people do rethink their decisions and there will be the chance for further discussion in the future.

Avoidance techniques

We also need to remain aware that avoidance behaviour and denial are commonly expressed defence mechanisms that some patients employ at this stage of their illness, which is why decision-making can be such a difficult task. It is not unusual for patients to say 'I'll do whatever the doctor thinks I should do' rather than take responsibility for their future care. We need to appreciate the internal conflict patients often experience at this time and sensitively find ways of addressing their dilemmas.

Following reflection

And, finally, we should remember that in this situation patients do quite often change their minds. As they become more symptomatic, so are they more likely to see dialysis as a means of reducing their symptoms and improving their health and quality of life. This is why it is important for a member of the renal team to continue to see these patients to offer them the opportunity to revisit their original decision, and to give them permission to change their mind.

With

CHAPT

Withdra

Dialysis is UK. For a in the first impaired b with dialys the limitat or choose is now co dialysis dea Although t (mean surv ence would professiona care in the is difficult to are quite di

Informed

The option The med

- or improv comorbid
- The patie themselve

In both cases take place to request and v e.g. good syr treatment. It family memb can be made

It is essent

- Informed d
- Open and I as 'facilitate option with
- A psycholo
 - · if the de OR
 - there is medicat perspect

- to establish that the patient has made an informed decision to withdraw and fully understands the implications and consequences of that decision.
- Time for reflection is encouraged.
- Treatment can be reinstated if the patient so wishes.

It is equally important that staff remember that the wishes of a patient who is able to make an informed decision should take precedence over all other considerations and that withdrawal from dialysis can offer patients a chance of taking control over the final days of their lives.

From the example of Mimi in the box below, it can be seen that many personal, family, and social factors contribute towards the decision to withdraw from treatment. These need to be understood by staff in order to appreciate the patient's dilemmas and difficulties. Support needs to be offered to both patients and their families at such times.

Mimi was 82 years old, widowed, with one married son. She lived alone and was mentally alert but physically struggling to manage daily living and personal care tasks. No longer able to carry out PD she found the rigours of HD difficult to tolerate and asked that treatment be withdrawn. Her son offered to pay for her to move into a nursing home where she could recommence PD, but she refused, saying she wanted to live with himsomething his wife refused to consider. Dialysis withdrawal and palliative care were gently introduced as treatment options and Mimi agreed that this would be her preferred course of action. However, within the next 2 weeks, she repeatedly vacillated, which resulted in treatment being recommenced and withdrawn three times. Her son thought her indecisiveness was aimed at making him feel guilty, but in discussion with her, it became clear that she had huge fears around death and dyingparticularly the time frame and way in which death from kidney failure would occur. Mimi was referred to both the hospital chaplain and the counsellor and died peacefully in hospital. Her son, who had stopped visiting because he found it too painful, sought emotional support for several months following her death.

Helping families consider withdrawal from dialysis and palliative care

I can't possibly make that decision—it's like I'm signing my father's death warrant.

One aspect of palliative care is that it can be seen as creating a voice for the voiceless, particularly when a person loses capacity. It is about recognizing that, when someone is ill and dying, they may be unable to voice what they want and how their needs can be met, which can leave families feeling that they are shouldering the responsibility of decision-making regarding withholding or withdrawal of dialysis.

A useful intervention and one which families would find more acceptable might be for medical staff to say 'In our opinion, dialysis is simply sustaining life; unfortunately your father is not going to improve and it is unlikely he will recover from the stroke. It is our clinical judgment that dialysis should be withdrawn and we were wondering if you feel able to support this decision?'. Or 'If your father was able to speak what do you think he would be saying now? What do you imagine his wishes would be?'.

Framed in this way, the onus of responsibility shifts and families feel better able to make decisions based on what they believe their loved ones

would have wanted. (See also Chapter 11.)

Palliative care necessitates comprehensive caring and places a high priority on both physical and emotional comfort. Its objectives include the management of pain and other symptoms, diagnosis and treatment of psychological distress, and assistance in maintaining independence for as long as possible. It also extends to supporting the family. For further information see A Chapter 10.

Bassing awareness and improving community skills

ter vita fill pignis success vita do do successo vecas electronic

Waltriev O

Putrition is used at raifed their of pain does but write, about donness, and feat of the maken two raises and feat for the proof of their properties and from a representations and feat of their properties of their properties of their proof donness and owner one particular and owner of the particular and owner owne

absolute where upon one draining and

senshive "andique" bad hews.

* active intended to patienting

Successful were of saving at the second of the second as

BETTE DESCRIPTION THOUSAND OF SAME SOUTH AND SAME

. 1959년 - (1910년 1915년 - 1950년 - 1953년 1951년 - 1951년 -- 1959년 - (1910년 - 1951년 - 19

Converse studies of way actions have consultanted to

- symptom William - Front Product Inc. 190 #

 In ordan appy the following at each related stup or markovithe patient by each controller document.

v ustrakldens or arms baser

สมพาการที่ (พี่ เล่า เล่า xalonua สู่เล่าสู่สมสภา กัก พี่ได้ เก็บ 🌞

ha dadd garud le real a

natus memora sons

And the second of the second o

or the first section of the control of the control

can principle of publisher in serior publisher research per contribute and the contribute of the contr

Raising awareness and improving communication skills

Improving communication can improve end of life care.

Overview

Patients have identified fear of pain, loss of dignity, abandonment, and fear of the unknown as major concerns in relation to their own mortality and have cited six themes that they consider to be of importance when issues around death and dying are being discussed. These include:

- an honest and straightforward approach:
- sensitive handling of bad news:
- · active listening to patients;
- encouragement of patients and relatives to ask questions;
- · a willingness to talk about death and dying;
- being attuned to patients by being prepared to be guided by them.

Conversely, studies of why doctors have difficulties in discussions with patients around the end of life highlight common issues:1

- personal discomfort with confronting mortality;
- fear of damaging the doctor-patient relationship or harming the patient by raising the topic of death;
- · limited time to establish trust:
- · difficulty in managing complex family dynamics;
- · fear of being blamed.

Poor communication

Dr X waited until my mother had left and then breezed in. He said 'Well things aren't going too well are they and I wonder if you have thought about going home to die, or perhaps going to a hospice?'. I didn't think I had heard him right. I mean I know I have had an uphill struggle but I didn't think I was dying. I said 'Are you giving up on me then?' and he said that nutritionally I was in a bad way and that this affected the quality of the dialysis I was receiving which he knew I was finding difficult to tolerate—and he couldn't see me improving. I just lay there trying to gather my thoughts—wondering what I should say—when he turned tail and left saying 'give it some thought'. I was so shocked and upset that when my husband came in about half an hour later, I just sobbed and sobbed. I didn't want him to go home and the nurses put the camp bed up in my room for him to use. But I couldn't sleep because I was frightened I wouldn't wake up and I was sick three times—probably through anxiety. Why couldn't he have waited till my family was here and broken it to me more gently? I don't want to see him again.

Appreciation of where patients think they are in their illness can be established by exploring not only what they understand of their prognosis but how they are coping with it emotionally. What we say to patients and how the message is communicated can profoundly affect the way in which a patient deals with what they have heard. If done badly, it can also cause a breakdown in the doctor—patient relationship as the example in the box shows.

This hurried and insensitive discourse and the way in which the doctor quickly left the ward emphasized the inequality in the relationship in that he could literally move on whereas she couldn't—neither physically nor emotionally. No doubt he felt he had carried out his duty in discussing prognosis and future care, but where was his duty of care to this patient? She was left feeling abandoned, frightened, angry, confused, and vulnerable. Ideally. the doctor should have stayed with the sense of denial she held around her own mortality and helped her acclimatize and integrate the new reality, but perhaps his own discomfort around death and dying, his lack of expertise of sharing bad news with patient, together with feelings of failure at not being able to cure her, may have prevented this.

It is also worth remembering that we can close all channels of communication with the gesture of a hand or an inappropriate response. But they can be opened up through eye contact, hand gestures, touch, or by adopting a genuinely caring and concerned approach.

Good communication needs to cover strategies to alleviate patient and family distress and best practice dictates a more acceptable way of approaching this patient would have been to ensure that:

- the consultation was not rushed;
- a family member or the patient's named nurse was present;
- the clinician established the patient's understanding of the situation;
- an empathic, sensitive, and patient-centred approach was used;
- the patient was not told that nothing further could be done but reassured that, even if dialysis was withdrawn, symptoms would be managed;
- questions were encouraged and honestly answered;
- the expression of patient and family emotions were appropriately facilitated and referral for ongoing support offered if deemed necessary;
- withdrawal from treatment was explored and support networks provided if appropriate;
- prognostic time frames were given as accurately and honestly as possible, where requested, to enable realistic decision-making;
- further consultations were offered to define primary goals and address any unanswered questions.

Reference

1 Calam B, Far S, Andrew R (2000) Discussions of 'code status' on a family practice teaching ward: what barriers do family physicians face? Can Med Assoc J 163, 1255–1259.

Sharing bad news

An acceptable way of starting communication that imparts bad news is to first find out what the patient understands of their illness. This can be done with straightforward questioning, such as:

Can you tell me what you understand of your illness and what might happen next?

Having established the level of understanding, the new and undoubtedly distressing information needs to be shared:

- I am sorry to have to tell you...
- Unfortunately it does look as though.
- Tests would seem to indicate you have...

For some patients, bad news comes as a relief—that at last their fears have been put into words. But it is also imperative to let the patient know that, whilst death is inevitable, treatment of some kind will continue:

Whilst there is no curative treatment we can offer, your symptoms will be managed and your wishes regarding future care honoured.

Effective communication comes through being comfortable with one's own discomfort. For many people the thought of dying evokes even more anxiety and fear than the thought of death itself. Dying should not be a taboo subject, and patients should be encouraged to talk about their limited future and consider how they want to live whilst waiting to die.

Effective communication can help allay fears, minimize pain and suffering, and enable patients and their families to experience a peaceful end to life. Avoid advising patients with 'shoulds', 'oughts', and 'musts' but invite them to reach their own understanding and decision-making by open and honest dialogue. This can be facilitated by questions such as 'Do you want me to tell you what is likely to happen now?' or 'Would you find it helpful if I told you how things might progress?'.

Having established the patient's level of understanding, thought can then be given to the information that needs to be gathered in order to address any underlying concerns the patient may have and not be able to voice.

Gentle probing can usually elicit what the patient is thinking and feeling:

- Knowing what the situation is, what would you say are your major concerns and are there any further explanations I can give to help you resolve them?'
- Have you thought about how you will cope during this phase of your illness, and what support you might need?"
- How aware of the situation do you think your family is. Would you like me to speak to them or be available when you talk with them?'
- 'We can't always talk to our closest family for fear of upsetting them and I am wondering whom you can talk to about how you are feeling."
- 'Is there anyone here you would find it easy to talk to?'

- 'Some patients find great comfort in their religious or spiritual beliefs. Is this something you identify with?'
- You know you have a choice about where you would like your end of life care to take place and I wonder if you would like to talk through these options.'
- 'There may be things you want to say to your family—or arrangements that need to be made. Have you thought about this and can we help in any way?'

Being too attached to one's own agenda can inhibit progress, so remain aware of the potential to manipulate discussions by imposing one's own beliefs on to the patient. Instead help them identify and 'own' their emotions and decisions by allowing the communication to be patient-led. Develop strategies for 'walking alongside the patient' and use empathic phrases such as 'I sense this is difficult for you so just take your time' to reassure that you are working at their pace.

Responses to difficult questions

Patients often project on to staff their own fears around death and dying. 'I think I am dying' one seriously ill patient said. Paralysed with anxiety, the nurse replied jovially 'Well, we've all got to die sometime', which immediately inhibited further discussion and left the patient's needs unmet.

Whilst platitudes, such as 'no-one has said that to me', 'of course you're not', or 'don't say that; you never know what's round the corner', might address the discomfort of the nurse, they deny the patient the opportunity to verbalize innermost fears and feelings that could have been facilitated by interventions such as:

'What makes you think that'; OR

- 'I'm aware that you have been having a difficult time lately but what's changed so significantly to make you think you are dying?'; OR
- · 'Do you think you are or feel you are?'

These interventions of empathic understanding make the patient feel they have been heard, their concerns recognized, and that they have been given permission to expand.

And remember, when you don't have the words, a silent presence or a gentle touch is enough.

Silences in conversations are significant and often occur following shocking news or when the patient is required to deliberate and process new information. Normal convention dictates that silences should be broken because they are uncomfortable to tolerate but, in a therapeutic setting, silences often denote that the patient is undergoing a period of deep reflection as they reframe thoughts and questions. To interject too soon can inhibit further exploration on the part of the patient who then feels that permission to speak the 'unspeakable' has been denied because it is too painful for the listener to hear. Sometimes patients need help to re-enter the present, and a sensitive way of appropriately moving on from a silence and getting back to the 'here and now' is to say 'I am noticing you are very quiet and wonder what you are thinking'.

Ending a discussion also needs sensitive handling. Patients need sufficient time to absorb what they have heard and to accommodate the accompanying emotions. It is imperative that the patient is left emotionally intact following any discussion, that all questions have been honestly answered, and, if distress is being experienced, there is someone available to offer support. This might be helped by summarizing what has been said, including an acknowledgement of the difficult things discussed, but with a definite person or point of contact for future questions, which often arise as soon as the doctor leaves.

Communicating with family members

dy ritualist i describente de la proposition de la company de la company

We hould have indeed a citizence of the nucleon that is virial desired when particles when the control of the particle of the

Farehor of the need freib to a source, journagent ou the reserved as they sould referred to the source freign product on the reserved to the product of the product of the source freign and the source freign and the source freign as their dworp low at once to up to between auch of the contemporary to the source of the sourc

e fillen ville film og verste et villet filmbakking storege fillet en verste storege. Fillet villet filmbakking i som og villet fillet storege villet en storege fillet en villet en storege fillet

conflicted the finding of children bad cows and ensured the broken of a way that still migrates the fittings that "amily" all expecting contracts.

e ensure ou enologici, supportuseavemente recipio sucritario dal policio. Allovi sufficienti bino for questfonti.

offer to meet with the fugicing no and or offer a little whon, ou will be actually to further the constructions.

 a spect and the entire is knowledge of their local and sures in the symptom, together with their process man skills and ability to coper with the entire of

i. word proj. ver to meet desire that found they as the doct.
 ii. Trittem availablet.

e recognize that apply which is conteined displaced on to stable of the

STOREST AND STATE TO STATE TO

• do type odgren in of ankey held too, anight mange the

Pork alumeir pace an incepture in updrageral all alme.

 according the costs of information pasks on whit to do following subside and when of become notices and one on the first subside.

had been in mind that after that had main milet as all bowley, it is one more contract in the replace miles in provided a few places. It was placed in the replace in the replacement of the set of th

Communicating with family members

Poor communication leaves doctors and family members stressed and dissatisfied; it also has the potential to neglect the patient's wishes.

We should be mindful of the needs of the nuclear family when dealing with patients who are facing end of life care and be sensitive to their issues.

On a practical level flexible visiting hours should be allowed and close family members should be invited to participate in some care tasks, which can make them feel useful rather than useless. Appropriate facilities should be made available such as a quiet room where they can reflect privately and express the thoughts and emotions that they find too painful to share with their dying loved one (see A Chapter 13, Integrated care pathway for end of life care, pp. 294-295).

Families often need help to mourn the lost health of their loved one as they too dip in and out of the grieving process, and onward referral for emotional support may be appropriate. They may also need help on how to best relate to their dying loved one-how to behave around someone who is dying. Family adaptation to the demands imposed by the dying requires variations in ordinary social roles that can often create or increase tensions within interpersonal relationships. Clinicians should, wherever possible:

- · meet with significant family members in a quiet, private setting with no distractions and a box of tissues handy to discuss diagnosis and future care plans;
- · consider the timing of sharing bad news and ensure it is broken in a way that will minimize the distress the family will experience;
- ensure psychological support is available for the family at this time;
- allow sufficient time for questions;
- offer to meet with the family again and/or offer a time when you will be available for ongoing consultations;
- respect family members' knowledge of their loved one's illness and symptoms together with their management skills and ability to cope with the situation:
- respond positively to their desire that their loved one gets the best treatment available:
- recognize their anger which is sometimes displaced on to staff and
- normalize the grief process;
- do not pass judgment when families find it too painful to manage the care of their loved one:
- work at their pace and keep them informed at all times;
- ensure they have access to information packs on what to do following a death and where bereavement support can be accessed.

And bear in mind that, after death, many relatives still have a need to remain in contact with the renal unit as it provides a way of remaining in touch with their loved one.

Communicating on issues around sexuality and intimacy

We've been married over 20 years and, apart from when the kids were born, have never spent a night apart. I long to climb into that bed and iust hold him.

Sexuality continues to be important at end of life but is often not included in discussion with patients. Emotional connection to others is an integral component of sexuality, taking precedence over physical expression. Lack of privacy, shared rooms, staff intrusion, and single beds are all considered barriers to expressing sexuality in hospital or hospice settings, but rarely are arrangements made for patients to share intimacies. Perhaps this is because it is assumed that sexual attraction and needs diminish with the progression of illness and, whilst this might be so, the need for 'closeness' would appear to be ever present. Patients should be asked how their distress could be minimized with interventions such as:

It's quite difficult to have private moments in this setting isn't it, and I am aware that you are finding this upsetting. Can you think of anything we can do to improve things for you and your partner?

Following which creative solutions should be sought to try and address unmet needs.

Communicating within teams and information sharing

 Information sharing should occur both between multidisciplinary team members (with consideration given to the need for confidentiality) and also between patient and caregiver.

• In palliative care, roles overlap and this can lead to blurred boundaries and uncertainty as to who does what. Staff need a strong sense of their own professional identity to allow others to share aspects of their

work without feeling threatened.

• Each professional needs to remember that they are part of a team with colleagues to support and be supported by. When in doubt or overwhelmed by sadness, seek this support. It is not a sign of weakness but an acknowledgement that we recognize our own areas of unmet need-that we too need to be cared for.

• Multidisciplinary team (MDT) meetings are a good place to start, and it is essential that each member's opinions and assessments are respected and valued and a 'named' person identified to carry out specific tasks. Conflicts do sometimes arise as the priority for reducing delayed discharges takes precedence over what might be in the patient's best interest, which is why it is imperative to include everyone involved in the patient's care in the decision-making—including the patient.

Good practice

• Elicit the views and assessments of everyone involved in the patient's care within the discussion and decision-making framework. This includes family members, nursing staff and other professionals, and, of course, the patient.

· Encourage sharing of thoughts, ideas, and feelings. Sometimes creative thinking can benefit patients and carers. For instance, giving a patient day or weekend release with the appropriate level of support can provide opportunities to deal with unfinished business and goodbyes.

Consistent communication is essential. Sometimes it is advisable for one named doctor or nurse to communicate with family members to

reduce the possibility of mixed messages.

- Collaboration—not just within the renal team but with community teams, district nurses, social services, and GPs-will enhance end of life care.
- There should be a contemporaneous record of MDT discussions.

Collaborative working at its best utilizes the skills and expertise of each discipline as they work towards providing the highest level of care for their patient. Individuals should not assume they fully understand the role of another team member but, in order to appreciate them, should listen to shared information and knowledge. This will lead to effective working within a MDT framework.

An example of good practice

John had been in hospital for 7 weeks and was desperate to be discharged home. He lived with his two children aged 20 and 22 and his wife who had ongoing mental health problems. He had been deemed 'medically fit for discharge' but the family had raised concerns and a case discussion was called to evaluate the situation:

- His children felt he would be unsafe at home and that his needs were too great to be met by a large package of care. But they had not felt able to discuss their concerns with their father as he had a history of bullying and making them feel as if they had failed him by not supporting his wish to be discharged home.
- The doctors felt his prognosis was between 3 and 6 months and therefore referral for a hospice bed at this stage was not appropriate.
- The occupational therapist spoke of the impossibility of providing ramps to access the property and other equipment that might have made discharge home a reality.
- The social worker reported that the maximum number of calls that could be put in a day was four and that there was no night cover.
- The community psychiatric nurse for the wife related that her client was at risk of an emotional breakdown if she had to participate in the care of her husband.
- The MDT assessment indicated that John's needs could not be met within the home environment and that a nursing home placement should be sought.
- The family was asked whether they wanted to discuss this with their father or whether they would prefer a member of the renal team to do so. They overwhelmingly supported the latter.
- The team then explored who was best placed to broach the subject of a placement with John.
- The social worker had not had any involvement with the patient only with the family—and she was identified as the most appropriate person to continue supporting them during this transition.
- The nursing staff felt John 'wouldn't listen' to them and would refuse to accept a placement.
- However, one of the senior doctors related that he had a good relationship with the patient and felt he could help him accept that this really was the only option at this time.
- The team had acknowledged that it was this gentleman's wish to return home; however, it was not felt to be a realistic or safe option.

John was discharged to a nursing home for placement and end of life care.

224 CHAPTER 11 Communicating with patients & families

Communication and team sharing can be improved by:

- learning about each other's roles through education, group discussion, and presentations;
- participation in advanced communication skills courses;
- use of clinical supervision;
- use of reflective practice;
- encouragement in full participation at MDT meetings;
- making sure everyone is heard;
- seeking feedback from patients, families, and other staff members on how a situation has been managed;
- learning from feedback or debriefing sessions;
- · carrying out audits.

It is hugely rewarding to see positive outcomes that have arisen through effective communication, information sharing, and collaborative working. It is only by acknowledging and working with the different areas of expertise and specialist knowledge that team members bring that we will be able to provide the optimal level of patient care.

Ethical and legal considerations

Principles of ethical decisions 226
A process of ethical decision-making 232
Choosing conservative management of ESKD 234
Renal replacement therapy and the elderly 238
Truth telling and collusion 240
Legal considerations: consent and capacity 242
Lasting power of attorney and court-appointed deputies 246
Advance decisions to refuse treatment 248
Multicultural issues 250

Principles of ethical decisions

For most patients with ESKD, decisions concerning current management and future care are made as part of an ongoing dialogue with their renal physician and other renal professionals within a relationship that has built up over many years. Difficult decisions are then made on the basis of previous honest communication and trust. Guidance and information supporting best practice in decision-making with respect to end of life care are found in the General Medical Council (GMC) document Treatment and care towards the end of life: good practice in decision-making¹ (Box 12.1; note that this has replaced the earlier document Withholding and withdrawing life-prolonging treatments: good practice in decision-making which was withdrawn in 2010).

Box 12.1 Treatment and care towards the end of life: good practice in decision-making

The GMC document Treatment and care towards the end of life: good practice in decision-making outlines five principles on which to base decisions in advanced illness:

- Equalities and human rights. This is about ensuring quality of care that is comparable to any other patients, including provision of dignity. respect, compassion, and ensuring privacy and confidentiality. It is also about acting within the context of the Human Rights Act 1988 which outlines the basic rights which all people are entitled to.
- A presumption in favour of prolonging life. This is based on longstanding ethical principles and practice, that considerations should start from the perspective of taking all reasonable steps to prolong and preserve life. It does not, however, impose any obligation to prolong life irrespective of the consequences and the patient's views (if known).
- A presumption of capacity. Every patient, regardless of age, disability. appearance, behaviour, beliefs, mental illness or other condition, or inability to communicate, should be assumed to have capacity.
- Maximizing capacity to make decisions. Support and help to make the most of any capacity must be provided; this includes appropriate specialist communication support, or friends and family who are much closer to a patient and can help communication.
- Decisions based on 'overall benefit', where capacity is lacking. This means decisions should bring most overall benefit, and be least restrictive of a patient's future choice.

To support doctors in putting these principles into practice, the GMC has produced a flowchart to aid decision-making in advanced illness (estimated to be in the last year of life), for use when patients may lack capacity (see Fig. 12.1). It is important to follow the guidance, because doctors are responsible to their patients and society at large, and individually accountable to the GMC and in the courts for their decisions about withholding and withdrawing life-prolonging treatments and related matters.

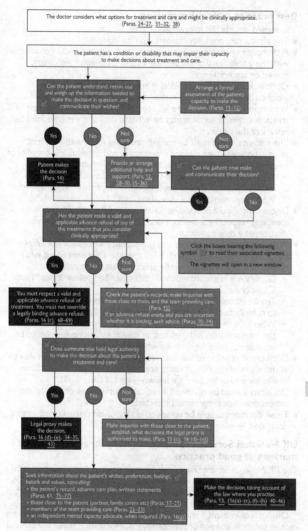

Fig. 12.1 End of life care: flow chart for decision-making when patients may lack capacity. Note that paragraph numbers relate to the guidance, and the flowchart with hyperlinks is available at http://www.gmc-uk.org/guidance/ethical_guidance/end_of_life_decision_making_flowchart.asp (© General Medical Council, 2010).

Best practice in decision-making

This should include the following elements:

- · The clinical responsibility remains with the consultant.
- A thorough assessment of the situation and prognosis with consultation with the whole renal team, seeking a second opinion if necessary, should be undertaken.
- Options for treatment considering burdens and benefits will be weighed before reaching a decision, bearing in mind overall benefit.
- In an emergency where there is uncertainty about appropriateness of treatment, then treatment may be initiated until there is time for a full review of the situation.
- The patient's views must be sought, providing them with sufficient information regarding diagnosis, prognosis, and burdens and benefits of treatment, and facilitating capacity as much as possible.
 - Where an option to discuss stopping life-sustaining treatment is involved patients should have the option to discuss how they would like their care managed—see also Box 12.2.
- Discussions should be handled sensitively and if necessary over several meetings, respecting a patient's decision not to take part in those discussions if they so wish.
- Where patients lack capacity and the patient's wishes are not known, the senior clinician has responsibility to make a decision about what course of action would be in the patient's best interests.
 - Guidance is in accordance with that described below under Mental Capacity Act 2005.
 - The aim should be to reach a consensus, enabling all relevant people to contribute but ultimately the responsibility lies with the consultant.
 - Where there is difficulty reaching a consensus, despite MDT clinical discussion, independent or clinical ethical review should be considered, using legal advice where necessary.
- Decisions that will result in death must be communicated effectively to all members of the clinical team, ensuring also that patient and family wishes for end of life care are known—see Chapter 11.
- Decisions should be reviewed if clinical circumstances change or the patient does not progress as predicted.
- These decisions should be reviewed in team audit discussion to ensure continued learning to improve practice.

UK National Service Framework (NSF) for renal services: markers of good practice

The UK National Service Framework for renal services, part 2: Chronic kidney disease, acute renal failure and end of life care was published in 2005. It contains specific quality requirements around end of life care that, if followed, contribute to the ethical management of these patients.

Quality requirement 4 states that 'people with established kidney failure receive timely evaluation of their prognosis, information about the choices available to them, and for those near the end of life a jointly agreed palliative care plan built round their individual needs and preferences'. The markers of good practice shown in Box 12.2 contribute to decision-making and care of the patient and thus ethical end of life care.

Box 12.2 Renal NSF, part 2: markers of good practice

- Access to expertise in discussion of end of life issues.
 - This emphasizes the importance of communication—see below
- Principles of shared decision-making. See also 'Guidelines from the Renal Physicians Association of the USA guideline' (Box 12.3).
- Training in symptom relief relevant to this group of patients
 - This is key to good end of life care—see Chapters 7, 8 and 13.
- Prognostic assessment based on available data available to all patients with stage 4 disease and beyond.
 - Patients and families can only make informed choices if they know the possible outcomes from the particular actions under consideration.
- Information about treatment choices.
 - · This includes non-dialytic therapy or stopping RRT once started.
- Jointly agreed care plan in line with palliative care principles.
 - This will mean joint working with primary care and palliative care teams.
- Ongoing medical care for those who choose not to dialyse.
 - Patients are reassured to know that the no dialysis option is not a no treatment option but rather a maximal supportive care option with full medical care to maintain function as long as possible.
- Support to die with dignity.
 - It is beholden on the physician to ensure the quality of care is maintained to death and into bereavement.
- Culturally appropriate bereavement support to family, carers, and staff.
 - Failure to do this will impact on the care families and professional carers are able to provide.

Source: Data from Department of Health (2005) The National Service Framework for renal services. Part two: Chronic kidney disease, acute renal failure and end of life care. London: Department of Health.

UK End of life care in advanced kidney disease: a framework for implementation

End of life care in advanced kidney disease: a framework for implementation was published in 2009.³ This contains specific recommendations to advance practice in providing care for renal patients nearing the end of life, and was the first speciality-based adaptation and extension of the UK's National End of Life Care Strategy.

Although this document does not specifically focus on the ethical and legal dimensions of care, the recommendations in it reflect best practice for delivering high-quality care to all patients with advanced kidney disease, and can be regarded as a blueprint for best practice, including the ethical and legal dimensions of care.

End of life care in advanced kidney disease

- 1. Raising the profile
- 2. Strategic commissioning
- 3. Identifying people approaching the end of life
- 4. Care planning
- 5. Coordination of care
- 6. Rapid access to care
- 7. Delivery of high-quality services in all locations
- 8. Last days of life and care after death
- 9. Involving and supporting carers
- 10. Education and training and continuing professional development
- 11. Measurement and research
- 12. Funding

Source: Data from Department of Health (2009) End of life care in advanced kidney disease: a framework for implementation. London: Department of Health.

Guidelines from the Renal Physicians Association of the USA

In the USA the recognition of the need for clinical practice guidelines in this area produced the Renal Physicians Association and the American Society of Nephrology clinical practice guideline (RPA/ASN guideline) Shared decision-making in the appropriate initiation of and withdrawal from dialysis, with the first edition produced in 2000, and the second edition produced in 2010.

The 10 recommendations in this guideline, summarized in the Box 12.3, form a framework for decision-making based on expert consensus opinion backed by systematic literature review where appropriate and based on US statutory law and ethical principles.

Box 12.3 Guidelines from the Renal Physicians Association of the USA

- Develop a physician-patient relationship for shared decisionmaking: that is at minimum between patient and physician but may include wider renal team and family or friends with patient's consent.
- Fully inform patients about their diagnosis, prognosis, and all treatment options. This should include the option of not starting dialysis.
- Give all patients an estimate of prognosis specific to their overall condition. This is to inform decision-making and should take into account up to date and personalised prognostic data.
- Institute ACP. Where an advance care plan is in place it should be honoured, and renal physicians should encourage dialysis patients to consider making one (although this is a dynamic process and often needs reviewing).
- If appropriate, forgo (withhold initiating or withdraw ongoing) dialysis for patients in certain, well-defined situations. These guidelines are clear that it will be appropriate to withhold or withdraw dialysis in certain situations.
- Consider forgoing dialysis for acute kidney injury (AKI), CKD, or ESKD patients who have a very poor prognosis or for whom dialysis cannot be provided safely. Those with a terminal illness other than kidney failure or in whom vascular access is technically impossible.
- Time-limited trial of dialysis. This is uncommon practice in the UK.
- Establish a systematic due process approach for conflict resolution if there is disagreement about what decision should be made with regard to dialysis.
- To improve patient-centred outcomes, offer palliative care services and interventions to all patients. Palliative care services are appropriate for people who chose to undergo or remain on dialysis and for those who choose not to start or to discontinue dialysis.
- Use a systematic approach to communicate about diagnosis, prognosis, treatment options, and goals of care.

Source: Data from Shared Decision-Making in the Appropriate Initiation of and Withdrawal from Dialysis: Clinical Practice Guideline, 2nd edition, Oct 2010. Available from http://www.renalmd.org/

References

- 1 General Medical Council (2010) Treatment and care towards the end of life: good practice in decision-making. London: GMC. Available from http://www.gmc-uk.org/guidance/ethical_ guidance/end_of_life_care.asp.
- 2 Department of Health (2005) The National Service Framework for renal services. Part two: Chronic kidney disease, acute renal failure and end of life care. London: Department of Health.
- 3 Department of Health (2009) End of life care in advanced kidney disease: a framework for implementation. London: Department of Health.
- 4 Renal Physicians Association and American Society of Nephrology (2010) Shared decision-making in the appropriate initiation of and withdrawal from dialysis, 2nd edn. Rockville, MD: RPA Clinical Practice Guidelines.

A process of ethical decision-making

Alvin Moss in Supportive care for the renal patient goes on to tabulate a process of ethical decision-making in patient care, which includes steps for conflict resolution if present. This is summarized and adapted slightly as follows:

- · Identify the ethical question.
- · Gather all medical and social facts.
- Identify relevant guidelines and values—particularly distinctive values for patient or family.
- Look for a solution that respects guidelines and values to proceed on if solution not possible.
- Propose possible alternative solutions.
- Evaluate these against values identified.
- Identify the best option with justification for choice.

An illustrative case study

What happens when a patient does not have the capacity to make an informed decision and the wishes of the next of kin regarding treatment differ from those of the physician? The following case study sets out such a scenario.

A profoundly physically disabled patient with severe learning difficulties is being looked after in a care home. With impaired cognition and unable to speak, mobilize, or feed himself he develops ESKD requiring RRT. A clinical decision not to offer treatment was made based on the facts that:

- the patient could not give informed consent to a rigorous dialysis regime;
- that quality of life would not be enhanced by undergoing RRT.

However, the next of kin has argued that the patient's quality of life, although limited, is worthy of life-sustaining treatment and a transplant from next of kin is requested.

Can this difficult situation be helped by working through Alvin Moss's process of ethical decision-making?

1 Identify the ethical issue

The professional opinion of what is in the patient's best interest differs from that of the next of kin.

2 Gather all medical and social facts relevant to the case

In this case this was done by referring to a renal social worker to carry out an independent psychosocial assessment. This was achieved by seeing the patient in his home setting where he was participating in his routine daily activities.

It was determined if there were any absolute medical contraindications to proceeding.

3 Identify relevant guidelines and values, i.e. particularly distinctive values for that patient or family or, in this case, his carers

This visit enabled the social worker to gain insight into what was important to the patient, and to invite the opinions of staff who were involved in his daily care. It also afforded an opportunity to educate those staff about the practicalities of dialysis and to define their role in terms of his care if he became a renal patient. The staff were able to offer observations, from their knowledge of the patient, on issues around quality of life for this individual. They were also asked how they felt the patient would cope with the regime and whether they could provide the increased level of care that would be required in order to meet his needs if he embarked on RRT. Family and carers wished to pursue RRT after this meeting so they proceeded to the next step.

4 Look for a solution that respects guidelines and values (if not, proceed to 5) To proceed with this a MDT meeting (to include GP, district nurse, nephrologist, care staff, social worker, dialysis sister, next of kin) was convened to discuss a plan of care and the logistics of implementation. Prior to this meeting practical hurdles such as the acceptance of blood tests were checked and it was agreed that dialysis would not be possible.

5 Propose possible alternative solutions

The possibility of a family donor transplant was considered. However, it was felt the case should go before an ethical committee for a decision. It was felt a disinterested opinion was desirable as the patient could not consent and the next of kin was also the potential donor.

6 Evaluate these against values identified

Before this could be done, the patient moved cities and care was transferred to another team. It was therefore not possible to proceed to the next step.

7 Identify the best option with justification for choice

Reference

1 Moss A (2010) Introduction to ethical case analysis. In Supportive care for the renal patient (ed. EJ Chambers et al.), pp. 1–6. Oxford; Oxford University Press.

Choosing conservative management of ESKD

When dialysis was first available it was limited to the fit under-50-year-old breadwinner. With technical advances and the increasing availability of RRT there has been a continuing increase in uptake, which now includes the very elderly and those with multiple comorbidities. However, take-up, even in developed economies, is variable from 103 pmp in the UK to 333 pmp in the USA. Not all patients do well on dialysis and for some there is a marked deterioration in quality of life, though this is not entirely predictable.

Dialysis: factors associated with a poor prognosis

- Low KPS
- Multiple comorbidity
- Frailty
- Age >75 years

However, all nephrologists will know of patients in whom a poor outlook was predicted but who experience good quality of life on dialysis, and vice versa.

Factors to consider before deciding to withhold or withdraw dialysis

Where possible, discussions around decisions about starting dialysis should be conducted before the absolute necessity to dialyse intervenes. This gives the patient and family time to assemble and assimilate the relevant information. This will also allow them to receive information from all members of the renal MDT, sometimes in their own home. Some patients are helped in their decision-making by talking to current renal patients. Mailloux describes eight factors that should be considered before a decision to withhold or withdraw dialysis is made:1

- Assessment of the patient's decision-making capacity—see Chapter 12, Legal considerations and capacity, pp. 242–245.
- Assessment of possible reversible factors.
- Detailed and effective communication with the patient.
- Family involvement, with appointment of surrogate (in the USA and also in UK after April 2007: referred to as 'lasting power of attorney').
- Interdisciplinary dialysis team involvement.
- The presence of an advance directive, either through a living will (called 'advance decisions' in UK after April 2007) or health care proxy ('lasting power of attorney').
- A trial period of dialysis if appropriate.
- Commitment to support the patient's decision whether it is to continue to dialyse, withdraw, or forego initiation.

Assessment of possible reversible factors

Renal physicians will always wish to assure themselves and the patient and family that all possible interventions have taken place to optimize the patient's medical management, including the dialysis prescription and, where appropriate, social support. All reversible acute events will need to be addressed before considering a decision to withdraw, including an assessment for depression and, if in doubt, assessment of cognitive function and capacity.

Detailed and effective communication with the patient

As indicated, discussions to withhold dialysis should if possible take place over time and at the patient's pace. It will be important to ensure the patient has understood the consequence of a decision either to withhold dialysis or withdraw from it. Physicians should check their patient's understanding before a decision is agreed, and allow the patient access to any other professionals the patient may wish to consult and appropriate support or counselling to assist decision-making.

Family involvement, with appointment of surrogate

If possible, and with the patient's permission, it is important to keep families in the picture if a patient is considering not starting dialysis. Sometimes a decision made over time between the physician and patient, perhaps with a family member present, is challenged strongly by another family member who has not been party to the early discussions. This can lead to considerable distress both for the patient and frequently for the team looking after the patient where the team believed a fully informed decision had been made and is now challenged, often when time is short.

Sarge was a 50-year-old clinically obese diabetic with visual impairment, neuropathy, and CKD who required imminent dialysis. He was unable to mobilize and lived out his life in the confines of the family living room with his wife acting as his primary carer. Whilst he had made a fully informed decision to be conservatively managed, his family were opposed and urged him to have a trial period on dialysis before making a firm decision. He steadfastly refused, which caused enormous emotional pain, turmoil, and anger for his family who felt rejected and abandoned, feeling that, no matter what they did for him, it simply wasn't enough for him to want to continue to live.

Interdisciplinary dialysis team involvement

It is important that the contributions of the whole renal team are taken into account, particularly where decisions are difficult, as non-medical team members may have unique insight into factors that do not emerge in the medical consultation. The usefulness of a MDT meeting comes into play here (see the box above).

The presence of an advance directive

In the event of the loss of capacity for decision-making, ACP with respect to refusal of treatment may help clinicians and family ascertain what those individuals' wishes were if the circumstances described in the advance directive apply to the clinical situation at the time. However, unless the advance directive is very detailed, it is likely that the specific clinical situation at the time may not be covered. Current and future UK law enshrines the principle of doing what is 'in the patient's best interest'. The difficulty may come in interpretation; an advance directive may help those making decisions when viewed in the light of previous communication and family knowledge of the individual. Use of Alvin Moss's suggested process for reaching decisions may help in the presence of uncertainty (see Chapter 12, A process of ethical decision-making, pp. 232–233).

A trial period of dialysis if appropriate

Formal trials of dialysis are uncommon in the UK, but may occur informally if dialysis is necessary to allow the full elucidation of the clinical situation. If a trial occurs it is important that key parameters for assessment of success or otherwise are identified and that patient and family understand that a review will take place in a defined time, at which time there will be discussion about the appropriateness of continuing dialysis. Not uncommonly, a decision for a trial of dialysis is made when a patient is wavering about conservative management. Too often, no review takes place after the 'trial' and the patient becomes committed to an extended time on dialysis.

Whole team commitment to support the patient and family's decision

When a decision has been made with appropriate consultation and discussion then it is important that the whole team commit to care based on that decision, even if some team members feel an unwise decision has been made.

Withdrawal from dialysis

Rates of withdrawal from dialysis are difficult to quantify as it varies markedly with age from around 6% of the under-60s to nearer 25% in the over-75s. In addition, it is not always listed as the cause of death or, conversely, may be listed when the patient dies after missing only one dialysis and actually dies from another condition. Much of the discussion above is equally relevant to decisions about withdrawal from dialysis. However, certain situations bring discussion about the option of stopping dialysis to the fore:

- rapid or clear reduction in performance status with increasing dependency;
- the development of severe symptoms from comorbid conditions;
- the development of other organ failure, particularly severe cardiac failure:
- the development of terminal malignancy;
- severe and symptomatic dementia;
- complications of PVD with multiple amputations.

Additional considerations when withdrawing from dialysis

- Does the burden of treatment outweigh the benefit it provides?
- What is the patient's prognosis with and without treatment?
- Has the patient been assured of ongoing medical and nursing care, though with a change of emphasis to comfort and relief of symptoms?
- Have the patient and family had time to consider this decision?
- If the patient wishes, have they been informed of the nature of dying should they stop dialysis to balance in their judgment against the nature of likely events if they continue with dialysis? (See also (L) Chapter 13.)

Reference

1 Mailloux LU (2010) Initiation, withdrawal and witholding of dialysis, Clinical. In Supportive care for the renal patient, 2nd edition (ed. EJ Chambers et al.), pp. 231–240.

Renal replacement therapy and the elderly

Older patients are less likely to have a primary kidney disease such as glomerulonephritis or polycystic kidneys and are more likely to have kidney failure related to vascular or other comorbidities. They have other problems including impaired vision, deafness, poor mobility, arthritis, and cognitive problems. In addition, they are often socially isolated, may well have financial problems, and are often depressed due to loss of independence or bereavement. These factors are all problematic for any dialysis modality.

- For HD, the associated vascular disease leads to a high risk of failure for vascular access. This results in increased reliance on venous access with all the associated risks of infection. Failure of vascular access can necessitate frequent hospital admissions for often unpleasant and painful radiological and surgical procedures. Cardiac disease in these patients can also cause hypotension and arrhythmias while on HD.
- PD is a home-based treatment and causes less cardiovascular stress. Many elderly patients, however, cannot do this independently and would have to be dependent on carers.

Truth telling and collusion

A frequently discussed moral dilemma is whether or not a patient should be told the truth that they are dying-particularly if they haven't specifically asked to know their prognosis or if their family wishes to 'protect' them from the truth. Lies and half-truths might be more comfortable for the informant but do the recipient a great disservice. Not being honest can induce short-lived euphoria, which can leave the patient feeling cheated when they learn the severity of their illness. By being economical or avoidant with the truth, we deny patients the right to make fully informed decisions about their future care and preferred place of death.

Professional carers must remember that they have a duty to the patient and, while supporting the relatives, must not withhold information from the patient at a relative's request unless the patient has explicitly stated that they wish for information to be given to their relative in preference to themselves. At the same time, the professional will not force unwanted information on a patient but rather check with them at each step of the information-giving when imparting bad news to ensure information is given at an appropriate pace for the individual. It helps to have explained to both relative and patient that no one will lie to them and, where possible, to impart bad news with the relative present.

If a patient asks if he or she is dying, they should receive an honest response followed by an invitation to seek further information as well as an opportunity to discuss future care options. But there is no need to impose information if it is not wanted, unless this is preventing decisions or plans about best care. The preference of a patient not to hear further details should be respected, and in the infrequent situations where this is proving an obstacle to care, can usually be addressed sensitively in terms of the practical challenges arising.

Legal considerations: consent and capacity

Many end of life decisions depend patients understanding the nature of the possibilities open to them and the consequences of any decision to forego or stop treatment. Where there is doubt as to a person's capacity to make such decisions, their competence should be assessed. The law in England and Wales has changed following the Mental Capacity Act 2005 (similar to the changes in Scotland following the Adults with Incapacity Act 2000) and the effect of this will be described below.

Patients who lack capacity

As the law stood in the UK in 2006, if a patient lacked capacity to make health-related decisions, particularly those relating to the withdrawal of a life-saving treatment, decisions were made by the healthcare team in the patient's best interest. Families should be involved in such decisions and would contribute to that decision-making through their prior knowledge of the patient. However, the final decision rested with the healthcare team, a fact that most next of kin are more comfortable with rather than finding themselves in the position of making life or death decisions themselves. Often being asked 'What do you imagine your father would have said if I had asked him whether he wanted to be resuscitated?' alleviates the burden and responsibility of decision-making and helps the healthcare team. However, the law in the UK changed in 2007.

Mental Capacity Act 2005 (England)

The Mental Capacity Act provides a statutory framework to empower and protect vulnerable people who may not be able to make all of their own decisions. It sets out who can take decisions, in which situations, and how they should go about this. It relates to anyone lacking mental capacity, including a temporary loss of capacity and it becomes a criminal offence of neglect to wilfully ill-treat or neglect someone who lacks mental capacity. It came into force during 2007 and applies to England and Wales; there is separate legislation in Scotland, The Adults with Incapacity (Scotland) Act 2000. It covers decisions concerning personal welfare including financial, social, and health aspects, and introduces the role of 'lasting power of attorney' (LPA), which replaces the previous 'enduring power of attorney' (EPA). Table 12.1 compares the legal considerations prior to and after implementation of the Act.

The aims of the 2005 Act are:

- · better protection of the public;
- · greater empowerment of patients;
- · to clarify legal uncertainties.

Table 12.1 Comparison of the legal situation before and after the implementation of the Mental Capacity Act 2005

Domain	Pre Act 'enduring power of attorney' (EPA)	Post Act 'lasting power of attorney' (LPA)
Financial	Yes	Yes - The second second second
Property	Yes	Yes garage and garage a
Health	No	Yes
Advanced refusal of treatment	No see a	Yes
Proxy healthcare decisions	No	Yes
Court of protection role	No series	Yes
Assessment of capacity	Specialist—lawyer	Each healthcare professional
Decision in patient's best interest	Yes	Yes
Context for consideration of capacity	In the context of decisions with grave outcomes	In the context of every decision
New public body	Public guardianship office	Public guardian (registering authority for LPA and deputies)
Court of protection	No jurisdiction	Will have jurisdiction in relation to the Mental Capacity Act

Principles enshrined in the Act

- Assumption of capacity until proved otherwise.
- Individual not to be treated as being unable to make a decision unless all practicable steps to help them to do so have been taken without success.
- A person not to be treated as lacking capacity just because they make an unwise decision.
- Acts done or decisions made for someone must be in their best interest.
- Before an act is done or decision made consideration must be given as to whether the purpose for which it is needed could be achieved in a way less restrictive on the person's rights and freedoms of action.

Assumption of capacity and supported decision-making

The Act sets out an assumption of capacity. It makes it clear that the professional:

- has an obligation to take all practical steps to help the person take his or her own decision:
- must make it clear that a person's age, appearance, condition, or behaviour does not by itself establish a lack of mental capacity:

244 CHAPTER 12 Ethical and legal considerations

- must give information in a way that is clear and easy to understand;
- must help the person who lacks capacity to communicate.

Each capacity assessment is decision-specific A person may have capacity to make some decisions but not others; at all times the person's best interest is the key principle governing all decision-making.

Defining mental incapacity

A person is deemed to have incapacity if they are unable to:

- · understand the relevant information:
- retain that information sufficiently long to make a decision;
- · use or weigh the information provided to make the decision;
- communicate their view on the decision they have made.

Determining a person's best interests

This is the same as current common law and should be done in two stages.

- Consider all relevant circumstances through taking into account the following, which will help define best interests:
 - Involvement of the person who lacks capacity.
 - · Having regard to the person's past and present wishes and feelings.
 - · Consulting with others involved in the care of the person.
 - Excluding any discrimination.
- Take the following steps:
 - · Give consideration as to whether the person may have capacity in the future.
 - As far as possible, permit and encourage the person to participate in the decision-making.
 - · Where a life-sustaining treatment such as dialysis is concerned, the person making the decision must not be motivated by a desire to bring about the person's death.
 - Consider where possible:
 - the person's previous wishes and feeling, beliefs, and values;
 any other factor the person was likely to have taken into account.
 - Where practical take into account the views of anyone named by the person as someone to be consulted.

How the Act helps planning ahead for the renal patient

The Act can be used to help forward planning through more clearly defined means such as the following:

- The provision of lasting power of attorney, with a role in health as well as financial concerns.
- The use of advance decisions to refuse treatment, e.g. not wishing for dialysis.
- Enabling patients to make their wishes and feelings known:
 - patients should be encouraged to let professionals and family know what their wishes and feelings are;
 - there is no formal process but written statements given to professionals or recorded by them, while not legally binding, would be taken into consideration when considering a patient's best interest should they later lose capacity.

AM WHITE

Further reading

The National Council for Palliative Care (2005) Guidance on The Mental Capacity Act 2005. London: NCPC Publications.

 $\label{thm:continuous} The \ Mental \ Capacity \ Act: \ http://www.justice.gov.uk/guidance/protecting-the-vulnerable/mental-capacity-act/index.htm.$

Lasting power of attorney and courtappointed deputies

Lasting power of attorney (LPA)

- This enables the patient to appoint someone they know and trust to make decisions for them.
- The areas covered by the Act include:
 - · property and affairs, which replaces the former EPA;
 - personal welfare, which is a new way to appoint someone to make health and welfare decisions;
 - · specified matters relating to the person's welfare or property.
- They must be appointed when the person has capacity.
- They must be registered with the public guardian if the person loses capacity.
- The person chosen can only make decisions in the patient's best interest
- An LPA in relation to welfare only applies if the person lacks capacity.
- An LPA for welfare can extend to giving or refusing consent to carry out or continue treatment but can only extend to life-sustaining treatment (such as dialysis) if expressly contained in the LPA and in writing and witnessed.
- The person appointing an LPA can appoint more than one holder.
- If doctors have any doubt about the validity or applicability of an advance decision they can provide treatment.

Court-appointed deputies (CADs)

CADs can be appointed by the court to make decisions on the patient's behalf without having to go back to the court and might be appointed in the following circumstances:

- Where there is a history of acrimony.
- Where it is in the patient's best interest to have deputy consult with all relevant people and have final authority.
- Exceptionally, if it is felt the patient is at risk of harm from family members.
- When there are a number of linked decisions that might otherwise each have to go back to court.

insuffice the territory of the cited as mental

The control of the control of the manner of the control of the con

and the control of th

He sign and the control of the early article of the angle of the control of the c

i ne voja u spoljene javenob je ini. Pobleni i mrvanske norijmo i na vojava nakon svrateli lena sboljetini

An advance decision of every times to the set of Statutes in meases

y Arribater sugarine in the layer of the course expension for ingelly bigging gundar the late the expension for the account of the course of t

Spring with 60 king and account of the second of the secon

ne parient uex done costi incigez inconsisenti sudatina, manerecore

e a company of the contract of

TOWN DESCRIPTION OF STORY STORY STORY CONTROL OF STORY STORY

en kantig gradining og tikke fram fram styrt menghasan i styrt

Advance decisions to refuse treatment

An advance decision to refuse treatment must relate to a specific treatment in specific circumstances:

- If it relates to a life-sustaining treatment such as dialysis it must be in writing, signed, and witnessed.
- It must also be valid and applicable.

Until the Act, advance decisions to refuse treatment were regarded in a similar light to those that are usually spoken of as 'advance directives' or 'living wills'. The Act distinguishes between advance decisions to refuse treatment and those to request treatment—both are advance decisions, however.

- It is only an advance decision to refuse treatment that is applicable within the meaning of the Act and is therefore binding under the Act.
- It allows a person to refuse a particular treatment in advance.
- Is legally binding without the Act, but the Act provides greater safeguards.
- The decision must be made when the patient has capacity and only comes into force if the person develops a lack of capacity.
- Doctors can, however, provide treatment if they have any doubt about the validity of the advance decision.
- Patients may make non-binding written 'advance statements' about the sort of health care they would like to receive.
 - · An 'advance decision' could be referred to as a 'binding advance decision to refuse treatment'.
 - An 'advance statement' is any other advance decision, not legally binding under the Act, but which must be taken into account when assessing a person's best interest.
- An advance decision is not valid if:
 - · the patient has withdrawn it (must be in writing);
 - · the patient has subsequently created a LPA who has authority to consent or refuse treatment;
 - the patient has done anything else inconsistent with the advance decision.
- · An advance decision is not applicable if:
 - when the time comes to implement it the patient has capacity for that decision;
 - · the treatment in question is not that stated in the advance decision;
 - · any circumstances specified in the advance decision are absent;
 - · there are reasonable grounds to think that the circumstances that currently prevail were not anticipated by the patient and if they had it might have affected their decision.

Communicating with patients about advance decisions

Communication regarding advance care decisions may not be easy to initiate, but giving in to feelings of discomfort and not broaching the subject may lead to outcomes not desired by the patient such as unwanted continuation of dialysis. Timely intervention is important and needs to be sensitively managed. If the question of resuscitation has not been discussed it might be introduced:

We've discussed the progression of your illness and end of life preferences, but what we haven't touched on is how active you want us to be should your heart stop beating. Would you, for example, want us to attempt resuscitation?

This could be accompanied by a description of the medical interventions that take place during this procedure and the likely outcomes.

What happens to the patient who loses capacity?

If there is no LPA or advance decision to refuse treatment, the patient will still be provided with care. Treatment decisions will be made in the patient's best interest by following the principles of the Act above, and decisions about withdrawal of life-sustaining treatment will be made in the same way as prior to the Act. Further possible resources include:

- An application to the court of protection for orders of the court in complex or difficult welfare decisions or one-off financial decisions or CADs when a series of decisions are needed and a single application is insufficient.
- The appointment of an Independent Mental Capacity Advocate (IMCA) where the person has no next of kin and when decisions are being made about serious medical treatments. The withholding or withdrawing from dialysis would come in this category.

Multicultural issues

When English is not the patient's main language

There are occasions when non-English-speaking patients need to make decisions about cessation of dialysis or advanced care directives. In this situation it is advisable to enlist the help of an interpreter rather than use a family member. Family members may interpret rather than translate, answering on behalf of the patient while thinking they know the right answer, or may indeed provide an answer that is contrary to the wishes of the patient.

By using an independent interpreter, you can be assured that the wishes of the patient are being accurately reflected (see box).

Mr YS who was Chinese and 78 years old was a nursing home resident receiving thrice weekly HD. He was admitted to hospital with septicaemia. He had multiple comorbidities and a poor performance status. His command of English was poor and his family usually interpreted.

A palliative care team referral was made to help with symptoms of pain and distress.

Day 3 of admission

- · One son wanted him to stop dialysis.
- Second son wanted him to continue.
- Inconsistent report of patient's view in the notes.
- Medical descriptors in the notes recorded that he was:
 - · fed up:
 - · upset;
 - · refusing medication but not dialysis.

First interview on day 4 of admission

Patient was interviewed with second son present. It was recorded that the patient was:

- · happy with quality of life;
- · wanted to continue dialysis.

Second interview on day 5 of admission

Patient interviewed by an independent interpreter, a senior doctor, who recorded that patient was:

- · alert and competent;
- clear that he wanted to stop dialysis.

Outcome

Patient therefore stopped dialysis. His notes record:

- demeanour changed—'settled, comfortable';
- · pain more easy to manage for remainder of life.

He died on day 12. The staff caring for him had not felt that the unspoken language of the patient accorded with the second son's interpretation, and his body language after the decision to stop dialysis was made indicated concordance with what was happening to him

Attitudes to death in different cultures

It should also be remembered that diverse cultures have differing attitudes towards death and it might not be appropriate to talk about advance directives with a patient who believes discussions around death will hasten their demise. If unsure, it is better to ask the patient or family if it is all right to discuss these issues before embarking on such a discussion. At all times one must respect cultural beliefs and values and find a way of working with those that are not one's own.

Attitudes are death in pillerent calcurers

If share also be come to end that accept the confidence of fluides for a formal parameters of the confidence of the conf

Management of the last few days

Introduction 254 Key issues to consider before cessation of dialysis 256 Where death is expected 260 Quality in end of life care 262 Domains of care 264 Symptoms at end of life 266 Symptom management: pain 268 Management: dyspnoea and retained secretions 272 Management: agitation, delirium, and neurological problems 274 Management: nausea and vomiting 276 Symptom management: syringe drivers and anticipatory prescribing 278 End of life symptom control guidelines 280 Dialysis at end of life 284 Preferred place of care 286 The nursing perspective of end of life care in the renal setting 288 Summary: main principles of end of life care 292 Integrated care pathway for end of life care 294

Introduction

Though recognizing the dying phase in patients with ESKD can be difficult (see Chapter 10), for those who withdraw from dialysis there is usually a predictable timescale to death. For some ESKD patients, where death is likely but not completely predictable, the integration of good supportive and palliative care alongside ESKD management can prepare the patient and family for when death approaches. Honest open communication about the likely prognosis and goals of care should be offered and revisited throughout the course of the illness trajectory. This becomes particularly important as complications increase, often an indication that death is likely within months rather than years. Thus, if and when death occurs, opportunities for communication with those important to the patient have not been lost and attention to improved quality of life has been given.

Care at the end of life is as important and active as the care has been throughout the management of the kidney disease. There is nonetheless a change in emphasis from prolongation of life and prevention of long-term complications to:

- relief of symptoms;
- · maintenance of comfort;
- attention to psychological concerns of patient and family;
- consideration of spiritual needs (see (Chapter 14);
- awareness of religious requirements (see (L.) Chapter 14).

key jesuas to ednelder betore residence et distrate

The exclusion of save this metric

Feder (1907) 1979 (1908) Francisco (1907) (1

Antique of the control of the contro

sylverial but the ten than which have the training family a

to por exponal carety and purpose no termy assisting allocations of positions who we will call the worldwise supposed to the property of the p

Depletementing capacity

dis til er of melder stomations mellem ved ved per til en som til en se ett i ved tre en se ett i ved tre en som til en se ett i ved tre en som til en se ett i ved tre en som til en se ett i ved tre en som til en som til

The first of Concrete and Secure 2 tense of Concrete 2007, deciding a control of Concrete and Co

Advance care painting

with a process that is always present to be under the courte for the process of t

Key issues to consider before cessation of dialysis

The exclusion of reversible factors

Renal teams will have ensured that all possible reversible causes of deterioration have been excluded or managed optimally and that, despite this, the current condition is seen as irreversible.

Anticipation of symptoms Pre-existing symptoms prior to dialysis with-drawal may intensify as death approaches; thoughtful anticipation of distressing symptoms and anticipatory prescribing of appropriate medication is good practice in planning for withdrawal from dialysis and end of life care. Patients and families will often ask 'what will it be like for me if I stop dialysis?': make a considered judgment taking into account factors such as; pre-existing symptoms, additional comorbid illness, psychological and spiritual concerns. Severe untreated symptoms are not only distressing to the patient and family but could also cause an abrupt change in (1) preferred place of care and (2) dialysis decision-making at the end of life.

Effective communication with patient and family

At all times contemporaneously documented communication between the professional carers and patient and family is essential for efficient team working and for the patient and family to have confidence in the team. A lack of effective means of communication can lead to patients and their families receiving mixed messages about the plan and goals for care. A well-documented plan will prevent this.

Decision-making capacity

At the time of the decision-making the renal team will need to ensure that the patient has decision-making capacity with full understanding of the consequences of their decision. If capacity is lacking, the decision rests with the team led by the consultant, the most important factor in that decision being that any treatment should be in the patient's best interest. It is most likely, however, that the considerations of the family will hold significant weight in any decision and that renal teams will have had extensive discussions with them.

The Mental Capacity Act 2005 (came into force on 1 October 2007) determines that those with LPA for their relation or who have been appointed as health proxy have the legal right to make decisions about treatment refusal, though not life-sustaining treatment such as dialysis, unless this has been specifically stated in writing and witnessed (see Chapter 12).

Advance care planning

ACP is a process that enables patients to document and communicate their views about appropriate future medical care when and if they become unable to make their own decisions and communicate them. With the passing of the Mental Capacity Act it is now possible for a patient to nominate a healthcare proxy to act as surrogate decision-maker in the event of incapacity. Their opinion will contribute to decision-making.

Advance decisions that are legally binding can only be made with respect to treatments that the patient wishes to refuse and the Act will not mean that unreasonable or inappropriate treatments can be demanded (see Achapter 12).

Multiprofessional team communication

Information sharing must occur between MDT members as well as between patient and caregiver, although issues around confidentiality have to be respected and sensitive information passed on only on a 'need to know' basis. It is helpful if there are formal means of communicating, such as MDT meetings and handover sessions, as well as the informal verbal passing on of information. The use of one set of multidisciplinary notes for hospital inpatients also contributes to good communication.

Estimating prognosis following dialysis withdrawal

Although the evidence and clinical experience would suggest that this is a relatively predictable phase of a patient's management, (median survival post-withdrawal is 8 days) bear in mind that in some cases, patients can either deteriorate and die sooner or live longer. Prior to communicating prognosis to the patient and family, it is important to consider the following: duration of dialysis therapy; residual kidney function and additional comorbid illness.

Family/significant other involvement

I live in Portsmouth and work full time. I really need to know the situation regarding my sister. If I need to be with her, then I need to organize my work and my family and it would help if I knew how long we were talking about.

Appreciation of the physical, emotional, and economic demands that are placed upon families, friends, and carers during the terminal/end of life phase is essential. Even as they attend to the needs of their dying loved one, families and care-givers must continue to meet their current daily responsibilities towards work, their own families, and existing commitments. Carer fatigue, emotional distress, and economic pressure need to be acknowledged and appropriate levels of support and advice given. If prognostic timeframes can be given, it can put an uncertain future into perspective and facilitate immediate decision-making on the part of family members who are so often trying to organize their disorganized and disconnected lives in order to meet the needs of their loved one. If this proves impossible, you could say 'It is difficult to give accurate timeframes for patients such as your father, but I would estimate it could be. . . '. Although uncertainty complicates decision-making, patients and families do appreciate an honest approach.

Whole team commitment to support patient and family whatever the decision

Teams may find it hard sometimes to accept a rational patient's decision to stop dialysis as some patients make a conscious decision to withdraw from treatment whilst others are asked to support a clinical decision to withdraw.

This can be a highly emotive situation where both family and patient are left in need of ongoing emotional support and it is crucial that staff are seen to work together and support the decision (see the case study below).

Informed consent to withdrawal of life-sustaining treatment should include honest, caring, and culturally sensitive communication with patients and family members. What we perceive to be a poor quality of life on dialysis might be considered a worthwhile existence to others. A glimpse of the patient's 'inner world' is gained not only through asking the right questions and actively listening to the answers, but by observing body language, heeding the tone of voice, understanding the patient's frame of reference and belief systems, and by noting what hasn't been said—what has so often been studiously avoided.

Case study

Michelle was 36 years old and a diabetic since the age of 12. Kidney failure came as a shock when diagnosed a year ago but she appeared to adapt well to PD and still managed to ride her horse and work part time. However, laser surgery on her eyes was unsuccessful and, within the space of just a few weeks, she had completely lost her vision. Unable to manage PD, she converted to HD and 3 months later asked to be withdrawn from treatment on the grounds that she couldn't tolerate the treatment and 'life was no longer worth living'. Exploration revealed that loss of vision and increased dependency were the main reasons for her reaching this decision.

Michelle never wavered from her wish to withdraw from treatment despite intense initial opposition from her husband and parents. Her end of life care was successfully managed in her own home, which is where she had requested to die. Team commitment to support her decision was crucial in facilitating her preferred place of care.

Further reading

Mailloux LU (2010) Initiation, withdrawal and withholding of dialysis. In Supportive care for the renal patient, (ed. EJ Chambers, EA Brown, MJ Germain) pp. 231–240. Oxford: Oxford University Press.

- - - e italiyere vitti yale isa ram dejiyediyey dhessa hawaren # One tinda ili dis of urso via.

Where death is expected

Preparation for the dying phase should be made for this group of patients with consideration of the domains of care (this chapter, Quality in end of life care, pp. 262-263). Each patient (or family in the case of someone who lacks competency) should be able to draw up and agree their own plan of care taking into account their wishes and their practical needs. It will not always be possible to accede to every wish, where lack of resources precludes either care at home or entry to a hospice if desired. However, every attempt should be made to provide the patient with an appropriate environment and dignity within the care facilities available and to enable those close to him or her to be present if that is his or her wish.

Withdrawal or cessation of dialysis

- 10-25% of patients on dialysis choose or will be advised to withdraw from it.
- The percentage increases with increasing age, comorbid conditions (particularly the presence of diabetes mellitus), poor functional and cognitive status.
- Prognosis is short; median survival = 8 days (range 1–46 days).

Conservative management

- Around 10-20% of patients reaching ESKD will opt for maximal medical care but without dialysis.
- Prognosis variable, though usually measured in months, but may stretch to a year or more.
- Many die with rather than from their kidney disease, however.
- One-third will die of uraemia.
- One-quarter will die of cardiac failure or pulmonary oedema, directly or indirectly related to their kidney failure.

Failure of other vital organs

- Heart or liver but without explicit cessation of dialysis.
- Cardiovascular disease.
- · PVD.

Death from malignancy while continuing to dialyse

· Patients with a terminal malignant condition may choose to continue dialysis until their death is caused by the malignant condition rather than precipitate their certain death by stopping dialysis. Others use cessation of dialysis as a means to control time of death.

DS had adult polycystic kidney syndrome, as did his brother who had died as a consequence. DS had received outpatient HD for many years when, at the age of 58, he developed a localized non-small-cell lung cancer that was treated with resection. He remained well for 18 months following this until he developed a biopsy-proven recurrence and over the next 18 months received three short courses of palliative radiotherapy to lymph node spread. Over the following 6 months symptoms from advancing cancer—hoarse voice, reducing performance status, and pain—developed until it was clear he was dying. As he approached his death he acknowledged and accepted that he was dying from his lung cancer and, when finally bedbound in hospital, was prepared to die from it but not from kidney failure insisting on dialysis to the end of his life.

Terry was receiving chemotherapy for stage IV lymphoma when he went into kidney failure. Depressed, scared, and aware that his prognosis was poor, he nevertheless elected to have dialysis. When asked why he had made this decision, he said 'I know if I don't have dialysis, I shall be dead within days or a couple of weeks and I don't think I can live every day just waiting for it to happen and wondering if I am going to wake up in the morning. It's a terrifying prospect—for me and my family—and I owe it to them to give it my best shot. You realize just how precious life is when you face death'.

Technical difficulties with dialysis

- Lack of vascular access.
- PD often not possible.

Patient unable to cooperate or to tolerate dialysis

Refusal of dialysis in the non-competent patient leads to difficult ethical considerations and considerable stress to the team caring for the patient. Physical coercion may be considered assault. However, consideration of the patient's best interest may require you to attempt to continue dialysis, particularly if, as far as you can judge, that is what the patient had indicated that they would want in the given situation before loss of competence (see Chapter 11).

Quality in end of life care

Each of us will have our own view on what constitutes quality of care at the end of our lives and, though there will be differences between individuals, there are many common themes. Studies that help to guide us in identifying key domains and theme include work by Singer et al. centred on patients' perceptions of their own needs and wishes. Forty-eight dialysis patients were included in the group he questioned; they identified five domains of care that were important. If these are used as a guide to assessment alongside an approach that enables the patient to identify their own particular priorities, then it is likely that a personal plan for end of life care can be formulated that can enhance the care given to the patient and their family and the quality of the time left to that person. Additional resources include the London-based Age Concern report highlighting 12 principles of a good death as defined by its members (see Box 13.1).

Domains of end of life care1

- Receiving adequate pain and symptom management.
- Avoidance of inappropriate prolongation of dying.
- Achieving a sense of control.
- · Relieving the burden to loved ones.
- Strengthening relationships with loved ones.

It behoves us to bear these domains in mind as we help patients and families prepare for death and to use them as a framework for assessment and planning care.

Last days of life

Recognizing the terminal phase

This is easy for those who choose to stop dialysis but much less clear for most ESKD patients, such as those dying from cerebrovascular disease or infection, for whom the dying phase is often not well defined. Sudden death is also common in ESKD and preparation for this can be achieved through good symptom management throughout illness and honest information about possible outcomes if the patient wishes. Supportive care as described above applies to these patients as well as those dying from their comorbid conditions or complications of chronic kidney disease.

An ICP for end of life care

The use of an ICP for end of life care. an initiative from Ellershaw and colleagues in Liverpool, is one way of supporting good practice at the end of life through prompts, guidelines, and documentation. In 2008 the Department of Health (DOH) published the Liverpool Care Pathway (LCP) guidelines for LCP drug prescribing in advanced chronic kidney disease. This is described below (this chapter, Integrated care pathway for end of life care, pp. 294-295).

Box 13.1 Principles of a good death (from Age Concern UK)

- To know when death is coming, and to understand what can be expected.
- To be able to retain control of what happens.
- To be afforded dignity and privacy.
- To have control over pain relief and other symptom control.
- To have access to information and expertise of whatever kind is necessary.
- To have access to any spiritual or emotional support required.
- To have access to hospice care in any location, not only in hospital.
- To have control over who is present and who shares the end.
- To be able to issue advance directives that ensure wishes are respected.
- To have time to say goodbye, and control over aspects of timing.
- To be able to leave when it is time to go and not to have lifeprolonging treatment.

Reprinted with permission from Debate of the Age, Health and Care Study Group. The future of health and care of older people: the best is yet to come, Melanie Henwood, London: Age Concern, 1999.

Reference

1 Singer PA, Martin DK, Merrijoy K (1999) Quality end of life care: patients' perspectives. J Am Med Assoc 281, 63–68.

Domains of care

Communication

This is an ongoing process from the first meeting with the renal team. It is important that patients have the opportunity to learn of all options available to them, including that of stopping dialysis, in a supportive environment with time to ask questions. It is important for significant family members to be involved if the patient wishes (see also (Chapter 9).

Comfort

Practical ways to provide comfort include:

- stopping all unnecessary investigations;
- stopping routine monitoring, e.g. blood tests;
- rationalizing medication;
- a change in emphasis of nursing care from observation of BP/ temperature, etc. to mouth care, pressure area care, and overall well-being.

Anticipatory prescribing for all pain and other symptoms

Crucial to relief of symptoms is the ready availability of the appropriate drug, correctly prescribed, so that there is no delay in patients obtaining attention to their symptoms. This is a key component of the LCP and the following core symptoms should be addressed (see this chapter, End of life symptom control guidelines, pp. 280-283):

- · pain;
- dyspnoea;
- agitation;
- · retained respiratory secretions;
- · fluid overload;
- nausea and vomiting.

Psychological

By the time many patients come to stop dialysis, they may have worked through the stages of grief as they approach death so that the stopping of dialysis is the final 'letting go'. Even for these people, however, there may be sadness and deep grief at the prospect of leaving their loved ones balanced by relief that they need struggle no longer. Fear of the unknown may still occur and, if time and cognition allow, active listening by staff and gentle reassurance that they will not be abandoned and will be cared for until the end are important. For others, deep-seated fears, inability to resolve long-standing family issues, or a lifetime of denial of the reality of their illness may lead to intense psychological distress at the end of life. Ideally, this would have been identified prior to the terminal phase when there might have been time for psychological support from a counsellor or psychologist. Even at this late stage, it is possible to help patients through open questions to elicit concerns. This gives the patient 'permission' to talk about what is troubling them most and listening in this context can be the most important intervention.

Social

Many patients have complex social concerns, such as care of a dependent relative, difficult financial concerns, and many others, that need the professional advice and support of a social worker and which, if not resolved, act as a bar to peace at the end of life. All patients should be offered social support as should their carers. The carers may be struggling financially through the patient's illness with, for example, travel to hospital or loss of income. There may be other concerns such as dependent relatives at the same time as dealing with their own grief.

LX. a 49-year-old single mother of two sons in their twenties, had encapsulating peritoneal sclerosis after 8 years of PD. Prior to this, socially, her life had been extremely complex. One son, M, had been in prison for grievous bodily harm and the other was in prison for attempting to murder her. This son, K, also had a diagnosis of schizophrenia. M could not accept LX's ongoing support of K and, until her serious illness EPS, had distanced himself from her. However, after she recovered and managed to convert to HD, he took her into his home to care for her. This was not entirely successful but, before she could make arrangements for herself elsewhere, her symptoms flared up and she was re-admitted to hospital. She continued to deteriorate, and was showing signs of extreme anxiety that could not be resolved until she had honest answers about her prognosis, facilitated by her social worker. She was then able to explain her deep concerns that her sons might harm each other, and the social worker was able to enlist the help of another family member to bring about a reconciliation between the brothers with their mother days before she died.

Spiritual support

At no time in our lives are the questions concerning our very existence more important than when we face death. How we see ourselves in the scheme of things will influence profoundly how we feel at the end of our lives. Some patients will also have religious beliefs and practices that need attending to (see Chapter 14), but all will have their own spirituality even if not recognized and articulated as such. Hospitals, communities, nursing homes, and hospices all have access to spiritual advisors or carers. All patients should have their spiritual needs assessed and support offered. If the word spiritual is difficult to understand or a bar to opening a discussion, then talking of pastoral support sometimes helps unlock the door to communication about deep and troubling issues. Allowing the patient to tell his or her personal story gives them a sense of self-worth. The telling of the narrative of 'your' story turns a patient with ESKD into a person with a whole life and history behind them and a network of family and friends who will come after them. This listening endorses the person's self-worth and may help enable them to accept with a greater sense of peace distressing past events or family problems that had been causing anguish.

Symptoms at end of life

It is often suggested that if one had to choose a mode of death that was not sudden then dying of kidney failure would be many clinicians' choice. This suggests a lack of recognition of the incidence and severity of renal-specific symptoms that occur in those who have chronic kidney failure compared with those whose kidneys fail as a terminal event after previously normal or near normal kidney function.

Causes

The causes of different symptoms can classified as follows:

- Generic (possible whatever the cause of death). Likely to occur in some patients whatever cause of death and include:
 - · pain, restlessness and agitation, nausea with or without vomiting, dyspnoea, and retained respiratory secretions.
- · More likely in renal patients because of high incidence of comorbid conditions, e.g.
 - · diabetic neuropathy;
 - · PVD:
 - ioint and bone disease.
- More likely in renal patients because of deteriorating kidney function:
 - · fluid overload:
 - · uraemia and electrolyte disturbance;

 - neurological dysfunction.
- Renal-specific:
 - pain and ulceration caused by calciphylaxis;
 - adult polycystic kidney and liver pain:
 - amyloid deposition in joints.

Types of symptoms

The types of symptoms experienced include the following:

- Generic (* indicates symptoms likely to show increased incidence in ESKD):
 - · pain;
 - dyspnoea*;
 - · agitation and restlessness*;
 - retained respiratory secretions (death rattle)*:
 - nausea and vomiting.
- Symptoms that develop in the dying phase related to kidney failure.
 - Fluid overload can lead to water-logging of the lungs and a sense of drowning both for the patient and those observing them.
 - Agitation and confusion may be of increased incidence because of uraemia.
 - Convulsions.
 - Adverse drug effects will also be increased due to ESKD, e.g. myoclonic jerks following morphine administration.

- Symptoms already present and remaining troublesome in the terminal phase:
 - itch and dry skin;
 - · lethargy;
 - · restless legs;
 - · cramps.

Incidence of symptoms in patients who discontinue dialysis

These are likely to be similar to those of ESKD and those who follow the conservative pathway with the addition of end of life symptoms. However, there are few studies that address this in detail. Cohen et al. in a survey of 79 patients showed that 87% needed analgesia, with 40% experiencing pain in the last 24h, one-third agitation, and a quarter dyspnoea. The changing composition of the ESKD population means that older patients with greater frailty and increasing comorbidity are being accepted for dialysis, it is therefore likely that symptom burden will increase amongst those who live and die on or after dialysis. With the increasing practice of prescribing in anticipation of symptoms, it is to be hoped that these symptoms will be alleviated more quickly and effectively.

Reference

1 Cohen LM, Germain M, Poppel DM, et al. (2000) Dialysis discontinuation and palliative care.

Am J Kidney Dis 36, 140–144.

Symptom management: pain

Pain is commonly experienced by those approaching death. Pain from comorbid conditions is common, but it is possible for some patients to experience pain related to their kidney disease which may also be added to by pain produced by immobility resulting in joint tenderness and/or pain from pressure areas. Regardless of the cause, pre-existing pain prior to withdrawal will only intensify in the terminal phase. Data from one study in the USA found that one-third of patients dying following withdrawal of dialysis experienced extremely severe pain at times, while 40% experienced pain in the last 24h. For detailed pain management see A Chapter 7.

Management principles

The principles discussed are relevant for all end of life symptoms; those for pain follow the WHO analgesic ladder detailed in 🛄 Chapter 7, and will include the following:

Good assessment of the cause(s):

including history and examination;

· diagnosis of cause and type of pain. Consideration of psychological and spiritual issues for the patient.

Use of an approach tailored to the individual.

A management plan of care with explanation to patient:

realistic goal setting.

The balance of pain relief against adverse effects by:

· monitoring for efficacy and toxicity;

careful titration: adjusting drugs and doses according to response.

Frequent reassessment of response.

 Use of anticipatory prescribing, which includes ensuring drugs are available to the patient by an appropriate route.

Though timescales may be short and the precise cause of pain may not be clear, it as important to consider causes of pain, such as bowel colic, for which non-opioid treatment is effective. However, as time is of the essence the assessment may need truncating in order to achieve a rapid relief of symptoms with frequent monitoring until pain control is achieved.

Where psychological or spiritual distress impacts on pain control it may be necessary to attempt to resolve these issues before pain control can be achieved. Conversely, there are times when the relief of severe pain i necessary to enable the patient to focus on other issues that are greatly troubling them.

Which opioid and which route?

If the patient can swallow and does not find swallowing medication burden then the oral route can be used (see Chapter 7). At the end c life when the patient is no longer able to swallow, the SC route is recom mended: it is the least painful and provides a rapid and smooth onset of action. Step 2 analgesia is omitted and step 3 drugs that can be given SC an used instead, starting at low doses in the opioid-naive. The metabolites of morphine are known to accumulate in kidney failure. M6G, a minor metal olite, but clinically the most important due to its potency as an analges is likely to be the cause of adverse effects particularly sedation, deliriun and myoclonus. Agitation and hyperalgesia can also occur in patients being given morphine. The alternative opioids, fentanyl or alfentanil, are recommended when the SC route is used as this group of drugs have no active metabolites. (See also Chapter 7, WHO step 3: opioids for moderatesevere pain + non-opioid ± adjuvants, p. 118 and this chapter. End of life symptom control guidelines, pp. 280-283.)

Parenteral strong opioids at end of life—fentanyl and alfentanil

All patients should have drugs prescribed and available in anticipation of symptoms as these can develop rapidly and cause considerable distress if not alleviated quickly. For prn medication fentanyl is the preferred drug, as it has a longer duration of action, 3-4h, than alfentanil, which may provide pain relief for less than 2h. Doses of 12.5-25mcg of fentanyl are usually used SC up to hourly if needed when the dose is being titrated against pain. If the prn dose is ineffective then it can gradually be increased to the lowest effective dose. If a patient needs more than three prn doses in 24h, it is usually necessary to use a syringe driver to deliver the drug continuously over 24h.

In the opioid-naïve, doses as low as 100-250mcg/24h are usually sufficient. The dose in the syringe driver can be adjusted upwards if further prn analgesia is needed. If fentanyl or alfentanil are unavailable ultra low-dose morphine, 1.25mg SC prn, can be used as a temporary measure. This is not best practice but may arise OOH. Morphine will have a longer duration of action than in those with normal kidney function and the patient must be monitored for toxicity, particularly agitation and myoclonus. If these occur,

no further morphine should be used.

Adjuvant agents

It may be important to continue these while the patient is able to in order to maintain pain relief.

Paracetamol

Up to 1g qds can be continued, using the rectal route when the patient can no longer swallow, if it is acceptable to them and considered important for ongoing pain control, particularly that from joints or pressure areas.

NSAIDs

NSAIDs may also be helpful for joint stiffness, if used carefully. ESKD patients appear to have a greater risk of GI bleeding with NSAIDs, and any residual kidney function will decline further. When comfort is paramount and the patient close to death, then it may be appropriate to use NSAIDs judiciously if they are likely to be the most effective agent for pain relief.

Neuropathic agents

These may need to be continued until death as the common causes of neuropathic pain such as ischaemia and diabetic neuropathy will continue to give symptoms:

- Clonazepam may be useful as an alternative drug if the person is no longer able to swallow their previous neuropathic agent:
 - it can be given SC as either a nocte dose or in a syringe driver; it has a long duration of action, allowing once daily nocte dose;
 - · doses of between 500mcg and 1mg per 24h are usually sufficient, but with titration this can be increased to a maximum of 2mg/24h.

- Gabapentin may be continued until the patient can no longer swallow, at end of life:
- following cessation of dialysis the dose given after the last dialysis will probably last several days and, if further doses are needed, a maximum of 300mg on alternate days is recommended.

Other neuropathic agents should be continued until the person is unable to swallow and clonazepam made available to them if pain returns. If previous neuropathic pain had been very severe, then it may be wise to start clonazepam as soon as they can no longer take their original agent.

Particular painful situations at end of life

Acute rejection of transplanted kidney

The patient who is dying from rejection of a transplanted kidney, and who has decided not to return to dialysis may develop severe pain in the kidney with associated 'toxicity' from cytokine release. Antirejection therapy may be continued for as long as feasible, but may need to be replaced with steroids such as dexamethasone, which can be given SC. Analgesia may also be needed to treat the pain.

Pericarditis with or without effusion

Chest pain with an audible rub may indicate this complication of uraemia. The pain should be managed in the usual way but steroids such as prednisolone 20mg daily may contribute to a reduction in inflammation and therefore pain-again this could be converted to SC dexamethasone if needed.

20mg prednisolone is equivalent to 3mg dexamethasone.

Painful procedures

Washing patients may be painful at the end of life as well as carrying out any dressings that may be necessary. Such activities can, where possible, be anticipated and SC fentanyl (or alfentanil, which can also be given buccally, if pain relief only required for a very short time) given prior to the activity. (See also A Chapter 7, Episodic, movement-related, or incident pain, pp. 130.)

Namegement: dyconoga and ratained secretions

Dyspinor.

ge carries et e, spincille e control e que a neumer. Fiebr over lord fred clips secondory aream affanotes

The incomplicated by common than count be understained in Manay Billions. Find we have a society of the common of the string and will died a single of the common of the

Thompsand but

And the state of t

- where the new early a not using a frequency of μ , and μ are sets and back ϕ
 - The same of the same of
- a might These ways a manifering settled of meanifements and the settled of a settle
- The best state of the second of the best of the second of

Sea Sea

Cashen Dec. Tolonog Telegig set al new acceptant as all in a confident of a confident of a confident of a confident and a confident of a conf

derectors)

This is a read to be found that problems to continuous body on the superstance of the continuous filters and the continuous for the continuous for

PER LIDEA NEXT BROKEN

This may be a case of the propertion of the community of the manager of the community of th

Visit and the control of the promoders and with the control instrument

Management: dyspnoea and retained secretions

Dyspnoea

The causes of dyspnoea include those listed below.

Fluid overload, including secondary pleural effusions

This is fortunately less common than might be expected in kidney failure. However, it can occur and be particularly distressing and will need active management.

It is unlikely that it would be appropriate to use high-dose diuretics at this stage, though consideration would be given to them in the light of the clinical situation and the ease and appropriateness of IV access if the patient is not dying imminently. In the imminently dying the clinical aim is to reduce the distress of the symptom by non-invasive medical means. These can consist of:

- · positioning the patient in as upright a position as they can tolerate;
- · oxygen;
- · cool fan on the face;
- opioids. These work by reducing the sensation of breathlessness and are used as for pain. The recommended parenteral opioid is fentanyl used at 50-100% dose used for pain and given SC as needed up to hourly (or continuously though a syringe driver if it is clear repeated doses will be required);
- benzodiazepines. If dyspnoea is associated with distress and agitation then low-dose midazolam, 2.5-5mg SC available hourly can give helpful relief. Again this can be added to a syringe driver. Usually quite low doses such as 5-10mg over 24h are all that is needed.

Pneumonia

In the final days of life any treatment is designed for comfort and relief of symptoms. The patient who is dying and asymptomatic from pneumonia is not going to benefit from antibiotics. For someone dying, but symptomatic, dyspnoea can be managed as above. In addition, if in pain, analgesia is indicated. The judicious use of rectal paracetamol may help if distressing pyrexia is present, but if symptoms are not relieved by the above means consideration to antibiotics should be given.

Acidosis

This is a theoretical risk for patients, particularly those who stop dialysis and their normal drugs. However, it is not usually justified to use the invasive approach of IV bicarbonate, etc. but rather to give symptomatic relief for distress and dyspnoea as described above.

Generalized weakness

This may be a cause of dyspnoea, and is likely to contribute to the high percentage of hospice patients who are reported to experience the symptom at end of life, many without other specific physical cause.

General physical measures of support, particularly positioning, will be important here, and the use of medication is not usually necessary.

Retained respiratory secretions

'Death rattle', the noisy rattling breathing that occurs at the end of life for between a quarter to a half of hospice patients, may be more common in renal patients, especially those who are anuric. How much, or indeed if, this distresses the patient is unknown, as usually the patient is unconscious at this time. It does distress a proportion of relatives and staff. This in itself would not normally be an indication for medical intervention as side-effects from the drugs used might inadvertently cause distress, e.g. through drying the mouth, or through paradoxical agitation or unwanted sedation if hyoscine hydrobromide is used. In the patient with kidney failure, however, the early symptoms from secretions in the respiratory tract may presage more symptomatic fluid overload and so it is customary to address them early in the hopes of preventing worse symptoms before death. Either hyoscine butylbromide or glycopyrronium are suitable drugs that may have to be used at maximum doses. Neither crosses the blood-brain barrier and they are therefore less likely to cause paradoxical agitation than hyoscine hydrobromide.

Management: agitation, delirium, and neurological problems

Agitation, delirium

Delirium is very common at end of life, occurring in up to 85% of hospitalized terminally ill patients. This high incidence is likely to be reflected in the ESKD population because of the metabolic disturbances. Causes include:

- uraemia and metabolic disturbance;
- hypoxia;
- drug toxicity or infection;
- alcohol or other drug withdrawal;
- existential distress.

Management

General measures are those for the confused patient:

- keeping stimuli to a minimum;
- familiar surroundings and gentle reorientation;
- minimize changes of staff;
- exclusion of reversible physical causes;
- presence of familiar family or friends and as small a group of professional carers as possible.

Specific measures include:

 Antipsychotic medication such as low-dose haloperidol 0.5–1mg SC prn up to 8-hourly or given initially more frequently until relief is obtained.

 Benzodiazepines may be indicated (see this chapter, End of life symptom control guidelines, pp. 280–283). Midazolam 2.5–5mg SC works rapidly and can be repeated prn. If more prolonged sedation is needed then it can be put in a syringe driver. Low doses are usually sufficient, particularly as there is increased sensitivity.

Neurological problems

Convulsions occur in about 10% of patients and it is usually possible to control this with midazolam, though other measures such as IV lorazepam may be necessary.

Myoclonic jerks may vary from the occasional jerk to distressing and quite violent spontaneous jerks causing patients to drop or 'throw' cups of tea. They suggest a lowered seizure threshold. Causes include:

- toxicity from the morphine metabolite M6G;
- gabapentin toxicity with myoclonus;
- antipsychotic agents such as clozapine.

If drug-induced, stop the drug. An alternative opioid such as fentanyl can be used instead of morphine (see this chapter, Symptom management: pain, pp. 268–270). Clonazepam can be used if gabapentin is the cause both to treat the myoclonus and as an antineuropathic pain measure. It can be given for immediate symptomatic relief both as SC injection and in a syringe driver if indicated.

Management: dauged and vorniging

As well known as a continue of the continue of the point of the point of the manner of the point of the manner of the point of the point of the manner of the point of the point of the point of the continue of the point of the

o Metro di los di 10 escendi di 1866. Cifer di cica de casa di constanti di 1866 di

Patients was few mustern fill for all communities should investing earning with the feet switching and the child feet with the feet switching and the child feet

Of horse on the contraction

Anthometics tento in begiven SC to dece

in-Come Pinempon, object and the

sole and the state of the state

sgnakironramo/sira

is the entire of the four a levid repromasing is a broad for the mounteenring with a good made recursor of a money, and can be a convenient levil of safe such that have a formed and a second that the safe and the

Management: nausea and vomiting

It is well known that uraemia can cause nausea and vomiting. However, most patients dying of or with ESKD will be used to living with uraemia and it is likely that many will have developed tolerance to this effect. (It is also possible that chronic nausea has been accepted as part of the chronic illness and therefore neither recorded nor managed.) At cessation of dialysis, uraemia will worsen and nausea may also worsen or appear for the first time. An assessment of other likely causes should be made and the symptom managed vigorously. As the commonest basis for the nausea is stimulation of the chemoreceptor trigger zone, appropriate anti-emetics include haloperidol (if not otherwise contra-indicated) at reduced dose or the broad spectrum anti-emetic levomepromazine, at ultra low dose. 5mg once or twice a day or in a syringe driver is often sufficient without causing excess sedation.

Patients who feel nauseated for other reasons should have anti-emesis tailored to the probable cause, e.g. metoclopramide for gastric stasis (see Table 8.2), or should continue on previously effective anti-emetics. If necessary these can be given SC.

Anti-emetics that can be given SC include:

metoclopramide (maximum 40mg/24h);

 cyclizine (may choose to avoid as it dries the mouth and may crystallize with hyoscine butylbromide and alfentanil);

· haloperidol:

levomepromazine.

If uncertain of the cause, levomepromazine is a broad-spectrum anti-emetic with a good track record of efficacy and can be effective at very low doses such as 5mg/24h.

Symptoin management: syrings drivers and anticipatory prescribing

under Stabilities which to remove the

ons are symptoms and allowed and interestion of medication tan best as a cell to a principle of continuous St., medication of and fill recommission of the introduction of a chiefe drive. Which be tall purificulty as a second of the production of a content transport of the content transport of

the nature of the posterior of the property of

to duces as else escribio distributed non prenor, incumerant of me effectivency in concepto, most continue to be available sonken necessaries chapter, in contrastion mechanisms of the effective services.

cipatra y prescribile

The medical properties of the second second

are article and the second particle are second and because or worming, can be supported to a common of the action of the second of the second

Symptom management: syringe drivers and anticipatory prescribing

Indications for using a syringe driver

Constant symptoms requiring repeated administration of medication are often best managed by means of continuous SC medication at end of life. Precise timing of the introduction of a syringe driver will be determined by discussion with the patient but specific indications include:

• the patient is no longer able to swallow medication;

the patient is too exhausted to repeatedly swallow medication;

unpleasant nausea or vomiting.

The doses necessary can be calculated from previous requirement of prn medication; prn medication should continue to be available to them. See also this chapter, End of life symptom control guidelines, pp. 280-283.

Anticipatory prescribing

The key to ensuring good symptom control is the prescription and availability of drugs to relieve symptoms when they occur, wherever the patient is being cared for. This is particularly so if the person is in their own home or a nursing home where it is important that drugs are available at short notice for the sudden onset of severe and distressing symptoms. A small supply of drugs to cover the main likely emergencies at end of life, namely, pain, agitation/distress, retained secretions, and nausea or vomiting, can be kept in the home with an up-to-date prescription so a district, hospice, or Marie Curie nurse can administer them as needed without delay.

End of life a marcan control guidelings

with a power of the representation of the re

The rest of the state of the st

Sammos vais?

Sol francisco del cultura especial del properti del constanti del consta

A district times a secure of the earlier and the civen of lenters of netwice in a time of the configuration of the earlier of

para pri subjeti en la companya de la companya del companya de la companya de la companya del companya de la companya del companya de la companya de la companya del compan

End of life symptom control guidelines

The aim of treatment is the comfort of the patient and the support of those close to them.

This section gives guidelines for the care of patients with established kidney failure who are in the last days of life and a detailed summary of symptom control for these patients.

- Use these guidelines when the whole team, the patient, and the family agree that the patient is in the last days of their life.
- This is a guide to treatment. Practitioners should exercise their own professional judgement according to the clinical situation.
- It is helpful to have considered the following questions.
- Do the patient, family, and healthcare professionals recognize that the end of life is approaching?
- Has the preferred place of care been discussed with patient and family and their wishes recorded?
- Have all unnecessary investigations, including blood tests and routine monitoring, e.g. BP, been discontinued?
- Have all non-palliative medications been discontinued and is comfort care, particularly care of mouth and skin, in place?
- Are the drugs needed for palliation prescribed by the route appropriate for the patient's situation and are they available as needed?
- Have the patient and family been asked about their cultural, spiritual, and religious needs at this time?

Pain control

For good symptom control prn medication should be prescribed for likely symptoms even when the patient is asymptomatic.

All of the drugs listed in this section should be given SC unless otherwise specified.

- All patients should have a strong opioid prescribed to be available as needed (prn).
- Recommendation: fentanyl 12.5–25mcg SC up to hourly.

Patient in pain: opioid-naive

Pain intermittent.

- See Box 13.2.
- Prescribe fentanyl 12.5 or 25mcg SC as needed up to hourly.
- After 24h or sooner, review medication.
- If patient still in pain set up SC syringe driver to run over 24h.
 - Starting syringe driver dose usually fentanyl 100–250mcg/24h.
 - 25mcg of fentanyl SC is approximately equivalent to 2mg SC morphine or 1.5mg SC diamorphine.

Pain continuous

Start continuous SC infusion in syringe driver with fentanyl.
Starting dose depends of frailty of patient and severity of pain;

100–250mcg/24h fentanyl.

- Prescribe prn medication, SC fentanyl one-tenth of the 24h dose, which can be given hourly.
- Increase or decrease dose in syringe driver depending on response or side-effects.

Box 13.2 Adjuvant drugs for specific indications

- Bowel colic. Consider hyoscine butylbromide 20mg SC stat and up to 240mg/24h.
- Joint stiffness, bedsores. Consider rectal paracetamol or NSAID.

 Neuropathic pain. Consider clonazepam 0.5mg SC prn or nocte; can be given 12-hourly.

Associated anxiety and distress. Add midazolam 2.5mg SC hourly.
 A combination of midazolam and fentanyl or alfentanil can be very effective in agitated patients who are in pain.

Patient in pain: already on strong opioid (see Box 13.3 if is patient already on a transdermal opioid patch).

 If the patient is on another strong opioid need to convert to dose equivalent of fentanyl—or alfentanil if >600mcg fentanyl/24h required.
 See Box 13.4 and contact palliative care team.

Opioid-responsive pain

- Increase present dose by 25–30%, OR
- add up previous day's prn doses and add to the regular dose (do not include doses used for specific movement-related pain, e.g. dressing change or washing),
- plus prn medication, SC fentanyl 12.5–25mcg hourly (see above).

Pain poorly responsive to opioid

Consider adjuvant (see Box 13.2 or contact local palliative care services).

Box 13.3 Patient with a transdermal opioid patch (fentanyl or buprenorphine)

- If the pain is controlled **continue** with the patch.
- If pain is not controlled, continue with patch, titrating additional analgesia with prn or continuous SC fentanyl or alfentanil.

If uncertain, please contact senior medical, nursing, or pharmacy staff on your team or your local palliative care services.

Box 13.4 Supporting information for pain control and other symptom management

 Fentanyl and alfentanil are suggested as alternative strong opioids to morphine for patients in kidney failure as they have no active metabolites with the potential to cause symptomatic and distressing toxicity such as myoclonic jerks and agitation.

 In the opioid-naive patient successful pain relief can be achieved with low doses, e.g. fentanyl 100–200mcg/24h without excess sedation.

SC fentanyl is about 75 times as potent as SC morphine so:

 200mcg/24h SC fentanyl is approximately equivalent to 30mg/24h oral or 15mg/24h SC morphine and 4mg/24h oral hydromorphone.

 Alfentanil is 1/4—1/5 as potent as fentanyl, and 10 times as potent as SC diamorphine or 15 times as potent as SC morphine. Use when doses of fentanyl exceed 600mcg/24h as fentanyl is less soluble and

the volume too great for the syringe driver.

 We do not usually recommend alfentanil for dose titration as it has a very short duration of action (30–60min). It is useful for painful procedures, however. Suggested dose for patient on SC alfentanil would be approximately 1/10th the 24h dose.

 Fentanyl and alfentanil can be mixed with all the common drugs in a syringe driver, though care should be taken with alfentanil and

cyclizine as it may crystallize.

 Clonazepam can be given SC and may provide a useful adjuvant for neuropathic pain. As there is increased sensitivity to benzodiazepines in ESKD, titrate carefully against toxicity, starting with 500mcg/24h to a maximum of 2mg/24h.

 NSAIDs may worsen kidney function. However, for patients in the last days of life this may not be relevant and comfort is paramount.

 Tramadol preferred to codeine for step 2 analgesia as idiosyncratic occurrence of respiratory depression with codeine for step 2.
 Maximum 24h tramadol dose of 100mg. Dextropropoxyphene and dihydrocodeine should be avoided.

 All strong opioids should be monitored carefully, recognizing that pain and the patient's clinical condition often change rapidly.

 If the patient develops Cheyne–Stokes respiration, it is usually a terminal event and the patient is often unconscious. It is important to explain this and reassure the relatives that we do not believe the patient is suffering at this time.

If uncertain, please contact senior medical, nursing, or pharmacy staff on your team or your local palliative care services.

At this stage the goal is relief of symptoms and the cause of the symptom may not be relevant.

Retained respiratory tract secretions

- Symptoms absent: hyoscine butylbromide 20mg SC stat and 2-hourly pm.
- Symptoms present: hyoscine but/lbromide 40–120mg/24h SC via syringe driver (SD) + 20mg 2-hourly prn up to 240mg/24h.

Terminal restlessness and agitation

- Symptom absent: midazolam 2.5mg SC up to hourly prn. NB: Increased cerebral sensitivity in ESKD.
- Symptom present: midazolam 2.5mg SC up to hourly prn. If two or more doses required, consider syringe driver with 10–20mg/24h + prn dose.

Nausea and vomiting

- Symptoms absent.
 - If already taking effective anti-emetic, e.g. metoclopramide, cyclizine, haloperidol, or levomepromazine, it can be given in a syringe driver over 24h.
 - If not taking an anti-emetic, prescribe levomepromazine 5mg SC pm 8-hourly.
- Symptoms present. Start levomepromazine 5mg SC prn up to 8-hourly or start 5-10mg/24h by continuous SC infusion with further two doses of 5mg/24h SC prn.

Shortness of breath

The following may be helpful whatever the cause:

- Positioning the patient. A cool fan on the face. Oxygen, if hypoxic, and the reassuring presence of family or staff.
- Strong opioids such as fentanyl used at half to the full recommended dose for pain: prn up to hourly or in syringe driver if repeated doses needed.
- Benzodiazepines such as midazolam 2.5mg SC can be given up to hourly if shortness of breath associated with anxiety or panic attacks.

Fluid overload

This is less common than might be expected but is very distressing if it occurs. Use guidance for dyspnoea (this chapter, Management: dyspnoea and retained secretions, pp. 272–273 and above) for symptomatic help or consider the following.

- Sublingual nitrates.
- If appropriate, high-dose furosemide or ultrafiltration to comfort.

Control of symptoms other than pain

For the symptoms described on this page all patients should have prn medication prescribed and available on the ward.

Dialysis at end of life

Even after recognizing that the patient is nearing the end of life, it may be appropriate to continue dialysis. Various factors do need to be considered, though, for both HD and PD.

Haemodialysis at end of life

- Vascular access may be problematic requiring frequent (and often unpleasant) catheter insertions.
- Patients become more dependent.
 - · Need transport to and from HD.
 - May no longer be able to manage at home and will have to consider moving to a nursing home.
 - Increasing problems of hypotension on dialysis with risk of cardiac arrest.
- Increasing dementia or confusion may make patient less able to cope with dialysis procedure.
- Preferred place of care (death) may not be achieved.

Peritoneal dialysis at end of life

- Patient often too sick to carry out self-care treatment.
- · May no longer be able to live independently.
- Increased risk of peritonitis.
 - PD may be being performed by ward nurses.
 - Patient technique may be poor.
- Transfer to HD may have to be considered.
- Preferred place of care (death) may not be achieved.

Preferred place of care

The preferred place of care document is a patient-held record, designed to record and monitor patient and carer choices and services received by all terminally ill patients. It aims to give patients and carers choices and to aid communication between visiting professionals. The desired place cannot be guaranteed and the document also acknowledges that patients may change their minds during the course of their final illness and aims to accommodate this. Patients are encouraged once they have complete such a document to take it into hospital with them if they are admitted to help with future care planning. Discussions around preferred place of care should take place with all patients in whom death is expected in days or weeks and these should be documented, and acted on where possible Support must be given particularly to patients who are not able to achieve their preferred setting for their final illness and who may experience great distress because of this.

The oursing perspective of end of life care in the renal setting

walveevC

Potentis serig prime rienal and have after been forem a stuff for much

Get in the second of the secon

A Viera august Medikangka budent responding end of Medikanga ar corp. Designating the model for the food of the

 Challenges, a sinflate draise in obusion from other enterior in once myrdes and the encorporar most or a segon position on the shapped with him specime mentioner are reasonable.

Propriesion of

On mogratificated units at admigracine every tradecists allocists to all concernances who has averally exponentiately logic organization. This revolution has all the historical over to apport migrations of the end of each with the above care with the manded over to apport on the penetral family and dielected to the following over the appointment family and dielected to the family and the penetral over the wall got to the public over the family appointment and with other have the major over the family among this research and with other have the major and the concern who are included on the concern which are confirmed the concern who are included on the concern when the concern when the concern who are included on the concern who are included on the concern when the

When a head meet that that we shaped could be a decreased by the could be a promised by the country of the coun

Caro pathways

Company or our algree of the one of the case of production of the set of the or of the control of the case of the

and the state of the second second of the second se

Exitadres curses confutantes in thorn things to treat syntys ons.
 Reduces your end it reservions to be filled out.

"ananciduraĝes n. 1. 157 (b. fosus 1916) port un arrag for the in indical and N. spiritual breds of the family to wall astino (palicin).

The nursing perspective of end of life care in the renal setting

Overview

 Patients dying in the renal unit have often been known to staff for many years.

 Staff have built up long-term professional relationships with such patients through their illness at clinic attendances, inpatient stays, and through dialysis sessions often conducted over many years.

 When such well-known patients enter the end of life phase of care the familiarity between staff and patient built up over such a long time poses both opportunities and also challenges for staff working in renal units:

 Opportunities: Patients entering the end of life phase are able to do so in the knowledge that they will be looked after by staff well known to them which can be a source of great comfort.

 Challenges: For staff the change in goals of care from active intervention to comfort, and the emotional impact of losing patients and their families who have become friends over the years can be emotionally demanding.

Practicalities

On most UK renal units at admission every patient is allocated to a trainer nurse who has overall responsibility for ongoing care. This responsibility will be handed over to another nurse at the end of each shift. The allo cated nurse will liaise with the patient, family, and the MDT and be centrated to the provision of care for each patient. She or he will act as the patient advocate in multiprofessional discussions and will often have the major contact with family members.

When it becomes clear that a patient's condition is deteriorating, th patient, family, and professional team will have discussions, usually ove several days, concerning the choices for ongoing care. The process conducting such discussions in a sensitive and open manner is crucial to ensure that the greatest chance possible is given to arriving at consensu decisions involving, patient, family, and staff. If it is considered appropriat to stop dialysis, many units, following discussion with patient and family will commence the patient on an ICP in an attempt to ensure that end c life care is optimal.

Care pathways

Contribution of the renal ICP to end of life care of patients in a renal unit

- Facilitates regular nursing assessment of patient comfort.
- Aids assessment, management, and recording of symptoms.
- Enhances nurses' confidence in their ability to treat symptoms promptly
- Reduces volume of paperwork to be filled out.
- Encourages nurses to focus attention on caring for the emotional and spiritual needs of the family as well as the patient.

Stopping dialysis

During the first few days following cessation of dialysis many renal patients will still be able to eat small amounts and take oral fluids. This is encouraged until the patient no longer wishes to eat or drink. Many patients will experience little deterioration in the first few days until more than usual inter-dialysis interval, making it difficult for patients and families to comprehend that death is imminent. In the knowledge that they may have these few days with the burdens of dialysis lifted, the decision has been made, with family, friends and healthcare professionals supporting them, some patients report feeling a sense of relief, even euphoria. Patients can use this time in the way that they want, perhaps meeting with family members to say goodbye or visiting their home for the last time. If a patient was receiving dialysis through a temporary line this usually should be removed to be less burdensome for the patient whereas a long-term dialysis patient's permanent fistula or graft causes no discomfort when not being used and would need no further intervention.

Many renal patients choose to stay in the unit where they already know the staff. Others may be discharged to nursing homes or hospices if such placement can be arranged. If the patient and family would like end of life care to be at home meticulous communication between the hospital renal and palliative care teams and the community primary and palliative care services using the most effective means possible is essential in order to plan and set up a package of home terminal care at very short notice. If hospice or home is their preferred place of death, allowing the patient to say goodbye to staff and fellow patients they may have known for years should be offered.

Death on the renal unit

When death occurs on the ward, after verification; nursing staff complete last offices and the body is taken to the mortuary. The patient's GP is informed of the death. It may also be important to inform sensitively other patients on the unit of what has happened, particularly if the patient who has died had been well known by other patients.

Changing focus of care

The biggest challenge for nursing staff is managing the change from active treatments, like dialysis, to comfort care with support of the relatives as well as the patient.

The length of time for supporting patients and families in the renal context through the dying phase is variable, but tends to be longer than is common in other conditions, sometimes up to 14 days or more. The family needs sensitive ongoing support and other specialists, including those from palliative care, psychology, and the chaplaincy team, can help with this.

At the time of death it is important that patients and families are afforded privacy and dignity, and awareness of support. When informing the family that the patient has died it is important that clear and unambiguous language is used and euphemisms avoided. It is also important that the professional informing the family of the death does not leave the room immediately but stays to offer support to the family.

Families can also be helped in other ways, including:

- Advice and instruction on what they need to do next (including written
- Nursing staff can accompany the family to view the body in the chapel of rest.
- Contact with the hospital's chaplaincy or pastoral support team can be made if not previously in touch.

Team support

In recognition of the stress that can occur for nurses and other team members there are a number of ways staff can be supported:

 The opportunities for informal support where staff can talk through difficulties with each other in the normal contact periods of each day.

- Regular team supervision/debrief sessions with the psychologist where staff have the opportunity, in a safe and controlled environment, to talk about the stresses of the ward.
- Attendance by a member of the hospital team at the funeral of long-standing patients.

 Follow up of family members with a phone call a few days later. See also Chapter 15.

 A formal post-death audit on all deaths on the unit can be a very useful forum for looking at the quality of end of life care, and acknowledging areas of care which can be improved or which need to be encouraged. The value of such meetings is maximized if they are viewed as a priority by all key staff working on the unit, attendance expected, minutes taken, and outcomes reviewed and monitored.

Summary; main principles of end of

tite card

Death is equest expected and firely for a sepadical report of patients was

I defocute at this page of the "Need prote integral page of the filed of a first order."
 I service many the protection of a page of a real page of a real page of a real page of a p

Fundamental to brund he ce who saveful compunication in brothers
 attent on the mission course and seem with provinciage in social,
 and primary beauty of the option. The time of interest

A cupación of cynipromawna de appropries presentationals.
 provision of the disarch seu advatrse garaning of forme card yell all contribus bins.

Further reading

The state of the second of the second second

Summary: main principles of end of life care

Death is either expected or likely for a significant number of patients with ESKD.

- Their care at this stage of their illness is an integral part of the work
 of a renal team; its importance cannot be overestimated as it is crucial
 for the alleviation of suffering where possible and it is the basis for
 bereavement support for the family and friends of those who die.
- Fundamental to end of life care are careful communication, meticulous attention to symptom control, and regard to the psychological, social, and spiritual needs of the patient, family, and carers.
- Anticipation of symptoms with the appropriate prescription and provision of medication and advance planning of future care will all contribute to this.

Further reading

Farrington K, Chambers EJ (2010) Death and end-of-life care in advanced kidney disease. In Supportive care for the renal patient (ed. EJ Chambers, EA Brown, MJ Germain), pp. 281–299. Oxford: Oxford University Press.

megrated care pathway for and of

Carb

The first include was to the depoler to the animal to the animal wife of pages of the entire that the first include the first include and pages of the first include the first include the entire that the first include the entire that the e

Quitodis mala is so path in dispring volvament dender and principle to go usual figures in a control of the control of the

week is continued on the can be seen as a seek of the continued of the con

ne. Lifferen se milio e france. Graen yn den u lag en purouw yn custur a effolio y sân ei earker Jane frefact fûn gilykwoedjine.

Find as of exercing designed is soon as not indicated as each or end of the end of the

Aggineration of case in a categories and appropriate and appropriate in a control of a cont

r forgrif cynthfor direction y gread i hiddeley. Heres ei A golfed geest proponer or gread ammer i'n seiney farunc

b. nace just vijusedigt in into dareg storions justicions periodical.
 c. into a presentation use of the expire on the PC majority of the PC majority.
 c. nace in the dainer participation.
 c. nace it the viginal release abord on the PC majority.

injust assessment

After language except mean analysis agreement personers their contents and turnly test the dates in a settle and of their fire.

e varante de pri la companyo sorga one i price gracine e un malaboli ingenga salik autorio e imperio prio odo cultura e paper i la pri qui mendacoli ingenga salik on i rui ci aldus valor, o i e albanu lo vesurvi le liga interval e didici funo i ci alcono 2011 in le seve e i l'inggoto co cunque e energia i ce el dicentar villace e e e

or department of the second of

aptivibenth ways •

a dis pri con turci ol aprigga di Sanga Rabadaharingkamu. Ana kerabahan di kong ggi labelah siyanan merupakaharingkamu.

Integrated care pathway for end of life care

The ICP for end of life care, developed by Ellershaw and his team from Liverpool, aims to build on best practice in end of life care as developed by the hospice movement by providing a framework of care so that this standard is translatable into all settings. It hopes to empower doctors and nurses as they care for people at the end of life, by setting goals of care and to facilitate multiprofessional communication, documentation, and audit.

There are clear steps for organizations who wish to introduce the pathway and a pathway specific to patients with end-stage kidney failure is

now in use across the UK.

It is hoped that by measurable improvement in the documentation of end of life care there will come actual improvement in the care both of the patient and their relatives but also greater confidence and job satisfaction for the professional carers as the importance of the care of those who are dying is recognized.

The goals of the renal pathway remain the same as those for the generic

one. Differences include the following:

 Units may start using the pathway at cessation of dialysis, i.e. earlier than the last 72h of life, because:

· once a patient has stopped dialysis death is certain;

principles of care can be applied as soon as needed;

 enables team to discuss preferred place of care when the patient is more likely to be well enough to indicate preferences;

· documentation of patient preferences and whether they are

achieved can be used to guide resource planning.

Symptom control guidelines are modified:

· to account for different drug usage in kidney failure;

· to include symptoms more common in kidney failure.

The care pathway is divided into three sections:

initial assessment and care of the dying patient;

ongoing care of the dying patient;

care of the family and carers after death.

Initial assessment

The initial assessment includes agreement between the renal team,

patient, and family that the patient is at the end of their life.

The criteria for diagnosing dying, and hence commencing the pathway in the generic document, i.e. that the patient is bedbound or semi-comatose or only able to take sips of water, or unable to take tablets, are not necessarily applicable to the renal patient stopping dialysis. In this specific situation the pathway is often started once the decision to stop dialysis is made. However, other key aspects of the pathway apply, including:

assessment of symptoms;

- review of medication:
- the prescribing of anticipatory drugs for potential symptoms;
- cessation of routine blood tests and investigations;
- institution of comfort care.

Importantly, the care pathway also addresses the insight of patient and family as to the situation, their spiritual and psychological needs, and the physical needs of the carers, who may be spending considerable time in hospital and need access to facilities such as bathroom and overnight accommodation for themselves.

An adapted initial assessment sheet is seen in Fig. 13.1.

IF PATIENT HAS RECENTLY STOPPED FOLLOWING	DIALTSIS CONTECT	- 11112
Was there a clear reason?	Yes 🗌	No 🗆
IF yes please state the reason:		
Not tolerating dialysis Deterioration in spite of dialysis Patient's wishes Patient unconscious Other		
Has reason for stopping dialysis been dia	scussed with the patien	t?
Yes 🗌	No 🗌	N/A 🗌
Has stopping dialysis been discussed wit Yes □	h the next of kin?	N/A 🗆
Have the patient and family been asked	about preferred place	of care?
Yes 🗌	No 🗆	N/A 🗌
What is the preferred place of care? Hospital Home Was the preferred place of care achieve	ed?	e nursing home
Yes 🗌	No 🗌	
Fig 13.1 Possible additional information	to be added to the rena	al ICP.

Source: Data from Susie Wilkinson and John Ellershaw (eds). Care of the dying: A pathway to excellence, p. 144, Table 9.1, copyright Oxford University Press 2003.

Ongoing care of dying patient is documented in a single set of multidisciplinary notes, with a minimum of 4-hourly checks on symptoms, and twice daily checks on psychological and spiritual aspects of care, including the needs of the carers.

Care of the family and carers after death is important as it ensures the ongoing care of the bereaved in terms of practical information about what needs to be done and information about bereavement resources.

Reference

1 Ellershaw JE, Wilkinson S (eds) (2003) Care of the dying: A pathway to excellence. Oxford: Oxford University Press.

IN DESCRIPTION OF THE PROPERTY OF THE

ben i Agrici (accente en Manala o 2016, es tre diagrat Ofici en entire anni en la proposition de la companion de la companion

An angle of public decession, a per isseen the

CHANGO BY AR BROWN STREET STANDS AND THE TO SHOW STREET STAND AND A STREET STANDS AND A STREET STANDS AND A ST DESTRUCTION OF STANDARD AND A STANDARD AND A

There's any appoint of the state of the stat

is another of the lasterally and anythe amorphic through the T. Mar.

Up Ab. () which is a passion of the branch their act exempt goldings a co

orand to ethic behavior of the contract of the

ปี อะเทศ ข้ามหาการแบบกระบาง เกิดเกศ ข้ามหาการแบบกระบาง เกิดเกศ ข้ายเกิดเกียง เกิดเกียง เกิดเกียง เกิดเกียง เกิดเกียง เกิดเกียง เกิดเกียง เกิดเกียง เกิดเกียง เกิดเกีย

The state of the s

white the state of a management of the state of the state

Organist care of dying patients a occurrer, with a stock much had a solution of the care of dying patients and a confidence on cyclic acts and confidence on the confidence on the care of the care of

Care of the tensity and remove after decards as ignorements from the street with the control of the street of the

Burner blafi

(4) Property and Property of the Company of 123 of the American May 21 has property of the Company of the Co

Spiritual and religious care

Introduction 298
Assessing spiritual and religious needs 302
Cultural issues and spiritual support 306
Religious practices of different faiths in relation
to end of life care 308

Introduction

The care of any patient, and specifically of one who is approaching death, must encompass the physical, psychological, social, and spiritual aspects of that person.

Spirituality is about making sense of what is happening to someone. It has to do with an individual's sense of peace and connection to others and their belief about the meaning of life. It is likely to be heightened at times of crisis such as facing a life-limiting illness or in the face of certain death. Spirituality may be found through an organized religion or in other ways.

Religion is defined as a specific set of beliefs and practices, usually within an organized group. It may contain rituals of worship or expression of faith, which vary with different beliefs and which helps that individual express their spirituality. It is important to differentiate the two, as a person who has no religious belief or needs may welcome spiritual care that affirms their humanity and supports their exploration of meaning, while not wishing any religious ritual.

It is helpful to know if the patient has any spiritual or religious beliefs or practices, and how much of a source of strength they are to that individual and therefore how they might help him or her during their remaining life. It is not uncommon for transient loss of faith at this time and patients should be asked if they wish to see a chaplain or religious leader.

End of life issues can challenge a patient's beliefs or religious values resulting in high levels of spiritual distress. Some believe their illness is a punishment for some previous misdemeanour, which may result in increased distress and loss of faith.

Spiritual care

Spiritual care is not just the facilitation of an appropriate ritual but engaging with an individual's search for existential meaning, as reflected in the existential domain of the McGill Quality of Life questionnaire.

P. Speck¹

Spiritual care is embedded within the holistic care of patient, family, and professional staff that palliative care embraces, yet it is often omitted or only has lip-service paid to it. This may be through ignorance, embarrassment, lack of confidence, or fear of opening a conversation that the individual either has not the time nor the personal resources to deal with. This is worrying and unnecessary, as all members of the multidisciplinary renal team who care for the dying patient can reach out to their patients' spiritual needs through normal practice and contact with patients. Often patients' spiritual needs are expressed at a time when pastoral or chaplaincy staff are not present. Usually, this will be when people are at their most vulnerable, such as while being washed or having dressings changed, yet individuals will trust the staff member sufficiently to express their deep concerns—maybe with a question relating to their death. Such opportunities are precious and should be responded to. This may involve

holding on to the silence, or listening and enabling the patient to continue their questioning or tell their story, or through touch and an honest meeting of the eyes. For the patient it is the professional 'staying with them' at a time of need or distress that counts. It is also possible to offer further spiritual support from chaplaincy staff if the patient wishes, but it is equally important not to miss the opportunity in everyday practice. Indeed, a recent Royal College of Nursing (RCN) survey² revealed that whilst nurses in the UK consider spirituality to be a fundamental aspect of nursing, RCN members wanted more education and guidance about spiritual care, clarification about personal and professional boundaries and support in dealing with spiritual issues.

Spirituality and spiritual distress

 Spirituality relates to the way people make sense of the world around them.

It is about finding meaning in life.

- The knowledge or fear of the closeness of death is likely to bring those aspects of our being sharply into focus.
- Everyone has a spiritual dimension, though not all have spiritual needs.
- If spiritual distress is not recognized and attended to, it may lead to difficult symptom control, particularly pain control.

 Spiritual distress may express itself as terminal agitation or difficult and unrelieved pain.

Relief of spiritual distress may be crucial to the 'healing' of an individual
as they approach their death, and such healing will enhance their quality
of life and aid symptom control.

Religious care

Religious care enables a person to express their spirituality through appropriate ritual and religious practice. A recently published audit of care of renal patients at the end of life demonstrated the wide variety of religious beliefs or none held by the patients in that unit; nearly a third were Christian but 44% were of unknown religion with the remainder of the patients distributed between five other faith communities.3 These proportions will vary according to the geographical site of the unit. This audit suggested that clinical staff failed at times to take these needs into account and demonstrates the need for understanding of religious customs and practices. For all people, however, personal events and beliefs through their lives may shape the approach to the end of life. Loss of faith, actions in the past for which they feel unforgiven, and actions by others whom they have not been able to forgive may lead to spiritual distress, which can be helped with either spiritual help such as listening without judgment to someone's story, or religious help using rituals and customs appropriate to their faith.

Further reading

End of Life Care for All—e-ELCA an e-learning project which includes a spiritual care module: http://www.e-lfh.org.uk/projects/e-elca/index.html.

References

- 1 Speck P, Higginson II, Addington-Hall JM (2004) Spiritual needs in health care. Br Med J 329,
- 2 Royal College of Nursing (2011) RCN spirituality survey 2010. London: RCN.
- 3 Noble H, Rees K (2006) Caring for people who are dying on renal wards: a retrospective study. EDTNA/ERCA | 32, 89-92.

Assessing spiritual and religious goods

and the first proceedings of process of process of process of the first of the second of the first of the second of the first of the second of

Manual section in a printing of a countries becaused

The second of th

est and angle \$5 nation for the notional standard of the country of the second of the country of

phone of plants and the second of the control floor and second of the control of

The second of th

and the second s

Assessing spiritual and religious needs

 The NICE guidance¹ for improving supportive and palliative care (2004) advocates that spiritual care is available to all patients receiving palliative care. Although written for patients with advanced cancer, the guidelines can be applied to patients with end-stage kidney disease. Point 7.15 states that:

Teams should ensure accurate assessment and timely evaluation of spiritual issues is facilitated through a form of assessment based on recognition that spiritual needs are likely to change with time and with circumstances. Assessment of spiritual needs does not have to be structured but should include core elements such as exploring how people make sense of what happens to them, what sources of strength they can draw upon, and whether these are helpful to them at this point in their life.

Overall guidance for spiritual care assessment

 Assessment of spiritual needs should take place prior to the dying phase as patients are unlikely to have the energy to address such issues and maintain concentration as death draws closer.

 Recognition that the needs of patients and family members change over time, requiring regular assessment of spiritual needs throughout

the disease trajectory.

 Open questions such as 'how do you deal or cope with life when faced with tough and difficult situations?' or 'is there anything that gives you a particular sense of meaning to your life?' let the patient know you are willing to engage in a discussion about spiritual matters and can be used to open a discussion.

 It is also important to gauge how important this is in the person's life, so you might ask 'how important is this (or your faith) in your life?'.

• If the person tells you of their faith this gives you the opportunity to ask if they would like to see a 'faith leader' and if so to ensure the chaplaincy team is aware of this.

They should also be asked how they would like these matters to be dealt with in their health care or could be asked 'are there any particular religious customs I need to know about to help you?'.

The Mount Vernon Cancer Network (MVCN)² adopted three simple questions as a way of opening an exploration of what is important to the patient. The questions are adapted from the work by Peter Speck. The three questions are:

- How do you make sense of what is happening to you?
- What sources of strength do you look to when life is difficult?
- Would you find it helpful to talk to someone who could help you explore the issues of spirituality/faith?

Data from Peter Speck, Spiritual/religious issues in care of the dying, in Susie Wilkinson and John Ellershaw (editors), Care of the dying: A pathway to excellence, pp. 91-92, copyright Oxford University Press 2003.

Giving spiritual support includes:

- being led by the patient;
- listening actively;
- using silence;
- avoiding judgment;
- liaison with appropriate pastoral support or religious leaders.

Spiritual and religious well-being is associated with quality of life, with some research showing that these beliefs can promote a more positive mental attitude that can enhance patients' remaining quality of life by:

- reducing anxiety;
- reducing depression;
- reducing a sense of isolation and 'aloneness';
- facilitating better acceptance and adjustment to their illness.

Spiritual distress may contribute to the patient's inability to cope with end of life issues. Knowing the role that religion and spirituality play in the patient's life may help caregivers understand the beliefs that affect the patient's responses to end of life issues.

Culturally specific spiritual care guidance

A research report prepared by Selman et al.² at King's College London gives guidance (introduced by Desmond Tutu) on spiritual care for black and minority ethnic communities; with special reference to the sub-Saharan African population, but is widely applicable, adaptable and transferable to renal patients in the UK receiving palliative care. The report (Section 2, Point 2.2) states that assessments of spiritual need can be categorized into three types: screening (on admission), spiritual assessment (once immediate concerns are met), and assessment using formal tools.

Assessing spiritual and religious needs: a practical summary

- Try to ensure privacy and sufficient time.
- Ask what is important in the person's life or if anything gives their life meaning.
- Find out how important this is to them.
- If a patient tells you of their faith, ask what kind of support they would like.
- Discover what if any religious practices are important for their spiritual well-being, e.g. opportunity to pray in a particular way.
- Find out if there are particular things to be avoided or others that are important in their faith life.
- Find out if they have a minister of religion whom they would like contacted at any time.
- At an appropriate time ascertain whether they have an up to date will and, if not, if they wish to produce one.
- Be prepared to discuss their funeral wishes if they would like.
- When the time is right enquire about practice around death itself and afterwards—this will depend on the person's response to previous questions.

CHAPTER 14 Spiritual and religious care

References

- 1 NICE (2004) Improving supportive and palliative care for adults with cancer. http://www.nice.org.uk/CSGSP.
- 2 Mount Vernon Cancer Network: http://www.mountvernoncancernetwork.nhs.uk/hcp.
- 3 Selman L et al. Spiritual care recommendations for people from Black and minority ethnic (BME) groups receiving palliative care in the UK. With special reference to the sub-Saharan African population. Available at: http://www.csi.kcl.ac.uk/files/Spiritualcarerecommendations-Fullreport.pdf.

the action if as the make and through containing the property of the property of

Cultural issues and spiritual support

In every culture loss is accompanied by grief, although it may be expressed in a variety of ways.

In a multicultural society patients have different attitudes towards discussing death. No individual can be separated from the context in which they live, be it family, medical, or wider social contexts. It can be a frightening and bewildering experience for those who do not speak the same language as those who care for them, and patients can be left feeling very isolated and misunderstood.

The cultural and religious backgrounds of patients may play an integral role in their interpretation of death and the coping mechanisms they use. Many view death as a transition rather than extinction, so it can be seen that religion and spirituality can influence one's concept of death and dying by offering a reason for being and a framework in which to interpret the inevitable.

Communication

Effective communication is needed when working in a cross-cultural setting. Otherwise one cannot check that a patient has fully understood the implications of end of life care discussions.

We need to recognize the following:

 Mourning behaviour and rituals must be understood within the bereaved individual's religious and cultural background.

 Having prior knowledge of cultural issues, including how the patient's cultural, spiritual, or religious beliefs influence the way they think about caring for the dying, avoids burdening the patient or the family with the additional role of being educators.

 We may not know how patients maintain good health, what they believe to be the cause of their illness, and whether religion or spiritual beliefs play a role in their illness, but we can establish this by admitting we are unfamiliar with their culture and asking how best we can help them.

 If language barriers are hampering good communication, the services of an independent interpreter should be sought.

All people expect their cultural values and way of life to be respected and understood, which is why we should try to think in terms of similarities between cultures rather than differences.

Religious practices of different faiths in relation to end of life care

See Table 14.1 for a summary of the end of life practices of different faiths.

It is not possible to cover all shades of each religion in this short section, it is important always to ask the individual and family what their personal practice and religious needs are, and not to assume that they will conform to a 'norm' as described here or in other texts.

Buddhism

There are a number of different schools of Buddhism, any of which may be represented among renal patients and all of whom practise meditation. Buddhism teaches the inevitability of death. Therefore, a practitioner is likely to be calm and dignified as they face death. Though relief of pain is acceptable, analgesics and sedatives may be declined towards the end of life, and sometimes earlier, so as to die with a clear mind.

Euthanasia is rejected but withdrawal of medical intervention when death is near is not seen as immoral so discontinuing dialysis for the indications discussed in A Chapter 13 would be permitted.

Customs at end of life include:

- inviting a Buddhist teacher or monk to be present with the patient;
- peace and quiet for meditation to ensure a calm state of mind as dying: single sex room particularly for monks:
- listening to Buddhist chants as death approaches.

Christianity

Within Christianity there are also a number of denominations with different traditions. Central to Christianity is the belief that Jesus Christ was the son of God and that he rose from the dead following crucifixion and thereby atoned for the sins of humanity. Christians believe in life after death. Attitudes to death will vary from a rejoicing acceptance to great distress, and all shades between; distress may be associated with feelings of guilt concerning unforgiven sins or a loss of faith. Many (but not all) are helped by seeing a priest or minister of their own or similar denomination for prayer, which may be accompanied by confession, absolution, holy communion, or anointing. It is important that a Roman Catholic receives the sacrament of the sick from a Roman Catholic priest.

Analgesia and sedation can be accepted for relief of pain and suffering. However, some Christians may wish to remain clear in their thinking and decline medication, or delay its use to give time for repentance or reconciliation. Intentionally bringing about death is forbidden; however, attempts to prolong life at all costs are not commensurate with Christian beliefs either.

Customs at end of life include:

- the sacrament of confession with absolution;
- receiving of communion;
- · laying on of hands:
- · anointing with oil;
- prayer with patient and family.

Hinduism

Hinduism is a family of beliefs embracing a diversity of traditions but with common beliefs relating to transition to another life either with reincarnation, life in heaven with God, or absorption into Brahman. A good death is an important part of spiritual life. Religious life plays a significant part in physical life and in this context suffering can be seen as a reflection of wrongs committed.

Purification of the body is very important, particularly to bathe in running water, as part of a daily routine. Many will wish to do so before praying in the morning. Most Hindus will wish to have physical care carried out by carers of the same sex as themselves and it is important that this

is respected.

A good death occurs peacefully in old age, having put affairs in order, said goodbye, and resolved conflict. The 'old age' aspect of a good death

can cause problems for younger Hindus who are dying.

Some Hindus will stop eating and drinking as they approach death as purification of body and spirit. Analgesia and sedation may also be declined to keep the mind clear as they prepare for death. Euthanasia is not permitted.

Customs at end of life include:

- placing the mattress on the floor at end of life;
- preference for death at home;
- having family present while dying;
- reading from Hindu holy books and hymns;
- being given Ganges water and Tulsi leaf in the mouth at the time of death:
- family likely to wish to want to wash the body after death.

Followers of Islam, known as Muslims, believe in one God and the presence of prophets to guide the faithful, the last and most influential of whom was Muhammad. They see the historic record of his actions and teachings as tools for interpreting the Qur'an. Muslims also believe in a final day of judgment. 'Islam' means submitting to the will of God. Most Muslims are strict about abiding by Islamic law with respect to diet, prayer, fasting, etc. Modesty is important in nursing care, with a preference for same-sex carers. Prayer is said five times a day, facing Mecca and after washing with running water. These aspects of religious life will be important at the end of life and professional carers must ask the patient what their wishes are.

Fasting during Ramadan from dawn to dusk is incumbent on Muslims in health. Many who are terminally ill may choose to fast a certain amount, particularly as it is also a time for resolving disputes. Meals will need to be provided before dawn and after dusk. As fasting includes taking anything into the body, medication may also be declined during the hours of daylight.

Muslims believe in life after death, that suffering is part of God's plan, and accept death as His will. For the individual, as in other religions, this can be a great comfort but also for some a source of guilt and distress.

Euthanasia is prohibited, but pain relief can be given and futile treatment withdrawn.

Customs at end of life include:

wish to die facing Mecca (south-east in the UK);

• family or other Muslims to recite prayers;

- · after death the body only to be touched by Muslims;
- if staff have to touch the body it should be while wearing disposable gloves;
- the person's face should be placed towards the right shoulder.

Judaism

The attitude of lews to death and dying is based on convictions. They believe the body belongs to God and that therefore there is an obligation to try to heal it. Most Jews will want to know the truth about their illness so they can plan well. Jewish law is binding and Jews may wish to consult family or rabbi before making serious treatment decisions.

Suicide and therefore euthanasia are against Jewish law. It is, however, generally permissible to withdraw life-sustaining treatment in the presence of a terminal illness, if it is in the patient's best interest. Pain control is permissible as long as it is not given with the intent of shortening life, though the patient may prefer to maintain clarity of thought and decline analgesia.

Customs at end of life include the following:

- Attention to the bereaved may be greater than that to dying person.
- A request to see a rabbi is an individual decision and not necessary for ritual.

Prayers may be said.

- Traditionally, closing the eyes, laying the arms straight, and binding up the lower jaw are done by a family member.
- After death the body is placed on the floor, feet towards the door, covered with a white sheet, and a candle lit.
- The body cannot be moved on the Sabbath (Saturday) so it is important to have anticipated this.
- Watchers stay with the body until burial.

Summary

This has been a brief sketch of some of the features of some faiths. Reference to more extensive texts and to the relevant faith community leaders may be necessary to ensure optimal religious care. All hospitals and hospices have access to chaplaincy or pastoral support teams; these will be an important source of information to local teams and should be

- The care of the individual is unique and assumptions based on religious faith should not be made.
- Patients and families should be asked their needs and preferences.
- Care teams should endeavour to honour those wishes.

Cultural resources and further reading

South Devon Healthcare NHS Trust (2001) Handbook on cultural, spiritual and religious beliefs.

Available at: http://www.e-radiography.net/nickspdf/Handbook%20on%20beliefs.pdf.

Lancet Viewpoint Series: End of life Issues for different religions (2005) Lancet **366**, 682–686, 774–779, 862–865, 952–955, 1045–1048, 1132–1135, 1235–1237.

Speck P, Higginson IJ, Addington-Hall JM (2004) Spiritual needs in health care. Br Med J 329, 123–124.

religions*
he different
of the
customs
of life
End
14.1
Table

Religion	Diet	Particular requirements	Customs around dying	Actions after death	Method of disposal	Autopsy
Buddhism	Many vegetarian	Peace and quiet to allow meditation	Wish to be calm and fully conscious; may request monk to chant	Contact priest immediately; body should not be removed until he arrives	Burial or cremation	May be permitted if religious teacher allows
Christianity	Individual; no forbidden foods	None	May wish to receive absolution, holy communion, or anointing from priest or minister	No special requirements	Burial or cremation	Permitted; with respect to body
Hindu	Strict handling rules; no beef	May prefer mattress on floor; home death preferred	May call Hindu priest for holy rites; Ganges water and Tulsi leaf placed in mouth	Family to wash (if done by healthcare workers, with permission, must wear gloves); jewellery left with body	Cremation as soon as possible	Is permitted
Islam	Special preparation; vegetarian or 'halal' meat; no pork	Modesty and cleanliness very important. Washing in running water before prayer. Fully dressed at night	If possible to sit or lie facing Mecca; privacy for continued daily prayer, declaration of faith made	Body washed by same- sex Muslim; non-Muslims need permission to touch body; body kept covered in clean white cotton garments	Burial only; within 24h	Permitted if required by law

o s a p	Orthodox kosher meals; check individual requirements	Dying person should not be left alone	I hose present may recite psalms; rabbi not essential but may be called	white sheet; body and on floor, feet to the door; candle by head	as soon as by law. Minimally possible invasive; return of organs to bod	by law. Minimally invasive; return of organs to body
Sikhism Usı bee ma	Usually decline beef and pork; many vegetarian	May like to recite or listen to hymns from Sikh holy book	Should die with God's name being recited	Do not trim hair or beard; cover body with plain white cloth; leave 5 Ks [†] with body; family members to wash body	Cremation as soon as possible	Permitted if required by law

it or sedation so as to maintain as clear a mind as possible, and there may be different interpretations of what is allowed by Five Ks: kesh, long hair; kacchera, shorts; kanga, small wooden comb; kara, bracelet; kirpan, sword.

목사님은 사람들이 있다면 하는데 하는데 하고 있는데 얼마를 하는데 없다.	
경인 화면 생물이 없는 아무리를 하게 되었다.	
- (B. 150 - 150 - 150 - 150 - 150 - 150 - 150 - 150 - 150 - 150 - 150 - 150 - 150 - 150 - 150 - 150 - 150 - 150 - (B. 150 - 150 - 150 - 150 - 150 - 150 - 150 - 150 - 150 - 150 - 150 - 150 - 150 - 150 - 150 - 150 - 150 - 150	
그 사람님이는 경영되는 것이 동네는 무슨 나를 가게 되었다.	
BB 1880년 이 교육 1980년 - 1882년 -	
yek (1980년) : [12] 전 10 전 10년 12년 12년 12년 12년 12년 12년 12년 12년 12년 12	
지 않아 있다면 하나 아니는 것이 얼마나 하는데 그런 그렇게 되었다.	
사람은 어로 되었다면서 가게 하는데 되었다.	
경기 가장 하면 하면 하다 내가 가장 없는데 가장 하는데 되었다.	
) - C. C. S. C. S. C. S.	
는 지수는 지점화사회자리에 가장하고 있는 걸 없는 그 것이 없다.	
는 경기가는 화물이 하지 않아 가장에 가장하다 하는데 하는데 없었다.	
그 그는 이번 회사에는 그 없는 것이 먹는 것이 그렇게 되는 것이 그렇게 했다.	
요리 회사 전에 하다 하면 됐습니다. 중에 없다면 없는데 하나 되었다.	
	5
경우다 사용 아무리 선생님은 경우를 하는 것이 없는데 보다 없다.	
그 작가게 가게 있다고 있는데 있는데 없는데 없었다. 중 성인데 되었다.	
그렇게 살아야 바다 되고 있다면 하는데 없어서 아니는 아니다 하나 때 없다.	
[2] 사용 (1) 1 1 1 1 1 1 1 1 1 1 1 1 1 1 1 1 1 1	
점점점점 구의원은 강하는 이 1의 이 등을 맞는 이번 등이 모든 그들은 나를 받아 없었다.	
7年,另名45年,,董多本的"蒙"	
(1) (1) (1) (1) (1) (1) (1) (1) (1) (1)	
78 76 1	

Caring for the carers

Introduction 316
Support for carers 318
Caring for the professional 320
Caring for the bereaved 322

Introduction

Counsellor: 'How's Ray?'

Wife: 'He's fine—why wouldn't he be with me running around after him day in and day out? Do you know what would be really nice—if once in a while someone actually asked how I was'.

The focus of care is naturally first and foremost on the patient and so it is easy to overlook the fact that the losses he or she is experiencing are also being experienced first hand by the patient's close family.

 It is important to recognize the contribution to patient care that family members give—the level of which is not always fully appreciated by members of the renal team or indeed by the patient. One wife commented, 'If I tell him I have a headache, he says "think yourself lucky that's all you've got to put up with." He would never think to ask me later in the day if it had gone'.

• Families and carers need to be reminded that we do value the working relationship we have with them and we need to address sensitively their reluctance to ask for help and to understand the difficulty they

have in accepting it when offered.

Finally, carers need permission to care for themselves too.

Caregivers are mostly:

 spouses and partners who had no idea when they committed themselves to the relationship that they would be sharing the limitations of a life of chronic illness;

adult children and grandchildren, particularly when the parent is

widowed and living alone with no other support;

parents when the adult child is still living at home or locally;

young carers, often the children of single parents.

What is expected from care givers?

 An up to date basic knowledge of kidney disease, its treatments, and medical jargon in order to provide the best level of care.

Monitoring of renal diet and fluid restrictions.

- Ensuring the drug regime is adhered to.
- Assisting with personal care and daily living tasks.
- Providing a taxi service to and from the renal unit.
- Liaising with the unit if the patient is unwell or if there are other concerns such as problems with hospital transport.
- Learning new skills both medically and socially.
- Adapting to relationship and role changes.
- No expectation of financial reward for the care given.

In order to identify potential problem areas, we need to make a comprehensive assessment of the carer's social situation to ensure that the planned provision of care is compatible with the home situation and level of support available. This is particularly relevant as we are now treating an increasingly aged population, some of whom may be living with equally elderly and frail partners or may, of course, be living alone. In such cases the duty of care often falls to close family members because the patient:

 may be unwilling to have 'a stranger' looking after him or her (i.e. a carer from social services);

would rather go without than pay for provision of care;

 may think it is their children's responsibility to care for them, or the children themselves may freely volunteer their services without consultation with their own families who may then feel neglected and resentful at the amount of time being spent with the patient.

This often onerous burden and isolation increases the sense of responsibility carers feel in relation to caring for their loved one. Their expressed concerns relate to:

risk of infection:

- access or any problem that could result in readmission to the unit;
- being criticized that they 'haven't done things right';

being perceived by unit staff as a 'nuisance';

- not being able to cope with tiredness and fatigue as a result of being constantly vigilant and 'on duty';
- a fear of becoming ill and unable to continue to care;
- not managing feelings of anxiety and foreboding;
- · guilt at feeling angry, resentful, and frustrated;

feeling taken for granted;

- isolation, together with lack of recognition and support;
- acknowledging that sometimes carers want to run away—not from their loved one but from the situation.

Support for carers

Statutory services

There is a lot that can be done do to support carers at this time. Under the Care in the Community Act 1990, patients are entitled to a community care assessment of their need, which could result in help being offered such as provision of personal care and equipment that would make life easier for the patient and carer. The carer may also be entitled to a carer's assessment, which is different from the community care assessment and will focus specifically on the carer's needs. Ideally, the carer assessment should not be carried out in the presence of the patient as this might inhibit an open and honest appraisal of how things are. Useful information on community care and carers' assessments can be found on NHS Choices website http://www.nhs.uk/CarersDirect/guide/assessments/Pages/Carersassessments. aspx (accessed 8 July 2011). Information can also be obtained on local carer support groups, respite care, sitting services, and benefit advice.

Patients sometimes encourage and in some cases apply pressure on their families to take them home before a comprehensive assessment of need has been carried out. It is important to ensure that all loose ends have been tied up prior to discharge home to make sure the carer is not

being set up to fail.

The renal team

Renal team members can offer ongoing support to carers by:

- keeping in regular telephone contact;
- · face to face meetings at clinic;
- community visits in order see if needs have changed and more support is required;
- 'normalizing' any negative feelings such as anger, frustration, resentment, or fear;
- offering counselling or psychological support, through the renal team and external resources such as the Expert Patient Programme for Carers—'Caring for Me';
- advising what is available locally for practical and emotional support such as:
 - onward referral for hospice or community palliative care; where there is holistic care for patient and carer;
- encouraging carers to share honestly what they can realistically offer their loved one;
- facilitating respite care if available and appropriate;
- being tolerant and understanding of frequent phone calls—recognizing that the carer is clearly struggling and in need of support;
- recognizing that trying to meet the patient's wish to die at home puts
 enormous strain on carers who need to be reassured that they won't
 have failed if they are unable to comply or sustain their loved one's wish.

• If home is the patient and carer's preferred place of care at the end of life, it is worth investing time in educating the carer on the potential 'crisis situations' they may encounter and who to contact in each of these different situations. This education and support can prepare carers, prevent crisis hospital admissions, and increase the chances of a well-managed home death.

Carer background issues

- Carers mostly do a wonderful job, rarely complain, and seldom ask for help.
- The patient and his/her treatment is the main focus of the renal team.
- The losses and limitation associated with CKD and the demands of dialysis are experienced by patients and carers alike.
- Those without family support have three times the mortality risk of those with highly supportive families.
- Carers are often taken for granted—not just by the patient but by renal unit staff too.
- They take on this role out of a sense of love and duty having no real appreciation of the commitment involved, or their eligibility for welfare benefits that exist in recognition of their role.
- They feel they can't be ill—they can't give in because who would then care for their loved one?

Useful contacts

- Princess Royal Trust for Carers (Tel 0844 800 4361) provides free and confidential help for all carers.
- Benefits Enquiry Line (free phone 0800 882200) for advice on attendance allowance, disability living allowance, invalid care allowance, and benefit eligibility in general.
- NKF (National Kidney Federation) helpline (Tel 0845 6010209), can deal with specific and general enquiries.
- Local patient associations.
- Expert Patients Programme—'Looking After Me' (Tel 0800 9885550).

Useful websites

http://www.carers.org/

http://www.kidney.org.uk/

http://www.expertpatients.co.uk/course-participants/courses/looking-after-me-1

http://www.scie-socialcareonline.org.uk/

http://www.direct.gov.uk/en/CaringForSomeone
http://www.direct.gov.uk/en/Paningson_deni http://www.direct.gov.uk/en/Pensionsandretirementplanning

Caring for the professional

Meanwhile, it seems, the world is suffering from compassion fatigue.

Salman Rushdie

Long, deep, and meaningful relationships are built with patients and families, who will inevitably at some point require end of life care and may choose to stop active treatment. This change in care aim may impact on the staff who have built up such a relationship. Working in this field can be both rewarding and demanding and staff need to protect themselves against emotional burnout and compassion fatigue.

The long association staff have with renal patients has the potential to render them too central in the lives of both patient and family. This can result in some relatives finding difficulty in 'letting go' even after death. This after-care attachment can manifest in visits to where their loved one was cared for and, whilst offering comfort and solace to the family, it can create a range of mixed emotions with staff members as they try to reconcile the needs of the bereaved family with the needs of a new cohort of patients. And so often the staff's own needs remain completely neglected.

We have to care for patients who are going to die, absorbing their

physical and emotional pain on a daily basis. The professional cannot change the fact that the patient has not only to cope with their prognosis but also with subsequent changes in family life, employment, and social contacts. If a patient is still in the angry stage of their grief process, this can be displaced on to staff who find themselves facing hostile outbursts, mood swings, and demanding behaviour—all of which is very hard to handle as it is often taken personally as a criticism of care given.

How do we cope with dissonant emotions that we fear may damage our relationship with a patient at a time when they need compassion and unconditional care? Sometimes there is a tendency to overcompensate, to be overly friendly and devoted, rather than to actually show the patient how we are feeling because it doesn't 'fit' with our professional persona.

This internal conflict, which many staff experience, can result in exhaustion and physical symptoms such as gastrointestinal disturbances, fatigue, insomnia, and headaches. Psychological reactions include depressed mood, irritability, anxiety, rigidity, negativism, and lack of motivation. On a social level it becomes easier to avoid contact with patients or to react impatiently to their constant demands.

Working in a renal unit can be very stressful for the staff primarily because of the psychological burden of continually working with incurably ill patients. Denial is a mechanism often used by staff to avoid burn-out. Patients' behaviour and ways of coping can depend on the way staff deal with their own emotions and it is helpful to develop strategies to prevent burn-out.

Introducing systematic clinical supervision for renal clinicians can encourage reflective practice and offer an environment to discuss difficult issues in a structured way. Quality clinical supervision has the potential to decrease the psychological burden imposed in caring for chronically ill patients and, ultimately improves patient outcomes.

Ways to support staff and reduce levels of stress

 Regular staff meetings that address not just the physical symptoms of the patient but also the psychological impact of caring for them.

 Opportunities to debrief and share their experiences either through peer support or regular clinical supervision groups.

 Permission to attend the funerals of patients with whom they have worked closely, if the staff member wishes, as this can bring 'closure'.

 Ongoing education to raise awareness of self and others within a palliative care setting.

 Training that focuses not only on the care of dying patients but also on the impact this has on the caregivers.

 Managers can recognize the emotional demands placed upon staff and show them that they are valued.

 Acknowledgement that not all nurses are comfortable with or feel they have the necessary level of expertise to work in this field—with a regular review of developmental needs.

Courses on stress management.

Adequate staffing levels.

Some healthcare workers and relatives experience difficulty being in the presence of the dying, which means that, whilst the immediate physical needs of a patient are met, the emotional distress is neglected.

This distancing can often be attributed to not knowing what to say or how to act due to:

discomfort at being put in touch with one's own mortality;

not making time to become involved;

feeling emotionally unable to contain the intensity of the situation;

 emotional distancing because dying is taking too long and is too painful to witness;

 anticipatory grief that can make it difficult to interact with the terminally ill patient;

 guilt and ambivalence experienced by those who feel they haven't been as supportive as they might have been;

relief because suffering is coming to an end and guilt at feeling this.

Whereas CKD creates excessive pressure on families who are trying to integrate dialysis into their lives, terminal illness destroys future hopes and aspirations, leaving families facing very different emotions. The prospect of dying is ever present and can reduce patients to waiting powerlessly for death. This is why we need to focus not so much on dying, but on helping patients identify and achieve what they want to accomplish whilst living. This requires recognition of the uniqueness of each individual patient, and working at their pace towards shared decision-making in terms of future treatment and end of life plans. The ability of staff to facilitate and manage cathartic interventions where patients can unburden themselves of fear and fantasies they hold around death and dying, can positively assist with their transition towards living whilst waiting to die.

Caring for the bereaved

Worden's identified tasks of mourning

- Accepting the reality of loss.
- Working through the pain and grief.
- Adjusting to the loss.
- Emotional relocation and acceptance.

Source: Data from Worden JW (1991) Grief counseling and grief therapy. New York: Springer.

Both patients with CKD and their families have usually had a long association with their renal unit, and bereaved families oft en find enormous comfort remaining in touch with the hospital staff who have supported them over a great many years.

The difficulty some relatives experience in 'letting go' and moving on needs to be acknowledged and there are many ways in which the bereaved can be helped with this task. It is important that we do not let our own sense of helplessness keep us from reaching out to bereaved relatives and that we demonstrate genuine concern, care, and a willingness to listen and talk about the dead person.

Unlike hospices, for which bereavement support is an integral part of their service, renal units do not usually have the resources or expertise to provide bereavement care. However, support could be offered through:

- condolence cards or letters of sympathy;
- anniversary of death card for the first year;
- bereavement information leaflets that give not just practical help but also information on counselling availability in the locality or national organizations that offer this service;
- · attending funerals;
- memorial services for those who have died within the past year.

Specialist palliative care services usually provide a bereavement service that is often targeted and might include:

- drop-in facilities:
- self-help groups;
- befriending schemes;
- professional or volunteer counselling;
- · group therapy.

The availability of ongoing counselling for those who seek it has the potential to identify when the bereaved person is not progressing normally through their grief process and affords an opportunity for onward referral for more skilled help.

Support can also be obtained from the following:

- CRUSE (Tel 0844 4779400) http://www.crusebereavementcare.org.uk/ E-mail: helpline@cruse.org.uk.
- Compassionate Friends (Tel 0845 123 2304) http://www.tcf.org.uk/ E-mail: info@tcf.org.uk.
- National Bereavement Service: a 'support organization for the bereaved' that provides information on where they can access support

locally; it also offers advice/counselling to people who ring their helpline (Tel 020 7709 0505; Helpline Tel 020 7709 9090).

 Bereavement—Patient UK http://www.patient.co.uk/health/ Bereavement-A-Self-Help-Guide.htm.

 Help for grieving children or their families http://www.winstonswish. org.uk/.

The Healthcare Commission¹ has highlighted the fact that more than 50% of hospital complaints it received were bereavement related, with poor communication and care identified as key areas of concern. We also know that 58% of all deaths in the UK, regardless of diagnosis, occur in hospital. At present the majority of renal deaths occur in hospital rather than at home or in a hospice, largely due to unpredictable disease trajectories often preceded by lengthy hospital admissions and familiarization with their surroundings and renal healthcare professionals. Renal units, therefore, need to develop high-quality coordinated bereavement support services, which are accessible for families and carers in line with the key recommendations from the DOH.^{2,3} Both DOH documents emphasize that experiences around the time of death and afterwards can have a profound impact on relatives grieving experience and their own longer-term health.

References

- 1 Healthcare Commission (2007) Spotlight on complaints. London: Healthcare Commission.
- 2 Department of Health (2005) When a patient dies—advice on developing bereavement services in the NHS. London: DOH.
- 3 Department of Health (2008) End of life care strategy. Promoting high-quality care for all patients at the end of life. London: DOH.

in the state of th

the second relation to the second rest to be second as the second relation to manufactor yell with the season of charts in the execution of the continue

Chapter 16

Drug doses in advanced chronic kidney disease

Wendy Lawson

Further reading 346

Drug handling in advanced chronic kidney disease 326
Dosages of commonly used drugs in advanced chronic kidney disease: introduction 328
Drug dosages in CKD5: analgesics 330
Drug dosages in CKD5: antimicrobials 332
Drug dosages in CKD5: antidepressants/anti-emetics/ antihistamines 334
Drug dosages in CKD5: antipsychotic and antisecretory drugs 336
Drug dosages in CKD5: anxiolytics/hypnotics 338
Some drugs not requiring dosage alteration in CKD5 with or without haemodialysis 340
Some drugs to avoid in CKD5 with or without haemodialysis 342
Notes on analgesics 344

Drug handling in advanced chronic kidney disease

Altered pharmacokinetics

Numerous drugs are excreted by the kidney through glomerular filtration. When reduced this affects clearance of the drug and metabolites.

Absorption

Absorption of drugs may be affected by excess urea generated by the internal urea ammonia cycle. This can result in gastric alkalization affecting absorption. Gastroparesis, nausea, vomiting, and anorexia may all reduce drug absorption.

Bioavailability

This parameter varies more in patients with uraemia. Advanced uraemia alkalinizes saliva, which reduces bioavailability of drugs preferring an acid environment. Phosphate binders can form insoluble products with some drugs and decrease their absorption.

Volume of distribution (Vd)

Following absorption, all drugs are distributed to different sites of the body depending on their Vd. Vd represents the ratio of administered drug to the plasma concentration and indicates the degree of distribution or binding of a drug to tissues. It will be increased in patients with oedema or ascites for water-soluble drugs and decreased in muscle wasting or dehydration. Reduced doses are required to distribute into a smaller volume. Those patients with ascites or oedema may require higher drug doses. Drugs with a large Vd (e.g. >0.6L/kg) are not confined within the circulation and tend to be lipid-soluble.

Protein binding

The amount of 'free' drug or drug available to result in a desired therapeutic effect may depend on degree of protein binding, often to plasma albumin. Drugs that are highly protein bound, i.e. not available to exert a pharmacological effect, may compete with the retention of urea and other substances trying to bind with plasma protein. Patients with stage 5 CKD frequently have reduced albumin levels and thus drugs that are displaced from binding, increasing plasma levels, pharmacological effect, and side-effects. Protein binding can also be altered by acid-base balance, malnutrition, and inflammation.

Drug metabolism

The metabolism of drugs in the liver is affected by increased levels of urea. Drugs may be retained and exhibit pharmacological activity, e.g. morphine. Hydrolysis is often reduced; however, glucuronidation, microsomal oxidation, and sulphate conjugation can remain unchanged. Metabolism may be altered unpredictably in kidney failure.

Renal excretionExcretion is often the main route of drug elimination. When reduced, this affects the active metabolites of some drugs, which are often eliminated renally. Toxic metabolites may accumulate.

Dosages of commonly used drugs in advanced chronic kidney disease: introduction

CKD guidelines classify the condition into five stages (see Table 16.1). Stage 1 indicates normal or elevated GFR with evidence of at least one parameter of chronic kidney damage while stage 5 (CKD5) indicates

established kidney failure where GFR <15mL/min/1.73m².

GFR has been regularly estimated using the Cockcroft and Gault equation and subsequent drug dosage adjustments in renal impairment calculated. This uses body weight and takes extremities into account. More recently, another GFR prediction formula has been introduced and referred to as modification of diet in renal dosage (MDRD). The resultant estimated GFR (eGFR) does not require patient weight and the result is normalized to 1.73m².

Drug dosing in renal impairment published in the literature has been based on the Cockcroft and Gault calculation. This should be used unless references state that drug dosing has been expressed for normalizing

The dosages outlined in Tables 16.2–16.9 represent those where GFR <15mL/min and are those used in clinical practice by authors of this text. The dosing guidelines are divided into CKD5 without or with support of HD.

Dosage guidance

Tables 16.2-16.9 list the dose adjustments for commonly used drugs in patients with CKD5. These patients may have withdrawn from dialysis support or may be in the latter stages of HD. Their creatinine clearance is <15mL/min/1.73m². Published data may conflict on the specific doses to be used in this patient population. The tables provide data that take into consideration doses used in practice by clinicians who have provided data for this handbook. Where there is more than one formulation for a specific drug the form referred to is listed. If the dose and/or dosing interval have to be altered this is stated. Standard dose refers to dosage used in patients with normal kidney function.

All doses should be confirmed with drug manufacturer's recommendations prior to use.

Table 16.1 Classification of chronic kidney disease*

Stage	Description [†]	GFR (mL/min/1.73m ²)
	At increased risk for CKD	>60 (with risk factors for CKD)
1	Kidney damage with normal GFR	≥90
2	Kidney damage with mildly decreased GFR	60–89
3	Moderately decreased GFR	30–59
4	Severely decreased GFR	15–29
5	Kidney failure	<15 (or dialysis)

^{*}Chronic kidney disease is defined as either kidney damage or a GFR $<60mL/min/1.73m^2$ for 3 months or more.

Abbreviations used in Tables 16.2-16.9

chapter

unknown or no data available

CII	Chapter		
CKD	chronic kidney disease		
g	gram		
HD	haemodialysis		
IM	intramuscular		
IV	intravenous		
LD	loading dose		
mcg	microgram		
mg	milligram		
on	every night		
PO	oral		
PR	rectally		
prn	when required		
q4h	every 4 hours		
q6h	every 6 hours		
q8h	every 8 hours		
q12h	every 12 hours		
q24h	every 24 hours, etc.		
SC	subcutaneous		
SD	syringe driver (drug administered si	ubcutan	eously)
SL	sublingual		
STAT	immediately		

^{*}Kidney damage is defined as pathological abnormalities or markers of damage, including abnormalities in blood or urine tests or imaging studies.

Drug dosages in CKD5: analgesics

See also 'Drugs to be avoided' and 'Drugs that do not need dosage modification' in CKD5 with or without dialysis (pp. 340–342) and additional notes on analgesics (p. 344).

Table 16.2 Analgesic drug dosing in CKD5 with and without haemodialysis

Drug	Serum half-life	% protein bound in	Dosage for CKD5	Person
	normaveskD (n)	normal kidney function	Not on dialysis	With HD
Alfentanil	1–2/unchanged	92	For procedural or breakthrough pain: 50–100mcg As for 'not on dialysis' SC SD dose depends on previous opioid dose Starting dose 500mcg-1mg/24h (see EL Chapters 7 and 13)	As for 'not on dialysis'
Buprenorphine	20–25 (30 transdem 96 al)/unchanged	96	TD: start 5–10mcg/h for 7 days and titrate to response (see 🖽 Chapter 7)	As for 'not on dialysis'
Clonazepam	20-60/-	98	SC or PO: 0.5–2mg/24h SD: 500mcg–2mg/24h (see 🗓 Chapter 13)	As for 'not on dialysis'
Codeine phosphate	2.5-4/13	make days of the same of the s	Avoid	15–30mg q6h (see 🖽 Chapter 7)

Fentanyl SC	2–7/possibly increased 80–85	80-85	Depends on pain and previous opioid dose. SC bolus acute pain 1.215meg. SD: suggested starting dose opiod-naive:100-250mcg/24h and itrate (see EL Chapters 7 and 13)	As for 'not on dialysis'
Fentanyl transdermal*	2–7/possibly increased 80–85	80-85	Established regime (see 🔲 Chapters 7 and 13)	As for 'not on dialysis'
Gabapentin	5–7/52	S	Avoid	100mg after HD on dialysis days only (see ☐ Chapter 7)
Hydromorphone (non-modified release)	2.5/—	7.1	1.3mg q4-6h + 1.3mg breakthrough (see 🛄 Chapter 7)	As for 'not on dialysis' (see 🖾 Chapter 7)
buprofen	2/unchanged	66-06	Use with caution	Standard dose
Methadone	13-47/—	06-09	Specialist advice (see 🖽 Chapter 7)	As for 'not on dialysis'
Oxycodone PO (non-modified release)	2-4/3-5	45	2.5mg q6–8h and titrate to response + 2.5mg breakthrough	As for 'not on dialysis'
Pregabalin	5-6.5/increased	0	Commence 25mg q24h and titrate to response	As for 'not on dialysis'
Tramadol IM/IV/PO (non-modified release)	6/11	20	50mg q12h	50mg q6h

The second of th

Drug dosages in CKD5: antimicrobials

See also 'Drugs to be avoided' and 'Drugs that do not need dosage modification' in CKD5 with or without dialysis (pp. 340–342),

Table 16.3 Antimicrobials drug dosing in CKD5 with and without haemodialysis

Drug	Serum half-life	% protein bound in	Dosage for CKD5	CKDs
	incliniau ESAD (iii)	normal renal function	Not on dialysis	With HD
Amoxicillin IV/PO	1-1.5/7-20	20	250mg-1g q8h	As for 'not on dialysis'
Amoxicilin/clavulanic acid IV/PO	Amoxicillin 1–1.5/7–20; clavulanic acid 1/3–4	20/25	PO: 375mg q8–12h IV: 1.2g stat, then 600mg q8h or 1.2g q12h	As for 'not on dialysis'
Benzylpenicillin	0.5/10	09	600mg-1.2g q6h maximum 4.8g/24h As for 'not on dialysis'	As for 'not on dialysis'
Cefalexin	1/16	15	250-500mg q8-12h	As for 'not on dialysis'
Cefotaxime	0.9-1.14/2.5(metabolite 10h)	40	1g q8-12h	As for 'not on dialysis'
Ceftazidime	2/13–25	<10	0.5–1g q24h	0.5-1g q24-48h
Cefuroxime IV	1.2/17	50	750mg-1.5g q12h	750mg-1.5g q24h
Ciprofloxacin IV/PO	3–5/8	20-40	50% standard dose	As for 'not on dialysis'

Clarithromycin IV/PO	3-7/prolonged	08	50% standard dose	As for 'not on dialysis'
Erythromycin IV/PO	1.5–2/4-7	70–95	50–75% standard dose; max 2g/24h	As for 'not on dialysis'
Flucloxacillin IV/PO	53-60min/135-173min	95	Up to 1g q6h	As for 'not on dialysis'
Fluconazole IV/PO	30/98	11–12	50% standard dose	As for 'not on dialysis'
Metronidazole IV/PO	5.6–11.4/7–21	10-20	Standard dose q12h	Standard dose
Piperacillin/tazobactam	Piperacillin 1-4/6 tazobactam 1/7	Both 20-30	4.5g q12h	As for 'not on dialysis' but supplement 2.25g post-HD
Teicoplanin IM/IV	150/62–230	90-95	Days 1–3 standard dose; then day 4 standard dose q72h or 33% standard dose q24h	As for 'not on dialysis'
Trimethoprim PO	8-10/20-49	45	Standard dose q24h	As for 'not on dialysis' but dose post-HD
Vancomycin IV	6/120–216	10–50	Stat dose and titrate to levels	As for 'not on dialysis'

Drug dosages in CKD5: antidepressants/anti-emetics/antihistamines

See also 'Drugs to be avoided' and 'Drugs that do not need dosage modification' in CKD5 with or without dialysis (pp. 340–342),

Drug	Serum half-life	% protein bound in	Dosage for CKD5	KDS
	norma/ESKD (h)	normal renal function	Not on dialysis	With HD
Dosulepin	14-24/-	84	Commence 25mg on and titrate to As for 'not on dialysis' response Commence low dose and titrate to response	As for 'not on dialysis'
Escitalopram	22–32/slightly increased	<80		As for 'not on dialysis'
Fluoxetine	Acute dosing 24–72/unchanged; chronic dosing 4–6 days/increased	94.5	Standard dose q48h	As for 'not on dialysis'
Mirtazapine	20-40/increased	85	Commence low dose & titrate to response	As for 'not on dialysis'
Nortriptyline	25–38/15–66	95	Reduce dose & titrate to response	As for 'not on dialysis'
Paroxetine	24/30	95	50% standard dose	As for 'not on dialysis'
Venlafaxine (non-modified release)	8-9/5	27	50% standard dose q24h	As for 'not on dialysis'

10	
.27	
S	
>	
_	
a	
-	
0	
0	
\simeq	
_	
-	
a a	
d	
-	
-	
-	
-	
=	
O	
-	
T	
-	
2	
-	
77	
0	
_	
77	
,,	
-	
100	
-	
>	
>	
2	
0	
V	
-	
()	
-	
_	
.⊑	
E i	
ni gu	
ing in	
sing in	
ni gnisc	
losing in	
dosing in	
dosing in	
g dosing in	
ni gnisob gu	
rug dosing in	
frug dosing in	
drug dosing in	
drug dosing in	
e drug dosing in	
ne drug dosing in	
ine drug dosing in	
nine drug dosing in	
mine drug dosing in	
amine drug dosing in	
tamine drug dosing in	
stamine drug dosing in	
listamine drug dosing in	
histamine drug dosing in	
tihistamine drug dosing in	
ntihistamine drug dosing in	
intihistamine drug dosing in	
antihistamine drug dosing in	
/antihistamine drug dosing in	
c/antihistamine drug dosing in	
tic/antihistamine drug dosing in	
etic/antihistamine drug dosing in	
netic/antihistamine drug dosing in	
netic/antihistamine drug dosing in	
metic/antihistamine drug dosing in	
emetic/antihistamine drug dosing in	
-emetic/antihistamine drug dosing in	
ti-emetic/antihistamine drug dosing in	
nti-emetic/antihistamine drug dosing in	
inti-emetic/antihistamine drug dosing in	
Anti-emetic/antihistamine drug dosing in	
Anti-emetic/antihistamine drug dosing in	
Anti-emetic/antihistamine drug dosing in	
5 Anti-emetic/antihistamine drug dosing in	
.5 Anti-emetic/antihistamine drug dosing in	
6.5 Anti-emetic/antihistamine drug dosing in	
16.5 Anti-emetic/antihistamine drug dosing in	
16.5 Anti-emetic/antihistamine drug dosing in	
16.5 Anti-emetic/antihistamine drug dosing in	
e 16.5 Anti-emetic/antihistamine drug dosing in	
le 16.5 Anti-emetic/antihistamine drug dosing in	
ble 16.5 Anti-emetic/antihistamine drug dosing in	
able 16.5 Anti-emetic/antihistamine drug dosing in	
Table 16.5 Anti-emetic/antihistamine drug dosing in	
Table 16.5 Anti-emetic/antihistamine drug dosing in CKD5 with and without haemodialysis	

Drug	Serum half-life	% protein bound	Dosage for CKD5	
•	normal/ESRD (h) in normal renal function	in normal renal function	Not on dialysis	With HD
Cetirizine	8-10/20	93	5-10mg q24h	As for 'not on dialysis'
Chlorphenamine IV/PO 12-43/—	12-43/—	~70	Standard dose but increased cerebral sensitivity	As for 'not on dialysis'
Haloperidol	12–38/—	92	PO or SC: 0.5–1.5mg q8h; SD: 1–3mg/24h	As for 'not on dialysis'
Levomepromazine	30/—		PO: 6mg or SC: 5mg up to q8h (see 🖽 Chapter 13); SD commence 5–10mg/24hr	As for 'not on dialysis'
Prochlorperazine*	-/6-9	96	Reduce dose PO: 5mg, IM: 6.25mg and titrate to response As for 'not on dialysis'	As for 'not on dialysis'

The control of the co

Drug dosages in CKD5: antipsychotic and antisecretory drugs

See also 'Drugs to be avoided' and 'Drugs that do not need dosage modification' in CKD5 with or without dialysis (pp. 340–342).

Table 16.6 Antipsychotic drug dosing in CKD5 with and without haemodialysis

Drug	Serum half-life	% protein bound in	Dosage for CKD5	
	normavesku (n)	normal renal function	Not on dialysis	With HD
Chlorpromazine	Chlorpromazine 23–37/unchanged	86-56	Commence with low dose and titrate to response	As for 'not on dialysis'
Haloperidol	12–38/—	92	PO/SC: 0.5-1.5mg q12–24h SD: 1–5ma/24h	As for 'not on dialysis
Olanzapine	30–38/unchanged	93	Commence 5mg q24h and titrate as required	As for 'not on dialysis'
Quetiapine	6–7/unchanged	83	25mg q24h, increasing in increments of 25–50mg q24h according to response	As for 'not on dialysis'
Risperidone	19.5/increased	06	PO: 0.5mg q12h, increasing by 0.5mg q12h to 1–2mg q12h As for 'not on dialyis'	As for 'not on dialyis'

Table 16.7 Antisecretory drug dosing in CKD5 with and without haemodialysis

Drug	Serum half-life	Serum half-life % protein bound in	Dosage for CKD5	
•	normal/ESKD (h)	normal/ESKD (h) normal kidney function	Not on dialysis	With HD
Glycopyrronium*	1.7/-	1	SC: 200mcg stat and q4h pm SD: 600–1800mcg/24h As for 'not on dialysis'	As for 'not on dialysis'
Hyoscine butylbromide	8	10	SC. 20mg stat and q2h pm SD: 40–120mg/24h; up to As for 'not on dialysis' 240mg used (see ED Chapters. 8 and 13)	As for 'not on dialysis'
Hyoscine hydrobromide	8	10	SC: 400mcg stat and q4h prn SD: 0.6–2.4mg/24h (see 🖾 Chapter 13)	As for 'not on dialysis'
Ocreotide	1.5/increased	65	SD: 250-500mcg q24h	As for 'not on dialysis'
Panitidine IV/PO	7-3/6-9	15	50-100% standard dose	As for 'not on dialysis'

*Excreted by kidney so drug accumulates.

Notes on antipsychotics

 Psychotropic medications are highly protein bound in kidney failure. This may mean that increased unbound/free drug is available to exert not only the desired therapeutic effect but also undesirable side-effects.

Many of these medications require dosage titration according to response.

Drug dosages in CKD5: anxiolytics/hypnotics

See also 'Drugs to be avoided' and 'Drugs that do not need dosage modification' in CKD5 with or without dialysis (pp. 340-342).

Table 16.8 Anxiolytic/hypnotic drug dosing in CKD5 with and without haemodialysis

Drug	Serum half-life	% protein bound in	Dosage for CKD5	
	normal/ESKD (h)	normal/ESKD (h) normal kidney function	Not on dialysis	With HD
Clonazepam	20-60/—	98	Reduce dose; then titrate to response	As for 'not on dialysis'
Diazepam (all forms) 24 48/increased	24 48/increased	95–99	Reduce dose and titrate to response	As for 'not on dialysis'
Lorazepam (all forms) 10-20/32-70	10-20/32-70	85	Standard dose; but increased cerebral sensitivity	As for 'not on dialysis'
Midazolam*	2–7/unchanged	86-96	SC: 2.5-5mg q2h SD: 10-20mg/24h (see 🖽 Ch.apter 13) As for 'not on dialysis'	As for 'not on dialysis'
Nitrazepam	24-30/unchanged	87	Commence with low dose and titrate to response	As for 'not on dialysis'
Oxazepam	3-21/25-90	85–97	Commence with low dose and titrate to response	As for 'not on dialysis'
Temazepam	7–11/unchanged	96	Reduce dose and titrate up to 10mg on (20mg if single dose) start sm dose	As for 'not on dialysis'
Zopiclone	3.5-6.5/unchanged 45-80	45–80	Commence 3.75mg on	As for 'not on dialysis'

Notes on anxiolytics

*Active metabolites accumulate in kidney failure.

prent drig can accumulate in kidney for

Oxazepam, There is an increase in volume of distribution and reduction in protein binding; therefore decrease dose.

Table 16.9 Miscellaneous drug dosing in CKD5 with and without haemodialysis

Drug	Serum half-life	% protein bound in normal	Dosage for CKD5	KDS
	normal/ESKD (h)	kidney function	Not on dialysis	With HD
Pramipexole	8–14/36	<20	88mcg q24h and titrate slowly to q8h As for 'not on dialysis'	As for 'not on dialysis'
restless leg syndrome)				
Thalidomide	5-7/unchanged	55-66	Expert advice see 🖾 Chapter 7	As for 'not on dialysis'
(pruritis)				

Some drugs not requiring dosage alteration in CKD5 with or without haemodialysis

Alfacalcidol

Amitriptyline

Bisacodyl

Carbamazepine

Cefuroxime (oral)

Chlorphenamine

Cinacalcet

Citalopram (use with caution)

Clopidogrel

Cyclizine

Dexamethasone

Docusate sodium

Domperidone

Doxepin

Esomeprazole

Ferrous gluconate

Ferrous sulphate

Fybogel[®]

Granisetron

Heparin (unfractionated)

Imipramine

Isosorbide mono/dinitrate

Lactulose

Lansoprazole

Levothyroxine

Linezolid

Loperamide

Metoclopramide

Movicol® (short term)

Naloxone

Nystatin

Omeprazole

Ondansetron

Pantoprazole

Paracetamol

Phenoxymethylpenicillin

Phenytoin

Prednisolone

Quinine sulphate

Senna

Sertraline

Sevelamer

Sodium valproate

Theophylline Triazolam Trifluoperazine Tropisetron Zolpidem

Some drugs to avoid in CKD5 with or without haemodialysis

Aluminium- and magnesium-containing antacids

Aminoglycosides

Angiotensin-II receptor antagonists

Aspirin (therapeutic doses)

Codeine phosphate (unless on HD)

Cyclo-oxygenase 2 inhibitors

Diamorphine

Dihydrocodeine (unless on HD)

Gabapentin (unless on HD)

Gaviscon®

Glibenclamide

Gliclazide

Glimepiride Glipizide

Lofepramine

Metformin

Morphine

Nitrofurantoin

Peptac[®]

Pethidine

Thiazides

Notes on analysics

Notes on analgesics

Notes on analgesics (see (Chapter 7).

 Choice of analgesics may depend on a number of factors including cause of pain (which is often multifactorial), effect of current treatment regimen, and severity of pain.

• The principles of the WHO three-step analgesic ladder can be applied to the management of pain in patients with CKD5, both those on and those not on HD, though there are minor differences in doses highlighted in 🛄 Chapter 7 and the Table 16.2. The commonest reason for modifying analgesic dose is that toxicity can occur due to accumulation of active metabolites. All analgesics require individual monitoring and dosage titration.

See Chapter 7 for full discussion of individual strong opioids.

 Sustained release forms of opioids should not be used because if accumulation occurs there may be prolonged toxicity. SC drivers—it is important to check compatibility with other drugs.

Further reading

- Ashley C, Currie A (2009) The renal drug handbook, 3rd edn. Oxford: Radcliffe Publishing. Cohen LM, Tessier EG, Germain MJ, et al. (2004) Update on psychotropic medications use in renal disease. Psychosomatics 45, 34-48.
- Davidson SN, Davidson JS (2011) Is there a legitimate role for the therapeutic use of cannabinoids for symptomatic management on chronic kidney disease. | Pain Symptom Manage 41, 767-778.
- DH Renal NSF Team and Marie Curie Palliative Care Institute. Guidelines for LCP prescribing in advanced chronic kidney disease (May 2008) http://www.renal.org/pages/media/Guidelines/Nati onal%20LCP%20Renal%20Symptom%20Control%20Guidelines%20(05.06.08)%20(printable%20 pdf).pdf (accessed 6 May 2011).
- Dickman A, Schneider J, Varga J (2005) The syringe driver: continuous subcutaneous infusions in palliative care. Oxford: Oxford University Press.
- Douglas C (2009) Symptom management for the adult patient dying with advanced chronic kidney disease: a review of the literature and development of evidence based guidelines by a United Kingdom Expert Consensus Group. Palliative Medicine 23, 103-110.
- Electronic Medicines Compendium http://www.medicines.org.uk/emc/ (accessed May 2011).
- Davison SN, Chambers EJ, Ferro CJ (2010) Management of pain in renal failure. In Supportive care for the renal patient, 2nd edn (ed. EJ Chambers, E Brown, M Germain), pp. 139-188. Oxford: Oxford University Press.
- Murtagh F, Weisbord SD (2010) Symptoms of renal disease; their epidemiology, assessment and management. In Supportive care for the renal patient, 2nd edn (ed. EJ Chambers, E Brown, M Germain), pp. 103-138. Oxford: Oxford University Press.
- Murtagh FEM, Addington-Hall JM, Donohoe P, et al. (2006) Symptom management in patients with established renal failure: management without dialysis. EDTA/ERCA | 32, 93-98.
- NHS Lothian (August 2010) Symptom control in patients with chronic kidney disease/renal impairment. http://www.palliativecareguidelines.scot.nhs.uk/documents/RenalPalliativeCarefinal. pdf (accessed 6 May 2011).
- Wyne A, Ria R, Cuerden M, Clark W, Suri R (2011) Opiods and benzodiazepine use in end-stage renal disease: a systematic review. Clin | Am Soc Nephrol 6, 326-333. Useful website: http://www.palliativedrugs.com/.

Audit and research in renal end of life care

Why audit and research are important 348
Linking audit and research to existing expertise 350
Data sources 352
Challenges in end of life research 356
Further reading 358

Why audit and research are important

It is only recently that end of life care in advanced kidney disease has been recognized as an important area of practice in its own right. For this reason, systematic study has so far been limited, and undertaking further audit and research is a critically important part of advancing practice and improving quality of care for patients and families. Specifically, the nephrology community needs to know more about:

- Which areas of care need most improvement, especially from patient
- and family perspectives?
- How are decisions about dialysis and care planning (including ACP) made?
- What is the effectiveness of introducing end of life care strategies and interventions?
- What is the cost-effectiveness of such care?
- How does implementing such care impact on patient/family outcomes?

Domains of care relevant to end of life

The US National Consensus Project for Quality Palliative Care¹ identified eight domains to provide a framework for assessing and measuring the quality of palliative care. These include:

- structure and processes of care;
- physical aspects of care:
- psychological and psychiatric aspects of care;
- social aspects of care;
- · spiritual, religious, and existential aspects of care;
- · cultural aspects of care;
- · care of the imminently dying patient;
- ethical and legal aspects of care.

It is challenging to define and operationalize quality standards for these domains and link them with relevant health outcomes. Quality standards need to be clinically meaningful, but also influenced or determined by healthcare, and they are being developed in the UK for end of life care.2

References

- 1 National Consensus Project for Quality Palliative Care (2009) Clinical practice guidelines for quality palliative care, 2nd edn. http://www.nationalconsensusproject.org/.
- 2 UK National Institute for Health and Clinical Excellence Quality standard for end of life care (due to be published November 2011; http://www.nice.org.uk/).

Linking audit and research to existing expertise

Although in the world of nephrology, renal end of life care has only recently been widely acknowledged and systematically studied, it is important to recognize that there is a long history of measurement of the quality of palliative and end of life care in other areas (not least in specialist palliative care itself) and much experience and expertise is available. Linking to and drawing on this expertise can help overcome and address some of the challenges of audit and research in this field.

Quality, audit, and research have always been important to practice in palliative and end of life care, and there is a long history of refinement of certain methods (for example interviewing bereaved caregivers; see Cartwright et al. which illustrates this).

Reference

1 Cartwright A, Hockey J, Anderson JL (1973) Life before death. London: Routledge and Kegan Paul.

Further reading

For a general overview of approaches to research and audit in end of life care, see:

Bruera E, Higginson IJ, Ripamonti C, Von Gunten CF (ed.) (2009) Part 5: Research and audit. In Textbook of palliative medicine, pp. 161-214. New York: Oxford University Press. Higginson IJ (ed.) (1993) Clinical audit in palliative care. Oxford: Radcliffe Medical.

Data sources

There are introduced in different possibilities as an object into the outto in sear corenal and of life care.

* administrative on clinical ustabases.

e patient que tignificia as or surveys.

* Europate - (am. v. ne protestionali aluest e mai de arca ence ence

 instribilité et pods to méasum the quality grand of life care and Jeach

dependion the fall suffer question under consider non

Maconet or regional administrative uptablish

Anni isuje ive ur dhilost orappese car de thie end prondo a grestid all obnisella dina and authrib Nationalezh, uponni datrbeses nuch la destri registration distribuses, klana Registry data, and fump al quisode sadistre and all verviusella in terms or Loverige and existent lasthouga may sufficition from missipp data than a veri markhanda el local claim to darente of towarder obtain the simple markhanda el motiva, in pronding of of electric kena Registribs collections above, electric keiment to those and distribusella in those manuged el pour unit of and carried collectid up Charles and been called a carried and the carried some Charles and been called and the carried and carried

Neverth less passinance, dunos data dave rus aug basin as dinnities. Us a provium version adapta frito patrema of dusch of those with a patrema of dusch of those with a patrema of the second of the conditions of the condition of the conditions of the condition of the condition

Local Cincol delabases

gwei chnical databescu (as opensation of findered with a company groups) may be also be selected as the contract of the contra

Rement surveys or direstrophames

Particular surveys call before weeklectively to capular and plante to making of the configuration before the capular of the configuration of the capular of

Samily or projectional questionisaires

Surveys of Sourie for a control death (port-contavement wirkeys) and enlarge established way of a control of the properties of a death Their are source for a the trainers of the source entable to be revivencent top small and a regulated as potentially on the surveys and assentative, and top acte on session specification.

Data sources

There are a number of different possibilities in terms of obtaining the data to research renal end of life care:

- administrative or clinical databases;
- patient questionnaires or surveys;
- surrogate (family or professional) questionnaires or surveys;
- instruments or tools to measure the quality of end of life care and death.

All have advantages and disadvantages, and the choice of data source will depend on the research question under consideration.

National or regional administrative databases

Administrative or clinical databases can be large and provide a great deal of useful data and analysis. National or regional databases, such as death registration databases, Renal Registry data, and hospital episode statistics, are all very useful in terms of coverage and extent (although may suffer more from missing data than a well-maintained local clinical database). However, death registrations are rarely accurate in reflecting renal causes of death. Renal Registries collect data which relates primarily to those on dialysis (and not those managed without dialysis) and rarely collected the kind of data useful in assessing quality of end of life care.

Nevertheless, death registration data have recently been used in the UK to provide very useful insights into patterns of death of those with kidney disease, and further work is being conducted using linked death registration and hospital episode statistics to study deaths from kidney disease. Efforts are being made to develop and refine data collection by Renal Registries, and in the UK, NHS Kidney Care is leading development work to implement the recommendations made in the 'Framework for Implementation of End of Life Care in Advanced Kidney Disease'.

Local clinical databases

Local clinical databases (as opposed to regional or national registries) may have fewer problems with data quality, but will yield evidence relating to smaller numbers. This can be problematic when the population is relatively small (such as conservative, or non-dialysis, care) or where attrition is high (such as towards end of life). Collaborative research, where several renal units work together to conduct an audit or study, is likely to produce the most fruitful results.

Patient surveys or questionnaires

Patient surveys can be an excellent way to capture data relating to quality of care, but those who are closest to end of life and/or most ill often struggle with the research burden of completing questionnaires, and so there may be an inherent bias in such studies.

Family or professional questionnaires

Surveys of family carers after death (post-bereavement surveys) are a longestablished way to access data about the quality of a death. There are issues about the timing of these in relation to bereavement; too soon is regarded as potentially distressing and insensitive, and too late raises problems of recall bias It is also important to consider the impact of anniversaries, such as 1 year after the death, which can be a difficult time for families. In the UK, most post-bereavement surveys are conducted between 3 and 9 months after death. Consideration should be given to the sensitivities of such research, including signposting appropriate bereavement support where needed.

Surveys conducted among surrogate respondents, such as family carers or professional carers, also have 'in-built' bias - both recall bias (where the passing of time may influence recall) and bias because of the emotions of the respondent (either emotions relating to the bereavement with family carers, or influences on professional interpretation of events when a death is viewed as either 'good' or particularly distressing by professionals).

Validated tools to capture quality of death

There are no formally validated tools to capture the quality of end of life care which are specific for use with kidney patients, although there are such tools available for generic use (see Further reading). It is important that such measures are properly validated in the renal population, because this tells us whether the tool or measure is actually reflecting what is

required, and how well it can do this.

Although there are no validated measures for the population with advanced kidney disease, an audit proforma to assess the quality of death has been developed and used by the pan-Thames renal audit group (Table 17.1). There is a validated tool to capture symptoms and other concerns close to death (the core POS and POSs renal; see Further reading). There is work proposed to develop and validate a tool to assess quality of death in the UK, and this measure may become available in the near future.

Table 17.1 The pan-Thames renal end of life audit tool

Date of birth:	Date of death:	THE .	9194	Sex:
Ethnicity		Caucas Afro-C	15 15 15 1 1 1 4 W	South Asian an Other
Renal replacement therapy at time of death	og desiration Alle Thosair		Home	
Details of death				
Place of death	retire milita enal, perfe	Hospit Home		d Dialysis unit ospice Unknown
Was there a DNR order?	5 Ya spinsup	Yes	No	ralogs tratagi
Was resuscitation attempted?	044271 YOU	Yes	No	amilia (maras)
If at home, was this a sudden d	eath?	Yes	No	Don't know
If in hospital, date of admission prior to death	u na palkbir v na palkina v	d sqc	14.5% 962.7	
Had dialysis been discontinued	? was in ham mid ing the	Yes Not or		Transplant sis
If yes, date of stopping dialysis	Suparity Street			
Were relatives/friends present time of death?	at 20 and a	Yes	No	Don't know
Was the Liverpool Care Pathw	vay in use?	Yes	No	
End of life planning				
Was this an unexpected death	?	Yes	No	
Was there discussion about en life wishes in the year prior to		Yes	No	Don't know
Had patient/family been told the patient was dying during admis leading to death?		Yes	No	Don't know
Had aim of care been changed palliative management?	to	Yes	No	Don't know
Were the palliative care team	involved?	Yes	No	Don't know
How effective was pain and symmanagement?	mptom	Good		oderate Poor

In your opinion, was there inappropriate prolongation of dying?			rith 5 being significant clongation: 1 2 3 4 5
In your opinion, was this a good quality death? *	Yes	No	Not sure

DNR, do not resuscitate.

* 'Characteristics of care during the last days of life, which have consistently been found to be important from the patient's perspective are, receiving adequate pain and symptom management, avoiding inappropriate prolongation of dying, achieving a sense of control, relieving burden on loved ones, and strengthening relationships with loved ones.' (DOH 2009, p. 29).

Reprinted from Stephen P. McAdoo, Edwina A. Brown, Alistair M. Chesser, Ken Farrington, Emma M. Salisbury and on behalf of pan-Thames renal audit group, Measuring the quality of end of life management in patients with advanced kidney disease: results from the pan-Thames renal audit group, Nephrology Dialysis Transplant (2011), doi: 10.1093/ndt/gfr514, first published online October 6 2011, Supplementary Table, with permission of Oxford University Press.

References

- 1 Palliative Care Outcome Scale (POS): http://pos-pal.org/
- 2 DOH (2009) Kidney Care National End of Life Programme. End of life care in advanced kidney disease: a framework for implementation. London: Department of Health.

Further reading

- Aspinal F, Hughes R, Higginson IJ (2002) A user's guide to the Palliative care Outcome Scale. King's College London: Palliative Care and Policy Publications.
- DOH (2009) Kidney Care National End of Life Programme. End of life care in advanced kidney disease: a framework for implementation. London: Department of Health.
- McAdoo SP, Brown EA, Chesser AM, Farrington K, Salisbury E, on behalf of the pan-Thames renal audit group (2011) Measuring the quality of end of life management in patients with advanced kidney disease: results from the pan-Thames renal audit group. Nephrol Dial Transplant, first published online October 6, 2011 doi:10.1093/hdt/gfs14.
- Murphy EL, Murtagh FE, Carey I, Sheerin NS (2009) Understanding symptoms in patients with advanced chronic kidney disease managed without dialysis: use of a short patient-completed assessment tool. Nephron Clin Pract 111, c74–c80.
- National End of Life Intelligence Network. Deaths from renal diseases in England 2001–2008. Available at: http://www.endoflifecare-intelligence.org.uk/resources/publications/deaths_from_renal_diseases.aspx
- Palliative Care Outcome Scale (POS) http://pos-pal.org/ (for core POS and POSs renal see the website where the tools can be down-loaded).

Challenges in end of life research

In addition to the challenges of how and where to obtain data for audit or research, there are also a number of specific issues which apply to end of life research among those with advanced kidney disease.

Prospective versus retrospective design

When data are being sought in relation to death, there is a challenge about whether a prospective or retrospective design is most useful. Prospectively, it is hard to predict death, and so larger numbers may need to be recruited or followed up, in order to obtain sufficient deaths in the study sample. This is especially true for survival studies, but also for any study which endeavours to study events or outcomes close to death.

Retrospective design overcomes this issue, because all deaths can be identified (having already occurred) and then studied looking backwards, but a retrospective design raises other problems; of data availability, quality and accuracy. In general, a prospective design is likely to be more robust.

When a study is prospective, it may also be desirable to analyse both prospectively (forwards from study entry) and retrospectively (backwards from death). This does not change the design, but maximizes the use of data to provide greatest breadth of understanding and insight.

Longitudinal versus cross-sectional design

It is much easier to conduct a cross-sectional study, because the resources and time required are markedly less than for a longitudinal study. However, a cross-sectional study only reflects one point in time. It is longitudinal research (research which employs repeated measures on the same study participants over time) which can tell us the most about the actual 'real world' experience of kidney patients and their families. This is important for certain research questions; such as questions about the trajectory or course of illness over time and towards death, about potentially changing end of life preferences, and about alterations in quality of life (including 'response shift'—the effect of reframing or altering goals and priorities, on quality of life or other scores over time).

Interventional studies may not be strictly longitudinal in design, but the outcome measures should be carefully timed to capture the optimal effect. This can sometimes only be determined by prior longitudinal work to inform the best timing for any outcome measure; outcomes measured too early may show little or no effect from the intervention, while outcomes measured too late, may be hindered by attrition.

Although the research question will largely determine the design, it is important to remember that, in general, longitudinal study is a crucial part of research to fully understand the nature and complexity of the end of life experience, and despite its difficulties, should be attempted where feasible.

Ethical issues

Patients near the end of life may be regarded as especially vulnerable, making it harder to achieve ethical approval for research. Others regard research towards end of life as raising no additional ethical concerns beyond those applicable to all research participants (whatever their stage of illness). Certainly, the burden of research can be harder to cope with in advanced disease, and measures and surveys need to be reasonable brief and manageable. End of life research may also focus on issues that are uncomfortable for patients and professionals, making recruitment more difficult, and sometimes leading to 'gate-keeping' (a wish to protect patients from research burden) by professionals or family.

Research consent must be voluntary and informed, with capacity to understand and weigh up what is required. Although many patients toward the end of life may have less energy to take part in research, and indeed may have impaired capacity, others are only too keen to contribute, citing an altruistic wish to 'give something back to others' which is particularly valuable to them as they become less well (and may

lose other contributory or participatory roles in their lives).

Further reading

Many of these issues have been fully discussed and elucidated elsewhere, and can be read about in more detail in the following sources:

Agrawal M (2003) Voluntariness in clinical research at the end of life. J Pain Symptom Manage 25, S25-S32.

Barron JS, Duffey PL, Byrd LJ, Campbell R, Ferrucci L (2004) Informed consent for research participation in frail older persons. Aging Clin Exp Res 16, 79-85.

Casarett DJ, Knebel A, Helmers K (2003) Ethical challenges of palliative care research. J Pain Symptom Manage 25, S3-S5.

Davidson SN, Murtagh FE, Higginson IJ (2008) Methodological considerations for end-of-life research in patients with chronic kidney disease. J Nephrol 21, 268-282.

Koffman J, Murtagh FEM (2006) Ethics in palliative care research. In Bruera E, Higginson IJ, Ripamonti C, von Gunten CF (eds) Textbook of palliative medicine, pp. 192-201. London: Edward Arnold.

Resources and careers attended

i in it ment ng Malaugi tana craft ama dop béz nagka vingmina mga mga pali anti an lataus, basalogia ann sausai afil faction na financiar padas esing zal ang saylasan at talagna na cadi gian iang mana ana aja financiar.

Patients and carers 360 Professionals 364

Digadeli

Discoblin Living Albamance (C.L.), Attendance Allorance (A.A.). He slight days over the last and in Section, sold (J. of the Section) actumble to the bar bar, and the section, sold (J. of the Section) and the section Actumble (J. of the Section) as percentary as an order of the section of the section and the section of the section of

Sheh partent can usin the Disabent Living Allowance or exertes, on America, a living a large of the control of

Ellie baayes ran and he sy ardod (conoclar vindem in receiptof methenal and monitors component of the DLA, are blind, or diging necessarient and some an intelligential which gauses inability to work to the consideration of the control was and Applications the delight for marks to attack our earlier and integration or the control in the control of the control.

Consider an advance (Claims in the permit be given the strong of a discussion of safety and the strong of the stro

a complex injected not not beautiful regiment

- *Chizens Advice Pareso hards were a stadycelory UK.
- MandhalkRanes, St. orbital Halphad Tollob IS 401020 (place (No.World) redoem secret is a relationative (Mediano) and a secret is a secret in the property of the control of t
- major is ver direct por librejud conglicir simpore (Lugres) and 6 arc.
 A svice und 0545 MO verbichers advise ou complet version on a facilities
 according to the consental sale, and infallulation for the concentration.

Practical nelp

- Tael Brischick Discriment on voc (1). The understas unlike is that a one of the electric lands of the property of voc confidence that a substantial and the engine of voc confidence is the property out another tay to day activities (1). The engine of material results of the electric lands of the electric lan
 - Commonitive, and The Alexandry Consider obtainate Community rands
 - service councils.
 the Lead role and December of Construction of Source of

Patients and carers

The most commonly expressed concerns that renal patients or their families raise when terminal or end of life issues are discussed relate to the level of financial help and practical help they can expect to receive.

Benefits

The main benefits at the time of publishing are the following.

Disability Living Allowance (DLA)/Attendance Allowance (AA) The legal definition of terminal illness under Section 66(2)() of the Social Security Contributions and Benefit Act 1992 provides that you count as being terminally ill at any time 'if at that time (you have) a progressive disease and (your) death in consequence of that disease can reasonably be expected within 6 months'.

Such patients can claim the Disability Living Allowance or Attendance Allowance under special rules that require a doctor's DS1500 report to be completed and forwarded with the application. This will enable the 3-month qualifying period to be waived allowing patients to immediately receive the highest weekly rate of benefit for help with personal care and for mobility if the criteria are met.

Blue badges can also be awarded to people who are in receipt of the higher rate mobility component of the DLA, are blind, or 'have a permanent and substantial disability which causes inability to walk or very considerable difficulty in walking'. Applications should be made to the Concessionary Fares Department of the patient's local authority.

Carer's allowance Claimants need to be over 16 and spending at least 35 h a week caring for a person who is in receipt of the AA or DLA (at the middle or highest rate for personal care). You are not eligible to claim if you are in full time education with 21 h or more a week of supervised study or earn more than £100 per week after certain deductions.

Further information on benefit eligibility

• Citizens Advice Bureau http://www.citizensadvice.org.uk/.

Benefit Enquiry Line: free phone 0800 882200.

National Kidney Federation Helpline: Tel 0845 6010209; http://www.kidney.org.uk; email helpline@kidney.org.uk.

http://www.direct.gov.uk/en/CaringForSomeone Counsel and Care.
 Advice line 0845 300 7585 offers advice on community care, benefits, care at home, residential care, and financial help for older people.

Practical help

 The Disability Discrimination Act (1995) defines disability as 'physical or mental impairment which has a substantial and long-term adverse effect on (your) ability to carry out normal day to day activities'.
 Further information from the Disability Rights Commission Helpline 0845 762 2633 or http://www.equalityhumanrights.com/.

 Community care. The first step towards obtaining community care services is an assessment of needs. Social services currently has the lead role but local authorities have a duty to invite the NHS to assist if there is a health need and they are required to work closely together using pooled budgets and joint commissioning of services to provide the most appropriate level of care for the patient (NHS and Community Care Act 1990).

 Carers are also entitled to an assessment of need in their own right (Carers (Recognition and Services) Act 1995).

Support for carers

- Carers UK (Tel 020 7378 4999; free phone Carers' Line 0808 808 7777) provides information and advice on all aspects of caring to both carers and professionals.
- Crossroads—Caring for Carers (Tel 0845 450 0350) is committed to providing practical support where it is most needed. Trained carer support workers take over caring tasks in the home to provide carers with a break http://www.crossroads.org.uk/.
- Princess Royal Trust (Tel 0844 800 4361) provides free and confidential help for all carers.
- Department of Health caring about Carers: Carers UK http://www. direct.gov.uk/en/CaringForSomeone/index.htm.
- Expert Patient Programme—'Looking after me' provides training in self-managing the stresses and emotions that arise as a result of being a carer http://www.expertpatients.co.uk/
- British Kidney Patients Association (Tel 01420 541424) offers financial help and advice to patients and carers.

Useful websites

http://www.scie-socialcareonline.org.uk http://www.direct.gov.uk/en/Pensionsandretirementplanning http://www.dwp.gov.uk

After a death

Following a death there can be many practical issues to deal with.

- If a death occurs in hospital or in a hospice, the ward staff should have leaflets, such as DWP D49 'What to do after a death in England and Wales' or D49S 'What to do after a death in Scotland', that give advice and information about all aspects of bereavement.
- If a death occurs at home, the district nurse should be able to offer advice.
- Practical help and advice is also available from funeral directors, GPs, solicitors, religious organizations, social service departments, and the Citizens' Advice Bureau.

Organizations offering support

- Age UK is an organization that can offer pre- and post-death advice and support. Tel information line 0800 1696565; http://www.ageuk.org.uk/.
- Cruse Bereavement Care (Tel 0844 477 9400 provides bereavement support, information, advice, and support groups. http://www. crusebereavementcare.org.uk/.

APPENDIX Resources

 Compassionate Friends (Tel 0845 120 3785; Helpline 0845 1232304) offers nationwide support from bereaved parent to bereaved parent and their immediate families. http://www.tcf.org.uk/.

Criss Selection of the Louis ATT YOU provides belong the rent

 Winston's Wish (Tel 0845 2030405) offers a service to bereaved families and young people. http://www.winstonswish.org.uk/. Bereavement—Patient.co.uk http://www.patient.co.uk/.

ornaiszator (

de selvant au seille 9

potential services (B) = 22 of two to the war and the services (B) = 22 of two to the war and the services (B) = 4 of two to the war and the services (B) = 4 of two to the war and the war and the services (B) = 4 of two to the war and the war and

a rudgorus in Acero con cone eau ingressionale abraga e agreciado de 1936 y 25 con a substancia de la rudgorus de la rudgorus

The Cooking of the Co

Commission pulled is utility. POCSE sale seen in currendum in occurring in the control of the co

्यक समित्र है जि

 The Life has been use, stoned posequifier that hospite is used to see more other realities in direct in Copins was in color one observed ones.

Kisama v ter svingos specialismova sniku 2010 3.4 mi se iljeba di e Tana ogsadnika v 190 saprak orov Nikoroviki poviny avaljet i

Arthraus Deverbla

The company securities is a second of the se

and the definition open is 1940.

ed earnot roted with rare bus Leep or write an old thin Allice Down to arm to call the Allice Down to the more than the and educer sont if early the Call th

4,000,100

The NCLAS BACKS triple also be added in the second of the

ou minuser un soci pouzgrati les muselmades les la factificación de propulation de Propulation de la contraction de la

Professionals

Palliative medicine

Drug information

 Palliativedrugs.com provides essential, comprehensive, and independent information for health professionals about the use of drugs in palliative care. It highlights drugs given for unlicensed indications or by unlicensed routes and the administration of multiple drugs by continuous SC infusion: http://www.palliativedrugs.com.

 The Cochrane Pain, Palliative, and Supportive Care Group (PaPaS) focuses on reviews for the prevention and treatment of pain; the treatment of symptoms at the end of life; and supporting patients, carers, and their families through the disease process: http://papas.

cochrane.org/.

Community palliative care The GSF is a systematic approach to optimizing the care delivered by primary care teams for any patient nearing the end of life in the community: http://www.goldstandardsframework.org.uk.

End of life care

 The LCP has been developed to transfer the hospice model of care into other care settings: http://www.mcpcil.org.uk/liverpool-carepathway/.

 Guidelines for LCP prescribing in advanced kidney disease are available at http://www.liv.ac.uk/mcpcil/liverpool-care-pathway/lcp-specialist-

kidney-disease.htm.

 The Preferred Priorities of Care Plan (PPC) is intended to be a patient-held record that will follow the patient through their path of care into the variety of differing health and social care settings: http://www.endoflifecareforadults.nhs.uk/tools/core-tools/ preferredprioritiesforcare.

 e-Learning for Healthcare has been commissioned by the UK DOH; it aims to enhance the training and education of health and social care staff involved in delivering end of life care to people: http://www.e-lfh. org.uk/projects/e-elca/index.html. There is a specific module for renal

patients.

• The NCPC is the umbrella organization for all those who are involved in providing, commissioning, and using palliative care and hospice services in England, Wales, and Northern Ireland. NCPC promotes the extension and improvement of palliative care services for all people with life-threatening and life-limiting conditions. NCPC promotes palliative care in health and social care settings across all sectors to government, national, and local policy-makers: http://www.ncpc.org.uk.

Renal medicine

- The UK Renal Registry provides annual reports about treatment of end-stage kidney disease in the UK: http://www.renalreg.com.
- The Renal Association is the professional association for renal physicians. Provides links to most renal websites in UK, documents about providing renal care, and information about renal courses in UK: http://www.renal.org.
- Renal NSF Part 2 provides guidelines of good practice for end of life management and patient choice in kidney disease: http:// www.dh.gov.uk/en/Publicationsandstatistics/Publications/ PublicationsPolicyAndGuidance/DH_4101902.
- End of Life Care in Advanced Kidney Disease: a Framework for Implementation explores the kidney-specific issues of end of life care: http://www.endoflifecareforadults.nhs.uk/publications/ eolcadvancedkidneydisease.
- Kidney End-of-Life Coalition is a website with links to many other websites and resources addressing end of life concerns predominantly in the USA: http://www.kidneyeol.org.

Penal medicine

 The risk Rong Teerings provides Characteristics about creatment of applicage admissible souther UK Transport and reasonable

The kind Alseration the professional action decrees the serial serial serial serial serial serial series of the serial serial series at the serial series of the serial series and serial series serial seria

Pend NST Part ha ovinct undoines of the a machine on a colof the own remember, not have a choice in maney discused have wandhood account bue not a repart sucoff underword. Publican one flex and Guidance DH, NIO 952

 Europe State II. Adopted States Disease a Francisco del Implementation explorer the sudney Specific Acres of ord of Bleedare's from reviewed do known concerns. Logical Caronia.

Foldney Cod in Specification of the annual section of the content of the content

Index

A

acidosis 272 acupressure 145 adjuvant analgesia 128 end of life care 269, 281 kidney patient use guidance 125 in WHO analgesic ladder 115 advance care planning (ACP) 178 best practice 178 preferred place of care 286 Preferred Priorities of Care Plan (PPC) 180, 364 dialysis cessation 256 quality of life improvement 88 advance decisions to refuse treatment 235, 248, 256 do not resuscitate orders 70 advance directives/ statements 176, 236, 248 age (patient) chronic kidney disease prevalence and 2 comorbidity and 16, 36 factors affecting quality of life and 86 modality choice in renal replacement therapy and 12 primary renal diagnosis distribution by 9 renal replacement therapy statistics 8, 10 agitation 95, 166, 274, 283 alfentanil breakthrough/movementrelated/incident pain 130 buccal/nasal/ sublingual 129 end of life care 268, 270, 281 kidney patient use guidance 125, 330 in WHO analgesic ladder 121-2, 125 Alport's syndrome 5 amitriptyline 125, 128, 166 amoxicillin 332 amoxicillin/clavulanic

acid 332

anaemia 46, 145 anaesthetic procedures. pain management 132 analgesia, see pain management; specific drugs/drug types angina 24 anorexia/poor appetite 95, 139, 146 antibiotics 272, 332 anticipatory prescribing 264, 278 anticonvulsants 128, 159 see also specific drugs antidepressants 128, 166, 334 anti-emetics 150, 152 dosages in CKD5 335 end of life care 276, 283 antihistamines 142, 335 antimicrobials 332 see also antibiotics antimuscarinics 152 antipsychotics 274, 336 antisecretory drugs 337 see also specific drugs anxiety 167 anxiolytic dosages in CKD5 338 depression manifestation 166 end of life care 281 prevalence 95, 139 appetite, poor (anorexia) 95, 139, 146 appetite stimulants 147 assessment in ICP for end of life care 294 of pain 110 spiritual and religious care 256 of symptoms (general) 92, 96, 98 Attendance Allowance (AA) 360 attitudes, to death 251, 307 audit and research 347-56 challenges in 356 data sources 352 importance of 348 linking to existing expertise 350 autoimmune disease, chronic kidney disease causation 4

amputation 17, 28

autonomic neuropathy 18, 162 avoidance behaviour 206 azathioprine, side-effects 62

B

baclofen 128 bad news, communication of 214, 240 benefits 360 benzodiazepines agitation and delirium 274 anti-emetic use 152 anxiety 167 dyspnoea 272, 283 muscle spasm 128 restless legs syndrome (RLS) 159 see also specific drugs benzylpenicillin 332 bereavement care 322, 361 best interests, determination of 244 bisacodyl 154 blue badges 360 blue toe syndrome 27 bone disease post-transplantation 63 renal 50 bone fractures 36, 50, 63 breakthrough pain 130 breathlessness, see dyspnoea (breathlessness) Buddhism 308, 312 buprenorphine 119, 281, 330 burning foot syndrome 54

C

capacity
advance decisions to
refuse treatment 236,
249
consent and 242
definition of
incapacity 244
dialysis cessation
decision-making 256
dialysis refusal 261
ethical decision-making
principles 226
Mental Capacity Act
(2005) 242–8, 256
capsaicin cream 141

calciphylaxis 51, 160

calcium disorders 50, 160

carbamazepine 128 cardiac arrest 70 cardiac deaths 68 cardiopulmonary resuscitation (CPR) 70 cardiovascular disease (CVD) 22 coronary artery disease and diabetes 18 post-transplantation 63 prevalence of 16 risk factors 22 see also cerebrovascular disease: ischaemic heart disease (IHD); peripheral vascular disease (PVD) Care in the Community Act (1990) 318, 360 carers 315-22 background issues 319 bereavement care 322 expectations of 316 professional 320 support for 317, 361 see also families Carer's Allowance 360 care team, see multidisciplinary team (MDT) cause for concern registers 178 cefalexin 332 cefotaxime 332 ceftazidime 332 cefuroxime 332 central venous occlusion 56 cerebrovascular disease 18, 20, 30, 68 cetirizine 335 Cheyne-Stokes respiration 282 chlorphenamine 335 chlorpromazine 336 cholesterol emboli 4 Christianity 308, 312 chronic kidney disease (CKD) 2 causes 4 classification 328 chronic obstructive pulmonary disease (COPD) 17, 20 chronic pain clinic, referral to 132 ciclosporin, side-effects 62 ciprofloxacin 332 citalopram 166 clarithromycin 332 classification, of CKD 328 claudication 17, 26 clonazepam dosage in CKD5 330, 338

muscle spasm/myoclonic jerks 128, 274 neuropathic pain 128, 269, 281-2 restless legs syndrome 159 CNS effects, opioid side-effects 126 codeine phosphate 116. 125, 282, 330 cognitive function, impairment 36 bowel 128, 281 renal 128 collaborative working, see joint/collaborative working collusion 240 comfort 264 communication 200-22 advance decisions 249 conservative care choice 192, 200, 235 dialysis withdrawal/ withholding 208, 235, 256-7 difficult questions 216 as domain of care 264 with family members 194, 218 in Gold Standards Framework 190 helping with decision-making 206 information sharing within teams 222, 257 palliative and hospice care discussion 204 sexuality and intimacy 220 sharing bad news 214, 240 skills improvement 212 spiritual support 306 translation issues 250 comorbidity 15-36 amputation 28 cardiovascular disease 22 diabetes 18 factors affecting 16 as increased mortality risk predictors 66 infection 34 ischaemic heart disease (IHD) 18 malignancy 32 non-pain symptoms related to 162 old age and frailty 36 pain causation 106 peripheral vascular disease (PVD) 26 renal replacement therapy patient statistics 16

complications 39-60 anaemia 46 calcium/phosphate disorders 50, 160 electrolyte disorders 44 fluid overload 48 of haemodialysis (HD) 56 as increased mortality risk predictors 66 neuropathy 54 non-pain symptoms of long-term treatment complications 160 pain causation 106 of peritoneal dialysis (PD) 58 poor nutrition 52 summary 40 of transplantation 60 uraemia 42 confusion, opioid side-effect 126 consent 242, 357 conservative care 74 communication in choice of 192, 200, 235 end of life care 260 ethical and legal considerations 234 symptom prevalence 95, constipation 126, 154 control, loss of 83 convulsions 274 coronary angioplasty 17, 24 coronary artery bypass grafting 24 coronary artery disease 18 court-appointed deputies (CADs) 246 cramps, muscle 160, 164 cultural issues 250, 303, 306 see also ethnicity cyclizine 152, 276, 282-3 cysts, kidney 57

D

danthron 154 data sources, audit and research 352 daytime somnolence 144 see also drowsiness death attitudes to 251, 307 causes of 68-72, 74 definition of good 263 increased mortality risk predictors 66 mortality rates 66 post-death audit 290 registration data use 352

on renal unit 289 resources for help after 361 see also dying (end of life); dying (recognition of) death rattle 273 decision-making avoidance techniques 206 capacity and consent 242 conservative care choice process 200 dialysis withdrawal 208-9, 256 ethical process 232 helping with 206 principles of ethical 226 reflection on 206 decubitus ulcers 129, 163 see also ulcers (skin) delirium 274 denial 206 depression 36, 166 fatigue association 144-5 prevalence 95, 139 screening 80 dexamethasone 147, 151, 270 dextropropoxyphene 282 diabetes 4, 18, 162-3 prevalence 9, 11, 16-17 diabetic foot 163 diabetic neuropathy 162 diabetic retinopathy 18 diagnosis (primary renal) 9 dialysis angina/arrhythmias during 24 complications of 57 continuation in end of life care 260, 284 difficult questions at end of life 196 health-related quality of life (HRQOL) 82-6, 90 modality statistics 8, 10 new patient statistics 8, 16 pain causation 106 patient comorbidity statistics 16 poor prognosis-associated factors 234 post-dialysis fatigue 145 refusal in non-competent patients 261 related non-pain symptoms 164 symptom prevalence in patients 95, 138 trial period 236 withdrawal/withholding, see dialysis withdrawal/

withholding

see also haemodialysis (HD); peritoneal dialysis (PD); renal replacement therapy (RRT) dialysis amyloid arthropathy 57 Dialysis Symptom Index (DSI) 96 dialysis withdrawal/ withholding as cause of death 68, 72 communication 208, 235, 256-7 end of life care 256, 260 ethical and legal considerations 234 factors to consider before 235, 256 impact of fatigue and 144 nursing perspective 289 symptom anticipation 256, 267 symptom prevalence 95, diamorphine 129 diazepam 128, 152, 167, 338 dihydrocodeine 116, 282 Disability Discrimination Act (1995) 360 Disability Living Allowance (DLA) 360 disease staging, chronic kidney disease 2 docusate 154 domains of care 262, 264 domperidone 152 do not resuscitate orders 70 dopamine receptor agonists 159 dosulepin 334 drowsiness 95, 126, 144 see also daytime somnolence drug dosages 325-44 analgesics 125, 330, 344 antidepressants 334 anti-emetics 335 antihistamines 335 antimicrobials 332 antipsychotics 336 antisecretory drugs 337 anxiolytics/hypnotics 338 dosage guidance background information 328 drug handling 112, 326 drugs not requiring dosage alteration 340 drugs to avoid 342 miscellaneous drugs 339 drug handling 112, 326

drugs to avoid 342 see also drug dosages drug-induced chronic kidney disease 6 drug information, professional resources 364 dying (end of life) end of life care, see end of life care patient and family perspective 194 prediction of 76 quality of life 88 recognition of, see dying (recognition of) symptom trajectories 98 dying (recognition of) 185-96 challenge of 186 Gold Standards Framework 190 nephrologist's perspective 196 patient and family perspective 194 supportive and palliative care need recognition 188 terminal phase recognition 192, 262 dyspnoea (breathlessness) 95, 139, 272, 283

E

Edmonton Symptom

education, patient 12

(ESAS) 96

elderly patients

Assessment Scale

chronic kidney disease

prevalence 2 comorbidity 36 renal replacement therapy 12, 238 e-learning for Healthcare 364 electrolyte disorders 44 emboli, cholesterol 4 encapsulating peritoneal sclerosis 59 end of life, see dying (end of life) end of life care agitation, delirium and neurological problems 274 anticipatory prescribing 264, 278 dialysis cessation considerations 256 dialysis continuation 284

domains of care 262, 264 dyspnoea and retained secretions 272 emphasis of 254 expected death 260 integrated care pathway (ICP) 262, 294 main principles summary 292 nausea and vomiting 276 nursing perspective 288 pain management 264, 268, 280 preferred place of care 286 professional resources 364 quality in care 262 spiritual and religious care 265, 308 symptom control guidelines 280 symptoms at end of life 266 syringe driver use indications 278 end-stage kidney disease (ESKD) 1-12 enduring power of attorney (EPA) 242-3 enemas 154 enteropathy, diabetic 162 entonox 130 episodic pain 130, 270 erythromycin 332 erythropoietin 142 erythropoietin resistance 46 escitalopram 334 ethical and legal considerations 226-50 advance decisions to refuse treatment 248 consent and capacity 242 conservative care choice 234 court-appointed deputies (CADs) 246 end of life research 357 ethical decision-making process 232 lasting power of attorney (LPA) 246 multicultural issues 250 principles of ethical decisions 226 renal replacement therapy in elderly patients 238 truth telling and collusion 240 ethnicity 2, 10, 16 see also cultural issues expectations, unmet 83

eye problems/visual impairment 18, 36

familial disease, chronic

kidney disease

F falls 36

causation 5 families bereavement care 322, 361 collusion with 240 communication with 194, 200, 209, 218 decision-making role 209, 235, 242 end of life care involvement 257 perspective on dying 194 support for 289 surveys/questionnaires 352 see also carers fatigue 95, 139, 144 post-dialysis 145 fentanyl breakthrough/movementrelated/incident pain 130 dyspnoea 272, 283 end of life care 268, 270, 272, 280 kidney patient usage guidance 125, 330 renal colic management 128 topical 129 in WHO analgesic ladder 118-20, 122, 124 flucloxacillin 332 fluconazole 332 fluid overload 48, 272, 283 fluoxetine 166, 334 fractures, bone 36, 50, 63

G

frailty 37

gabapentin
dosage in kidney
disease 125, 330
myoclonic jerk
causation 274
neuropathic pain 128, 269
pruritus 142
restless legs syndrome 159
gangrene 27, 163
gastroparesis 18, 162
gender
primary renal diagnosis
distribution by 9, 11
renal replacement therapy
differences 8, 10

glomerular filtration rate (GFR) in chronic kidney disease definition and staging 2, 328 estimation of 328 uraemic symptoms and 42 glomerulonephritis acute post-infectious 5 chronic kidney disease causation 4-5 diagnostic prevalence 9, 11 glycopyrronium 273, 337 Gold Standards Framework 176, 190, 364 good death, principles of 263 good practice frameworks/ guidelines 229 granisetron 152 grief 194, 218, 264, 306

H

haematological malignancies 5, 32 haemodialysis (HD) choice of 12 complications of 56 elderly patients 13, 238 in end of life care 284 health-related quality of life (HRQOL) 82 usage statistics 8, 10 see also dialysis; renal replacement therapy (RRT) haloperidol 152, 274, 276, 283 dosage in CKD5 335-6 health-related quality of life, see quality of life (healthrelated (HRQOL)) hearing impairment 36 heart failure, fluid overload and 48 heat sensation. paradoxical 54 hepatitis B 5, 34 hepatitis C 5, 34 Hinduism 309 HIV (human immunodeficiency virus) 5, 34 hospice care 204 human immunodeficiency virus (HIV) 5, 34 human leukocyte antigen (HLA) antibodies 63 hydromorphone breakthrough pain 130 kidney patient use guidance 125, 330

movement-related/ incident pain 130 in WHO analgesic ladder 118, 121, 124 hyoscine butylbromide 128, 152, 273, 283 dosage in CKD5 337 hyoscine hydrobromide 152, 337 hyperkalaemia 44 hyperparathyroidism 50 hyperphosphataemia 50 hypertension 4, 9, 11

hypnotics 156, 338

hypokalaemia 44 hyponatraemia 44 hypotension 24, 30, 164 ibuprofen 330 immunosuppression, complications and side-effects 60-1 incident pain 108, 130, 270 infection as cause of death 68 of central venous catheter 57 comorbidity 34 diabetic patients 18 kidney failure causation 5 pain causation 106 peritonitis 58 post-transplantation 60 pyelonephritis 9, 11 information sharing 222, 257 insomnia 156, 166 see also sleep disturbance integrated care pathways (ICP) 262, 288, 294 intimacy 220 Intrasite® gel 129 ischaemia. limb-threatening 27 ischaemic heart disease (IHD) 17, 20, 24, 163 ischaemic neuropathic

ioint/collaborative working 173, 182 information sharing 222, see also multidisciplinary team (MDT)

pain 26

Islam 309, 312

ischaemic rest pain 26

itch, see pruritus (itch)

joint stiffness/pain 50, 57, 281 ludaism 310, 312

K

kidney cysts 57 Kidney Disease Quality of Life (KDQOL) measure 80 kidney tumours 5, 32, 57

language barriers 250, 306 lasting power of attorney (LPA) 242-3, 246 laxatives 154 legal issues, see ethical and legal issues lethargy, see daytime somnolence; fatigue levomepromazine 152, 276, 283, 335 limb-threatening ischaemia 27 line infection 57 liver disease 17, 20 Liverpool Care Pathway (LCP) 262, 294, 364 lorazepam 152, 167, 274, 338

м

macrogols 154 malignancy as cause of death 68 diabetes comorbidity 20 dialysis continuation in terminal 260 as haemodialysis complication 57 kidney failure causation 5 post-transplant 61 prevalence 17 malnutrition 36, 52, 146 mast cells, pruritus pathophysiology 140 mental capacity, and incapacity, see capacity Mental Capacity Act (2005) 242-8methadone 121, 330 metoclopramide 146, 152, 276, 283 metronidazole 332 microalbuminuria 3 midazolam agitation/restlessness/ delirium 274, 283 anxiety 167, 281 convulsions 274 dosage in CKD5 338 dyspnoea 272, 283

muscle spasm 128 mirtazapine 142, 334 morphine breakthrough pain 130 end of life care 268 myoclonic jerk causation 274 topical 129 in WHO analgesic ladder 118 mortality 66 see also death mouth dryness 95, 148 movement-related pain 108, 130, 270 multicultural issues, see cultural issues; ethnicity multidisciplinary team (MDT) dialysis withholding/ withdrawal decisions 235-6, 257 information sharing 222, support for 290 see also joint/collaborative working; professionals muscle cramps 160, 164 muscle spasm 128 mycophenolate 62 myocardial infarction 24 myoclonus 95, 126, 274

nalfurafine 142 naltrexone 142 National Council for Palliative Care (NCPC) 364 National Service Framework (NSF) for renal services 228-9, 365 nausea and vomiting 150 end of life care 276, 283 management 150, 152 opioid side-effect 126 prevalence 95, 139 neurological problems, end of life 274 neuropathic pain ischaemic 26 management of 108, 128, 269, 281 neuropathy 18, 54, 162 nitrazepam 338 nociceptive pain 108 non-English speaking patients 250, 306 non-pain symptoms 137-68 anticipatory prescribing 264, 278 causes of 138 at end of life care 266, 280

prevalence of 94, 138 summary 168 see also specific symptoms NSAIDs (non-steroidal anti-inflammatory drugs) end of life care 226, 281 - 2kidney disease usage guidance 125 renal colic 128 topical 129 in WHO analgesic ladder 116, 124 nutrition, poor 36, 52, 146

ocreotide 337 oedema 48 olanzapine 336 ondansetron 142, 152 opioids breakthrough/movementrelated/incident pain 130, 270 dyspnoea 272, 283 end of life pain management 268, 280 kidney patient usage guidance 125, 330 renal colic 128 restless legs syndrome 159 side-effect management 126 topical 129 in WHO analgesic ladder 116, 118-24 oxazepam 338 oxycodone breakthrough pain 130 kidney patient use guidance 125, 330 movement-related/ incident pain 130 in WHO analgesic ladder 119, 121, 124

pain assessment 110 causes of 106 clinic referral 132 impact of 104 incidence/prevalence of 95, 104 management, see pain management in peripheral vascular disease (PVD) 26 types of 108 see also specific types

pain management 103-34 adjuvant analgesia, see adjuvant analgesia anaesthetic procedures 132 anticipatory prescribing 264, 278 assessment of pain 110 chronic pain clinic referral 132 end of life care 264, 268, 278, 280 episodic, movementrelated, or incident pain 130 hindering factors 112 kidney patient drug use guidance 125, 330, 344 neuropathic pain 108, 128, 269, 281 opioid side-effect management 126 palliative care team referral 134 WHO analgesic ladder 114-24, 344 palliative care 171-82 advance care planning, see advance care planning (ACP) aims 173 cause for concern registers 178 definition 172 discussion with patients and families 204 joint working 173, 182 preferred priorities of care 180 quality of life trial results 88 reasons for requirement of 174 recognition of need 188 referral to 134, 182 resources for professionals 364 UK specialist service provision 174 pan-Thames renal end of life audit tool 353-5 paracetamol end of life care 269, 272 in WHO analgesic ladder 116, 124 paradoxical heat sensation 54 parathyroid hormone (PTH) 50 paroxetine 334 Patient Outcome Scale, renal version (POSs renal) 96

patient surveys/ questionnaires 352 pelvic tumours 5, 32 pericarditis 270 peripheral neuropathy 18 peripheral vascular disease (PVD) 26, 162 as cause of death 68 diabetic patients 17-18, 20 peritoneal dialysis (PD) ambulatory (APD) 58 assisted 13 choice of 13 complications of 58 elderly patients 13, 238 in end of life care 284 health-related quality of life (HRQOL) 82 usage statistics 8, 10 see also dialysis; renal replacement therapy (RRT) peritonitis 58 sclerosing 59 pharmacokinetics 112, 326 phosphate disorders 50 phototherapy, ultraviolet B 142 physiotherapy 145 piperacillin 332 place of care, preferred 180, 286 pneumonia 272 polycystic kidney disease 5, 9, 11, 106 polyethylene glycol 154 post-bereavement surveys 352 post-death audit 290 post-transplant lymphoproliferative disorders (PTLDs) 61 pramipexole 339 prednisolone 270 preferred place of care 286 Preferred Priorities of Care Plan (PPC) 180, 364 pregabalin 330 prevalence, chronic kidney disease 2 prochlorperazine 335 professionals resources 364 support for 320 surveys 352 see also multidisciplinary team (MDT) prognostication 76, 188, 191, 257 protein binding, drugs 326 proteinuria 3

pruritus (itch) 95, 139-40,

339

quality (of care) 262 see also audit and research quality of life (health-related (HRQOL)) 77-90 conclusions 90 conservative care 74 contributory components 78 dialysis patients 82-6, 90 at end of life 88 factors affecting 86, 144 measures of 80 terminology 78 questionnaires 352 quetiapine 336

R

ranitidine 337 referral (to nephrologist), timing of 16, 66 rehabilitation programmes 145 religious care, see spiritual and religious care Renal Association, the 365 renal bone disease 50 renal carcinoma 5, 32 renal colic 128 renal excretion, drugs 327 renal medicine, professional resources 365 Renal Physicians Association of the USA, guidelines 230-1 Renal Registries 352, 365 renal replacement therapy (RRT)

comorbidity statistics 16 complications of 56-60 elderly patients 12, 238 modality choice 12 usage statistics 9 see also dialysis; haemodialysis (HD);

peritoneal dialysis (PD); transplantation renovascular disease 9, 11 research, see audit and research

resources patients and carers 319, 360

professionals 364 respiratory depression, opioid side-effect 126 respiratory secretions, retained 273, 283 restless legs syndrome (RLS) 54, 158, 339 prevalence 95, 139 restlessness 283 see also agitation

rest pain, ischaemic 26-7 retained respiratory secretions 273, 283 retinopathy 18

revascularization 27 risperidone 336

sclerosing peritonitis 59 selective serotonin reuptake inhibitors (SSRIs) 166-7 senna 154 sensitization post-transplantation 63 pruritus pathophysiology 140 sensory symptoms/ syndromes 54 sertraline 166 sexuality communication 220 sexual dysfunction 18, 161 Short Form-36 80 Sikhism 312 silent myocardial ischaemia 24 sirolimus, side-effects 62 skin cancers, post-

skin care 141, 163 skin dryness, pruritus and 140 skin ulceration, see ulcers (skin)

transplantation 61

sleep disturbance 95, 139, 156, 166

see also restless legs syndrome (RLS) smoking 17, 20 social isolation 36 social support 265

spiritual and religious care 297-308 cultural issues 306 definitions/

terminology 298 end of life care domain 265

needs assessment 302 religious practices of different faiths 308 steroids

anti-emetic use 152

appetite stimulation 147

end of life pain management 270 pruritus management

inefficacy 141 side-effects 61 see also specfic drugs stroke 30

subacute bacterial endocarditis 5

supportive care definition 172 recognition of need 188 see also palliative care

suppositories 154 surprise question, the 76, 178, 188

surveys 352 survival rates, 5-year 66 symptoms

assessment of 92, 96, 98 dialysis withdrawal and anticipation of 256,

at end of life 266 non-pain, see non-pain

symptoms pain, see pain; pain management prevalence of 94, 138

recognition challenges 92 trajectories 98 see also specific symptoms syringe drivers 278

т

tacrolimus 62, 141 tamoxifen 59

tazobactam 332 teicoplanin 332 temazepam 338

thalidomide 142, 339 thirst 148

trajectories, symptom 98 tramadol end of life care 282

kidney disease usage guidance 125, 330

in WHO analgesic ladder 116, 118, 124

transplantation choice of 12 complications of 60 see also transplant rejection living donor 12 treatment rate statistics 8,

transplant rejection 6, 60, 270

tricyclic antidepressants 128,

152, 166

trimethoprim 332 tropisetron 152 truth telling 240 tuberculosis (TB) 35 tuberous sclerosis 5

U

ulcers (skin) calciphylaxis-related 160 decubitus 129, 163 diabetic foot 163 management 129, 163 prevalence 17 ultrafiltration failure, peritoneal dialysis 58 uraemia 42, 74 urinary tract infection, post-transplantation 60 urinary tract tumours 5, 32

V

vancomycin 332
vascular access failure 56, 238
vascular calcification 51
vascular disease 4
see also specific types
venlafaxine 334
visual impairment/eye
problems 18, 36
volume of distribution (Vd),
drugs 326
Von Hippel–Lindau disease 5

weakness 139, 144, 272 weight loss 146 WHO analgesic ladder 114–24, 344

younger patients 86

Z

zolpidem 156 zopiclone 156, 338